# HIDDEN HISTORY

# of

# TACOMA

*Little-Known Tales
from the City of Destiny*

## KARLA STOVER

Charleston · London

THE
History
PRESS

Published by The History Press
Charleston, SC 29403
www.historypress.net

First published 2012

Manufactured in the United States

ISBN 978.1.60949.470.4

Stover, Karla Wakefield.
Hidden history of Tacoma : little-known tales from the city of destiny / Karla
Stover.
p. cm.
Includes bibliographical references.
ISBN 978-1-60949-470-4
1. Tacoma (Wash.)--History--Anecdotes. 2. Tacoma (Wash.)--Social life and
customs--Anecdotes. 3. Tacoma (Wash.)--Biography--Anecdotes. 4. Historic
buildings--Washington (State)--Tacoma--Anecdotes. 5. Tacoma (Wash.)--
Buildings, structures, etc.--Anecdotes. I. Title.
F899.T2S77 2012
979.7'788--dc23
2012000249

*To my husband, Ed,*
*forever the wind beneath my wings,*

*and my parents,*
*who told me stories about the old days.*

# Contents

# Contents

*Part I*

# God Made the World and Men Made Tacoma

## JUST GIVE THE MAN A RULER: LAYING OUT A TOWN

*The Tacoma Land Company has begun selling lots on what they call Pacific*
*Avenue where they hope a downtown will develop. Two hundred and fifty*
*dollars will buy you a lot with a corner. Non-corner lots go for two hundred*
*dollars. Rental property is one dollar a frontal foot. The land has been*
*burned off but stumps and piles of debris remain. The hill is so water-*
*soaked that the railroad could be trying to build a city in the shallowest*
*lake or steepest swamp known to man.*
*—an Oregon observer*

On September 10, 1873, the Northern Pacific Railroad's board of directors
chose Tacoma as the railroad's western terminus. Soon after this, the
company purchased three thousand acres of land, including that on which
the city is located. The railroad company kept some acreage for railroad
shops and depot buildings and assigned to its subsidiary, the Tacoma Land
Company, the task of selling the rest.

Laying out cities in the 1870s was child's play. The ideal was a broad
rectangle subdivided into squares. All that was required was a map and a
ruler. James Tilton, who had been surveyor general of the territory back in
the Isaac Stevens era, was still around. The Land Company handed him a
ruler and asked him to start drawing.

One story going around at the time was that General Morton Mathew McCarver suggested Tilton follow the plan that had been used to plat Sacramento. Another was that Tacoma's layout was patterned after that of Melbourne, Australia.

Tilton's sketches didn't survive, but on October 3, 1873, in a *Weekly Pacific Tribune* article, he said he just made a few modifications to the basic grid plan then in vogue. He drew three main avenues 100 feet wide to parallel the waterfront and two others slanting diagonally up the face of the hill. The slant was a concession to the difficulties both horse-drawn streetcars and pedestrians would encounter on a direct climb. He flanked these five streets with blocks 120 feet deep. Additional streets for future residential areas were 40 feet wide—too broad to degenerate into alleys but not grand enough to detract from the designated thoroughfares.

He left open a twenty-seven-acre area of land approximately one thousand feet south of the bay for development as a central park or as the campus for a complex of buildings should Tacoma become the county seat or territorial capital. And finally, he left land at both the north and south ends of town for two smaller parks.

This first dream of how Tacoma would look failed to get off the drawing board. Though board members expressed some dissatisfaction with Tilton's proposals for solving drainage problems on the clay-bank hill, far more important was financier Jay Cooke's slide into bankruptcy. As Cooke's railroad bond sales slowed, whatever money the Land Company could raise offered the best hope for working capital. The railroad's directors chose C.B. Wright to head the Land Company, and almost immediately President Wright began to discuss replacing Tilton. Wright wanted the future city platted by the country's best-known landscape architect, the brilliant, unorthodox, opinionated and highly controversial Frederick Law Olmsted.

A journalist turned planner/administrator, Olmsted was most well known for conceiving and bringing into being New York's Central Park. And Olmsted liked "gracefully-curved lines, generous spaces and the absence of sharp corners, the idea being to suggest and imply leisure, contemplativeness, and happy tranquility."

The thought that Wright and the board were concerned with prompting happy tranquility at their terminus is a stretch. What more likely appealed to them was Olmsted's capacity for attracting attention, and his reputation for finding novel solutions to difficult problems of terrain. Whatever their reason, the board summoned Olmsted to the railroad's New York headquarters

the day after Cooke's bank closed and commissioned him to make "in all possible haste" a preliminary study for the town site.

Olmsted teamed with G.K. Radford, an experienced sanitary and hydraulic engineer, in creating the plan. How the two men divided the labor isn't known, but it is likely that Radford concentrated on drainage problems and Olmsted on creating a town that would "blend with sea, forest, and mountain." Olmsted never actually came to Tacoma; he worked from contour maps and sketches. His final design featured a meandering latticework of diagonals that climbed the hill from the bay. The plan was delivered to the Northern Pacific on schedule in early December and reached Tacoma the week before Christmas. Tacoma Land Office officials immediately put it on display.

The Land Company building was one of the first in New Tacoma. It was at Ninth Street and Pacific Avenue and was built on pilings over a skunk cabbage swamp. The site was chosen because building over a swamp meant the men didn't have to fell trees and clear a lot. Almost immediately, the company had acres of adjacent woodland slashed down. Thirty-foot-deep piles of wood covered a 480-acre tract, and when the weather was warm enough, the piles were burned. Initially, Tacoma's town site was a smoking ash heap with stumps and a few logs.

Meanwhile, residents, who had been eagerly awaiting the metamorphosis of the clay cliff into the metropolis of their dreams, studied Olmsted's vision with consternation.

Tacoma Land Office, 1874.

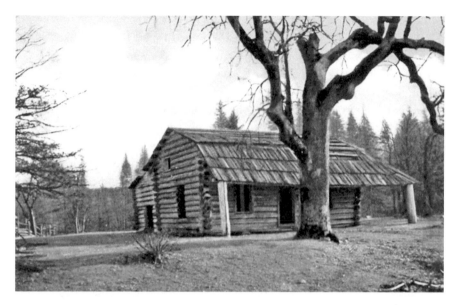

An old homestead.

Thomas Prosch, who had bought the Olympia newspaper *Pacific Tribune* from his father, Charles, and moved it to Tacoma on the strength of its prospects as a terminus, reflected the ambivalence of the locals in a long but subdued story that appeared on December 23.

The plan, he said, was "unlike that of any other city in the world" and "so novel in character that those who have seen it hardly know whether or not to admire it, while they are far from prepared to condemn it." The most peculiar features, he wrote,

> *were the varying sizes and shapes of the blocks, and the absence of straight lines and right angles. Every block, street and avenue was curved. The lots had uniform frontages of twenty-five feet, but differed in length. The curvature of the blocks did away with corner lots, and the varying lengths eliminated many of the problems that occurred when people crossed street at corners where collisions and accidents most frequently happen—corners that because of their frequent use resulted in problems with mud and dust.*

Olmsted's three main avenues were Pacific, Tacoma and Cliff, which is now Stadium Way. He designated Pacific Avenue, which came up the bank from the railroad dock and out into the country, for businesses. Two-mile-long Cliff Avenue, which ran along the edge of the bluff, was the residential street. And one-mile-long Tacoma Avenue, which intersected with Pacific Avenue before

extending to the water at a spot between Old and New Tacoma, seemed to have no particular designation other than that it would pass the seven parks of varying size Olmsted's plan allowed for. Mr. Prosch felt that time alone would prove the plan's practicality but added, hesitantly, "Certainly, if a large city is ever built here, after that plan, it will be through and through like a park, and have very many important advantages over other cities."

Newspapers in Portland, New Tacoma's main rival at the time, also took a look at Olmsted's plan. The *Bulletin* conceded the originality of the famous planner's concept but noted, "Tacoma is already set upon a hill, or two hills for that matter; it would be ridiculous for such a city to copy after places like Chicago or San Francisco. Tacoma resolves to have individuality and to assert it." The paper also noted that the curve, the favorite geometrical line at Tacoma, was supposedly "borrowed from the movements of the celestial spheres, or other aspects of nature. With these movements," the paper concluded, "Tacoma was determined to be in harmony, and with her new plat, would be almost as perfect as anything can be in this ill-favored world."

Tacomans were neither amused nor enthusiastic about Olmsted's plan. The *Pacific Tribune* had a follow-up story and focused on the "assumed wisdom" of the managers of the Pacific Division of the Northern Pacific rather than on the plan itself. The paper agreed that the Olmsted concept was approved by men of "ripe judgment and unquestioned taste whose views were that it would make a beautiful city and was adapted to the character of the ground." However, many in Tacoma were skeptical. Speculators who wanted to buy corner lots saw no merit in a downtown deliberately left deficient in four-way intersections. To them, Olmsted's dream of a business district without bottlenecks was a nightmare. Nor were the engineering crews assigned to run lines amid downtown's many stumps in order to locate Pacific, Cliff and Tacoma Avenues persuaded by Olmsted's dictum that "speed of traffic is of less importance than comfort and convenience of movement."

Early settlers, who had seen others profit from the rise of foursquare business districts, grumbled that the plan resembled "a basket of melons, peas and sweet potatoes." They said that "in the street patterns one could find representations of everything that has ever been exhibited in an agricultural show, from calabashes to iceboxes."

In prosperous times the Olmsted plan might have survived, even benefited from the controversy and ridicule. But the Northern Pacific's board lacked the confidence to wait out the discontent. Also, after Jay Cooke's bank failed, the financial panic deepened into depression, and the railroad was desperate for capital.

Only forty-three days after he had submitted the plan, Olmsted was notified that his ideas would not be used and his services were no longer required; Tacoma would be built on a traditional grid. Neither the letters of dismissal nor Olmsted's reply have ever been located. And Olmsted did not publically mention the rejection.

As people started buying lots, one of Tacoma's most successful real estate investors was a man named Peter Irving. In 1874, he spent $400 and bought lots at 909 and 911 Pacific Avenue. In 1882, he built two buildings at a cost of $1,500. From then on, tenants made and paid for all the improvements and repairs. For the next twenty-three years, one building was vacant for a month and the other was constantly rented. Generally, the rents were $200 to $225. After the original cost, all taxes and insurance, Mr. Irving netted a profit of between $40,000 and $50,000. In 1905, he turned down an offer of $40,000 for the property and then a second one of $45,000. Instead, he took down the wooden buildings and replaced them with a single brick one. The new building was 16 by 120 feet and had three floors and skylights. It's still in existence, and most old-timers will know it as the building where Ghilarducci's florist used to be.

Not long after the Land Company constructed its little cabin, the Squire Building at 726 Pacific Avenue became Tacoma's first frame building. North School, built at 246 St. Helen's, soon followed. William J. Fife, who moved to

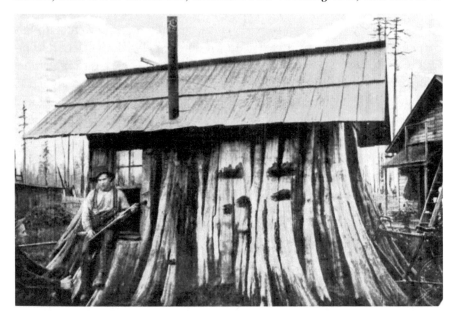

A typical stump house.

New Tacoma with his family in 1874, said he went to school for two years in a dugout with six other pupils because that was all the town could afford.

As 1875 drew to a close, quite a little settlement had developed. Seventy people lived in town; two families lived in the suburbs, and thirteen people lived down on the wharf. A wagon road connected New Tacoma and Old Tacoma. Steilacoom was the county seat, and land office employee Colonel C.P. Ferry had to make frequent trips there to take care of things such as taxes. The easiest way to get to Steilacoom was by wagon or horseback on an old road that went from New Tacoma to Old Tacoma and doubled back close to New Tacoma on the other side of a substantial wooded hill. Colonel Ferry finally persuaded officials to let him use some of New Tacoma's tax revenues to build a shortcut up from Pacific Avenue, creating what is now Ninth Street. The officials allotted thirty-six dollars, which was only enough to slash the road and cut the logs into lengths. New Tacoma residents finished the job. The city's three businesses—a livery stable, store and the land office—shut down for the day, and everyone turned out to clear the road. The work took two days and was followed by a big picnic with lots of speeches. The new road intersected the Old Tacoma–Steilacoom road at about where Division and Ainsworth now meet.

New Tacoma soon had two other buildings. The Washington House, believed to be Tacoma's first hotel, was built at 700 Pacific Avenue in 1875 by a Mr. Fairhurst. In spite of being called a hotel, it was mainly a lodging house for men the Land Company hired to grade roads and lots. The other building was the American Hotel at 702 Pacific Avenue. Both were destroyed by fire.

But the Tacoma Land Company wasn't the only real estate office in town. Its competition was First Real Estate, located in a plain frame building with pine fixtures, owned by Samuel Wilkeson. Mr. Wilkeson was the son of the Northern Pacific board's secretary. In addition to the real estate office, he owned additional downtown property, part of which was at Ninth and Pacific. Before the Rust Building was built there, Mr. Wilkeson built structures that lasted for years. His home, which was considered a city mansion at the time, was at Seventh and Broadway. He also owned much of the property on which Stadium High School now stands.

At some point in the 1880s, the Land Company moved to the Viant and Pierce Building at 728–30 Pacific Avenue. Currently, it's on South Union. And finally, apropos of nothing but an interesting footnote to Tacoma as it used to be, when Commencement Bay was at high tide, the water came clear up to where the Union Depot now stands.

## Peril with Piling Worms: Life on the Wharf

One day in 1890, a fisherman named Casper Witt, whom papers called "large and fleshy," was walking down Second Street when his leg seemed to collapse under him. He fell onto the sidewalk, and several people rushed to his aid. They were horrified to see what appeared to be pieces of bone protruding through the fabric of his pants.

"Who shot you?" someone shouted.

"Shot, hell!" snapped Casper.

Apparently, Casper had made a fishing haul and, along with other men, brought his catch to shore. As was the custom, he immediately cleaned his nets. Casper wore a rubber boot on one foot, but the other leg was wooden.

"It's them cussed teredoes [piling worms]," he said. I might have known they'd get to work on me. There's a forty-dollar wooden leg gone to smash."

Civilization may have been making its mark on Puget Sound, but Mother Nature had her own ways to strike back.

<center>❧</center>

After Nicholas Delin built a mill on Commencement Bay but left during the Indian Wars and Job Carr arrived ten years later and settled in Old Town, Civil War veteran William Blackwell and his wife, Alice, came with the Northern Pacific Railroad to run a hotel on the wharf. They were instrumental in building Tacoma.

The Blackwells left Kalama on November 15, 1873, spent the night at Tenino and reached Tacoma on the evening of the following day aboard the first passenger train to Tacoma. Railroad employee General John W. Sprague met them at the edge of Commencement Bay below Fifteenth and A Streets, where the tracks stopped, and led them to a boat; several Chinese men then rowed them to the hotel below where Stadium Bowl is today. The tide was out, but men laid planks on the beach, and the couple picked their way up them. The hotel was on a dock built on pilings, so they climbed more planks to the dock.

Their new home and place of business was a covered frame with floors and partitions for the rooms, of which only two were finished. The Blackwells had no food, no place to buy any and no place to cook if they could find some. A man operating a pile driver invited them to dinner and breakfast the following morning, and William hired two railroad workers to return to the

<center>14</center>

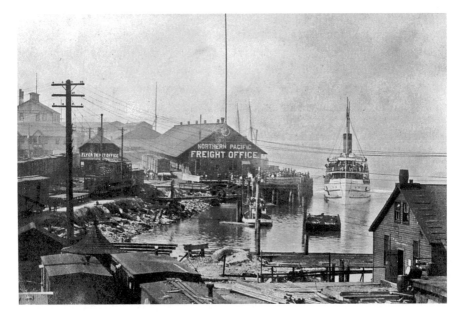

The wharf. *Courtesy of Robin Paterson.*

train and bring back their bedding. Over the next two months, some railroad employees finished the hotel, and others extended tracks there. Both train and hotel business officially began on January 1, 1874.

The Northern Pacific Hotel and the Blackwells' private apartment were on the second floor of the building, which was twenty feet wide and two hundred feet long. William Blackwell and railroad officials had their offices on the ground floor. The hotel had forty bedrooms, some single and some double, and in a pinch slept one hundred. There were two bathrooms, a dining room and a bar. The bartender, Jacob Mann, maintained a two-drink maximum. Chinese men did all the cooking, and Alice Blackwell and one Chinese helper took care of the rooms. After a few years, because of vibrations when ships docked, the building was moved off the pilings and onto land close to the bluff.

As the hotel developed, Alice had hundreds of flower boxes made. At the end of their workday, railroad employees carried back sacks of dirt and leaf mold to fill them. She also bought property in her own name on the hill above the hotel. At the end of her workday, she climbed the hill to her property and took care of her roses and chickens. Until her death, Mrs. Blackwell provided flowers for every important event and to every important visitor who came to Tacoma.

Within a matter of months after their arrival, the Blackwells acquired neighbors. In addition to the railroad officials, there were three families; two

small stores; a telegraph office that had been on a floating barge but relocated to a permanent facility; Mr. and Mrs. M.V. Money's combination printing business, newspaper, stationery store and aviary; and Mr. Doughtery's shoe shop. Mr. Dougherty found a three-foot-wide space between two buildings, roofed it and began repairing and making shoes there. The Moneys did all the printing for the local railroad officers—at least for a while. Mrs. Money was very popular with sailors because she ran the shop with a parrot on her head. But after a few years, General Sprague said he was tired of finding parrot tracks on his stationery and, as soon as another printer showed up, took his business elsewhere. Finally, at the far end of the wharf, down near Twenty-first Street, Robert Scott had a dairy. He delivered milk by scow or by wagon, which he decked out with bells, and for additional income he toted visitors around. Tacoma had a shortage of coins, so to supplement them people used brass coins made at the Hanson and Ackerson Mill. The mill's blacksmith hammered out the slugs in three denominations: one dollar, forty-five cents and forty cents. They were intended for use at the company store but soon became accepted currency around town. Mr. Hanson credited residents' honesty, plus the fact that for a time he employed the only blacksmith, for the system's success.

As it continued to develop, the wharf wasn't always a safe place. Part of the land behind it and directly below the bluff was divided into corrals from which animals regularly escaped. One day, a bull got loose, raced through a freight house, gored a horse and two men and disappeared. Another time, it was a flock of sheep. One man walked off the edge of the wharf and fell into the water, and another fellow froze to death in his shack. When the body of a third man was found floating in the bay, it was left all day because Tacoma's limited legal structure had no provisions for the unclaimed dead.

Farmers came by horse and wagon to deliver produce to waiting ships, and merchants picked up goods and staples from the various warehouses. But their horses were known to bolt and upset their wagons. Trains transported coal from the foothills of Mount Rainier and wheat from eastern Washington. However, at least once, a warehouse collapsed under the sheer weight of the wheat it held. In 1894, a strip of land approximately 250 feet long and 50 feet wide slid into the bay, taking with it the home and freight house belonging to H.H. Alger. And the teredoes continued to wreak havoc with peoples' lives. An unnamed young lady slipped into an unexpected hole when a piece of planking gave way and nearly broke her leg.

Nothing in New Tacoma was easy, but it was a vibrant, exciting place, and until the financial panic of the 1890s, opportunities made men rich.

## WATER, WATER EVERYWHERE,
## BUT NOT A DROP TO DRINK

In 1874, Tacoma was a hamlet of three hundred or so people on Commencement Bay—a cluster of shacks, tents, lean-tos and a few businesses bunched together on the waterfront at the south end of Pacific Avenue—a Pacific Northwest town where, in spite of the rain, water for home use was a major problem.

Springs did trickle out of the hills on the west side of Broadway, and several Chinese families created irrigation systems for a laundry and for vegetable gardens that extended up St. Helens Avenue. However, in those early days, a man named Tom Quan hauled drinking water in a wagon pulled by a mule, Long Ear Nellie, and sold it around town. Then, William Fife built several earthen reservoirs in the vicinity of Ninth and Market Streets. He ordered bored pipes (hollowed-out logs) from Olympia and promised the women of Tacoma that they'd soon have water for Monday morning washday. When water did start filling the pipes, most of it went to put out a fire at the Godkin & Durr Furniture Store. Mr. Fife attached a hose to a faucet, and that helped the bucket brigade, but it was a jerry-rigged system at best. And Tacoma housewives had to wait four more years before all the pipes were laid.

As the 1880s approached, Tacoma had outgrown Mr. Fife's system, and in 1883 two men, John Burns and Philip Metzler, dug into the hill underneath Mr. Burns's house at 945 Market Street. They drove a tunnel, tapped into a number of springs and built a flume that was 350 feet long and 3½ by 7 feet in circumference. The flume ran diagonally across an alley, across another lot and over Market Street, bent a few feet north and emptied into a reservoir. The 100,000-gallon-capacity reservoir was 10 feet deep and 23 by 26 feet above ground. A four-inch "main" came out of it and was laid across various nearby lots on its way down to Pacific Avenue. When it reached Pacific, the flume headed south toward Tenth Street, gradually changing and narrowing from a two-inch wooden pipe to a one-inch galvanized pipe as it reached its end near Ninth Street. Other wooden pipes of varying sizes carried water on to Fourteenth Street with a branch at Twelfth Street over to A Street. The pathetic system was described as one of "puny little arteries."

This crude system, known as the Burns & Metzler Water Plan, was still under construction when, in June 1884, city council members began negotiations with Charles Wright, Tacoma's major patron.

Mr. Wright also owned a water company in Tacoma. He had built two dams in local gullies that were fed by Gallagher's Creek and a reservoir 260

feet above sea level and supplemented the creek water with water that came from Spanaway Lake. Gravity fed water to homes and businesses downhill, and a Holly turbine and wheel pump forced water to the higher elevations. By December 1884, water mains had been distributed through the town. On the seventeenth of that month, the Tacoma Hotel was the first to get service, thus making the occasion AN EVENT.

Five years later, Charles Wright visited Tacoma and told a reporter he had no interest in selling his water company to "men who haven't the interest of the city at heart." However, his system wasn't very clean. "Pure Water Snakes!" was the *Tacoma Daily News'* headline.

In May 1891, Deacon Rancipher found and put on exhibition thread-like worms belonging to the *Gordius* family that he'd discovered in the city's drinking water. The horrified reading public was told that the worms ran from six to eighteen inches long; that when divided into segments, each segment grew a head and became its own entity; and that if dried, they would live for three years and revive themselves when put back in fresh water.

Following this disclosure, a *Daily News* reporter went to the home of Reverend W.B. McMillan at 1926 J Street and was shown water samples taken from a neighborhood fire hydrant. Not only did the water have the worms, but it also contained several other aquatic entities all clearly visible with a microscope. Mrs. McMillan was straining her water through muslin. And local vegetarians were warned about what they were eating when they were drinking the water.

By 1892, Charles Wright had changed his mind about selling. His system was proving to be a cash hog. Negotiations between the city and Mr. Wright dragged on until 1893. He finally sold out for $1.75 million.

Unfortunately, no one had checked out the newly acquired system's infrastructure. It was, in fact, falling apart. Tacoma's downtown business district had suffered from four serious leaks, and the flume was so rotten in places that people could push holes in it with a finger. The city engineer estimated that the flume was losing 1.5 million gallons daily. Worse was a lack of a dependable source. Mr. Wright's promise of 5 million gallons of water a day from Thomas and Patterson Springs was a substantial overestimate.

While residents suffered, men checked out Puyallup's Maplewood Springs, Clover Creek's headwaters, Lake Kapowsin, the Chenius River near Fairfax, Canada Creek near Carbonado and an artesian well on the prairie southwest of town. A man named Fred Plummer filed claims on water from Clear Lake and the Big Mashell River, eliminating both of them. Exasperated city officials sued Charles Wright and won.

Tacoma's drinking water. *Courtesy of Robin Paterson.*

In 1906, Mayor George Wright appointed Harnett Fuller to supervise the sorry little water system, the wells and the gravity lines. Mr. Fuller called the South Tacoma wells "a patchwork of everyone's ideas" and said that the "present water supply was a disgrace to a civilization and a standing menace to the community." He sent two crews to check out the untapped and clean Green River. He also recommended abandoning Clover Creek as a source because ducks were paddling in it, cows wading in it and children frolicking in it. And then Tacoma residents shot themselves in the foot. In 1906, voters decided against a Green River gravity line.

Back at square one, the councilmen found that water from Gallagher's Gulch was fed by "chicken yards and cesspools," and the bottom of the Hood Street Reservoir was coated "with a generous stratum of ooze, disease-laden and of an unholy smell." The *Tacoma Times* blasted the council, and the council formed a committee. The committee came up with a long-range plan; an injunction stopped the plan. A local engineer was elevated to special engineer status, and he sunk wells. The wells provided an abundance of water—until they started to go dry. The city started using water from Maplewood Springs, and the council voted to put the Green River gravity line back on the ballot. This time, voters approved it by a two-to-one margin.

Work on the gravity system took two full years. The job required securing right of ways, fighting injunctions from landowners, digging tunnels, creating a bypass line and building a spillway. Men hacked out several miles of roadway through timber and brush and transported sixty-inch pipes forty-three miles, sometimes having to shoulder the pipes and carry them in. The pipeline crossed the White and Puyallup Rivers. Hugging the land's contours, it went from one hundred to nine hundred feet above sea level. Once, the water pressure blew up a wastewater pipe. A verbal altercation broke out over whether the water should be turned on before a hydrochlorite water purification plant was built. Mayor William Seymour said to wait, but public works commissioner Nicholas Lawson ignored him. On July 12, 1913, all the water valves in Tacoma were opened, and 42 million gallons a day of Green River water flowed into Tacoma. At last, Tacoma's water was clean and safe for everyone—even vegetarians.

## A TISKET A TASKET, THE STREETCAR HAS A CASKET: PIONEER CEMETERIES

*Thursday, June 11, 1874, Frances Desdemona Coulston, daughter of Mrs. Root, now McNeil, aged nineteen years, five months—In the ground just allotted for a cemetery by the Railroad or town company, being the first burial there.*
*—Reverend Mr. Bonnell*

In the early 1870s, when the Northern Pacific Railroad and Tacoma Land Office were establishing Tacoma, the Land Office donated land for the Prairie Cemetery, the fledging community's first official graveyard. It was situated on a knoll alongside what was known as the South Tacoma Plain. This area eventually became the town of Edison and is now South Tacoma. And the cemetery became the Oakwood Cemetery.

The second person buried was General Morton Matthew McCarver, an advocate for Old Tacoma, and the next burials came as the result of a boating accident. A man named John Croft, an engineer from Black Diamond named Chambers and two boys—John Ralston, age sixteen, and his brother Harry, age eleven—were in a rowboat at the mouth of the Puyallup River when it capsized, and they all drowned.

They would not have been alone during their trip to the graveyard. Daniel Collins, Pierce County's coroner, was so conscientious in his duty that he

attended every funeral in the area. Wearing a vest, swallowtail coat and top hat, Mr. Collins ensured that his clients were properly interred. When that was done, he of course lingered on to enjoy the free lunch and liquor that families of the deceased provided.

Adjacent to the Oakwood Cemetery was another little graveyard referred to as either the Pierce County Cemetery or the Paupers' Cemetery. Little is known about it except that the remaining inscriptions suggest it was the final resting place of sailors from foreign ports who died in Tacoma.

In 1881, the Tacoma Land Company donated land at Forty-eighth Street and South Tacoma Way for Old Tacoma Cemetery. Three years later, the land was officially transferred to the city, and a cemetery association was formed. About this time, when there wasn't anything except a blacksmith shop at 4810 South Asotin, a man named R.F. Radebaugh began developing the land around South Fortieth and Forty-first. He built his own estate, which included a pavilion at 6602 South Alaska, and was involved in getting the Tacoma and Puyallup Railway lines extended out to the cemetery. Once completed, streetcar funerals became popular. Rather than chance transporting a coffin to the graveyard by wagon on Tacoma's muddy roads, people loaded the caskets onto streetcars, and all the mourners rode out with it.

Also in 1884, a fellow named A.J. Littlejohn took over land that is now part of both Oakwood and Tacoma Cemeteries, bought more from John Rigney and platted it. Then he started selling lots. Eventually, this led to problems.

By 1905, 205 deceased soldiers resided in Tacoma cemeteries. And by coincidence, Oakwood and Old Tacoma each had the graves of 99 veterans. At Old Tacoma, 92 were Union soldiers from the Civil War, 2 were Confederates and 5 were from other wars. At Oakwood, 95 were Civil War veterans, their various companies not known, and the remaining 4 were from other wars. In May, the *Tacoma Daily News* listed every deceased soldier, where they were buried and the company they served in, if available, and a huge memorial took place. Everyone who could donate flowers left them at various schools, and floral committee members picked them up to distribute. There were speeches and services, and all the remaining veterans who were able participated.

For the next twenty years, Oakwood continued to grow, adding a "crematory" that became a popular option. However, by 1927 the paupers' field was in bad shape. The county's rule was to do the job as cheaply as possible. Pierce County contracted with various undertakers, who, for $4.50, were supposed to provide a wooden box, deliver the body to the cemetery, dig

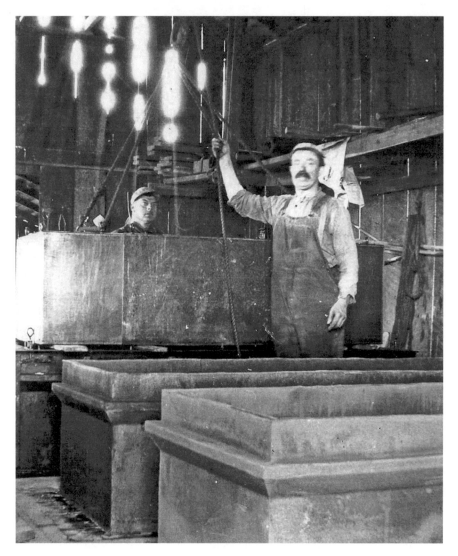

Casket sealer. *Courtesy of Automatic Wilbert Vault Company, Inc.*

the grave and see to the burial. The contract passed to a different undertaker every three months. According to the *Tacoma Daily Ledger*, diggers sometimes dug holes barely four feet deep, put the coffin in, sprinkled a little dirt over the box and left the rest piled nearby. Blame was twofold: officials were held responsible for the graveyard's unkempt appearance, and the undertakers were responsible for the slipshod burials. After complaints, Commissioner Harry Ball proposed that a new grave site be purchased, and in May 1928, by city ordinance, the old paupers' field was closed.

Old Tacoma Cemetery also had a problem. In 1900, someone discovered that a few of the bodies were buried on the street right of way, an issue that took finesse to resolve.

Many of the grave markers and burial sites at Old Tacoma Cemetery have interesting stories. One tombstone reads, "Here lies the body of Pickhandle Shorter, all as John Davis." The gentleman in question was a longshoreman whose co-workers passed the hat to buy a stone. It was supposed to read "alias John Davis," not "all as." The stonecutter goofed. Another, commemorating a veteran of the California gold rush, reads, "In Days of Old, In days of gold, In days of 49, John W. Kline." Lena Clark was buried in a huge plot with a granite spire indicating that others would one day join her. They didn't. She rests bereft of family. One family plot has three heavy, sunken vaults, the center one containing the body of a girl buried in 1918. Her parents were supposed to be on either side, but her father is buried elsewhere and her mother disappeared. Two nightlife characters are buried close to two women who did their best to keep the sailors away from said nightlife.

And those who know local history will find the graves of a number of the city's major movers and shakers: the Proctors of Proctor Street, Allen C. Mason of Mason Street and School, the Howard Carrs of Carr Street and many others. Cemeteries are places where dead men do tell tales.

# SMOKE GETS IN YOUR EYES: 1889, THE YEAR OF FIRES

In the year 1889, Washington cities burned. Seattle was nearly wiped out in June, Ellensburg in July and Spokane in August. Vancouver, Roslyn and Goldendale also had devastating fires. But some towns seemed to have more fires than others, and Tacoma was one of those.

On May 29, 1880, the New Tacoma Hook-and-Ladder Company No. 1 became Tacoma's first firefighting company. It consisted of a wagon, period. In October, the company fought its first officially noted fire when druggist Walter St. John opened a can of gasoline while holding a candle. His carelessness started an inferno that destroyed both his store and living quarters, leaving St. Johns destitute. The next day, city officials called an emergency meeting and approved the immediate purchase of a water cart and fire hose.

Nine years later, fire department officials were still warning city council members that Tacoma was inadequately prepared to fight anything bigger

than a burning match. The fire department had five hand-drawn hose carts, but three were unfit for use. There was a hook-and-ladder truck, but it was out of order. The fire hose was only 2,600 feet long, and a reliable source of water was almost nonexistent.

Faced with these facts, however, the council erred on the side of economy because $6,700 of city funds had already been committed for the purchase of a Gramwell Fire Alarm System. The firefighters pointed out that the alarm might ring, but it didn't much matter if there was no equipment with which to fight the fires—but their comments fell on deaf ears. In fact, if it hadn't been for the massive Seattle fire in June, it is debatable whether council members would ever have taken action. As it was, within days of Seattle's fire, a public meeting was held.

To say that Tacoma residents were upset is an understatement. They blamed Tacoma's fires on lax law enforcement, leniency within the judicial system or "a crazy arsonist running amok in Tacoma and through the state leaving burning towns in his wake."

"You may call it vigilance, Christianity or hell!" shouted one man. "Preservation is the first law of nature. I'll shoot any 'sluzer' found around my house after dark!"

City officials received a petition asking for greater fire protection, steam engines and fifty fire hydrants. The signers also expressed concern about

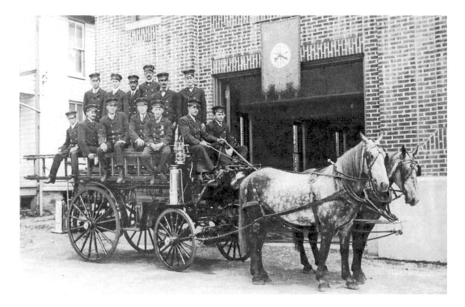

At ease on the fire wagon.

the availability of water for the hydrants. As a result of the petition, council members approved the purchase of two steam engines and some horses. They also hired full-time, salaried firemen.

Tacomans were beginning to feel a little more secure when, on August 29, a man named John Bell went to a local paint and oil store to buy some "asphaltum," a petroleum residue consisting mainly of hydrocarbons. When he turned the faucet of the drum in which it was stored, fire came out instead. Flames immediately spread across the store's wooden floor, up the walls and onto neighboring buildings. The fire department was alerted, but piles of construction materials in the roads delayed arrival. Once again, downtown Tacoma lost businesses (many of which were uninsured), and the owners had to rebuild.

Once again, the community was highly irate.

Then, a local man named C.P. Ferry suggested fighting fires with salt water. It was, he pointed out, a more reliable source than trying to use water from the various springs that dotted Tacoma's hills. Ferry proposed either a 200,000-gallon wooden tank or a 3-million-gallon reservoir to be built on the hill above the town but connected to a pumping station on the waterfront. He figured the cost would be $100,000, and the community was pretty well convinced of its viability. However, and perhaps just coincidentally, a lecturer named Dr. De Witt Talmage came to the Germania Hall to speak. His topic, "Big Blunders," apparently resonated with the locals. Ferry's plan was dropped.

City officials were doing their part. Toward the end of the year, Tacoma owned four steam engines, four hook-and-ladder trucks, a chemical engine, seven horse-pulled carts and ten horses, a life net, life-preserving belts, electric wire scissors, ten thousand feet of hose and, of course, the Gramwell Fire Alarm System. On December 19, two cottages and the St. James Hotel at South Ninth and Yakima caught fire. The flames broke out at 11:17 p.m., but it was 12:15 a.m. before actual firefighting began. The firemen blamed the water department, and the water department said the firefighters were negligent. As it turned out, the city council was at fault. Imagine its chagrin. Apparently, it had taken delivery of, but never bothered to test, the Gramwell System, and it wasn't functioning properly.

The situation was a case of the city council fiddling while Tacoma burned.

## WANDERING GHOSTS AND WATERY GRAVES

Before Old Town became trendy, it was a place of lumber mills and loggers, fishing boats and fishermen and a ghost—or so it was said—a tiny figure with coal black hair and bound feet shod in embroidered shoes. Down the hill she floated, away from the gingerbread house, long since gone, that was her prison, toward a houseboat that only briefly was the home of her heart. Dark and empty, it floated in shafts of moonlight, waiting for its captain and his little Apple Blossom.

One hundred and thirty years ago, all the schoolchildren knew the story of the handsome sea captain who loved the daughter of a Chinese Mandarin. The captain's route regularly took him from Tacoma to Victoria Harbor in Hong Kong. Once there, and after he'd docked and taken care of business, he went to visit the home of a Mandarin. And after dinner, while the old man dozed, the captain and little Apple Blossom trysted in the garden.

One night, she met him with the sad news that she was to be married. As the tears flowed from her beautiful, almond-shaped eyes, the captain picked her up, carried her to his ship and set sail for Tacoma.

The young Chinese bride was happy in Old Tacoma, but her actions had caused both her father and bridegroom to lose face. Their retribution wasn't far behind. One day, the captain came home and found her gone. "Apple Blossom was stolen by a *genji*," the servants said. And search though he might, the captain never found his bride.

One hundred and thirty years ago, the white skeletal remains of a house with glassless windows haunted a hill in Old Tacoma, and passersby, especially schoolchildren, crossed to the other side of the street. Everyone in the neighborhood knew that sometimes, especially at night, a white apparition appeared in the garden, stared with grief out of empty eye sockets and held out tiny hands toward a phantom boat in the harbor that only she could see.

Did she know she wasn't alone?

One hundred and thirty years ago, the land south of Old Tacoma, where the docks remain, was also haunted, and worse: it was cursed. The small beachfront shacks that had once been homes to Indian fishermen were, instead, housing natives dying from white men's diseases. And over the body of his third dead son, one elderly man gazed across Commencement Bay and murmured, "The Great Spirit is angry. The ground is cursed."

The Indian disappeared from history, leaving behind nothing but his prophecy. Forty years later, the hotel that graced the area suddenly caught fire and burned to the ground. Among those gathered to watch the flames,

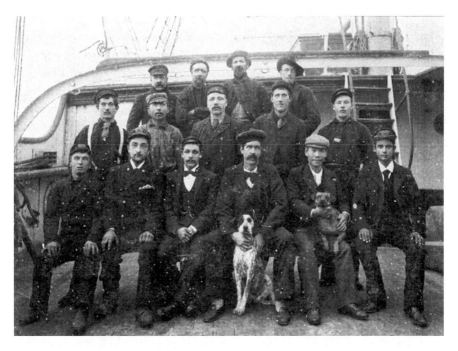

The crew of the *Andelana, Courtesy of www.jawsmarine.com.*

a few were old enough to remember the prophecy. After the fire, the burned land remained vacant. It was said that sometimes those who ventured far enough into the woods above the beach caught glimpses of ghostly figures and heard the sounds of Indian drums.

Commencement Bay also holds its share of restless dead. Emma Stubbs was only fifteen when, on November 14, 1894, her home on the Northern Pacific Railroad's warehouse pier slid into the bay. There she remained, alone amid the mud and debris, until the evening of January 14, 1899. On that night, the ship *Andelana* and its entire crew disappeared.

The *Andelana* was a four-masted barque launched ten years earlier in Liverpool, England. While at anchor in Tacoma a few hundred yards northeast of the St. Paul and Tacoma Mill's deep-water wharf, the captain had its ballast removed and dropped a three-ton anchor off the starboard side. For additional security, both sides were fastened to heavy logs. The barque was riding the current, pointed in a southerly direction, when a freak windstorm came up. In the heavy gale, the ship rose up, the ballast chains gave way and it toppled over and sank. At dawn, a signal lamp rode the waves, flashing its warning lights where only hours before a fine steel ship had been. Over the next few days, oars, a mattress, a compass and

other small articles washed up along a half-mile stretch of shore. Six days after the tragedy, one South Tacoma man posited that the men in the ship were probably still alive, holed up in some airtight compartment, waiting desperately for rescue. But nothing was done. Back then, divers said the spot where the *Andelana* had gone down was too deep for them to make successful descents. Except for one man who had been in the hospital, every member of the crew drowned that night.

The ship has apparently been found from time to time. In 1935, a diver looking for a tugboat's anchor stumbled upon its silt-covered hulk. A year later, some of the ship's ironwood railing was hauled up and made into gavels for Republican clubs around the state, but the wreck has never been explored by divers. And the dead crew members are still there, keeping company with Emma Stubbs.

But perhaps the most bizarre story involving the walking dead occurred in 1958, when three Tacoma people became eligible to inherit a share of the estate of Mrs. Helen Dow Park. Mrs. Park, who had been addicted to Ouija boards since she was nineteen, claimed to have been communicating with the ghost of John Gale Forbes for eighteen years. As a result, she left him money in her will. The Connecticut Supreme Court ruled that a ghost couldn't inherit, and Mr. Forbes's very-much-alive Tacoma relatives were happy to step in on behalf of their deceased relative.

*Part II*

# Anything You Can Do, Tacoma Can Do Better

## Catch It If You Can: Turnip Tossing from the National Realty Building

On February 27, 1910, a large steel girder being shipped to Tacoma for use in construction of the National Realty Building was lost in transit. The building's frame was several feet tall, and all the other steel pieces were piled up and waiting when the fact of the missing girder was noticed. How something that large could actually be lost was never explained. But it was MIA until March 20, when someone found it in Three Forks, Montana.

Land on Pacific Avenue's east side, between Eleventh and Twelfth Streets, was first developed in April 1883, when the Tacoma Land Company sold lots to a man named A.S. Baker. Mr. Baker paid $1,700 for them and sixteen months later sold the property to Philo S. Mead of McPherson, Kansas, for $10,000. Mr. Mead held on to the land, passing it on to his widow, Alverda, upon his death. When Mrs. Mead sold the lots to the National Realty Company in 1909 for $80,000, its value had increased by 4,600 percent, or 175 percent a year. Checks this size didn't often clear Tacoma banks, and as soon as it was cancelled, the National Realty Company's president, L.W. Pratt, got hold of it and kept it as a souvenir. Interestingly, Mrs. Mead was represented by D.P. Calkins and Mrs. W.H. Gratton of Rae, Calkins & Company. There can't have been many female attorneys in Tacoma in 1909.

At the time of the sale, the property had a wood-frame building. Its occupants were Samuel Wolff's German Bakery; the Pullman Saloon, run by Misters Martin and Boyer, which was an exact replica of the inside of a Pullman railroad car; Ben Klegman's loan office; and a jewelry store. Mr. Klegman vacated immediately. The others were given notice to be out by July 1.

National Realty paid architects Heath and Twitchell $12,500 to draw up plans and brought in a man named John L. Hall from a New York company of structural steel engineers to assist the architects with the details of the steel work. The plans were to be completed by June 1, and the contractors had thirty days to assemble teams so work could start the first of July. It was anticipated that construction would be completed and the building occupied by April 1, 1910. A group of men, including President Pratt, sank test holes on May 24, 1909, to determine the character of the soil where the footings would go, and the president officially broke ground. The total cost of the building was expected to be $350,000.

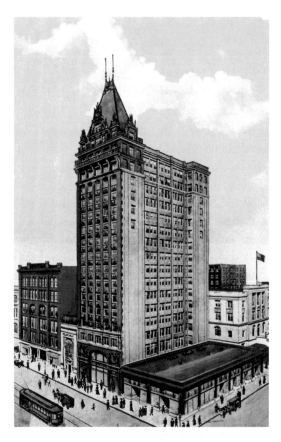

The National Realty Building, circa 1912.

On October 2, 1909, a concrete retaining wall went up along Pacific, and the next day the first footing forms went in. To get this far, four thousand cubic yards of dirt had to be removed. The steel frame—approximately nine hundred tons of it—started arriving in mid-November.

By November 21, the *Tacoma Daily Ledger* was referring to the building as nineteen stories—8,400 tons of iron, steel, brick, plaster, wood and other things. It was also announced that it would not have what was called a party wall; that is, it wouldn't share walls with adjoining buildings.

According to the paper, even though the footings of a "party line are buried, their existence was known to be impractical, and sometimes involve structure damage that caused litigations." In an excess of information, reporters went into great detail about the new skyscraper's cantilever construction and the numbers of and placement of every concrete footing, steel I-beam and cast-iron base block. Tacoma reporters were nothing if not detailed. This was, they claimed, the tallest such building on the Pacific Coast.

The building opened onto Court A in the back and Pacific Avenue in front. The front was in the French Renaissance style using terra cotta and Roman-style bricks. Over the entrance were life-sized groups of statuary symbolizing agriculture, mining, manufacturing and transportation—Puget Sound's main industries. Above a terra cotta balcony at the fourteenth floor were groups of dormers. The roof was 226 feet above Pacific Avenue and held a 57-foot flagpole.

The basement had a restaurant in front—naturally, reporters referred to it as "one of the finest cafés on the coast"—and the heating and power apparatus in the rear. The first floor had two stores, one each facing Pacific Avenue and Court A. The other floors were all offices—367 of them. There were four elevators enclosed in bronze grillwork and polished wire glass and a main staircase of similar design.

As construction went on, naysayers were claiming the building wasn't needed and that it would become a white elephant. However, President Pratt said that applications for space were coming in.

This was a good time to be a laborer in Tacoma. A carpenter made four dollars a day, and there were plenty of jobs. Unfortunately, a rush of business at eastern steel mills delayed construction crews at National Realty from getting their beams and girders, and the first ones sent were inferior and were rejected. Beginning in December, full crews of structural steelworkers in Tacoma sat largely idle. After the situation with the inferior beams and girders was straightened out, high winds and torrential downpours continued to keep work on hold, and then the situation of the missing girder popped up. Apparently, because of a storm and flood blockade, the railroad stopped all freight shipments over its northern lines—and forgot to let anyone know.

The National Realty Building was finally done in the fall of 1910. According to an ad, all the offices were outside rooms, meaning they had windows. They were finished in marble and mahogany. There were thirty-two marble-lined bathrooms, steam heat and hot and cold water in each office, as well as electric lights, something called direct and alternating current gas, compressed air, four high-speed elevators, a law library and a Cutter mail chute. That's a sort of tube that runs from the top floor to

the bottom, with places on each floor in which to drop envelopes. Mailmen emptied the chute at the bottom. The chutes were regularly jammed when someone tried to stuff in an oversized envelope.

Now that the building was completed, the unconventional users appeared. A juggler named Zanetta was first. Zanetta's specialty was standing on a stage and having turnips, which he caught on the tines of a fork, thrown at him from different areas of the theater. To drum up business, his manager claimed that Zanetta could catch a turnip thrown from the tallest building in town. According to the *Times*, the procedure was somewhat dangerous as the veggie picked up considerable force during its fall. Nevertheless, a *Tacoma Times* employee offered $100 if Zanetta could catch the turnip the first time it was thrown from the National Realty Building and $50 if it took two times. The *Times* held the money, and a date and time were set: April 20, 1917, at 1:30. Approximately ten thousand people crowded the streets, windows and roofs to watch. It took Zanetta three times to catch the turnip. He didn't get a cent and disappeared from history. The turnip went on display at Mr. Bonney's Pharmacy.

The next unusual event began seven months later, coincidentally at the same time the Puget Sound State Bank moved into the first floor. Already, some remodeling was deemed necessary. The floor and wainscoting were redone with Alaska marble and the rooms in mahogany with ornamental plaster ceilings. Verde antique marble, Mexican onyx and bronze screens were added, as was a burglarproof safe. After the facelift, a pigpen was installed on the roof. Dr. C. Stuart Wilson had a sty built, and 125 porkers moved in. They were well fed and kept in good physical condition, but Dr. Wilson was the city's pathologist, and they were his guinea pigs. Pigs' blood and organs were considered at the time to be more like that of humans than any other animal. Every day, an assistant took a pig to the doctor's office and inoculated it with water from the Green River or fed it milk, food or various other items to determine if they were safe for human consumption. This went on until the animal died. The experiments cost Tacoma sixty-five cents a day.

In 1915, the pigs were gone, and architect George Gove put a garden on the roof. In a ten- by fifteen-foot space, he planted flower boxes and large jars with verbena, nasturtiums, pansies, begonias and sweet Williams and designed trellises of white lattice and mesh for vine flowers. He watered his plants daily and moved them inside in winter.

Also in 1915, Mr. C.L. Andrews, a local baggage agent for the Milwaukee Railroad, fell down the elevator shaft. According to the elevator operator, Neil Webster, he brought the elevator to a stop and opened the door. When

Andrews stepped out, the cage started up and stopped between the twelfth and thirteenth floors. Andrews had just started out, and he fell from the elevator, hit his head on the floor and fell back into the shaft, falling thirteen floors down. The dead man was only twenty-three.

In 1916, more than twenty local businessmen were busted at an illegal drinking party. One of the building's tenants was the Electric Logging Company, which doubled as a private men's club. The club operated by selling membership cards, a secret signal and keys to potential members at a cost of $2.50. The key admitted the men any time, day or night; the elevators ran until midnight, and a drink cost fifteen cents.

"Jump if you want to, but eleven floors is a long way down," Detective Teale said during the bust when three men rushed to windows.

Newspaper accounts claimed that 350 prominent businessmen and physicians were associated with the company and that the "blind pig" was being held in five rooms behind the legitimate business portion of the office. The police seized eight quarts of whiskey, eighteen bottles of seltzer water and several cases of ginger ale. Proprietor Fred Plugardt was arrested and immediately ratted out bartender Fred Lucas. The names of the "350 prominent businessmen and physicians" were never released.

One had to read between the lines to figure out the building's financial situation. In August 1917, based on its second mortgage, the building was sold to a syndicate composed chiefly of men from eastern Washington. Five weeks later, Jack "the Human Fly" Williams climbed up an outside wall, reaching the roof in an hour and a half. Jack was a former trapeze artist who got his start climbing when he rescued a crippled woman trapped on the fourth floor of a burning building. In Tacoma, the street crowd passed a hat and collected $257.10. Jack gave $64.00 to the Soldiers' and Sailors' Club and kept the rest as his due.

In 1920, the National Realty Building became the Puget Sound National Bank Building. Someone was killed in the elevator shaft, owls nested in the tower and Munsey Gymnasium opened on the fourth floor. Businesses came and went in renovated offices. It remains a symbol of Tacoma's historical, or possibly hysterical, past.

## ALL ROADS LEAD TO RHODES

At the end of the nineteenth and the turn of the twentieth century, Tacoma was rich with department stores. Gross Brothers, built in 1889 and demolished

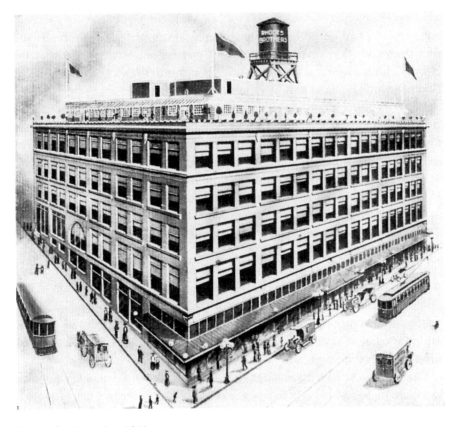

Rhodes Brothers, circa 1911.

to make room for the Pantages Theater, was the first. People Store followed six years later at the southeast corner of Eleventh and Pacific. Stone-Fisher-Lane on the corner of Eleventh and Broadway was built in 1905.

Rhodes Brothers began as Rhodes delivery wagons, with Albert, William, Henry and Charles Rhodes delivering tea and coffee throughout Pierce County and picking up orders for the following week. In 1892, the brothers took over the rooms occupied by the R.S. Albright Company at 938 Broadway. Their stock could have fit in one of their delivery wagons. A year later, the brothers moved into the Warburton Building at 1101–03 Broadway, a building occupied by Owl Drug Company. In 1894, they made yet another move—right across the street. But the moves weren't over yet. After three years on Broadway, the brothers moved to Pacific Avenue, a few doors below Eleventh Street. Not until 1903 did Rhodes Brothers Department Store open at the address most people recall, at 950 Broadway, across from Woolworth.

# Anything You Can Do, Tacoma Can Do Better

The first mention of the new store was on January 18, 1903; the grand opening was a mere ten months later, on November 8, 1903. The new Rhodes Brothers department store was modeled after Philadelphia's Wanamaker's and Chicago's Marshall Fields. In recognition of the store's horse-and-buggy days, three old wagon wheels were made into a chandelier and were a fixture—in more ways than one. Other than that, mahogany wood and large plate glass windows were the main features for both the building and the display cases. The new store had three floors, each 12 by 110 feet. A mezzanine between the first and second floors provided wicker chairs in which shoppers could sit and rest, with a lavatory and ladies' lounge on one side and the cashiers' cage, large enough for eight people, on the other. Lawson's cable carriers connected the cashiers to the various departments. An orchestra played continuously during the three days of the opening. After that, a piano player entertained from the gallery.

The first floor was dress goods, men's wear, some domestics, a shoe shop, a candy department and Bargain Square. The entire north side was the tea and coffee department, personally handled by Henry Rhodes. Four "electric grinding mills" operated constantly under the attention of "uniformed nurses." Saturday shoppers received complimentary cups of coffee.

Glass, crockery, china, stoneware and pottery took up most of the second floor. The rest of the space was taken over by infants' wear, a suit department and fitting rooms. A "large force of competent seamstresses" had space on the third floor and handled alterations. They shared the floor with furniture, art and framing and a large basket department. All totaled, the store employed one hundred people, of whom fifteen were deliverymen who made daily deliveries from four delivery wagons or, if necessary, by streetcar. The wagons were replaced with cars in 1912. The clerks were well screened and trained in efficiency and courtesy. The female clerks wore dark dresses with white collars and cuffs in the winter and fall and dark skirts with white blouses in spring and summer. The men dressed in suits.

Thanks to hundreds of signs, most everyone in south-central Puget Sound knew about Tacoma's prestigious new department store. No records remain of when Rhodes Brothers began putting up road signs. It's believed to have been around the turn of the twentieth century. The signs read, "All Roads Lead to Rhodes," and included the number of miles to the store in Tacoma. They were placed throughout southwest Washington as far south as the Columbia River and east to the Grays Harbor area. For many years, they served the same purpose as a yellow line does today. The Rhodes signs were Washington's first highway signs.

Rhodes Brothers was definitely the place for upscale shopping, but to stay on top, Rhodes continually made improvements: in 1905, a sprinkler system; 1907, the first enlargement; 1908, a tearoom; and 1911, a major addition that doubled its size. The dining room was located on the top floor at Rhodes. It sat three hundred people. The tables were covered with white linen tablecloths and napkins and crystal vases holding fresh flowers. Lunch was served every day, and dinner was served one or two nights a week. Favorites on the menu were broiled crab, mulligatawny soup, clam chowder and Rhodes' cheesecake. In 1914, improvements included a rooftop garden. The Roof Garden was located just off the Sixth Floor Tea Room. Lunch was served daily from 11:30 a.m. until 2:00 p.m., afternoon tea was served daily from 2:00 p.m. to 5:15 p.m. and evening dinner was served on Saturdays from 5:30 to 7:00 p.m.

As most women wore hats when they went out, the store included its own millinery department. At that time, store buyers traveled back east once or twice a year to buy "model" hats in the latest fashion. The models were quite expensive and were used by local hat makers to make copies for sale to the public.

One of the department store's most interesting features, though, was its date book. For many years, a lady named Marguerite Darland took care of an appointment register where people could leave messages. Every day, she put fresh paper in the book and set out a supply of sharpened pencils. Wives left word for their husbands about where the car was parked, women left short groceries lists, girls broke dates and shoppers arranged to meet friends. Some notes were in code and others in foreign languages. One squabbling couple left messages that became ever less vitriolic until they eventually made up. Newspapers called it an index of life.

In 1920, the store, in need of more floor space, purchased the Judson Block. They connected it to the main store with a sky bridge and named the addition the Annex.

Henry Rhodes retired in 1925, but that didn't stop the progress. In 1936, Rhodes became one of the few department stores in the country to have a library annex. On the building's sixth floor, a librarian took care of seven thousand books, many about etiquette, gardening, cooking and home making, and answered dozens of questions daily: "How can I test this fabric to see if it is pure silk?" "What would be a good name for our new baby?" "Do you have instructions on how to build a cottage?" When the beleaguered librarian wasn't giving advice about proper hats for a wedding, she was answering questions or finding books for people on banking, finance, salesmanship and any number of other issues.

The store employed a professional window dresser who was expected to be on top of all news and trends. When Weaver studios made *Hearts and Fists* in Tacoma, one window display was of an average living room with assorted camera equipment. When cars became popular and people took to the roads, the latest in luggage was on display.

Another favorite feature at Rhodes was a miniature Milwaukee Railroad train, the Hiawatha. During the Christmas shopping season, children could ride the Hiawatha to the North Pole to visit Santa.

During World War II, the *Saturday Evening Post* made pocket-sized versions of its magazine that were sixty-four pages long. They were called *Post Yarns*—except by the servicemen, who called them dehydrated *Saturday Evening Posts*. *Post Yarns* were available at Rhodes, which also had a special *Post Yarns* mailing center and provided free delivery for the miniature magazine plus a personal note from the sender.

When escalators became the vogue, Rhodes Brothers added them. It provided a parking garage. *Seventeen* magazine sponsored a back-to-school style show at the store. But by the 1970s, the store was making plans to move to the Tacoma Mall. At some point in time, Western Department Stores, Inc., bought Rhodes. Most of the stores became Rhodes Western and were bought by Amfac, but the Tacoma and Lakewood stores were sold to Frederick and Nelson, which went out of business in 1992.

# ELEVENTH STREET BRIDGE: THE PREQUEL

When in 1892 the idea of building the first bridge connecting Tacoma and the tide flats was under consideration, not everyone thought it was a good idea. Midwest farmers had experienced several years of drought, which left them short of cash needed to pay their debts; the railroads were overbuilt and overextended; and the Sherman Silver Purchase Act was requiring the government to purchase millions of ounces of silver. Signs pointed to an impending financial panic. Nevertheless, the second reading of an ordinance to call a special election for the issuance of bonds to build the bridge took place on the afternoon of December 3, 1892.

Bank president William Blackwell and businessman E.T. Durgin thought the chosen location was bad. Alexander Parker objected to property owners on the flats paying little or nothing for the bridge when they reaped the majority of the benefits. Colonel J.M. Steel, W.H. Fife and Alexander Parker

# Grand Opening
# Eleventh Street Bridge
## Tacoma, Washington
## February 15, 1913

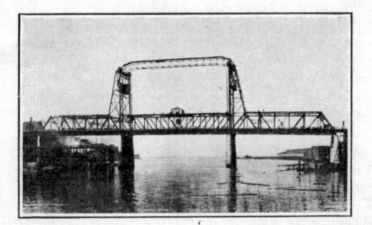

W. W. SEYMOUR  -  -  -  -  -  -  -  - Mayor

OWEN WOODS  -  -  - Commissioner of Public Works

A. U. MILLS  -   -   - Commissioner of Public Safety

RAY FREELAND  -  -  -  - Commissioner of Finance

N. LAWSON  -  - Commissioner of Light and Water

W. C. RALEIGH  -  -  -  -  - City Engineer

WADDELL AND HARRINGTON  -  - Consulting Engineers

were concerned about the city going into debt that would be passed on to their children, and C.L. Mangum pointed out that the plans he'd seen showed the proposed bridge stopping in five feet of water. "The tide flats should be improved, first" he said. But other businessmen, such as department store owner Abe Gross and Stampede tunnel builder Nelson Bennett, felt differently. The ayes had it, and all the hemming and hawing actually saved Tacoma money. Voters had approved a $115,000 bond with 5 percent interest to be paid the first year. However, as written, the bond failed to include subsequent payments. The first bids received had to be set aside because of legal quibbling. The second bids were also set aside, and by the time the third set of bids came in, the price of steel had dropped substantially. The United States War Department approved a design, and construction began.

Construction began, but the work actually began many years earlier. Territorial governor Isaac Stevens ordered a survey of the Puyallup and Muckleshoot Indian Reservations in the 1850s. The boundaries they established governed how Tacomans could develop land for industry and shipping along Commencement Bay's south shore and within the Puyallup delta.

When the Northern Pacific Railroad came, it determined waterfront development because the railroad owned and/or controlled all of the bay's south shore on into the Thea Foss Waterway. The railroad's subsidiary company, the Tacoma Land Company, had been trying to buy the Puyallup Indians' tidelands for $2.50 an acre. Land patents were issued to the Indians on January 30, 1886, and filed in Tacoma/Pierce County on March 20. The Dawes Act, adopted by Congress in 1887, authorized the president of the United States to survey tribal land and divide it into allotments for individual Indians. However, the secretary of the interior was holding back delivery of the patents, so a Tacoma man named Frank C. Ross wrote to President Grover Cleveland, who had just been sworn in. Almost immediately, the Indians received their deeds.

Back then, all the tide and hill lands as far south as the old Chicago, Milwaukee & St. Paul Railroad yard's ocean terminal was in King County. Three men—Puyallup Indian Jerry Meeker, Fremont Campbell and Frank Ross—thought that the land should be in Pierce County. So Mr. Meeker got the Indians to sign a petition requesting the annexation, which they presented to members of the state legislature. The members approved it unanimously, and Governor John Rogers signed the bill on January 10, 1901. Realizing they'd been snookered, King County went to the legislature and had a bill passed to the effect that in the future a change of annexation would require

the approval of the majority of county voters, not just those in a particular neighborhood. But for the tide flats, the damage was done as far as King County was concerned.

With that taken care of, Jerry Meeker then got the Indians to sign quitclaim deeds on the property adjoining the state tidelands east of the Puyallup River, and that gave Frank Ross the right to buy the tidelands from the state. Mr. Ross then hired Walter M. Bosworth from the Oregon firm of Ogden and Bosworth to survey East Eleventh Street from A Street across the state tidelands as far as the bluff on the west side, being sure to keep on state land only. Governor engineers had put in four- by four-foot stakes painted white to designate the locations of the Indians' land. Mr. Ross had Mr. Bosworth put in a stone monument near East Eleventh and Taylor Way because he was afraid that during a high tide, and with water rushing into the river, a log would knock out the stakes. All his work was instrumental in Tacoma's ability to construct the first Eleventh Street Bridge.

Two issues the first bridge had to consider were the approaches. On the west side, engineers built a 340-foot-long iron viaduct—a viaduct is a bridge composed of several small spans—with one plate girder span of 60 feet and one of 64 feet. The drop in elevation on the east approach was resolved via a pile trestle. The St. Paul and Tacoma Lumber Company, which was instrumental in getting the bridge built, got the contract to make the trestles. The bridge itself had 6-foot-wide sidewalks, two fixed spans of 185 feet each and a draw span of 250 feet. A Bowers dredge in the channel excavated a spot for a pivotal pier for a drawbridge. Two hoisting engines, chains, pulleys, hawsers and a gang of from twenty to thirty men maneuvered eight-ton, sixty-foot girders into place all under the supervision of crowds of people standing on the bluff.

The total cost of the first Eleventh Street Bridge was $100,000, and it lasted for thirteen years. In 1913, when it had to be replaced, not a few people claimed that city neglect made the new bridge necessary.

## GIRDER TO GOD ON THE RUST BUILDING

When Dr. Samuel A. Ambrose needed a larger facility where he could treat patients using "radio vitant rays, spinal concussors, hydro-therapy, solar arc rays" and other non-drug methods, he moved the Ambrose Physiological Clinic, his burgeoning medical practice, into the newly completed Rust Building. As it

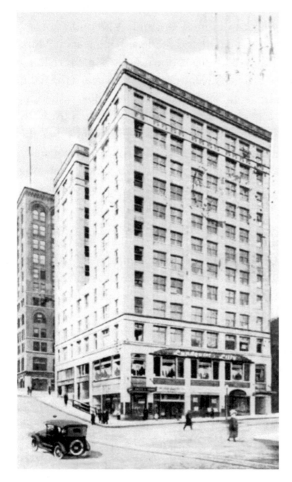

The Rust Building, circa 1924.

turned out, he soon outgrew his twelve-room suite there and built his own clinic, but the Rust Building had plenty of other tenants to take his place.

Construction on the Rust Building, known between 1929 and 1931 as the Townsend Building and occasionally as Seafirst Center, began in 1919. Not long before that, Olympia's Temple of Justice had been successfully built from Wilkeson sandstone, so owner William Rust and his architect chose the same material. It was the first office building in the United States to use the local material.

Unlike other Tacoma buildings, the newspapers were more interested in who the tenants would be than in particulars of the construction. Lundquist-Lilly, whose labeled merchandise occasionally shows up at vintage clothing shops, was a big local clothing store at the time. It leased the entire second floor and was in operation for over twenty years. Attorney General James M. Ashton also had an office in the building. A would-be tragedy turned into a farce when the well-known attorney was attacked. On January 23, 1931, fifty-year-old Andrew Marr, an angry coal miner, walked into the general's office and thrust a piece of paper in the attorney's hand.

"Sign this or there will be trouble," he said.

The general started talking to Marr while at the same time backing him out of the office. But Marr caught on and whipped a pistol out of his pocket. The seventy-two-year-old general grabbed the man's wrist, and the

two began scuffling—fighting for possession of the gun. A second attorney, William R. Lee, heard the racket, rushed in and made a flying leap at Marr. He landed on the man's back, they both went down and then Marr flung Lee under a table. Stenographer Lucile Davenport, who also heard the fight, called the police. As she hung up, someone fired two shots. She rushed in, stepped between Marr and the general and was roughly pushed away by Marr. She then grabbed him by the wrist and ordered him to give her the gun. To everyone's amazement, he did. After that, she frisked him for more weapons and told him to sit down. When the police arrived, he was cowering in a chair while she kept his own gun trained on him. Just before officers led Marr away, he said goodbye and shook hands with the general. At the police station, the story came out.

Marr claimed that General Ashton owed him $25,000. The previous October, Marr had sued the Carbon Hill and Oil Company for $20,000. During testimony in federal court, it was proved that a contract giving Marr $25,000 if he "secured the election" of Martin Flyzik as president of the mine workers' union in 1913 was bogus. General Ashton was both a witness and council for the coal company. Marr said he never really meant to kill General Ashton, but he was held in jail for attempted murder anyway.

Two years after the shooting, KVI radio moved into the Rust Building. KVI had been on the air as a part-time station, broadcasting out of a small facility and sharing time with KMO. However, Tacoma residents demanded a full-time station. More than twenty thousand letters poured into the Federal Radio Commission, which granted KVI that status.

The new status required a bigger studio.

"We want a station second to none," E.M. Doernbecher, president of the Puget Sound Broadcasting Company, said.

The company rented three thousand square feet of space on the building's southwest side and finished the rooms with western knotty cedar, weathered oak and hammered iron chandeliers. A large studio made of Weyerhaeuser Nu-Wood was actually a room within a room. It included balsam curtains to ensure soundproofing.

These were not good years for the Rust Building, however, and they should have been because even before completion the building was blessed with a baptism.

On August 7, 1920, Earl L. Powell took his baby and began climbing up an unsteady, swaying series of ladders, after which he walked carefully over isolated six-inch girders, two-by-fours and sagging planks to the tenth floor, all the while dodging rivets and flying board ends. Waiting for him,

on temporary flooring, were C.V. Crumley, Mr. Powell's boss; Charles Perryman Gaumond, a Seattle cameraman; M.D. Boland, a photographer; a *Tacoma Daily Ledger* reporter; and fifty structural steelworkers who acted as godfathers to the baby, little Marjorie. Then, Mason Methodist Church's Reverend Joseph O. Marlatt, holding a bowl of water, and R. Crawford, a structural worker who held Marjorie during the ceremony, mounted a girder at rest on the platform, and with men grasping the derrick chains, the girder was hoisted fifteen feet from the tenth story and swung out over Eleventh Street. While men shouted, boards crashed, riveters riveted and street traffic filled the air, Marjorie crowed with delight as she was anointed. The girder was then lowered back to the tenth floor, where all the godfathers gathered to shake the baby's hand. There's no word on where Mrs. Powell was during all this.

The girder to God didn't protect the Rust Building. William Rust died in 1928. A year later, Townsend and Company Investment Bankers leased the building and changed the name. Two years later, the company went bankrupt. The court gave the building to W.R. Rust Investment Company, and the Rust name was reinstated. Arthur Rust, William's son, said how pleased the Rust estate was.

On January 1, 1937, G-men took up headquarters there during the Charles Mattson kidnapping. In September 1942, a man fell down the elevator shaft. During the Red Scare of the 1950s, the Rust Building had an air raid shelter. The building was remodeled in 1985 and reopened in 1986 with a new look. Pink marble, gargoyles, large plants and artwork salvaged from the top were relocated to the lobby for people to enjoy.

## DRINK TO ME ONLY WITH THINE EYES, BUT THE BREWERIES WILL OBJECT

One thing that was true of every frontier town was that they were populated by thirsty, hardworking men who wanted beer. And saloons were among the first buildings to go up. Until the advent of local breweries, beer was shipped in from larger cities, but as soon as a brew master arrived, he usually started to make his own. And for a small, developing frontier town, Tacoma had quite a few breweries.

Ignatz Fuerst established the New Tacoma Brewery at 2331 Fawcett Avenue in 1884. There isn't any information about it other than that, according to

Here's to you!

the history of the Milwaukee Brewing Company, a man named Diedrich Stegmann established a brewery the same year at the same site. He ran it as a sole proprietorship until 1886 and then took on a partner, Henry Lusthoff. The two formed a new company, the United States Brewing & Ice Company. Their Fawcett Street address also included 2330 Jefferson Avenue.

Four years later, two other men, Zacharias Zimmerman and George Harrel, a wealthy brewer who already owned the United States Brewing Company of Portland, entered Tacoma's beer market. They got in as a result of reorganizing the Stegmann and Lusthoff brewery. The new stock company, with Stegmann as president and a man named Mathies Karasek as secretary/treasurer, lasted three years. In 1891, local liquor dealers Samuel S. Loeb and Albert Weinberg, along with various other businessmen primarily from the Jewish community, bought the United States Brewery and renamed it the Milwaukee Brewing Company.

Soon after the reorganization, a *Tacoma Daily Ledger* article announced that the plant was being enlarged. The new facility consisted of four buildings. The office building, part of which was the superintendent's residence, was 25 by 80 feet and two and a half stories high. The four-story storehouse, which measured 120 by 40 feet, included the brewery proper. Beer was brewed in a fifty-barrel kettle, and the kettle could be used twice a day, though at that time Milwaukee was turning out only fifty barrels daily. A refrigeration system cooled fifty barrels an hour. And a fifty-horsepower boiler and engine kept it all running. The brewery did its own hauling, so it housed fifteen horses in a two-story, on-site stable measuring 30 by 44 feet.

# Anything You Can Do, Tacoma Can Do Better

One of the changes under consideration at the time of the enlargement was adding a malt house to store germinated grain, which beer brewing requires. Most Puget Sound breweries imported everything from San Francisco; however, Milwaukee used Puyallup Valley hops and kept 120 bales on hand.

Thanks to the enlargement and improvements, the company had a daily capability of 125 barrels. A year-end recap of the business stated that Milwaukee had increased its annual output to sixty thousand barrels valued at $200,000, employed twenty-three men and had a payroll of $2,250.

Two years after establishing the company, the partners incorporated the business and issued 350 shares of stock. Misters Loeb and Weinberg were trustees, and a man named Kasper Hoffmeir was the brew master. An Interstate Fair held on October 7, 1894, featured a German-American Day. According to the newspaper, members of the German-American community had been indefatigable in their efforts to put the Milwaukee Brewing Company in the front line of West Coast brewery houses.

Of course, Milwaukee wasn't the only brewery in Tacoma. The Donau Brewing Company opened in 1888 at 1001–23 East Twenty-sixth Street; the Old Tacoma Brewery opened in 1889 at the rear portion of a lot at 2118–22 North Thirtieth Street. The next big one was Puget Sound Brewery (PSB) at 2501–15 Jefferson, although the address is now considered to be 2500 South Holgate.

PSB, owned by Anton Huth and John Scholl, started in a four-story building measuring eighty by eighty feet but quickly added a forty- by forty-foot wing. It had a steam-heated beer boiler with a capacity of 4,300 gallons and a mashing machine that held 6,500 barrels and produced 260 barrels a day under the brand names Walhalla and Der Goetten Trank. The owners incorporated in 1891 with Scholl as president, but three years later Mr. Huth bought him out. Mr. Scholl went to Chico, California, and bought a brewery there, and Mr. Huth ran Puget Sound Brewing until 1897. He then took on a partner named William Virges, and the two made plans to take over the local competition. PSB merged with Milwaukee Brewery, creating a new company called Pacific Brewing & Malting Company, and Milwaukee Brewery officially closed in 1899. The new company undertook major expansion projects, one of which was to start Washington Brewing Co. in Everett. Another was to aid in the startup of a second brewery in Tacoma, the Columbia Brewing Company.

In 1900, Emil Kliese, a German-born brew master, came to Tacoma. When he couldn't find work as a brew master, he decided to start his

Columbia Brewing label. *Courtesy of BreweryGems.com.*

own brewery. Kliese and a man named Willian Kiltz filed articles of incorporation on February 8, 1900. Pacific Brewing and Malting was a major shareholder. Work on Columbia Brewing began in 1900 at 2120–32 South C (Broadway). It was in a five-story wooden building built over an artesian well. Columbia's output was fifty barrels a day under several brands: Columbia, Golden Drops, Golden foam and Old Pilsner. In 1912, it added Alt Heidelberg.

Pacific Brewing completed its expansion in 1905, but shareholders weren't happy. They felt that the merger deals were underwriting expansions, and they wanted larger dividend payments. Samuel Loeb brought a lawsuit requesting that Pacific Brewing sell its interests in the Everett Company and in Columbia. The sale left Loeb in a very good financial position—until Washington went dry.

Prohibition came to Washington State in 1916, several years before the Volstead Act. Pacific Brewing began making cocoanut butter and high-grade soaps. Columbia became Columbia Bottling Company and made soft drinks such as Birch Beer, Chocolate Soldier, Blue Jay and Green River. In 1919, the company introduced a near beer called Colo and, in 1925, a new soft drink called Orange Kist.

Heidelberg bought Columbia Brewery in 1949 and, four years later, changed its name to Heidelberg Brewing Company. The company dropped the "alt" from the name of what became its flagship beer. Then, in 1953, Carling Brewing Company of Canada bought Heidelberg.

The history of Tacoma's first breweries is complicated. The same men were buying, selling and merging both here and with breweries in Seattle.

After repeal of the Volstead Act, even more breweries came along. Northwest Brewing Co. relocated to 105–07 East Thirty-sixth Street in 1931. Independent Breweries, Inc., followed in 1934 at 5624 McKinley Avenue. In 1950, Port Orchard's Silver Springs Brewery also relocated to East Twenty-sixth. And these are just the legal breweries. Illegal liquor is a story all its own.

## A ROOF WITH A ZOO: THE WASHINGTON BUILDING

Until a Tacoma medical laboratory decided a roof was a terrible thing to waste, the Washington Building had a fairly humdrum existence. It began on July 27, 1919, when the *Tacoma Daily Ledger* announced that Tacoma was getting a new fifteen-story building to be called the Scandinavian Bank Building. However, from then until the following January, the papers had very little information. On January 4, 1920, readers were told that it would be sixteen not fifteen stories, would replace an existing bank building at Eleventh Street and Pacific Avenue and would be second to none to on the Pacific coast. Depositors were advised that the existing bank's business would be moved to Thirteenth and Pacific. The architect, who was interested in using as much Tacoma labor as possible, asked all the local contractors to put in their bids.

By the end of February, many individual contracts had been issued: Tacoma's Ben Olson Company would handle all the plumbing and heating; the Tacoma Mill Work Supply Company would do all the interior finishing, which included mahogany wainscoting and sash and door work; Hunt and Mottet, a business that is still around, would provide the hardware; Far West Clay was responsible for all the tile; and a Spokane company, Washington Brick and Terra Cotta, would provide terra cotta for the walls. Washington Brick was the only company in the state that could furnish the necessary materials in the specified time. Brick from the old building had been salvaged for reuse; the bank floor was going to be granite. Various aspects of the construction were job by job because apparently Tacoma contractors had failed to submit complete bids. And since a Seattle man named Nick Georig was already doing excavation work across the street for the new Rust Building, he was given the excavation contract. Construction continued

throughout the rest of the year. More contracts were issued. Standard Oil leased the entire tenth floor, steel shipped from East Coast mills arrived and the beams attracted all kinds of attention, not all of it good.

Many years after the bank was complete, a Swedish man named Anders Johansson was interviewed as part of Pacific Lutheran University's oral history project. He said that in the 1920s he was the caretaker at a Covenant Bay beach camp, earning thirty-five cents an hour. The camp director, a Norwegian named Wendels, told Mr. Johansson that the Americans wanted the Scandinavians to invest their money in the Bank of California and other Tacoma banks because the Scandinavians were considered industrious and prosperous, and the men wanted the Scandinavian-American Bank out of the way. The bank did go away, but not because of the investment practices of men such as Mr. Johansson.

On the morning of January 14, 1921, there was a sort of a milk run on the bank. However, thanks to rumors that had been swirling around town, many people who had been issued checks from the bank found that some local stores refused to honor them, and contrary to its custom, the bank didn't remain open to cash pay checks. The following evening, state bank commissioner Claude P. Hay closed it with a brief but devastating statement.

In 1917, the bank's president, J.S. Chilberg, lobbied for creating the Washington Bank Depositor's Guarantee Fund. Mr. Hay issued a statement saying that while every other bank in Tacoma was a member of the Federal Reserve System and the state's Association of Banks, which guaranteed bank deposits, the Scandinavian-American Bank was not. Hay said that though the bank had repeatedly claimed the building had been financed by outside capital, it wasn't true. Approximately $1,200,000 of the depositors' funds had been used. The twelve thousand depositors could expect to possibly be repaid 75 percent.

On January 15, 1921, Chilberg surrendered himself to answer five indictments issued in King County. Four of the charges were for making excessive loans to himself, and the fifth was that he lent a large sum of money to one of the bank's directors without the authority of the board of directors. According to an article on Historylink.org, Chilberg's case was principally a problem of his stewardship of the bank. Chilberg had been one of the most prominent men in the Pacific Northwest, especially in Seattle, and a King County Grand Jury found him not guilty.

The collapse left many depositors holding the proverbial bag—in this case, an empty one. Putting a human spin on the issue, one report stated that most of the depositors who lost their savings were from the "humbler walks of life."

In the meantime, the bank's steel skeleton was erected to its full height, and the brickwork was completed to the twelfth floor. It stayed that way for several years.

On April 28, 1925, a young man named Wolstiuholme (no first name given in the paper) snuck up the back stairs of the uncompleted building, went to the northwest cornice, took off his jacket and stood on his head. Seventeen stories below, people watching from the street were thrilled. A police detective and the foreman took a lift to the roof and saw the boy with his feet pointing skyward. However, they didn't know how to approach him without "causing a serious accident." After Wolstiuholme was right side up, he said he'd been doing stunts such as this one since he could walk, and he was just looking for some excitement. The detective explained that such displays required a license and took the young man to jail. He was interviewed, found to be sincere and given a job working on the building.

Construction was finally done, and the building opened for business on June 29, 1925. Its major tenant, Brotherhood Bank, opened on July 2. On July 5, there was a rooftop party. At 4:30 p.m., a delegation of California realtors arrived at the Union Depot and was met by twenty men, sixteen women and a fourteen-member glee club in a caravan of cars supplied by Tacoma realtors. The California delegation was driven across the Eleventh

The Washington Building's zoo. *Lenard Eccles, artist.*

Street Bridge for a tour of the waterfront and Tacoma's industrial section and then back to town for a reception on the roof. After the cocktail hour, they were driven through the Stadium residential district and on to Point Defiance for a picnic supper.

From then on, life at the Washington Building was fairly quiet until the aforementioned biological laboratory decided to establish a scientific zoo on the roof. It brought in mice, guinea pigs, rats developed by the Wistar Institute of Anatomy and Flemish giant rabbits. According to the paper, the rabbits were important in "criminal experiments and medico-legal work where the authorities sought to determine whether bloodstains were those of humans or animals." Scientists did this by inoculating a rabbit with human blood and, after a certain period of time, testing the chemical reaction of the rabbit's blood on the stains discovered at a crime scene. Also, "the experiment had to be carried on indefinitely by the inoculation of the rabbit with the blood of other animals if it is desired to determine the exact nature of the bloodstains." The guinea pigs were used for various diseases to determine a diagnosis in cases where the microscope was unable to detect disease. The mice were valuable in determining the four different types of pneumonia, and the rats were used for diet tests and food research. The rats had a slightly better life in that they were allowed to breed.

After the '20s, nothing particularly unusual happened at the Washington Building. Businesses came and went; the Tacoma Club leased quarters in 1937 and stayed until 1991. And a little seven-bed hospital operated there (the pun's intentional). It was the predecessor of Allenmore Hospital.

# Dancing with the Stars, or at Least Under Them: The Winthrop Hotel

At nearly ninety years old, the Winthrop Hotel is no longer the shining star of Tacoma it once was. Over the years, since its completion in 1925, the hotel has been remodeled and its purpose reinvented several times, but now it's just a venerable old building with a great history and questionable future.

The drive to build a top tourist hotel in Tacoma began on May 14, 1922, with the formation of a group of citizens who called themselves the Flying Squadron. They went from business to business, soliciting investors, and eventually 2,300 people chipped in to form what was initially called the Citizens Hotel Corporation. From then until it opened on May 15, 1925, local newspapers covered every aspect of the hotel's construction.

The articles began with an announcement on March 13, 1923, that the Daniel M. Linnard Company had obtained a hotel lease on the building. Mr. Linnard was a well-known hotel tycoon whose other hotel interests were mainly in California. The 1920s were the "Age of Great Hotel Resorts," and he was prominent in a number of ventures.

After the deal with Linnard closed, the corporation had a year in which to build the hotel. A call for bids went out on April 25, 1923. A contract was let on May 11. On May 27, the *Tacoma Daily Ledger* printed a sketch of the interior plans, and in July, it announced a contest to give the hotel a name that was better than Citizens Hotel. George Dickson, owner of Dickson Brothers clothing company, won the contest when he suggested Winthrop in honor of explorer and writer Theodore Winthrop.

Two hundred construction workers began work on the Winthrop in December. The result was a ten-story building with addresses on two different streets: 761–83 Broadway and 762–86 Commerce. From the Commerce Street entrance, a half flight of stairs led to the mezzanine. Another half flight ended at the ballroom, and a quarter flight of steps went down to the lobby. Guests' bedrooms were on eight floors. Each had a private shower or bath. Gregory Furniture Company of Tacoma made the rooms' beds, desks, tables and wooden chairs using American walnut. Carman Manufacturing, also of Tacoma, provided the mattresses. The Immanuel

The Winthrop Hotel, circa 1935.

Presbyterian Church of Tacoma donated Bibles. In addition, each room had a telephone, but calls had to be connected through the private branch exchange switchboard located on the roof near the garden. Guest floors were accessed by five elevators. Each landing had its own little lobby.

The Broadway entrance opened onto a combination lobby and dining room that measured 40 by 120 feet. Five tall Italian-style floor lamps provided light. Furnishings included small hexagonal tables with Rookwood pottery bowls on them and small lamps of blue Chinese porcelain with gold-fringed shades of Chinese embroidered crepe.

A main feature at the Winthrop was its 38- by 120-foot Crystal Ballroom. The ballroom had vaulted ceilings with four six-hundred-pound, Austrian-cut crystal chandeliers and twenty six-candle wall brackets draped with crystals. Cream-colored enamel walls were accented with dark wainscoting. There was old-rose relief work highlighted with gold and plenty of mirrors. Those who wanted to watch the dancing could do so from a small balcony.

The Winthrop's top floor had a rooftop garden dining room painted burnt orange and black. Art glass in the ceiling hid the lights. Guests entered a foyer with a terra cotta marble floor and then walked under a vaulted archway decorated with stars and moons. Tacoma's Washington Parlor Company provided specially designed reed dining room furniture. For intimate dinners, the hotel had two small dining rooms: one blue and one rose and gold. A sliding door separated them. They were finished in mahogany and had columns of inlaid panel relief work. Above the columns' heads were shields and coats of arms. All the public parts of the building were marble with ornamental iron balustrades. The final construction cost was $2,500,000.

A few weeks prior to the grand opening, the Linnard hotel organization sent a pastry chef to train the kitchen staff in the fine art of cakes, pies, bread and rolls. The chef allowed the paper to print six of his recipes and challenged Tacoma homemakers to give them a try. His waffles called for brandy in dough that had to rise three hours before it was baked, not fried. No one is on record as having accepted the challenge.

On May 15, the general public was allowed in to have a look. The grand opening was the next day. People came from all over Washington, Oregon, California and British Columbia. However, though 3,000 were expected, only 1,700 showed up—the women in evening gowns and the men in tuxedos. It was the style, in those days, to send telegrams on such occasions. Dozens arrived, coming from New York, Pittsburgh, Chicago, Detroit, Philadelphia and Washington, D.C. Flowers filled the rooms

where people dined and danced. The *Tacoma Sunday Daily Ledger* called the meal a "culinary triumph of French cuisine." Thereafter, having tea at the Winthrop became *de rigueur.*

Eight days after the grand opening, KBG radio station began broadcasting from the Winthrop. Then a thirty-five-foot arrow pointing toward the airport was put on the roof to help out low-flying planes.

One of the Winthrop's most exciting events was a thirty-one-hour flagpole dance put on by entertainers Betty and Benny Fox, a circus act that was advertised as a brother-and-sister circus, though they are now known to have been husband and wife.

They came to town in the middle of the June 1934 and began practicing for the event, sometimes on a little platform sixty feet above ground and sometimes on the roof's cornices. While they cavorted, a small dancing platform—a circle of wood about twenty-four inches across—was attached to the top of the roof's flagpole. People used binoculars or spyglasses to watch them. When Benny picked Betty up, one of the papers made a subtle remark about modesty. The paper also sent up a handwriting expert to get some writing samples for examination. Benny was wearing white overalls over his regular clothes. He felt his pockets and said he forgot to include pen and paper.

When asked what they would do when they came down, Betty said they might go dancing. It all made for a good story to help with the general anxiety of the Depression.

Try as it might, though, the Winthrop never made any money. Its only era of prosperity was World War II. At first, stockholders received a few cents in dividend payments, but the original investors never did get their money back.

As of this writing, the Grand Dame is low-income housing, but the Crystal Ballroom is exactly as it was in 1948 when actor Peter Lorre was there signing autographs.

# Civilized Living

## THE HOTEL HESPERIDES:
## GRACIOUS LIVING AT TITLOW LODGE

At the beginning of the twentieth century, Titlow Lodge was Tacoma's smaller-in-every-way answer to Michigan's Grand Hotel on Mackinac Island. While Titlow Lodge was on two hundred acres, the Mackinac resort covered 3.8 square miles. While Titlow Lodge had a sizeable porch, the Grand Hotel's porch was once the longest in the world. But hey, they were both on water—the Grand Hotel on Mackinac Island in Lake Heron and the Hotel Hesperides on a stretch of Puget Sound at the bottom of Sixth Avenue.

Today, little remains of the lodge Aaron Titlow called Hesperides in honor of his daughters and which calls for knowledge of Greek mythology. The Hesperides were nymphs who attended a blissful garden.

Before white men came along, the Puyallup and Nisqually Indians called the site Tranquil Bay and often camped there. However, the land eventually became part of William B. Wilton's donation land claim. In 1903, Mr. Wilton sold the property to Ohio-born Aaron Titlow and his business partner, state fish commissioner A.C. Little. Right away, Mr. Titlow began promoting an extension to and the paving of Sixth Avenue down as far as his property. Seven years later, the Northern Pacific Railroad paid the two men $55,000 for a right of way, a move that eventually came back to bite Mr. Titlow.

Thanks to advertising, Tacoma was in the midst of a tourism boom, and Pierce County prosecuting attorney Aaron Titlow was well aware of this. In 1911, he used the majority of his railroad money to begin the process of building a luxury hotel/resort.

However, right from the start, when he began dredging the lagoon, his actions got Mr. Titlow mixed up in a lawsuit over land use. The issues involved were twofold: Tacoma's right to condemn and appropriate a right of way over certain land both in and outside city limits and the need for the state legislature to locate and establish harbor lines in the navigable waters of all the state's harbors, bays and inlets. Once these issues were resolved—oddly enough in Mr. Titlow's favor because courts weren't so much into all that eminent domain stuff the way they are now—he built a house; planted orchards and vegetable gardens; brought in horses, pigs and a herd of pure-blood Jersey cows; and started a dairy. Finally, after these preliminaries were done, he started building his resort hotel.

The Golden Age of Resorts was all about going someplace where people dressed for dinner and strolled afterward on open, covered verandas with pleasant views while listening to an orchestra playing somewhere in the background. And that was exactly the place and ambiance that Mr. Titlow created.

Frederick Heath, who had already designed Stadium and Lincoln High Schools, Central School and the Knights of Pythias Temple, among many other buildings in Tacoma, was the architect. What he came up with was a three-and-a-half-story Swiss chalet that faced west toward the water where, all day long, steamships, tugboats, rowboats and three- and four-masted ships passed by, headed for Tacoma or for Olympia and Shelton. The cedar and pine lodge had thirty two-room suites, each with a private bath and usually a private balcony. Hot and cold fresh and salt water was piped to each suite. A concrete basement had a large fireplace, billiard room and barbershop. The housekeeper and servants' quarters were on the top floor, where the guests' luggage was stored. In the dining room, twenty-two Tiffany lanterns illuminated tables set with linen, china and silver. Columns of Douglas fir supported beamed ceilings, and at one end of the room was another large fireplace. In fact, the resort had a number of fireplaces.

The Titlow farm had an ostrich farm where the nine-foot birds ran around squawking. As a result, the breakfast menu offered ostrich eggs. A typical dinner was chicken and dumplings, fresh vegetables and salads, pie made from different kinds of berries and peach butter. The original Titlow farm provided all the food.

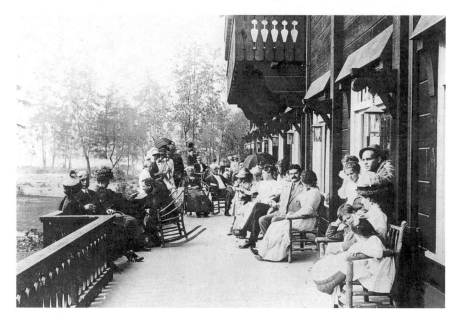

Veranda of the Hotel Hesperides. *Courtesy of Robin Paterson.*

The custom, in those days, was for the ladies to withdraw after dinner. At the lodge, they had a choice of adjourning to a ladies' parlor or a covered pergola across the back with floors of Moravian blue tiles. Meanwhile, their husbands discussed business, smoked cigars and drank brandy—or they would have had a brandy except for one thing: the ladies of half a dozen neighborhood churches joined together to have the lodge's liquor license denied.

During long, lazy summer days, guests dug clams, hunted for crabs and went beachcombing or fishing. Some hiked in nearby groves of giant cedar, fir and maple trees. Others played tennis on the lodge's courts, took their children to the wading pool or swam in the lagoon. Mr. Titlow had a small dam, which included sea locks, constructed. The locks held the lagoon's water at a stationary level a few feet below high tide, and the incoming and outgoing tides changed the water every twelve hours. There were also campsites if people wanted to come and put up tents on the grounds. And in the 1920s, guests could walk across the street to the Weaver Studios and see how a movie was made.

The hotel had its own dock and owned a glass-bottomed boat and two other boats, the *Folly* and the *Lady of the Lake*, which were used to transport guests to Day Island, Fox Island, Wollochet Bay and other nearby islands and inlets.

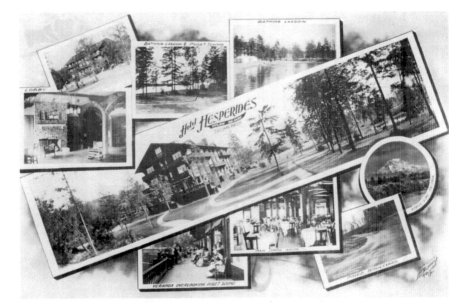

Hotel Hesperides.

Guests arrived by both boat and car and came from as far away as New Jersey. Chauffeurs stayed in a two-story building separate from the resort. Their bedrooms and baths were upstairs; downstairs was for the limousines. That building was eventually moved near the lagoon and became a bathhouse.

And then in the end, there was the shooting oneself in the foot thing, figuratively speaking. First, Mr. Titlow never wanted to actually run the place himself, and the various majordomos he hired weren't very good at it. And second, in 1913, the Northern Pacific Railroad built a railroad line on the land he'd sold to it, separating the resort from the beach. It was a case of the railroad giveth and the railroad taketh away, and the clickety-clack of trains racing by was no one's idea of a high-end resort asset.

Times changed. In the off-season, young bachelors made the Hesperides their home. When World War I came along, the army housed officers and their families in the resort. After the war, high-style beach resort vacations faded in popularity. The lodge quit making a profit, and Mr. Titlow sold out. In 1928, the Metropolitan Park District bought the land, concessionaires ran the hotel and people came merely to swim in the lagoon. During the Depression, a WPA project was launched to enlarge the park facilities. Workers cleared away great portions of underbrush and fallen timber, created roads and trails and built a boathouse, restrooms and community shelters. A custodian moved into the front part of the hotel, and the top

floors were taken off, leaving one and a half stories. The Park Department put on a new roof, remodeled the kitchen, added new restrooms and either added or replaced parts of the floor with refinished oak. The dining room became a public meeting room. Some of the old interior support beams were crooked—one park district employee said they twisted like a snake— and had to be replaced. In 1955, the old swimming lagoon was retired, and an Olympic-sized swimming pool was put in. The cost to upgrade the structure alone was $187,000. There's no word on whether the sale of those Tiffany lanterns paid for anything.

## THE ICEMAN COMETH

A prevailing can-do attitude in the 1880s was widespread in Tacoma. So when businessmen organized a company to build a sixty-mile chute from Mount Rainier's Nisqually glacier to town, the idea seemed perfectly feasible. Residents needed the mountain's ice, so why not cut blocks and slide them down a chute? Well, no one ever said every idea was a good one.

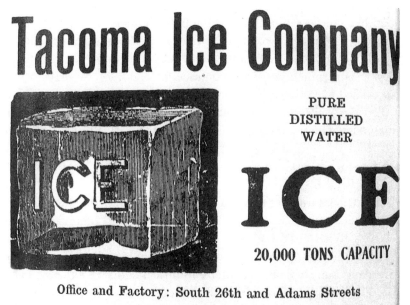

Advertisement for Tacoma Ice.

As soon as ice did become available in Tacoma, Mrs. Alice Blackwell built an icebox. She selected two stout wooden boxes of different sizes so that one would fit inside the other with about a two-inch space on all sides; she then packed the space with sawdust. She removed the lid of the inner box and reattached it with hinges, put a piece of ice in the bottom of the box and a sheet of wood over the ice and used the box to keep butter, milk and eggs cold. As the ice melted, the water soaked through the sawdust and ran out through a hole. She found the instructions in the June 1875 issue of the *American Agriculturist.*

Tacoma got ice in 1887 when the Tacoma Ice and Storage Company built a facility on Holgate Street. The company owned twelve horses and employed fourteen men who made deliveries by wagon. The deliverymen wore leather aprons that hung down their backs and used pronged clamps to grip the blocks they carried over their shoulders. In addition to town, Tacoma Ice delivered to cities along the railroad lines in the southern part of the state and eastern Washington. People such as Mrs. Blackwell subscribed to ice delivery. Sometimes subscribers put in special orders for things such as flowers, bottles of wine, fish or game to be frozen in a block.

In the United States, the ice business started early in the nineteenth century when a man named William Tudor visited the Caribbean and decided he could create a business shipping ice there. In 1806, he bought the brig *Favorite* to carry frozen pond water from Boston to Martinique and, at the same time, sent his brother, Frederick, and cousin James to various Caribbean governments to secure contracts for Tudor ice. By 1810, William's profits totaled $9,000, but he was only able to keep $1,000 because of what he called the "villainous conduct of his ice agent." Gradually, William's debits exceeded his income, and he spent parts of 1812 and 1813 in debtor's prison. In 1815, he borrowed $2,100; had an icehouse built in Havana, Cuba; bought ice; and set sail with the sheriff, as he said, "pursuing him right to the wharf."

His subsequent trips were so successful that William decided to experiment by exporting tropical fruits from Cuba to the United States preserved in fifteen tons of ice and three tons of hay. Once again, he ended up in debt. Nevertheless, William soldiered on, experimenting with sawdust, wood shavings and rice chaff as insulations and learning to have the ice cut and packed like masonry blocks. He built icehouses on various tropical islands and created a demand for ice drinks. William was doing well, but cutting the blocks correctly was difficult and expensive—until a man named Nathaniel Jarvis Wyeth harnessed horses to a metal blade to cut ice in blocks of twenty-

five, fifty and one hundred pounds. Wyeth's ice plow made mass production a reality and allowed William to more than triple his production.

In 1833, Boston-based merchant Samuel Austin proposed a partnership for selling ice to India, some sixteen thousand miles and four months away from Massachusetts. On May 12, 1833, the brig *Tuscany* sailed from Boston for Calcutta, carrying 180 tons of ice in its hold. When the ship approached the Ganges in September 1833, many believed the delivery was an elaborate joke, but the *Tuscany* still had 100 tons of ice on arrival. Over the next twenty years, Calcutta became William's most lucrative destination, yielding an estimated $220,000 in profits.

In the early 1830s, William also began to speculate in coffee futures with his ice business as collateral. Initially, coffee prices did rise, and he made millions of dollars, but in 1834, he fell more than a quarter million dollars in debt, forcing him to refocus on the ice trade. By then, the ice business had expanded from New York up through Maine. Newly constructed railroad lines sped up the process of transporting ice and made it more efficient. By the 1840s, ice was being shipped all over the world, and although William Tudor was now just a small part of the trade, his profits allowed him to pay off his debts and live a very comfortable life.

Meanwhile, in 1861, an icebox was developed. It was very much like Mrs. Blackwell's, except that manufactured iceboxes were lined with lead or zinc and had shelves and compartments. And in Tacoma, as elsewhere, trucks gradually replaced horse-drawn delivery wagons. Tacoma Ice built a new five-story brick cold-storage building in 1923.

When refrigerators came along, stockholders wanted a more aggressive management team. John and Pat Reisinger bought the company and began packaging a new product called party ice. They still packaged ice blocks but also made and sold ten-pound blocks of ice and snow, crushed ice in large and small bags and dry ice.

Thirty-nine years later, the *News Tribune* declared that the ice age here was officially over. The Olsen family of Parkland finally decided to get rid of their icebox. Mr. Olsen said keeping it around was too much of a luxury. During the summer months, the Olsens used five to six hundred pounds of ice, and that was okay when it was one and a half cents a pound. However, in August, their ice bill had been eighteen dollars, so they felt forced to change to a refrigerator. The Olsens were not a family who liked change. For years they had lived on a house on the PLU campus. When the college decided to enlarge, rather than move to a new house, they moved the house to a new location.

At the time the Olsens made the big change, Tacoma Ice still had five men delivering ice, mostly to businesses. A fire destroyed part of the building on March 5, 1979, and the ice-making portion was rebuilt in a separate structure.

These days, the occupation of ice delivery lives on mainly in Amish communities.

## WAITRESS! THERE'S A FLY IN MY FOOD! ESTHER ALLSTRUM AND THE CLEAN FOODS ACTS

*In one restaurant in Seattle a sewer overflows and floods the floor and people are compelled to eat food prepared in such places.*
*—Delegate Alice Lord addressing the State Federation of Labor*

Service with a smile.

Alice Lord, who made her statement on January 11, 1908, went on to say that cooks and waitresses were often expected to change their clothes in the bathrooms, many of which were located in the kitchen. Clearly, reforms were called for, and that's where Esther Allstrum came in. For three years, she was Tacoma's food inspector.

Miss Allstum was born in Minnesota to Louis and Eva Allstrum, who had come to the States from Stockholm, Sweden. She went to school in Minnesota, but after that reports differ. She either learned the printing trade in Minnesota and then came to Tacoma or she came to Tacoma and learned the

printing trade here. Either way, she found work as an apprentice press feeder and moved on to typesetting, ruling and binding. Ruling means she drew lines on blank paper, and though lined paper dates to the early nineteenth century, it had yet to become common. The books Miss Allstrum was ruling and binding were used by the first Alaska federal court, over which Judge James Wickersham presided. There were eighty of these books in all. She managed both the mechanical aspects of the job and then the business side, after which she became a partner in the firm. Miss Allstrum had what was normally considered to be a good-paying *man's* job, and the men in the office weren't shy about making her life there difficult any time they could.

The 1891 *Tacoma City Directory* lists her as working for Washington Book Bindery. Two years later, she was associated with the Western Blank Book Company. From there, she went to work for Waller Printing Company. In 1909, Miss Allstrum went into the printing business for herself, opening the Allstrum Printing Company at 729 Commerce. Because of her broad background, she was able to show a profit almost immediately. In fact, her printing business became one of the most comprehensive in the state.

In 1911, she hired her brother, David, who for the previous fourteen years had been an employee of the Carstens Packing Company, where he worked his way up to company treasure. This move may have been necessary because the previous year Mayor Angelo Fawcett had made Miss Allstrum Tacoma's city food inspector, replacing Mrs. Mary Macready. According to reports, Mayor Fawcett appointed Miss Allstrum to the post because Mrs. Macready had been excessively competent, and he was hoping Miss Allstrum would be too busy with her printing business or, as he put it, with her "money-making affairs" to bother with inspecting food.

"I've lived a long time without having my food inspected," he said, "and I've never been poisoned yet." Unfortunately for the mayor, Miss Allstrum was equally vigorous in pursuing dishonest and lackadaisical market operators.

At the time, Tacoma had one thousand food dealers, of whom only two hundred had their proper licenses. So she started by insisting that all the city's food dealers take out a one-dollar license. She made lists of the food regulations and asked grocers and butchers to frame and post the food ordinances on their premises. Naturally, there was sizeable opposition, and the merchants started asking her how far she was prepared to enforce the rules. "All the way to the Supreme Court," she told them. It was tough going, though, because the market owners just didn't want to comply. When that happened, Miss Allstrum would sometimes go to the newspapers. Once, she found that spoiled clams were being used to make clam nectar. She could

The danger of bad food.

have just gotten the proof and worked through conventional methods to stop their sale. Instead, because she wanted the sales to stop immediately, she gave the facts to a reporter. After the paper got involved, clam nectar became a very unpopular drink in Tacoma.

Another time, she poured kerosene over a box of food scraps that a dealer claimed was bologna, and at yet another market, when the shopkeeper had been warned to move his sidewalk display inside the sidewalk line and refused, she sawed the legs off his table.

In those days, Tacoma had a public market on South D Street, and she demanded that the market make improvements. One was the construction of uniform stalls or stands for every dealer who rented space. Contractors built thirty-four new stalls, which were eleven feet, four inches long and five feet high at one end and two feet high at the other. The result was a sloping stand eight feet deep for its full length. The entire stand was raised above the street level more than eighteen inches, permitting merchants to wash out any refuse that might gather underneath. The new stalls made the whole market easier to clean. Another improvement came when she arranged for additional tanks and pipes needed to supply greater amounts of water for said cleaning. Since the city paid for all this, it naturally charged fees. Interestingly enough, in spite of the fees, there was an increased demand for the new stalls.

Nationally, magazines began picking up her success story and named her "the woman who has made Tacoma famous for its model food ordinance." Inquiries came in from all over. Her track record caused Seattle, Spokane and Yakima to appoint female food inspectors.

Miss Allstrum was making major headways in cleaning up Tacoma's food when one of the newspapers published an account claiming that in order to keep his office, Mayor Fawcett had promised to appoint a new inspector, one with lax standards. Once this got out, the dealers ignored Miss Allstrum's orders, and the authorities ignored her appeals for help. Finally, she resigned. In a letter to the newspapers, she said, "The situation has become intolerable, and for my self-respect I cannot [any] longer hold this office and be a party to the betrayal of the pure-food law."

As it turned out, Mayor Fawcett didn't appoint a new food inspector, and the office remained vacant until he was out of office and William Seymour was elected. The public demanded that Miss Allstrum be reappointed, but she said the strain of the job was too great, and besides she had her own business to run. However, when the mayor appealed to her "ardent suffrage beliefs," she changed her mind and worked for him until his administration ended.

In addition to her job as food inspector, Miss Allstrum was a charter member of the YWCA and belonged to the United States Typothetae [sic] of America, which later became the Printing Industries of America. She was a member of the Woman's Club of Tacoma, was state treasurer of the National Council of Women Voters, was a member of the Republican county executive committee and was the only female member of the Employers' Association of the State of Washington.

Miss Allstrum bought a house at 644 Trafton in 1906 and lived in it until her death in 1917. The house is still there.

## THE EYE OF THE LAW FALLS ON WOMEN

One day in the last quarter of the nineteenth century, a woman named Bethena Owens Adair—wife, mother, domestic, teacher, milliner and doctor—drove madly through a Portland neighborhood with the husband of a woman whom, he said, was in labor and dying. During the drive, two women signaled frantically from a curb to summon Dr. Adair. When she pulled up, they rushed to her side of the buggy and whispered, "Bethena, do you know you're hatless?"

Back then, the importance of women covering their heads in public could not be overemphasized.

Mrs. Kittie Strobel was one of Tacoma's most skilled milliners, and like Dr. Adair, she learned by observing. She regularly went to hat stores during

their grand openings and studied what she saw. Armed with nothing but her observations and skill with a needle, she went to work as an apprentice to a woman named Mrs. M.H. Berry. Mrs. Berry gave Kittie four hats a year in lieu of a salary. From Mrs. Berry, Kittie went to work for a Miss McCutcheon, earning five dollars a week.

Because Portland was bigger than Tacoma, Kittie and her employer regularly took the train south to look at for new styles and patterns and to visit wholesale houses. They returned with silk, velvet and feathers and sewed like crazy to make new hats and refurbish old ones. In Puyallup, they displayed their work in glass cases at the Puyallup Fair. And once or twice a year, they traveled up to the foothills of Mount Rainier to sell their wares at coal mining towns such as Buckley, Carbonado and Wilkeson. When Kittie and Miss McCutcheon arrived at the first town, they'd find a place to stay and then go door-to-door, passing out handbills. The beauty-starved women flocked to their hotel. When they'd sold all they could at the first town, they rented a horse-drawn wagon and drove to others. Most of their customers couldn't speak English and brought their children to translate. Kittie said that they always came back "loaded with greenbacks."

A lady and her hat.

At that time, when large hats were back in style, women wore huge ones known as the Merry Widow, and men didn't like them. They particularly didn't like them being worn on the streetcars. Three men not only complained to officials of the Tacoma Traction Company but also filed charges. They wanted

damages for things such as broken glasses, facial scratches and at least one broken derby, all caused, they claimed, by Merry Widows. Some men thought that women who wore large hats should have to pay double, but the traction company wasn't willing to go that far.

Tacoma men had other issues with the ribbons, felt and feathers that adorned the Merry Widows. They claimed that the masses of furbelows obstructed vision. Tacoma city council members decided they were right and ordered a series of fines ranging from five to ten dollars "to be levied for wearing a hat in a theater or other place of public entertainment." The ladies were furious. Fashion was fashion, and where, at the theater, were they supposed to put their hats?

And then the men tried to take the law one step further: enforce it at church services. That one didn't work; the official reason given was that because of the separation of church and state, they had no authority over churches. The unofficial one was that a big hat provided a handy shield behind which a man could doze.

Meanwhile, Kittie Strobel got married. Unusual for the time, her husband said she could continue working, if she wanted, as long as he remained the provider for the household (and presumably as long as she did all the household chores).

One day, Susan Graham Jacobi, who lived and had a millinery shop in the Winthrop Hotel, ran an ad for a trimmer. Kittie applied and was immediately hired. Every morning, Mrs. Jacobi came down from her apartment and went to her office on the balcony to go over the books. Then she went to the sales room to chat with customers. Jacobi's made hats for all Tacoma's most prominent women. Mrs. W.R. Rust, whose husband established the Tacoma Smelting & Refining Company, sent her chauffeur to the shop to pick up a selection of hats and take them back to her home for inspection. He then returned those that she didn't buy.

Kittie stayed with Mrs. Jacobi until she was seventy-six and then retired. By that time, the custom of wearing hats was going out of style. The reason given rests with the military during World War II. Photographs of dashing aviators, hatless but wearing newly developed sunglasses known as Ray Bans, put paid to headgear.

Tacoma's men also had issues with women's dresses. According to one editorialist, dressmakers were so skilled that they were able to take several yards of fabric and cut and stitch it so that a woman appeared to be wearing tights, which were illegal, without actually breaking the law. Again, the city council members weighed in. First, they ordered all posters of scantily clad

Watch those hands!

or nude burlesque dancers taken down. Then, they cast their hairy eyeballs on the two statues of nymphs in Wright Park. "It is certainly not unwarranted," one newspaper claimed, "that the ankles of these dancing girls are such as to justify their demolition"—the entire statue, not just the ankles.

The statues survived, and the men moved on to take up the issue of flirting in church. And not only that, they accused homemakers of refusing to take their servants to church for fear people would ask, "Which is the mistress and which is the maid?" Women, of course, hotly denied both these allegations. They most certainly did not flirt in church, and their servants were welcome to attend. Household help was hard to come by. A group of ladies had gone to a slum neighborhood and tried to entice some of the young women living there away from their fast-and-loose lifestyles. Unfortunately, the wages these ladies offered didn't compare favorably with the wages of sin.

And then, because the council members seemed to spend a lot of time looking at women, they created a dancing rule. "The lady, in dancing, shall place her left hand on her partner's arm and not on his back or shoulder." Men were allowed to accommodate themselves if "they had a short arm and/or a buxom dance partner."

According to the *New York Times*, which felt called upon to report the new dance rule, "The unhappy part of the situation is that the dance has fallen from the high estate of the days of the polka and schottische."

How much attention women paid to these rules isn't known. For the most part, they were too busy running their homes to bother. Suffice it to say, city council members seemed to have too much time on their hands.

# Civilized Living

## CLEANLINESS—NEXT TO GODLINESS?

*Tacoma is going to have a city bathhouse. No doubt the municipality needs one.*
—*The* Olympian

In 1972, Tacoma pioneer Ruby Blackwell looked back to the 1880s and her family's home at 1110 A Street:

> *The lavatory was off the bedroom, containing a "set"—wash bowl and toilet. Water was piped into the house from John Burns Springs on E Street. Uncle Will devised sufficient pressure for water in the bathroom by putting an oak barrel on stilts in the corner. Of course, the tub was galvanized iron. Waste was taken care of by a cesspool under the garden as there were no sewers yet.*

Miss Blackwell was wrong about Tacoma not having sewers. Community sewers constructed in 1880 ran down Pacific Avenue—the shortest route to the tidewaters of Commencement Bay. The pipes were wood, and when one broke, it was discovered that the system had no bottom. Sewage mostly remained where it was deposited.

When Miss Blackwell wrote that water in the family bathroom was stored in a barrel supported by stilts, she didn't say whether the water was for the commode or for bathing. However, people generally bathed only once a week and shampooed their hair less frequently because soaps left a dull film, making hair uncomfortable and unhealthy looking. Also, since the first commercial deodorant, Mum, wasn't patented until 1888, clearly the late nineteenth and early twentieth centuries were smelly times. One solution was public baths.

Back then, bathing meant swimming to most people. On March 18, 1891, the *Tacoma Daily News* reported that John Nannary's death was the result of bathing and that he had probably hit his head when diving into a pool. To James Tait, however, bathing meant getting clean.

Tait dropped into the *Tacoma Daily Ledger* office one day "with a roll of stiff brown paper as big around as a common stovepipe under his arm." He commandeered a desk, spread the paper out and said that for months he had been trying to come up with a way to provide the people of Tacoma with a public bathing facility.

"In nearly every city in the Union of the size of Tacoma," he said, "public baths have been established and in a general way intimating that it would be

a good idea to open a first-class bathing house here, I thought it about time for me to strike out."

Tait was born in England, where twenty years earlier he had managed a public bathhouse. In Tacoma, he worked for the city as a civil engineer. Tait and architect C.A. Milligan had been bathing every week in the Puyallup River, and the two came up with the idea for the public bath.

As the plans showed, their building would be ninety by fifty-five feet on the outside and sixty-six by forty-five on the inside. The men planned a brick foundation and double-thick brick walls up to the edge of the foundation and then wood from there on. The bathing pool ranged from four and a half feet to seven and a half feet. The deep end was to have a springboard for diving. The plans included an office, boiler room and fourteen dressing rooms with locks. Their plan was to build it on the A Street bluff near Ninth Street and pump up salt water from the bay. Fresh water, Mr. Tait said, "wasn't seen as advisable."

A lady and her bath.

On ladies' days, a female matron would be in charge. On children's days, the water level would be lowered. In winter, the pool would be converted into an ice-skating rink. No one explained why keeping clean was only a summer activity.

Mr. Tait needed something, though—$6,000 to get started. The bathhouse was never built.

The cleanest people in town back then were the Japanese. Kenjo Kametaro came to town in 1906 and worked as a logger for two years. After that, he opened a barbershop and bathhouse at 1503½ Commerce Street and was both the president and treasurer of the barbers' guild and board member of the Tacoma Japanese Association.

Reynolds & Parker 2302 S Wilkeson  Thomas Grocery 4028 McKinley av

**MOOREFIELD SANITARIUM**
BATH AND MASSAGE PARLORS
*Sulphur, Steam, Medicated, Hot Air, Vapor and Shower Baths*
Good for Rheumatism, Lumbago, Kidney Diseases and Lagrippe
Two Departments, Lady and Gentleman Attendants
702½ Pacific Ave.                    Phone Main 5284

Advertisement for the Moorfield Sanitarium.

Two years later, Niiyama Shuzo came to Tacoma. He was also a board member of the Tacoma Japanese Association and president of the Tacoma Japanese Barbers' Union. In addition to a bathhouse, barbershop and laundry, he started a hotel and a combination arts/variety/clock shop.

Ishida Kaname came to town in 1912 and started a barbershop. He soon became vice-president of the barbers' union, councilor of the Japanese Association and owner of a barbershop, laundry and bathhouse at 1154 Commerce Street.

These baths were for the Japanese clientele; white Tacoma residents had their own: C.C. Swanson's Baths at 915 South Tenth Street, the Sanitorium [*sic*] Baths at 5424–26 South Puget Sound Avenue, an unnamed bathhouse at 5040 South K Street, the Royal Baths at 116 South Ninth and the Moorfield Turkish Bath in the Colonial Hotel at 701–05 Commerce Street. However, the most well known and most notorious was the Hamman Baths.

The Hamman Baths started out as a legitimate enterprise under a Pacific Avenue barbershop. It opened on December 17, 1890, with F. Fritz Keeble, a well-known "tonsorial artist" (barber) as manager. A brief article in the *Tacoma Daily News* described the baths as "handsomely decorated and fitted up with all the newest appliances." The baths were open both day and night and had accommodations for men and women. Amenities included "after-the-bath, spacious and airy cooling and lounging departments, Turkish and Russian massages, a gymnasium, a 14 ft. x 40 ft. swimming pool, and a female attendant to shampoo women's hair." The floor was covered with hexagonally shaped ceramic tiles in red, green, purple, white and ochre. The walls were tiled up approximately five feet with rectangular-shaped white tiles. Support columns were encased in marble. Mostly, the bath seemed to attract loggers. And then, in 1901, Tacoma's prostitution vice lord, Peter Sandberg, bought the facility.

Sandberg added three floors and reopened it in 1902 as the Kentucky Liquor Store. When he doubled the building's size in 1909, the address

became 1128 Pacific Avenue. Sandberg took out a liquor license in 1911, and not long after, a sixteen-year-old "country girl" was wooed into the facility. The unnamed teenager told the police that she had come to town to shop and met a "sociable woman" named May Brown at a five-and-ten-cent store on C Street (Broadway) who took an interest in her. The woman suggested that she stay in town and see some picture shows, and then her new hostess invited the girl to stay overnight with her. The girl phoned her mother, after which the two went to dinner and the shows. They ended up on the seventh floor of the Kentucky. There the teenager saw "kimono-wearing girls, bottles of beer and whiskey"—and a connecting door in her room through which two men appeared saying "they were there for romance."

After several hours of the girl's refusing both the liquor and the romance, the police knocked at the door, and May Brown had the girl roll under the bed and told her to keep still. May, it turned out, was well known to the police, and when they searched, they found the teenager. The girl was the third to disappear from Tacoma's streets, and blame was placed on Sandberg's procuring methods.

Sandberg's liquor license was revoked in January 1912 and re-granted by accident eleven months later. It was a well-known fact that Sandberg made payoffs to various police officers and elected officials. A man named Edward Ackerman bought out a fellow named James Kelley and applied for a transfer of Kelley's liquor license. A third man, A.U. Mills, approved it, and the application was snuck through with a bunch of other applications and legislation requiring approval. Mayor W.W. Seymour said, "Had he taken time to read everything he'd signed, he never would have approved a liquor license for the Kentucky Hotel."

Would that he had been more careful! Police officers raided the place in 1916 and found a stash of illegal whiskey in a compartment accessed by a trapdoor that was hidden under carpeting in the women's area.

Prohibition and the country's moral movement hit Sandberg hard. He died a poor man in 1931.

The bathhouse was uncovered in 1968 and then lost to history again until 2008. Sadly, rather than turn it into a moneymaking tourist attraction, it became a rain cistern for Pacific Plaza.

## CURSED ABODE?
## THE QUICK AND THE DEAD AT THE RUST HOUSE

Tacoma's most recognizable house has to be the big old Classic revival colonial home on North I Street. There are others equally elegant, but it is the Tara-like house that is most often requested on the Tour of Historic Homes. This is the house that Rust built.

William and Helen Rust and their son, Howard, came to Tacoma in 1889 from Colorado. Mr. Rust was in the smelting and refining business, and he came here to buy the Tacoma Mill and Smelting Co. After the purchase, he spent a year remodeling and upgrading the facility. Eventually, Mr. Rust's smelter became the largest in the Pacific Northwest.

Mr. Rust ran the facility for fifteen years. In 1905, famed financier Bernard Baruch negotiated a deal in which Mr. Rust sold it to the Guggenheims. With a portion of the proceeds, he bought eight lots on North I Street on which to build a family home. What he apparently chose to ignore was that part of the land had belonged to embezzler Paul Schultz. And Schultz had committed suicide as the way out of his mess.

Ignoring the property's taint, Mr. Rust decided the house would be a replica, on a significantly reduced scale, of Shadow Lawn, the home owned by New York businessman John A. McCall. Shadow Lawn had 130 rooms and the Rust mansion 18. And Shadow Lawn was built from Indiana limestone; the Rust home was built from Wilkeson sandstone. But hey, that was huge for Tacoma, and there were similarities in the floor plan.

The first floor of the house that Rust built had a library, a dining room, a small domed-ceiling reception room that adjoined a south veranda, a kitchen, a butler's pantry and a pergola (a walkway supported by posts and covered by latticework over which vines grow) with a northern view of Puget Sound. The family bedrooms, sitting rooms, bathrooms, dressing rooms and guest bedrooms and baths were all on the second floor. The third floor had spare guest facilities, plus the servants' bedrooms and sitting room.

Puget Sound was chock full of cedar, oak and pine, so much so that it was *déclassé*. The walls that Mr. Rust didn't cover with imported gold and green French wallpaper were oak or mahogany. There was also a vacuum cleaning system, trunk elevator and telephone intercom, a billiard room with a floor of interlocking rubber plates, a ballroom with a maple dance floor, a laundry room with a clothes dryer and furnace and fuel rooms in the basement. Altogether, Mr. Rust's home sweet home consisted of eighteen rooms, four baths and eight gas fireplaces.

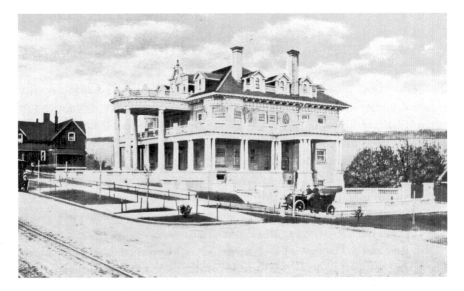

The Rust House, circa 1907.

South of the house was the carriage house and north was a two-car garage, chauffeur's quarters and robe room. The garage was designed to support a summer garden. The grounds also had a sunken Italian garden.

Mr. McCall lived at Shadow Lawn for three years; the Rusts occupied their home for five years. In 1910, while William and Helen and their youngest son, Arthur, were in Europe, their oldest son, Howard, had a sudden heart attack and died. The memories of their son, in combination with such a large, empty house, were too much for Mrs. Rust. Also, a man named Samuel Glenn built "an ugly little laundry building" directly across the street. The Rusts sold their home to George Savage and W.R. Nichols, who in turn sold it to Francis Bailey. Mr. Bailey lived there a year before A.E. Grafton took it away in a foreclosure and sold it to Orville Billings, president of the Pacific Building and Loan Association, and his wife, Minnie. They partitioned off rooms and created twelve apartments to help alleviate the World War I housing shortage.

Mr. Billings lost his job when a fourteen-year-old hearing- and speech-impaired girl brought assault charges against him. Just before he was to stand trial, while in the dining room showing a new pistol to his wife and a friend, Orville Billings put it to his head and pulled the trigger. Investigating authorities came to the conclusion that Mr. Billings had been unaware there was one bullet still in the chamber, and therefore the death was an accident. However, the insurance company may have thought differently because Mrs. Billings had to sue for benefits.

Mrs. Billings sold the house to James E. Bell, and it became the Bell Mansion Apartments. In 1931, when the occupants included a family named Krueger, Fred Williams of Paramount Securities Loan Company obtained a lien against some of their furnishings for back taxes due. On Christmas Eve, Mr. Kreuger armed himself with a double-barreled shotgun and Mrs. Kreuger with a rifle. Their maid, Izotta, had a double-bitted axe, and their friends Fred Massie and Johnnie Kennedy each held revolvers. They barricaded the doors and windows and held the authorities at bay. The standoff was the excitement of the Christmas holiday that year. It was also a complicated affair that ended up in court.

To summarize, William Rust bought land that included lots previously owned by a suicide victim. The oldest Rust son died unexpectedly of a heart attack; after the Rusts moved, the second son may or may not have staged his own kidnapping. Mr. Billings died in the dining room by his own hand, and an armed siege took place at the house during the Depression.

The Rust home continued as an apartment complex until 1983, when it was purchased and returned to a single-family dwelling. So far, there have been no untold incidents.

# LEAN BACK AND OPEN WIDE

For a time, Charles Spinning was Pierce County's only doctor. When people sent for him, he traveled by foot, horse or canoe and used what was at hand to treat the patient. Dr. Spinning used spider webs to stop bleeding and treated achy joints with heated slices of lily roots. He made enema bags from deer bladders or kelp. And when one of his patients complained of a toothache, Dr. Spinning had him lay on the floor, sat on the man's chest and pulled the bad tooth with a bullet mold.

Throughout history, dental procedures have been risky business. To remedy the pain caused by bad teeth, barbers/surgeons/dentists tried alcohol, chloroform, hashish, marijuana, mesmerism, exotic ointments and cocaine. Sigmund Freud was a strong proponent of cocaine, "thinking it a miraculous answer to a variety of behaviors as well as dental problems." In 1887, an unnamed reporter from the *Tacoma Daily Ledger* had a tooth pulled under the effects of cocaine and reported it to be "a happy experience."

However, pioneer settler Fred Nunns had nothing either good or bad to say about his anesthetic—and for a good reason. For several years, Fred

Dr. Spinning performs his bullet mold dental procedure. *Lenard Eccles, artist.*

treated several of his troublesome teeth with carbolic acid. One day in 1923 when he had to go to town, Fred decided to have them pulled and be done with them. The pain went away, but so did Fred. Shortly after the extractions, he died from a suspected case of Novocain overdose.

By the early twentieth century, the hypodermic needle had been substantially refined, making the use of cocaine a lot easier, but dentists weren't convinced that it was the best way to go; the results were highly unpredictable. In 1912, two local men volunteered to undergo unnecessary extractions in the interests of science. Dr. E.J. Doty sat in the midst of a group from the Pierce County Dental Association and let a fellow dentist treat him with a "mixture in the form of quinine" and pull a tooth. A second "unidentified business professional" was treated with a combination of nitrous oxide and oxygen and also had a tooth pulled. Their sacrifices were part of a national movement to find an anesthesia that was safe, reliable and non-addictive. Being painless wasn't one of their priorities.

Extractions, however, weren't the only dental problems. Gun disease was rampant. One common treatment for problem gums that lasted well into the twentieth century was the application of a leech (the best-quality leeches were believed to be those imported from the Dalmatian coast) to the affected area. A leech practitioner coaxed the worm into a leech tube, the patient held the end of the tube against the infected gum for twenty to thirty minutes and the leech nibbled away. It was a procedure requiring patience,

care and a firm, steady hand because it wasn't unknown for a "lively leech to escape from the tube and start down the patient's throat."

And then there were false teeth. They date to 700 BC, when Etruscans made dentures from human or animal teeth. At about the same time, the Japanese were making wooden dentures. Porcelain teeth came in the 1770s with Wedgewood providing most of the porcelain paste. Over the years, dentists experimented with elk or cow teeth and walrus or elephant tusks. Battleground scavenging for teeth was common from the Civil War through the various Indian wars. Those who couldn't afford dentures had three choices: do without teeth altogether; stuff rolls of cloth between the cheek and gum to fill out the space, as Queen Elizabeth I did; or try to find some comfortable dentures. Interestingly enough, the dentures weren't for eating; they were for wearing out in public. To eat, people either hid in another room and gummed their food or invested in a masticator. Dental supply catalogues sold masticators, and some cookbooks even suggested them with their recipes. Smart mothers may well have used them to pre-chew food for their babies.

For as long as soldiers used muskets, the military required its soldiers to have at least two teeth—an upper and corresponding lower—so they could tear open the paper patch. During World War I, at the request of a Camp Lewis medical officer, the following inquiry was sent to the provost marshal general: "Medical officer assigned to this department asks to be advised whether contemplated scope of dental work referred to (in section 185) includes bridge and plate work."

An answer came back saying, "Men who are otherwise physically fit but would need dental bridge or plate work in order to have the mastication requirements set forth in the regulations (four molars that met) would have to take care of their dental problems themselves."

Edgar "Painless" Parker was a well-known pioneer dentist. The "mogul of the mouth" was as much a showman as a man of dentistry. He took medicine shows on the road using troupes of actors, singers, acrobats, jugglers, magicians and tap dancers to attract business. Detractors said his principal anesthetic was noise and confusion. Nevertheless, he opened a chain of clinics around the country. His Brooklyn clinic had a ten-foot-tall advertising sign. His Tacoma clinic, located at 1101–03 Broadway, was on the second floor, and the sign was about two feet tall.

On August 14, 1939, Dr. Paul Hallock of 5401 South Tacoma Way retired thirty years to the minute after beginning his dental practice. When leaving his office, he took with him a box containing every tooth he'd ever pulled. He said he was thinking about incorporating them in a barbecue he was building.

## SILENT STEEDS: RECREATIONAL WHEELS

In 1888, thirty-seven men organized the Tacoma Wheelman, a bicycling club that met in the Davis Building (since demolished) at 910–12 Pacific Avenue. Not long after, the women organized the Ladies' Bicycle Club. The men assumed a uniform that included knee pants, and most of the women went for bloomers. Both clubs were united in their frustration over Tacoma's plank roads.

The club members were a little behind the time when it came to biking. Safety bikes hadn't made it to Tacoma yet, and the wheelmen rode something nicknamed the boneshaker. It had a wooden frame and wheels and pedals attached to a large front iron tire.

By 1895, tough safety bicycles were becoming commonplace. They had equal-sized wheels, pedals attached to a sprocket through gears and a chain. Additional innovations included hollow steel tubing, coaster brakes and adjustable handlebars.

The bikers' aims were threefold: for the members to ride their own bikes, to teach others to ride and work to get decent bike-riding roads. They wanted a network of paths from ten to fifteen feet wide and surfaced with cinders "so as to be suitable for riding throughout the city and beyond." One of their first projects was to improve the old water ditch road that ran along the Clover Creek flume from the Twenty-eighth and G Streets reservoir to the prairie. The club raised $300 and improved the road for five miles. The improvement was a mixed blessing. It gave cyclers a road out to the country but also gave them views of ducks, cows and children frolicking in the city's drinking water. Undoubtedly, however, the men's greatest achievement was the Tacoma Bicycle Bridge.

Ladies take to the road.

In in addition to meeting in the Davies Building, the men also had an indoor track at the Columbia Hall on the southwest corner of Ninth Street and Tacoma Avenue. The Tacoma Wheelmen sold bicycle licenses and by 1896 had enough money to pay for a wooden bridge, built on top of steel poles high above Gallagher's Gulch near Holy Rosary Church. It was 440 feet long, 127 feet high and 12 feet wide. It connected Delin Street with the paths leading to the Hood Street reservoir. The bridge opened the way for cyclists to bike undisturbed from Tacoma's east side to South Tacoma. For more than twenty-five years, it was the "longest, highest and only exclusive" bicycle bridge in the world.

Cycling became so popular that some Tacoma residents had small bike garages attached to their homes. The city imposed an annual one-dollar-per-bike tax and set speed limits of six miles per hour in the city and twelve miles per hour in residential areas. Peter C. Lawson was arrested on July 24, 1893, for riding his bicycle on the Tacoma Avenue sidewalk and hitting and cutting a little boy. He was released when it was discovered that the ordinance covering streets with sidewalks where biking was illegal didn't include Tacoma Avenue. When fines and revenues were collected, the money went toward additional trail improvements. Two years after the bridge was built, the Tacoma Police Department formed an experimental bicycle squad. A year later, it was declared a success. Not only could the beat cop cover a larger territory, but he could also do it in silence. And the local roads were in such poor condition, and the automobiles so noisy, that bike patrol officers could easily overtake them.

One day when a "dangerous resident of Western State Hospital" escaped, Dr. John Wesley Waughop "dispatched several of his men after the fugitive on bicycles." Another time, a man named Peter Pepe was surprised by "three masked highwaymen at his South K Street saloon." There was no policeman in sight when the first shots rang out, but within minutes an officer burst through the door on his bike, gun drawn. Tacoma police officers rode safety bikes until 1908, when a motorized bike patrol was created.

Uniformed employees of the Postal Telegraph Cable Company at 1105 A Street were forerunners to bicycle messengers.

During bicycle riding's peak years of popularity, every professional man and a great many women rode one. Homemakers fastened baskets to their handlebars when they went for groceries or wanted to give the baby some fresh air. W.W. Seymour, benefactor of the Wright Park Conservatory, was a familiar sight riding to social functions with the tails of his tux tucked into his back pockets for protection. A good biker could to ride to The Lakes (Lakeview)

and back in two hours. People biked as far as Lake Lawrence to fish. Once, four men rode to American Lake to hunt a cougar that had disrupted a picnic the previous day. There was even a Tacoma-to-Portland race.

"Learn to ride a bicycle," Mark Twain said during the heyday of the craze. "You will not regret it—if you live"

## BEHIND THE WRONG KINDS OF BARS

"Unfit for Beasts. Death Lurks in the Cells," was a headline in the *Tacoma Daily News*. The first thing an investigating reporter saw was the doorless toilet whose smell overpowered lime, iodoform and carbolic acid. Up to thirty-five prisoners shared seven cells on the first floor. Three cells on the lower level were considered too damp to use. The others were also damp but were occupied nevertheless. The day the reporter visited, a half-inch puddle of water measuring six by fifteen feet covered the floor. Overall, he was almost unable to handle the odor. Wooden bars separated a fifteen- by fifteen-foot space that constituted the women's prison. It was not unusual for prisoners to sleep on the floor and, if being released the next morning, to be sent away hungry. Nor was it unusual for unemployed laborers to ask for a place to sleep at night.

Tacoma's first jail was a small, wooded, two-cell building built out of two-by-four planks that were laid flat and spiked together. It was built around 1871 near McCarver and Starr Streets in Old Town. There was also a small police station at North Twelfth and G Streets, and both of these were eventually moved, first to the Old Town Wharf at the foot of Starr Street and again, in the 1890s, to the bluff at North Thirtieth and Starr. The Old Town jail remained in use until 1913, but people in New Tacoma needed a more convenient facility. The city built a combination police station, jail and dog pound at Twelfth Street and Cliff Avenue sometime around 1880. It was a two-story wooden building with the jail in the basement. After 1889, when Old and New Tacoma merged, it became the police headquarters building.

At the time the two Tacomas merged, there were twenty-five patrolmen, thirty saloons and twenty-one ways to lose money at Harry Morgan's Theatre Comique. When hired, rookie policemen received guns and badges but no training. Hires were often political appointees, and one mayor gave the jobs to elderly Civil War veterans. Among their duties was the task of assisting women—carrying them, if necessary—across the muddy roads.

Behind the wrong kinds of bars.

When it came to providing for the police, Tacoma's city council members were, not surprisingly, very tight-fisted. In 1890, Chief M.A. (Mart) Dillon went before the council to request a paddy wagon.

"When prisoners refuse to or are unable to walk to jail," he said, "the officers use a rusty old wheelbarrow to haul them in."

In a nineteenth-century version of political correctness, the chief was careful to point out that it wasn't just sailors, loggers and mill hands who required the wheelbarrow's services.

"The good laboring people of the city must not be overlooked," he added. "As this class of our fellow citizen had but little time for leisure, much leniency must be allowed them when known by the officers to be honest and industrious people."

A paddy wagon was a serious and expensive proposition, and one that required a lot of discussion. Then someone pointed out that Seattle had one, and that settled it. Chief Dillon got his wagon.

The wagon rolled out of the police station in June 1890. It had black sideboards and gilt lettering, two large rear wheels and two smaller front ones. It was pulled by a pair of matched roans. Eighteen years later, when the police upgraded to gas-powered automobiles, the old wagon was said to have traveled 100,000 miles and worn out twenty pairs of horses.

Next to go before the city council was Marshall E.O. Fulmer. Fulmer was there because members realized it had a potential workforce in the city jail, and why not let prisoners earn their keep by working in road gangs? Fulmer said that it could be done but that he didn't have enough men to act as guards. Rather than hire more men, the council members approved

Chief Dillon's wheelbarrow.

the purchase of leg irons. The chain gangs never did get much work done, but their presence drew crowds, and parents used them to point out the degradation as a threat to their children.

Deputy city marshal George Cavanaugh's problem was a lack of handcuffs. When he asked the council to approve their purchase, he was called before it to explain why the time-honored rope was no longer good enough. Cavanaugh explained that his request was the direct result of a neighborhood squabble in Old Women's Gulch, the current site of Stadium Bowl. Apparently, a new member of the squatters' community complained to the owner when a flock of her chickens roosted on his back porch. She told him where to go jump, and he countered with where she could go. Things got ugly, and a real knock-down-drag-out fight began. The police were called in and tried to restrain the new resident with a piece of rope. Cavanaugh pointed out how hard it was to get a rope around the hands of a man who didn't want to be tied, and the councilmen were convinced.

In 1895, a deputy who owned a Kodak camera was given the task of creating a rogue's gallery of photographs.

In 1899, the police moved to the basement of Old City Hall. There were no separate facilities for women; juvenile offenders were tossed in with hardened adult prisoners, and the smell was as bad as ever. Nine years later, some improvements were made. However, the dungeon, or "Dark Hole," remained the same and was still used to make prisoners talk.

Considering the jail facilities, it's easy to understand why the idea of even temporary residence there made the men less than cooperative.

*Part IV*

# Comings and Goings

## GET THEE TO THE BROTHEL:
## SARAH BERNHARDT ENTERTAINS

French tragedian Sarah Bernhardt was not an attractive woman, but she certainly didn't deserve to be mistaken for a prostitute. Nevertheless, that is what happened in Tacoma.

A performance at the one-year-old, 1,300-seat Tacoma Theater was part of a worldwide trip that had already taken the actress to Australia and British Columbia. At 2:00 p.m. on the afternoon of September 23, 1891, a wooden railroad sled pulled a twelve-car chartered train onto a siding at Seventeenth Street and Pacific Avenue, where a crowd had gathered to welcome the thespian.

While Madame Sarah; her son, Maurice, and daughter-in-law, Princess Therese Jablonowska; and traveling companion, Mademoiselle Suzanne Seylor, slipped away for a carriage ride through the business district, a reporter from the *Tacoma Daily Ledger* visited her train. Besides the engine and caboose, it consisted of three Pullman sleepers, five baggage and scenery cars and several private coaches, he wrote. Her manager, Henry E. Abbey, his wife and a maid traveled in the Hazelmere, and the Divine Sarah, Maurice and his princess wife, who was generally referred to as Countess Terka, and Mademoiselle Seylor rode in the Coronet; other members rode in the Alcatraz. One of those other members was a French chef who regularly prepared five-course dinners for the company.

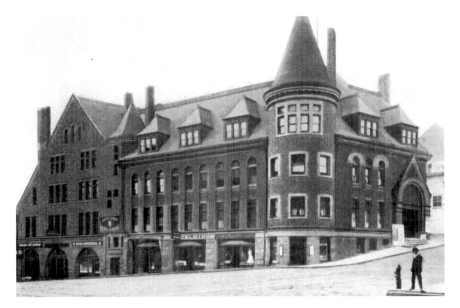

The Tacoma Theater, circa 1907.

The *Ledger* reporter devoted a full paragraph to Mr. Abbey's appearance, courage and sagacity and two lines to Madame Bernhardt, saying, "She talks rapidly and earnestly, gesticulating the while. She is not handsome or even attractive looking."

Things started going wrong for the actress in the late afternoon of her first day in town. After the carriage ride, Madam Sarah, who carried a gun and was accompanied by a dog, Maurice, the princess and Mademoiselle Seylor, decided to visit Wright Park, which had just been logged and replanted with deciduous trees. On their way back downtown, they got lost. Who better to ask directions of than a policeman? Sadly, the policeman they asked wasn't a fan of theater, or he didn't speak French or he didn't like the cut of their jib. For whatever reason, he directed them to Harry Morgan's Theatre Comique, a disreputable bawdy house that, at the time, was featuring, "Forty Beautiful Ladies." Thirty years earlier, when Madame Bernhardt had applied for a job in burlesque, she was turned down. And she wasn't about to make a career change and join Morgan's ladies at this late date. She found her way to Ninth Street and eventually back to her train.

The next thing to go wrong had to do with the theater programs. When Madame arrived at the theater, she waited in her "copay" and sent her valet to find the manager, a man named Heilig. When he came out, he saw that

the actress was in shock, and not from the afternoon's misunderstanding. And he also quickly learned that she wasn't the sweet little thing she played on stage. Madame Sarah shrieked a "monosyllabic, stentorian soliloquy of prefatory expletives." Mr. Heilig rushed to the door of her coupe. "Tell me," he implored, "what has happened?"

All Madame could do was point at the program, where on the first page were printed the following words: "Bonnie Kate Castleton—The Dazzler—Full of Ginger Start to Finish."

"Is zis not an ensult to ze great Sarah to put zees Dazzlaire in ze program when Sarah eez here?" the newspaper wrote in its version of French-accented English. "Ake him out, toot sweet, or I do not play tonight."

After her grand announcement, Madame was assisted to her dressing room and helped to a sofa, where "she lay gasping and sobbing and plucking out her hair in a wild and foreign way."

As he stood a distance away, manager Heilig was heard to mutter, "I'll have no more foreign stars."

Nevertheless, the play, *Fedora*, went on—four acts of "turgid tragedy about nihilist violence in St. Petersburg and Paris." The *Ledger*'s critic called the play "brutal" and Madame Bernhardt "perfect."

And then she was gone, leaving town before reading some of the spectators' comments. To wit:

"Why should she speak in French all the time?"

"Of course I went to see Sarah Bernhardt last evening. It was not that I cared so much to see her, but as everybody else was going, I went to see them."

"I resent it. I do not understand French, and I don't want to pay four or five dollars for something I cannot understand."

And another comment from Mr. Heilig: "Nobody is great to his own valet."

The next time she appeared in Tacoma, though Madame was more appreciated, she unfortunately met up with Murphy's Law. The date was June 13, 1913, and she was acknowledged as being "long past her prime." For this performance, she did the last act of *Camille*, and again she spoke entirely in French, but the *Tacoma Times* theater critic said "she held the audience in a spell."

No, the problem wasn't her French or her performance; it was her accommodations. Madame asked for seven rooms: a parlor, bedroom and bath for herself, a room for her physician and three for servants. Unfortunately, the Masons and the Catholic Foresters were both holding conventions in Tacoma. There was "no room at the inn," or at least not the

kinds of rooms she wanted. In the end, Madame Sarah stayed in Seattle and was driven down to entertain.

Sarah Bernhardt died ten years later. Her problems in Tacoma played no part in her demise.

## EXPLETIVES DELETED: MARK TWAIN IN TACOMA

Mark Twain didn't want to come west. He was a few months short of sixty and had a hacking cough, aching bones and a giant carbuncle (a large pus-filled abscess deep in the skin). He was $320,000 in debt (more than $1 million today), and his publishing company had just failed. Someone suggested that every person in the country send him a nickel to help out; however, both Mr. and Mrs. Twain said, "Thanks but no thanks." They, alone, would pay their debts. This in spite of Twain's close friend and business advisor, H.H. Rogers of the Standard Oil Company, who told the humorist that he couldn't think of a single man he knew older than fifty-eight who had been able to recover from financial failure.

Mark Twain wearing his "don'tcareadamn suit."

And so Twain and his manager, Major J.B. Pond, decided Twain would make a round-the-world trip giving a talk called, "Ninety Minutes of Chat and Character Sketches." The Twains, their daughter,

# Comings and Goings

Clara, and Major and Mrs. Pond left Elmira, New York, on July 14, 1895, and headed west; first stop, Cleveland, where the tour began the next day. From Cleveland, it was on to Sault Ste. Marie, Mackinac and Petoskey, Michigan; Duluth, Minneapolis and St. Paul, Minnesota; Winnipeg, Manitoba; back to Crookston, Minnesota; on to Great Falls, Butte, Anaconda, Helena and Missoula, Montana; Spokane, Washington; Portland, Oregon; and then back to Washington at Olympia, Tacoma, Seattle and New Whatcom, to be followed by Vancouver and Victoria, British Columbia. Twain had given nineteen talks in the twenty-seven days before he hit Tacoma.

Ill health plagued Twain much of the way, and he missed many dinners that had been planned in his honor. But he played to packed houses, sometimes over one thousand people at a time, and at the end of the U.S. leg of his tour, he was able to remit some $5,000 to his creditors.

Just about everywhere Twain went, the newspapers commented on his appearance. Lute Pease of the *Portland Oregonian* wrote that he wore "a blue nautical cap which confined a part of his big mane of hair, which bulged out at the sides and behind—a grizzly wilderness."

A reporter for the *Tacoma Morning Union* said, "Twain's hair seemed to be dressed very much like Ophelia's hair after she loses her mental reckoning."

Twain was packing a dress suit at the Fairhaven Hotel and was only half dressed when he received a reporter from the *New Whatcom Blade*. The reporter's opinion was that Twain's shaggy head of hair reminded him of "one of the Albino freaks with a little black pepper thrown in."

The general agreement among the various newspapers, though, was that Mark Twain didn't look like a funny man.

The *Morning Union* noted that Twain wore brown socks and brown velvet slippers with his dark suit. For those interested in palmistry, the paper printed the front and backs of his hands. Seeing this, Twain said that "some readers of his palm, not knowing his identity, had described him as troubled by excessive alcoholism, as a man easily swayed by the ladies, a vigorous individualist liable to lose money, and a person with absolutely no sense of humor."

As the touring party approached the Pacific Northwest, Twain was quite frankly apprehensive. For one thing, the area was still recovering from the 1893 Financial Panic. John D. Rockefeller had withdrawn his investments from Everett; fourteen banks in Seattle and twenty-one in Tacoma had failed. Sixteen hundred Puget Sound men were getting ready to march on Washington, D.C., to urge public works programs. Forest fires had been raging in virgin timber throughout the Olympic Peninsula. The country was gripped by a severe drought, and heavy smoke lay on the water. The inland

air was so smoke filled that at times it obscured the sun. And he faced plenty of competition. In Seattle, HMS *Pinafore* was playing at Madison Park; Leschi Park had a concert by the First Regimental Band and Madrona Park was holding a nightly electric fountain exhibition.

Tacoma was working on plans for an upcoming tennis tournament and was heavily involved in the baseball rivalry with Seattle. In Olympia, the Woman's Christian Temperance Union was holding its annual convention. Vice President Adlai B. Stevenson was in the area, and an alleged sea serpent had been sighted in the bay.

Twain and party traveled from Seattle to Tacoma on the steamboat *Flyer*, with Twain complaining most of the way. He referred to the baggage handlers as baggage smashers and quite frankly wished his luggage was filled with dynamite that would "blow them all to kingdom come." But then, before the *Flyer* docked, he encountered an old friend, Lieutenant Commander Wadhams, who invited him to dinner aboard the USS *Mohican*, and after arriving in Tacoma, he renewed a friendship with Mrs. Frank Allyn, who hosted a tea for the writer and his wife and daughter. For a little while, at least, things looked up.

The group stayed at the Tacoma Hotel, and Mark Twain spoke at the Tacoma Theater on August 12, 1895. The *Tacoma Daily Ledger* described his talk as "not exactly a lecture nor yet readings." They were "odd little tales of no particular moral but having a point." The *Tacoma Daily News* said that "some of the audience was unable to swing into line with Mark's particular line of humor and they looked tired, too tired even to smile." Nevertheless, most of the audience roared with laughter, and when they did, the humorist "pulled his moustache and scowled."

He was even more entertaining at the Tacoma Press Club banquet held later that evening. Using his I-used-to-be-a-newspaperman-myself persona, Twain and the men swapped stories until long after midnight. When an Olympia man apologized for the heavy smoke, Twain said, "I don't mind so much. I am accustomed to it. I am a perpetual smoker myself." When Major Pond said this was his fourth visit to Puget Sound and he had yet to see a single mountain, Twain responded, "But really, your scenery is wonderful. It's quite out of sight." When the major commented on Clara Clemens's skill on the piano, Twain explained modestly that it was transmitted genius. Ever the diplomat, in Seattle he called the mountain Rainier and in Tacoma, Tacoma.

For the time he was here, Puget Sound newspapers were full of stories about the great American humorist, but Twain himself seemed to remember

little about the Pacific Northwest. Writing *Following the Equator*, published in 1897, he made particular note of his relief in finally setting sail and his pleasure in the "enticing and welcome sea after the distressful dustings and smokings and swelterings of the past few weeks."

## So You Want to Be a Star?
## Hollywood Beckons

Movies were almost an obsession by the mid-1920s. Theater owners changed their playbills on Mondays and Fridays, which meant that a movie had a three-day life expectancy. Silent films didn't require stage-trained actors as the talkies soon would. An attractive face and a lot of hyperbolic body language sufficed. Low-budget westerns and stunt and action thrillers were the bread-and-butter of the business, and the studios were turning out nearly 750 films a year. With such seemingly favorable odds, young people poured into Hollywood hoping for stardom—and the numbers included several Tacoma women.

Mildred Davis—"Mid," as she was known—was born in Philadelphia in 1900 and for a few years attended a Quaker grade school there. The Davises came to Tacoma when Mid was still young enough to attend Lowell Grade School. From Lowell, Mid went to Annie Wright Seminary and Stadium High School. Her education included training in classical dance, and she developed a great love of theater.

After high school, Mid went back east to attend college. While there, her photograph ended up in the hands of a couple of Los Angeles movie directors. They thought she had Mary Pickford potential and suggested that she go to California for screen tests. Mid tested well and landed a movie role. For a few years, she made movies for Metro, Pathe and Mutual Studios. But eventually, she decided that her film career was over and returned to Tacoma.

In the meantime, a New Yorker named Hal Roach was kicking around the Pacific Northwest and Alaska. When he came into a small inheritance, Roach used it to start Hal Roach Studios in Los Angeles. He hired a bit player named Harold Lloyd and told him to come up with a comedy persona comparable to either that of Charlie Chaplin's Little Tramp or Buster Keaton's deadpan expression. Harold went to work and developed a character, the forerunner to PBS's Mr. Bean, an ordinary man who becomes involved in extraordinary circumstances. Tortoise-rimmed glasses were his main prop and identification.

Hollywood Boulevard in the movies' Golden Years.

Roach and Lloyd made a lot of one-reel comedies, many of which featured leading lady Bebe Daniels. Eventually, Miss Daniels left the Roach studios to make dramatic films for Cecil B. DeMille. The hunt was on for a new leading lady.

One day, Roach and Lloyd saw a movie called *Weaver of Dreams* starring blond-haired and blue-eyed Mildred Davis. The men decided that she was just what they were looking for. There was just one little problem: they couldn't find her! Lloyd contacted various producers, sent telegrams to his contacts and even ran newspaper ads. Finally, he hired private detectives, who traced Mildred to Tacoma. Both men hightailed it up to convince the actress to return to pictures. When they got here, however, what they saw was not what they wanted. Instead of the tomboy street urchin they'd seen on screen, they found a lovely young woman who wore elegant dresses and liked fancy hairstyles. In addition to that, Mid's father didn't think much of movie stars and wanted his daughter to stay in Tacoma and get a "real job." Facing an uphill battle, Roach and Lloyd used the ultimate weapon: money. Mid returned to Hollywood with their promise of high wages and her promise to them to return to her boyish, urchin image. With her went kid brother Jack, who was hired as the villain in eleven episodes of the *Our Gang* comedy series.

# Comings and Goings

Mildred Davis was Harold Lloyd's leading lady in fifteen comedies made in the 1920s. The most well known was *Safety Last*, which featured a memorable scene of Lloyd dangling high above the street from the hands of a clock.

Mid was not only Harold Lloyd's leading lady on the screen, but she also became his leading lady in real life. Harold used to say that he married her to keep her from going to another studio.

The famous pair and their children returned to Tacoma often to see friends and family, and those same family and friends really liked to return the visits. Over the years, the Lloyds amassed a fortune. They built a twenty-five-room house on twenty-two acres in Beverly Hills and put in a nine-hole golf course, a handball court and an eight-hundred-foot canoe stream that included a waterfall and pool. In typical Hollywood style, however, their marriage wasn't always smooth sailing. Lloyd was both an unfaithful husband and a workaholic, and Mildred suffered from depression and bouts of alcoholism. One of her closest friends was Marion Davies, William Randolph Hearst's actress/mistress and no stranger to the attractions of John Barleycorn herself. Nevertheless, the Lloyds' forty-six-year marriage may be a Tinsel Town record.

Mildred Davis died in 1969, and Harold Lloyd followed in 1971. Initially, the studios may have been looking for a Mary Pickford knock-off, but they got something better: a woman who achieved her own on-screen success and whose career outlasted that of Pickford.

Wanda Hawley was another local girl who found success in silent films. She was born in Scranton, Pennsylvania, on July 30, 1897, but her family moved to the Puget Sound when she was a child. She went to high school in Bremerton and then attended the Master School of Music in Brooklyn and the University of Washington. Her studies in piano and composing led to a concert tour of the United States and Canada. Wanda was living in Tacoma, either on South Seventh and Ainsworth or South Ninth and Grant (newspaper articles differ), when she decided to give Hollywood a try.

Wanda, whose real name was Selma Wanda Pittack, made her debut in 1917 with the William Fox Company. She then joined the Famous Players-Lasky Studio and was Douglas Fairbanks's leading lady in *Mr. Fix-It*. She worked for Cecil B. DeMille and acted with some of the most famous leading men of the time: Wallace Reid, William S. Hart and Rudolph Valentino, among others. She was Realart Studio's most important star and was one of the biggest stars of the silent era, receiving more fan mail than Gloria Swanson.

Wanda's acting career ended with the advent of the talkies. Her second career was as a San Francisco call girl. She died in 1963.

Tacoma newspapers had a number of articles about Juanita Hansen, but they don't say where, in Tacoma, she lived. Juanita was born on March 3, 1895, in Des Moines, Iowa, became a Sennett Bathing Beauty and stared in a number of serials, such as *The Lost Jungle*, during the teen years of the twentieth century. *The Lost Jungle*'s fifteen episodes were run at Tacoma's Pantages Theater in November and December 1920. Juanita particularly remembered that film because the animals employed weren't well trained, and she was painfully scratched by a leopard during filming. Other serials she made were *The Jungle Princess*, *The Phantom Foe* and *The Yellow Arm*. She also made two Oz movies, *The Magic Cloak of Oz* and *The Patchwork Girl of Oz*. However, Juanita's fast-and-loose lifestyle and subsequent cocaine addiction overwhelmed her. In 1924, she wrote a series of articles published in the *Tacoma Daily Ledger* telling how she was introduced to and became addicted to "Gutter Glitter."

Juanita made her first and last talkie in 1933. After that, she did some live theater. In 1938, she wrote a book, *The Conspiracy of Silence*, in which she advocated treatment instead of jail time for addicts. Juanita's habit ate up all her money, and during the Depression she worked for the Works Progress Administration. Nevertheless, in Hollywood's version of destitute, it was her maid who found the actress's body in her West Hollywood home on February 11, 1961.

Opera singer Valentine Grant, born on February 14, 1881, was a member of Tacoma's Ladies' Musical Club when she went to New York in 1913. One day she was singing for the Metropolitan Opera, and the next day she had disappeared, leaving the Met in the lurch. A couple months later, she turned up in Jacksonville, Florida, as a member of Sid Olcott's International Players. She was the heroine in a serial called *When Men Would Kill*, the story of a Florida feud. She became Olcott's companion and acted in his film *Nan o' the Backwoods* and starred in *All for Old Ireland*. She was also in movies made by the Lubin Studios and Famous Players-Lasky. Valentine married Olcott, and after appearing in a few more films, she retired in 1918.

Minerva O'Callaghan was a young Tacoma homemaker with a four-year-old son when she made the startling discovery that her life held an "endless eternity of dirty dishes." So she packed up and moved to California with a younger sister. Minerva wrote a lengthy article for the *Tacoma Daily Ledger* in which she described the process she undertook in order to get into the movies. Minerva did act, at least once for the Goldwyn Studio and also for Famous Players-Lasky, but she isn't listed under O'Callaghan as a silent screen actress.

Samaria Outouse, who lived at 2106 North Steele Street, was a University of Washington junior when she won a Metro-Goldwyn-Meyer screen test in 1928. She isn't listed anywhere, either, so apparently the test wasn't successful.

Proving, then as now, going Hollywood isn't all skittles and beer.

## IT STARTED AT WARNER BROTHERS: ART GILMORE

There was a time when Art Gilmore's voice was so familiar to radio listeners, TV watchers or moviegoers that he needed no introduction. His was the voice of hundreds of announcements. "It wasn't especially deep like some announcers," Leonard Maltin once said, "but it had authority, command and yet also a kind of friendliness. I think it was an all-American voice."

And that voice grew up in Tacoma.

Art was born on March 18, 1912. He went to Washington Grade School, Jason Lee Jr. High and Stadium High School. Radio was just developing, and Art loved it. He was only fourteen when he built his own broadcasting set. And he could also sing, which he did at recitals and weddings and in concerts.

From high school, Art went to the College (now the University) of Puget Sound for a year and then transferred to the University of Washington. He became an executive officer on a Sea Scouts ship commanding twenty boys on a voyage to Vancouver and worked as an announcer at KWSC radio and as a dishwasher. In one of those Schwab Drugstore stories, someone heard him singing to the dishes and asked him if he wanted to be a star. Art quit college, sold insurance during the day and sang with dance bands at night. He began a five-year study of voice, and in between studying, selling insurance and performing at nightclubs, he sang in church choirs and for anyone who would hire him or at any place where he could pick up a few bucks. However, when Art got a job at KVI radio in Tacoma, it was a step toward the big time.

While tracking down an insurance prospect, Art heard that the station was looking for a radio announcer. He talked himself into applying and then convinced the station manager that anyone who could sell in person, as he was doing with insurance, could certainly do the same thing over a microphone. The manager hired Art for the princely sum of fifteen dollars a

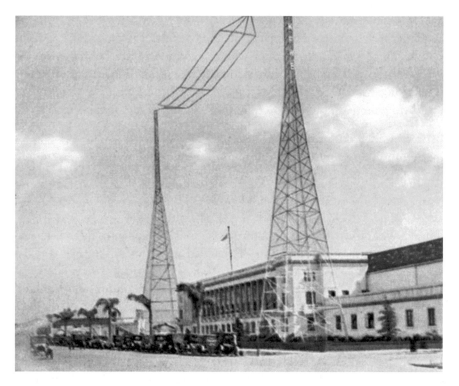

Warner Brothers Studio in the early 1900s.

month, and the duties included singing, reading poetry, introducing various acts and announcing the Hollywood news. Art was so good that KOL radio in Seattle hired him away from KVI.

In 1936, Art Gilmore and his friend, Maurice Webster, went to Los Angeles, and while Maurice seems to have disappeared into history, Art hit the big time in Hollywood. As luck would have it, he learned of an opening for an announcer's job at KNX. After repeated auditions, KNX, a CBS affiliate, hired him, and he remained on staff there until 1941. After that, he freelanced.

Some of the shows Art was the announcer for are pretty much forgotten: *Stars Over Hollywood*, *America's Home Front*, *What's on Your Mind?* and *Dr. Pepper*, for example. Others, such as *Red Ryder* and *Amos 'n' Andy* are still remembered. Art was the announcer for the *Ford Sunday Evening Hour* and the Los Angeles Philharmonic. Warner Brothers Studios hired him to provide narration on a number of shorts it was producing, two of which were *Power Behind the Nation* and the *Cradle of the Republic*. *Joe McDoakes* was a series of one-reel comedy shorts released between 1942 and 1956. Titles included *So You Want to Be a*

*Gambler* or *So You Want to Build a House*. The show had regular guest stars such as Doris Day and Ronald Regan, with whom Art worked. He narrated Joe's humorous efforts to accomplish the activity that was the focus of the shorts until 1946.

When television came along, Art decided he'd better get ready for the new medium, at least as a salesman if nothing else, so he opened two television shops. His voice was so familiar, though, that the change of medium was no problem. Art worked as an announcer for *The George Gobel Show*, the *Red Skelton Hour* and *An Evening with Fred Astaire*. He narrated 156 episodes of *Highway Patrol* with Broderick Crawford, 39 segments of *Mackenzie's Raiders* with Richard Carlson and 41 episodes of *Men of Annapolis* with Guy Williams and Daryl Hickman. He announced "A Time for Choosing," also known as "The Speech," which was Ronald Reagan's prewritten speech, presented on a number of occasions during the 1964 U.S. presidential election campaign on behalf of Republican candidate Barry Goldwater.

Occasionally, Art was seen and not just heard. He appeared on the *Mary Tyler Moore Show*, *Adam-12*, *Emergency*, *Dragnet* and *The Waltons*. Art was Franklin Delano Roosevelt's voice in the 1942 production of *Yankee Doodle Dandy*, and he was the dramatic voice heard on literally hundreds of film trailers. Rita Hayworth's *Gilda* was one, as were *Shane*, *Born Yesterday*, *Vertigo*, *Dumbo* and *It's a Wonderful Life*.

In 1944, Art and CBS producer Glenn Middleton decided that the country needed a good book on the job of radio announcing. They created an outline, hired fellow announcer Jimmy Wallington to write a foreword and then wrote 130 pages of text on microphonic techniques. Included in the book were biographical sketches of top-draw announcers, sample scripts, voice production studies, microphone methods and practices and patter patterns. Hollywood Radio Publishers published the book, and when word of it got out, the company was flooded with inquiries. The University of Southern California hired Art to teach radio announcing, and he used his own textbook.

As an adult, there were only two occasions when Art wasn't working in show business. One was during World War II. He served as a navy fighter-director on an aircraft carrier in the Pacific from August 1943 until November 1945. The other was when he was on vacation. Art's mother and sister, Dorothy, still lived in Tacoma. Dorothy was head of the music department at Grant School.

In high school, Art met a girl named Grace Weller. They dated for eight years before marrying. Grace's family had a place on Steilacoom Lake, so

Art and Grace returned to Tacoma once a year for three or four weeks to visit family and so Art could fish. Fishing, golf, tennis, horseback riding and swimming were his hobbies. And if the name Weller sounds familiar, well, Art and Grace were aunt and uncle to Robb Weller, a radio producer who was once a host on *Entertainment Tonight*.

For a time in the 1960s, Art was president of the American Federation of Television and Radio Artists, a labor union. In 1966, Art, Ralph Edwards and Edgar Bergen founded the Pacific Pioneer Broadcasters. The 178-member organization provided an opportunity for those who had been involved in broadcasting for twenty years or more to socialize, network and honor fellow pioneer broadcasters for outstanding achievements. Five times a year, the PPB hosted luncheons at which a guest of honor was presented the Art Gilmore Career Achievement Award. During the luncheons, members and invited entertainment personalities shared personal memories of the honoree. In addition, members seventy-five or older were inducted into the Pacific Pioneer Broadcasters' Diamond Circle. Diamond Circle members were broadcasters who may not necessarily have been celebrities in the usual sense of the word but who had, nonetheless, made significant contributions to the broadcasting industry. Tom Kennedy and Nanette Fabray were two members.

Art Gilmore died at age ninety-eight on September 25, 2010. He and his wife, who survived him, had been married for seventy-two years.

## Anti-Self-Fueling Air Engines?
## Cartoonist Frank Beck

Tacoma's jail at the end of the nineteenth century, a nine-year-old, two-story wooden building on South Twelfth Street, slightly east of A Street, was easy access for mischievous little boys. Just the right kind of place to jump up and down in front of the bars of a window and shout, "Oh, you crooks!" before running away. This was a favorite activity for future cartoonist Frank Beck and his friends. That is, until a rough-looking character popped up on the other side of the bars and shouted, "Take off your hat, son! Show a little respect or we'll look you up when we get out."

Frank Beck was born in 1893 in a log cabin near the boundary of Point Defiance Park. Eventually, his family moved closer to town, and Frank went to Bryant Grade School, then at 708 South Ainsworth. He also had a part-

time job working for his contractor father, who was supervising some of the work involved in converting a badly burned hotel into what became Stadium High School. As a teenager, Frank was a delivery boy for the J.W. Fiddes Grocery Store. Fiddes's motto was: "We cater to good livers." Another job Frank had was at the Tacoma Smelting and Refining Company hammering blisters out of slab so it would pack down better.

When he wasn't working or at school, Frank loved to draw. At Stadium, he drew for the school's monthly newspaper, the *Tahoma*. He was listed as a staff artist on the yearbook along with J. Stedman Wood, who became a well-known artist in his own right. After graduation, Frank worked for a year on a ranch in Canada. Then, in 1912, he enrolled at the University of California–Berkeley, where he took mechanical drawing and studied to be an automotive engineer. However, he ran out of money and had to get a job. Later in life, Frank said that finding employment was pretty easy. Cadillac Motor Company hired him to work in its Detroit, Michigan advertising department. The job gave him time and money to attend classes at the Chicago Art Institute. At Cadillac, Frank specialized in designing car bodies. He also created the insignia—referred to as the Cadillac Crest—that is still used today. Frank served in World War I. During a temporary assignment at Camp Lewis, he drew cartoons for the camp's newspaper, *Trench and Camp*. After the war, he began his first cartoon strip, *Down the Road* (1920–36).

Classic Cadillac, circa 1907.

At that time, there was a little-known war going on within the automobile industry—the war to keep knowledge of air-run engines away from the public. Gasoline-driven engines were well established, and gas was cheap. Nevertheless, the general public loved air cars, or at least the idea of air cars. The self-filling air tank was around long enough for folks to discover what those early industrialists and air car inventors already knew: "air was tougher than stone, more plentiful than sunshine, cheaper than white bread and extremely powerful." Walt Disney drew a cartoon in which Goofy built a self-fueling air car, and Mickey mocked him for trying to "break the laws of thermodynamics." Mickey went on a ride with Goofy anyway, and the car crashed, but only because Goofy forgot to install brakes. Disney's assessment of the situation, put into the mouth of Goofy, was: "You can't stop it! Yuh can't stop air cars, because when people find out about them they will go hog wild!" (Presumably the people not the cars).

During this time period, from 1926 to 1937, Americans began reading Frank's daily cartoon, *Gas Buggie*. Also known as *Hem and Amy*, it depicted an obsessed man and wife "exercising ill-conceived delusions trying to invent an air car." Some readers wondered if Frank was creating subliminal, anti–air car messages.

One day, Frank met a *New York Tribune* executive who, seeing his work, said, "You ought to go to New York and be a cartoonist." Frank thought it was a job offer, so he quit his job and went east. When he arrived, the man explained that it had just been a comment. For a year and a half, Frank camped out on the fellow's doorstep. Eventually, he got a job as illustrator for the paper's automobile section.

Between 1935 and 1962, after cars stopped being new, Frank married, had a daughter and changed his cartoons to focus on family life. *All in a Lifetime* drew on their experiences. He also had a dog. By 1940, the cartoon was called *Bo*, and a dog became the central figure.

Frank had a collection of old ephemera about Tacoma and occasionally used bits and pieces for inspiration, sometimes including boyhood friends by name. He was usually six to eight weeks ahead of schedule, and on awkward occasions, his cartoons were published after a friend he mentioned had died.

The Becks lived in Canaan, Connecticut, and San Diego but regularly returned to Tacoma. Frank and his friends dined together either at the Winthrop Hotel or the Top of the Ocean. At one dinner, a three-layer cake was brought in, and using frosting tubes, Frank drew cartoons all over it.

During his peak years, Frank worked for the McNaught syndicate, and more than two hundred nationwide newspapers published his cartoons. At

the time of his death, he was working on a series of books based on the cartoon strips and panels. He also had some deals in the works for a series of movies and a television show featuring talking dogs.

Frank Beck died in March 1962 before these ideas could come to fruition.

## Tinsel Town in Tacoma? The Weaver Studios

Was ever a town luckier than Tacoma? An enormous natural harbor, miles of railroad tracks connecting the sails to the rails, seemingly daily announcements of a new skyscraper to be built, a beautiful mountain on the horizon that would have been called Mount Tacoma if not for some shenanigans pulled by Seattle involving the Board of Geographic Names and booze and then a Hollywood movie studio. It seemed as if there was no stopping the City of Destiny.

In 1924, H.C. Weaver formed H.C. Weaver Productions on five and three-quarters acres of land across the street from where Titlow Pool is today. It was the first movie studio in the Pacific Northwest. The main building of the studio was 105 by 180 feet with a 52-foot-high ceiling, a size considered adequate to allow three or four companies to work simultaneously under an abundance of klieg lights A separate administration building had executive offices, a projection room and fifteen dressing rooms for the stars and several others for lesser individuals. And there was one final amenity, a feature sure to entice other companies to use the Weaver studios facility: a developing laboratory. Right off the bat, four motion pictures were contracted.

Hollywood had come to Tacoma!

*Hearts and Fists* was the first movie made, and Tacomans were agog. The stars were John Bowers, who had recently appeared with Clara Bow in *Empty Hearts*, and Marguerite de la Motte, who was fresh from making *The Three Musketeers* with Douglas Fairbanks. However, before shooting could begin, the production unit had problems to work out. If the scene required white clothing, the clothes had to be dyed blue; white glared too much. Also, blue eyes photographed black. To counteract that, a prop man stood close to the actor but out of camera range and held up a piece of black cloth. Staring at it reduced dilation. Klieg lights lacked protective glass, and the arc threw off ultraviolet rays. Enough exposure and actors' eyes turned pink and swelled up. The first day's shooting of *Heart and Fists* was scheduled to begin at 9:00 a.m., but the dozens of arc lights and kliegs required two hours of additional

adjusting. John Bowers appeared on time and fully made up but was worried about a hollow that showed up occasionally in his profile shots. He wanted the lights softened. And then there was costar Dan Mason's Van Dyke beard. To shave or not to shave? That was the question. Men wasted a full hour discussing the Van Dyke's fate. Finally, Mr. Weaver himself decided that Dan could keep his facial hair, which was really nothing more than a soul patch.

Indoor shooting finally began at 11:00 a.m. and went on all day. The outdoor shots were later done at Kapowsin.

The movie was about a successful lumber business Old Man Pond built but which had declined drastically while his son and heir, Larry, was away at college. Larry learns of a contract that, if filled, will save the business. The villain tries to force him out. Loyal employees step in to help. The movie ends with a logging train's race to get the timber to the mill while coping with burned-out bridges, loggers made intentionally drunk and a giant fir across the tracks. Larry marries the banker's daughter, and the villain is foiled.

*Hearts and Fists* premiered at Tacoma's Rialto Theater on January 22, 1926, and was released the next day. For the first time, a picture of the mountain and the words "Made in Tacoma" flashed on a motion picture screen.

*The Totem Pole Beggar* was next, but after "a psychological study," Mr. Weaver changed the title to the more evocative *Eyes of the Totem*. Wanda

On the set.

Hawley, Anne Cornwall, Gareth Hughes, Tom Santschi, Dan Mason (again), various local talent and the totem pole at the corner of South Tenth and A Streets starred. It's the story of an Alaskan woman and her child waiting for her husband's return from a prospecting trip. When he finally makes it back, he's murdered and robbed. Reduced to begging, the wife sits in front of a totem pole by which "all eyes must pass sooner or later."

According to the paper, "Everyone in Tacoma not working, and some who should have been" turned out to watch the filming, and at the end of the day, Wanda Hawley had been so convincing in her role that she had six copper pennies in her beggar's cup. "My dear daughter," she said to costar Anne Cornwall, "I'm afraid this won't send you very far through school."

*Raw Country* followed *Eyes of the Totem*. Anne Cornwall was back, and so was John Bowers, but the real star of the film was a team of sled dogs that achieved worldwide prominence during a race in 1925 to rush diphtheria antitoxin serum to Nome. The movie was their story.

For *Raw Country*, the production team built a Yukon town street scene at the studio. Tacoma resident J. Smith Bennett remembered that the buildings were all fronts supported by braces in the rear and that icicles were made of cotton dipped in melted paraffin. For real icicles and snow, outdoor action was filmed on Mount Rainier around Paradise Inn, Longmire and Narada Falls. During filming, a blizzard caught the cast unprepared. After a long wait, a break in the clouds let them see where they were in relation to the lodge. Safely back in front of a toasty fire, some members admitted to their fear, while others said they got some really wonderful views of the Tatoosh Range.

Other memories of these movies include the Winthrop Hotel's crystal ballroom made up as a cabaret, the tables filled with locals and the hotel's façade used as the exterior of a Chinese garden.

In May 1927, H.C. Weaver announced that the three movies would be released throughout the country by Pathe. However, *Raw Country* was distributed in the East under the name *In the Heart of the Yukon*, so no one would get the impression that it was "one of the usual wild westerns." It was released on May 29.

Alas, for H.C. Weaver, and for Tacoma, 1927 was the year Al Jolson made *The Jazz Singer*, the first talkie, and talkies led the inadequately equipped company into insolvency. The studio was converted into a ballroom. One night in August 1932, two men were seen leaving the premises. Shortly after, flames shot out of the structure. The caretaker and his wife barely escaped the fire, which destroyed all their belongings, including their car.

Automobiles lined both sides of Sixth Avenue for more than a mile; more than one thousand people watched a fire department, handicapped by lack of fire plugs, battle the blaze. In the end, all was destroyed.

After the fire, General James M. Ashton, legal representative for the Weaver concern, said the films had never been marketed. Researchers said that many of the old nitrate-based negatives failed to survive, these three included. As of this writing, it appears that *Eyes of the Totem* can be seen on the web. But if nothing else, the memories of people like J. Smith Bennett remain to herald a time described locally as a "Great Civic Event."

## RISING TO THE OCCASION: LESSER-KNOWN VISITORS

Not all the famous or infamous people who traveled to the Pacific Northwest stopped at Tacoma. On their way to the Klondike, Wyatt Earp and his wife, Josie, skedaddled right on by Puget Sound, preferring a quick stop at Wrangell, Alaska. Mae West also skipped Tacoma when headed for British Columbia's Campbell River. And young women waited at the Union Depot for three days hoping that Clark Gable would make an appearance before going north to Mount Baker to make *Call of the Wild* with Loretta Young.

Nor was everyone who did visit Tacoma really famous except for short periods of time. David Warfield was a well-known American stage actor when he appeared at the Tacoma Theater in 1913 as the kindly old man in *The Return of Grimm*, a roll he created. Vaudeville actress

Lillian Russell at the height of her beauty.

Ethel Barrymore as she looked when she appeared in Tacoma.

Nell Kelly appeared on the RKO Orpheum with lesser-known Bob Hope in 1931. Martha Graham danced "in a modern extravaganza to soothe the savage beast" a few years later. Rod La Rocque helped open a new theater, and when John Phillip Sousa and his band traveled to Tacoma, the group needed special railroad cars for all the men and their equipment. Ethel Barrymore and Lillian Russell were both well received here, but Tacomans seemed to prefer Miss Russell, referring to her as having a "Juno-like stoutness"—a kind way of saying she was fat. The opera singer Madame Schumann-Heink was a particular favorite. Her oldest son, August, was in the German army during World War I, and she had three sons who were in the United States Navy, one who was a field artillery officer and her youngest son, Hans, who enlisted in the American cavalry. Both August and Hans died during the war, and Tacomans admired her courage as well as her talent.

Jumbo was a catalo, a cross between a buffalo and a cow. He and his human companion, L.C. "Buffalo Bill" Wilson of Colville, Washington, traveled more than 4,000 miles throughout the South and Northwest selling postcards to support themselves. However, Jumbo's trip was small potatoes compared to Rattlesnake Jim's 124,000-mile, around-the-world trek. Jim, whose real name was James Lauhno Lonefeather, was half Italian-Swiss and half Sioux. He didn't so much appear in Tacoma as he was found there, reading a Spanish dictionary and Latin grammar in the library's reference room.

Cowboy, comedian, humorist, vaudeville performer and social commentator Will Rogers flew here in 1927 and landed at the old Mueller-Harkins Airport. Rogers met with the mayors of Tacoma, Puyallup, Steilacoom, Centralia and Bucoda, and as he was the mayor of Beverly Hills, California, the men exchanged "freedom of my city" permits. Once these formalities were over, Rogers visited Camp Lewis, where silent screen star Richard Barthelmess was filming *The Patent Leather Kid*. Rogers was hugely popular at the time. His newspaper column full of wry observations ran in local papers. These days, he's mostly forgotten.

A number of visiting entertainers bought property in Tacoma. The famous American baritone David Bispham was one; so was Harry Houdini's brother, Ferencz Dezso Weisz (Houdini's real name was Erik Weisz). It was Ferencz, who went by the name of Hardeen, who came up with the idea of escaping from a straitjacket, a trick Houdini perfected. Sir Henry Irving, the first British actor to be knighted, made $17,000 by investing in property on C Street (now Broadway). Concert vocalist Madame Emma C. Thursby also invested in C Street property but forgot she owned it. When she discovered that her agent had sold the land without her permission, she sought legal advice and won, eventually netting herself a tidy profit. Stage actors Hans Robert and Max Figman and actress Henrietta Crosman all invested in Fircrest property.

Charlie Chaplin was billed only as "the clever English comedian" when he appeared with the Karno Company in a play called *The Wows Wows*. Johnny Weissmuller was just a swimmer when he appeared in a series of exhibition events at the Oakes on Steilacoom Lake. MGM star Jeannette MacDonald's career was on the wane when she and her dog, Stormy Weather, came on tour. However, Al Jolson had yet to make the *The Jazz Singer* when he was at the Tacoma Theater, and Billie Burke had not yet become known to the world as Glinda the Good in *The Wizard of Oz* when she visited friends Captain and Mrs. J.A. Toon.

Among Tacoma's more unique entertainers, conjoined twins Daisy and Violet Hilton were probably the most unusual. "Mayor Gets Two-Fisted Job (Handshake) When Introduced to Twins," the *Tacoma Daily Ledger* noted, adding that amongst their differences was the fact that Daisy liked to sew and Violet liked to cook. The sisters, born in 1908, were fused at the pelvis and buttocks; they shared blood circulation but no major organs. At the time, doctors felt it would be too dangerous to try and separate them. Their unmarried bartender mother, Kate Skinner, sold the girls to her boss, Mary Hilton. Hilton and her husband trained the girls to sing and dance and

controlled them through abuse. They eventually died four or five days apart from Hong Kong flu. However, that was many years after the seventeen-year-old girls "offered song, dance, music and comedy" to Tacoma audiences.

Whether they were older, such as Lillian Gish and Basil Rathbone; still young, such as Johnny Sheffield; in the middle of their career, as was Mickey Rooney; or near the end, like Marjorie Rambeau, entertainers, politicians, writers and royalty came to Tacoma to entertain and in some cases be entertained. And a good time was had by all.

*Part V*

# The Century Advances

## LABOR SPEAKS: THE GENERAL STRIKE OF 1918

*The Russian revolution was planned in the office of a Seattle lawyer, counsel for the organization…during those three overheated days wherein Lenin and Trotsky tarried in the city's midst, enroute [sic] to Russia, an American revolution was planned or at least discussed at that time, it was evident that bolshevism has put forth its supremest [sic] effort in America and has failed.*
—Saturday Evening Post

World War I and the burgeoning war industries brought an influx of laborers to Puget Sound that pushed up demand for everything from food to housing and strained utilities almost to the breaking point. Companies made huge profits by padding their shipping costs and sending large amounts of goods to Europe. But their greed resulted in shortages on the homefront. In three years, the cost of living rose by 50 percent, while at the same time workers saw their earning power decrease. Clearly, a situation was brewing.

At the time, Seattle had approximately thirty thousand shipbuilders and Tacoma about fifteen thousand. The men were members of the Metals Trade Union, part of the American Federation of Labor (AFL). However, the navy and most shipbuilding companies were organized under the United States Shipping Board. The shipping board had the power to set wages.

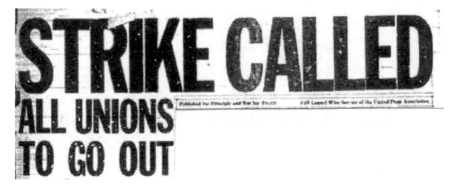

A strike is called.

Shortly after Germany's surrender, the board announced a nationwide, uniform wage scale for all shipbuilders.

Puget Sound laborers were incensed. If it was going to cost more to live here than in other parts of the country, and it did, and if local shipbuilding companies were willing to negotiate, and they were, union members felt there was no reason to submit to some sort of national wage scale that didn't take the cost of living differences into consideration. A local representative for the workers took their grievances to Washington, D.C. He returned with guarantees that the cost of living and wage negotiations would be given serious consideration. In reality, though, the Labor Adjustment Board's intent was quite different. In a telegram to the Metal Trades Association, the board's chairman said any company that raised wages beyond the set guidelines would be denied steel shipments—effectively putting them out of business.

By some strange "coincidence," Western Union "misdirected" the telegram to the Metal Trades Council's union. Once the union learned that the employers had no intention of negotiating, it called a strike. On January 21, 1919, shipbuilders in Tacoma and Seattle walked off the job. The Metal Trades Council then asked the Seattle Central Labor Council to call its members out on strike in a show of solidarity. One by one, unions and their members from many different industries—motion pictures projector operators, laundry workers, stage hands, allied painters' trades, longshoremen, smelter workers, carpenters—were drawn into the dispute. One hundred and ten unions had voted, and many of them voted to strike. A strategy committee agreed that a few bakeries, dairies and wholesale butcher shops could stay open to prevent suffering around town, but all the other food sources were to be closed so that everyone would see and recognize labor's power.

Strikers were supposed to be fed at a commissary. Early morning of the first day, several thousand men and women milled around Tacoma's Labor Temple, waiting—and waiting and waiting. Those in charge underestimated the logistics of getting thousands fed. In the middle of the morning, bakery trucks began to arrive. Volunteers carried in loaves of bread and "stacked them like cord wood." Around noon, kettles of stew from a restaurant kitchen operating under commissary direction showed up. Two hours later, the doors opened, and people sat down to cold stew, chunks of bread and no silverware. After the first day, word went out that only the homeless would be fed.

In the meantime, the unions were busy forming a strike committee. The committee had the power to provide for auxiliary police and to decide which trades could continue to operate. For example: milkmen, yes; hearse drivers, yes; telephone operators, on standby basis only; janitors for the county and city buildings and labor temple, no.

Businesses in operation during the strike displayed placards stating that the business was operating with the approval of the General Strike Committee.

As the strike deadline neared, Tacoma became very quiet. Some people stockpiled supplies and stayed home. Streetcars stopped running. The armory at Eleventh and Yakima became headquarters for troops from Camp Lewis who, among other things, were sent to Tacoma to guard public utilities and maintain order.

In Seattle, the streets were also deserted. Unfounded rumors spreads: that the mayor had been assassinated, the water supply poisoned and power plants dynamited and that arson was rampant. Many wealthy residents left the state.

At the University of Washington, President Henry Suzallo called out ROTC students and told them to "save the world from the Bolsheviks." Although it was hardly revolt on a massive scale, a revolutionary spark did exist in Seattle, and both the strike leaders and government officials knew it. For that reason, union leaders ordered the rank and file to avoid crowds, and the *Union Record* was told to cease publication. Taking full advantage of the situation, Seattle mayor Ole "Holy Ole" Hanson got his picture "on the front page of most national newspapers and was featured in four national magazines."

Mayor Hanson immediately drew up plans for calling in troops to protect his city. Camp Lewis soldiers were already guarding reservoirs, power stations and various utility sights. But he wanted to secure shotguns and machine guns, stock up on ammunition and find additional places where soldiers could be stationed.

Tacoma laborers quickly decided that they'd been tricked into striking, and they quietly returned to work. Strikers in Seattle also figured out that because of governmental wage restrictions their actions accomplished nothing. With the loss of popular support, the strike ended rather ignominiously after five days—and five days' lost wages.

With the end of the strike, many workers had to reapply for their jobs, and not a few left the state. Mayor Hanson left the state, too. He resigned from his position, went on a nationwide lecture tour, wrote a book and tried to get himself nominated as the next Republican presidential candidate. He ended his days as a California real estate promoter. One man described Hanson as a man who, though "energetic and picturesque, said nothing in his speeches and accomplished even less—a Chamber of Commerce hero everywhere but in Seattle."

Meanwhile, Albert Johnson, a Washington State House representative, cried for deportations.

"There are five hundred Russians and Finns out there who ought to be started out of the country as soon as possible," he said.

For many years after the general strike, labor struggled. It seemed that every time the national government imposed cutbacks involving national contracts, the government saw to it that the Pacific Northwest got cuts before other parts of the country.

And though it irritated some and amused others, politicians of the time occasionally referred to "the forty-seven states and the Soviet of Washington."

## LOOSE LIPS SAVED THE SHIPS

America hadn't even entered World War I yet when Jim Bashford, a veteran newspaper reporter covering Tacoma's waterfront, stumbled on a plot to blow up ships there and sabotage the docks. Had the plan succeeded, it would have been a rare act of unprovoked aggression perpetrated against the United States.

One day, as was his custom, Jim dropped by L. Benjamin's store on Pacific Avenue to see the waterfront regulars and call in to his newspaper. While doing these two things, he overheard a stranger say the word "Vladivostok." It struck Jim as odd, so he sidled up to the man and started a conversation. The man said he was headed to the Russian port and was making a few purchases for the trip. The reporter, however, knew that there was only

one ship in the harbor, a British freighter, and it was highly unlikely that Vladivostok was its destination. So he asked the fellow what business he was engaged in, and the man lost his temper.

"My business is none of your damn business, my friend!" he snapped and left.

After a while, Jim also left Benjamin's and went to Olson's Tugboat Company. There he saw the stranger, chatting with George Marvin, a salesman for the DuPont Powder Company. Jim ducked out of sight, and after the man left, he asked George what the fellow wanted. George said that the stranger claimed to be a Pierce County chicken farmer and that he wanted to buy several hundred feet of fuse to use while blasting out some stumps. He was supposed to return later that afternoon.

Jim smelled a rat. He immediately contacted U.S. deputy marshal Ira Davison, and they staked out the tugboat office, but the stranger was a no-show. Two nights later, while riding at anchor outside Seattle Harbor, a scow loaded with dynamite was blown up.

Police officers from both Tacoma and Seattle went on a manhunt and arrested the supposed traveler to Russia. He was living on North Ferdinand and had no alibi. Unfortunately, none of the three law enforcement agencies involved had sufficient reason to detain him; also, there was some sort of dispute about what country owned the dynamited scow. And so the stranger was turned loose, and Jim Bashford forgot all about him—for a few months,

Boathouses on the waterfront. *Courtesy of Robin Paterson.*

anyway. Then Jim learned that the man had been arrested for trying to blow up a canal near Detroit. Bill Bryon, a U.S. Department of Justice agent, brought the man back to Tacoma, and he talked. He said he'd had big plans to blow up Tacoma's waterfront and industries and that, among other places, he'd hidden dynamite in some brush below Stadium Bowl and near the Northern Pacific Railroad's roundhouse. Jim and Agent Bryon found these two stashes. However, the big reveal came when the man implicated the German consul in San Francisco and Lieutenant Wilhelm Von Brincken, Germany's military attaché there.

But that wasn't all. He said that the schooner *Annie Larson* and the cargo steamer *Edna* had been surreptitiously loaded with ammunition and arms and had kept a rendezvous with German raiders operating in the Pacific. He also talked about a small Filipino steamer that had taken on cargo in Tacoma but had been held off Brown's Point because someone reported that a bomb was aboard. A search showed up nothing; the ship sailed away—and disappeared. No trace of it was ever found.

The stranger, whose name was never revealed, had one more secret. According to his sister, before he died, he told her that he had thrown the bomb during the Preparedness Day Parade that took place in San Francisco on July 22, 1916. This important-at-the-time-but-now-largely-forgotten parade was in anticipation of the United States' imminent entry into World War I. During the parade, a suitcase bomb was detonated, killing ten and wounding forty. Two men, Thomas Mooney and Warren Billings, were convicted in separate trials.

In a peculiar trick of fate, the accused Wilhelm Von Brincken was luckier. Although he did serve two years at McNeil Island, after being released, he went to Hollywood and made movies.

However, that wasn't Tacoma's only brush with terrorism. A few weeks after the United States entered the war, someone planted a five-gallon can of nitroglycerine on the ship *Saxonia*, in harbor for repairs. The 4.424-ton ship from the Hamburg-American line had been at Eagle Harbor, across the bay from Seattle. When the United States declared war on Germany, it was turned over to the navy. Shortly after the *Saxonia* docked, a navy man walking down the main deck saw the can and kicked it to see if it was empty. Realizing, from the sound, that it was full of something, the sailor sniffed it to see if it was gasoline. It wasn't, nor was it any other fuel that he recognized. He reported the matter to a superior officer, and as a matter of routine, government experts analyzed the contents and found pure nitroglycerine. It was immediately taken to the depot at Ostrich Bay in Kitsap County.

With safety ensured, what concerned the military was whether or not the can was placed on the ship as part of a foiled plot to blow it up. If so, in order to board the ship the individual had to be someone in either the government's or the military's confidence. Nothing was ever discovered.

Little has been written about World War I in the Pacific. The day before the *Saxonia* incident, two men at Fort Rosecrans in San Francisco reported sighting a submarine off the entrance to San Diego Bay, but sea and air investigations turned up nothing. Nevertheless, the commanding officer alerted other bases about the possibility of their existence. Historians now know that Germany was actively involved in trying to get the United States and Mexico in a war to divert the States from the European conflict. In 1917, the foreign secretary of the German Empire, Arthur Zimmermann, sent the Zimmerman Telegram to Heinrich von Eckardt, Germany's ambassador in Mexico. It was a diplomatic proposal from the German Empire encouraging Mexico to make war against the United States. The proposal was intercepted by British cryptographers, and the American press revealed its contents on March 1. The resulting outrage contributed to the United States' declaration of war against Germany in April.

Tacoma continued to be under Germany's eye. On April 8, 1918, several people saw a man named John Nagley standing on the bluff near Firemen's Park with pencil and paper in hand, either writing or sketching. At the time, the military police had rooms in the fire department headquarters. They were notified, and two military police officers went to arrest Nagley. When he saw them coming, Nagley tore up the paper and casually dropped it at his feet. The officers frisked Nagley and found a copy of the Morse code and another of the Continental code. The Continental, or International Morse code, as it was sometimes known, had been developed because radio telegraphic communication didn't work well with the early Morse code. It contained embedded spaces that were actually an integral part of several letters. The Continental code became the universal standard for Radio Telegraph Communications and for European land-line telegraphic communications. However, in America, railroad and intercity land-line telegraph operators continued to use the original Morse code until well into the 1960s. Getting back to Nagley, he also had a copy of the army's regulation code for flag signals and a code where Greek letters replaced letters of the alphabet. The men didn't find the scraps of paper until the following day. When they pieced them together, they saw a sketch with all the major bridges, warehouses and boatbuilding companies marked.

Nagley claimed to be a logger and an American, but he refused to explain the sketch or the codes he carried. Federal Secret Service special agent J.W. McCormick was called in, and Nagley was told he would probably be held for the duration of the war.

It was really thanks to alert residents that Tacoma was never attacked during World War I.

## RAPID TRANSIT

*Due to the danger of Spanish Influenza, all passengers and crew members are required to wear face masks to help prevent contagion. Anyone who refused to comply will be put off the train.*
*—Puget Sound Electric Company*

In the days when land developers platted their property, laying out roads and putting in private streetcar lines, they did so with no obligation to connect them to those in the neighboring developments. That's the reason Tacoma has some peculiarly crooked streets. Nor did developers have an obligation to maintain the streetcar lines after the last plat was sold. The result of this, of course, was chaos.

In 1890, city officials hired the Boston firm of Stone & Webster to review Tacoma's transportation situation and make suggestions. The firm recommended that all the lines in Tacoma be owned and operated by one company and that the company build an additional line to connect Tacoma and Seattle. This concept immediately set up a battle over right of ways; people living along the Duwanish and White Rivers, for example, were served with notices that land along the proposed track that the company hadn't already acquired would be condemned. Claims for damages had to be presented in open court in Seattle on August 12, 1901. Other issues included control of timberlands, a source for the required electricity and stock and bond sales. It was ten years before the Puget Sound Electric (PSE) Company—or the Interurban, as it was known—was organized.

The PSE's intention was to provide top-of-the-line accommodations and service. The company hired the best streetcar operators from Seattle and Tacoma. The trains had Westinghouse's highest-quality airbrakes. Each passenger car accommodated sixty passengers and had wine-red upholstered seats and white linen headrests for their comfort. Each also carried its own

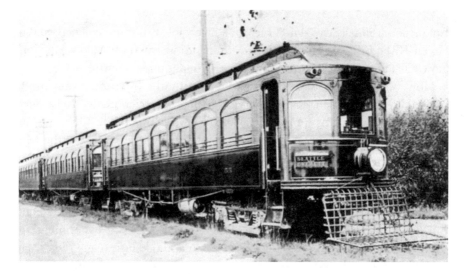

The Interurban.

tool kit for minor emergency repairs. Motormen were inaccessible to the riding population so as not to be disturbed while driving. Telephones dotted the tracks in case of major emergencies.

Passengers and people shipping commodities had twenty-three stops to consider. As many as twenty-five cars at a time made the run from Renton's brickyards and coal yards into Seattle. The Allentown quarry shipped crushed rock. Milk, meat and veggies were carried from valley farms into Seattle and Tacoma. And there were private excursions—to picnic grounds, Renton's Dance Pavilion or to Meadows Race Track near today's Boeing Field.

Tacoma's first train left the Seventh and A Streets terminal on September 25, 1902. A one-way trip from Tacoma to Seattle took about fifty-five minutes and cost sixty cents. Round trip was a dollar. The limited ran hourly and the local every two hours. The locals stopped at such bygone places as Sawmill, Stuck, Christopher, Thomas, O'Brien, O'Rilla, Black River, Argo and Flats. The trains were geared to run sixty miles an hour but could reach seventy miles per hour for short distances. Once, however, a train slipped its brakes at Milton and raced out of control down the hill into Tacoma. Neither passengers nor crew were willing to estimate its speed.

Over all, a trip on the Interurban was safe, though there were some incidents. The third rail, called the "Sleeping Monster" because of its high voltage, was responsible for the deaths of numerous wandering cows and horses. Snow, if sufficient to gather on the track, stalled the trains and caused the rail to flash and spark "like the Northern Lights." A tunnel through a sand hill near

Auburn occasionally caved in. Once, in a heavy fog, two trains collided on the Green River Bridge. Another time, a train ran a switch at Willow Junction (now Fife), injuring forty-two before it was brought under control.

However, regardless of its speed and efficiently, the Interurban was rarely profitable. A less-expensive boat service, which had been plying the waters between the two towns for years, provided keen competition. Only during the 1907–08 Alaska-Yukon-Pacific Exposition, when tourists made the trip to Seattle from all over Puget Sound, and during World War I, when the trains carried troops and shipyard workers back and forth between stations, did it make any money.

The trains and the rail system were a typical railroad in looks and function. But down on Tacoma's tide flats a Mr. William Boyles was experimenting with a more modern system. His cars had a streamlined nose to cut resistance and ran on a steel channel beam on top of a wooden beam supported by trestles, with side wheels running along the side of the beam. If that seems difficult to visualize, take a look at a modern monorail system.

Little is known about Boyle or his invention. It was apparently intended to run between Tacoma and Seattle, and Mr. Boyle had tried to sell stock in the venture. His prototype was a short-lived sight in 1911 and then disappeared.

The Interurban continued to operate, but even after a rate increase it lost money. And after twenty-six years of service, the roadbeds showed wear. When the ride was no longer comfortable, and automobiles became affordable, people took to the roads, and trucks took over the freight business. The PSE took an inventory and survey and decided that updating the equipment would be too expensive. The last train made its run on December 31, 1928. Railroad stations and waiting rooms were torn down and tracks taken up. Some of the old cars enjoyed second lives as restaurants, but they, too, were short-lived.

Now that there is a new rail system between Tacoma and Seattle, train aficionados can relish the fact that it was the availability of automobiles that "tooketh away" the original commuter trains, and it has been the sheer numbers of automobiles that caused their return.

## WOMEN'S WORK

When manufacturing was local, Tacoma, like most mid-sized cities, was self-supporting. And many of the long-gone businesses speak of different interests and needs, especially women's work.

A lady and her apron.

Madsoe Manufacturing had a male CEO, Sydney Madsoe, but otherwise the company was created and run by women. Madsoe was born and raised in western Montana and came to Tacoma in 1937 for a change of climate and scenery. He had a background in marketing and store management and went to work at a Parkland market. From Parkland, he moved on to a store on South Thirty-eighth Street, where he had a chance encounter with Mrs. Freeda Wheeler. Mrs. Wheeler came in one day to see if she could sell some aprons she'd made.

"They were a good design and well made," Madsoe said, "and when I put them on display, they sold right away."

Madsoe was pleased with the interest homemakers showed in the aprons and asked Mrs. Wheeler to make more. Mrs. Wheeler not only made aprons, but she also made little girls' dresses. They, too, sold well. As a result, and in a really impulsive move, Madsoe quit his job and went into businesses with Mrs. Wheeler manufacturing aprons and dresses. He opened a shop at 1702 South K Street, with Mrs. Wheeler as the designer and superintendent of seven seamstresses who were piece workers; that is, each was paid by the number of items she finished in a day.

With twelve layers of cloth laid on a flat surface, employees cut out the pieces with electric scissors. They used colorfast print cotton or permanent finish organdy for the aprons. For the dresses, it was dotted Swiss, taffeta, rayon or crepe. The women did all the stitching but left the hems and buttonholes for a finisher to do. On an average day, each seamstress assembled thirty-five to forty aprons and somewhat fewer dresses.

Mrs. Wheeler was entirely self-taught but apparently very competent. Within two months, the Madsoe Company was shipping articles to shops in Montana, Idaho and Oregon. The business fit well in the female niche of the times.

It is difficult now to understand the value once placed on handmade lace. True lace is created when a thread is looped, twisted or braided to

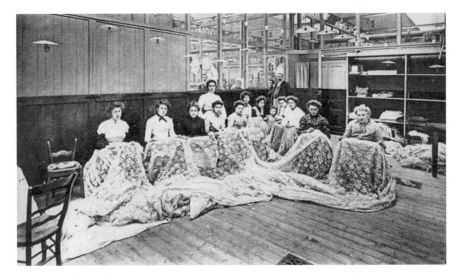

Showing off the lace.

other threads independent of a backing fabric. The oldest laces were made from linen, silk, gold or silver and are mentioned in pattern books as far back as 1540. Until lace-making machines largely destroyed the market for handmade lace, it was highly prized for its extraordinary beauty and intricate patterns and was considered to be quite a valuable item that only the wealthiest families could afford. Even after 1832, when cotton thread came along, people took particular care of their lace, constantly removing pieces from one item of clothing, washing it and stitching it onto others. But those people lucky enough to own lace curtains needed a professional to clean them, and in Pierce County that professional was Mrs. O.M. Yant.

In 1931, the *Tacoma Daily Ledger* had a series of articles it called "Old Timers on the Job." Most of the elderly people featured were men. Mrs. Yant was one of the few women. She lived at 342 Fifth Street in Puyallup and had a virtual monopoly on the cleaning and care of lace curtains. Even today, it's a fairly lengthy process and not an easy one because wet lace is more fragile than dry lace.

To clean old lace, Mrs. Yant soaked it in a tub of warm soap and water until the water was cool. Lace can shrink, so the water temperature is important. She repeated the process for twenty-four hours. When the lace seemed to be about as white as it was going to get, she rinsed it and laid it out flat on a towel, then rolled the towel up, pressing down carefully to get out the water. Then she unrolled the wet towel, transferred the lace to a dry one and left it flat to dry. Or, she put it on a tenter frame, which is a frame that

allows fabric to dry evenly and in the right size. When the paper featured her as an "Old Timer still on the Job," Mrs. Yant was seventy-six.

In the days before Social Security, it was a frightening experience for a woman to unexpectedly have to find a way to earn a living. Mrs. Ethel Naubart Hamilton earned hers by converting a spare bedroom into a gift shop and selling items she made. Mrs. Hamilton learned the principles of design at Stadium High School and put what she'd learned to work in decorating fine Japanese and French china, some of which she sold to stores back east. She was a regular contributor to the monthly magazine *Keramic Studio*, contributed designs to various art schools and taught locally. When she wasn't designing and painting china, Mrs. Hamilton made dipped candies, lacquered baskets and rose potpourri.

Mrs. Lillian Stilton, on the other hand, made lavender sticks. When she moved to Tacoma from the east, lavender was a novelty to her. In 1910, she planted six cuttings, which fortunately for her thrived. Thereafter, every July she cut the blooms all at once, stripped off the leaves, divided the sticks according to length and quality and put them in her attic to dry. When she was ready to begin work, she put the sticks through a steaming process of her own invention to make them pliable. After that, she either made sachet bags or braided the stems with ribbons, pink and blue for babies or lavender for adults. In 1921, she made $500 and the following year, $1,000. She had standing orders from Rhodes Brothers Department Store in Tacoma, as well as stores in Seattle, Portland and Spokane and a few smaller towns. During an interview in 1922, she said that she didn't want to expand. She liked what she did; it kept her busy and provided a "fair-sized income."

Mrs. Charles Kuhn came to Tacoma from Vienna, where she was born and raised and where she learned the art of quilt making. Before Tacoma, she had lived in New York and worked for twelve years at Wanamaker's and Macy's department stores. When she and her husband came here, she found that there were no firms making down quilts, so she went into the business. Roughly every four months, a canvas sack of from two to four hundred pounds of grease-free eiderdown "plucked from the breast of live geese" arrived from Bohemia, which is how the Czech Republic was known. Each quilt took two and a half to three pounds of down, and the fabrics she used were silk or satin. A large portion of her quilts were hand-stitched, and she used her own designs and color combinations. In less than two years, she expanded and started making down pillows; she made them for adults, infants and dolls. One room in her home became a

workroom, and a second room became a storeroom and showroom. She also had to hire two women to help with her business.

While these women were all doing well, Miss Agnes Joyce was having a harder time. Miss Joyce made paper flowers. All summer, she visited friends' gardens and the local parks and gathered samples to copy. At home, she dissected the blossoms to see how they were constructed and then copied nature. She made rose corsages, arrangements of marigolds and violets and mums for Thanksgiving and supplied hotels, private clubs, restaurants and homes. East Coast window trimmers used some of her paper flowers in yearly competitions. She was also interviewed for the newspaper and said that while she loved the work, there wasn't much money to be made—too much competition.

It was always difficult for a woman to go into business because she couldn't get financing in the way a man could. When Mrs. Westerdahl started Model Bakery at Thirty-eighth and Yakima, her husband did the baking, but she was the salesperson, the delivery person and everything else required to keep the business going.

Spinsters, widows and especially elderly women struggled just to be able to eat.

## The Summer of '42: Bond Drives

Whether they were for raising money to help finance wartime military operations, to remove currency from an inflated economy or just to make people feel they were supporting the country's needs, United States Bonds played a vital role in World War II. However, the bonds didn't sell themselves. On June 9, 1942, when Tacoma was scheduled to kick off a major war bond drive, Mayor Happy P. Cain announced that actress Lana Turner was coming to help.

Miss Turner was one of MGM's defense bonds sales girls on loan by the studio to the U.S. Treasury Department. Prior to the announcement, she, her mother and her agent had been traveling up the Pacific coast, stopping at various towns along the way. When they reached Portland, Leon Titus, Pierce County's bond salesman, went down to Oregon and personally escorted the twenty-two-year-old starlet to Tacoma. During the trip, the party made official visits in Centralia, Chehalis, Toledo, Olympia and Tumwater and unofficial stops at other smaller towns. They arrived in Tacoma at 5:00 p.m.

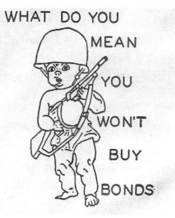

WHAT DO YOU MEAN YOU WON'T BUY BONDS

Promoting bond drives.

and headed for the mayor's office in Old City Hall. There, Mayor Harry Cain pinned a corsage on the dark-colored suit Miss Turner wore and told her some important facts about the tide flats and waterfront. They posed for photographs, and then the actress hurried to her hotel to eat, bathe and change for a morale-boosting trip to Fort Lewis.

The next morning, a 1924 Lincoln Touring car, sporting a large flag, picked up the actress and took her to the Seattle-Tacoma Shipbuilding Corporation for an 11:30 a.m. appearance. She wore a white short-sleeved dress with a small black print and a black hat with a brim so big it blocked out backgrounds in many photographs. Nevertheless, in thirty minutes she sold $94,545 worth of bonds, giving kisses to men who bought them in the largest denominations. Then it was back to Tacoma for a big sales rally at Liberty Square.

Liberty Square, a small building built in the middle of two lanes of Tenth Street and Pacific Avenue, was still under construction. Miss Turner addressed the crowd from a bandstand, saying that many of the virile young bond buyers could kiss just as well as Clark Gable. At the end of her speech, a band started playing swing music, and the actress went to work selling bonds and signing each one so the buyer would have an autograph. Mayor Cain stood nearby chanting, "Buy bonds, buy bonds."

A huge crowd gathered. Children climbed onto rooftops and created so much racket that police officers ended up chasing them down the fire escape ladders. While this was going on, Miss Turner sold $120,000 worth of bonds, the highest denomination being $500. Then, after several hours in the City of Destiny, she left for stops in Seattle, Spokane, Coulee City and her birthplace, Wallace, Idaho.

Hot on Miss Turner's bond-selling trail came child star Johnny Sheffield, well known for his role as Boy in the Tarzan movies. Johnny was traveling with his mother and a tutor, and for whatever reason, Mr. Titus didn't see the need to meet him at the Oregon/Washington border. However, once Sheffield was in Tacoma, he did feign terror in the presence of the "boy of the jungle," pretending fear of a physical assault by Tarzan Jr.

Lana Turner's slogan was: "Over the top with bonds." For ten-year-old Sheffield, who wore a Boy Scout uniform and arrived at Liberty Square with a thirteen-ton army tank, it was: "Buy tanks for Yanks."

Nineteen-year-old starlet Linda Darnell came on July 11. Hometown boy Bing Crosby paid a visit on August 4. Workmen completed the Liberty Square building just in time for a Labor Day dedication on September 8 and a visit by British actress Joan Leslie, American actor Adolphe Menjou and Canadian actor Walter Pigeon.

Their day began at 10:00 a.m. with the obligatory stop at the mayor's office, followed by an 11:00 a.m. visit to the Seattle-Tacoma Shipyards, where they put on a program. After lunch, they joined a crowd of ten thousand at Liberty Square. Miss Leslie addressed the spectators, and Menjou held a mock soldier-dressing stunt, asking onlookers to buy bonds to help outfit a private. One man bought $500 worth of bonds to provide the soldier with a right foot boot; another spent $400 for a belt buckle. A bayonet and other required pieces of apparel eventually cost the crowd $23,635. However, Walter Pigeon was the hit of the day. As a former stock-and-bonds broker, he talked about knowing a good investment when he saw it. City officials made speeches and read congratulatory telegrams from various Washington, D.C. officials, and the Fort Lewis band provided music. At 3:30 p.m., the stars attended a ship launching and reception and then left for Seattle. The next day, the *Tacoma News Tribune* announced record sales of $509,095.

After the war, there were plans to move the Liberty Square building to 800 Broadway, but the idea fell apart; it was demolished instead. Fading memories and possibly an autograph or two are all that's left from Tacoma's summer of '42.

# Bibliography

Ambrose, Mary J. Family history. March 15, 1978.

Ambrose, Samuel. Advertising letter with photographs and descriptions.

———. *The Ambrose Clover Creek Sanitarium*. Biennial report, 1918.

———. *The Highway to Health: Speed Laws*. N.d.

———. Letter from the Dr. Ambrose Sanipractice Institute, February 28, 1928.

Bergman, Hans. *A History of Scandinavians in Tacoma and Pierce County*. N.p.: Bergman, 1926.

Blackwell, Alice. *Reminiscences of Tacoma*. Tacoma, WA: Tacoma Public Library, 1911.

Blackwell, Ruby Chapin. *A Girl in Washington Territory*. Washington State Historical Society, July 10, 1973.

City Planning Commission. *Outline of a Master Plan for Tacoma: A Preliminary Report*. Tacoma, WA, December 1947.

Department of Community Development. *Glimpse at Tacoma's History*. Report, 1980.

Forslund, Stephen J. *The Swedes in Tacoma and the Puget Sound Country, 1852–1976*. Edited by Doris Gundstrom King. N.p., 1976.

*History of Pierce County*. Vols. 1 and 3. N.p.: Heritage League of Pierce County, 1990, 1992.

Hunt, Herbert. *History of Tacoma*. Chicago: S.J. Clarke, 1916.

Konzo, Seichi. "Far Away and Long Ago." Bank of California, 1977.

# BIBLIOGRAPHY

*More Than a Century of Service: The History of the Tacoma Police Department.* Tacoma Police Department, 2009.

Morgan, Murray. *Puget's Sound: A Narrative of Early Tacoma and the Southern Sound.* Seattle: University of Washington Press, 1979.

Reese, Gary Fuller. *Did It Really Happen in Tacoma? A Collection of Vignettes of Local History.* Tacoma, WA: Tacoma Public Library, 1975.

Ripley, Thomas Emerson. *Green Timber.* New York: American West Publishing Company, 1968.

Swan, James G. "Closing the Frontier, 1853–1916." In *Northwest Passages: A Literary Anthology of the Pacific Northwest from Coyote Tales to Roadside Attractions.* N.p.: Sasquatch Books, 1994.

Weightman, Gavin. *The Frozen Water Trade: A True Story.* New York: Hyperion Books, 2003.

Wiley, Martha. "South Tacoma." In *History of Pierce County, Washington.* Dallas, TX: Taylor Publishing Company, 1990.

Wynbrandt, James. *The Excruciating History of Dentistry.* New York: St. Martin's Press, 1998.

# NEWSPAPERS

*News Tribune*
*New York Times*
*Puyallup Valley Tribune*
*Seattle Times*
*Senior Scene*
*Tacoma Daily Ledger*
*Tacoma Daily News*
*Tacoma Herald*
*Tacoma Times*

# INTERNET REFERENCES

www.brewerygems.com/histories.htm
www.cityoftacoma.org
www.etext.virginia.edu/railton/onstage/world.htm

# BIBLIOGRAPHY

www.historylink.org

www.plu.edu/archives/sie/Oral-History-Collections/home.php

www.scribd.com/doc/29005616/Compressed-Air-Conspiracy-Timeline-
   Pt-1-4pp

www.tacomapubliclibrary.org

www.tysto.com/articles06/q4/20061017hats.shtml

wikipedia.org/wiki/Preparedness_Day_Bombing

# About the Author

Karla Stover graduated from the University of Washington with honors in history. She has been writing for more than twenty years. Locally, her credits include the *Tacoma News Tribune*, the *Tacoma Weekly*, the *Tacoma Reporter* and the *Puget Sound Business Journal*. Nationally, she has published in *Ruralite* and *Birds and Blooms*. Internationally, she was a regular contributor to the *European Crown* and the *Imperial Russian Journal*. In addition, she writes two monthly magazine columns. In 2008, she won the Chistell Prize for a short story entitled "One Day at Appomattox." Weekly, she talks about local history on KLAY AM 1180, and she is the advertising voice for three local businesses. Her book *Let's Go Walk About in Tacoma* came out in August 2009. She is a member of the Tacoma Historical Society and the Daughters of the American Revolution. Her entire working career was at Merrill Lynch.

Cameron Addis

# Jefferson's Vision
## *for* Education,
## 1760–1845

PETER LANG
New York • Washington, D.C./Baltimore • Bern
Frankfurt am Main • Berlin • Brussels • Vienna • Oxford

Library of Congress Cataloging-in-Publication Data

Addis, Cameron.
Jefferson's vision for education, 1760–1845 / Cameron Addis.
p. cm. — (History of schools and schooling; v. 29)
Includes bibliographical references and (p. ) index.
1. Jefferson, Thomas, 1743–1826—Contributions in education.
2. Education—Philosophy. 3. Education, Humanistic—United States—History.
4. Education, Higher—United States—History. I. Title. II. Series.
LB695.J42 A33    370'.1—dc21    2001038904
ISBN 0-8204-5755-8
ISSN 1089-0678

Die Deutsche Bibliothek-CIP-Einheitsaufnahme

Addis, Cameron:
Jefferson's vision for education, 1760–1845 / Cameron Addis.
–New York; Washington, D.C./Baltimore; Bern;
Frankfurt am Main; Berlin; Brussels; Vienna; Oxford: Lang.
(History of schools and schooling; Vol. 29)
ISBN 0-8204-5755-8

Cover art, *Glasses,* by Frank Borges Llosa

Cover design by Lisa Barfield

The paper in this book meets the guidelines for permanence and durability
of the Committee on Production Guidelines for Book Longevity
of the Council of Library Resources.

© 2003 Peter Lang Publishing, Inc., New York
275 Seventh Avenue, 28th Floor, New York, NY 10001
www.peterlangusa.com

Printed in the United States of America

*For my mother, Georgi (Johansen) Addis*

Your abuse of Jefferson is a trifle crude and wants delicacy of touch, but it is always safe to abuse Jefferson and much easier than to defend him.

Henry Adams to Henry Cabot Lodge
June 7, 1876

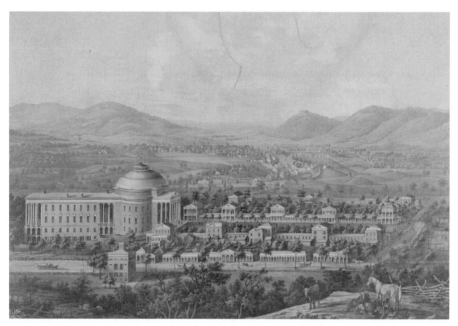

Edward Sachse, *View of the University of Virginia, Charlotesville and Monticello, Taken from Lewis Mountain,* 1856. Lithograph published by Casimer Bohn. The annex was not rebuilt after an 1895 fire destroyed the Rotunda. *Courtesy of University Virginia Library Special Collections.*

# Contents

# Acknowledgments

I want to thank my adviser, Shearer Davis Bowman, along with the rest of my dissertation committee at the University of Texas: Howard Miller, Neil Kamil, Jim Sidbury, George Forgie and Anthony Alofsin. Other scholars who have lent a helping hand include Tom Baker, Richard D. Brown, Chris Curtis, Robert Forbes, Scot French, Frank Grizzard, Ronald Hatzenbuehler, Dan Haworth, Charles Irons, Charles Israel, Burt Kummerow, Kenneth Lockridge, David Mattern, Robert McDonald, Rebecca Montes, Peter Onuf, Anne Ramsey, Anita Rivera, Bill Rorabaugh, Richard Samuelson, James Rogers Sharp, Herbert Sloan, Jennings Wagoner, Douglas Wilson, Richard Guy Wilson and the entire staff of the International Center for Jefferson Studies in Charlottesville.

Too many librarians and archivists have helped along the way to list here. Among the most helpful were Jeanne Pardee and Michael Plunkett of the Alderman Library at the University of Virginia, Michelle McClintock of the Virginia Historical Society in Richmond, Margaret Cook of the Swem Library at the College of William and Mary, Kenneth Ross of the Presbyterian Historical Society in Philadelphia, Jen Tolpa and Peter Drummond of the Massachusetts Historical Society, C. Vaughan Stanley of the Leyburn Library at Washington and Lee University, Jennifer Peters of the Episcopal Archives of America in Austin, and Bill Smith of the Morton Library at Union Theological Seminary.

Numerous people have offered rides, couches, food, and company during my research. Included among these good souls are Blair Barter, Blair Haworth, Matt Ipsan, Delia Hagen, and Joan Lynch. Winston and Georgi Addis financed the laptop on which I took notes and wrote, and Lisa Addis Proehl, Siva Vaidyanathan, and Sean Kelley helped format my database. Phyllis Korper, my acquisitions editor at Peter Lang and Tania Bissell, my copyeditor, were also helpful, along with the readers and Jacqueline Pavlovic, Sophie Appel, and Lisa Dillon in the production department.

# Introduction

⊛

This book shows why Thomas Jefferson promoted publicly funded education and why he wanted it free of organized religion. Though he failed to bring about a public school system in Virginia during his lifetime, his vision partially materialized at the University of Virginia, and his broader goals presaged modern education. In 1880 the editor of the *Chicago Tribune* referred to Jefferson's educational plans when he wrote that "now and then a man lives who seems to have in his head every important idea that all his countrymen together get into theirs for a century after he is dead . . . almost any new project of human welfare was anticipated, and likely enough the whole identical plan worked out in detail, somewhere in Jefferson's writings."[1]

Today over 90 percent of children in the U.S. attend public schools, where formal religious indoctrination is prohibited. The state systems which they are educated in are similar to Jefferson's 1779 plan for Virginia, which called for secular, free, and compulsory schooling, but was not passed into law. When Southern states reinvigorated their school systems after the Civil War, Jefferson became a national symbol of public education, and remains so today.[2] His story is illuminating because the obstacles that precluded a fuller realization of Jefferson's dream, including resistance to government prescriptions and disagreements over instructional content, are lasting features of democracy.[3]

Southern sectionalism and a commitment to humanism are what distinguished Jefferson's vision for education from those of other revolutionary leaders.[4] His commitment to states' rights republicanism helped Jefferson's cause in his home state because most of his fellow Virginians concurred with him. He met more resistance with his emphasis on science over revealed religion as the basis for learning.

The Bill of Rights originally checked the power of only the national, not state, governments. Before the 1940s the First Amendment did not restrict religious

establishments within the states. Rather than smothering debate on church-state relations (words not even mentioned in the Constitution), the Bill of Rights opened a dialogue within each state.[5] State governments misconstrued Isaiah 49:23 to argue that government should be "nursing fathers of the church." As president, even Jefferson conceded that the power to "discipline religion" lay with the states.[6] Religious tolerance was a trademark of most state constitutions, but full rights of citizenship and access to education for non-Protestants were not. Legal incorporation of non-Christian churches was disallowed in state constitutions and plural, or nondenominational, taxes were levied to support Protestant churches all over the country.[7] No one was tortured or burned, but everyone had to support Protestants, and non-Protestants were ineligible for public office.

In most New England states as well as in Virginia, moderates advocated a compromise, such as the multi-denominational church establishment of Massachusetts. In John Adams's Massachusetts the public supported education more than in Virginia, but through their state-sponsored multi-denominationalism they also maintained a tie with the Congregational Church until 1833.[8] Support for education and religion were linked, as they had been in colonial America. Still, in 1817 Adams shared Jefferson's optimism that the "multitudes and diversity" of [religious denominations] "is our security against them all. . . . What a mercy it is that these people cannot whip and crop, and pillory and roast, as yet in the U.S.! If they could they would."[9]

Adams came to believe in separation of church and state and campaigned against state-sanctioned religion in Connecticut and Massachusetts. When the church establishment in Connecticut was barely defeated in 1818, clergymen feared an attempt to dismantle religion generally, but Jefferson sent his congratulations to Adams. "I join you in sincere congratulations that this den of priesthood is at length broken up and that a Protestant popedom is no longer to disgrace the American history and character."[10] In 1820 Adams tried but failed to get his 1780 Massachusetts constitution rewritten in keeping with Mason's, Madison's, and Jefferson's strict defense of religious liberty in Virginia.[11]

Virginia, the most populous state in the South, was a key battleground in the controversy over church-state relations. There Protestants supported education, but were determined to control the process. A general (multi-denominational) assessment bill advocated by Patrick Henry was thwarted by Jefferson and James Madison in the 1780s. Jefferson and Madison played the establishment Anglicans off against dissenting Protestants (Presbyterians, Baptists, Methodists), driving a deeper wedge between church and state than elsewhere. The wedge was guaranteed by their Statute of Virginia for Religious Freedom (1786).[12] The statute forbade the use of any taxes for Christian instruction. Nonetheless, the Presbyterian and Episcopalian churches in Virginia were strong institutions that considered it their rightful role in society to shape the young. For them, the statute precluded a

monopoly on the part of a single denomination, but did not prohibit Protestant colleges from competing for public funds through the democratic process. Before Jefferson's establishment of the University of Virginia, there was no reason for them to think otherwise.

In the educational sphere, the American Revolution failed to wrest control away from Christian churches in any of the states, including Virginia, just as the French Revolution failed to in Europe. University College of London, the first college in England independent of the Anglican Church, did not open until 1828.[13] Many American schools were private seminaries, and those that were public were subject only to their own state constitutions. By the early nineteenth century, more so than the late eighteenth, colleges were organs of denominational influence.

Jefferson's idea of using colleges for purposes other than religious seminaries was not new. Christians so dominated higher education that they assumed responsibility for teaching a variety of classes.[14] Harvard and Yale, for instance, were begun as Puritan/Congregational seminaries, but provided education to non-ministerial elites such as lawyers and merchants. The Calvinism of seventeenth-century New England was also transformed. At Harvard, Congregationalism grew into liberal Unitarianism in the early nineteenth century.[15] Reverend Ezra Stiles, a man of science, presided over Yale during the early republic. By 1800 only 9 percent of college graduates were entering the ministry and 50 percent were becoming lawyers.[16]

But branching out into secular training did not mean the Protestant denominations gave up control of their colleges' curriculums. Throughout the upper South, even public schools such as the University of North Carolina and Transylvania University in Kentucky fell under denominational control.[17] Their challenges were similar to that experienced at Presbyterian Princeton: how to balance a combustible mixture of Christianity, republican politics, moderate Enlightenment philosophy, and mandatory attendance at chapel among students who prized the rebelliousness of their patriot fathers.[18]

Jefferson's divisions of study for the University of Virginia, which stressed the natural sciences and professional training for law and medicine, were similar to those drawn up by William Davie for the University of North Carolina in 1795.[19] That plan caused a clash between "infidels" and Christians in Chapel Hill that led to rifts and resignations among the administration and faculty. Eventually North Carolina followed the pattern typical of the era's public colleges when its administration was taken over by Presbyterians.[20]

Given the spirit of the times and the precedents of controversy set in North Carolina and Transylvania, Kentucky, Jefferson was hard-pressed to set up an institution openly hostile to denominational control. "Rational religion," as Jefferson's faith in the god of nature was sometimes called, was mostly overrun by

the explosion of evangelical Christianity that mushroomed in the United States around the turn of the nineteenth century. When rational religion reemerged among intellectuals in the late 1810s under the guises of Christian Unitarianism or natural religion, clerics at America's colleges were anxious to stamp it out quickly, as were most of their students.

Anti-intellectualism in America was stronger by the 1820s, when the University of Virginia opened, than during the 1760s, when Jefferson attended the College of William and Mary. Christian fidelity triumphed over the liberal religious sensibilities of the Enlightenment *philosophes* and Anglican clergy. John Quincy Adams, the last eighteenth-century man to occupy the White House, was ridiculed in the election of 1828 by Andrew Jackson's supporters because he advocated a national university in Washington and wanted to build celestial observatories.[21] Jefferson, who boldly advocated white male suffrage, was distraught at the coarseness of characters like Jackson, who dominated state legislatures by the 1810s and 20s.[22] He hoped the University of Virginia would encourage more sophistication in future rulers than what he saw around him in politics.

The proposal Jefferson introduced as governor of Virginia during the Revolutionary War was the most radical idea for education in America. His basic concern for educating the populace was not unique among the revolutionary generation. Many Americans hoped to emulate the example set by Frederick William I and Frederick the Great in Prussia, where a statewide system was set up earlier in the century. John Adams's Massachusetts constitution of 1780 included a provision for an educational system.[23] The American Philosophical Society awarded prizes for the best essays on education in 1797.[24] There was a consensus among leaders such as Adams, Madison, Benjamin Rush, and Alexander Hamilton that public education was necessary for representative government to succeed.[25] But they also feared that representative government precluded such systems because the public was unwilling to finance them.[26] Monarchies and dictatorships may have depended partly on the ignorance of their subjects to survive, but they also had the power to enforce unpopular initiatives such as compulsory education. The political ideology that revolutionary leaders encouraged to fight off British tyranny was naturally hostile toward any form of domestic taxation, including that earmarked for learning.

The question in the 1780s and 90s was whether or not republican governments had enough power to mandate school attendance and taxation on an unwilling population. The elite were able to afford private education, and they ran the state governments of the early republic. They had no need for public subsidies themselves, but some argued for public education as a means of controlling the working classes. What forms should education take? Who should be instructed and who should be in charge of dispensing it? Whatever consensus

existed on education among the revolutionary leaders broke down over the question of education's ultimate purpose: to control or empower.

Noah Webster, of dictionary fame, hoped to use education to inculcate subordination to authority.[27] Those more strenuously opposed to monarchies or power from above, such as Jefferson, thought just the opposite. They believed a basic knowledge of liberties and natural rights was necessary to guard against tyrannical infringements. Jefferson wrote, "No other sure foundation can be devised for the preservation of freedom."[28] Rush and other Christians, such as Reverend Stiles of Rhode Island, thought the primary purpose of literacy should be to read Scripture, just as it had been in colonial times.[29] Stiles, like most Enlightenment theologians, also saw science as revelatory.

Jefferson's challenge in Virginia was exacerbated by two factors. First, like Congregational New England, but unlike the middle colonies and farther south, Virginia had a strong tradition of church establishment, in their case Anglican. This made it harder for Virginia than other states like Georgia (1785), North Carolina (1789), South Carolina (1805), and Maryland (1807) to charter a public university.[30] Second, Virginia's rural and dispersed population made it difficult to assemble primary and secondary students efficiently. The poor were oftentimes too proud to attend public schools because they viewed them as charity, or had no interest in reading, writing, and math.

Most important, the aristocracy of central and eastern Virginia (Jefferson's own social class) resisted paying taxes for middle- and lower-class whites when they could afford to send their own sons to private academies and British or Northern universities. They had no stake in encouraging upward mobility among those who could not afford education. These obstacles frustrated Jefferson during and shortly after the American Revolution, blocking the passage of his 1779 Education Bill and preventing him from making educational reform the key to his assault on aristocratic privilege.

As president, Jefferson could not use the central government to coerce education without completely compromising his states' rights Constitutional principles. He did manage to establish the United States Military Academy at West Point in 1802 in an effort to purge military leadership of Federalist influence. After his retirement from the presidency in 1809, Jefferson's priorities began to change. He began to lose interest in lower levels of education because he thought the capstone to his original plan, a state university, would better counter the Northern trend toward nationalist politics. Only by instituting a bastion of Southern ideology could Jefferson combat the threat to states' rights posed by the U.S. Supreme Court. He hoped to inhibit the flow of antislavery sentiment, which he viewed as an insincere plot on the part of Northerners to gain political power.

Jefferson also hoped to curb the trend toward denominational control of higher education by advocating religious pluralism. Jefferson thought nature, not Scriptural revelation, was the proper moral and religious framework for education. One of Jefferson's most famous phrases concerning education, carved into the walls of the Jefferson Memorial in 1943 at the height of World War II, captures his concerns: "If a nation expects to be ignorant and free, in a state of civilization, it expects what never was and never will be."[31] Those words take on more significance when one looks at the entire letter from which they are drawn. The letter was a request for a donation to the University of Virginia, written around the time Jefferson abandoned hope for using primary and secondary education to offset aristocratic privilege. He argued that a successful university would rescue Southerners from the "Toryism" (national, or Federalist politics) and "fanaticism" (orthodox Protestantism) which their young men were then imbibing and importing from Princeton (then the College of New Jersey), or New England Congregationalist colleges such as Harvard and Yale.[32] Jefferson went on to essentially define ignorance as believing in strong central government, which is ironic given that the memorial was built by the expanding federal government of Franklin D. Roosevelt.

Struggles over religion, politics, privilege, and the meaning of the American Revolution were the contexts of Jefferson's educational initiatives. Jefferson's work on education during retirement was more than just an epilogue tacked onto his more famous accomplishments. His ideas on education began as the vision of one man, but were transformed as he grew older, the country changed, and the execution of his university was implemented by those around him. The important story is how Jefferson and his allies negotiated their vision with the world around them, including opponents such as Federalist politician Charles Fenton Mercer and Presbyterian minister/administrator/publisher John Holt Rice. These negotiations, not the pure ideas of one man, reveal the contested culture of early national Virginia.

# The Evolution of Jefferson's Vision, 1760–1814

❀

When Thomas Jefferson was seventy-four years old, he claimed that education was his "single anxiety in the world . . . a bantling of forty years' birth and nursing."[1] In fact, Jefferson's ideas on the subject formed over fifty years earlier, when he was a teenager at the College of William and Mary. The decades that followed his 1760 move to Williamsburg included his 1778–1779 education bill that failed, his proposal for dividing counties into smaller self-governing units, and a bill for religious freedom in Virginia that was passed into law in 1786. These initiatives were radically democratic for their time and buttressed the education plans of Jefferson's retirement.

Those fifty years also included Jefferson's travels in Europe and his presidency (1801–1809), the election to which embroiled him in a bitter fight with clerical opponents. The slanderous politics of 1800 stimulated his thinking on religion and confirmed his interest in education. While president, he established the academy at West Point in 1802. Jefferson's own schooling, revolutionary political experience, and presidency shaped the philosophy he arrived at by 1814, the year he initiated his campaign for the University of Virginia. The centerpiece of his thinking was that education should reinforce republican politics by teaching citizens and leaders their rights and responsibilities. Second, education should be rooted in humanism, emphasizing scientific revelation over Scriptural.

## Jefferson's Education

Most Virginians never attended school, but for planters the South was an outpost of the Enlightenment. It provided them with moral justifications for slavery and

frontier expansion, but also kept them plugged into more progressive aspects of European politics and science.[2] Jefferson enjoyed the intellectual and economic privileges of the squirearchy. He learned English and the classics with Parson James Maury for two years as a teenager. Then, rather than studying abroad, he chose to stay near home and attend the College of William and Mary.

Virginia's capital of Williamsburg was the biggest town Jefferson had been in. It was where the sons of tobacco gentry attended the best school in the South. There they gathered to acquaint themselves with one another and take stock of current politics. Many of Virginia's luminaries attended William and Mary, including John Marshall, Peyton Randolph, James Monroe, and John Tyler. Jefferson trained himself there as a lawyer and affirmed connections with powerful families. He graduated at age nineteen in 1762 after two years of study, then turned his attention to law and politics.

Jefferson was already forming opinions on how education should be implemented. His irreverence for degrees, expressed in his original plans for the University of Virginia, reflected his earlier environment at William and Mary. There he studied subjects for their own sake, including science, Greek and Roman classics, and Euclidean geometry. In college he also took part in the sort of town riots he hoped to avoid at his own university.[3]

American colleges did not merely reflect republicanism after the break with England; they were agents of rebellion during the Revolutionary War.[4] Williamsburg was no exception, and Jefferson's study of law under George Wythe after 1762 coincided with the initial falling out between Britain and her colonies. Jefferson had to examine fundamental political questions at a young age. The politics that motivated his initial plans for public schools grew out of these years in the taverns, dining rooms, and classrooms of revolutionary Williamsburg. The fundamentals that girded Jefferson's ideas on religion, science, and politics, including the way those topics should be addressed within education, took shape then. Jefferson encountered the Enlightenment philosophy that laid the basis for his lifelong assault on orthodox Christianity.

The College of William and Mary taught Jefferson a mix of Newtonian science, liberal Christianity, and classics—all future elements of his educational plans. Most of his professors at William and Mary were Anglicans, and Jefferson attended mass regularly at Bruton Church.[5] There Jefferson developed his love for the Anglican liturgy and interest in the Bible. He turned to both the rest of his life for sustenance.[6] The Anglicans at William and Mary were latitudinarians, meaning that they held broad and liberal beliefs by orthodox Christian standards. His professors' temperaments conflicted with the strictness of New England Calvinism and the emotionalism of evangelical Christianity.

Jefferson was influenced by European thinkers, but the immediate connection to their books came from his teachers and their friends. During his first year,

the professor of moral philosophy, Jacob Rowe, was fired for getting drunk and leading students into a fight with townspeople. William Small, a natural philosopher (scientist) hired to replace Rowe, encouraged a latitudinarian and humanist approach on Jefferson's part.[7]

Through Small, the only member of the faculty who was not an Anglican clergyman, Jefferson met Wythe, under whom he studied law. He was invited to dinner at the mansion of Governor Francis Fauquier.[8] The precocious teenager discussed politics and science with leaders and was introduced to writer Henry St. John (Viscount) Bolingbroke (1678–1751).[9] Jefferson's *Literary Commonplace Book* (personal journal) reveals the influence of Bolingbroke on his religion.[10] Bolingbroke introduced Jefferson to biblical criticism and the rejection of Scripture. Bolingbroke saw natural, rather than Scriptural, revelation as the genuine path to religious enlightenment.[11] He argued that Christianity rested on miracles and superstition, not reason or experience.

In his *Philosophical Works* (1754), Bolingbroke asked how it was that the God of the universe revealed himself only to a small group of people on the eastern Mediterranean. Why did the designer of the entire cosmos send a son to the same small group to be sacrificed? He criticized the Christian tradition of persecution, an idea echoed by another Jefferson favorite, Lord Shaftesbury, in *Characteristics of Men, Manners, Opinions, Times* (1776).[12] These writers described the Christian tradition in terms of the Crusades, the Spanish Inquisition, the Thirty Years' War, and French wars of religion, all negative examples of fanaticism and bigotry. Their work gave Jefferson no appreciation of how faith bolstered the spirituality and sanity of everyday believers. They did not entertain the notion that religion may have lessened, rather than increased, warfare. For these writers, science was a more trustworthy path to spiritual enlightenment than the violent and checkered past of organized religion.

William and Mary was typical of colonial colleges in that its philosophy was grounded in Scottish Common Sense Realism. Realism employed Englishman John Locke (1632–1704) to demonstrate the empirical and rational powers of humankind. It rejected the skepticism of critics like David Hume and Bishop Berkeley, who argued that ultimately humans could know nothing.[13] The pragmatic Common Sense philosophy was popularized in Scotland by Frances Hutchinson, Thomas Reid, and Reid's successor at the University of Edinburgh, Dugald Stewart, all lifelong influences on Jefferson.

Common Sense was the philosophy of moderate Presbyterians and Anglicans. It was how college administrators, intent on curbing radicalism while maintaining a healthy sense of educability, adopted the Enlightenment.[14] Jefferson was taught by the Scotsman Small, a follower of Hutchinson, and later advocated it in his educational plans. Meanwhile, Scotch-Irish Presbyterians spread Common Sense all along the frontier. William Tenant's log college at Neshaminy, Pennsylvania,

which grew into the College of New Jersey (Princeton) in 1746, was grounded in Scottish Common Sense. Like most administrators, Princeton president John Witherspoon, used Common Sense as a two-edged sword against evangelical enthusiasm and intellectual skepticism.[15]

Another linchpin in Jefferson's evolution was Henry Home (Lord) Kames, a jurist and Common Sense philosopher who anticipated some of Immanuel Kant's more elaborate theories of inborn sensibilities. Kames was a defender of reason against skepticism, but argued that knowledge alone was insufficient as a basis for morality. In *Essays on the Principles of Morality and Natural Religion* (1751), Kames argued that God intended humans to be social creatures and imbued them with an internal sense of morality.[16] For Jefferson, Kames helped bridge the gap between ethics and the religious criticisms of Bolingbroke and Shaftesbury. In his future educational schemes, students would be guided by this natural moral sense, rather than coerced by external religious orthodoxy. In turn, their studies of nature through science would help foster their moral development, especially in conjunction with the study of history.[17]

In the 1760s and 1770s, Jefferson feared that religious power threatened the kind of education he supported, an idea echoed in Locke's *Some Thoughts Concerning Education* (1693). American rebels believed that monarchies depended on the ignorance of their subjects to stay in power.[18] Jefferson shared the views expressed by future William and Mary president James Madison (the second cousin of James Madison, the U.S. president) in his 1772 "Oration in Commemoration of the Founders of William and Mary College." Speaking to the Virginia gentry, the man who would later become bishop of the Episcopal Church discussed Locke's contractual theory of government, stressed individualism and said the church was enslaving minds and coercing absurdities: "Fellow Students . . . we were born to be free . . . crouch not to the Sons of Bigot-Rage."[19]

Jefferson learned from classical authors that, aside from informing republican citizens of their rights against spiritual and political tyranny, education was also important for training future leaders. Plato, Aristotle, Cicero, Xenophon, Seneca, Plutarch, and Marcus Aurelius all argued that successful governments were directly contingent upon the training and wisdom of their rulers. Jefferson probably encountered Erasmus's *The Education of a Christian Prince* (1516), which was written to guide Charles V (future emperor of the Hapsburgs) and argued for the necessity of educating future rulers.[20] In his *Commonplace Book,* Jefferson noted the French theorist Montesquieu's consideration in *Spirit of the Laws* (1748) that "every government should provide that its energetic principle should be the object of the education of its youth."[21]

The result of Jefferson's grounding in Williamsburg was that he believed in education that stressed reason, natural religion, and political acumen. Organized religion threatened the genuine development of morality by discouraging students

to seek religious meaning in nature, and threatened the educational process because of its ties to oppressive government. Education was the cornerstone for building a successful republic, because leaders required the wisdom of education to go along with real-world experience, and their subjects needed education to understand their rights and ascend the social ladder.

Williamsburg judge St. George Tucker (1752–1827) either planted the notion of a state-subsidized university in Jefferson's mind, or was influenced himself by Jefferson. In 1797 Tucker drew up plans for a national university and, by 1805, formalized a plan for a state school in Virginia.[22] Tucker thought William and Mary was inadequate and wanted to build a university in Virginia's Piedmont where religions could worship side by side, scholarships would fund deserving poor, and discipline would be meted out by an internal court system independent of the county courts.[23] Jefferson later proposed all three ideas.

During the American Revolution Jefferson saw education used as a tool of rebel propaganda—as critical to the long-term revolutionary effort as muskets and political manifestos. For Jefferson to succeed in his avowed goal of eradicating aristocratic privilege, education would have to serve as the primary avenue of upward social mobility. Consequently, Jefferson brought a sense of urgency concerning education when he became governor of Virginia during the Revolutionary War. The war provided the backdrop for Jefferson's initial attempts at creating a statewide education system, his struggle (in cooperation with James Madison) to separate church and state in Virginia, and his advocacy of schools in the new western territories beyond Virginia.

### Jefferson's Education Bill of 1778–1779

In the late eighteenth century Enlightenment ideals transcended the coffeehouses and pamphlets of Europe, inspiring concrete social and political reforms.[24] During the Revolutionary War, delegates Jefferson, Wythe, and Edmund Pendleton set about overhauling the Virginia constitution, curtailing aristocratic privileges and disestablishing the Anglican Church.[25] At the heart of their reforms was the Bill for the More General Diffusion of Knowledge, item No. 79 in the "Catalogue of Bills Prepared by the Committee of Revisers."[26] Jefferson drafted the bill late in 1778 and introduced it in the Virginia Legislature in June 1779, shortly before his election as governor.

Jefferson liked to take talented youths under his wing and open his library to them, just as his mentors at William and Mary had, but the kind of statewide project he envisioned by 1778 entailed something much more.[27] Jefferson's goal was to lay the "axe to the root of pseudo-aristocracy." Had the education bill been successful, he wrote John Adams thirty-five years later, "our work would have

been complete." Jefferson believed that an aristocracy was necessary for the "instruction, the trusts, and government of society," but that status should be earned rather than inherited, in order to separate the "wheat from the chaff."[28]

Jefferson called the Bill for the More General Diffusion of Knowledge the most important of the 126 he submitted in 1779.[29] The bill advocated a pyramid-shaped system of public education, with many elementary schools feeding into a more select level of grammar schools, and a single university at the top. The primary level was intended to teach the basic literacy necessary for everyday business transactions and familiarize young republican boys and girls with their political rights and obligations. Tuition rates were based on a sliding scale: poor students would be subsidized, but those who could pay would. The university was intended to train future leaders and professionals in law and medicine.[30]

Excluded from the plan were girls at the advanced levels, and African Americans altogether. Jefferson wrote little about these exclusions, perhaps because his racist and patriarchal outlook made their omission self-evident.[31] When he did address the topic of education for black people, Jefferson fell into his familiar pattern of circuitous logic—their inferiority was environmentally based, but he did not suggest changing the environment.

Writing to black astronomer and surveyor Benjamin Banneker in 1791, Jefferson said that Banneker's almanac "proved the equal talent of our black brethren, when separated from the degraded condition of their existence."[32] Jefferson sent the almanac to Monsieur de Condercet, Secretary of the Academy of Sciences at Paris, to "quell doubts which have been entertained" against the black race. But Jefferson privately suspected that Banneker's genius was due to help he had received from his friend, Quaker Andrew Ellicott. Years later he sent an appraisal to Joel Barlow that contradicted the ones he had sent Banneker and Condorcet: "I have a long letter from Banneker, which shows him to have had a mind of very common stature indeed."[33] In a letter to James Pleasants in 1796, Jefferson wrote that for those in bondage, "ignorance and despotism seem made for each other."[34] Jefferson did write that his education bill could easily be altered to include free blacks and those destined for freedom, but he made no motion in that direction.[35]

The bottom line for African Americans and education in Virginia was that white politicians feared education would encourage knowledge, ambition, and independence among the slave population. In 1818 the Virginia Legislature passed a law denying readmission to any black who left the state to attain an education.[36] One of the primary purposes of education for Jefferson was to develop the skill of reasoning. By the early 1780s, he convinced himself that Africans did not have the capacity for reason.[37]

Jefferson thought white females needed a modest amount of learning to hold their own in civilized society, and included them in the first three years of his 1779 plan. Jefferson saw no reason for girls to attain higher education because he did

not envision them in positions of leadership.[38] His view on female education was captured best in a letter to his daughter, Martha, where he draws up a schedule for her day. The schedule included two hours of practicing music; four hours of dancing, drawing, and letter-writing; one hour of French; another hour of music; and the reading and writing of English in the evening.[39] This style of education, though worthy in its own right, was intended as social ornamentation and discouraged empowerment.

One of Jefferson's collaborators on the University of Virginia, John Hartwell Cocke, proposed an academy for females in 1820. Jefferson replied that he had not thought much on the subject and offered no encouragement. In his letter to Cocke he echoed the sentiments he expressed to Martha in 1783, minus the suggestion to read English. He complained that one great obstacle to educating girls is their passion for novels, poisons that "infect the mind" and distract it from "wholesome reading" and "the real business of life." Females, instead, should concentrate on dancing, drawing, and music while learning a little French.[40]

For white males the plan was rigorously meritocratic by modern standards, with only a handful of students picked to advance after the elementary level. Still, only a tiny percentage of white males (around 1 percent) attended college in the United States prior to the Civil War.[41] The 1779 bill was progressive for its time because it included opportunities for advancement and leadership for a small number of poor whites. Most other leaders disregarded the poor altogether.

Promising youths who would otherwise be unable to pay their way were granted three years of education at the state's expense. After those three years, the going got tougher. One poor boy a year was chosen from each of the elementary schools and allowed to attend one of twenty grammar (secondary) schools, the next tier up, to join all the sons of gentry. Half of the scholarship recipients were pruned away after one year, and all but one in each grammar school were sent home after two years. The remaining student would then attend the grammar school for four more years. Jefferson calculated that after the "residue was dismissed," twenty geniuses (from twenty grammar schools) would be "raked from the rubbish" annually by these means.[42] Each year half the remaining poor boys from all of the grammar schools would be chosen to attend William and Mary for three years, free of charge.[43] The administrative structure was very decentralized, with no state board to oversee the process. This basic pyramidal, locally initiated scheme characterized all of Jefferson's educational plans thereafter.

The geographical unit of organization for each elementary school was based on the English *hundred,* an idea Jefferson referred to during retirement as the *ward.*[44] Jefferson's ward idea, inspired by the tight-knit efficiency of Yankee townships, originated in his education plans of the 1770s. It was intended to educate children while simultaneously involving their fathers in direct political participation.[45] His aim was to divide counties up into small republics (five or six

square miles) that would administer many of the everyday functions of government, each one big enough for around one hundred people (hence the name hundreds). He hoped that self-government within the wards would take care of the basic workings of government: roads, police, elections, militia training, small court cases and, most critically, education.[46] The plan was similar to the small *polis* of classical Athens, and the school plan was similar to the one Lycurgus drew up for the Greek Spartans.[47]

Wards were one of Jefferson's most democratic ideas because they demanded so much local initiative.[48] Jefferson later wrote, "These wards, called townships in New England, are the vital principle of their governments, and have proved themselves the wisest invention ever devised by the wit of man for the perfect exercise of self-government, and for its preservation."[49] He hoped the local taxes would "throw on wealth the education of the poor."[50] Jefferson's aversion to big national governments was not due to an inherent dislike for either active government or wealth redistribution. He did want that power federalized down to local units and restricted to white men.

With his education bill of 1779, Jefferson hoped to use schools to jump-start the implementation of wards. After retirement he wrote that public education and the subdivision of counties into wards were the two subjects he would push "as long as I breathe," and considered "the continuance of republican government as absolutely hanging on these two hooks."[51] Jefferson wrote, "It is by dividing and subdividing these republics from the great national one down through all its subordinations, until it ends in the administration of every man's farm by himself; that all will be done for the best."[52] "These little republics would be the main strength of the great one."[53]

The Bill for the General Diffusion of Knowledge met resistance and was defeated again when it was reintroduced in June 1780.[54] Neither wards nor a school system came about in Virginia in Jefferson's lifetime. The public's dislike of the bill was threefold. First, many voters were opposed to taxation generally. Discontent over high taxes was a primary cause of the conflict in which Virginians were then engaged against the British. Second, Virginia was rural and thinly dispersed. Though it may seem counterintuitive to some, its scattered population did not lend itself to localism in politics. Unlike New England, where it was easier to assemble in central townships, great distances often separated families on the Virginia frontier.[55] In 1780 Virginia included Kentucky, western Pennsylvania, land beyond the Ohio Valley, and present-day West Virginia. The ward scheme was thus impractical.

Finally, Christians were offended that Jefferson's curriculum did not promote their faith. The rector of Hampden-Sydney Academy, Samuel Stanhope Smith (later president of Princeton University), reviewed the bill and wrote Jefferson that its biggest obstacle in the state would arise from religious denominations.[56]

Christians questioned the lack of religious instruction in Jefferson's plan. The curriculum he proposed reflected the humanist values he had formed as a student at William and Mary. Jefferson's plan did not utilize the clergy, even though they traditionally had worked as teachers because of their high rate of literacy and familiarity with low pay.

Given the fact that Jefferson was simultaneously working to disestablish the Anglican Church in Virginia, many Christians supposed that Jefferson was basically "replacing parishes and pulpits with wards and teachers' desks."[57] Smith, who admired Jefferson and his devotion to science, wrote to him concerning the possibility of using Episcopalians and Presbyterians to run the university that capped the system. Jefferson replied cordially, but said he saw any clerical involvement as a step on the path toward church establishment.[58]

Jefferson planned to drop the Bible in favor of the secular histories of Greece, Rome, England, and America. While reading, writing, and arithmetic would be taught in each school, special attention would be given to books of historical content. Jefferson hoped that exposure to history would alert students to various forms of tyranny (monarchical and spiritual) and encourage their resistance to it. Like Bolingbroke, Shaftesbury, and other eighteenth-century *philosophes,* Jefferson felt that criticizing Christianity through reason alone was not enough. He underlined his point by criticizing Christianity's long history of senseless conflicts, hoping to demonstrate organized religion's absurdity by attacking it from an elevated, historical position. Jefferson wrote about other purposes of studying history and its power to deter immorality, but mainly advocated its use as a weapon wielded against Christianity and monarchy.[59]

For Jefferson literacy was not only important for everyday transactions and studying history, it was necessary to read newspapers and stay up to date on politics. Jefferson agreed with John Adams, whose *Defence of the Constitutions of Government of the United States* (1787–1788) argues the same point.[60] Jefferson wrote on numerous occasions of the importance of newspapers. To Edward Carrington he wrote, "Were it left to me to decide whether we have a government without newspapers, or newspapers without a government, I should not hesitate a moment to prefer the latter."[61]

Jefferson hoped that newspapers and history would provide individuals with enough moral sense and reason to make responsible political decisions.[62] The specific decisions Jefferson hoped students would make were to resist tyranny and concentrations of aristocratic privilege, be they monarchical or ecclesiastical. Jefferson was not bothered by the ideal of objectivity in journalism, having pioneered the use of politically partisan newspapers in the 1790s on behalf of his Democratic-Republicans.

Virginians of the late eighteenth century resisted tyranny, but not because they learned to resist it in schools or because they read newspapers. Instead,

Jefferson's bill represented a tyranny of its own in their minds. It was voted down again in 1783, and the basic parameters of the bill were not passed into law until 1796, when the county courts were empowered to levy taxes for ward schools.[63] Without centralized control or coercion, and no wards, Bill No. 79 never materialized among the widely scattered population, even after 1796. Norfolk was the only county where the schools were started.[64] Other counties chose not to raise the necessary taxes, and Jefferson's idea foundered.[65]

The 1779 education bill embodied Jefferson's views on politics and religion. It was a vehicle intended to create a natural, rather than an artificial, white male aristocracy. At the same time, its success hinged on local, participatory democracy, because it was neither administered nor initiated from a central office. The prescribed curriculum encouraged republican values and was based on history and science, rather than on Scriptural revelation.

In the early 1780s, Governor Jefferson affirmed these emphases in his only published writing, *Notes on the State of Virginia,* an explanation of his views to Europeans on education, race, religion, commerce, and the natural history of Virginia. Jefferson's short piece on primary education follows his infamous seven pages on race and eugenics, in "Law" (*Notes,* Query 14). The passage in *Notes* is a rehash of the 1779 bill. In the wards, the "principal foundations of future order will be laid." In the curriculum of elementary students, only history would "enable them to judge the future; it will avail them of the experience of other times and other nations; it will qualify them as judges of the actions and designs of men; it will enable them to know ambition under every disguise it may assume; and knowing it, to defeat its views." The study of history would serve as an early instiller of morality. "Instead of putting the Bible into the hands of the children at an age when their judgments are not sufficiently matured for religious inquiries, their memories may here be stored with the most useful facts from Grecian, Roman, European and American history."[66]

As for organized religion, Jefferson wrote in *Notes* that it only retained power by suppressing thought: "It is error alone which needs the support of government. Truth can stand by itself." Religion, he wrote, caused "millions of innocent men, women, and children" to be "burnt, tortured, fined, imprisoned," and made "one half the world fools, and the other half hypocrites."[67] Science, religion's replacement, would not be taught until the university level, when students were ready for its mental rigor. Language training at the earlier levels would serve as a precursor, "an instrument for the attainment of science."[68]

Jefferson's advocacy of education and Anglican disestablishment occurred in tandem as part of the reformation of Virginia's revolutionary government. The humanist education Jefferson envisioned in *Notes on the State of Virginia* would not be politically viable in Virginia over the long term unless he and others acted to destroy the religious establishment. This created a conundrum because religious

establishments were the historical friends of education. Nonetheless, Jefferson got his chance to ensconce religious freedom as a fundamental political right because the plurality of dissenting Protestant denominations in Virginia feared the Anglican establishment, and each other.

### Religious Freedom in Virginia, 1776–1786

Virginia was fertile ground for debates over church and state because of its denominational pluralism.[69] Virginians held a variety of beliefs, including religious indifference. Many of the Protestants practiced evangelical Christianity, which democratically preached salvation to all willing people. Evangelicals were more emotional than New England Puritans or the drier, more intellectual, Anglicans. Evangelicals and other dissenters had bristled under the control of the established Anglican Church for decades prior to the Revolution.[70] Anglicans looked down on "dissenters" as low class and ridiculed their emotional enthusiasm. Dissenters, in turn, helped catalyze revolutionary sentiment.[71] In *Notes on the State of Virginia,* Jefferson wrote that "two-thirds of the people had become dissenters at the commencement of the present revolution."[72]

The evangelicals found a receptive audience among rural whites and slaves, and later among upper-class planters and urban professionals. Small revivals occurred in Virginia during the mid-eighteenth century among Presbyterian, Baptist, and Methodist churches. Virginia experienced interdenominational revivals throughout the mid-1780s. The Baptists and Methodists were the most demonstrative and egalitarian, and planters valued Anglicanism as a bulwark against their democratic pretensions. The persecution of evangelicals at the hands of Anglicans caused preachers to flee into the backcountry of Tennessee and Kentucky.[73]

Presbyterians in Virginia were unpretentious and shared an evangelical spirit with the Baptists and Methodists. Scotch-Irish Presbyterians came from the lowland of Scotland and Ulster, in present-day Northern Ireland. In the eighteenth century they migrated to the Piedmont, in central Virginia, and the western Shenandoah Valley, which separates the Alleghenies and Blue Ridge Mountains and runs from Harper's Ferry to Lexington, Virginia. (The valley was a commercial route to the west from New York, Philadelphia, and Baltimore.) Presbyterians were mainly middle-class farmers, many of whom supported Jefferson. The Frenchman Ferdinand Bayard, traveling in the Shenandoah Valley in 1791, recorded sympathetically a Sunday he spent with them. He and other travelers "worshipped with the inhabitants in a plain wooden building, its gallery filled with Negro men and women, the white mothers below nursing their infants publicly without shame. They sang Psalms and then had plain-hearted speeches."[74]

Despite their egalitarianism, Presbyterians coveted conversions among the upper, influential classes, which they attained during the first quarter of the nineteenth century. They advocated religious liberty from the established church, but also challenged Jefferson for control of education. Presbyterians required a college education of all their ministers and involved themselves in politics. They set up log colleges and worked for educational reform. Neither the Baptist nor the Methodist churches gave Jefferson problems at any point during his crusade for humanist education in Virginia, partly because they appreciated his support for religious freedom. Importantly, neither of those denominations required a college education of its ministers, which Presbyterians did. Conversely, Presbyterian influence on education in the South was so profound it influenced Jefferson's own educational ideas.

Jefferson's plan for public education arguably came from Scotland. Scottish thinkers advocated the subordination of theological training to more general instruction, the dividing up of schools into various grade levels, and the funding of education through public, rather than private, donations.[75] Jefferson's educational ideas may even have been influenced by a Scottish Presbyterian. The blueprint for Jefferson's 1779 education bill was similar to that proposed by the founder of Scottish Presbyterianism, John Knox, in *Book of Discipline* (1561). Jefferson owned a copy and he was familiar with the book through Knox's fellow Scotsman William Small, his professor at William and Mary.[76] Knox's book also instructed that "everie severall churches have a school maister" and that each father in a congregation be compelled, no matter what his "estait or conditioun," to bring up his children in "learnying and virtue."[77]

Jefferson shared Knox's notion that education was a rightful mechanism for the state, but had the opposite intention for the state's role: to prevent the sort of spiritual tyranny he thought Knox advocated. Years later, when Jefferson was fighting the Presbyterians for control of higher education in Virginia, he lamented the impact of Knox: "They [Presbyterian clergy] are violent, ambitious of power, and intolerant in politics as in religion and want nothing but license from the laws to kindle again the fires of their leader John Knox and to give us a 2nd blast from his trumpet."[78] In Knox's unrealized scheme, the Presbyterian Church financed the school system by confiscating property from the established churches, anticipating what happened in Virginia to the Anglicans on the part of the legislature.[79]

The confiscation of the Church of England's lands (or glebes) did not occur in Virginia with independence in 1776, but after a protracted struggle. The initial incorporation of the Episcopalians (the former Anglicans) after the Revolution roused the fury of both Baptists and Presbyterians, because they feared a return to the abuses of Anglican power.[80] In theory the role of colonial governments under the English Act of Toleration (1689) was to tolerate dissent, but promote estab-

lished religion financially.[81] The act supposedly held sway in colonial Virginia, but judges were imprisoning dissenting preachers, and the House of Burgesses never resolved the problem. In the Piedmont and Tidewater, Baptist ministers were dragged from the pulpit and horsewhipped.[82] Unitarians and deists were outside the protection of the Toleration Act altogether, and Quakers were prevented from landing in Virginia's harbors by a seventeenth-century law.[83] Presbyterians believed in the superiority of Calvinist Protestantism, but backed religious freedom whenever and wherever they were in the minority.

Presbyterians were divided on church establishment when they were not being harassed, but their policy shifted in 1776 when they began to favor an open market of denominational competition.[84] Jefferson and the Protestant dissenters thus made for uneasy allies as they worked to reform Virginia's constitution in 1776. Jefferson was a religious activist allied with the Presbyterians, but the Presbyterians wanted tolerance and rights only for everyone who was a Protestant Christian. Jefferson wanted to push it further, giving full rights of citizenship to all white males, regardless of their religious beliefs.

Jefferson was busy in 1776, shuffling back and forth between Virginia and the Continental Congress in Philadelphia. George Mason assumed leadership in drafting a new Bill of Rights for Virginia.[85] Jefferson refused an appointment to France so he could return to Williamsburg in October.[86] He chose to focus mainly on abolishing slavery and defending religious liberty.[87] Jefferson was a member of the Committee on Religion in the Virginia House of Burgesses, which intended to extend toleration to all Protestant subjects in Virginia. He wanted to insure religious liberty without allowing that liberty to be used as a cover for seditious political attacks. Jefferson finally settled on the policy advocated by Reverend Philip Furneaux: that religion should not concern the state unless it results in overt acts of disorder.[88] The balancing act was left to Mason, whose 1776 proposals for the Virginia Bill of Rights declared religious tolerance, but vaguely stipulated that everyone "had to practice Christian forbearance, love, and charity, towards each other."[89]

Initially, Jefferson was unsure how the Presbyterians would react to Mason's Declarations. While preparing for Virginia's first assembly as a state, he spelled out his position in "Notes on Religion" (1776).[90] The Presbyterian spirit was "congenial to liberty," but he understood the limitations of their generosity. In red-colored ink Jefferson explained their qualified definition of freedom:

> Presbyterian wd. open just wide enough for hms. [himself]
> others wd. open it to infidelity, bt. keep out fanaticismTrue mode only for all to concur,
> & throw open to all.ye prest. chch. too strong for any 1 sect, bt. too weak agt.all.[91]

Jefferson was behind in his assessment of the Presbyterians, at least as far as their formal strategy. In 1776 the Presbytery at Hanover, Virginia wanted more than

mere tolerance within a system that still favored the Anglican Church. They wanted complete liberty, equality, and free speech regarding religion. Under the leadership of Caleb Wallace, Presbyterians from Prince Edward and Hanover Counties petitioned the Legislature for religious emancipation.[92] Late in life, Jefferson wrote in his *Autobiography* that the "petitions of the dissenters brought on the severest contests in which I have ever been engaged."[93] It recalled for him how Presbyterian dissenters allied with Whigs in England to check monarchical power with the Toleration Act of 1689.[94] The Glorious Revolution of Dutch and English Protestants in England in 1688–1689 granted religious liberty to all Trinitarian Protestants (those who believed in God the Father, the Son, and the Holy Ghost).

The idea of religious liberty held by the dissenting Protestants was inherited from English history, formally articulated by John Locke in *A Letter Concerning Toleration* (1689). The constitution Locke drew up twenty years earlier for the colony of Carolina extended freedom of worship to anyone who acknowledged God, but funded the established Anglican church.[95] Though he appreciated Locke's ideas on representative government, Jefferson differed from Locke in two ways: he advocated public, not private, education; and he wanted to extend religious toleration to everyone. Jefferson hoped to expand on Locke's limited idea of natural rights and toleration, replacing it with one based purely on voluntarism and persuasion, and devoid of forced taxation:

> [Lo]cke denies toleration to those who entertain opns. contrary to those moral rules necessary for the preservation of society. . . . It was a great thing to go so far (as he himself sais of the parl. who framed the act of tolern.) but where he stopped short, we may go on.[96]

Jefferson's American extension of Locke helped set a new precedent in Western history; one where religious freedom was not just bestowed reluctantly from above as a privilege, but a natural right that should not be violated in any way.[97]

The religious freedom clause of the Virginia Declaration of Rights in 1776 called for toleration, but some discriminatory laws remained on the books. Parliamentary codes and involuntary taxation were discontinued and church salaries were stopped, but (English) Common Law still prevailed in the Virginia assembly.[98] According to a 1705 law, heresy prevented public office-holding. One lost the ability to sue in court or collect inheritance after the second offense, and a heretical father could lose custody of his children. Heresy was legally punishable by burning, though that did not happen.[99]

The failure to establish genuine religious liberty in the 1770s was matched by Jefferson's failure to alter the curriculum of his alma mater, William and Mary.[100] The college was tied to the Church of England by tests of conformity to the Thirty-Nine Articles imposed on its students and faculty. Customarily the school's chancellorship alternated between the bishop of London and the arch-

bishop of Canterbury.[101] Jefferson tried to use his power as governor to close the school of divinity, a source of Anglican dogma, but legislators deemed the school a private institution, immune from state control. Dissenters were afraid that reform would actually increase the prestige of the Anglican establishment at William and Mary and helped table the bill in 1785 and 1786.[102]

As a member of William and Mary's Board of Visitors in 1779, Governor Jefferson affected changes at the college that the legislature was unwilling to accept. He was unable to get the positions in civil and ecclesiastical history he desired, but he did destroy two professorships—one of divinity and the other education—and replace them with positions in law and police, medicine, anatomy, chemistry, and modern languages.[103] Jefferson likely feared Anglican influence on elementary teachers, which accounts for his hostility toward both the divinity and education departments. Most of the original rules, including the school's overall allegiance to the Anglican Articles, remained in place.

Jefferson drafted a more sweeping bill on religious freedom in 1777 and introduced it into the legislature in 1779 (Bill No. 82), but it failed. Given his understanding of the connection between politics and religion, it was logical that Jefferson introduced his education and religious freedom bills simultaneously. When Jefferson went to Paris in 1784, he left it to James Madison to follow through on his plan, just as Madison did later with his presidency and overseeing the University of Virginia. Jefferson met his close friend and political ally from Orange County on the floor of the Virginia House in 1776, when Madison was just twenty-four. In October the two were thrown together on the Committee on Religion, the Committee to Draft a Bill Abolishing Some Special Privileges of the Anglican Church, and the Committee of Privileges and Elections.[104]

Madison had worked with George Mason on the Virginia Bill of Rights the previous spring, while Jefferson was in Philadelphia. Only half Mason's age, Madison altered the colonel's initial inclusion of religious tolerance to affirm everyone's right to "the free exercise of religion, according to the dictates of conscience" (article 16). Madison also attached an amendment disestablishing the church.[105] A believer in natural rights, Mason no doubt concurred with the changes. Madison was hesitant to debate publicly, but according to one friend he kept up a dialogue with older politicians that made them "wish to sit daily within the reach of his conversation . . . [where] he delivered himself without affectation upon Grecian, Roman, and English history from a well-digested fund."[106] Madison and Jefferson were perfect allies in the fight for religious freedom.

Like Jefferson, Madison's religious background was linked to Presbyterianism and latitudinarian Anglicanism. Madison was interested in religious liberty as a teenager, and returned to Virginia from the College of New Jersey (Princeton) deeply committed to its cause.[107] His concept of political plurality was refined there under Presbyterian John Witherspoon in the late 1760s and early 1770s.[108]

The rights of minorities had to be protected against the will of the majority, both in economic and religious matters. Protecting minority rights in a pluralistic society was Madison's solution to the democratic riddle.[109]

Madison teamed up with Jefferson in 1779 to gut the theology department at William and Mary.[110] He then collaborated with Jefferson to bring down the Anglican establishment in Virginia during the mid-1780s. Fearing religion as a conduit of democratic agitation, the new Episcopalian gentry wanted to diffuse general political unrest among the lower classes by compromising with the dissenters.[111] The non-Episcopalian planters (such as Madison and Jefferson) who desired their own political freedom had to take the religious convictions of the lower classes into account while fighting off the traditional establishment. As religious minorities, Jefferson and Madison were hard pressed to disestablish the Anglican/Episcopalians without merely overseeing the transfer of power to their Protestant dissenter allies.

More than Jefferson, Madison understood the subtleties of placating the opposition. He convinced Jefferson, for instance, that the cause of church-state separation would be endangered, not advanced, by excluding ministers from the legislature.[112] But in order to avoid the excesses of Europe, Madison did not want churches incorporating and accumulating property.[113] In Virginia, no one seriously entertained the idea of transferring power and property from the Anglicans to a specific dissenting denomination. The alternative to religious freedom was a general assessment law, similar to the multi-establishment compromises enacted in Massachusetts, Connecticut, and New Hampshire, and almost passed in Georgia and Maryland.[114]

In Virginia such a law was proposed by Patrick Henry, the member of the gentry most closely identified with middle- and lower-class whites, and the only politician in Virginia with a more democratic reputation than Jefferson. Henry's idea was to use public funds to train Christian teachers. By the 1780s, the Virginia Presbytery at Hanover reversed their 1776 stand and advocated a general Christian tax, while still hoping to keep the Episcopalians in check.[115] Some Presbyterian leaders, such as Samuel Stanhope Smith, advocated Henry's idea of a Protestant coalition.[116] The idea was that taxes could be paid into the Protestant denomination of the taxpayer's choice. George Washington, John Marshall, and Richard Henry Lee supported Henry's "Bill for Establishing a Provision for Teachers of the Christian Religion." Jefferson callously wrote to Madison, "What we have to do I think is devoutly pray for his [Henry's] death. . . . I am glad the Episcopalians have again shown their teeth and fangs. The dissenters had almost forgotten them."[117]

Henry did not die, but with the calculated help of Madison he left the legislature to accept the governorship in 1785.[118] His bill was postponed, giving the opposition time to mobilize.[119] Reminded of the discrimination they had suffered

under the Anglican establishment, some Protestant dissenters organized opposition to Henry's general assessment.[120] Eventually nearly eleven thousand signatures were gathered against the tax.[121] The most famous and eloquent of the petitions was Madison's anonymously published *Memorial and Remonstrance against Religious Assessments* (1785), which attracted over fifteen hundred signatures.

Madison extolled the virtues of Christianity, but argued eloquently against mixing faith and politics. Abridging religious freedom was an "offence against God, not against man." He reminded readers of the "torrents of blood spilt in the Old World" in the name of bigotry.[122] Religion thrived before states existed, Madison argued, so it was ridiculous to argue it would die without state support.[123] He predicted that if religion were tied to the political system, the magistrates would become arbiters of religious truths.[124] *Memorial and Remonstrance* helped persuade the Virginia Legislature to vote down Henry's law.

Building on the momentum of Henry's defeat, Madison then pushed Jefferson's 1777 religious bill through the legislature in 1786. In the Statute of Virginia for Religious Freedom, Jefferson penned his most memorable phrases concerning religion as a natural right, stating that "Almighty God hath created the mind free" and the "Holy Author of our Religion . . . chose not to propagate it by coercions." Religious opinions "shall in nowise diminish, enlarge, or affect their [public officials'] civil capacities."[125] The Virginia legislature voted down an amendment limiting its toleration to Christians. The statute included freedom for all, including "the Jew, the Mahometan, and the Hindoo."[126]

Of course, there were very few Jews and no Muslims or Hindus in Virginia at the time, making the statute easier to pass and postponing the realization of its full implications. Despite that, the Virginia statute was a landmark piece of legislation, surpassing the contemporary English, Lockean conception of toleration. It was circulated by radicals throughout Europe and America, reprinted in French, and inserted in Denis Diderot's and Jean Le Rond d'Alembert's *Encyclopédia*.[127] It was translated into Italian and reprinted in London by Richard Prince in 1786.[128] In Paris, Jefferson was ecstatic upon hearing the news of the bill's long-fought victory.

In addition, the Baptists and Methodists helped revoke the incorporation of the Episcopal Church in 1787, leaving it with no legal standing.[129] These new laws did not prevent the Virginia Legislature from making bigamy and polygamy punishable by death in 1788.[130] Jefferson himself helped placate the opposition by writing a Sabbath law to sanction civic days of prayer and fasting and incorporating the restrictions imposed by the Old Testament book of Leviticus into Virginia marriage law.[131] Still, according to one religious historian, the bill, "by common consent, was the most decisive element in an epochal shift in the Western world's approach to relations between civil and religious spheres of life after fourteen centuries." Before that, religious authority was presumed necessary to social and political order.[132]

The restrictions against state-sponsored religion in Virginia set the standard for the national Constitution's First Amendment's protection of religious freedom.[133] Contemporary critics blamed Jefferson for the First Amendment, which was authored by Madison. In 1838 Henry W. Warner argued in the book *Moral and Religious Character of American Government* that this doctrine of political irreligion was never accredited until Jefferson gave it currency, executed it in Virginia, and read it into the United States Constitution.[134]

Aside from insuring full religious freedom and prohibiting any compulsory worship or religious taxation, the statute was unambiguous on the issue of religion and public education. In its opening sentence, which runs over a page and a half, it states:

> that to compel a man to furnish contributions of money for the propagation of opinions which he disbelieves, is sinful and tyrannical; that even the forcing of him to support this or that teacher of his own religious persuasion, is depriving him of the comfortable liberty of giving his contributions to the particular pastor, whose morals he would make his pattern, and whose powers he feels most persuasive to righteousness . . . [and] is depriving him injuriously of those privileges and advantages to which in common with his fellow-citizens he has a natural right.

Although the 1786 statute prohibited the taxed support of religious instruction, dissenting Protestants viewed religious freedom as an opportunity to consolidate their power through education.[135] Rather than prohibiting public financing for organized religions, they felt the statute merely created an even playing field for various denominations to compete for state funds through the democratic process. The disestablishment of the Anglican Church in the 1780s initially hurt the cause of education in Virginia, since established Christianity had provided the impetus for literacy in colonial America.

In the new State of Virginia, somebody had to fill the vacuum of educational leadership, and dissenting Protestants saw it as their prerogative. Presbyterians hoped to further their impact on higher education in Virginia by tapping into state support. When the Anglicans revived their sect as the new Episcopalian Church, they too tried to garner public funds. Despite their efforts, the 1786 statute established the parameters whereby Jefferson's humanist plans for the University of Virginia were politically justified.

### 1801–1814

Jefferson and Madison influenced religious history with their 1786 statute, but Jefferson's impact on education in Virginia was negligible up until that point. His plan of 1778–1779 failed, though a watered-down version of it passed in 1796.

Abroad from 1784 to 1789, Jefferson bided his time by studying European universities and toying with ideas for a national or Virginia university. Jefferson's biggest influence on education before the late 1810s came nationally, as Continental Congressman and founder of West Point.

On the Continental Congress, his authorship of the Land Ordinance of 1785 left a permanent mark on the American landscape. Jefferson devised a scheme to divide land up into thirty-six square mile townships, which were further subdivided into single square miles (sections) and acres, the basic grid system still in use. Regarding education, Jefferson proposed that each township set aside a space near its center for a common school.[136] The Congress also resolved to grant each new state one hundred thousand acres of land for the endowment of a university.[137]

In the frontier territories the ambiguities of church-state relations were apparent. Jefferson could not influence the curriculum of territorial schools. The very purpose of schools according to the Congress was to spread Christianity. Though cognizant of separatist sentiment among its constituents, the Continental Congress was openly pro-Christian, and it used Christianity to justify the need for territorial schools. The Northwest Ordinance of 1787, which set up the procedures whereby territories would become states, was based on Jefferson's proposals of 1784–1785, but passed while he was serving as minister to France.[138] It stated that: "Religion, morality and knowledge being necessary to good government and the happiness of mankind, schools and the means of education shall forever be encouraged."[139] In addition to one plot set aside for a school, another was designated for a church. Jefferson himself advocated Christian education when it came to Europeanizing the Indians of the Western territories.

Jefferson also influenced national education as a U.S. president. His biggest contributions were the founding of the United States Military Academy at West Point and the appropriation of federal lands toward the endowment of colleges in several states.[140] Jefferson's establishment of West Point in 1802, part of the Military Peace Establishment Act, is a political story in its own right.[141] Originally he conceived of the school more narrowly, as being solely for the Army Corps of Engineers.[142] Jefferson himself was considered a statesman of the American Revolution only, not a military hero. As governor of Virginia, he had fled during Benedict Arnold's invasion. More damaging to his standing among military leaders, he had argued against the establishment of a professional military elite during the 1790s. Jefferson argued against the founding of a military academy when Alexander Hamilton advocated one in 1793, calling the idea "useless."[143] Consequently the military establishment viewed Jefferson with suspicion, especially since his brand of political idealism was dangerous. With no battlefield experience himself, he was willing to use force to win democratic revolutions and to protect the republic.[144]

The Revolution itself had proven the necessity of war; it was the relationship between the military and the rest of society that was critical for Jefferson. In his opinion, a strong military that failed to subordinate itself to civilian rulers would jeopardize the republican experiment. Since wars offered great opportunities for advancement and ambition, Jefferson feared that the elite would constantly be getting the nation into conflicts. Great Britain exemplified how the nobility could then dictate the country's politics and diplomacy. The Quasi-War with France (1797–1800), led by the militarily-aligned Federalists, and the campaign Washington and Hamilton led against the whiskey tax rebels in western Pennsylvania, provided cases in point.[145] Of course, like Hamilton's proposal for an academy, neither the French war nor the Whiskey Rebellion coincided with Jefferson's political agenda.

The key was to train a generation of officers who supported Jefferson and shared his understanding of the role of the military in a republic. At West Point, he and his Secretary of War, Henry Dearborn, hoped to train Democratic-Republican officers so that they could eventually purge the military of the Federalists who had taken control in the 1790s.[146] After Jefferson's "Revolution of 1800," the troops would be comprised of the citizen-soldiers idealized by militia during the Revolution.[147]

Signing an academy into law was a way for Jefferson to accommodate the military, silence criticism, and co-opt an important wing of power. By having the government fund and oversee the academy, the school's constitution embodied the principle of military subordination to civilian control. In keeping with Jefferson's commitment to meritocracy, deserving leaders would be trained through public education rather than being born into a military nobility.

West Point was also an opportunity for Jefferson to employ the scientific emphasis he advocated in his earlier plans for Virginia. He rightfully thought that a military that was scientifically superior could win on the battlefield. Under Jefferson's choice as first superintendent, Jonathan Williams, West Point emphasized languages (French and German), and practical sciences such as mathematics, geography, nautical astronomy, and physics. It specialized in any subjects necessary to build bridges, fortifications and artillery.[148] The academy's scientific leaning dovetailed with Jefferson's ambition of westward expansion. The Army Corps of Engineers was indispensable to the surveying and settlement of the West.[149]

Jefferson considered moving the academy to Washington, D.C., where it would double as a national school of engineering.[150] But since he did not advocate a strong central government, he could not otherwise promote education from the executive branch. He was willing to use the national government to promote education, but only if empowered by a Constitutional amendment. Jefferson compromised this stance on other issues (such as the Louisiana Purchase and his 1807

Embargo), but not on education. With an amendment, Jefferson visualized using a foreseen treasury surplus in 1806 for public education and internal improvements, but it never occurred.[151] Because the federal government was tiny in Jefferson's time, he was powerless to do anything other than support private education. In his sixth annual message of December 2, 1806, Jefferson said that, "although education is . . . among the articles of public care," he would not "take its ordinary branches out of the hands of private enterprise, which manages so much better all the concerns to which it is equal."[152]

Jefferson had flirted with the idea of national universities before.[153] He was usually warmest to ideas that placed the campus in Richmond, safely near his sphere of influence. He corresponded with Quesnay de Beauprepaire (a former captain in the American army under Lafayette) in the mid-1780s about establishing a French-style art academy in Richmond, with branches in New York, Baltimore, and Philadelphia. In 1794 Jefferson and Francois D'Ivernois advocated transplanting the University of Geneva staff wholesale to Richmond, but Washington vetoed the idea (partially because he considered the professors too aristocratic).[154]

In his second term, Jefferson promoted Joel Barlow's idea, published as the *Prospectus of a National Institution to be established in the United States* (1806), but he knew the support was not there in Congress. The reason for Jefferson's ambivalence was that he already had his sights set on a project near Monticello. He knew he would lose control of ideology at a national school, whereas in Virginia he stood a better chance of leaving his own stamp on an institution. Washington had thought the reverse: that Virginia could influence the rest of the country better through a national school in the Capital. Jefferson never put his weight behind a national university of the sort advocated by Washington and others in the late eighteenth century, and by John Quincy Adams in the 1820s.[155] By his second term (and probably before) Jefferson wanted a university near the safe proximity of Monticello, where he could directly shape young minds on natural religion and republican politics.[156]

Despite his provincialism when it came to location, Jefferson still looked to Europe for ideas. In the 1790s and 1800s Jefferson corresponded with intellectuals like Thomas Cooper, Joseph Priestley, and Samuel-Pierre Dupont de Nemours about education. Dupont visited Jefferson at Monticello in 1800 and consulted him on his plans.[157] When overseas as Minister to France, Jefferson studied universities in Paris, Italy, Switzerland, and Scotland.[158] During his first term he solicited advice from the National Institute of France and the Universities of Edinburgh and Geneva.[159]

Jefferson's libertarian religious views were affirmed by the campaign that preceded his presidency. The mudslinging election of 1800 included attacks on him by Federalist-aligned Christians. Jefferson was lampooned in the Northeastern

press for his hypocrisy regarding slavery and his affair with mulatto house servant Sally Hemings. Additionally, Federalists wanted to smear him on religion. Since he was not an orthodox Christian they labeled him an infidel and atheist, though in fact he believed in God. They linked Jefferson in the popular imagination with the clerical persecution and violence of the French Revolution.[160] Federalists used his commentary on religion in *Notes on the State of Virginia* against him. In *Notes* Jefferson wrote that "it does me no injury for my neighbour to say that there are twenty Gods or no God. It neither picks my pocket nor breaks my leg."[161] Now those words of toleration came back to haunt him.[162]

Yale president Timothy Dwight, whose sermons and lectures defended Federalists against Democratic-Republicans and the pernicious influence of French philosophy, led the attack against Jefferson's alleged infidelity. At Yale's commencement in 1801, he encouraged all graduates to take an oath that they would never vote for Jefferson.[163] Reverend Jedidiah Champion of Litchfield, Connecticut asked the Lord to "Bestow upon the Vice President [Jefferson] a double portion of the Thy grace, for Thou knowest he needs it."[164]

Alexander Hamilton, Jefferson's adversary on the country's economic policy in the 1790s, used religion as a weapon against him. Despite Hamilton's own religious indifference, he wrote to John Jay in 1800 that "a legal and constitutional step ought to be taken to prevent an atheist in religion and fanatic in politics from getting possession of the helm of the state."[165] One writer to the *Massachusetts Mercury* had a more accurate understanding of Jefferson's theology: "My objection to Jefferson being promoted to the presidency is founded singly upon his disbelief of the Holy Scriptures, or, in other words, his rejection of the Christian Religion and open profession of Deism."[166]

Because of the alliance between Federalists and ministers, and the bitterness of the 1800 election, the two groups fused in Jefferson's mind.[167] After winning the hard-fought election, Jefferson wrote bitterly to Yankee ally Elbridge Gerry: "Your part of the Union tho' as absolutely republican as ours, had drunk deeper of the delusion, & is therefore slower in recovering from it. The aegis of government, & the temples of religion & justice, have all been prostituted there to toll us back to the times when we burnt witches."[168] From January 1800 to August 1801, Jefferson wrote more on religion than in his entire preceding life, mostly criticizing the role of the clergy and their association with his Federalist enemies.[169]

Jefferson's most famous oath of opposition to religious bigotry came after the 1800 election, in a letter to Benjamin Rush (1745–1813). Rush, who served on the Continental Congress, was a well-known Presbyterian, social reformer, politician, physician, and medical professor from Philadelphia. Jefferson and Rush were correspondents because of their mutual interest in ridding medicine of superstition and because Jefferson valued Rush's opinions on religion.[170] One of Jefferson's

letters to Rush in 1800 reveals how sensitive he was toward Federalist attacks that characterized him as an atheist: "They [especially the Episcopalians & Congregationalists] believe that any portion of power confided to me, will be exerted in opposition to their schemes. And they believe rightly; for I have sworn upon the altar of god, eternal hostility against every form of tyranny over the mind of man."[171]

President Jefferson began a lifelong interest in original, or restored, Christianity, and in Christ as a moral philosopher. The 1800 campaign motivated him to beat Christianity at its own game—to out-moralize and even out-Christianize orthodox Christianity by getting at the more original, or primitive, meanings of the gospel. Most Restorationists of the early nineteenth century were Christians, but Jefferson did not believe in Christ's divinity.

Jefferson wrote Rush that "to the corruptions of Christianity I am indeed opposed; but not to the genuine precepts of Jesus himself."[172] His correspondence with Rush in the late 1790s, along with the campaign of 1800, also rekindled Jefferson's interest in Christianity as a force in politics.[173] Jefferson wanted to fend off false criticism and counter the negative associations drawn by enemies between his Democratic-Republicans and the French Revolution. Turning the tables and out-Christianizing his attackers was Jefferson's strategy to separate Federalist voters from their leaders .[174]

Around this time he read English Unitarian and chemist Joseph Priestley's *History of the Corruptions of Christianity* (1782) and *Socrates and Jesus Compared* (1803). Inspired by Priestley, Jefferson made his peace with Christianity by focusing on its philosophy instead of its superstition, "scraping off the heavy barnacle that impeded Christianity's smooth passage around the globe."[175] Jefferson's "Syllabus of an Estimate of the merit of the doctrines of Jesus, compared with those of others" (1803) compared the morals of Jesus with other ancient philosophers, as did "The Philosophy of Jesus" (1804). One purpose of Jefferson's biblical scholarship was to draw attention to the simplicity of Christ. Unlike the intricacies of theology, which were engrafted on Christ's words over the course of European history, Jefferson thought the "doctrines which flowed from the lips of Jesus himself are within the comprehension of a child."[176]

In keeping with his counterattack on Federalists and their clerical allies, he titled his 1804 work "The Philosophy of Jesus of Nazareth extracted from the account of his life and doctrines as given by Matthew, Mark, Luke and John, being an abridgment of the New Testament for the use of the Indians unembarrassed with matters of fact or faith beyond the level of comprehensions." The long title sounded like an arrogant reference to the simplicity of Native Americans, but Jefferson undoubtedly intended to distinguish "sensible Indians" from his political enemies among the clergy, who were guilty of trying to comprehend complicated things beyond their grasps.[177] Jefferson's later attempts to establish a seminary that would serve as the "future bulwark of the human mind in this hemisphere"

had a double meaning: to shield Southern youth from both Federalist politics and orthodox Christianity.[178]

Jefferson made his first reference to the University of Virginia in an 1800 letter to Priestley: "We wish to establish in the upper & healthier part of the state, [a] University on a plan so broad & liberal & modern, as to be worth patronizing with the public support, and be a temptation to the youth of other states to come and drink of the cup of knowledge & fraternize with us." He asked Priestley for advice on how to group the sciences, explaining his desire to draw the best professors from Europe, organized in such a way as to bring the "whole within the power of the fewest professors possible."[179] Writing to Swiss scientist George Pictet, in 1803, Jefferson reiterated his aim to introduce a major university into the Virginia Legislature.[180] His plan was similar to that advocated by fellow Virginian St. George Tucker.

The first bill for the University of Virginia was introduced into the Virginia Legislature in 1805, during Jefferson's second term as president.[181] He was optimistic at first, writing to Littleton Waller Tazewell that those in the legislature "are likely at length to institute [a] University on a broad plan." Jefferson had a clear vision of his future school a full twenty years before it opened. The Tazewell letter explained how the Board of Visitors would be named after chartering, the recruitment of professors, and the layout of the academic "village," which would be located near Monticello. Unlike Oxford, Cambridge, and the Sorbonne, which were "a century or two behind the science of the age . . . only the useful branches of science" would be taught at his university.[182] For instance, it would be a center of agricultural research.[183] The University of Virginia would share West Point's emphasis on science.

After retiring from the presidency Jefferson refocused his efforts. In 1809 he met with Governor John Tyler, who advised him to construct a plan. The War of 1812 delayed initiatives, but Jefferson started his planning before the war's conclusion. In keeping with the localism of his earlier plans, Jefferson fastened onto nearby Albermarle Academy, a grammar school founded by the Virginia Legislature in 1803. The school had no funding other than the state lottery and never materialized. Jefferson invited himself to one of Albermarle's board meetings at the Old Stone Tavern in Charlottesville in March 1814 and joined the school's trustees.[184] Jefferson's nephew Peter Carr was president of the academy's foundation. Jefferson's son-in-law, Thomas Mann Randolph, helped him petition the legislature for profits from glebe lands to support the school.[185]

Jefferson used Albermarle Academy to fulfill Tyler's recommendation, investing all his ideas on higher education into a plan for the school, what one historian called the "paper chrysalis" of his future university.[186] He wrote to Carr in 1814, during the grimmest period of the war, when most of Jefferson's male relatives were busy guarding Richmond.[187] Jefferson's letter to his nephew is one of

the fullest expressions of his educational vision, including more than just proposed changes to Albermarle Academy.[188] Jefferson echoed his 1778–1779 plan of a meritocratic pyramid of education, with twenty grammar schools and select poor students drawn from a base of decentralized, publicly funded elementary schools.[189]

The Carr letter bore the imprint of French philosopher Destutt de Tracy, a relative of Lafayette's and correspondent of Jefferson's.[190] Like Tracy's "Little Tract on Education," Jefferson's students in the Carr letter were divided into two groups, the "laboring and the learned."[191] After the elementary schools, the learned were separated from the laborers (the wheat from the chaff), and the laborers began "the business of agriculture, or enter into apprenticeships to such handicraft art as may be their choice." Those destined for the professions and the pursuit of science could proceed to the next two levels. The wealthy, who "possessing independent fortunes, may aspire to share in conducting the affairs of the nation," were thrown in with the professionals and scientists in the secondary grammar school.

Jefferson laid out a curriculum dividing the secondary level into three branches—language, mathematics (broadly defined to include "every branch of science, deemed useful at this day), and philosophy, which included government, economics, ethics, and ideology. Language was studied in conjunction with history, and philosophy included the "law of nature and nations" under one subheading.

The university, at the top level, included professional schools for engineering, agriculture, law, and medicine. The Carr letter does contain a provision for a theological school, probably permissible in Jefferson's mind because Albermarle drew from private subscriptions.[192] Fine arts were for gardeners, painters, musicians, and "gentlemen." Technical (as opposed to moral or natural) philosophy covered a broad range of skilled professions, including shipwright, clockmaker, mariner, carpenter, glassmaker, tanner, soapmaker, vintner, cutler, druggist, brewer, and distiller.

How Jefferson distinguished all these "technical philosophers" from the artisans among the laboring class is unclear. Evidently, he wanted to use the education system to glean the most talented craftsmen, instead of relying merely on the apprenticeship system to carry that out. These classes were to be taught at night, to allow the young men to labor during the day. He stressed that their educations should be completely funded by the public. Artisans would be included in Jefferson's later university plans, but dropped by the time it opened.

In an effort to combine physical fitness and preparedness, all students in Jefferson's letter would devote two hours every afternoon to military maneuvers. Soon after Jefferson's election to the Albermarle Board, he wrote to scientist and radical democrat Thomas Cooper, informing him he hoped to hire Cooper at a

university he envisioned near his plantation.[193] Virginians were too busy practic-
ing live military maneuvers against the British, though, to implement the ideas in
Jefferson's letter to Carr. Despite the public circulation of the ideas contained in
the letter, nothing came of it for the time being.

## Conclusion

The main outlines of Jefferson's 1814 plan for education crystallized during the
American Revolution. Ironically, two Presbyterians, John Knox and John With-
erspoon, contributed indirectly to the outlooks of Jefferson and Madison—Knox
through his design for a school system in Scotland; Witherspoon through his tu-
telage of Madison at Princeton. Presbyterians and other dissenters worked with
Jefferson to overthrow the Anglican/Episcopalian establishment during and
shortly after the Revolution. Presbyterians and Episcopalians maintained qual-
ified support for religious freedom, but understood that freedom as the right of
factions to compete within the democratic arena for dominance, not the protec-
tion of minority rights. They considered it a natural exercise of their rights to
provide elementary teachers and dominate higher education. The election of
1800 confirmed to Jefferson that the Protestant clergy was conspiring with his po-
litical opponents to defeat his vision of a republican utopia.

Jefferson's model for education was shaped like a pyramid, with a broad base
at the bottom to encourage egalitarianism and opportunity. The pyramid shape
symbolized Jefferson's overall view of the perfect republican society. Education
would serve as a catalyst for upward social mobility—the way to create a natural,
rather than hereditary, aristocracy. All white children would be educated suffi-
ciently to transact business and vote responsibly in elections. There was tension,
though, between Jefferson's egalitarian ideas on primary education and his idea-
listic vision of a university training leaders. Because of limited public resources
Virginia could not afford both, and the two aspects of Jefferson's vision came into
conflict after 1814.

# The Politics of Virginia's Literary Fund, 1814–1819

✹

Except for the University of Virginia, which opened in 1825, Jefferson's basic suggestions did not come to fruition until Reconstruction, in 1870. No substantial system of public schools existed in Virginia until after 1900. The sparseness of Virginia's rural population made the clustered school systems of New England townships unfeasible. The rich who formed the electorate prior to 1851 had no desire to fund education for the lower and middle classes, which would have cost them money and encouraged social mobility among poorer whites. These factors undermined Jefferson's advocacy of a statewide education system.

During his lifetime, the sectional rift between eastern and western Virginia and the idiosyncrasies of its party politics shaped the debate on education. Economic and cultural sectionalism blocked political reform and ended up pitting Jefferson himself against the egalitarian spirit of his 1778–1779 education bill. Farmers from western Virginia argued for establishing primary schools first, against the wishes of university supporters, who were mostly eastern planters. From 1814 to 1819 Jefferson concentrated on the university at the expense of primary education.[1]

Virginia remained an aristocratic state into the early nineteenth century, with property restrictions on voting. Political power remained in the eastern part of the state, among the planters, merchants, and lawyers who had ruled Virginia since 1624. A small elite of around fifteen hundred households (2–5 percent) controlled the land, slaves, and politics.[2] Prior to 1830, around one-half of white males were disenfranchised. Forty percent of Virginians were slaves. Reapportionment of political representation was a live topic in the lower house and supported by Jefferson, but the senate blocked substantial reform and no constitutional convention was even called until 1830.[3] Voting restrictions that

incorporated a mixture of population and property to determine representation remained in place until 1851.[4]

The early nineteenth century was a paradoxical time in Virginia politics because the triumvirate of Jefferson, Madison, and Monroe maintained national power in Washington, but the state suffered from emigration and a relative decline in power. The focus of the Southern economy shifted from the Virginia and Carolina Piedmont to the Cotton Belt of the Southeast. Other than flour milling in the eastern cities and a few salt and iron works in the west, Virginia had no industrial base. Farmers and planters migrated west across the Appalachians when Virginia's tobacco soil was exhausted. The 1820 census showed Virginia was smaller than either New York or Pennsylvania, and far behind in wealth.[5]

Each year the politicians met in Richmond for three months during the winter, spending most of their time on property matters and personal petitions. The governor and his council were weak. Power was in the legislature, which was drawn from one hundred counties, all with their own narrow interests.[6] The delegates from these counties often canceled out each others' interests, preventing action on education and infrastructure.[7] Virginians west of the Blue Ridge Mountains wanted banks, schools, and infrastructure, but held only one-third of the representation in Richmond, despite their larger geographical size. Jefferson's eastern neighbors—the planters and merchants of the Piedmont and Tidewater—held more power, but also the burden of taxation to pay for the improvements those in the west desired. The west included many Protestant dissenters and yeoman farmers, typical of the voters who brought Jefferson to the White House in 1800. But one western delegate wrote to his wife in 1822 that the west "[was] treated like a foreign nation" by the easterners.[8]

The politicians who occupied Virginia's statehouse in Richmond during the 1810s attempted two civic projects, neither of which succeeded. One was to dredge the James River and build an inland network of canals connecting the Chesapeake to the interior. The goal was to boost commerce in Norfolk and Richmond the same way New York City's was after 1825, when the Erie Canal connected the Atlantic and Hudson River to the Great Lakes.[9]

The second project was to build a school system. Colonial patterns of education had persisted into the early national period. Planters' and merchants' sons were educated by tutors, attended private academies, and often went on to study in the European or Ivy League seminaries. The private academies were sometimes incorporated by the state, which made them legal entities, but no other support was offered.[10] Charity schools survived where they could on scattered donations, but carried with them the stigma of welfare.[11] Jefferson's middle-class constituents were mixed on public education, regardless of whether or not the rich would finance it. Many Protestants, including Scotch-Irish Presbyterians, German Lutherans, Moravians, and French Huguenots in western Virginia, established their

own schools taught by ministers. These communities later became the champions of public education in the mid-nineteenth century.[12]

The political impasse frustrated Jefferson, who wanted to see the smattering of private schools supplanted by something that could affect science and government more directly: "I mean of education on the broad scale, and not that of the petty academies, as they call themselves, which are starting up in every neighborhood, and where one or two men, possessing Latin, and sometimes Greek, a knolege [sic] of globes, and the first six books of Euclid, imagine and communicate this as the sum of science. They commit their pupils to the theatre of the world with just taste enough of learning to be alienated from industrious pursuits, and not enough to do service in the ranks of science."[13]

Despite public education's failure to take root in Virginia, the legislature did create a Literary Fund out of the profits the state earned from its 1802 seizure of Anglican property (escheats, or glebes), and other fines and forfeitures collected over the next eight years. After Jefferson's 1809 meeting with Governor John Tyler, that future president issued a strong message to the legislature urging some action on education.[14] A bill that Jefferson introduced in 1810 failed for the most part, but a clause for the creation of a literary fund (drafted by James Barbour) survived.[15] The Literary Fund was the political terrain that Jefferson navigated to implement his university.

The permanent endowment was typical of the only funding available in many states.[16] The fund rose from fifty thousand dollars to half a million after debts from the War of 1812 were paid back to Virginia by the U.S. government. The legislators collected a nest egg of over a million dollars by 1817, but did not spend the principal.[17] If they had, Jefferson's full-blown education plan would have come about, but their funds would have been quickly exhausted.

Jefferson's plans for the Literary Fund ran into conflict with his Federalist counterparts throughout the state. The Federalist Party was more than a reactionary clique of rich elitists and monarchists, as historians once depicted them. Known as Federalists in the 1790s, Virginians who supported government activism to boost commercial and industrial interests were usually called National-Republicans by the 1810s. Jefferson's party, the Democratic-Republicans (later the Democrats), wanted to keep the national and state governments small, and the states strong in relation to the national government. They supported the interests of wealthy slaveholders in Virginia. The Federalist merchants and farmers of the Potomac, Shenandoah, and Kanawha watersheds wanted the state to fund internal improvements (infrastructure). They were both more nationalistic and democratic than the elite of eastern Virginia, but never had the organizational capacity of their Democratic-Republican counterparts.[18] In the 1810s and 20s Virginia Federalists followed a more consistent line of reform than Jefferson's Democratic-Republicans on education, abolition of slavery, and women's rights.[19]

On education, the Federalists had a record of moderate support. Richmond Federalists like Edward Carrington and Abel Parker Upshur served on the boards of local academies, much like western Federalist Philip Doddridge.[20] As intended, the 1814 letter from Jefferson to his nephew Peter Carr circulated publicly, but it resonated with a future opponent of Jefferson's. It struck home with Charles Fenton Mercer, a young Federalist politician and Episcopalian from Loudoun County.[21] Mercer emerged as Jefferson's primary political adversary on education for the next five years.

Loudoun County is in northern Virginia, bordered by the Potomac River and Appalachian Mountains, and Mercer identified with western interests in Virginia.[22] After graduating at the top of his class from Princeton, he worked as a farmer, lawyer, and colonizationist (those in favor of returning slaves to Africa). Like fellow Princeton alumnus James Madison, Mercer was diminutive and lacked an oratorical presence, but was one of the brightest and most popular politicians in Richmond.[23] One writer for the *Richmond Patriot* wrote that, "tho a federalist . . . no member surpasses him . . . he stands first as a legislator in whom all place confidence . . . whose sincerity is doubted by no man in the house."[24]

Mercer's father, James, was a contemporary of Jefferson's, who graduated from William and Mary in 1767 and served in the Continental Congress. His son served in the War of 1812 and was member of the State House from 1810 to 1817. Charles Fenton led the progressive wing of the Federalist Party in Virginia. Like Jefferson, Mercer favored reapportionment of Virginia's senatorial seats, and he became one of the leading advocates of public education in the South. He promoted education and the construction of the Chesapeake and Ohio Canal as chairman of the Virginia House Finance Committee. Mercer pushed to collect the recent war debts from the national government, and advocated using the Literary Fund for poor and elementary school children.[25]

Public resources were limited, though, and Mercer and Jefferson disagreed over how to spend the money. Jefferson wanted to start at the tip of the pyramid with his university; Mercer wanted to build elementary schools first as a building block, partly because he thought the American Revolution had cut off the flow of good teachers from Britain.[26] He also wanted to locate the university, when it could be afforded, in the Shenandoah Valley, since the center of gravity in the state was shifting away from the eastern Tidewater.[27]

His efforts at democratic reform and public education seemingly put Mercer in alliance with Jefferson, but Jefferson disliked Mercer and was too rooted in the aristocratic establishment of eastern Virginia to work constructively with him. Jefferson needed the aristocracy's support to build his university, and relinquishing support for primary schools was the political cost he paid. Thus, Mercer forced Jefferson's political machine in eastern Virginia to oppose the egalitarian

Charles Fenton Mercer (1778–1858).
*Courtesy of the Virginia Historical Society.*

spirit of his 1779 education laws. Jefferson also had his heart set on a university within site of Monticello, and Mercer wanted the university in the west.

Jefferson was also unable to work with Mercer because his animosity toward Federalists (whom he called Tories or Consolidationists) grew even stronger after the War of 1812. The idea that New Englanders considered seceding and joining

England during that war solidified Jefferson's political partisanship toward the South, and his bitterness toward anything antirepublican. At one point during the War of 1812, Jefferson implied he would not mind a civil war within New England to permanently rid our shores of tory politics.[28] Virginia could then confederate only with those who were for "peace and agriculture."[29] With early market capitalism taking root in the North, Jefferson lived to witness the very European-like developments he prophesied and feared in the 1790s.[30] In 1816 he wrote that "the agricultural capacities of our country constitute its distinguishing feature; and adapting our policy and pursuits to that, is more likely to make us a numerous and happy people, than the mimicry of an Amsterdam, a Hambourgh, or a city of London."[31] Politicians like Mercer provoked Jefferson's provincialism.

Jefferson correctly perceived that Northeasterners wanted to break the South's stranglehold on national politics, but he became more paranoid during the War of 1812 than he had been in the 1790s (especially after the ill-fated Hartford Convention of 1814, where New England Federalists voiced their complaints against the Southern hegemony). As the first party system and its corresponding labels collapsed in the 1810s, Jefferson relied instead on terms like "stock-jobber," "tyrant," or "licentious gambler" to describe Northerners and businessmen.[32] Jefferson wrote that party names could change (such as the transition of Southern Federalists to National Republicans) but, "in truth, the parties of Whig and Tory, are those of nature: "The sickly, weakly, timid man, fears the people, and is a tory by nature. The healthy, strong and bold, cherishes them, and is formed a whig."[33]

Jefferson saw the North as the source of America's Europeanization, but he also feared Federalist infiltration among the lawyers and politicians in nearby Richmond, especially Federal Supreme Court Chief Justice John Marshall and his followers. Though Marshall and Jefferson both grew up in the Virginia Piedmont and studied law under George Wythe at William and Mary, the distant cousins disagreed over how to preserve the republican experiment. Marshall thought natural rights could only be preserved by expanding the power of the national government, while Jefferson supported state power, and local power within states.[34] Jefferson's opposition to Marshall's Federalism, locally and nationally, motivated his planning of the University of Virginia.

Given the democratic thrust of Jefferson's politics, it must have pained him to see one critic refer to Virginia's elite as an "aristocratic cancer in the very bosom of the republic."[35] An informal coalition known as the Richmond Junto represented Virginia's squirearchy and served as a "clearinghouse of Old Republican doctrine."[36] They controlled the central committee of the Democratic-Republicans in Virginia.[37] The Junto was similar to, but smaller, than its Northern Democratic counterpart, the Albany Regency of New York.[38] Such groups were an inevitable outgrowth of party politics, but the Junto's elitism and secrecy ran counter to the democratic philosophy otherwise encouraged by Jeffer-

son. Their main purpose was to protect elite interests by preventing democratic reforms in Virginia. Unlike Jefferson, the Junto opposed constitutional reform (including reapportionment and broadening of the suffrage) and was opposed to internal improvements.[39]

According to the anonymous "Letters on the Richmond Party" (printed in Washington, Richmond, and Lynchburg in 1823), the coalition of old Virginia families consisted of no more than around twenty members, and was spearheaded by Judge Spencer Roane (Chief Justice of the Virginia Supreme Court); his cousin Thomas Ritchie, editor of the *Richmond Enquirer;* John Brockenbrough (Roane's brother-in-law), director of the Bank of Virginia; and Brockenbrough's brother-in-law, Andrew Stevenson, leader of the house of delegates. Other family names associated with the group were Nicholas-Randolph, Barbour, Preston, Cabell, and Wirt.[40]

Despite controlling most of the key positions of power in Virginia, the Richmond Junto was not an omnipotent political machine, or even a coherent organization by modern standards. The counties were autonomous political entities, and those from the western part of the state could not be directly manipulated in the House or Senate. As the west slowly gained power in the 1820s through natural growth, the influence of the Junto waned.[41] Nonetheless, they articulated Virginia's position nationally in the 1810s and 20s and could mobilize sentiment in the eastern part of the state.[42] The Junto also controlled the state banks, which held the Literary Fund money. Since Jefferson was not an elected official himself, he was forced to rely on this informal caucus of allies as his coadjutors, or what he called "Friends of the University."

Since the Junto was too weak to effect change by themselves, Jefferson had to persuade Virginia's public of the viability of his ideas. He turned to the medium he used in the 1790s, and the one he saw as the lifeblood of republican government: newspapers.[43] The most important Democratic-Republican paper was the *Richmond Enquirer,* edited by Thomas Ritchie, a Junto member, official state printer (of House and Senate journals) and close friend of Jefferson's. Ritchie was an important political operative who helped seal the New York-Virginia alliance in the Democratic Party.[44] Jefferson once spoke of him as "culling what is good from every paper as the bee from every flower."[45] Jefferson enlisted Ritchie to support his university. In addition, Jefferson oftentimes wrote in the *Enquirer* anonymously (the custom of the day), and even wrote a traveler's account praising the beauty of his university.[46]

While Jefferson promoted his cause in the *Richmond Enquirer,* he transformed Charlottesville's Albermarle Academy into Central College, but these two predecessors to his university existed only on paper. The legislature officially changed Albermarle Academy to Central College in February of 1816, but did not grant the school any money from the Literary Fund.[47] The directors of the

fund signaled that they would contribute to a university in 1816–1817, but it was not determined it would be in Charlottesville.[48] Since that was Jefferson's dream, his first big political challenge was to get the legislature to agree on Central College as the site, preferably within spyglass-viewing range of Monticello.

In order to raise funds and secure the site, Jefferson needed more than the private subscriptions he could round up among his supporters. He needed public sanction and funding, and he had to employ the Richmond Junto to attain it. The key to locking in their support was the creation of Central College's Board of Visitors. The Central College bill also called for the dissolution of the original Albermarle Board of Trustees, which Governor Nicholas replaced in October with the new Board of Visitors. The new board was shrunk in size from sixteen to six to increase Jefferson's influence. He then cleared out the old trustees and replaced them with Friends of the University. The Board included Madison and James Monroe, who replaced Madison as U.S. president in March 1817.[49]

Jefferson, Madison, and Monroe contributed one thousand dollars apiece and Central College had thirty-five thousand dollars in pledges by the spring of 1817.[50] They agreed to look for a two-hundred-acre site. In April they purchased land along Three Notched Road, a route between the Blue Ridge Mountains and Richmond. The board purchased the site with $1,580 of Albermarle Academy's glebe money (local share of escheats from the Anglican Church).[51]

John Adams was skeptical about the project, because the "noble Tryumvirate" of Jefferson, Madison, and Monroe could only lend it political support temporarily. "But," Adams wrote, "if it contains anything quite original, and very excellent, I fear the prejudices are too deeply rooted to suffer it to last long, though it may be accepted at first."[52] Jefferson exploited the fame of the three presidents by holding his next board meeting on May 5, Court Day in Charlottesville, in order to maximize exposure.[53] Jefferson already had his layout in mind for a series of separate pavilions surrounding a central square, and in May picked out the precise spot for the university.[54] In July, at age seventy-four, he personally surveyed the land for his "academical village," laying off the three terraces that would become the interior lawn.[55]

The next day Jefferson wrote "our squares are laid off, the brickyard begun, and the leveling will be begun in the course of the week."[56] By fall Central College had forty-four thousand dollars in subscriptions, some in the form of bacon, wooden planks, and medical services. The Freemasons, a group who shared Jefferson's religious liberalism, wanted to lay the first brick.[57] He voiced his approval, but the board settled on President Monroe instead, fearing a political backlash against the Masons. In October a large crowd assembled outside the village of Charlottesville to hear a band play "Hail Columbia" and see Monroe lay the cornerstone for the first building (Pavilion 7) of what later became the University of Virginia.[58]

Madison, along with Adams, was a correspondent with whom Jefferson could

be trusted to write in earnest. One historian wrote that Jefferson "relished the prospect of reviving the old Jefferson-Madison collaboration one more time, in yet another campaign to lead reluctant citizens toward truths that lay just beyond their vision."[59] The two often talked about the project in advance of their meetings with other board members.[60] Madison realized that the plan was Jefferson's all along, and he and the other board members usually deferred to his judgment.[61]

Another new board member, Joseph C. Cabell (1778–1856), became Jefferson's most prolific correspondent during his retirement, despite being thirty-five years younger. Cabell, known as the "DeWitt Clinton of Virginia" for his work in promoting infrastructure (similar to Clinton in New York), was Jefferson's legislative representative in establishing the University of Virginia.[62] He stepped in for Peter Carr, the former president of the Albermarle Academy Board, who died in February of 1815 and never delivered the petition of the board to the legislature for that session.[63] Cabell helped Jefferson in the legislature as far back as 1810, when the Literary Fund was created. He was a delegate for two years and, after 1810, a state senator whose district encompassed Albermarle County. Cabell was part of a long tradition of political talent that came out of that part of Virginia (Fredericksville and St. Anne's Parish before the Revolution).[64] He was a dyed-in-the-wool Republican who "bordered on the gloomy verge of Atheism" as an undergraduate at William and Mary in the late 1790s.[65]

Cabell lost his slaves during the War of 1812 and opposed abolition. He was less disposed than Jefferson toward legislative reapportionment or increased suffrage for poor white men. An old-fashioned aristocrat, he wrote in 1825 that Jefferson's support of democratic reform was the "most unfortunate part of his life."[66] Despite Cabell's higher degree of elitism, he was honored to do Jefferson's bidding for education in the legislature. For ten years he fought Jefferson's battle to win state money from the Literary Fund for Central College and the University of Virginia. In early 1815 Jefferson wrote to Cabell that, "on yourself, Mr. Rives [William Cabell] and Mr. Gilmer [Francis Walker], when they shall enter the public councils, I rest my hopes for this great accomplishment." His hope was for these men to "complete and secure our republican edifice."[67]

Some of Jefferson's aristocratic cohorts, including Spencer Roane, were still interested a broad system of education, not just a university.[68] James Barbour, then Speaker of the House, favored Mercer's ideas of spending the money on public elementary schools.[69] Jefferson and Cabell knew that Wilson Cary Nicholas, as governor and head of the Literary Fund, would author the education report issued to legislators for the 1816–1817 session.[70] After Cabell got Jefferson's 1814 Carr letter published in the *Richmond Enquirer,* Nicholas issued a circular asking for ideas on a system of education in May of 1816.[71]

A number of people from all over the nation and within Virginia responded, but the real contest was between the bills proposed by Cabell and Charles Fenton

Mercer, the Federalist who shared in creating the Literary Fund (with Governor Barbour) and who chaired the Virginia House Committee on Finance. It was through Mercer's efforts that the fund increased from fifty thousand to four hundred fifty thousand by 1816. Mercer also gave official sanction to Governor Nicholas's circular, introducing a motion into the assembly requesting the Literary Fund directors to report a plan of education during the next session.[72] This resolution was the first official sanction of what became known as the University of Virginia, because the new system Mercer hoped the directors would propose included a university by that name as its capstone.[73] Cabell originally viewed Mercer as an ally because of his enthusiasm for Jefferson's letter to Carr, but Mercer was friendlier to elementary schools and churches than were Cabell and Jefferson.

Publishing the Carr letter was a tactical error for Jefferson and his allies. The sudden interest in education and the Literary Fund triggered political conflict between denominational colleges, private academies, and those who favored public elementary schools.[74] Presbyterian and Episcopal Churches vied with Mercer's faction and Friends of the University for access to the Literary Fund. Washington College (later Washington and Lee), a Presbyterian school in the Shenandoah Valley town of Lexington, wanted to be converted into the new state university.

Cabell wrote Jefferson that, "Should the next assembly sanction the scheme of a university, you will see the Presbyterians about Lexington, and the Scotch-Irish about Staunton, striving to draw it away from Albermarle, and the whole western delegation, according to custom, will threaten to divide the state unless this institution should be placed beyond the [Blue] Ridge. Northerners in the House of Delegates will be a advocates for a western site. Washington College at Lexington will be the bantling [favorite] of Federalists."[75] Mercer represented those interests and arrived at the 1816–1817 session armed with his own plan.

Some legislators were skeptical toward both Mercer and Jefferson and thought academies should be established first to provide teachers for the elementaries.[76] The eastern Republicans opposed spending their tax dollars on either proposal. At one point it was suggested the Literary Fund should be abolished and the money returned to the state treasury.[77] Jefferson needed the support of Mercer and westerners, but when Mercer proposed a system that emphasized elementary schools and an eventual university in the Shenandoah Valley, Jefferson opposed this "consolidation."[78]

The plan the directors of the Literary Fund submitted in early December 1816 elevated the public elementary schools over the university, suggesting that the fund be used from the ground up. Mercer must have influenced the report because Jefferson's architectural plan was ignored and no mention was made of the site.[79] Mercer's idea of creating a state board of education conflicted with the localism of Jefferson's ward scheme (see chapter 1). Mercer also wanted to finance

education through a network of state-run banks. He tried to push through too much in 1816–1817, including reapportionment and the bank bill/education plan. Mercer introduced a bill requiring each county to have a primary school, with tax support from the general assembly.

There were no banks west of Staunton in 1817 and Mercer's bank plan threatened the Junto's monopoly on state finance. Most of the Republicans came from the eastern part of the state, where they already controlled the banks.[80] Mercer introduced bills for two new banks, hoping to use bonuses from the banks to boost the Literary Fund to two million dollars.[81] His ambition was to eventually raise five to seven million dollars from a network of banks in Norfolk, Richmond, Fredericksburg, Winchester, and Lexington.[82] This would have been more than adequate to provide for primary schools, twenty to twenty-five academies, four colleges, and one university, and could have grown to over twenty banks.[83]

Ritchie's *Richmond Enquirer* called Mercer's bank bill "magnificent but impractical" after it was safely defeated. Ritchie was glad it was defeated and called it unconstitutional.[84] He printed nine essays in January and February by strident Republican William Branch Giles condemning both Mercer's and Jefferson's educational ideas.[85] He also printed delegate Thomas Blackburn's call for "unequivocal protest against this bill [Bank] & the doctrines it maintains." Mercer used England and Frederick of Prussia as examples where "literature, liberty and banks" went together, which for Ritchie was like "draw[ing] sweet water from a bitter fountain."[86] One editorial in the *Enquirer* asked if it was the role of government to take such an active role in education. Since it was assumed that education was dominated by Christianity, would not Mercer's bill mix church and state?[87] Republicans asked, why not "create a gambling house or houses of ill-fame in every county on condition of their paying a bonus to the use of the Literary Fund?"[88] Blackburn spoke for the Republicans in 1817, arguing against this "unhallowed embrace, this sacrilegious touch, this incestuous intercourse."[89] Mercer's Literary Fund bank bill passed the house but was killed by Jeffersonians in the senate, where Cabell used some of Jefferson's calculations to show it was unfeasible.[90] Mercer revised his plan slightly, but it too failed.[91]

Jefferson's supporters in the legislature tried to reverse Mercer's emphasis on primary schools over the university and get the site moved east and closer to the James River.[92] In the upper house, Cabell gutted the Mercer bill of its crucial primary school plan, which subverted its intention even before it failed on a tie-breaking vote. This explains why Cabell himself voted for Mercer's bill in the senate.[93] Malapportionment was also crucial to its defeat, since twenty of twenty-four senatorial districts were east of the Blue Ridge Mountains.[94] It was also discussed late in the session, when most of the delegates had gone home.[95] There was too much discord in the assembly to do anything with the Literary Fund, though it had now grown to one million dollars.

Mercer's plan, published as *Sundry Documents,* had popular currency in the summer of 1817.[96] The prevailing opinion, according to Cabell, was "to establish schools first, and colleges afterwards."[97] Luckily for Cabell and Jefferson, Mercer was elected to the U.S. House of Representatives, removing their biggest obstacle in the Virginia Legislature. Jefferson and Mercer disliked each other intensely. Mercer later wrote of Jefferson, "No matter what evil invades the land, what dreadful ruin breaks up our institutions, what disgrace attacks and leaves its foul spots on our character, all may be traced to the damnable policy of Thomas Jefferson and his party."[98] Jefferson was traditionally against banks and claimed that Mercer's plan was too expensive, but the plan he drew up for Cabell and the assembly in 1817 included nine academies to Mercer's four. Also, the Literary Fund already had its money invested in banks, including the U.S. Bank, along with two state banks and the James River Company. Nevertheless, Cabell called the bank bill "mammoth" in a letter to Jefferson.[99]

The bottom line for Jefferson was to monopolize the Literary Fund for Central College during the next session, even though the first draft of the next bill he sent Cabell did not mention the university. By October of 1817, construction on the first building in Charlottesville had begun. Jefferson expounded the benefits of Central College, and its assets were offered to the state in exchange for making it into the public university.[100] That fall, Jefferson countered Mercer by sending Cabell his eleven-page "Bill for Establishing a System of Public Education" from Poplar Forest.[101] Like his earlier plans, it avoided a central board and provided three years of free public schooling for white boys and girls.[102] Scholarships to the academies would be provided to promising youth. Jefferson argued disingenuously for forcing the cost of schools directly on local citizens by taxing within wards, an idea he had to have known was unworkable from past experience. Teachers would be drawn from the laboring classes, including the sickly, crippled, or aged, but not the ministry.[103] "No religious reading, instruction, or exercise" was allowed, and no ministers could serve on boards or act in a supervisory role.[104]

The most significant addition to Jefferson's 1779/1814 plans was tying citizenship directly to literacy, an idea influenced by the constitution of the new post-Napoleonic Spanish Cortes. Jefferson called the idea a "fruitful germ of the improvement of everything good and the correction of everything imperfect in the present constitution."[105] He commented on the provision favorably in a letter to Dupont de Nemours:

> It is impossible sufficiently to estimate the wisdom of this provision. Of all those which have been thought of for securing fidelity in the administration of the government, constant ralliance to the principles of the constitution, and progressive amendments with the progressive advances of the human mind, or changes in human affairs, it is the most effectual.[106]

Jefferson mulled over the idea during the following year and half and included it in his 1817 bill. Tyranny of mind and body, he hoped, would "vanish like evil spirits at the dawn of day" with the enlightenment of the people.

It was a striking instance of state coercion given the weak government rhetoric of Jeffersonian politics. Jefferson wrote often about how he did not fear the political power of the people, but his proposed insistence on literacy as a qualification for citizenship qualified his radicalism, especially when one considers the low rate of literacy among white males in Virginia at that time. Jefferson pondered how far the rights of the state extended over the upraising of children and whether or not it included the child's instruction and morals. He generally thought the father was supreme in these matters, but he wanted to "strengthen parental excitement [about education] by disqualifying the citizenship of their children." Society had this right, he rationalized, because education would be offered for free. Education was one sphere where Jefferson's natural rights morphed into natural obligations. His cohorts did not concur with his logic, and got rid of the citizenship requirement before the bill was submitted.[107]

Jefferson had given Cabell and other Junto members permission to revise the bill, in order to make it passable. Cabell, his brother William, Governor Nicholas, and Judges Coalter and Roane struck two key items from his education bill of 1817. They knew the literacy clause for citizenship doomed the bill, and objected to its abolition against using ministers as teachers, a carryover from the 1779 and 1814 plans. Jefferson did not consider public schools the proper realm for spiritual matters, but Roane and Ritchie disapproved of excluding ministers from teaching school. Cabell and the Junto struck the phrase: "but no religious reading, instruction or exercises, shall be prescribed or practiced inconsistent with the tenets of any religious sect or denomination." Jefferson had to maintain the alliance of his supporters, and voiced no criticisms of the revisions.[108] Despite his fame and passionate concern for education, he was not an elected official after retirement, and he was willing to let Cabell and the Junto make revisions if they were the ones who backed him politically. Jefferson probably knew most of his plan would fail when he sent it, hoping to get his site for the state university as a bottom line, and intending the rest as a bargaining chip.

Cabell had his hands full trying to balance the sectional tensions in the assembly. He wrote to Jefferson about efforts "to convert this subject into a question between the East and West side of the Blue Ridge."[109] Jefferson complained in his response that "so many biases are to be honored—local, party, personal, religious, political, economical & what not . . . the prospects are not very flattering."[110] Disagreement over the primary schools remained the biggest stumbling block. Jefferson's enemies began to "scatter about the imputation of intrigue." Cabell was accused of being a tool of the Friends of the University. Jefferson, a private citizen, was known to have authored most of the bill.

The Virginia Society of Cincinnati, a heritage group of Revolutionary War veterans and their offspring based in Richmond, met to decide where to donate their funds. The Cincinnati Society was a touchy subject for Jefferson because it was hereditary, and Jefferson had argued vehemently against the formation of an aristocratic military elite in the 1790s.[111] Fittingly, the group was allied with the Federalists. Cabell reminded Jefferson that Presbyterians favored giving Literary Fund money to Washington College and that "the federal members are under strong political prejudices against yourself, whom they justly regard as the parent of the Central College."[112] The preponderance of Federalists in the Society of Cincinnati, in turn, led them to oppose Central College and give their share to Washington College. Jefferson tried in vain to elicit funds from the group himself by promising to endow a professorship in gunnery and fortification to be called the Cincinnati professorship.[113] According to alumni of Washington College, someone was smearing the school's reputation by circulating unfavorable reports.[114] One rumor had it that Jefferson was spreading malicious rumors around about Washington College, in order to prevent Lexington from attaining the state university. The college felt compelled to give the Society of Cincinnati a full-blown report on their state of affairs and history. The Washington College Board of Trustees issued a denial they had mismanaged funds and suffered poor academics.[115]

Jefferson was a likely culprit because of his rivalry for control of education with the Presbyterians who ran Washington College, and because of his dislike of the Society of Cincinnati. In the partisan atmosphere of the 1790s, when Jefferson supported France and Federalists supported England, he called the society the "Samsons in the field and Solomons in the council . . . who have had their heads shorn by the harlot England."[116] Cabell wrote that "the friends of Rockbridge College [Washington College], perceiving the state of things, have profited of it to alienate these persons from Central College, and to draw them into their interests."[117] Washington College already had George Washington's personal endowment. With the Society of Cincinnati gift they ended up receiving in 1824, their assets totaled twenty-five thousand dollars.

Cabell stayed in Richmond during the Christmas holiday strategizing against Federalist and Presbyterian opposition and copying over a revised plan, which he sent to the Committee of Schools and Colleges. Samuel Taylor of Chesterfield sponsored the revised bill in the house of delegates.[118] In the new bill one-third of the fund would be given outright to Central College; the other two-thirds would continue to draw interest to finance the rejuvenated ward schools. If anything, Jefferson's enthusiasm for wards had grown since the 1770s, because the protest against his 1807 Embargo in New England reminded him of the power of grassroots politics.[119] He knew they were impractical in Virginia, however, so tying wards to his plans for elementary schools doomed the schools and kept the money safe for the university.

Cabell worked in the assembly to "to open the eyes of my friends to the designs of the opposition" and check the "backcountry sentiment," which wanted the capital and university moved to Staunton or Lexington.[120] Cabell lamented to Madison that the assembly was so deficient and the "Delegates beyond the Ridge are exceedingly hostile to [Central College] . . . the Presbyterian clergy are very hostile to that seminary. The Federalists view it with a malignant eye. The friends of William and Mary regard it as a future rival."[121]

Jefferson's plan to convert Central College to the university was not adopted in the winter of 1818, but the legislature voted to build a university somewhere.[122] After delegate Hill of King William County introduced a compromise in the house, Cabell engrafted a university on a substitute bill in the senate. The senate passed the Hill Bill, establishing a university, in February. The Hill Bill gave fifteen thousand dollars from the Literary Fund to an unplaced university and forty-five thousand to existing and newly built charity schools in the counties, based on their white populations.[123] Some of that money was for poor children to attend existing private schools.

The 1818 authorization to build a state university was a blow for the former Protestant dissenters of the Piedmont and Shenandoah Valley, and the Episcopalians of eastern Virginia. Though the university and poor schools were given some of the interest on the Literary Fund, no money went to middle-class schools or academies, and none went toward the Presbyterian schools of Washington College and Hampden-Sydney, or Episcopalian William and Mary.[124] In addition, no centralized system of controls was set up over the charity schools.[125] Since the Literary Fund was now up to one and a half million dollars, the sixty-thousand-dollar figure amounted to less than 4 percent of the principal.[126] Federalists gave the bill overwhelming support and Republicans were evenly divided.[127] The Hill Bill did not resolve the location of the university, and the fifteen-thousand-dollar figure was minuscule. Central College was a long way from becoming Virginia's new state university.

Cabell was still upbeat about the support Jefferson enjoyed among Richmond's "liberal men." He wrote, "We have some strong men in the city, but out of the Assembly, in our favor. Judge Roane, Judge Brooke, Col. Nicholas and his brother, the editor of the *Enquirer,* and some others, are in favor of the Central College, and should the question of location come on, will be valuable friends."[128] The cost of building the pavilions was already beginning to outrun the subscription funds of Central College, and Jefferson needed sympathy from the banks the Junto controlled. John Brockenbrough, head of the Bank of Virginia, agreed to a policy of extending Central College's loans from time to time.[129]

Jefferson got more publicly involved in the proceedings, endeavoring to convince a state-appointed commission that Charlottesville and Central College were the logical choice for the new school. One stipulation of the Hill Bill was that

Governor Robert Preston appoint an advisory group to recommend the site and curriculum for the new university. A meeting was scheduled for summer, at a mountain pass called Rockfish Gap, to discuss the new university. The chief rival for the site was Lexington, in the Shenandoah Valley. Washington College saw to it that one of their own, James McDowell, would be appointed to Rockfish Gap to look out for Lexington's interests, while their administration mobilized local citizens.[130]

Just as Jefferson offered Central College to the state, a local whiskey distiller and horse trader named John Robinson promised his entire estate, worth over one hundred thousand dollars, if Lexington was chosen as the site for a university by the legislature.[131] Central College had but two hundred acres and a little over forty thousand dollars. Washington College offered over three thousand acres, fifty-seven slaves, the anticipated donation from the Cincinnati Society, buildings, equipment, and all of the one hundred shares in the James River Company that George Washington donated in his will.[132]

Jefferson enjoyed a political advantage over western interests, though. Eastern Virginians still had the upper hand despite a law that had slightly reapportioned the state senatorial districts.[133] Fifteen of the twenty-four delegates appointed to the Rockfish Board of Commissioners were from the eastern part of Virginia, where Presbyterian influence was weakest. Governor Preston also appointed one of Jefferson's main collaborators on the project, James Madison, to the commission. The partisan board unanimously elected Jefferson as its president.[134]

Of the westerners appointed to the commission, two—Archibald Stuart of Augusta and John Jackson of Harrison—were former neighbors of Jefferson's. A.T. Mason of Loudoun, Hugh Holmes of Frederick, Washington Trueharr of Louisa, and Randolph Harrison of Cumberland were generous donors to Central College who were appointed to the commission.[135] Other members—William Brockenbrough, Creed Taylor, Spencer Roane, and Littleton Tazewell—were aristocratic friends of Jefferson.[136] Cabell wrote that if "liberal men" like Jackson were elected to the next assembly from the northwestern part of the state, "the game would be safe."[137]

Central College's own board met twice in the spring and approved of Jefferson's plans for turning it into the new university.[138] Jefferson appreciated his allies on the state commission, but still concerned himself with "the floating body of doubtful and wavering men" who could spoil his dream. In his written report he therefore threw in "some leading ideas on the benefits of education . . . in the hope these might catch on some crotchets in their mind, and bring them over to us."[139]

Jefferson met with Madison, Cabell, Roane, and John Hartwell Cocke in the days leading up to the August 1 meeting at Rockfish Gap.[140] Jefferson refused an invitation for himself and Madison to spend the night at a friend's in Staunton

(on the way), in order to "avoid not only the reality but the suspicion of intrigue; and be urged to short work by less comfortable settings."[141] But Jefferson met with his key coadjutors ahead of time at Monticello to plan strategy. He hoped "that even this little conciliabulum may be unknown and unsuspected."[142]

The trip to Rockfish Gap to present his case for Charlottesville was the most important event of Jefferson's retirement. As a seventy-five-year-old man, Jefferson had to muster all the will his body and mind could generate to draw up the plans, make the trip, and then get Central College approved as the site of the university. The meeting came in the midst of financial headaches for Jefferson. The U.S. Bank in Richmond was demanding partial repayment on a loan, and the twenty-three thousand dollars he received from the Library of Congress for his personal library did little to ease his burdens. Unbeknownst to his colleagues, he had to borrow one hundred dollars from a Charlottesville bank for the journey to Rockfish.[143]

Jefferson made the trip from Charlottesville on horseback in two stages, along rough roads. Rockfish Gap is a pass nearly two thousand feet above sea level, along the crest of the Blue Ridge Mountains. It is the gateway from the Piedmont into the Shenandoah Valley, straddling eastern and western Virginia, thus its symbolic importance as a meeting spot.[144] Easing Jefferson's obstacles, four commissioners who failed to attend were from a part of the state loyal to William and Mary.[145] Jefferson's old neighbor John Jackson felt that most of the hostility directed at Central College during the meeting was aimed at the "Old Sage," who was regarded by a minority as the cause of their political frustration. But Jefferson won over his audience by holding back, relying on his reputation to sway sentiment toward him among the majority.[146] Jackson wrote that, "Mr. Jefferson did not even intimate a wish at any time or shape except when his name was called & his vote was given."[147]

Jefferson knew that important criteria for the site of the university would be healthiness of the climate, fertility of the surrounding area, and centrality of the white population.[148] He arrived with shameless geographical propaganda inconclusively showing Charlottesville as the center of the white population.[149] Central College won approval for conversion to the university, winning easily over Staunton and Lexington. The victory merely advised that Central College would be the site recommended by the commissioners, but did not insure the legislature would charter Jefferson's school in the upcoming session.

Jefferson's plan for the school's curriculum and design—the Rockfish Gap Report—is the founding literary document of the University of Virginia, even though it mostly updated earlier ideas from the 1779 plan and 1814 letter to Peter Carr.[150] In the report he stated that the purpose of education was to "engraft a new man on the native stock, and improve what in his nature was vicious and

perverse into qualities of virtue and social worth." The plan included provisions for elementary and secondary education, but Jefferson knew the legislature could not afford both a school system and the university described in the report.

After the Rockfish meeting Jefferson contracted a staph infection in the baths at Warm Springs, in the Appalachian Mountains, and had to return home in small intervals by carriage.[151] It took him months to recuperate from the journey, which was the farthest west he ever went.[152] Jefferson wrote of Warm Springs that sometimes "the medicine which makes the sick well, may make the well sick. Those powerful waters produced imposthume [abscesses], general corruption, fever, colliquative sweats, and extreme debility, which aggravated by the torment of the return home over 100 miles of rocks and mountains reduced me to extremity."[153]

After suffering from the Rockfish/Warm Springs trip, Jefferson prepared poorly for the 1818–1819 session, not setting his mind toward strategy until early December.[154] The governor and directors of the Literary Fund tacitly acknowledged the viability of a university by earmarking the fifteen thousand dollars and requesting the Rockfish Gap Report, but the assembly still made no guarantees about adopting Central College as the site. Sectional rivalries generated conflict over the Rockfish Commission's report, and some returning delegates laughed openly at Jefferson's map.[155] Cabell's hopes for the project began to sink. Westerners were angry over the proposed location and many easterners felt William and Mary served their purposes fine already.[156]

Cabell was even sicker than Jefferson during the 1818–1819 session.[157] He spat up blood from ruptured vessels in his lungs during the winter, sometimes on the floor of the legislature.[158] His friends wondered if someone else should be brought in to fight for Central College.[159] Cabell claimed he was "sinking under the subject," but he managed to get his points across to fellow senators in between periods when he could not speak for days.[160] Sick and dejected, Cabell needed help getting votes for Jefferson's proposals.

Friends of the University, such as Francis Walker Gilmer, wrote editorials in the *Enquirer* supporting Central College's adoption. Gilmer, writing under the pseudonym "a Virginian," made the argument that money was leaving the state because its sons went north for college. England was powerful because of education and the university was necessary to safeguard the ideals of the American Revolution.[161] Spencer Roane, "a farmer," made the same argument, complaining about Princeton's religious influence and Yale's pernicious political domination.[162]

A special committee drawn mostly from eastern Virginia was formed to break a deadlock in the house, where the adoption bill for a new university escaped with Central College retained as the site.[163] Jefferson got the word to Cabell not to amend the adoption bill in the senate, otherwise it would be endangered by going

back to the house.[164] Cabell was cautiously optimistic after the tight victory in the house.[165] Cabell's main concern in the senate was with easterners who viewed Central College as a threat to William and Mary. Supporters of William and Mary demanded a bribe of five thousand dollars annually to their school for their support. Cabell's mind "sought far and wide for the means of awakening the eastern people to a just view of their rights."[166]

Committed to education in 1779 as a means of "lay[ing] the axe to the root of pseudo-aristocracy," and in favor of reapportionment, Jefferson had to rely on the malapportioned aristocracy of the Piedmont and Tidewater to get his university secured.[167] Though the original Hill Bill was passed with western Federalist support, eastern representatives were necessary to get the university built in Charlottesville. After five days of "intrigue and cabal" employed against Central College in the house, Briscoe Baldwin of Augusta County made a plea for his fellow opponents to give up the fight.[168] The fate of the bill in the eastern-dominated senate was "easily foreseen" by the *Norfolk & Portsmouth Herald:* "It will glide smoothly thro' that body."[169]

Roane, Nicholas, and Brockenbrough mustered the Junto's influence.[170] Dinner parties were held and swing voters were wined and dined. Finally Cabell was able to "rouse the eastern pride" of numerous politicians after personally searching out every opposed senator east of the Blue Ridge. He used "every exertion of [his] power" to swing their votes against the "enemy beyond the mountain."[171] The key for Cabell was exploiting eastern senators' fears about the growing power of western Virginia.

The University of Virginia was formally chartered in the senate on January 25, 1819.[172] It did not receive any funding beyond the fifteen thousand promised in the Hill Bill of 1818. As promised, the buildings and land of Central College were converted to property of the state's Literary Fund. The new Board of Visitors named by the governor—including Jefferson, Madison, Cabell, Cocke, Breckenridge, and Robert Taylor of Norfolk—were university supporters. He also appointed Chapman Johnson of Augusta, who had fought against Central College, to conciliate the opposition.[173] William and Mary supporters had "sour grapes" about the new university, but Jefferson assured Madison that they had nothing to fear from the "enlightened part of society."[174] Jefferson's biggest concern now was not alternative locations for the university, but the competition for Literary Fund money from elementary school advocates: "If there should be a dearth in the Treasury, there may be danger from the predilection in favor of the popular schools."[175]

It did not take Jefferson and his supporters long to look toward the charity schools as a source of further funding for the university. Jefferson hoped that the unclaimed portion of the forty-five thousand promised the poor could be used to build more pavilions. "Could not the Legislature," he asked, "be induced to give

the University the derelict portions offered to the pauper schools, and not accepted by them? . . . these unclaimed dividends might enable us to complete our buildings, and procure our apparatus, library, etc., which, once done, a moderate annual sum may maintain the institution in action."[176]

Cabell helped get the university charted by attaching a rider to the bill giving an extra twenty thousand dollars to the poor schools.[177] He considered concerns for the poor a "retrograde movement," however, and he was able to get the appropriation repealed before the end of the session. He wrote Jefferson, "we are now happily extricated from an awkward dilemma."[178] The battle over state money was not over, however, and the ensuing six years showed that Cabell and Jefferson were not extricated from the dilemma.

What Jefferson's project did have now was legal footing as the state-sanctioned university. What it lacked was money to build the school and hire professors. Jefferson hoped to see the project through within his lifetime and optimistically began planning the university's opening. In the summer of 1819 Jefferson asked Ritchie to insert advertisements for students in the *Enquirer* at intervals of about a week.[179]

## Conclusion

Forced to choose between primary and higher education, Jefferson acted politically to defeat primary school measures in the late 1810s. When pressed on the topic, he referred to his failed attempts in 1779, just as he referred to his attempts at abolition in 1776 when discussing his later support of slavery.[180] Jefferson thought that public education would arise in the long run without his aid, while this was his only chance to leave an imprint on higher education. With Central College in 1816, Jefferson was unwilling to purchase an adjoining house for a proposed deaf, dumb, and blind school, because the "objects of the two schools are distinct. The one is science; the other, mere charity."[181]

Increasingly, Jefferson viewed the distinction between his university and precollegiate education in the same light, despite protestations to the contrary. The base of the pyramid he envisioned in 1779 and 1814 was a casualty of limited public funding. Four years after the chartering of the university, Jefferson commented to Cabell that, given the choice, he favored spending money on elementary schools rather than a university, but he wrote those words only after further funding for UVA was secured at the primaries' expense.[182] He never admitted it, but he now viewed the different levels of schooling in conflict, rather than in conjunction, with one another. In the meantime Jefferson clung to the hope of local funding for elementaries in the wards, an unworkable idea that rationalized his opposition to Mercer's statewide plan.[183]

In Mercer's view literacy was necessary to *counter* the expanding white franchise advocated by people like Jefferson. Like Jefferson, Mercer thought society could not have one without the other.[184] Jefferson came at the same conclusion from a more optimistic angle. He supported broadening the suffrage, but spoke of education as a means of liberation rather than control. Unfortunately, his and Mercer's views on public education canceled each other out, and nothing substantive was done on the matter until later in the nineteenth century.[185] Just as Madison and Jefferson defeated general assessment in the 1780s partly because of Patrick Henry's promotion to governor, Jefferson and Cabell prevented the establishment of common schools partly because their rival Mercer was elected to the U.S. House of Representatives.

The reason behind Jefferson's favoritism of higher education was not that he ceased believing in the importance of general literacy. If it had been up to him, the state would have built a comprehensive system with all levels. But there was only enough money for one or the other, and the urgency of creating a university in Jefferson's own backyard grew during his retirement. During this period in Virginia's history, Presbyterians and Episcopalians competed openly for the public education funds that Jefferson hoped to monopolize. Like the clergy, Jefferson knew the most direct and immediate impact on society resulted from control of higher education, not elementaries.

Jefferson was also among those diehard Republicans in Virginia who feared the growing power and Northern interests of the federal government. In order to secure the sort of republic he envisioned, Jefferson needed to build a humanist, pro-Southern institution. These worries occupied Jefferson for the six years between the University of Virginia's chartering in 1819 and its opening in 1825.

John Henry Isaac Browere's 1825 bust of Jefferson.
*Courtesy of Fenimore Art Museum, Cooperstown, New York. Photo by Richard Walker.*

# The Philosophy of the Rockfish
# Gap Report

❀

The Rockfish Gap Report established the curriculum of the University of Virginia (UVA). It was controversial because of its humanist values.[1] As an Enlightenment theologian Jefferson advocated the universal, natural God of the philosopher over the interventionist, supernatural God of Jehovah. His plan for UVA emphasized scientific revelation over Scriptural adherence. It was radical for its time because neither the French nor American Revolutions had stripped the power over education away from Christian churches. By the 1820s, chapel was required at all American colleges, public or private, and most schools originated around seminaries or divinity departments. UVA was free of denominational influence, chapel and a professor of theology. In the basement of the Rotunda, the library and centerpiece of the inner lawn, was a small spare room set aside for worship.

The Rockfish Gap Report was a touchstone of conflict among Virginia's leaders. Jefferson hoped to diminish Presbyterian influence in Virginia, and whatever remained of the Episcopalians' influence at William and Mary, by planning and pushing through the Virginia legislature his own "seminary" based on what he called "natural religion." His fear that clerics would control precollegiate education are also why Jefferson preferred plans that would "keep elementary education out of the hands of fanaticising preachers, who in county elections would be universally chosen."[2]

The conflict motivated the elderly Jefferson to resurface publicly as a radical religious thinker. His enemies had worked hard to depict him as an atheist during the campaign of 1800 and in the late 1810s (see chapter 1). But he was only an infidel by the strictest definition of the term—he did not believe in the supernatural elements of Judaism, Christianity, or Islam. He distrusted the miraculous side of

Christ's life altogether and did not adhere to Christ's divinity. Jefferson opposed organized religion, which in his opinion bankrupted the believer morally and intellectually and could led to pure atheism. He hoped to avoid that outcome at UVA by ensconcing the natural world as the basis of religious faith.[3]

Jefferson was a monotheist with faith in a single, benevolent deity whose workings could only be grasped through science. Some theologians were too unsophisticated to discriminate between Jefferson's natural religion and atheism. Other clerical opponents saw natural religion as a slippery slope on the path to atheism. In higher education, it did not provide the moral framework most college administrators needed to keep order.

By 1816, orthodox clergymen and administrators focused their attention on Jefferson, whom they considered the heir apparent to Thomas Paine (1737–1809), the most famous infidel of Revolutionary America. His religion was similar to the deism Paine advocated in *The Age of Reason* (1794). Up until 1816, though, Jefferson's religious infidelity was kept under wraps. He stood fast against religious establishments politically, but kept a private profile as a natural theologian. He was connected to the Christian establishment. He attended Anglican or Episcopalian churches in Washington and Virginia and a Unitarian church in Philadelphia.[4]

Jefferson was not publicly hostile to Christianity, and his philosophy embraced the social benefits of Christ's teachings. He maintained friendships with local ministers and contributed to the Episcopalians financially throughout his life. Many of Jefferson's clerical friends were Anglicans/Episcopalians, or Unitarians like Joseph Priestley and Jared Sparks. He also corresponded with Presbyterians Benjamin Rush and Samuel Miller. But Jefferson avoided any formal allegiances to established churches. To Ezra Stiles, a Congregationalist and natural theologian scientist from Rhode Island, he wrote, "I am of a sect by myself, as far as I know."[5]

President Jefferson maintained his ties to Christianity. He encouraged, but did not demand, national prayers, and he authorized the War Department to fund Presbyterian missionaries among the Cherokee.[6] He also allowed churches to use the Supreme Court and War and Treasury offices for services.[7] He contributed liberally to at least nine churches in and around Washington, and attended services himself at the Episcopalian Christ Church, which met in a tobacco barn near Capitol Hill. (Buildings were scarce during the first years of Washington D.C.) The most irreligious act of Jefferson's presidency was to end George Washington's and John Adams's tradition of proclaiming national fast days and thanksgivings.[8] As president, Jefferson retained popularity among Baptists and Methodists in the early nineteenth century because of his association with religious freedom.[9]

During retirement Jefferson was freer to express himself. Despite being plagued by health problems and debt, he was happy to drop the public religious position he projected as president and engage in an ideological contest he had prepared for for all his adult life. The political volatility of religion sometimes made Jefferson irrational and bigoted, but it also motivated his attempt to integrate reason and faith.[10] Jefferson once told minister Isaac Story he had ceased reading or thinking about religion, instead reposing his head "on that pillow of ignorance which a benevolent Creator has made so soft for us, knowing how much we should be forced to use it."[11] He was merely dodging an exchange with Story, because Jefferson was anything but indifferent toward religion.

His interpretation of the American Revolution was rooted in the Jewish and Puritan traditions of a chosen people acting on behalf of a progressive and benevolent deity.[12] God was Jefferson's basis for the otherwise unintelligible claim of *natural* rights, like civic freedom, land (and human) ownership, and religious liberty. Jefferson struggled with religion and morality all his life, but never arrived at a coherent philosophy. Religion "mesmerized him, enraged him, tantalized him and sometimes inspired him."[13]

Jefferson sent his daughters to a Catholic nunnery in Paris.[14] He found solace in the Anglican mass and he lived briefly in a French monastery.[15] Jefferson believed in the efficacy of prayer and an afterlife, according to his grandson.[16] His most unusual view was pushing materialism to the point that he considered spirit to exist, but consist of physical matter. In other ways Jefferson's ideas were commonplace among Western elites in the eighteenth century, solidly rooted in the Protestant/Enlightenment tradition.

One way to understand Jefferson's thinking on religion is to view him as a natural trajectory of the Protestant Reformation. Protestantism had a strong political tendency toward civil rights because it questioned the theological underpinnings of monarchs and popes.[17] Protestantism encouraged independent thinking about religion through independent reading of Scripture and, by extension, helped encourage scientific research and literacy. In *Notes on the State of Virginia* Jefferson argued that the Reformation unhinged a "spirit of free inquiry, without which the corruptions of Christianity could not have been purged away."[18] When Jefferson wrote that "without priests there would never have been infidels," he was writing in the tradition of Martin Luther.[19] Like many *philosophes* Jefferson held a faith in God and historical progress closely related to that of Protestants.

But for Jefferson the Protestantism brought from England to America in the seventeenth century created more problems for Christianity than "its leaders purged of old ones."[20] Though Calvinism, strictly speaking, was not really the dominant mode of Protestantism in America after the 1740s, Jefferson continued

to use that phrase to characterize his most orthodox Protestant enemies, especially Presbyterians and Congregationalists.[21] Just as Protestants wanted to strip Christianity of superfluous rituals and trappings, Jefferson wanted to streamline Christianity yet further by ridding it of priests and supernatural elements altogether. He wrote about completing the task initiated by Luther and Calvin:

> His [Christ's] doctrines are levelled to the simplest understanding: and it is only by banishing Hierophantic mysteries and Scholastic subtleties, which they have nick-named Christianity, and getting back to the plain and unsophistic precepts of Christ, that we become real Christians. The half reformation of Luther and Calvin did something towards a restoration of his genuine doctrine; the present contest will, I hope, compleet [sic] what they begun, and place us where the evangelists left us.[22]

Jefferson appealed to Protestant sentiment when he appealed to the "plain and unsophistic precepts of Christ." Yet Jefferson believed that Christ was a philosopher of morals only, not a magician or healer. Jefferson even mistakenly suggested that Christ did not claim to be on a divine mission.[23] Despite that, he was more interested in Jesus than in any other religious figure.[24] Jefferson was part of a movement known as Restorationism—a movement to restore the New Testament and Christ's message to their primitive purity. Unlike most Restorationists of the early nineteenth century, Jefferson rejected Christ's divinity.

One of Jefferson's most consuming projects during retirement was his abridgment of the Bible. The catalysts for Jefferson's initial interest in primitive Christianity were his exchanges with Presbyterian Benjamin Rush and the attacks of Federalists and their clerical allies during the 1800 campaign. Political concerns over the University of Virginia rejuvenated his interest after he retired. Jefferson thought that Jesus reformed the superstitious Judaism of Palestine, and he hoped to aid in a similar process in nineteenth-century Virginia. History justified the support of primitive, simple religions. He wrote that "no historical fact is better established than the doctrine that one God, pure and uncompounded, was that of the early ages of Christianity."[25]

Sometime around 1819–1820 Jefferson completed a "wee little book" entitled *The Life and Morals of Jesus of Nazareth* (the Jefferson Bible), where he presented the philosophy of Jesus by stripping all the supernatural elements from the New Testament.[26] He simply cut all the moral teachings of Jesus from the Bible and pasted them onto blank pages.[27] The result was similar to the idea proposed by Benjamin Franklin during the Revolution. Jefferson's friendship with Charles Thomson, a veteran of the Continental Congress (1774–1789), who retired to a life of liberal biblical scholarship, also helped motivate him.[28] In the 1810s he corresponded with a Dutch-born Unitarian minister named Francis Adrian Van der Kemp, whose idea it was to write a secular biography of Jesus.[29]

Gone from the Jefferson Bible were Jesus' virgin birth, his deification, his miraculous powers, his resurrection and visible ascension and presence in the Eucharist and Trinity. Also lacking are original sin, atonement, and regeneration—the underpinnings of Christianity. He wrote, "Abstracting what is really His from the rubbish in which it is buried, easily distinguished by its lustre from the dross of His biographers, and as separable from that as the diamond from the dunghill, we have the outlines of a system of the most sublime morality which has ever fallen from the lips of man."[30] As for his purged Bible, "a more beautiful or precious morsel of ethics I have never seen; it is a document in proof that I am a real Christian, that is to say, a disciple of the doctrines of Jesus."[31] Jefferson saw himself as more Christian than his orthodox enemies.

Most important to him, Christ's profundity as a philosopher did not entitle denominations to political power in the modern age. Jefferson argued in 1776 that we must go beyond John Locke and grant full rights of religious liberty to all, not just inter-Protestant toleration qualified by political restrictions for non-Protestants (see chapter 1). He and James Madison thought advocates of religious monopolies and establishments had no historical grounds to argue that those institutions improved the morals of society. To Jefferson and Madison the result of granting religions political power was a long train of abuses that corrupted both politics and religion and stifled progress.[32] Unlike other colleges at the time, the University of Virginia would not be affiliated with any religious denomination.

Jefferson's position reflected what he learned as an undergraduate at William and Mary in the 1760s. There liberty, rather than conformity, was seen as the path to moral virtue. Democracy and religious freedom were compatible for Jefferson because the clergy represented another artificial form of aristocracy designed to think for the people.[33] The liberal Episcopalians at William and Mary exposed Jefferson to Enlightenment writers who opposed superstitious dogma. These English and Scottish philosophers looked within for moral guidance, instead of to the heavens.

However inspirational Jesus may have been as a philosopher and social reformer, Jefferson intended students at UVA to look within and around them for moral guidance.[34] Two letters to his nephew, Peter Carr, represent his worldly but individualistic moral philosophy. In 1787 Jefferson reminded Carr how important morality was, but in 1814 he advised Carr that one "lost time to attend lectures" for the formal study of ethics.[35] The key for Jefferson was to focus only on universal precepts upon which all religions could agree, and avoid discrepancies in dogma that he saw as unrelated to morality.

Not only did Jefferson reject official impositions of organized religion; he believed that organized Christianity actually inhibited moral development. Ethics could only be attained through self-actualization and observing history and

nature. In 1814 Jefferson wrote that moral foundations lay within and that the vehicle for those foundations was an inborn instinct, not religious coercion.[36] Any infringement constituted a cheapening of the growing process. Jefferson wrote to Adams that the world would be better off without organized religion, but we were prevented from a hellish existence by these moral precepts, "innate in man," which were "part of his physical constitution, as necessary for a social being."[37] God has "taken care to impress its precepts so indelibly on our hearts that they shall not be effaced by the subtleties of our brain."[38] His belief that morality was built into the human brain was similar to German contemporary Immanuel Kant's (1724–1804).[39] Jefferson's moral philosophy connected to politics insofar as organized religion destroyed the sense of independence and responsibility requisite in a republican society.

At the University of Virginia, Jefferson planned to rely on the natural moral sensibilities of the students, and their studies of science and history.[40] He hoped to restore a sense of republican virtue based on competitive individualism free of religious superstition. The Rockfish Gap Report stated that: "we have proposed no professor of divinity . . . proofs of the being of God, the creator, preserver, and supreme ruler of the universe, the author of all the relations of morality, and of the laws and obligations these infer, will be within the province of the professor of ethics . . . "[41] The function of philosophy for Jefferson was to generate harmony in society.[42]

Jefferson hoped to convince UVA students that the working of government, economics, and morality was grounded on models found in nature.[43] Like his earlier plans for education, Jefferson also hoped to stress history, along with science, to help provide moral instruction. He wanted to use history selectively to support his own views while not letting it impede forward-looking, progressive attitudes on the part of students. In the Rockfish Gap Report Jefferson cautions that the factor responsible for the "barbarism and wretchedness of our indigenous neighbors [Indians]" was a "veneration for the supposed superlative wisdom of their fathers and the preposterous idea that they are to look backward for better things and not forward."[44]

On the other hand, looking backward was a convenient way for Jefferson to support his political and religious views. History could be used, for instance, to undermine religious dogmatism. Jefferson enlisted his friend Madison to compile a large and comprehensive list of theological works dating from the first centuries of the Christian era, requesting works of both pagan and Christian writers.[45] Madison's topics ranged from original sin, deism, natural theology, Moravians, and Quakers to the Catholic Council of Trent; his authors included Aquinas, Leibniz, Luther, Calvin, Newton, and Penn.[46]

Madison concurred that broadening the students' exposure to religion was important, and agreed there should be no divinity chair at the university. He con-

sidered such a chair a direct violation of his 1776 Virginia Declaration of Rights and 1786 Statute for Religious Freedom. Madison preferred overcoming short-term charges of irreligion to allowing any sect to monopolize the teaching of religion. That alternative would have insured "an arena of theological gladiators."[47]

The curriculum Jefferson drew up in the Rockfish Gap Report was heavily weighted toward the physical sciences. He promoted the French physiocrats, who shared his dream of an agrarian utopia and hoped to use mathematics, rather than religion, to structure society and solve its problems. The most compelling part of physiocratic theory for Jefferson was sensationalist philosophy, which argued that the human brain can be comprehended entirely (and exclusively) through the study of its chemistry. He was interested in a sensationalist named P.J.G. Cabanis, Monsieur Flourens.[48] Jefferson met Cabanis in Auteuil before the French Revolution, at the salon of Madame Helvétius. Cabanis indoctrinated him into positivism, the theory that all true knowledge is based on natural phenomena and their properties, and relations verified by the empirical sciences.[49] Cabanis argued that thoughts and emotions are entirely chemical in *Rapports du physique et du moral de l'homme* (1802).[50]

Cabanis sent the book to his friend during Jefferson's presidency. Ten years later, Jefferson still referred to the book as the "most profound of all human compositions."[51] In an 1820 letter to Adams, Jefferson spelled out his position:

> On the basis of sensation, of matter and motion, we may erect the fabric of all the certainties we can have or need. I can conceive thought to be an action of a particular organisation of matter . . . to say that the human soul, angels, god, are immaterial, is to say they are nothings, or that there is no god, no angels, no soul . . . At what age of the Christian church this heresy of immaterialism, this masked atheism, crept in, I do not know. But a heresy it certainly is. Jesus taught nothing of it. He told us indeed that 'God is a spirit,' but he has not defined what a spirit is, nor said that it is not matter.[52]

Jefferson's God was physical and alive in nature.[53] He did not hold that God created the world and then retired from the scene, as did many deists in the seventeenth and eighteenth centuries. Jefferson believed that God continued to create and sustain the world moment by moment. At one point Jefferson even hoped to subsume the University of Virginia's departments of ideology (English, rhetoric, and fine arts) and government under the heading of zoology. Zoology, in turn, would be divided into the physical and the moral. Jefferson was certain "the faculty of thought belongs to animal history, is an important part of it, and should there find its place."[54]

Jefferson never subsumed the study of humans under zoology at the University of Virginia, but he hired John Patton Emmet on the faculty. Emmet, the son of an Irish political rebel named Thomas Addis Emmet, was the most promising sensationalist in America. In 1822 he received a medical degree from New York

University with a dissertation called "An Essay on the Chemistry of Animated Matter."[55] Emmet was unable to find work for three years, primarily because he argued that the proximate cause of all organic formation is chemical affinity. By not accounting for an ultimate cause, or "vital [theistic] principle," He outraged the profession and was accused of heresy. The *American Medical Recorder* condemned Emmet as a materialist and infidel. It was the last time anyone challenged the vital principle in print until 1844, but Emmet found employment at Jefferson's university in 1825 as a professor of chemistry and *materia medica* (medicine).[56]

The Rockfish report's divisions and spirit are similar to those at the University of Paris.[57] Science would further the comprehension of God and inborn morality through the study of what we now call neurology. Proficiency in Latin, a prerequisite for admission, allowed for the reading of classics and aided in the study of medicine. Hebrew was offered as well, presumably to encourage biblical criticism. The breakdown of the report's curriculum was as follows:

1. Ancient languages—Latin, Greek, Hebrew

2. Modern languages—French, Spanish, Italian, German, Anglo-Saxon

3. Mathematics, pure—Algebra, Fluxions, Geometry (elementary, transcendental), Architecture (military, naval)

4. Physico-Mathematics—Mechanics, Statics, Dynamics, Pneumatics, Accoustics, Optics, Astronomy, Geography

5. Physics, or Natural Philosophy—Chemistry, Mineralogy

6. Botany—Zoology

7. Anatomy—Medicine

8. Government—Political Economy, Law of Nature and Nations, History (being interwoven with politics and law)

9. Law—Municipal

10. Ideology—General Grammar, Ethics, Rhetoric, Belles Lettres, and the fine arts[58]

Scientific inquiry, in the tradition of Francis Bacon, was the cornerstone of Jefferson's vision for the University of Virginia, just as he predicted in *Notes on the State of Virginia*.[59] Natural religion was the way out of the sectarian warfare that plagued mankind throughout history and was also democratic: "The planet, still warm from the creative touch of God, spoke the language of a natural religion equally accessible, equally comprehensible to all."[60]

But Jefferson was on guard against letting materialism degenerate into atheism at the University of Virginia. His plan was to implement the philosophy most typical of early nineteenth-century colleges, including those of the Presbyterians:

the Scottish Common Sense school. Common Sense, or realist philosophy, re-
acted against skepticism about the limits of human knowledge by embracing the
moderate Enlightenment vision of a rational and perceptible order.[61] Just as em-
piricists try to mitigate the postmodern assault on knowability today, so too
eighteenth-century pragmatists struggled against the disillusionment of skeptics
like David Hume. Common Sense was likewise a philosophy that promoted
Jefferson's sense of inborn morality.

Jefferson hoped to use Common Sense Scot Dugald Stewart to recruit fac-
ulty for his university in Scotland. Stewart's pragmatism was the kind of philo-
sophy that Jefferson valued.[62] Jefferson preferred anyone who studied in Edin-
burgh over Oxford and Cambridge, since the latter schools practiced more
metaphysical and less empirical philosophy at that time, and both were con-
trolled by Anglicans.[63]

Jefferson feared the Presbyterians and Episcopalians in Virginia more than
the Anglicans of Oxford and Cambridge. The Presbyterians were the foil against
which he wrote the Rockfish Gap Report. The Presbyterian Confession of Faith
stressed the Holy Trinity and original sin, two of Jefferson's least favorite things
about Christianity.[64] He hated the Calvinist roots of Presbyterianism, its strong
denominational pride and, most of all, the aggressive ministries that challenged
his ideological leadership in Virginia.

Jefferson never disapproved of Baptist or Methodist emotionalism, partly be-
cause of his political alliance with those groups, but also because his main gripe
with organized religion was its obsession with intricate theologies. Given
Jefferson's love of the classics, one might expect he blamed Christianity for eradi-
cating Greek and Roman philosophy, but the opposite is true. Jefferson blamed
interest in Plato and the Greeks among medieval monks for ruining primitive
Christianity. Monks and early Calvinists engrafted abstract absurdities and com-
plicated suppositions onto Christ's message.[65]

For Jefferson, Presbyterians carried on this tradition by emphasizing a power-
ful, anthropomorphic God. Presbyterians were Trinitarians, worshipping God as
three entities—the Father, Son, and Holy Ghost, as prescribed in Matthew 28:19.
Jefferson saw the Trinity as an unfortunate throwback to the polytheism of the
ancient world.[66] One big influence Unitarian chemist Joseph Priestley had on him
was the rejection of Trinitarianism.[67] Like Priestley, Jefferson thought the Trinity
was a "metaphysical insanity" that represented a "relapse into polytheism,"
contradicted the teachings of Christ, and differed from pagan superstitions "only
by being more unintelligible."[68] The Trinity typified "its [Calvinism's] basis of
impenetrable darkness."[69] Jefferson lamented that over such concerns Christians
have "tortured one another for abstractions which no one of them understand,
and which are indeed beyond the comprehension of the human mind."[70]

The Presbyterians' doctrine of human depravity conflicted with Jefferson's

philosophy. He wrote to Adams that Calvin's God "is not the God whom you and I acknowledge and adore, the Creator and benevolent governor of the world; but a demon of malignant spirit. It would be more pardonable to believe in no God at all, than to blaspheme Him by the atrocious attributes of Calvin."[71] It was the "absurdity" of these points "and the impossibility of defending them" that left the Presbyterians "irritable and prone to denunciation."[72] Formulas like the Trinity and original sin, Christianity's "own fatal invention," have been its ruin and turned Christendom into a "slaughter-house."[73]

The Presbyterians' strong emphasis on denominationalism conflicted with the ecumenicalism Jefferson hoped to foster at the University of Virginia. Jefferson put his political theology in succinct terms to Jewish correspondent Joseph Marx: "divided we stand, united we fall."[74] Referring to Jesus, he said, "no doctrines of his lead to schism."[75] While Jefferson labored to rewrite the New Testament, he continued to attend interdenominational church services, riding into town on horseback carrying a small folding chair of his own invention. He described these services in a letter: "The court house is our common temple. Here Episcopalian and Presbyterian, Methodist and Baptist, meet together, join in hymning their Maker, listen with attention and devotion to each other's preachers and all mix in society in perfect harmony. It is not so in the districts where Presbyterianism prevails undividedly."[76]

The role of the Presbyterian ministry threatened the notion of freedom Jefferson saw as critical to republicanism. Civic freedoms were jeopardized by priests abetting monarchical abuses (Federalists) in return for protection of their own.[77] Jefferson thought "religion a concern purely between our God and our consciences, for which we were accountable to him, and not to the priests."[78] He disliked the learned clergy for drawing their dogmas from what Christ "never said or saw," and for creating a religion that would be unrecognizable to Christ.[79] Jefferson believed that ministers merely perpetuated heresies to keep themselves in business.

When Timothy Pickering of Massachusetts warned him of the evil effect of his views, he shot back, "Had there never been a Commentator [minister], there never would have been an infidel."[80] Jefferson thought his experiences as a politician gave him insight into the chicanery behind the priesthood:

> They [politicians and lawyers] live by the zeal they can kindle, and the schisms they create. It is contest of opinion in politics as well as religion which makes us take great interest in them, and bestow our money liberally on those who furnish aliment to our appetite. The mild and simple principles of the Christian philosophy would produce too much calm, too much regularity of good, to extract from its disciples a support for a numerous priesthood, were they not to sophisticate it, ramify it, split hairs, and twist its text till they cover the divine morality of its author with mysteries, and require a priesthood to explain them. The Quakers seem to have discovered this. They have no priests, therefore no schisms.[81]

Presbyterianism manifested the negative traits Jefferson associated with religion—an aggressive ministry willing to involve themselves politically and theological roots in Calvinism. Presbyterians also constituted the greatest threat to Jefferson's vision, since education in Virginia was largely in their hands.[82] Moreover, the popularity of Christianity was booming in the United States, more so than when Jefferson was a student at William and Mary in the 1760s.

Between 1802 and 1815, major evangelical awakenings occurred at campuses such as Yale, Williams, Middlebury, Princeton, and Dartmouth.[83] Timothy Dwight, president of Congregationalist Yale, was influential nationally as a critic of Jefferson's religion. Princeton's seminary, opened in 1812, became the stronghold for Presbyterianism during the remainder of the century.[84]

Hampden-Sydney and Washington College extended Princeton's Presbyterian influence into Virginia. Both schools actively opposed Jefferson and pursued state funding. If Jefferson's plans for the University of Virginia had been implemented in the early 1790s, when natural religion was fashionable among America's elite, he would have had an easier task. Instead, his presidency delayed his vision until the popular currents flowed against him.

Observers from out of state were aware of the Christian monopoly on education in Virginia and elsewhere. The *North American Review* noticed the revolutionary character of the Rockfish Gap Report in 1820 and commented upon it favorably, but pessimistically. Edward Everett wrote that the journal's readers would be gratified to view portions of the report since this was the "first instance, in the world, of a university without any such [orthodox religious] provision."[85] Others had tried to implement nondenominational curriculums before, but Jefferson had few successful precedents for his project in American or Europe.

Universities in Holland were torn between the teachings of medieval theologian Thomas Aquinas and Enlightenment philosopher René Descartes in the 1650s, but Descartes was a Jesuit.[86] The University of Leiden came the closest of any college in Western society to advocating free thought.[87] It supplied preachers but was not affiliated with any Christian denomination. Some American schools at least shared power among Protestant denominations. King's College in New York City was nonsectarian on paper, but originally controlled by Anglicans. During the American Revolution King's College relaxed its denominationalism to placate Presbyterians, but never advocated an openly secular curriculum.[88] It was reorganized into Columbia University in 1784 by the New York legislature and put under the control of the board of regents of the State University of New York.[89]

In the 1750s Benjamin Franklin had the idea nearest to what Jefferson later advocated. The Franklin Academy, which later grew into the College of Philadelphia, started nonsectarian but its lay board was beset by rivalries between Presbyterians and Anglicans.[90] In 1776, it was rechartered by Presbyterians, who

broadened its curriculum and renamed it the University of Pennsylvania.[91] Colleges that tried to establish a nonsectarian grounding in the upper South became hotbeds of controversy.

The University of North Carolina began as a nondenominational college in 1795, but early in the nineteenth century Presbyterians took over its board and faculty.[92] Federalist professor William R. Davie and the school's president, fellow alleged infidel David Kerr, were both run out of Chapel Hill by hostile Protestants who, in conjunction with the 1800 legislature, cut off funding to the school for five years.[93] Presbyterian Joseph Caldwell, a graduate of Princeton, served as president from 1804 to 1812 and from 1817 to 1835.[94] As late as 1900 the university was bitterly attacked by Dr. John C. Kilgo as a Jeffersonian organ of infidelity, despite the fact that North Carolina predated the University of Virginia by thirty years and was overtaken by Presbyterians. Kilgo was president of Trinity College, a Methodist school that became Duke University.[95]

Denominations struggled with religious libertarians in the western part of Virginia (present-day Kentucky). Transylvania University, in Lexington, was the beacon of Enlightenment philosophy on the frontier at intermittent periods in the late eighteenth and early nineteenth centuries.[96] It was founded as a seminary by Presbyterian David Rice. At the urging of board member John Breckenridge, who was in turn encouraged by Jefferson, an English Unitarian and democrat named Harry Toulmin was elected Transylvania's president in 1794. In 1796 Presbyterian trustees ousted Toulmin from office.[97] By the time Jefferson initiated his plans for UVA, Presbyterians were engaged in a fight for control of Transylvania with liberals and Republican critics who identified Presbyterians with Northern Federalism.[98] A liberal Unitarian minister from Boston named Horace Holley served as president from 1818 to 1827, but after 1830 Christians of mainstream denominations (Presbyterian, Baptist, and Episcopalian) shared control of the school.[99]

Jefferson admired Transylvania in its original form, but by 1815 regarded the University of Pennsylvania as the best college in the United States. His goal was to improve on Penn and set up an institution that taught humanism and supported denominational pluralism.[100]

## Conclusion

Jefferson was famous (or infamous) by the 1810s for his 1786 Virginia Statute and his later metaphor that the First Amendment erected a "wall of separation" between church and state.[101] However, the fact that the phrase came from a letter he wrote to grateful Baptists in New England is telling. Whatever positive image Jefferson enjoyed as an apostle of religious freedom did not result from his own

radical views, but rather from the success of dissenting faiths like the Baptists, Methodists, and Presbyterians, who allied with him during the Revolution.

The very rise of those denominations led to a decline in Jefferson's reputation as the nineteenth century wore on. In the case of North Carolina, that state's legislature (run by Jefferson's own Democratic-Republicans) cut off the endowment in response to the university's alleged infidelity.[102] Jefferson's plan would also be subject to the whims of a state legislature, and the clergy from whom politicians took cues. These were the same clergy whom Jefferson claimed were "pant[ing] to reestablish the Holy Inquisition."[103] The chartering of the University of Virginia in 1819 thus commenced a bitter debate over its curriculum.

# Christian Opposition to UVA

❀

After the 1818 publication of Jefferson's plan for the University of Virginia, Presbyterians and Episcopalians attacked it from their pulpits and presses. Their place in Virginia's society was at stake. Christianity's role in running colleges was taken for granted throughout Western civilization, even France, where anticlericalism had helped fuel its revolution. Without strong colleges, it was impossible for Christians to retain their legitimacy in the elite circles they strove to be part of and affect, so they embraced learning. Theologians also wanted to maintain literacy among their missionaries. Jefferson, in turn, recognized Christianity as the primary alternative to humanism in postrevolutionary America. His philosophy was based on religious faith as well, but more rooted in nature and science than the Judeo-Christian God. Whoever controlled the curriculum of local colleges would influence the ideology of Virginia's elite; to "poison or nourish the stream at the fountain," as Episcopalian Francis Lister Hawks later wrote.[1]

The First Amendment of the Federal Constitution offered no protection from infringements on religious rights or liberties within the respective states until the 1940s. Jefferson's university was founded when higher education was a primary battleground between Virginia's clergy and defenders of the state's 1786 Statute for Religious Freedom. The Presbyterian and Episcopalian Churches of Virginia ran presses, organized significant blocks of voters, and were willing to fight for control of public education funding. For them religious freedom was not defined as a wall of separation between church and state, but rather as the equal right of all denominations to use the levers of democracy to fight for their interests.

Jefferson's key ally in the fight to disestablish the Episcopalian (formerly Anglican) Church during the 1780s, the Presbyterians, dominated higher education in the region. Graduates of Presbyterian Princeton built an educational empire that included New Jersey, Pennsylvania, Virginia, and Kentucky.[2] Presbyterian influence fanned out from Princeton and their national headquarters in Philadelphia,

and included satellite colleges in Virginia such as Hampden-Sydney (formerly Prince Edward Academy) and Washington College (previously Augusta Academy and Liberty Hall and later Washington and Lee University) at Lexington.[3]

Presbyterians wanted to influence the powerful, to "reach to the magistrate on his chair of state, to the judge, the bench, to the legislator in his hall."[4] Although very few men attended college at the time (around one percent), the ones who did exercised disproportionate power in society, serving as lawyers, merchants, politicians, and ministers. Presbyterians and Jefferson shared a commitment to education in Virginia, but there was no agreement on who should control it, and the denominations themselves were divided. The consensus among leaders forged by the struggle with Britain had long since evaporated.

During the Revolution Jefferson shared with Protestants a common belief not only in education and religious liberty, but also in the restorative power of the French Revolution to bring about a pure and primitive social order.[5] Although Protestants emphasized the role of God in this restoration, while Jefferson emphasized the role of man, they shared a sense of inevitable progress brought about by reason. To Enlightenment thinkers, who often mixed democratic politics and Protestantism, monarchies and Catholicism were twin pillars of tyranny.[6] English Puritans and French Huguenots (Protestants) viewed the Roman Catholic Church as the "embodiment of the [Satanic] Beast."[7]

Protestants viewed religious liberty in tandem with political liberty, and promoted education as the key to checking monarchical and spiritual tyranny. In 1793, Presbyterian Samuel Miller delivered a sermon to the Tammany Society in New York City declaring that the French Revolution, however "sullied by irreligion and vice . . . [was] fundamentally Christian . . . a great link in the chain, that is drawing on the reign of universal harmony and peace."[8] Aside from his distaste for monarchies, Jefferson shared an admiration for philosopher John Locke with many Protestants. Presbyterian Benjamin Rush, a revolutionary and student of John Witherspoon's at Princeton, believed in the Lockean malleability of citizens, calling for education as a way to shape them into "republican machines."[9]

But in the 1790s Protestants lost their enthusiasm for Revolutionary France because of its radicalism, anticlericalism, and war with England, which was still seen as the mother country. Upending monarchies and Catholics was good, but not if atheists were tying priests to rocks and tossing them in the Seine River. In America, the Whiskey Rebellion in western Pennsylvania (a tax revolt against Washington's federal government) also alerted many to the dangers of too much democracy. The common thread between Protestants and humanist democrats like Jefferson frayed in the second half of the 1790s, as the conflict in France whipsawed American politics.

Another concern for Protestants was the deism of Thomas Paine, whose *Age of Reason* became popular on college campuses throughout the United States in

the late 1790s.[10] Paine was popular at the colonial colleges originally established as religious seminaries. Virginia Episcopalian William Meade wrote that "at the end of the century the College of William and Mary was regarded as the hotbed of infidelity and of the wild politics of France."[11] In Chapel Hill, North Carolina, Presbyterian math professor Joseph Caldwell complained "everyone believes that the first step which he ought to take to rise into respectability is to disavow as often [and] as publicly as he can all regard for the leading doctrines of the scriptures."[12] After 1800 the momentum shifted back to Christian orthodoxy and American campuses experienced a backlash among both faculty and students against liberal philosophy. Protestants valued education and viewed religious and political liberty in tandem, but also used orthodox Christianity to check the excesses of political liberty and Enlightenment philosophy. New England minister and Yale President Timothy Dwight wrote that "without religion, we would retain freedom . . . but only the freedom of savages, bears and wolves." For Dwight, religion and liberty were the "meat and drink of the body politic . . . withdraw one of them, and [the other] languishes, consumes and dies."[13] Protestants feared Paine's and Jefferson's religions would separate Dwight's "meat from the drink," unraveling the delicate balance between liberty and order. After colleges managed to snuff out Paine's popularity during the revival of evangelical Christianity around the turn of the nineteenth century, Jefferson was the foremost public symbol of the old discredited radicalism.[14] For Jefferson religious freedom was fundamental to civic freedom, not civic order.

Jefferson's denial of Christ's divinity, along with his lifelong callousness toward ministers, got him in trouble with the intellectualized Protestant denominations in Virginia. They were in direct competition with Jefferson for the attention of the elite. He got along better with the more unabashedly evangelical faiths. Many Baptists and Methodists appreciated Jefferson's struggles on behalf of religious liberty. Most whites on the frontier, and the majority of slaves, were not affiliated with any Christian church in the 1810s. Those who were were usually evangelicals more concerned with repentance and rebirth than with institution-building and political influence.[15]

Presbyterian Samuel Stanhope Smith, president of Princeton from 1795 to 1812, wrote that the "Baptists and Methodists content themselves with other kinds of illumination than are afforded by human science."[16] When American Methodist Francis Asbury attempted to found a college, the denomination's English founder, John Wesley, lashed out at him in a letter for his worldly concerns, and for being overly ambitious.[17] Baptists and Methodists, the most popular denominations by this period in Virginia and farther west, were not active in college-building until after 1830.[18]

Even though Jefferson fought organized Presbyterians and Episcopalians as opposed to Baptists and Methodists, his opponents were still more evangelical

than seventeenth-century Calvinists or eighteenth-century Anglicans. On the frontier, Presbyterian ministers cooperated with Baptists and Methodists in developing revivalist techniques for mass conversions.[19] Some Presbyterians rejected their Calvinist roots by denying the "elect of God."[20] Instead they embraced the universal and democratic doctrine that Christ died for all men.[21] Emphases on universal salvation and emotional preaching did not sit well with more formal Presbyterians, including some church elders.[22] The Presbyterians contained within their own ranks many of the schisms that had divided Protestantism since the Reformation. Presbyterians in Virginia, Pennsylvania, and Kentucky argued over universal salvation versus predestination, the merits of the emotional revival method, reason, slavery, music during service, baptisms, and the role of the ministry.[23] Consequently, Jefferson and his university allies did not face unified fronts on religion, even from within single denominations like the Presbyterians or Episcopalians.

Rifts within each denomination were matched by tension between Presbyterians and Episcopalians. The churches were in direct competition for the learned and influential classes of Virginia, and animosity existed between their leaders. In the minds of most Presbyterians, the Episcopal Church still retained too many vestiges of Catholicism in its services, and had not gone far enough after setting out on "true evangelical principles."[24] There was also residual animosity from the revolutionary period. The Anglican Church was dismantled in all the Southern states after 1776, but its parishioners organized as the American Protestant Episcopal Church in 1785. The Presbyterians were among the dissenting Protestants who had railed against the Anglican establishment and who encouraged Virginia's public appropriation of Episcopal land. In 1802 the Episcopal Church was forced to forfeit its property at the behest of Protestant dissenters, leaving it only with its churches and graveyards as capital.[25]

The motivating factor for both churches to attain educational influence was straightforward. Most people on the frontier were young, and they would shape the future. Evangelical Christianity, with its straightforward, emotional style, was the best way to appeal to young and old alike. Even the Episcopal Church of Virginia, once a bastion of rationality and gentlemanly behavior, embraced the new, revivalist Protestantism in the 1810s.[26]

The Episcopalians who ran William and Mary were considered cold and overly rational by some evangelicals because they reconciled moderate Enlightenment philosophy with Christianity.[27] William Meade, who became the most powerful force in the Episcopal Church during the first quarter of the nineteenth century, favored taking the church and William and Mary in an evangelical direction. Meade, Bishop James Madison (a holdover from the Enlightenment era at William and Mary), and others revived the Diocese of Virginia by incorporating threads of Baptist, Methodist, and Presbyterian theology. Predestination

was stricken out of the new articles drawn up by the resuscitated Church.[28] They rejected the exclusivity of the church, relaxed some of its formalities, trained itinerant (traveling) ministers, and encouraged home worship in the evangelical style.[29]

After the death of Bishop Madison in 1812, William and Mary and the Episcopalian Church rejected the tolerance, or latitudinarianism, of the colonial Anglicanism on which Jefferson was raised. Episcopalians came out against worldly amusements such as gambling, dancing, and drinking.[30] Spearheaded by Meade, Episcopalians opposed Jefferson's university, both because of their newfound evangelism and the natural threat UVA posed to William and Mary's preeminence. Episcopalian and Presbyterian educators were trying to hold the center between the outright anti-intellectualism of the Baptists and Methodists, and the unstructured natural religion of Jefferson's proposed university.

The Episcopalian and Presbyterian churches catered to the elites of eastern Virginia, but also needed young ministers on the frontier, where emotional revivals predominated. The urgent need for ministers made both denominations anxious to attain state chartering and public money to fund their seminaries. Their mission was to propagate their faiths among both Indians and young whites. Their needs increased exponentially along with American expansion. Unlike the Methodists and Baptists, the Episcopalians and Presbyterians required their ministers to be college graduates. That trait was a strength in Scotland and England, lending their ministers a certain credibility, but it made it difficult for American denominations to keep up with demand along the frontier.[31] Presbyterian minister Samuel Wilson warned fellow clergyman William H. Foote to expect "regions of darkness" even in the northern neck and Piedmont of Virginia.[32]

Lack of ministers was the primary problem facing Presbyterian churches, and it was partially a result of their own successes at generating more congregations.[33] Aside from this expansion, shortages resulted from competition with other sects. It was not enough merely to print pamphlets and spread the written word on a mostly illiterate frontier. Presbyterians like John D. Blair hoped to send ministers along with the waves of emigrants leaving Virginia. As president of the Board of Education for the Presbyterian Synod of Virginia, Blair told his ministers: "Your sons and daughters are going by the hundreds and thousands to fix their habitations in the fertile plains of Alabama and Missouri, and they call on you who gave them the means of a better life."[34]

Presbyterians lacked manpower in the Piedmont and Tidewater of central and eastern Virginia as well. On occasion even Unitarians filled vacancies in Richmond's Presbyterian churches.[35] Jefferson's own experience of informal interdenominational services in Charlottesville was probably typical of Virginia in the early national era, but not a satisfactory solution for Presbyterians. Even

among people already converted to their church, the Presbyterians had around five hundred preachers nationally to minister to nearly nine hundred congregations in 1816.[36]

In 1817 Jefferson's educational advocate in the legislature, Joseph Cabell, warned that, "in the Presbyterian sect . . . we have a more silent, but a more formidable foe [than the Federalists, their political rivals]." Cabell was "confident that the leading members of that sect look with a scowling eye on the rising prospects of the [university] and will use their whole influence against all our efforts to advance its interests . . . the pretext for opposition . . . is that you are an infidel yourself and will cause your opinions to be introduced into the institution."[37]

Cabell liked to inflate the opposition's strength in order to lower Jefferson's expectations. In truth, the Presbyterians exercised only a portion of their influence fighting Jefferson, because he was not their main concern.[38] They drained most of their energy and resources training ministers for the frontier and teachers for all levels of schooling. Presbyterians struggled to minister to the settlers flooding over the Appalachians and to convert Indians, all the while quelling dissension within their own ranks. The effect of the Protestant Great Awakening created a need for ministers that institutional churches could not match. Consequently, the Presbyterian agenda was splintered at the same time that Jefferson narrowed his own, dropping his advocacy of primary schools and focusing on the University of Virginia after 1816.

The proliferation of the Presbyterians' responsibilities did not prevent them from challenging Jefferson, though, or from competing for state funds. The pressing need for ministers and money drove them further into politics and conflict with Jefferson. What made the Presbyterians so formidable politically was their high level of organization. Even without concentrating all their resources on opposing UVA, Cabell was right that Presbyterians constituted the biggest threat to Jefferson's educational plans. Jefferson knew that Presbyterians and Episcopalians enjoyed intellectual and moral influence out of proportion to their numbers in Virginia, and he wanted to check the threats their denominations posed to his vision of higher education.

The Presbyterian Church's general assembly was headquartered in Philadelphia, but its influenced radiated out in a network of around a dozen synods and sixty presbyteries.[39] In 1819 the assembly established a board of education for "poor and pious" youth and directed that subsidiary societies be created at the presbyterial and synodical level.[40] The formation of the Board of Education coincided with the economic Panic of 1819. At their general assembly meeting in 1819, Presbyterian leaders concluded that "the spirit of corrupt and mischievous speculation, which is probably to be regarded as both a cause and an effect of these embarrassments, would best be remedied through holy religion."[41]

Virginians were sometimes unable to attend annual meetings in Philadelphia, but the presbyteries in Lexington, Winchester, and Hanover supported educational societies. A general board of education was established in Richmond, which reported to Philadelphia periodically. The board's impact was slow to materialize, but they did manage enough money to subsidize the educations of a few poor students.[42] Presbyterians also supplied many of the state's teachers at private academies.

In 1816 the Presbyterians in Virginia wanted to incorporate what became Union Theological Seminary and elicit state funding, but failed because of the 1786 Virginia Statute for Religious Freedom. Jefferson, meanwhile, predicated the plans for his University of Virginia on the freedom that bill engendered. After the publication of Jefferson's plan for the university—the Rockfish Gap Report—the debate between Jefferson and the Virginia clergy began to heat up. Scotch-Irish Presbyterians in Lexington and Staunton wanted to lure the state capital and university west of the mountains, and had the support of Episcopalian Federalist Charles Fenton Mercer (see chapter 2).[43] Cabell complained that the "friends of Washington College hang upon our flanks, and encumber every step of progress. If that pitiful place were not in existence we could get along, but it is."[44]

The leader of Presbyterianism in Virginia during the 1810s was John Holt Rice (1777–1831), the grandson of Transylvania University's founder, Kentuckian David Rice.[45] John Holt Rice was a graduate of well-respected New London Academy in Bedford County, Virginia (founded 1795). In 1807, Rice started a Presbyterian seminary at Hampden-Sydney that grew into Union Theological Seminary, which moved to Richmond in 1897. He had strong political instincts and a missionary zeal for education, institution building, and publishing.

Rice thought religion was a unifying force and was necessary to the survival of civil government and society.[46] He felt that without being reminded of their human depravity, college boys would lack the spur toward moral discipline that organized religion provided. Rice was centrally located in Richmond and occupied himself preaching at the Old Time Apple Church (which was nondenominational), founding the First Presbyterian Church, and publishing pamphlets and newspaper editorials prolifically.[47] He hated Jefferson, and Jefferson returned the sentiment. Jefferson disliked Presbyterian ministers generally, and Rice constituted a roadblock to his plans for the University of Virginia.

Rice was founder and editor of *The Virginia Evangelical and Literary Magazine* (originally *The Christian Monitor*), which went to nearly one thousand subscribers annually from 1816 to 1827.[48] It was the most successful Southern magazine of its kind before the *Southern Literary Messenger,* lasting eleven years promoting American literature and opposing slavery.[49] Rice exercised his influence against Jefferson's university partly through his connections in politics, but mainly through the power of his press.

John Holt Rice (1771–1831).
*Courtesy of Union Theological Seminary
and Presbyterian School of Christian Education.*

Jefferson and Rice conflicted on the definition and degree of religious liberty, but were both against a single denominational establishment. Rice never wanted to establish the Presbyterian Church with the government in the traditional way of the colonial Anglicans. He considered the "two kinds of government [civil and ecclesiastical] altogether independent of each other," but did not agree with treating churches as legal "nonentities," which they arguably were under Virginia's 1786 statute.[50] Rice wanted a religious presence at the University of Virginia, but claimed publicly to support an ecumenical environment, permitting all denominations, including Jews and Catholics, to endow professorships.[51] Jefferson understood that Presbyterian privilege at UVA would antagonize competing denominations, and that the Presbyterians' real goal was domination of the school.

Along with Timothy Dwight at Yale, Samuel Stanhope Smith at Princeton and other late Enlightenment ministers, Rice struggled to find the right balance between reason and faith.[52] Before the rise of evolutionary biology and geology, theologians like Rice enthusiastically endorsed science. Scotch-Irish Presbyterians encouraged the readings of astronomer Isaac Newton and chemist Joseph Priestley at Washington College, for instance.[53] Harvard and Yale, both begun as religious seminaries, were centers of science. Clergymen supported science because they were confidant it would substantiate biblical revelation; any admission otherwise would have damaged the intellectual credibility of their faith.

Rice wrote that "science, or Philosophy, or knowledge . . . though it may now explode as a mine of gunpowder beneath our feet . . . will at another time remove some cumbrous obstruction."[54] Like Jefferson, Rice located the scientific revolution within the broader revolt of Protestantism: "In Luther arose a champion who at once freed religion from her corruptions, and knowledge from her chains."[55] In the tradition of Luther, Rice continued to emphasize Scripture and protest against the sacraments of the Episcopal Church long after the decline of the Anglican establishment.[56] But Rice associated the suppression of intellectual freedom with the Catholic Church only, not Protestant Christianity, whereas Jefferson associated it with all organized religion.

Belief in science, God, and religious liberty were not the only things Rice and Jefferson had in common. Both promoted economic mobility among whites and more power for middle-class farmers, and both saw American politics as a fragile experiment necessitating a literate public.[57] Both viewed Virginia's decline as caused, in part, by weak education.[58] Both advocated higher education as the most critical vehicle for social engineering. Rice wrote that higher education "often [gave] to a few individuals more actual influence than a thousand honest husbandmen can possibly possess."[59] Unlike Jefferson, however, who advocated subsidizing a few deserving poor, Rice thought money spent on the poors' education would be wasted because of their "laziness and inactivity."[60] He asked, "Why should we put [money] in the hand of a fool to buy wisdom, when he has no

heart for it?"[61] Since Rice was an elitist, Jefferson and Cabell did not have to worry about him aligning with their other foe, Mercer, the Federalist promoter of elementary schools.

Rice wanted to influence and be around important people. Urban ministers competed for the attention of professionals, but also competed with doctors and lawyers for professional status.[62] Rice needed UVA open to ministers-in-training because he demanded a professionalized ministry.[63] Influence in critical sectors of society was also deemed necessary to discourage heresy. There was a resurgence of Unitarianism among the wealthy during the 1810s, 20s, and 30s which precipitated Rice's concern. Baltimore Unitarian Jared Sparks toured Charleston, Augusta, Louisville, Savannah, Nashville, New Orleans, Mobile, and Richmond, sparking a brief revival of liberal Christianity in the South.[64]

Traditional Calvinists within the Presbyterian Church considered Unitarianism and universalism (the idea that salvation is available to everyone) their "gravest concerns."[65] Minister Moses Hoge worried that "many of the intelligent and the wealthy and the influential," the exact sort of people who concerned Rice, had an aversion to the "occasions and requirements of Christian worship."[66] When a Unitarian minister was called in to replace Rice for a day at his church in 1823, "all the world . . . appeared to be running after [him]," according to one Episcopalian observer.[67] Jefferson admired Unitarians while Rice feared their influence.

William Ellery Channing, the most prominent Unitarian minister in the country, argued in 1819 for the restoration of humanity through the influence and example of Jesus Christ and the rational (non-fundamentalist) interpretation of Scripture. Rice disagreed with Unitarians because they denied the depravity of the human heart (original sin), the doctrine of atonement, and the exclusive divinity of Christ.[68] He argued that Unitarians were really deists who did not have the courage to go as far down the spectrum toward infidelity. He called for "war against them, neither making truce nor giving quarter, until they either quit the field in sullen despair, or surrender themselves unreservedly to our adorable Commander [Christ] . . . we must join our prayers to God for their recovery out of the snare of the wicked one."[69]

Despite Jefferson's and Rice's disagreement over the virtues of Unitarianism, they shared an animus toward the North. After the crisis over slavery's extension in Missouri in 1819–1820, Rice warned a friend in Washington, D.C. to beware of Yankees and to "send J.Q.A. [John Quincy Adams] back to Cambridge, to compile lectures . . . it's all he is fit for."[70] Rice was not a proponent of slavery, though. His primary concern with Northern influence was Unitarianism.

Both Rice and Jefferson feared the role of the Northern Congregational Church: Rice its Unitarian wing, and Jefferson its traditional wing. Rice linked Jefferson's University to Northern Unitarianism, the religion Erasmus Darwin

once referred to as the "feather-bed for falling Christians."[71] "They [Northern-ers] are laying plans to get our University" and "sway an intellectual sceptre over us."[72] "We say these things, because we suspect that a new set of propagandists [Unitarians] from a certain quarter, are scheming to fill up the literary institu-tions of the south and west, with men of their own training."[73]

Jefferson hoped, on the contrary, that Unitarianism would come and "drive before it the foggy mists of Platonism [intricate theologies] which have so long obscured our atmosphere." Jefferson hoped Unitarianism would "lop off the false branches" of corrupted Christianity.[74] It is ironic that he founded UVA to coun-ter Northern values, but hoped it would be infused with a spirit of New England Unitarianism.[75] When it came to religion, as opposed to politics, Jefferson hoped that Harvard would influence the rest of the country by sending Unitarians to the South: "The pure and simple unity of the Creator of the universe is now all but ascendant in the Eastern states, it is dawning in the West, and advancing toward the South; and I confidently expect that the present generation will see Unitarian-ism become the general religion of the United States."[76]

Rice wanted to keep Unitarianism and free thought out of the University of Virginia's curriculum. Nonetheless, he supported UVA's chartering because he wanted Virginia to have a university and he thought he could gain control over its curriculum. He also wanted money from the Virginia legislature for the state's Presbyterian schools as part of the arrangement. Rice led the Presbyterians' cam-paign to get public money and an official charter for Union Theological Semi-nary. But the policy under the 1786 statute was that no churches or denomina-tional schools (except those already chartered before 1776, like William and Mary) could apply for state incorporation. Neither Rice's Presbyterians nor the Episcopalians could use public money for education. The Episcopal Church had its charter revoked in 1787 after inheriting Anglican properties in 1784, and subse-quent cases within the Virginia courts ruled that William and Mary had become a private institution after the Revolution.[77]

Denial of church incorporation, which occurred in the United States only in Virginia, meant churches had no legal standing in the state courts and could not enforce contractual arrangements with their congregations. In other states subsi-dies insured churches against financial ruin and provided tax shelters.[78] Virginia churches could not even sue, or be sued, as legal entities, let alone demand public revenue. Jefferson and Madison argued that Christianity had thrived despite that fact (or even because of it) under the 1786 statute. Madison told the churches they should be grateful for the situation, because what the government could create, it could also destroy.[79] Presbyterians provoked the first real test of this policy in 1815, when the Virginia Synod appointed trustees to Union Theological Seminary and requested that they obtain a state charter of incorporation.[80]

Attitudes among Virginia's leaders on public funding for religion had

changed between the passage of the 1786 statute and 1815. Jurist and legal scholar St. George Tucker upheld the seizure of the Episcopal glebes, but did suggest levying a general assessment tax for "the support of teachers of religion and morality, and for the erection and keeping in repair of places of worship, and public schools," arguing that such a tax did not infringe at all on liberty of conscience.[81] Though Tucker remained a deist until the end, by 1816 he was persuaded that Christian morals were the only sound source of republican virtue.[82] Bishop James Madison (the president's cousin) concurred, arguing the 1786 statute did not erase the possibility of a general assessment among Christian (Protestant) denominations.[83]

Rice hoped lawyer William Wirt could help him and Charles Fenton Mercer develop arguments as to why incorporation did not conflict with Virginia laws, and also help construct a definition of "establishment" that would circumvent the 1786 statute.[84] He honed his arguments by analyzing U.S. President Madison's First Amendment rationale for denying incorporation to a District of Columbia church, even after it passed Congress. Rice published a pamphlet entitled *An Illustration of the Character and Conduct of the Presbyterian Church in Virginia* (1816), in which he staked out higher education as the legal battleground for church-state relations.[85]

Jefferson countered by turning the incorporation controversy toward one of Northern influence, realizing that Union Seminary could potentially garner funds otherwise earmarked for UVA. In 1816 Northern Congregationalist Lyman Beecher called for "newspapers, pamphlets and tracts to sound their trumpets long and loud" in opposition to Unitarianism. Jefferson and his ally, *Richmond Enquirer* editor Thomas Ritchie, reprinted the quote, hoping Beecher's location would steer their readers toward a fear of sectional dominance. They equated Presbyterianism with New England, even though the Unitarianism Jefferson admired also originated there, and Presbyterianism had been strong in Virginia since the eighteenth century.[86] Referring to the entire Northeastern region, Jefferson followed the quote by informing the *Enquirer*'s readers: "No mind there [Northeast] beyond mediocrity develops itself . . . flights to the west are people fleeing from persecution, religious and political . . . leaving the despotism over the residue more intense, more oppressive. They are now looking to the flesh-pots of the South, and aiming at a foothold there, and have lately come forth boldly with their plan to establish a qualified religious instructor for every thousand souls, in the United States."[87] It was a stretch, but Jefferson was arguing that Union Theological Seminary did not deserve state funding because it encouraged Beecher's Northern influence.

Rice, on the other hand, emphasized the patriotic role of the Presbyterians during the Revolution and underscored their rejection of traditional establishments. Publicly, he stressed the common ground of all Protestant sects, pointing out he

had never known a single Presbyterian minister who quibbled with the Thirty-Nine Articles of the Church of England. Rice did his best to convince his readers that incorporating churches was no different than incorporating a turnpike road.[88]

Rice's arguments and Wirt's legal advice were not enough. The Jeffersonian opposition was able to defeat the seminary's incorporation request simply by arguing that it constituted establishment and violated the Statute of Religious Freedom.[89] The 1786 statute stated that the rights hereby asserted are of the natural rights of mankind, and . . . if any act shall be hereafter passed to repeal the present or to narrow its operation, such act will be an infringement of natural right."[90] Many legislators in Virginia saw any act of incorporation or state funding for theological purposes a violation of their natural rights, and the Virginia Synod was forced to look elsewhere for funding.[91] Union Theological Seminary, which went into operation in 1823, was incorporated in Philadelphia under the general assembly of the Presbyterian Church.[92]

The Presbyterians were hurt by the malapportionment of Virginia politics, which favored the Anglican planters of the eastern part of the state. The incorporation debate also coincided with the governorship of Wilson Cary Nicholas, a strong supporter of religious liberty who favored Jefferson's plans for UVA.[93] It seemed to the Presbyterians that any sort of "party zeal" [political involvement] was off limits to organized religion.[94] They were forced to rely on newspaper editorials, Rice's pamphlets, and the influence of the Society of Cincinnati, an historically Federalist society that wanted state support diverted to Presbyterian Washington College in Lexington (see chapter 2).[95] The influence of the society was too weak, though, and Rice understood that the legislature would not commit its Literary Fund money to boost Hampden-Sydney, Washington College, or a Presbyterian seminary. The Society of Cincinnati's money attracted Jefferson's interest too, but they snubbed him and gave their twenty-five-thousand-dollar endowment to Washington College.

Since the Presbyterians were checked in the legislature, Rice tried to enter Jefferson's college on a Trojan Horse. He supported its creation but hoped to use his influence to infuse it with compulsory Christianity. Rice shared many of Jefferson's elitist and sectional concerns and maintained cordial relations with the group of UVA supporters known as Friends of the University. Rice echoed a familiar theme among the university's supporters by writing editorials in the *Richmond Enquirer* complaining about all the lost tuition money being spent up North.[96] Under the pseudonym "Crito," Rice figured that a quarter-of-a-million dollars was leaving the state annually for out-of-state tuition.[97]

The article was critical in getting the university chartered later that month, arresting the spread of opposition in the eastern half of the state and pleasantly surprising Cabell.[98] Rice implored his readers to support UVA's chartering and sent

Jefferson a copy of John Smith's *History of Virginia* (1624) for use in the school's library. In Jefferson's thank you letter, he wrote that he shared Rice's concern for the students' moral and character development, and expressed his "hope the school will merit the continuation of your [Rice's] friendly dispositions towards it."[99]

As soon as the school was chartered, Rice and fellow minister Conrad Speece wrote an article entitled "The Mountaineer" expressing their hope of getting a good Presbyterian placed at UVA, and making organized worship and Bible instruction compulsory.[100] As before, Rice publicly encouraged Jews and Catholics to do likewise, but privately he hoped the Presbyterians would assume control. He confided his strategy in a letter to friend William Maxwell:

> Now is the time to make a push. The friends of the University are alarmed. They fear a defeat; and dread Presbyterians most of all. I have seized the crisis; gone in among the Monticello-men, and assured them that we are so far from opposition that we rejoice that the state is about to support learning in a style worthy of Virginia . . . we shall thus gain influence; and if we know how to use it, may make ourselves to be felt in the University, and through all its departments.[101]

Rice's motive was to establish the primacy of faith over reason.

In his *Virginia Evangelical and Literary Magazine* Rice insisted that emphasizing revelation over reason would not repress the "boldness of the human mind." Rather, it would promote truth by preventing "that rashness of decision, that overweening confidence in our own powers that invariably drives man into error."[102] The Virginia Synod concurred, stating in their minutes that "it must be very improper, to ascribe to the light of nature what can be known only by divine revelation. In this way much injury has, there is reason to believe, been done to revealed religion."[103]

Rice contemplated the Rockfish Gap Report and the role of religious education in a democratic society when he visited UVA's partially built campus. He later wrote to his readers, "There is no neutral ground religiously . . . there is not a literary institution of any note in the world, that has not a decided character in reference to religion." Rice was confidant that democratic politics would encourage Christianity at the school. Its public stature would ensure that any "Deistical or Socinian" tendencies would excite "warm controversies by angry taxpayers not happy that their money is being spent contrary to their wishes."[104]

Rice did not want to alienate or embarrass UVA's board, or "cool the zeal of a single individual [Jefferson]," but he reminded his readers "THE UNIVERSITY OF VIRGINIA BELONGS TO THE PEOPLE OF VIRGINIA. . . . It is their money which has founded, and will endow their institution; it is their children who are to be educated there; it is they and their posterity, who are to partake of the good or suffer the evil, which it will produce." Rice argued that

the people who run a public college have no right to make independent hiring and curricular decisions. He reminded them that the university was "the property of the people . . . and they will see to it . . . that infidelity, whether open or disguised under a Christian name, shall not taint its reputation and poison its influence."[105]

The teachings of no particular sect should dominate, but Rice and Speece hoped the doctrines of the Protestant Reformation would be honored.[106] They wanted the public to screen professors based on moral standing and require worship among the students. Only then would UVA be a "fountain of living waters diffusing health and vigor" instead of "a poisoned spring, spreading disease and death":

> Will those men who manage her interests have the wisdom to consider, that mere knowledge is not sufficient to make men good citizens? Will its Alumni go into life, with passions inflamed by indulgence; and with hearts hardened and minds darkened by the pride of philosophy falsely so called—and thus prepare to scatter around them arrows, firebrands, and death? Or will they, after years of laborious study and willing subjection to wise discipline, appear among their countrymen, modest, humble, unassuming, pure, benevolent?[107]

Rice and Speece were correct when they predicted that UVA's public status would force it to sanction Christianity, though it never did formally. They voiced a democratic claim that "we [the people] shall demand from time to time, a full exposition to the transactions of the university."[108]

Jefferson hoped he could placate UVA's critics by hiring a minister to teach subjects other than religion. Years before he hired materialist John Patton Emmet to teach science (see chapter 3), Jefferson made an offer to Marylander Samuel Knox, a liberal Presbyterian educator. He hoped Knox could teach history, rhetoric, geography, languages, and *belles-lettres*.[109] In 1797 Knox and Samuel Harrison Smith were the co-winners of a contest put on by the American Philosophical Society to design a national education plan.[110] Jefferson sent the offer to Knox eighteen months before the chartering of the university, when the board was planning the first pavilion. Knox did not approve of natural religion, but was a Jeffersonian Democratic-Republican who supported religious liberty and defended Jefferson publicly. During the 1800 presidential campaign he authored a pamphlet entitled "A Vindication of the Religion of Thomas Jefferson and a Statement of his Services in the Cause of Religious Liberty."

Knox was ideal for Jefferson because of his political support, his stance on religious liberty, and his grounding in the Enlightenment educational theories of John Locke and Francis Bacon. Knox opposed sectarian influence in higher education and favored rural settings for colleges like Charlottesville. He advised that various denominations be invited to build seminaries around the periphery of

campuses, an idea Jefferson later advocated.[111] Knox's *Essay on the Best System of Liberal Education* (1799) also suggested building a college around a square rather than a single building, which Jefferson implemented at UVA. Knox either refused or never received the job offer, but the invitation briefly diffused hostile religious sentiment against the university. Jefferson thereafter avoided hiring any ministers.

The next professor Jefferson tried to hire—atheist and political radical Thomas Cooper—was a public relations disaster. Cooper convinced Jefferson that no theologian should be hired at UVA, despite Jefferson's original qualms about a potential backlash.[112] Cooper's recruitment is telling because his atheism was not what Jefferson wanted taught at the University of Virginia. Cooper paid lip service to Unitarianism, but was really a strict materialist who called the Scottish Common Sense Jefferson had learned at William and Mary "lady's philosophy."[113] Could Cooper promote moral and civic virtue that *surpassed* the morality taught by Protestant seminaries, the way Jefferson hoped his natural religion would? Despite his academic reputation as a chemist and mineralogist, his choice was probably motivated by Cooper's politics. Nothing at UVA, including religion or architecture, was as important to Jefferson as its political ideology.

Like Jefferson, Cooper came from wealth, was opposed to slavery as a younger man, and defended its cause later in life.[114] He was a radical, going from England to Revolutionary France as a youthful member of a democratic club.[115] Many Irish and English democrats escaped to the United States after the Reign of Terror and war with England discredited their support of the French Revolution, making it treasonous. Cooper was among those political refugees who came to America and rallied around Jefferson.

In the 1800 campaign Jefferson distributed copies of Cooper's *Political Arithmetic,* which argued in favor of Adam Smith's free market and opposed Alexander Hamilton's interventionist boost to commerce. Cooper figured that the food and fiber exports of America would attract enough customers that taxes were not needed for a navy or merchant marine.[116] Cooper envisioned a government active in promoting infrastructure and schools, but drawing its revenue from undirected customs.[117] Cooper was the architect behind Jefferson's policies in much the same way that Hamilton had designed George Washington's. Jefferson did not want tariffs that protected New England manufacturing interests while raising domestic prices in the South and alienating the foreign consumers of Southern exports. Cooper got jailed under the Sedition Law in 1800 supporting the Democratic-Republicans.[118]

Most British radicals were tossed aside by Jefferson after they helped him win in 1800, but Cooper was different because he shared so much in common with Jefferson intellectually.[119] In the intervening years Cooper made his way as a scientist, making him even more appealing as a potential professor. Jefferson envisioned hiring him as early as 1814, shortly after Jefferson was elected to the

Albermarle Academy Board.[120] As an adjunct science professor and literary critic at the University of Pennsylvania, Cooper was a diehard materialist whom Jefferson considered the finest mind in America at that time. Cooper had long since gained a reputation as a brilliant troublemaker. He did not graduate from Oxford because he refused to sign the (Anglican) Thirty-Nine Articles. Later he quarreled with the administration at Dickinson College in Pennsylvania, and passed up a presidential appointment at Transylvania because of his refusal to "be under the direction or control in any way of any clergyman." He told that institution, "you will do no good with a clergyman at the head of your institution, you must have a gentleman and a man of the world."[121]

Jefferson coaxed UVA's board into hiring Cooper in March of 1819, despite entertaining some doubts.[122] It was the biggest mistake he made in founding the university. Cooper was an easy target for the Presbyterians to link to the radicalism of the French Revolution. He was mistakenly identified with Unitarianism because, in England during the 1790s, Joseph Priestley's Unitarian chapel was ripped down by the same Tory mob who burned Cooper's home, and Cooper later married Priestley's daughter.[123] Had they known he was an atheist they would have disliked him even more.

The prospect of Cooper's hiring at UVA provoked John Holt Rice. In 1819–1820, Rice launched a campaign against the hiring of Cooper as a science and law professor. Since he supported the university, Rice was under extra pressure from his readers and congregation to throttle Cooper's appointment. Subscribers to the *Virginia Evangelical and Literary Magazine* from the Shenandoah Valley sent him letters, and he reminded his readers that Cooper was associated with the darkest days of the French Reign of Terror.[124] Rice exposed an 1806 book review Cooper had written of his father-in-law Priestley's *Memoirs*. It revealed the infidelity of Cooper and his idea that "the time seems to arrived, when the separate existence of the human soul, the freedom of the will, and the eternal duration of future punishment, like the doctrines of the Trinity and transubstantiation, may no longer be entitled to public discussion." Rice believed passionately in things that Cooper did not even think were open to discussion. He warned his readers that the university "will become a party affair, countenanced and supported only by a particular class of persons among us [infidels]."[125]

Rice hoped that the forces of democracy would encourage Christianity instead at the University of Virginia. In keeping with that plan, he turned the forces of popular sentiment against Cooper: "We have no doubt of Dr. Cooper's ability as a Chemist, but still we, as part of the people of Virginia, deeply interested in the prosperity of the University, do decidedly disapprove of this appointment . . . the professors and officers are public officers . . . it is our duty to inquire into them. Let the people enquire [sic]."[126] In the Enlightenment tradition of Voltaire,

Rice employed satire, writing stories set on the Moon which parodied the religious thought of infidels like Cooper and signing them "a Lunatic."[127]

Rice maintained friendships on the school's Board of Visitors with John Hartwell Cocke (1780–1866), and in the senate with Joseph Cabell. Cocke was a large plantation owner in Fluvanna County who campaigned against the evils of tobacco and slavery and worked actively in the American Colonization Society, serving as its vice president. Cocke was a former deist from William and Mary who converted to a "fervent though nonsectarian Protestantism" upon the death of his wife in 1817.[128] Rice expressed his concerns in a letter to Cocke.[129] In the meantime Cabell complained to Jefferson that Cooper's views and cantankerous personality made him unpopular with the "Enlightened part" of society.[130]

Jefferson assumed that Madison supported him on the Cooper hiring, writing that the two could get Cabell to acquiesce, but Madison understood it was not a judicious move.[131] It was bad timing given the precariousness of the university and the economic downturn caused by the Panic of 1819.[132] Madison, Cocke, and Cabell recognized that Rice was right: as a public institution, UVA could not retain Cooper and retain the requisite financial support from the legislature to finish building UVA.

Pulpits across Virginia condemned Cooper and the board was relieved of an embarrassing situation when, sensing the public hostility toward him, he removed himself from candidacy.[133] Cooper remained at the College of South Carolina from 1820 to 1834 after he was offered a dual professorship and presidency of that school.[134] Rice bragged to Princeton president Ashbel Green that his public relations campaign killed the appointment.[135] Rice's connections on UVA's board were also critical. His Trojan Horse strategy worked in keeping Cooper out of Virginia.

Also unaware that Madison did not side with Jefferson on the hiring, Cocke expressed his relief to Cabell that a potential showdown was averted: "The thought of imposing my individual opinion upon a subject of this nature against the high authority of Mr. J. and Mr. M. [caused] me a conflict which has shaken the very foundation of my health, for I feel now as if I should have a spell of illness . . . I am induced to infer you would have supported me in this course." Cabell replied: "I concur entirely in opinion with you in regard to Mr. Jefferson's plans as to Dr. Cooper . . . so does Chapman Johnson [another board member, who was Episcopalian] . . . I think our old friend went a little too far . . . [but] we must stand around him . . . and extricate him as well as we can."[136]

Cabell thought Cooper's defense was bad public relations, so he omitted any mention of it from the board proceedings he turned over to the *Richmond Enquirer*.[137] At first, Jefferson denied the democratic implications of Rice's criticism of the Rockfish Gap Report and Thomas Cooper. He focused on the resistance to

Cooper by the clergy rather than their followers, many of whom were loyal supporters of the Republican Party. To Cooper he wrote:

> The Presbyterian clergy alone, not their followers, remain bitterly federal and malcontent with their government. They are violent, ambitious of power, and intolerable in politics as in religion . . . Having a little more monkish learning than the clergy of other sects, they are jealous of the general diffusion of science, and therefore hostile to our seminary, lest it should qualify their antagonists of the other sects to meet them in equal combat. He [Rice] could not have more effectively hidden his diatribe than by consigning it to that deposit [*The Virginia Evangelical & Literary Magazine*].[138]

Jefferson later conceded to Cocke that he had underestimated the general opposition.[139] He conceded to Unitarian Jared Sparks that reformation of the "genuine doctrines of Jesus" to their "original purity" would not occur in his lifetime, because of the "overbearing inquisition of public opinion."[140] After the Cooper fiasco, Jefferson wrote bitterly that Presbyterians "dread the advance of science as witches do the approach of day."[141] He complained to his former private secretary William Short about the Presbyterians' loudness and tyrannical ambitions.[142] On religious matters at least, Jefferson's enthusiasm for democracy diminished as he got older.

Jefferson stubbornly wanted to reopen negotiations with Cooper in 1824, but Madison wisely rejected the idea, fearing it would "poison his happiness and impair the popularity of the school."[143] At South Carolina College Cooper stirred up his customary trouble on religious freedom and became a fanatical pro-slavery, states' rights advocate during the Nullification Crisis of the late 1820s and early 1830s.[144]

## Conclusion

Jefferson, Madison, and Cabell were lucky that John Holt Rice was an elitist who shared their fear of the North, otherwise he could have combined forces with Episcopalian Senator Charles Fenton Mercer to defeat UVA's charter and promote primary schools taught by ministers. Still, during the Cooper affair Rice's impact on the university's Board of Visitors checked Jefferson's, since Cocke and Johnson shared Rice's religious convictions, and Madison and Cabell were aware that those convictions could ruin UVA's chances in the legislature. Later, the early history of the university proved Rice correct: democratic forces encouraged Protestantism on campus.

For Jefferson, religious freedom was a fundamental component of civic freedom, as well as a prerequisite for political virtue and moral growth. Rice continued to support religious freedom, but that included the freedom of the Protestant

majority to pursue its interests by influencing the democratic system. Historian Carl Becker wrote in 1932 that "Ideas cannot fight unless they occupy the same ground." This was true of Jefferson and clergymen like Rice, whose struggles vindicated the spirit of Becker's take on the Enlightenment: it was a "competition for the holy between secular and Christian."[145] Jefferson's debate with the clergy reveals overlapping visions for Revolutionary America, both rooted in democracy and both predicated on faith.

# Jefferson's "Hot Potato," 1820–1825

❁

Controversy over the University of Virginia increased between its chartering in 1819 and its opening in 1825.[1] There was wrangling over the misuse of Literary Fund money and Episcopalians at William and Mary tried to maintain the preeminence of their school. Tension between the North and South over the extension of slavery beyond the Mississippi motivated Jefferson to open UVA and control its ideology. Virginia's students were going North just as Northerners threatened to strengthen the national government. He and Madison prescribed the future students' reading list of political and religious texts while searching for a properly indoctrinated law professor. Jefferson teased funding out of the state legislature to build a beautiful campus and hire top professors. He fought off clerical opposition and charges of elitism as he oversaw the construction of the campus. In the process Jefferson incurred the wrath of a variety of Virginians, including former friends.

In the early 1820s, the school's rising cost was one of the main issues in Virginia politics, along with the dredging of the James River, proposed tax deductions on slaves and other property, and debate over the democratic reform of the state's political system. The basic problem for Jefferson was that the fifteen-thousand-dollar annual appropriation from the Literary Fund was nowhere near enough to build the campus he wanted, let alone hire professors or buy a large library. Construction on the ten pavilions surrounding the inner lawn began in 1817, but the capstone of the campus—the Rotunda—overran its budget and created another flash point of religious controversy because of its secular symbolism. Jefferson's reservoir of goodwill in Richmond and Williamsburg was nearly exhausted by the 1820s. Senator Joseph Cabell performed a juggling act on behalf of the university, diligently balancing political and religious interests while suffering ill health. Cabell tried to prevent Jefferson from pushing for too much money and jeopardizing the whole project.

Joseph Carrington Cabell (1778–1856).
*Courtesy of the Virginia Historical Society.*

Jefferson concentrated on using UVA, especially the law school, as a vehicle for Southern sectionalism. He claimed the Missouri Crisis, which blocked the spread of slavery onto the Plains, was the only thing that reawakened him to the world of politics. By 1820, concerns over sectional politics and education were one and the same in Jefferson's mind.[2] That year he wrote to Thomas Cooper that he envisioned the University of Virginia as "the future bulwark of the human mind in this hemisphere." But as historian Roy Honeywell wrote in 1931, he quickly came to regard it as a bulwark of the South.[3] For Jefferson, his region now assumed the former role of the whole United States as the last outpost of republican faith. Ostensibly encouraging free speech and intellectual inquiry, UVA could be used as a propaganda machine to curb the trend toward nationalist, Northern politics.

The Missouri Crisis did not make the chartering of UVA possible, since the date of the school's chartering preceded the Congressional debates on Missouri by three weeks. Still, the thorny politics of slavery in the territories galvanized support and deflected controversy away from financial and religious criticism.[4] Missouri came into the Union after similar but less dramatic admission debates on Alabama, Illinois, Indiana, and Mississippi from 1816 to 1819. The Missouri Crisis also deepened Jefferson's resolve. His original Northwest Ordinance of 1784 would have barred slavery from *territories,* but Jefferson believed each new *state* came in on an equal basis, and had the right to decide the slavery issue for itself. The sovereignty and equality of the states were therefore at stake, especially if the United States was to avoid the British colonial model of bringing in new territories on an inferior basis.[5] Political theory aside, Jefferson opposed the expansion of slavery in 1784 and advocated it by 1820.

Jefferson thought slavery was being used as a front by Northern politicians to divide the country sectionally and insure them better success in presidential elections.[6] Northerners like Rufus King and DeWitt Clinton were capitalizing on slavery for political purposes only, in his opinion. In Jefferson's most cynical commentary on Northern motives, he said that the Missouri question has "just enough semblance of morality to throw dust into the eyes of the people . . . while with the knowing ones it is simply a question of power . . . real morality is on the other side."[7]

American sectionalism, born in the 1780s and 90s and solidified during Jefferson's trade embargo and the War of 1812, reemerged during the economic downturn of 1819 and the debate over the admission of Missouri. The economy of Virginia still had not recovered from the War of 1812, and wheat and tobacco farmers in the eastern half of the state were suffering from western competition, wasteful cultivation, and soil exhaustion. The economic downturn and the large emigration that followed weakened Virginia's overall power in the Union, even as Virginians James Madison and James Monroe sat in White House. When the newly reorganized Bank of the United States called in notes from local banks in

1819, those banks panicked and pressured their indebted farmers. Many Southerners, including Jefferson, blamed the North, banks, and the national government for their problems.

Jefferson hoped UVA would help reverse the emerging trend toward Northern industrialism. He feared that the independence of artisans and farmers, crucial to the maintenance of virtue in a republic, would be undermined by their dependence on bankers, merchants, and industrialists.[8] Young Southern men were being educated in the North, compounding the problem. Despite liberal use of centralized power during his own presidency, Jefferson now felt Congress and the Courts had "gone more than halfway to meet the Federalists [National Republicans]" in conceding the power of the states.[9]

There was no clear two-party system in the late 1810s, but there was a more nationally oriented wing of Jefferson's Republican Party, led by Henry Clay of Kentucky and John C. Calhoun of South Carolina. They, along with John Quincy Adams, favored using the national government to support internal improvements (infrastructure) and promote economic development through targeted tariffs. They called this cluster of policies their American System. Many Southerners thought these policies would hurt their agrarian region because the import tariffs would endanger the export trade they depended on if Europe retaliated.

Also, the trend on the Supreme Court under fellow Virginian John Marshall was to support the power of the national government in cases where its jurisdiction conflicted with that of the states. The Supreme Court asserted that they, not the state supreme courts, had jurisdiction over suits brought against the respective states in *Martin v. Hunter's Lessee* (involving Virginia, 1816), *McCullough v. Maryland* (1819), and *Cohens v. Virginia* (1821).[10] To states' rights advocates, these rulings seemed like a violation of the Eleventh Amendment, which says that the national courts do not have jurisdiction over cases brought against any of the states by citizens of another state or foreign country. The Eleventh Amendment does not mention suits brought by citizens of the state in question against that state.

Jefferson and his fellow planters were adamant that states were not subordinate to the national government.[11] In their interpretation of federalism, the state and national governments were coequal, with the role of the national government involving only "foreigners and exchanges between the states."[12] In the judicial system, Jefferson believed that neither the state courts nor the Federal Supreme Court had jurisdiction over each other, even though his philosophy could ultimately lead to conflicting interpretations of the Constitution within the states.[13] As for the 1821 *Cohens* case, which ruled otherwise, Jefferson wrote "the remedy . . . [is] to inform discretion by education. This is the true corrective of abuses of constitutional power."[14]

Jefferson and editor Thomas Ritchie saw to it that John Taylor, a states' rights advocate from Caroline County, had his book *Construction Construed, and*

*Constitutions Vindicated* (1820) published in the *Richmond Enquirer*. Earlier in his life, Jefferson's main interest in Constitutional theory concerned the balance of power between the three branches of the national government. Reading Taylor confirmed Jefferson's growing interest in the Constitutional relationship between the states and central government.[15]

Spencer Roane, Judge of the Virginia Supreme Court of Appeals, was another focal point of Virginia's counter movement against nationalism, joining Jefferson in a vigorous denunciation of Marshall's jurisdiction.[16] John Randolph's half-brother, Henry St. George Tucker (who later taught law at UVA), viciously attacked the administration of Virginian James Monroe for being too nationalistic.[17] A decade before, someone like Taylor would have been too extreme for Jefferson or other members of the Richmond Junto; now they embraced Taylor as political philosopher.[18] Jefferson, Roane, and Taylor were transition figures between the revolutionary and antebellum South.

While Roane fought the judicial system and Taylor published tracts, Jefferson tried to find UVA a law professor who properly understood federalism. Textbooks would be screened to avoid political heresy (nationalism). Sectionalism was the real reason Jefferson had been lukewarm on creating a national university in Washington, D.C. The idea of transplanting French professors to a national school on the scale of the French Sorbonne perked the interests of Adams, Madison, and Washington, but not Jefferson. In the 1790s Jefferson favored putting a national university in Richmond, but opposed putting branch campuses along the cities of the eastern seaboard. Madison pressed for a "national seminary" three times during his administration, but the idea had lost steam after being mothballed during Jefferson's two terms. States' rights advocates opposed the project and Jefferson did nothing to convince them otherwise. Given the proximity of Virginia to the District of Columbia, though, George Washington may have been right that Virginia could have influenced the country more through a national, than a state, university.[19]

Jefferson's conflation of orthodox Christianity with his political opponents, begun in 1800, worsened after his sectionally divisive embargo and the War of 1812. His began to use terms like "political heresy" and "apostasy."[20] For Jefferson the Federalist conventioneers at Hartford, Connecticut, who wanted to overturn the Southern domination of U.S. politics were "reverend leaders . . . like bawds, religion became to them a refuge from the despair of their loathsome vices. They seek in it only an oblivion from the disgrace with which they have loaded themselves."[21] Sectional interests shaped Jefferson's thoughts on education from the time he walked into Albermarle Academy's first board meeting in 1814, the year of the Hartford Convention.

Jefferson used sectionalism to deflect attention from religious opposition to UVA. In the context of the Missouri Crisis, it was one strategy that resonated in

the Virginia legislature. Jefferson argued that a well-funded university for Virginia would alleviate the impact of western emigration and Northern infiltration:

> If our legislature does not heartily push our University, we must send our children for education to Kentucky or Cambridge [Harvard]. The latter will return them to us fanatics & tories, the former will keep them to add to their population. If however we are to go a begging any where for our education, I would rather it should be to Kentucky than any other state, because she has more of the flavor of the old cask than any other.[22] All the states but our own are sensible that knowledge is power. The Missouri question is for power. The efforts now generally making thru the states to advance their science, is for power; while we are sinking into the barbarism of our Indian aborigines, and expect, like them, to oppose by ignorance the overwhelming mass of light and science by which we shall be surrounded. It is a comfort that I am not to see this.[23]

Jefferson echoed similar sentiments in numerous letters coinciding with funding arguments in the Virginia legislature. How could Virginia entrust the molding of its finest young minds to those who opposed her political interests?[24]

In 1820 Jefferson sent his grandson to South Carolina College, "rather than anywhere northwardly."[25] Jefferson wrote UVA board member James Breckenridge (of Botetourt County) that "this canker [students going north to college] is eating on the vitals of our existence, and if not arrested at once, will be beyond remedy."[26] Jefferson recognized that "knowledge is power," and that "ignorance is weakness," and claimed to have learned this lesson directly from Massachusetts: "She is the twenty-first only in the scale of size, and but one-tenth of Virginia; yet it is unquestionable that she has more influence in our confederacy than any other State in it. Whence the ascendancy? From her attention to education, unquestionably."[27] Jefferson complained to Cabell that six professors would not be enough:

> Harvard will still prime it over us with her 20 professors. How many of our youths she now has, learning the lessons of anti-Missourianism, I know not, but a gentleman lately from Princeton told me he saw there the list of the students at that place, and that more than half were Virginians. These will return home, no doubt, deeply impressed with the sacred principles of our Holy Alliance of Restrictionists [those who wanted to outlaw slavery in Missouri].[28]

Jefferson indicated privately he was using the Missouri Crisis as a scare tactic to get another sixty thousand dollars out of the legislature for the university, but his sectional fears were genuine.[29]

Jefferson knew that to displace William and Mary and compete against Harvard and Yale, UVA's preeminence should be embodied in magnificent architecture. He sketched and surveyed the campus himself, arranging a quadrangle with a large library at the head—the Rotunda—and rows of professors' pavilions interspersed with dormitories down the long sides, connected by colonnades. There is an even number of ten pavilions, in keeping with Jefferson's usual adherence to the decimal system. Each professor was housed in a separate pavilion, where classes

were taught on the first floor and their families lived on the second. Behind each pavilion was an expansive garden, an idea contributed by Joseph Cabell.[30]

The University of Virginia is a monument to Enlightenment rationality. The five pavilions that line each side of the rectangular lawn are spaced increasingly farther apart toward the south, and the wooden colonnades get slightly higher, creating the appearance of uniformity to a viewer on the northern (Rotunda) end of the lawn. From the south end the effect is reversed and the parallel lines converge toward the Rotunda. The natural slope of the land is graded into terraces. English-style serpentine walls, supported by a single row of bricks, line the pathways to the east and west of the Rotunda. The south side of the rectangle was left open for further growth.[31]

Jefferson's architectural genius was his ability to adapt others' ideas, not originality or boldness. His designs were inspired chiefly by sixteenth-century Italian Andrea Palladio, one of several Renaissance architects who measured and documented Roman ruins.[32] Such books were a godsend to architects like Jefferson, who wanted to emulate Rome in construction, just as he did in politics. In his library, Jefferson owned Giacomo Leoni's 1721 edition of Palladio's *Four Books of Architecture*.[33] Palladio's sense of symmetry and love of villas informed Jefferson's design of UVA.

The professors' pavilions have facades that replicate classical styles—Doric, Corinthian, and Ionic.[34] One pavilion was patterned after the designs of Frenchman Claude Nicolas Ledoux. The designs of others were suggested by William Thornton and Benjamin Henry Latrobe, an English architect living in Washington, D.C.[35] The capitals at the top of the pavilion columns were based directly on the designs of Palladio and Fréart de Chambray.[36] The Rotunda is a small-scale replica of the Pantheon in Rome, and seven of the pavilion porticoes have two-story columns in the style of the Maison Carrée, at Nîmes in southern France.[37]

Jefferson designed the campus as a museum to train architects in the neoclassical style he saw as appropriate to American republicanism. He avoided the boxiness of Georgian architecture and the Gothic style of Oxford and Cambridge because of its monastic association. Jefferson loved plazas and the Roman ruins he viewed traveling Europe in the 1780s. Buildings spread around courtyards of trees and grass were an especially common sight at hotels and hospitals in Paris.[38] He also admired the layout of New England townships when he visited there with Madison in the early 1790s.

Jefferson's design transcended uniform sight lines and Enlightenment proportions. For him architecture was as important for social engineering as was UVA's curriculum. New England villages and the close-knit tribal culture of Native Americans inspired both Jefferson's ward idea (see chapter 1) and what he called UVA's "academical village."[39] Raised desks for the master, which symbolized dominance, were prohibited because Jefferson wanted to encourage mutual

respect between student and teacher.[40] When Jefferson attended William and Mary, it was a single building, like most colleges, but at UVA he designed what travel writer Harriet Martineau called a "piazza surrounding an oblong square."[41]

UVA's architecture was intended to be everything his alma mater William and Mary was not, but to foster the same fellowship between students and professors that he enjoyed there as a student. By interspersing the student dormitories among the professor's pavilions Jefferson hoped to replicate the intellectual camaraderie he enjoyed with William Small and George Wythe in Williamsburg in the 1760s. But instead of cramming the students into "a large common den of noise, of filth and fetid air [William and Mary's Wren building]," Jefferson created his academical village (just as plantations were often called "villages").[42] He hoped that by spreading the classrooms and living quarters around, diseases would not spread as rampantly among the student body. When professors did need to communicate with each other apart from the students, they could walk across rooftop paths entered onto from triple-sash windows.[43]

Jefferson oversaw the layout of the village and the exteriors with more precision than the pavilion or dormitory interiors. At age seventy-six, he designed five pavilions for the east side of the lawn in a two-week stretch. The work began in 1817 and seven pavilions were up by 1819. After 1819, Arthur Brockenbrough began direct oversight of construction while Jefferson watched through his spyglass atop Monticello, four miles to the southeast.[44] From his hilltop plantation Jefferson could see his dream being realized just west of the village of Charlottesville.

The designs were inspired by Palladio, but carpenters had to copy their own drafts of the designs and often improvised on interior details. A notice in the *Richmond Enquirer* warned that builders had to "work from their own draughts," and many changes and additions were made by carpenters to Jefferson's general blueprints.[45] Richard Ware of Philadelphia contracted to build pavilions two, four, and six.[46] The sculpting duo of Michele and Giacomo Raggi tried unsuccessfully to carve the column capitals out of local stone, and ended up importing marble from Italy.[47]

The campus was built by a combination of two hundred slaves and white carpenters, overseen by Brockenbrough, a slave driver named James Harrison, board member John Hartwell Cocke, and occasionally Jefferson, who rode to the site when weather and health permitted.[48] Slaves rented for between thirty-five and seventy dollars per year levelled off the land, dug foundations, hauled quarried stone, and made bricks.[49] The exteriors to the buildings were done by Lynchburg masons, who used the bricks slaves made in the kiln. Sand and lime were dragged to the campus by slaves from as far as ten miles away.[50]

Jefferson loved nothing more than to show off the campus to visitors, but construction took much longer than he hoped.[51] Much of the delay was due to its ballooning cost; and the alienation of legislators in Richmond was a direct result

of Jefferson's architectural ambition. Jefferson could only hope his reminders about Northern threats to Southern political and economic interests would divert attention away from the cost of his extravagant buildings. By 1820, three of the ten pavilions were unfinished and work had not yet begun on the Rotunda.[52]

Jefferson's son-in-law, Governor Thomas Mann Randolph Jr., solidified the public's association of UVA with religious heresy in December of 1820.[53] In the wake of John Holt Rice's smear campaign on Thomas Cooper, Randolph used his annual communication to emphasize the "glorious distinction" of Virginia's 1786 statute, which removed that "frightful disorder of the public imagination," which "confounds piety and cruelty, makes religion give sanction to the most atrocious outrages against humanity. The unrestrained right . . . to make free choice of religious instructors . . . is the only security against the recurrence of that dreadful calamity." Randolph went on to point out that religious freedom, "contrary to the expectation, and predictions of foreign politicians, and of too ardent zealots in our own country," leads to an *increase* in morals and religious fervor.

Randolph's affirmation of the separation of church and state was not surprising, but he pushed the boundaries of respectability by going on to publicly avow his faith in the God of nature. He commended the "rising taste for that unassuming and silent system of religious doctrine . . . perpetually displayed in the endless variety of visible works, and in the admirable excellence of their internal structure and properties." In a probable reference to Rice, Randolph wrote that "few indeed, can now be found among us, fanatical enough to stigmatise as atheists, their blameless fellow creatures, who conscientiously substitute patient resignation for prayer, and silent admiration for labored praise, or ceremonious worship." Randolph hoped that natural religion would provide "a means of extinguishing his [the religious zealot's] humiliating imbecility."[54]

Randolph's comments, along with his liberal ideas on abolition and political reform, did not lead to a precipitous decline in his popularity. In subsequent campaigns, opponents tried to use Randolph's opinions against him, but to no avail.[55] His controversial views were outweighed by the legislature's sectional concerns and Virginia's decline. Randolph was also director of the Literary Fund, which helped minimize whatever effect the speech had on funding for UVA.

Economic depression afflicted Virginia after 1819, and the elderly Jefferson's personal finances and health degraded into bankruptcy and pain. His expensive tastes, combined with the 1819 forfeiture of a note he cosigned for Wilson Cary Nicholas (his grandson's father-in-law), buried him deep in debt.[56] Jefferson consoled himself with wine, books, and grandchildren, but also threw himself into education. Without having to do his own farmwork, he was able to spend long hours writing letters and planning the architecture and curriculum of his retirement project.

It was a distraction from Jefferson's worries over debt and health, but threw

him directly back into the political ring. Still, this was a political fight he could engage in without leaving the comfort of Monticello and Poplar Forest. On numerous occasions he wrote that the university had become the overriding interest in his life.[57] Jefferson told John Adams that the school was the hobby (horse) on which he was fortunately mounted.[58] Historian Herbert Sloan wrote that the University of Virginia was Jefferson's "safe haven in the remaining years of his life, a pursuit he preferred to unpleasant reality . . . he could plan a world of his own, indulge his passion for 'putting up and pulling down,' modeling a small universe according to his own desires."[59]

Jefferson could not have left for Washington, Philadelphia, or Paris if he had wished. He and his legislative advocate, Joseph Cabell, were both ill by 1821. Jefferson could ride horses for most of his retirement, but he could not walk a lot or write his many correspondences without pain in his legs and wrist.[60] His letter-writing dropped from around twelve hundred to six hundred per year.[61] His joints ached, and he never recovered his vigor after suffering a blow to his constitution on the Rockfish/Warm Springs trip in 1818. He experienced the same intestinal problems he had in 1774 and early in his presidency.[62] In 1822 he broke his arm in a fall off the back steps of Monticello. He still managed to rise at dawn, ate mostly vegetables, fish, and poultry, and enjoyed three to four glasses of wine a day.[63]

Cabell was thirty-five years younger than Jefferson, but suffered from bad lungs. He coughed up blood on the senate floor during the chartering debates of 1818 and 1819. In 1821 Cabell's "pulmonary affection" worsened and he considered dropping out of politics, but Jefferson would not allow it. He rallied Cabell by arguing to him in a letter that the university mission was bigger than either man's life, and if he (Jefferson) was "willing to die in the last ditch," than Cabell should be too, along with "our firm-breasted brothers and colleagues."[64]

Jefferson and Cabell had to stand fast against different levels of Virginia society. The rich viewed Jefferson's ideas on public education as a "plan to educate the poor at the expense of the rich."[65] Most people resented taxes, regardless of how rich or poor they were, and viewed them as a repudiation of the American Revolution. Jefferson thought that too much of the Literary Fund money went toward the poor and their charity schools. Many poor people were too proud to accept an education handout and some of the funds for the charity schools went unclaimed.[66] Cabell and Jefferson hoped to appropriate as much of the poor money as possible in order to finish building the pavilions and Rotunda.

Jefferson's strategy was to get started on the impressive buildings in 1817 and hope the legislature would ultimately dispense more money than originally promised. He did not ask for as much as he needed up front, but he knew if he could tease the legislature along gradually, eventually they would go too far to leave the project unfinished. Cabell, whose job it was to implement the plan in Richmond, endorsed the strategy after some persuading.[67] To give the illusion of a soundly

planned budget, precise figures, including cents, were used for building esti-
mates.[68] Cabell advised the strategy to the board of Central College in 1818.[69]

The Christian colleges still wanted public funding, and they too hoped to
collect the leftover money from the charity schools. The denominations drew at-
tention to Jefferson's plan for coaxing all the state money out of the legislature.
Another of Jefferson's advocates, W.C. Rives, advised him when UVA was char-
tered that "there certainly would be danger in attempting to stretch the string too
far, of breaking it—several of the existing establishments have already put in
claims to the residue of the fund—William and Mary, Hampden-Sidney, &
Washington Academy."[70] The preponderance of western delegates made the
house much less cooperative with Jefferson and Cabell than the eastern-
dominated senate.[71]

Jefferson coaxed a sixty-thousand-dollar loan out of the reluctant legislature
in February 1820 at 6 percent interest. Of the over forty thousand dollars un-
claimed in time by the county poor schools, William and Mary got four thou-
sand. The rest was given to UVA, with another twenty thousand tacked on in
May.[72] The Friends of the University enlisted Cabell's brother, William, to work
the dinner party circuit in Richmond in order to expedite passage of the loan.[73]
Jefferson was still disappointed. Figuring the Rotunda would cost at least another
two hundred thousand to build, he asked the legislature for exactly $162,364.

During the 1820–1821 session many delegates, including UVA supporter
Philip Doddridge, were unconvinced that charity school funds were really going
unclaimed.[74] Given his egalitarian reputation, Jefferson felt self-conscious about
his betrayal of elementary schools. He instructed Cabell to act interested in pri-
maries and to suggest his ward plan again in the legislature. Jefferson combined
his disrespect of religious orthodoxy and faith in local democracy, writing that
wards, as opposed to counties, would be better able to resist the hiring of "fanati-
cising preachers" as teachers. Toward elementaries, Jefferson instructed Cabell to
"assume the character of the friends, rather than the opponents of that object,"
and help concoct a plan whereby the ward schools could each get enough money
without taking a big slice of the Literary Fund. Without elementaries, Jefferson
now wrote that Virginians would "fall into the ranks of our own negroes."[75]

But Jefferson was undercutting the primary school movement in Virginia
and rationalized it in a letter to James Breckenridge: "If it be asked what are we to
do, or said we cannot give the last lift to the University without stopping our pri-
mary schools . . . I answer, I know their importance." Jefferson could make the
same argument concerning education that he made concerning slavery and aboli-
tion during the Missouri Crisis:

> Nobody can doubt my zeal for the general instruction of the people. Who first started
> that idea? I may surely say, Myself. . . . It is well known to those with whom I have acted
> on this subject, that I never have proposed a sacrifice of the primary to the ultimate grade

of instruction. Let us keep our eye steadily on the whole system. If we cannot do every thing at once, let us do one at a time. The primary schools need no preliminary expense; the ultimate grade requires a considerable expenditure in advance.[76]

Even though Jefferson opposed Mercer's 1817 plan because of its centralized board of education, he now said the current primary school plan should be abandoned because "under no responsibility, [it] is entirely inefficient."[77] Jefferson's long-term advocacy for primary schools remained sincere, though, especially since he was concerned that his original cause on their behalf was being trumped by the growing Sunday school movement.

The real issue was Jefferson's correct perception that the university had to be built then to bear his stamp, while elementaries would arise in due time with or without his aid. (It took until after the Civil War, longer than he thought.) In the meantime he could take credit for initiating the movement in Virginia in the 1770s. Jefferson hoped to cut off elementary funding altogether for a few years while "some other thing must be thought of" and then the university and primary schools "go on, hand in hand, for ever. . . . I believed that the course and circumstances of my life had placed within my power some services favorable to the outset of the institution [UVA]."[78] A week earlier, a letter to the *Richmond Enquirer* signed by "Philo" concluded that "an examination into the state of schools throughout the state, will demonstrate unequivocally that they require no legislative assistance."[79]

The Friends of the University's pursuit of charity school money, combined with the rising costs of the buildings, began to turn public sentiment against UVA. Cabell wrote that "in the Southern parts of the State, in the quarter of Brunswick, Greensville, &c. I am informed, it is now the fashion to electioneer by crying down the University."[80] A motion to forgive the sixty-thousand-dollar loan was defeated twice in the house, the second time by just one vote.[81] A bill authorizing more loans still managed to pass both houses by the end of February.[82]

At the close of the 1820–1821 session Cabell told Madison directly what he had tactfully hinted to Jefferson: "It is the universal opinion of all our friends that we should never come here again for money to erect buildings. This is the last donation for that object. Our friends tell me—'For God's sake, beg Mr. Jefferson & Mr. Madison to finish the buildings with their $60,000 and if it should not be enough, not to commence any building which cannot be finished.'"[83] The Rotunda alone would cost more than sixty thousand dollars and it was barely started.

In May 1821 a letter arrived at the *Enquirer* from someone who claimed that, although he was not one of Virginia's sons, he had "venerated the virtue and wisdom of [its] sages." The author of this anonymous editorial constructed the kind of physical analogy popular during the eighteenth-century Enlightenment.[84] Like

Jefferson's letter to Breckenridge in February, 1821, it implored the reader to keep his eye on the whole system:

> Keep a watchful eye on the principle of your primary school, and foster the spirit that directed it: But do not let the operations of your University languish; it is the master spirit that must direct and give efficiency to the rude and detached parts of the former. The supreme architect and lawgiver of the universe, did not place farthing and rash lights in the extremities of his mighty system, and say to the spheres, foster these, and let them generate suns to preserve you life and light, and perpetuate the glory and splendor of your creation. But he commanded the sun into existence, that he should send forth his rays into the depths of darkness, at once to enliven the inert mass—and call forth from the latent elements exhaustive fuels, for his own beneficent rays.[85]

The astronomical logic of the editorial rationalized Jefferson's subversion of the primary school movement on terms concocted from Old Testament patriarchy and Newtonian astronomy—Jefferson's university would be the master spirit/sun generating light for the rude and detached spheres in the Virginian solar system. The editorial did not persuade Virginia's Presbyterian and Episcopalian clergy that the unclaimed money from the charity schools should be distributed to anyone other than William and Mary, Washington College, and Hampden-Sydney. These three colleges supplied many teachers to Virginia's academies, but did little to help the primary school movement because they wanted their share of the Literary Fund.

The question of public funding for Christian colleges was not resolved by the incorporation debate over Union Theological Seminary in 1815–1816 (see chapter 4). Unlike Union Seminary, the state's three denominational schools already had state charters granted during the colonial or revolutionary eras.[86] Jefferson advised Cabell in 1817 never to negotiate or compromise with the denominational schools in any way, especially given their lack of economic clout.[87] But by the 1820s the influential classes of eastern Virginia, historically associated with either the Anglican Church, deism, or religious indifference, began joining the Presbyterians and revitalized Episcopalians. Both churches' political strength increased.[88]

Cabell wrote to Madison that the Thomas Cooper controversy had united the Presbyterian and Episcopalian opposition. He warned him that any ideas Jefferson had about reviving the Cooper appointment would sink the project:

> The enemies of the Institution are gaining ground with the Bulk of the people generally thro' the state. The appointment of Dr. Cooper has enlisted all the religious orders of society against the Institution. You have not an idea how exceptionally unpopular Doctor Cooper now is in Virginia. I verily believe that 99/100 of the people of Virginia would now vote against him. Even all the free thinkers of my acquaintance about Richmond protest against him being made a professor of the University; all on the ground of policy, & some on the ground of principle. I sincerely believe that should Doctor Cooper be made president, it will cause the entire overthrow of the institution . . . . even as a professor . . . his support would be a reluctant homage to yourself and Mr. Jefferson.[89]

In 1821 John Holt Rice and other trustees at Hampden-Sydney petitioned for the leftover Literary Fund money from 1820. The legislature expressed interest in giving up to twenty thousand dollars annually to colleges and academies, but opposition by Friends of the University prevented the appropriation of any money.[90]

Hampden-Sydney had political support in Virginia south of the James River. They wanted the state endowment they never received at their inception in 1775–1776 because of the Revolutionary War.[91] In July 1821 their trustees appealed to the public by emphasizing the school's patriotic past, from its support of the rebel cause to its name, which refers to famous English whigs. A reinvigorated Hampden-Sydney would also bolster the region's economy.[92] They, too, needed public funds to build a beautiful campus. Cabell wrote Jefferson in August that the Presbyterians "now talk much of the University [of Virginia] in their synods and presbyteries," hoping to set up an establishment of their own control in order to prevent Unitarians at UVA from "overthrowing the prevailing religious opinions of the country."[93]

Episcopalian William and Mary was formerly an Enlightenment fortress, where Bishop Madison agreed with Jefferson's elimination of the divinity chair during the American Revolution.[94] After Madison's death William and Mary tried to reestablish the chair and planned to build a seminary (mostly Episcopalian) adjacent to their campus. Until 1824, the Episcopal Church refused to authorize the seminary because it did not want it contaminated with Williamsburg's reputed liberalism.[95] Episcopalians also joined forces with Rice to block Unitarianism and natural religion at UVA. In 1821 William Meade, Richard Channing Moore (bishop of the Episcopal Church) and John A. Smith (president of William and Mary) warned the *Richmond Enquirer's* readers that, while "without knowledge religion degrades into bigotry and superstition . . . without religion, the paths of learning are dark and cheerless."[96] Smith, William and Mary's president, wrote editorials pointing out that Episcopalians "were the friends of true philosophy" and that some of the greatest scientists, like Isaac Newton, were Christians.[97]

During the 1821–1822 political season Cabell stood firm on the idea that "religious opinions should form no test whatever for faculty hirings." But he and the UVA board understood they had to negotiate with the unified Episcopalians and Presbyterians. Board member Chapman Johnson agreed with Cabell that Cooper should be excluded from further consideration and that religious men should not be excluded. Cabell resolved to meet with both Bishop Moore and Rice, in order to assure them that clergymen would not be automatically excluded.[98]

Cabell met with Rice in January. Rice told Cabell that Presbyterians had heard rumors that Jefferson knew they feared Unitarianism, and that Jefferson was mocking the clergy in letters. He told Cabell the Presbyterians "desired no particular advantage," by which he meant that they would also tolerate Episcopalians. Cabell gave no promises and only assured Rice that "no desire existed any

where to give any preference to the Unitarians; and, for my own part, I should not vote against any one on account of his being a professor of religion or free-thinker."[99] Jefferson did not cave in and create a professor of divinity. Critics viewed the school as "not merely of no religion, but against all religion."[100] Most businessmen and planters who backed the Presbyterian and Episcopal churches were lost as allies in UVA's campaign for state money.

Jefferson made a direct plea for debt forgiveness to his son-in-law, Governor Randolph, in 1820, whom he knew backed plans for UVA.[101] A bill was introduced in the 1821–1822 session whereby the university was absolved of principal on debts to the state, and the interest on those loans was suspended.[102] The suspensions were important questions because the Literary Fund relied on interest from loans to UVA, as well as dividends from the James River Company, state banks, and the United States Bank. By 1821 UVA was paying over five thousand dollars in interest annually on nearly ninety thousand in loans.[103] The *Enquirer* urged the legislature to offset emigration and decline in Virginia's stature by committing itself to the university. Editor Ritchie wrote, "She [Virginia] must make up by the intelligence of her sons what she is losing in her census . . . N. Carolina, S. Carolina and Georgia all have schools. Let us avail of the assistance of Mr. Jefferson while he lives to give it."[104]

Those sympathetic to neither the university nor the religious schools argued that the Literary Fund was mismanaged and should be transferred back to the state treasury. At the beginning of the 1821–1822 session the Friends of the University obstructed any inquiry into the finances of the school and Literary Fund: "The motion to lay on the table [an investigation into the Literary Fund] was negatived," according to the *Richmond Enquirer*.[105]

Some legislators were willing to forgive all the debts if Jefferson and Cabell promised not to ask for more money, but Cabell turned down the offer, knowing Jefferson needed much more at this point.[106] Representative Richard Morris, of Hanover County (site of the Virginia Synod), was barely able to garner support for the university in his district the previous year, and blocked the transfer of the Literary Fund surplus to UVA. He relented after reading some of Jefferson's carefully worded letters that Cabell showed him distinguishing between the terms "remission" and "suspension of debt payments."[107] His support allowed for a compromise and another sixty thousand dollars was granted to UVA out of money the federal government owed Virginia from the War of 1812.[108] The motion to transfer the Literary Fund back to the general treasury passed the house, but was defeated in the senate.[109]

"What interest of our own . . . ought not to be postponed to this?" Jefferson asked Cabell.[110] Only after the funding for UVA's buildings was almost secure did he reaffirm his interest in primary education. Given the choice between higher and precollegiate education, Jefferson now disingenuously encouraged abandon-

ing the university, knowing full well the legislature could not quit the project with the campus half built. To Cabell, Jefferson wrote in favor of giving the elementaries priority over UVA: "it is safer to have all the people moderately enlightened than a few highly educated and the many in ignorance."[111]

Jefferson undoubtedly hoped Cabell would disagree and reassure him it was ethical to build the university first. Cabell obliged, expressing his fear that an acknowledgment of the importance of primary schools was premature, advising that "our most prudent course . . . is neither to enter into an alliance with them [advocates of elementary schools], nor to make war upon them . . . it would be difficult to imagine a state of things in regard to these other branches of the system more favorable to us than that which already exists."[112] Mindful of Cabell's sagacity, Jefferson acknowledged in his rejoinder it "would be better for the friends of the University to avail themselves of the temporary discredit brought upon the public-school movement by the extravagant proposals of some of its supporters until the University should be secure, then to come forward heartily as patrons of the primary schools."[113]

Jefferson's strategy of stringing out the legislature had mixed results, but was ultimately successful. Charges of elitism continued to plague university politics in the early 1820s. By October 1822, all the buildings were done except the Rotunda, which would house the library and provide the keystone to the inner lawn.[114] In the summer of 1822, Jefferson had an engraving of the campus made by New Yorker Peter Maverick to impress the legislators and deflect criticism. His granddaughter, Ellen Randolph Coolidge, made longhand notes about the pavilion facades along the top margin.

Copies were distributed at the capital in Richmond and sold to prospective students for fifty cents.[115] The Maverick engraving attracted interest in the buildings, but also drew attention to the Rotunda, UVA's next serious political liability.[116] From 1822 to 1824 bills that proposed either suspending or forgiving the university's debt generated controversy over the cost and design of the Rotunda.[117] Jefferson tried to downplay the Rotunda's rising tab in his annual Rector's Reports to the Legislature, but public debate centered on the cost and secular symbolism of its architecture.

Jefferson designed the Rotunda as a smaller replica of the Pantheon in Rome, a temple built by the emperors Trajan and Hadrian in the second century A.D. Jefferson followed through on an idea suggested to him by Benjamin Latrobe, who was then completing restoration of the U.S. Capitol (burned down during the War of 1812).[118] The design called for ten granite columns to hold up the portico, pine floors, and a circular skylight at the top of the dome.[119] Controversy surrounded not just the exorbitant cost of the structure, but also the predominance of the expansive, domed library at the expense of a chapel.[120] The Pantheon was, after all, a pagan temple dedicated to the planetary gods. Jefferson elevated

the intellectual above the spiritual in his temple, and its spherical design suggested an affinity with nature.[121]

The Rotunda had no chapel except for a small room located in the basement under the library set aside for worship, drawing, and music. The library, banished to the third floor at Jefferson's alma mater, William and Mary, was front and center at UVA, leaving no doubt that reason prevailed over revelation.[122] In Jefferson's design "the human is at the center, and the library is the mind of the university—the repository of wisdom, knowledge of the past, and ideas for the future."[123] The basement worship space was small and humble, representative of Jefferson's moderate Enlightenment philosophy.

Inspired by the Roman Seneca, who described a similar dome in Emperor Nero's Golden House, Jefferson wanted to paint the ceiling of the Rotunda dome sky blue, with gilt stars in their respective celestial positions. He designed a saddled roving seat propped on the end of a boom. Instead of designing a revolving floor underneath the dome, the lecturer could simply move the stars with the boom.[124] Nothing ever came of the idea that would have been America's first planetarium.[125]

Jefferson's enemies resented the cost of his Enlightenment temple, but so did some his supporters on UVA's Board of Visitors. In 1822 Chapman Johnson, a prominent and forceful attorney from Staunton, tried to "strike a bargain between the two parties" on the Rotunda issue.[126] He publicly vowed to withdraw his support for further funding unless the Rotunda received no more money.[127] At first, Johnson swung Cabell over to his and UVA proctor Arthur Brockenbrough's position that the board should go on without the Rotunda. Cabell wrote that he tried to resist the forces of compromise, "but the idea of the extravagance in the erection of the buildings, had spread far and wide among the mass; and even among a part of the intelligent circle of society."

Johnson wrote Jefferson himself concerning suspension of work on the Rotunda, a building he did not consider "indispensable to the commencement of the institution."[128] But the Rotunda was the keystone of the campus Jefferson had envisioned for decades. To Madison, Jefferson said of Johnson, "manage our dissenting brother softly; he is of too much weight to be given up."[129] Johnson eventually caved in, voting in favor of loaning more money without suspending work on the Rotunda.[130]

Another loyal board member, John Hartwell Cocke, was a fervent nondenominational Christian who appreciated the university's nonsectarianism, but questioned the Rotunda.[131] Cocke was a leading advocate in Virginia of temperance, slave evangelization, and agricultural reform.[132] At one point during the 1822–1823 session, Cocke tried to talk Cabell into a compromise that would have suspended UVA's debt only if the Rotunda's construction was stopped, but Cabell overrode him.[133]

Cabell had all he could do to overcome Johnson's and Cocke's influence on the board while bringing around reluctant politicians such as Bath County delegate Samuel Blackburn. Blackburn endorsed an amendment to that session's university bill that would have restricted expenditures on the Rotunda.[134] His motion failed, but Cabell reported strong opposition to the Rotunda among Federalists in Staunton and Richmond. Cabell considered compromising but changed his mind when reminded of Jefferson's wishes.[135]

Many legislators continued to question the management of the Literary Fund, but the university managed to get a third sixty-thousand-dollar loan, partly from the unclaimed charity school money, in February 1823.[136] Bursar Alexander Garret said that Jefferson received the news of the loan like a man learning of the birth of his first, long-awaited son.[137] By 1823 the university had three sixty-thousand-dollar loans on top of its fifteen-thousand-dollar annual apportionment.[138]

The unpopularity of the Rotunda, however, dried up private subscriptions to the school and galvanized those who opposed UVA's elitism.[139] The Board of Visitors had not squeezed a single cent in private subscriptions from the Shenandoah Valley or beyond the Blue Ridge Mountains and, without more money, the Rotunda could not be built.[140] On top of that, legislators suspected somebody embezzled money from the charity schools and clamored for a full investigation into the use of the Literary Fund.[141] Money owed by the federal government to Virginia was earmarked for the charity schools, but was never paid out.[142] According to one Richmond correspondent, the university was now the single most contentious subject in the legislature.[143]

The county charity school reports of 1822 and 1823 varied widely. Most counties used the money as vouchers to send poor boys to private schools, rather than building separate public schools. Some counties had leftover, or unclaimed funds, but there was no overall surplus of money for elementary schools in Virginia. Many commissioners (each county had five to fifteen) reported that they could do more with more money. Some commissioners wanted the power to coerce children into attendance. Brooke County officials hoped that mandatory attendance would produce "boys of talent from vagabonds, to become not only useful citizens, but even ornaments to society." Isle of Wight County had limited success, but some poor children were embarrassed to come to school with no food or proper clothing. Sunday schools got around this problem by opening their doors to all on a free basis and consequently got the upper hand on the public education system in Virginia.[144] The public charity schools' best successes were with middle-class farmers who could not afford private academies. Some counties reported that the program was very successful, and that many poor children attending the private academies were exceeding expectations.[145]

Newspapers in towns like Lexington and Lynchburg criticized the Rotunda

and asked where the money for charity schools went. A writer named "Virginius" noticed how the "voracious jaws" of UVA were swallowing up state funds:

> [I]n an effort to spew forth another generation of Washingtons, Madisons, Jeffersons [instead of] imparting elementary instruction to the poor and destitute . . . The Literary Fund . . . should not have been converted into perishing and useless finery [the Rotunda] . . . the architectural beauty of the school will lead to a corresponding display of furniture and dress among the faculty and students. It will lead to ostentatious pride, and will give this image to the rest of the country.[146]

The Lynchburg *Virginian* distanced itself from any personal attack on Jefferson implied by the writer from Lexington, but added that its views were "not dissimilar."[147]

As the charges of elitism increased, religious criticism subsided for two unrelated reasons. The first was John Holt Rice's departure from Richmond. Rice turned down the presidency of Princeton in 1823, but did accept the chair at Union Theological Seminary. Since the seminary was then located at Hampden-Sydney, he became less influential among politicians in Richmond.[148] For his part, Jefferson "manifested a good deal of anxiety" for the Presbyterians to locate their new seminary near Charlottesville.[149]

Second, Jefferson diffused opposition by inviting all denominations to build seminaries around the outskirt of UVA's campus on an equal basis.[150] St. George Tucker and Samuel Knox, the Maryland reverend Jefferson tried to hire five years earlier, both had suggested the idea.[151] Jefferson called for bridging the "chasm now existing" [between science and religion] by giving theological students "ready and convenient access and attendance on the scientific lectures of the university; and to maintain by that means those destined for the religious professions on as high a standing of science, and of personal weight and respectability as may be obtained by others from the benefits of the University."[152] Privately, Jefferson wrote that access to a sound education for ministers-in-training would "soften their asperities, liberalize and neutralize their prejudices, and make the general religion a religion of peace, reason and morality."[153]

Students, in turn, could attend any of the surrounding chapels. Jefferson hoped that the idea would silence charges that the university was not only irreligious, but antireligious.[154] He may have anticipated that jealousies among the sects, and their collective refusal to validate his experiment in ecumenicalism, would prevent them from accepting his offer. If so, he was right. No religious groups built seminaries or affiliated themselves with UVA until the YMCA in 1858, perhaps because each desired a monopoly. Cabell wrote, "Your suggestion regarding religious sects has had a great influence. It is the Franklin [rod] that has drawn the lightning from the cloud of opposition."[155]

A total of three hundred thousand dollars was spent on the academic village, with each pavilion costing around seven thousand dollars and the Rotunda run-

ning around two hundred thousand.[156] In 1824 the legislature, realizing it might as well finish what it had started and not bury UVA in debt, voted to cancel the school's debt and appropriate another fifty thousand for the Rotunda out of more money from the federal debt owed Virginia.[157] Jefferson now had enough money to complete the school under his own living supervision, but he still wanted another fifty thousand for books to put in the domed library.[158] White plaster and whitewash were used instead of marble facing on the columns to save costs, but the Rotunda was completed in 1826.

With the campus taking shape and religious opposition waning, Jefferson returned to the aspect of UVA he cared most about: politics. In the wake of the Missouri Crisis, Jefferson feared Federalist and Northern influence among the lawyers of Virginia's eastern cities, especially Richmond. He cared most about who would teach law and what textbooks would be used to teach government, law, and history. Jefferson compromised his spirit of academic freedom when it came to these delicate positions, though no more than his counterparts elsewhere or later.[159] Madison and Jefferson corresponded about which candidates were "converts to the constitutionality of canals" [National-Republicans] and which could provide a "nursery of Republican patriots" [Democratic-Republicans].[160]

UVA had a hard time recruiting a law professor who met its expectations. Aside from Thomas Cooper, who would have taught law along with science, Francis Walker Gilmer, Henry St. George Tucker, Philip P. Barbour, Dabney Carr (Jefferson's nephew), William Wirt, and George Ticknor (later professor of modern languages at Harvard) all refused offers before John Tayloe Lomax accepted the post in 1826.[161] Jefferson's and Madison's first choice was Gilmer, a lawyer and protégé of Jefferson's who turned them down, but later went to Europe to recruit faculty for the university.[162] Wirt, the biographer of Patrick Henry, wanted the law position in conjunction with the school's presidency, but UVA had no presidency.[163] Jefferson was willing to create a presidency to land him, but Wirt declined.[164]

For most fields, they wanted Europeans to teach. Jefferson may have feared the influence of Europe and the North, but he was not afraid to go into enemy territory in search of talent (just as he was not afraid to pluck the idea of local democracy and townships from Native Americans and New Englanders). UVA's bell was made in Boston, for instance, because that town was known for bell-making.[165] Jefferson wanted to go abroad to hire good scientists and mathematicians, since "even a second-rate European is better than an American."[166] As historian Joseph Ellis wrote, for Jefferson, Europe was "both a den of political iniquity and the cradle of all learning."[167]

Gilmer sailed out of New York in May of 1824, bound for Britain to recruit professors.[168] Dugald Stewart, a Scottish philosopher of the Common Sense school, was enlisted by Jefferson to alert Gilmer to any good prospects. Gilmer also carried a letter of introduction from Jefferson to Richard Rush, the American

minister in London.[169] New England newspapers, conscious of Jefferson's dislike of England, made fun of Gilmer's recruiting trip, and even the worldly Adams took issue with Jefferson's lack of patriotism. After Jefferson ruined the fortunes of some New England merchants by enforcing the embargo against England during his presidency, Yankee pundits saw irony in his turning there for fine minds.[170] Adams thought Europeans were too infected with orthodox religion to be of much use anyway, at least in comparison with the "more active ingenuity and independent minds" of America.[171] Jefferson hoped that at least his friend Edward Everett in Boston would understand: "I know the range of your mind too well ever to have supposed for a moment, you could view, but with contempt, the miserable sneers on our seeking abroad some of the professors for our university."[172]

Gilmer arrived home sick and died shortly after the voyage. Across the Atlantic he had ordered books for the library and hired five professors: George Long, ancient languages; George Blaetterman, modern languages; Thomas Hewett Key, mathematics; Charles Bonnycastle, natural philosophy, and Robley Dunglison, anatomy.[173] Jefferson wanted Americans only for the key ideological areas of politics, law, and moral philosophy. The only non-Europeans he tried to hire for other areas were scientists Cooper and John Patton Emmet (who lived in New York but was born in Ireland), and Nathaniel Bowditch, a prominent mathematician from Massachusetts who turned down the offer.[174] George Tucker, another American, was added at Madison's suggestion to teach moral law.[175] With the addition of Emmet, the faculty totaled seven.[176]

Tucker, cousin of distinguished judge St. George Tucker and friend of Ritchie's and Roane's, was an essayist, national politician, and novelist from Lynchburg, Virginia.[177] All the faculty were young, except Tucker, who was fifty when UVA opened.[178] Besides moral law, Tucker also taught economics and was knowledgeable on English and politics from his own experiences. In the school's early years, he carried the most weight among faculty in dictating the political climate.

Madison provided input for textbook selections in the sensitive areas of history, law, religion and politics.[179] Jefferson warned Madison that "Even . . . Mr. Gilmer . . . was believed by some . . . to be too much infected with the principles of the Richmond lawyers, who are rank Federalists, as formerly denominated, and now Consolidationists. I do not believe this myself . . . but now that he is withdrawn . . . I think it a duty to guard against danger by a previous prescription of texts to be adopted."[180] Madison concurred with Jefferson's general motives, but tempered his choice of political textbooks. He advised that prescribing textbooks had its drawbacks and suggested Jefferson was guilty of the same sort of orthodoxy he condemned in theologians.[181]

Madison did not quarrel with Jefferson's suggestions of Algernon Sidney and John Locke, "the basic sources for English republican theory," or the Declaration of Independence and *Federalists Papers,* but he thought reading neither would

guard against "unsound constructions." The *Federalist* (penned by Madison, John Jay, and Alexander Hamilton), although probably the most authentic exposition of the federal Constitution, "did not foresee all the misconstructions which have occurred." Madison thought that "neither of the great rival Parties have acquiesced in all its comments." He thought that their 1798–99 Virginia and Kentucky Resolutions would be dangerous to prescribe, "since not all members of even one party [Republican] had agreed upon their [states' rights] doctrines."[182] Jefferson took Madison's advice on adding Washington's valedictory address, but left in the Virginia and Kentucky Resolutions.[183]

Jefferson advocated John Taylor's states' rights manifesto *The Constitution Construed* to UVA's students just as he did to general readers. He also promoted interpretations of English Common Law that supported religious liberty and republican politics.[184] Jefferson was opposed to Sir William Blackstone's *Commentaries on the Laws of England* (1765–1769) and the *History of England* by David Hume because he considered both too pro-monarchical.[185] Blackstone could only be studied after exposure to less conservative commentators like Sir Edward Coke, or in an edition by St. George Tucker (a republican jurist) which included an appendix correcting Blackstone's erroneous principles.[186] When Jefferson told Madison that "it is in our seminary that the Vestal flame is to be kept alive," he was guarding against young lawyers who, thinking they were republicans, were actually tainted by Blackstone's Toryism.[187] As for Hume, Jefferson promoted a "revised" edition of his philosophical works by an obscure London democrat named John Baxter. Baxter's version left in most of the facts, but simply changed the political conclusions around to meet his liking.[188]

With the campus mostly done and the law and the textbooks agreed upon, Jefferson and Cabell faced one last legislative hurdle. In 1824–1825 they lobbied to prevent William and Mary from relocating to Richmond, where it would have provided more direct competition to UVA. The end of the Anglican establishment during the Revolution was hard on William and Mary, reducing its capital to little more than its real estate value. The school had most of its assets (western lands and surveyor's fees) divested and transferred to Transylvania College by Virginia's General Assembly in 1787.[189] It struggled through low enrollment and student rioting during the early nineteenth century.[190]

Some faculty and board members at William and Mary opposed the move, but Richmond leaders were enthusiastic about the proposal.[191] The Episcopal Church knew it could only strengthen its influence by proximity to the state's capital.[192] UVA supporters were concerned that Federalist politics in Richmond would be augmented by ties to the Episcopal Church.[193] Jefferson did not want UVA threatened by this "side wind."[194] He was especially concerned with competition to his proposed medical school in Charlottesville. The Friends of the University of Virginia countered the removal plan by introducing a bill into the assembly to

disband William and Mary and use its capital (one hundred thousand dollars) to establish and reinforce the network of ten feeder colleges. The feeder colleges, like what Jefferson envisioned in earlier plans, included Hampden-Sydney, Washington College, and a college in Williamsburg in William and Mary's existing building.[195] Jefferson and Cabell knew that their bill to abolish William and Mary would fail, but they could at least force proponents of removal to back down.

Jefferson's opposition to their plans cost him political capital. He had attended William and Mary himself and received an honorary doctorate from there in 1783. He had a role in revamping the school as a visitor in 1779. Dr. John Augustine Smith, president of William and Mary, corresponded with Jefferson about political textbooks in the previous decade, before writing his own.[196] The college wanted to use their endowment to improve their lot and move to Richmond. Jefferson's jealousy drove him to crush their initiative and actually propose breaking up the oldest college in the South, even though he and Cabell were alumni.[197] His threat to disband William and Mary ruined his friendship with Smith and further alienated Episcopalians.

Cabell was instrumental in getting Smith hired as president of William and Mary and always felt "somewhat delicately situated in regard to that seminary."[198] He waffled on the issue before backing Jefferson.[199] The exchange of letters between the understandably bitter Smith and Cabell included the usual charges of self-aggrandizement, elitism, and monopolization on the part of Jefferson that characterized editorials in Virginia for the previous five years. Smith reluctantly began to speak of Jefferson publicly "in a manner not calculated to gratify his feelings or to advance his reputation."[200] By his own account, Cabell himself was "assailed in the newspapers and vilified all over Richmond . . . the object of extensive & bitter obloquy." He asked Smith to reconsider his personal attacks on Jefferson and reminded him that he was caught in the middle, trying his best to "reconcile the duties of a friend with those of a patriot and a representative."[201]

Smith wrote back that Cabell's and Jefferson's "doctrines are directly hostile to the literary interests of the state. Of those interests I am one of the regular defenders. . . . The Friends of Science [or Friends of the University] are misguided . . . and are supported almost exclusively by [Jefferson]." Smith undertook an early revisionist account of Jefferson, "lowering a reputation which had heretofore cast a lustre upon Virginia . . . Mr. Jefferson's character will be exhibited in a light directly the reverse of that in which it has hitherto appeared."[202] Smith threatened to publish a pamphlet exposing the intrigues of Jefferson in the matter, but the strategy of the "Monticello men" worked well. As according to Jefferson's plan, the extinction and removal bills of William and Mary both died, and the college remained in Williamsburg.[203]

## Conclusion

Jefferson lamented his loss of popularity in the House of Delegates, but admitted privately he had manipulated the legislature for six or seven consecutive sessions.[204] Asked toward the end why he had not asked for all the money up front, he answered, "Do you think I am such a fool as to cram two hot potatoes down [their] throat at once?"[205] Jefferson was embarrassed when the quote was printed in the *Enquirer* and some loyal UVA supporters in the legislature were offended enough that they vowed to refuse any future grants.[206] He wrote Cabell that, more accurately, he was "discharging the odious function of a physician pouring medicine down the throat of a patient insensible of needing it."[207] The record shows, though, there was support for education at different levels of society, and among different parties. It was the cost of UVA's campus, especially the Rotunda, that Jefferson poured down the public's throat.

Conor Cruise O'Brien wrote that Jefferson's other interests helped him as a politician because they allowed him to "wait unobtrusively, for as long as necessary, and then pounce decisively."[208] The founding of UVA was an example of this attribute, except that instead of waiting for a single decisive moment, Jefferson persevered for a decade. During the last ten years of his life, the other interests that distracted him were not of the bucolic retirement variety. Aside from wondering about the American experiment as a whole, and his role in it, Jefferson was preoccupied with running his plantation, slavery, insurmountable debt, and physical decline. He also had concerns about his offspring by Martha Jefferson and Sally Hemings. Jefferson fought through those problems to achieve his goal of opening the University of Virginia in 1825, a year before his death. He was customarily confident that within twelve or fifteen years, "a majority of the rulers [of Virginia] will have been educated there. They shall carry hence the correct principles of our day."[209]

Jefferson's goal of using UVA as a bulwark of states' rights politics coincided favorably with controversy surrounding Missouri in 1819–1820. The silver lining in the Missouri cloud for Jefferson was that it helped the school get funded. Would UVA now indoctrinate generations of Southerners against a powerful central government? Would it foster a humanist and ecumenical approach to religion? Would the campus avoid the religious infighting and student rioting that plagued Princeton, the University North Carolina, Transylvania, and William and Mary in the early nineteenth century? Jefferson provided the vision, but after his death in 1826 it was up to UVA's faculty, administrators, and students to answer those questions.

# Early History of the University of Virginia, 1825–1845

❋

During its first twenty years, the University of Virginia continued to generate political and religious controversies, just as it had during its founding. UVA's early history embodied Jefferson's strengths and contradictions, but its story is connected to the broader political, religious, and educational history of the South before the Civil War. The institution suffered through the same rioting and disease epidemics as other schools, but avoided reverting to coerced worship. It was enriched by progressive pedagogy and exemplary architecture, but poisoned by slavery.

In two ways the school fulfilled Jefferson's expectations. His anti-North message was beaten like a drum into the ears of antebellum students, especially by alumni speakers. Likewise, his goal of avoiding denominational control at UVA was partially realized; religious worship was voluntary and pluralistic, but only within mainstream Protestantism. Protestant theologians played an increasingly big role on campus as the nineteenth century wore on. Ministerial candidates were given small scholarships beginning in 1837.[1]

Before Jefferson died in 1826, he reminded his successor as University Rector, James Madison, "It is at our Seminary that the Vestal flame is to be kept alive [republican principles] . . . it is to spread anew over our own and other states."[2] Madison replied, "You do not overrate the interest I feel in the University, as the Temple thro' which alone lies the road to that of Liberty."[3] Madison, who oversaw the school until he died in 1836, shared Jefferson's view that UVA should be a "nursery of Republican patriots as well as genuine scholars."[4]

Their goal of inculcating states' rights ideology succeeded beyond their expectations prior to the Civil War, but the planters' sons who studied in Charlottesville were overly conscious of their republican rights. The rich students resented being

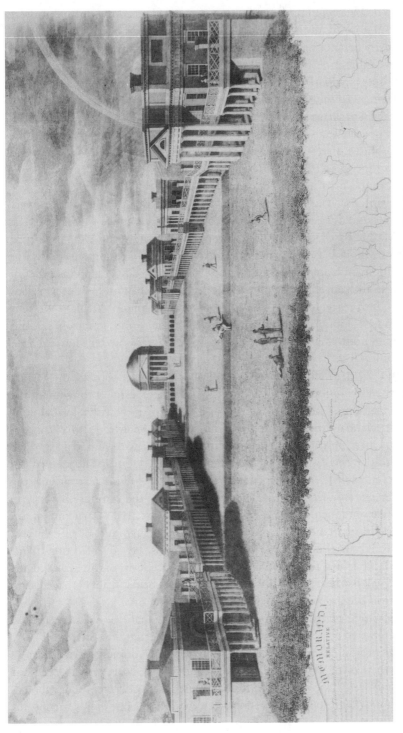

Benjamin Tanner's Engraving published on 1827 Herman Böye Map of Virginia. The sunbursts and rainbows evoke Enlightenment learning. *Courtesy of University of Virginia Library Special Collections.*

told what to do by foreign professors and were angered when the Europeans were too respectful toward the slaves and free blacks who serviced the university. Jefferson's early reliance on self-discipline to maintain order backfired. One professor was even shot by a student in 1842.

Three things in particular are emblematic of the challenges the university's administration faced in its early history: a typhoid epidemic in 1829 that resulted in an evangelical backlash against UVA; the political volatility of alumni and student society speeches; and the musket rebellion of 1836, which symbolized the students' absolutist understanding of natural rights. The epidemic, speeches, and rebellion warrant special attention, but are best understood in the everyday context of life "on the lawn" (the inner courtyard).

By the winter of 1824–1825 the campus was taking shape and professors were hired. The Rotunda was unfinished, but the library was moved there after the first year. Marble bases for the Rotunda arrived from Italy and were exempted from over two thousand dollars in import duties. Low water and icy conditions prevented shipment from Richmond, so they were dragged by wagon instead. On his last visit to the campus, in April 1826, Jefferson watched as the four-ton slabs were hoisted into place, followed by the columns and capitals.[5] William Wertenbaker, a student appointed librarian, brought a chair, and Jefferson sat and watched for an hour. When the capital was in place he mounted his horse, Eagle, and rode home.[6]

Jefferson was naturally proud of the campus.[7] In November 1824 the French hero from the Revolutionary War, Marquis de Lafayette, came through Virginia on his American tour. Jefferson, Madison, and Lafayette rode with a formal military escort in a landau from Monticello to the campus.[8] An introductory toast described UVA as a "future temple of literature and science." When Jefferson's speech was read at the Rotunda, "the General was moved to tears; he grasped the hand of the venerable friend who penned it, and sobbed aloud."[9] A reporter at the time for the *Charlottesville Central Gazette* wrote that "the campus charms . . . from the solitary grandeur which it exhibits, and the waste and destruction of the social and political elements, with which it has been surrounded."[10] Lafayette himself detected social destruction within the campus. He confided to a friend from Norfolk, Virginia, that "even as I enjoyed the reception a most afflicting intelligence struck my heart: the only remaining evil of British entail—negro slavery, had not yet been removed."[11]

Another visitor, Harriet Martineau, noted privately that "the evil influences of slavery have entered in to taint the work of the great champion of freedom . . . these ladies [professors' wives], seeing apparently only domestic slaves kindly treated like their own, spoke lightly on the great subject, asking me if I did not think the slaves were happy; but their husbands used a very different tone, observing, with gloom, that it was dark question every way."[12] Lafayette's and Martineau's

misgivings were prescient, since slavery and states' rights emerged as political issues on campus and the school operated, in some respects, like a plantation.

The students who came to Charlottesville in the mid-1820s were used to plantations. Northeasterners in Congress expressed fears that their young men would be attracted to the university because of Jefferson's fame and become reconciled to slavery, but almost all the students were rich Southerners.[13] University historian Philip Alexander Bruce wrote that "by 1842 not a single mansion of distinction in the social life of Virginia, during those years, failed, at one time or another, to be represented in the person of a student within those stately precincts. To call the roll of their names is to call the roll of families who have deeply stamped their virtues and their talents upon every aspect of the state's history during the long interval,—now serene, now stormy,—that followed the Revolution and preceded the Civil War."[14] The 1825 role included names like Brockenbrough, Carter, Cary, Harrison, Mason, Lee, Marshall, Page, Randolph, and Tazewell, among others.

UVA was the most expensive school in the nation prior to the Civil War.[15] Consequently, the charges of elitism that hounded it in the early 1820s continued long after it opened.[16] Lectures were open to the public, but the students were wealthy. Some of the more democratically minded students argued that if tuition were lowered, the increased enrollment would offset the cost of the decrease.[17] Other students were less generous. In 1845 the legislature began to examine the cost problem again, inciting UVA alumni to complain about those "who promise to reform whilst seeking to destroy, and pretend friendship for the poor in efforts to take from those whose circumstances enable them to command the privileges of a thorough education."[18] In response to the criticism, scholarships were given to poor representatives from each of the thirty-two senatorial districts, which spread the distribution of students around the state.[19] This small token was the only effort ever made to revive the spirit of Jefferson's 1779 bill, and the scholarship winners from the senatorial districts were still the sons of average planters or merchants.[20]

No agricultural school was established either, even though Jefferson and board member John Hartwell Cocke had wanted one.[21] Jefferson also wanted to build manual training workshops where artisans and UVA students could use the tools for free, while craftsmen attended lectures on campus for free—an idea similar to the one Samuel Knox advocated for religious seminaries in 1822.[22] Neither idea ever came about, but for formal and professional education Jefferson's college was the best in the South. Its students got a relatively unstructured, scientifically progressive education, with no religious coercion.

UVA's best feature was its use of the lecture method, as opposed to rote memorization and recitation. The lecture method was cutting edge at the time and more effective.[23] Jefferson learned of it from William Small at William and

Mary. The medical school was slow to take off, but its existence set UVA apart from most colleges of the time. Dr. Robley Dunglison, twenty-six in 1825, was the first full professor of medicine at an American university. His building, near present-day Alderman Library, was built with a skylight rather than windows so the public would not gaze in.[24] The law school was also good, educating future leaders in Virginia and the nation.

In the fall of 1824 the board drew up regulations for the university.[25] Along with George Ticknor at Harvard, Jefferson adopted the elective system originally initiated at William and Mary in the eighteenth century.[26] All of UVA's classes were electives, since Jefferson opposed general requirements. These ideas were ahead of their time because Princeton and Yale, with their more traditional curriculums, still set the pace by influencing the new colleges of the South and West.[27] Students could receive a graduate diploma by studying in any one school for at least a year, and then undergoing a public examination in the Rotunda.[28] Students did not limit themselves to one subject, despite the seemingly narrow graduation requirements. In the public exam they had to demonstrate proficiency in wide-ranging topics such as the use of cadavers, Lavosier's theory of (oxygen) combustion (pro and con), the effects of alcoholism, a description of Virginia, and arguments as to whether or not capital punishment should be public or private and whether or not classics should be studied in translation.[29]

Higher degrees were obtained only by a select few after doing the same, and demonstrating proficiency in Greek and Latin in additional public exams. Jefferson's unstructured degree program was typical of Continental Europe, but most of the faculty were British and were used to operating on the traditional bachelor-master-doctorate model.[30] After 1831 a more traditional degree program and core requirements came into being.[31] Most students studied languages and math during the first year, and law or medicine the second.[32] Jefferson wanted to improve commercial, diplomatic, and scientific relations with foreign countries by learning their languages and literature. Instruction in Continental European literatures and Anglo-Saxon (Old English) was strong, but no instruction of modern English literature was offered.[33]

Jefferson was unable to donate his own library because of his indebtedness.[34] Instead he took the fifty thousand dollars granted by the Virginia legislature for a library and opened an account with a bookseller in Boston. He worked for months, compiling a list hundreds of books long dealing with history, law, religion, ancient literature, and science. His choice of library books emphasized republican and whig politics, similar to his textbook selections (see chapter 5). Robert Molesworth's *Account of Denmark,* for instance, was chosen because it stressed the negative implications of the Danes' transition to an absolute monarchy in the mid-seventeenth century.[35] The theological works chosen by James Madison ranged from early Church fathers to Aquinas, Erasmus, Luther, Calvin, Newton,

Pascal, Hooker, Leibniz, Paley, Penn and Wesley. Other topics included the Council of Trent, Moravians, Lucifer, and "astrotheology."[36]

Local people donated books and two boxes were sent by the British government. Each professor donated volumes of his own and Madison contributed over one thousand volumes when he died in 1836. Once a week a student librarian came to check books in and out. There was no due date on books and students often hoarded them in their dormitories. Some of the most popular books were those by Miguel de Cervantes; William Shakespeare; and the English historian of Rome, Edward Gibbon.[37] Cervantes's *Don Quixote* was the only work of modern fiction listed on Jefferson's original catalog for the university. Since Jefferson loathed romanticism, the new "cult of intuition," he would have been distressed to learn that the most popular author overall (if one includes local sales and library rentals) was English poet Lord Byron. Concerning romanticism, Jefferson wrote disdainfully to Adams that "every folly must run its round."[38]

After a storm-delayed passage through the English Channel and across the Atlantic in 1824–1825, the lecturers arrived in Richmond, where Joseph Cabell introduced them to the legislature.[39] For faculty, Jefferson wanted some leading minds of Europe, including George Pictet (scientist from Geneva), Dugald Stewart (philosopher from Edinburgh) and Jean-Baptiste Say (political economist from Paris), but none agreed.[40] The five young professors Francis Walker Gilmer recruited on his trip to Great Britain in 1824–1825 joined Americans John Patton Emmet and George Tucker, the professor of moral philosophy (see chapter 5). Both were ratified by the board in March. UVA also lured geologist William Barton Rogers from William and Mary in 1835. Rogers served as chair of natural philosophy and conducted pioneering research on the structure of the Appalachian Mountains. (After leaving UVA in 1853, Rogers moved to Boston and started the Massachusetts Institute of Technology in 1861).[41]

UVA did not have the normal administrative hierarchies of schools like William and Mary.[42] There was no president and each of the seven faculty members served as chairman for one year. They were referred to as "Mr.," but not "doctor" or "professor." During his year in the rotation, the chairman was the highest presiding administrator at UVA.[43] Even though they had almost no collective teaching experience, the professors were paid fifteen hundred dollars per year, plus thirty dollars per student for their classes, a very respectable amount for the time.[44] Being administrators and disciplinarians made their jobs hard, though, and even dangerous.

The University of Virginia opened its doors unceremoniously with three of the ten pavilions (and professorships) vacant and no textbooks on March 7, 1825. The faculty began teaching classes to about thirty students. Twenty or thirty more arrived by the end of the first month, and by May there were nearly eighty students.[45] Enrollment during the first five years peaked at 177, in 1826.[46]

Getting to Albermarle County from anywhere but the central part of the state was not easy in the 1820s. Trains were not around until the 1830s, but stagecoaches serviced the area in dry weather.[47] A hack (a durable but simple coach) was commissioned to go to Richmond from Charlottesville once a week to pick up students. The young men slept in the coach or at a tavern while waiting for the return route to Charlottesville on Sundays. From the west, public coaches traversed the Allegheny and Blue Ridge Mountains; from the northeast coaches wound through Fredericksburg, Spotsylvania, and Gordonsville on the way to Charlottesville. Students from southern Virginia and the Carolinas came through Lynchburg.

No one under sixteen was allowed to attend unless accompanied by an older brother.[48] All of the students under the age of twenty were required to live on the lawn. The 108 dormitory rooms were built for two and cost seven dollars and fifty cents, or fifteen dollars per year, depending on whether the student lived alone or with a roommate.[49] Tuition for one year was set on a sliding scale: one class cost fifty dollars, two cost sixty, and three cost seventy-five.[50]

The campus that greeted the young men was as nice as the plantations on which most of them had grown up. With the Rotunda near completion, the lawn of the University of Virginia now stood as one of the most impressive architectural accomplishments in the United States. The red brick buildings blended well with the whitewashed columns and green grass in the arrangement of a Roman villa.[51] George Ticknor, a Jefferson correspondent who later presided over Harvard, visited the campus with Massachusetts Senator Daniel Webster in 1824. For Ticknor the campus was "more beautiful than anything architectural in New England, and more appropriate to an university than can be found, perhaps, in the world."[52] Jefferson must have savored Ticknor's reference to New England. UVA's symmetrical layout, moderate proportions, and intricate landscaping make it a monument to neoclassical architecture.[53]

Some observers disapproved of UVA's campus, just as they had since its construction began in 1817. One critical (and prophetic) editorial predicted that the intimate architectural layout would lead to disciplinary problems. The professors in the pavilions were exposed to the "playing of pranks upon them. The professors will fear the students more than the students fear them."[54] Editorials questioned the strategy Jefferson proposed for self-discipline.[55] In 1816 Jefferson wanted each professor to have legal rights of policing and imprisonment over his adjacent dormitories, but the legislature rejected the idea.[56] UVA's board would expel students for serious infractions, but otherwise wanted the students to police themselves. The professors lacked real power because their rule was contingent upon self-incrimination among the students.[57]

Jefferson was aware of the rioting that pervaded early American colleges, and that the rioting was often blamed on Jeffersonian "irreligion."[58] He wrote Ticknor

in 1823 that "the rock which I most dread is the discipline of the institution, and it is that on which most of our public schools labor."[59] Jefferson was optimistic, though, that the best way to control young men was to appeal to their personal sense of honor and maturity, minimize their supervision, and rely on their own moral instincts (see chapter 3). To Jefferson's credit, schools that used more traditional techniques had not demonstrated success by 1825.

The faculty realized during the first year that the students were not prepared academically for their curriculum. Students were confused by the lack of structure and were too inadequately trained in classical languages to study most of the topics. History, one of Jefferson's most cherished subjects, was mainly taught in Greek and Latin.[60] Two-thirds of the students dropped out after the first year.[61] The code of self-imposed discipline he envisioned and the architecture he designed for interaction between faculty and students led to unrest within months of UVA's opening. It was Jefferson's precocious seriousness and intellect which had allowed him to hobnob with professors, lawyers, and governors as a teenager. That experience could be encouraged by architecture but was hard to replicate on a mass scale.

Jefferson died in 1826, one year after UVA opened. He enjoyed hosting students for dinner on weekends, which many remembered fondly because of Jefferson's informal and hospitable nature.[62] Unfortunately, the respect the students paid the elderly statesman did not carry over to their treatment of instructors. Soon after the school opened, in June 1825, fourteen drunk students wearing masks broke pavilion windows up and down the lawn, chanted "down with European professors," and threw a large bottle of their urine through Professor Long's window.

The board and faculty wanted to crack down and instate more orthodox rules. John Hartwell Cocke pleaded with Joseph Cabell to get the "old sachem's" [Jefferson's] consent to reform UVA's regulations.[63] Henry Tutwiler, a student at the time who later taught at UVA, recounted a dramatic student trial where Jefferson met with Madison, Monroe, and the rest of the board in front of the student body. Jefferson said it was one of the most painful experiences of his life and broke down emotionally, unable to go beyond his introductory comments.[64] Chapman Johnson took over from there and cajoled some of the guilty offenders to come forward and confess.[65] The guilty were expelled from the university. Pouring salt in Jefferson's wound, his great-great-nephew—Wilson Miles Cary—was identified as the ringleader and was the first to be dismissed.[66]

The Old Sachem was sadly persuaded that his experiment in self-discipline, combined with intimate living quarters, was a bust. Luckily the spirit of his plan, with its strategy of exploiting an individual's sense of honor for positive purposes, was rejuvenated in the early 1840s with the idea of self-proctored exams.[67] Jefferson's philosophy of innate morality was not formally taught at UVA, but it lived on in this traditional code of honor.

The students had no interest in self-incrimination nor respect for the professors, but they did have a healthy appreciation for the spirit of the American Revolution. Bolstered by the libertarian politics they learned, their spirit was marked by an obsession with personal rights and a propensity for mob violence. They came by those traits honestly. Virginians were notorious for their rebellious behavior at Princeton (the College of New Jersey). Bolstered by democrat Thomas Paine and skeptic David Hume, Virginians there protested against Presbyterianism, Federalist politics, and Enlightenment philosophy.[68] Joseph Cabell Breckinridge complained to his mother after the Princeton uprising of 1807 that the students were unable to assemble in political clubs and that the faculty were "unjust, tyrannical, and unaccommodating."[69] Protests were articulated in the language of republicanism, "rhetorical parallels to the Stamp Act Resolves, the Declaration of Independence, the Bill of Rights, and the Kentucky Resolutions."[70]

On Jefferson's campus, likewise, republican texts that stressed students' rights were assigned. The students articulated the rationale for their misbehavior in revolutionary language, but basic Southern honor also contributed to problems between students and faculty throughout UVA's early history. Aside from being concerned with oratorical and forensic skills in political debates, scholars have noted that wealthy Southerners possessed a code of honor that "encouraged an emphasis on personal confrontation, a passion for the perquisites of position, and a commitment to social distinctions."[71] The boys were spoiled brats but skilled in defending their right to be that way.

The students disrespected the authority of the professors partially because foreigners did not understand the subtleties of Southern honor. The American faculty were not effective disciplinarians either. When the two American professors (John Patton Emmet and George Tucker) tried to break up the June 1825 disorder on the lawn, they were assaulted with bricks and canes. The following day the students were outraged at Emmet and Tucker for pulling the shirts of the students when they attacked the professors! Sixty-five students signed a resolution denouncing the faculty.[72]

In Virginia in the 1820s, assaulting one's professor was considered by some a natural right, but neither the disgruntled Jefferson nor the rest of the board accepted the students' complaints. After the bottle-throwing incident in 1825, Jefferson and the board regulated all aspects of the students' everyday behavior. Even before the riot no student could have his own gun, horse, dog, or slave on campus, and dueling was forbidden.[73] Now bedtime was set at 9:00 p.m. and the students were not allowed a break over Christmas.[74] Money had to be stored in the bursar's office.[75]

These rules alienated the rich youth who were used to the freedom of living on a plantation and issuing, not taking, orders. They did not deem anyone but their parents qualified to tell them where and when they could conduct their activities,

certainly not professors alien to their way of life.[76] And of course they did not respect the black dormitory servants whose job it was to get their day started. The day started early, usually at dawn or just before.[77] Since servants and slaves rang the bell and enforced the wake-up call, sentinels were used to warn oversleepers of their approach, and booby traps were set up to pour water on their heads inside the doors.[78] The boys resented the wake-ups and were often crabby at that early hour, so they commonly molested the blacks. Since the help had to clean the dorms anyway, the students spit tobacco juice on the walls.

The boys spent so much of their parents' money competing against each other for the fanciest clothing that the faculty and board had to implement a uniform rule. The school was fighting against its elitist image and they were embarrassed by the ostentatious clothing worn by the boys on trips to Charlottesville and Richmond.[79] Most faculty agreed that English-style caps and gowns would look ridiculous in such a republican setting, but Madison, who always wore black, wanted caps and gowns of the same color for the students. Instead it was agreed the boys should wear a gray (or salt-and-pepper) coat, waistcoat, and light-brown pantaloons with a round black hat (similar to a minister's). Gaiters were required in the winter and white socks in the summer. The uniforms were mandated for Sabbath, exams and, most importantly, whenever a student left campus for any public occasion. For accessories the young men were allowed to wear satin and silk scarves and socks. They carried canes and elaborate snuff and cigar boxes. In the 1830s the boys wore pumps nicknamed "nullifiers" after South Carolina Senator John C. Calhoun.

The students enjoyed showing off the uniforms when away from campus, but they resented being told what to wear on campus. They rebelled against the rule, just as they did against mandatory hours and the food.[80] The students ate in separate hotels located behind their respective dormitories, which were run by private businessmen.[81] The hotel keepers not only fed the students; it was usually the keepers' own slaves who cleaned pots and bedding and repaired furniture in the dormitories. Their total charge to the students could not exceed one hundred dollars a year.[82] Students could go to an inn if the temperature fell below zero.[83] Usually when it was cold the students just dragged the sheets off their beds, nearer to the fireplace.

Jefferson understood that the way to learn foreign languages was everyday usage, so he wanted all the hotel keepers to speak French, which the students would have to speak while eating at each meal. The language plan never took root, but since initially the hotel keepers competed with each other, the students ate fairly well, despite their complaints about the monotony of the offerings. Other students smuggled food into their dorms purchased from enterprising black children.[84] Since any student could go to any hotel, the hotel keepers bribed the students and gambled and got drunk with them. There was also no real recourse for

the hotel keepers when they conflicted with students, though. One keeper named G.W. Spotswood called a student a "puppy" for not getting out of bed on time, and the student attacked him with an iron shovel. Since UVA needed tuition more than hotel keepers, the student was not expelled.[85]

Jefferson demanded that students exercise for two hours each day, and the students supplemented that with ice-skating, marbles, or pitching quoits (small rings thrown around upright pins). Participation in martial exercises was required of everyone, a suggestion Jefferson made in the Rockfish Gap Report, against Madison's wishes, to combine physical fitness with military preparedness. The military company paraded through Charlottesville on the Fourth of July and Jefferson's and Washington's birthdays.[86] In 1836 UVA's militia even tried to secede from the University of Virginia.

At one time or another, the students rebelled against all the strictures that regulated their everyday lives. When the faculty enforced the rules, it only amplified the students' proclamations of tyranny. Thus, students threw dangerous projectiles at the professors when they wished, blocked their coaches to Richmond in the middle of the night, and hurled drunken slurs at them on the steps of the Episcopal Church in Charlottesville.[87] It was not uncommon for a boy to attack a professor in the classroom.[88] Another student was dismissed when he shot at a tavern keeper in Charlottesville. Professors George Long (ancient languages) and Thomas Key (mathematics) saw enough during the first year and submitted their resignations, but were talked out of it by the board.[89] The students then threatened to continue flogging the professors if they protested to the board.[90] Emmet's pavilion was broken into.[91] Another professor was given a good "drubbing" and "sent off" when he tried to obstruct their vandalism.[92] Professor Gessner Harrison, Edgar Allan Poe's professor of languages and literature, was horsewhipped by two students as others stood around and watched.[93]

Poe was socially typical of the aristocratic youth who arrived in the first years. During his one year at UVA, the young genius from Richmond devoured works of history and French literature.[94] Poems like "Tamerlane," "William Wilson" (both 1839), and "A Tale of the Ragged Mountains" (1844) reflect his time at the university. In 1826 he began to imbibe "peach and honey" (homemade peach brandy)[95] and ran up a gambling debt of twenty-five hundred dollars.[96] His debts forced him to withdraw from school and go to work for his stepfather.

Gambling and drinking were two recreational staples. Brandy, eggnog, and mint julep were favorite drinks among the students. Dueling occurred only rarely, and usually off campus.[97] The students were white, but their pastimes were multicultural. Their favorite outlet was to don masks, get drunk, dance in the manner of Indians around a fire, and mimic slaves by singing the "corn songs" they learned on their plantations.[98] They carried weapons, stole slave cadavers from the medical school, tortured cows and chickens, and gambled on horses, cards, and cockfights.[99]

Small riots similar to that of 1825 happened again in the fall of that year, and routinely in the early 1830s.[100] In 1826 Poe wrote home that factions from Richmond and Norfolk often faced off against each other, and when the local sheriff came to quell disturbances the guilty parties would retreat into the mountains.[101] When faculty tried to break up a disturbance on the lawn in 1832, the students aimed their guns at them and told them to retreat amidst a barrage of stones. It was the students' way of protesting the uniform rule. Later that summer they attempted to smoke out the pavilion that the Board of Visitors were staying in.[102]

In 1833 the students called a meeting to resist the "late tyrannical movements of the faculty." The source of the complaint was a decision on the part of the board to ring the college bell whenever there was a riot, intending that as a signal for everyone to retire to his room. On top of everything else, the board was now interfering with students' right to riot. The faculty then violated their freedom of assembly. They barricaded the entrance to the room where the students planned to hold their meeting (Hotel C, present hall of the Jefferson Society), and the students tore down the door. The young men warned that if anyone was punished for destroying the door or holding the meeting, the entire student body would withdraw.[103]

The European professors had difficulty adjusting to the students' exaggerated sense of honor and to slave culture, but eventually they acculturated. Most of the professors built quarters and kept slaves under yoke.[104] Slaves were so integral to the original construction of the university that during some years in the early 1820s the hiring of slave craftsmen constituted the majority of expenses.[105] Their role continued after UVA opened. The cost of one slave usually ran between five and six hundred dollars, but as many as four were an acceptable number for each pavilion.[106] Each slave and servant was licensed by the university proctor.[107]

Free and slave black men and women serviced the university as janitors, cooks, carpenters, gardeners, nursemaids, and laundresses/seamstresses. Pendleton Hogan, historian of the lawn, wrote that "servants built fires before dawn, exchanged ashes for fire-wood, brought shaving water (which sometimes froze on the way), polished mud-caked boots, and, while students were in class, made beds, swept dried clay from floors, "damp-wiped paint work," and scoured rooms.[108] To top it off, blacks also "played the fiddle for the waltz and reel at hotel balls."[109]

The students did not own slaves, but every afternoon the slaves of hotel keepers or professors ran errands for students in Charlottesville, after taking instructions at exactly 2:45 p.m.[110] There were rumors of students keeping slave mistresses every year and, in the late 1820s, a white woman and free black man from Philadelphia ran a brothel on the southeast side of campus.[111] Though the faculty prevented free blacks from residing within the hotels, there was a settlement just south of campus called Venable Lane.[112] The white students were forbidden to

keep firearms, but most carried a pistol, knife, and cowhide. The slaves, free blacks, and professors understood this, and usually submitted on the occasions students chose to beat or berate them.

The threat of abuse was usually enough. Science and math professor Charles Bonnycastle tried to stop the pounding of his slave, Fielding, who mouthed off to two students. He was told by student Madison McAfee of Mississippi that "anyone who would protect a negro as much in the wrong as Fielding was no better than a negro himself," and that Bonnycastle would be whipped if he persisted.[113] If a hotel keeper sided with an African American in a dispute, he too could be whipped. More common was for the students to yell or chant at the servants and throw food at them.[114] Nothing much was done because it was mostly these boys' fathers, not the legislature, board, or hotel keepers, who paid the bills.

The politics of the university were shaped by the faculty, the student body, their parents, and the legislature. At most colleges of the time, the critical position for religious and moral instruction was the professor of moral philosophy. Customarily the president of the college taught the course to seniors. John Witherspoon of Princeton, for instance, taught Scottish Common Sense philosophy to James Madison and poet/democrat Philip Freneau during their last years there.[115] UVA's professor of moral philosophy, George Tucker, was also a political economist because of his own background as a politician.

He and law professor John Tayloe Lomax occupied the two posts most important to Jefferson.[116] The law professor could not be a supporter of John Marshall and his Federalist Supreme Court (see chapter 5).[117] Lomax preached strict constructionist interpretations of the Constitution, as did his successor John L. Davis.[118] Davis built his political doctrine around the Virginia and Kentucky Resolutions of 1798–1799 and taught his students to deny the supremacy of the Supreme Court over the states.[119]

Tucker served as faculty chairman of UVA three times between 1825 and 1833.[120] He taught ethics/metaphysics, political economy, statistics, and *belles-lettres*. As a moral philosopher Tucker defended the rationalism of Locke, Newton, and Franklin and taught the same Common Sense philosophy that was prominent throughout late eighteenth- and early nineteenth-century America.[121] For Tucker, Enlightenment philosophy and liberal Christianity merged perfectly.[122] In this way he partly satisfied the philosophical spirit of Jefferson's Rockfish Gap Report.

Politically, Tucker preached qualified free market economics and opposed president Andrew Jackson's attack on the National Bank.[123] He assigned Jean-Baptiste Say's *Political Economy* and advocated a group of three national banks.[124] He lectured against the American System of tariffs and funding for infrastructure proposed by Kentuckian Henry Clay, Virginian James Monroe, and many Northerners. Like many Southerners, Tucker thought trade barriers would discourage the English from buying Southern cotton, and that Americans should learn to

manufacture products more cheaply rather than having competition from European imports artificially precluded.[125]

As a child in Bermuda, Tucker was taught math by a young slave, and he doubted the inferiority of blacks. Later, though, he defended the extension of slavery into Missouri as a congressman.[126] Like Jefferson, he stressed the environmental detriments of slavery to blacks and whites, but feared emancipation would lead to a race war.[127] Tucker nonetheless taught his students (many the sons of slave owners) that slavery led to a lack of industriousness, and was why the Northern states had economies superior to those of the South.[128]

Tucker ended up being too cosmopolitan for antebellum Virginia.[129] In 1837 he compiled his lectures and published an amoral economic critique of slavery, based on elaborate calculations of wages, profits, rents.[130] After he returned from abroad to UVA in 1839, he found that his views against slavery and in favor of schools, manufacturing, and centralized banking were out of step with the state's public. Before he retired in 1845, he became very unpopular by arguing that slavery and tobacco cultivation were an inefficient use of land and labor.[131] Despite opposing abolitionism, he hoped that the exhaustion of soil would provide the "euthanasia of slavery."[132] In 1845, he freed his own five domestic servants. Then, as on old man on the eve of the Civil War, Tucker became an apologist for slavery. Before he left UVA in 1845, Tucker had impressed some fairly diverse political economy upon his students.[133] But like Jefferson and Thomas Cooper, Tucker lost much of his idealism with age.

Tucker and other professors at UVA discouraged the reading of newspapers (one of Jefferson's pillars of citizenship), hoping to inculcate basic republican ideology without stirring up genuine debates or passions.[134] After the tumultuous political years of 1829–1831, which included a constitutional convention in Richmond and Nat Turner's revolt against whites in southern Virginia, the faculty acted to snuff out controversial debates more formally. Student newspapers within the confines of campus were instructed to avoid controversy. *The Chameleon* (succeeded by *The Collegian*), which ran from 1831 to 1842, dealt mainly with lightweight topics. When students dealt with politics and religion, it was discouraged by the faculty and board.[135] The professors also tried to diffuse Northern hostility toward UVA through a quarterly publication called *The Virginia Literary Museum and Journal of Belles-Lettres, Arts, Sciences, Etc.,* but had difficulty. It was dropped because Northerners were uninterested in its neutral scholarship, which avoided partisan politics and religion.[136]

Less shy were the students' own political societies and the anniversary and alumni orations on campus. These sources tell us more about UVA's political environment than the faculty publications and student newspapers. Oratorical skills were valued in the early nineteenth century and, in response, the students formed debating societies as soon as UVA opened. The Patrick Henry Society, named

after Jefferson's nemesis, met to hone their forensic skills and talk politics. Rival societies named after Jefferson and Washington also formed. Though most were Democrats, the students detested the nationalism and military despotism of Andrew Jackson. They preferred states' righters Calhoun and William Crawford of Georgia as Democratic leaders.[137]

The faculty restricted public discussions by the societies to relatively neutral topics at gatherings on Washington's birthday and the Fourth of July. These talks included parallels between Washington and Napoleon Bonaparte, comparisons between the principles of ancient Greece and Rome and those of Great Britain and her North American colonies, the United States' policy of western expansion, the character of North American Indians, the effects of climate on national character, policies of manufacturing, and the influence of the American Revolution on the rest of the world.[138] The students preferred more local and volatile topics and ignored the guidelines.

The trouble began after the Virginia constitutional convention of 1829–1830, when emancipation was discussed, along with suffrage reform and reapportionment of the legislature.[139] On Jefferson's birthday in 1832, a student named Merit Robinson spoke in favor of emancipation and quoted Washington and Jefferson espousing similar positions.[140] Most of the faculty disapproved because the university was supported financially by slaveholders, and they now owned slaves themselves. Thereafter, the faculty screened all public speeches by students for volatile political or religious material.[141] *The Collegian* announced: "We are forbidden to speak; the tongue falters, the lips are closed."[142]

After 1830, alumni were invited back to give political speeches in the Rotunda on behalf of the student groups. The guest speakers reinforced UVA's role as a defender of states' rights and slavery, becoming more inflammatory as the 1830s wore on. In 1836 the Jefferson Society invited back O.N. Ogden of Louisiana to honor their namesake's birthday, April 13. Ogden delivered a classic strict constructionist interpretation of the Constitution, underscoring the threat that Senator Henry Clay's American System posed to the republic: "The Clouds are gathering on our horizon—The black material of hate and havoc,—ungenerous jealousy, and fanatic fury, are rife in the Northern sky." The growing power of the national government was a threat, but "most to be feared" was the sort of religious enthusiasm that was "agitating the question of slavery."

Ogden warned against "those who in their real or pretended zeal for another race will have then forgotten all kindness and courtesy to their countrymen, and have shown no mercy to a people of kindred color and fraternal blood." He credited Northerners with being "smart and liberal," but warned that emancipation of slaves would lead irrevocably to "an equal distribution of property." Ogden closed by suggesting that Jefferson's educational plans be spread to every state in the South, in order to cope with the aforementioned problems. Only if politi-

cians have *reason,* declared Ogden, could they avoid making "brash judgments" about slavery.[143]

In 1838 the Washington Society brought back graduate Robert Hamilton of Spotsylvania, Virginia to honor the first president's birthday. After screening the speech, the Board of Visitors prohibited students outside the society from hearing it, perhaps because Hamilton predicted a civil war between the South and North. He hoped that someone of Washington's stature would arise to preserve the liberty of the South if need be. Hamilton criticized "lawless agrarianism," an English movement he compared to American abolitionism: "That [abolitionists] forebode no good to the cause of liberty is at once apparent to everyone who is at all acquainted with the nature of man. It is an unhappy characteristic of the human race that in avoiding one evil they are too prone to err on the opposite extreme . . . retarding the progress of improvement."[144] The other students demanded it be printed, which only attracted more attention.

In 1840 the Jefferson Society recruited graduate Richard Barnes Gooch of Richmond to celebrate Jefferson's birthday. He honored the occasion by predicting civil war with the North. Gooch lamented the "cheapening of the household economy" by "Yankee ingenuity." He warned that "if we forget our common origin and the invaluable heritage of a free constitution," by abolishing slavery, it would be followed by "the appalling miseries of intestine commotion—a servile war more replete with horrors than the famed rebellion of Spartacus—the marching and countermarching of armies . . . commerce prostrated, harvest fields pared of their substances, hamlets razed and cities sacked."[145]

At an alumni society meeting the same year, James Bruce delivered a similar address, complaining bitterly about the misguided spirit of radical Northerners and Europeans: "With the unreasoning purpose of striking fetters off the chains of Southern slaves, they [abolitionists] would risk the extinguishment of the beacon-torch of liberty, which lights the world . . . Satan never showed himself to our first parents in a more fascinating guise, than do the leading abolitionists to those whom they would win. It is a crusade against . . . the democracy of the Bible."[146] Obviously Professor Tucker's denial of slavery's economic viability was not sinking in among many students.

In the mid-1830s students vented anger about their own servitude within the university. The proctor's house was pelted with rocks and firecrackers.[147] The following April Professor Tucker's pavilion experienced the same. Professor Harrison's dog was attacked with a pitchfork and he with bricks.[148] In November, 1836 the student military corps assembled as usual, but this time without the faculty's permission. It did not like the regulations the faculty customarily drew up, because they forced the company to wear uniforms and prohibited them from firing real ammunition on the lawn. The student corps had never formally authorized the faculty to control them in that way.

The captain said the unit would consider abiding by the rules, but "did not admit the right of the faculty to prescribe terms of organization" to the militia. The company now considered itself a state military unit independent of the university, and perhaps opposed to it. If necessary, they were prepared to dissolve their relationship with the University of Virginia. They shot off their muskets for two hours to underscore their message to the faculty. The faculty promptly told the company they were disbanded and no longer existed, then ordered them to return their muskets to the armory at the jail in Charlottesville. Those retaining their muskets were now subject to the rule against firearms on the lawn.

When the military corps was informed of the rulings, they marched to the Rotunda, raised their flag, and shot it to shreds. They rang the bell continuously while other students fired their guns, broke the glass of the professors' pavilions, and beat on their doors with sticks. The professors hid themselves and their families on the second floors of their pavilions while the students taunted them from outside. They repeated the same routine the next night. When the students told the professors that things could get worse, the professors considered arming themselves. Instead, two magistrates and a sheriff were called in, military guards were placed at the Rotunda, and a grand jury was convened.[149]

The corps handed back its ruling, signed by prominent names such as Cocke, Chapman, Minor, Carter, and Eppes. They resolved that:

> The company is not disbanded and that they will continue to drill as usual, what the faculty may say to the contrary notwithstanding. Also, every member of the company pledges his honor to stand by his comrades, and that action of the faculty against one shall effect every individual . . . Resolved that we have our arms and intend to keep them.[150]

All sixty-five boys who signed the petition and shouldered muskets in protest were immediately dismissed from UVA. At a large public meeting in the Rotunda the board declared it would readmit those who complied with the weapons rules.[151] Non-corps students circulated a petition seconding the original argument that the faculty had no legal basis for setting up such regulations or disbanding the corps. Their rallying cry came directly from 1776: "Resistance to tyrants is obedience to God."[152] The petition was sent to local newspapers and the parents of the dismissed students, along with the Board of Visitors.[153] These were hardly the type of citizen-soldiers Jefferson had envisioned when he founded West Point and endorsed militia training at UVA.

Around half of the suspended students gave up their protest and returned to school.[154] Professor Emmet wanted all the guilty students gone, but law professor John Davis argued that those who repented should be forgiven. Since he took such a lenient stand on the 1836 uprising, Davis tried to break up future anniversary celebrations before they got out of control. The students nonetheless rioted

every year afterwards on the anniversary of the "musket rebellion." Ironically, on November 12, 1840, Davis was killed by a student on such an occasion.

Davis went to pull the mask off a rioter named Joseph Semmes, who shot him in the face. Semmes carried no grudge against Davis, but had vowed to his friends to shoot the first professor who unmasked him. Davis saw his face but refused to name him as he lay dying for several days. Davis's wife was also forgiving, but she miscarried their child a short time later. Semmes was arrested on the basis of his shoe prints and the unusual shape of his bullets. Meanwhile, the students published an apology in the *National Intelligencer* (Washington, D.C.) on December 1, 1840. Semmes refused to take an oath in court because he was an atheist, instead laughing and joking his way through the trial. Semmes broke his twenty-five-thousand-dollar bond and later committed suicide.[155]

Semmes's atheism was atypical for UVA students. American society embraced the political, scientific, and technological aspects of the Enlightenment, but mostly rejected rational religion, to say nothing of atheism. The atmosphere Jefferson hoped to foster at UVA—a religious devotion to science and reliance on innate morality—was never really encouraged. Instead the school changed with the times and voluntary Protestant worship was by far the most common religious practice. UVA did not have a particular professor of ethics as Jefferson envisioned in lieu of theological instruction, though courses on the subject were taught. Since the moral philosophy professor, Tucker, was an economist, and the professor of ethics was subsumed under the politically determined law chair, there was no compulsory moral instruction at UVA.[156]

Jefferson's vision of an open religious culture was partly realized, however. Students who refused invitations to dine with him at Monticello on the Sabbaths in 1825–1826 were invited on another day.[157] A volume on the evidence for Christianity was ordered for the library. Jefferson rejected a proposal for Sunday services on campus, but said the worship room in the Rotunda could be used "under such impartial regulations as the Visitors should prescribe." Given the fact the university was subject to public opinion, this left a lot of leeway for the board to negotiate after Jefferson's death.[158]

Most of the faculty were Anglicans, while two others were Catholic and Lutheran.[159] Emmet was a materialist, but there were no Unitarians or natural theologians.[160] Jefferson did not object to courses being taught on religion, but he did not want a single denomination controlling a single chair of divinity. A year after Jefferson died, board member Chapman Johnson wrote that since the "old sachem" was gone, they should hire a scholar from Oxford or Cambridge who was educated in the ministry: "Tell Cabell," he wrote John Hartwell Cocke, "it is time to give up his old prejudice upon this subject, the offspring of the French Revolution, long since a bastard by a divorce of the unnatural alliance between liberty and atheism."[161]

At first the rest of the board held firm against Johnson's and Cocke's desire to hire a clergyman. John Holt Rice claimed the public favored more religious influence on campus, but the board rejected his idea of relocating Union Theological Seminary to UVA's campus.[162] One early student viewed the university "as a school of infidelity [and] nursery of bad principles, designed in its origin to crush the Institution of Religion."[163] Student R.L. Dabney, a future Presbyterian minister, complained about the low moral standards there in a letter to a friend, citing cases of gambling, drinking, cheating on exams, and rampant venereal diseases.[164] Jefferson's advocacy of free thought compounded the charges of UVA's elitism as well. Protestant Christianity, the religion of mainstream Virginians, was misunderstood as being discriminated against on campus.[165]

Despite these forms of misbehavior, charges of "godlessness" contradict the account of Episcopal Reverend Frederick Hatch, an acquaintance of Jefferson's who happily reported in his 1827 journal that he had recruited "50 to 60 youths from the University of Virginia" to Christian worship (a number approaching half of the total enrollment).[166] Missionaries are prone to exaggerating their success, but both Hatch and Francis Bowman, the local Presbyterian minister, preached sermons in the Rotunda during the university's early years. Neither could conduct services regularly because they had their own flocks to attend to in Charlottesville.[167]

Both the Presbyterian and Episcopal churches continued to convert upper-class Virginians in the 1820s and 30s (see chapter 4). Conversion to evangelical Protestantism was one avenue whereby the old Virginia aristocracy assimilated into a more unified nineteenth-century South.[168] Under the leadership of Bishop Richard Channing Moore, the Episcopalian church shed the intellectualism of the eighteenth century and turned its focus toward sin, damnation, Scripture, the necessity of atonement, and regeneration through Christ. Critics called it "Methodist" because of the enthusiasm of their ministers and their general focus on the pulpit instead of the communion table or the liturgy.[169]

By the mid-1820s the Episcopal Church had rebounded from its lowest ebb during the Revolution, and was cooperating with the Baptist, Methodist, and Presbyterian churches. In 1824 the Episcopalians opened their own theological school at William and Mary, though some diehard Episcopalians boycotted the school because of its evangelical flavor.[170] Reverend William Meade (1789–1862) restored approximately half of the original Anglican parishes to the church by tireless circuit riding, preaching to African Americans, and emphasizing a message simple and emotional by traditional Church of England standards.[171]

The Presbyterians and Episcopalians both wanted a stronger presence on UVA's campus than they had in its first years.[172] With Jefferson out of the picture, their chances for affecting change improved, and Meade got his chance in 1829. That year a typhoid epidemic swept the campus, killing four students and

at least three slaves.[173] The spread-out design Jefferson had implemented partly to avoid such epidemics failed. As the Assistant Bishop-elect of the Diocese of Virginia, Meade seized on the eulogy as an opportunity to lash out at the school's perceived secularism, with particular aim taken at its founder.[174] Just as Presbyterians capitalized on a Richmond theater fire in 1811 to accentuate the evils of the acting profession, Meade suggested that Jefferson's infidelity had caused the deaths of the students.[175] At one point he admitted that making that direct link would be idiotic since true Christians die tragically too, but he spent the better part of his oration arguing exactly that.

Meade noted that God "takes part in all the trivial affairs of men, and actually appoints all the accidental and seemingly irregular occurrences of life." He then asked the students and faculty assembled in the Rotunda: "Shall a trumpet be blown in the city and the people not afraid? . . . was [it] superstition or weakness to wonder if these visitations have not been sent to show the rulers thereof, their entire dependence on God? . . . the design of God, therefore, in these dispensations, and the use to be made of them by us, are as plain as they are important. When God visits us with the rod of affliction, it is that we may search our hearts, and try our ways, and turn to him."[176]

Meade considered Jefferson and the "dignified and philosophic" French revolutionaries the "most diligent, indefatigable and daring enemies of all religion which the world ever witnessed," comparing them unfavorably to Enlightenment Christians like Locke, Bacon, and Newton. He tied Jefferson to the French Revolution and its "war against everything holy and venerable." He equated Jefferson's natural religion with atheism because, God is "at best . . . the soul of the world, not the creator of it . . . let it not merely be said, that nothing is taught contrary to Christianity; that the mind is left free to its own choice." In France "the poison took effect; the contagion spread far and wide and among all classes general infections prevailed." Hopefully UVA could avoid that fate and turn to Christianity, not allowing the "goddess of reason" to "set up in the form of a lewd prostitute in the great hall of atheistic legislation."[177]

Meade pointed out the glaring fact that theologians taught everywhere else, including the North and the Carolinas. He later soft-pedaled his message in his memoirs, but Meade's speech had a great effect at the time.[178] Despite protests on the part of both students and faculty to the tenor of Meade's sermon, his criticisms (along with the fear of typhoid) did hurt recruiting efforts enough to make the board consider hiring a full-time chaplain.[179] They rejected the idea of a chapel for the time being, partly because Unitarians would be denied its use, and also because it violated UVA's principle of religious freedom and toleration.[180]

UVA's board did decide to rotate a chaplaincy among the four main Protestant denominations: Methodist, Baptist, Episcopalian, and Presbyterian.[181] The post was coveted by Methodists and Baptists like James B. Taylor (who served in

1839), though many evangelicals argued that the campus was an improper training ground.[182] Beginning in 1835, voluntary contributions from the students and faculty supported chaplains who performed Sunday services, weekly lectures, and a "monthly concert for prayer." Ministers were even allowed to stay on campus.[183] In 1835 a Sunday school was begun and the Bible Society formed.[184]

When Presbyterian William Maxwell addressed the university's Bible Society in 1836, he said that if the school was going to be the "nursery of republican patriots" that Jefferson and Madison envisioned, then the Bible should be required, for it is the "best statesmen's manual I know."[185] The Bible would also help prevent the spirits of corruption and abolition from infecting the campus, "and twenty other spirits I will not name—all mingling their drugs together, with infernal incantations, in the caldron of confusion, on purpose to brew up the blackest storm that has ever threatened to destroy the vessel of state in which we are all embarked."[186]

In addition to Jefferson's original worship room, one of the gymnasia spaces under the Rotunda terraces was converted into a chapel in 1837.[187] The Rotunda space had become too small. After 1828 the faculty passed a regulation prohibiting the breaking of the Sabbath.[188] Strict impartiality was at least observed among the Protestant sects, and many students were enthusiastic about the ministers. One wrote: "Mr. Hammet preached for us yesterday and the Sunday preceding—gives general satisfaction, shown by the overflowing crowds which throng from the Univ. & country & town to hear him. Our room is far too small to contain them and many are obliged to stand."[189] Chaplain James Taylor attended free lectures in classics, philosophy, and chemistry and later founded the Virginia Baptist Seminary in 1832, which became Richmond College.[190]

Jefferson's hopes for an ecumenical climate were realized within Protestantism, but an exception was the prohibition of Alexander Campbell from speaking at UVA in the late 1830s. He alienated many when he spoke on campus in 1838.[191] Born in Ireland, Campbell (1788–1866) withdrew from the Presbyterian Church and carried on his father Thomas's interest in primitivism, the restoration of the New Testament back to its apostolic simplicity. Though he denied Christ's divinity, Jefferson took part in this movement himself when he edited his versions of the New Testament in the late 1810s. In some ways the apocalyptic, evangelical Campbell was the Christian counterpart to Jefferson—he admired John Locke and Thomas Reid, disliked elaborate creeds and denominational strife, and respected nature as a basis for religion.[192] After 1827 Campbell led the Disciples of Christ, a denomination that hoped to obliterate religious pluralism, not accommodate it. He was controversial at UVA because he advocated mandatory readings of the Bible as the basis of education and his teachings were outside the mainstream.[193]

Dissatisfied with the University of the Virginia's relative ecumenicalism, many clergymen continued to lambaste it and its founder. Some critics com-

plained of a decline in religion at UVA after 1835, even though a revival was arguably mounting. Journals attacked UVA because they hired a Jew (Englishman J.J. Sylvester in 1841) and a Roman Catholic (Hungarian Charles Kraitser in 1840) on their faculty.[194] North Carolina Episcopalian Francis Lister Hawks, who considered himself a mortal enemy of Jefferson's, viewed the school as an "alliance between the civil authority and infidelity," a subject on which "revolutionary France has once read to the world an impressive lesson."[195] It was Hawks who accused Jefferson of "poisoning the stream at the fountain." In 1837 Professor Tucker published his own biography of Jefferson, to help counter the criticism of Jefferson's religious impact on UVA. Hawks issued a rebuttal as editor of *The New York Review and Quarterly Church Journal* because it failed to depict Jefferson as a hater of Christianity.[196] Despite Tucker's claims, the students refused to erect a statue of Jefferson at UVA for twenty-five years after he died.[197]

UVA was an easy target for any clergy who misunderstood Jefferson as an atheist, but those who visited the campus got a different impression. The Reverend Septimus Tuston claimed to experience "nothing but kindness and courtesy" during his stay at UVA.[198] The school's enthusiasm toward Christianity was confirmed by an 1840 account of S. H. Tyng (1800–1885), an Episcopal minister and newspaper editor from Philadelphia. Henry Ward Beecher once characterized Tyng as "the one man I am afraid of."[199] His hatred for Jefferson's infidelity ran so deep that he refused to tour the inside of Monticello. In his initial letter, after he had visited Monticello but before he had visited the campus, Tyng wrote:

> I have never heard his name spoken with so little respect, and so much aversion, as in this very neighborhood [Charlottesville] in which he lived and died. I had never conceived his character so bad as I have found it here. His plans are all defeated. The religion of Jesus triumphs over all opposition. The whole spirit of the community as awakened against the spirit and tendency of Mr. Jefferson's example. All his greatness has perished and is forgotten because he was an infidel.[200]

Tyng changed his mind about UVA, if not Jefferson, after preaching there. Although he thought the university was set up in "direct and designed hostility to Christianity," and Tyng was an orthodox hard-liner, he found most of the faculty and students were practicing Christians, including George Tucker.

In the Rotunda, Tyng preached to what he called the "most attentive and interested auditory of [his] entire priesthood. Not a single college in New England would've furnished me with such an attentive and respectful audience."[201] Travel writer Harriet Martineau commented on the controversy that Jefferson's humanist university caused in the North, but pointed out the students actually heard a wider variety of sermons than at denominational schools. Agreeing with one of Jefferson's and Madison's longtime contentions, she also thought that the voluntary nature of church services actually increased their attendance.[202]

An even stronger Christian presence was ensconced at UVA with the hiring of George McGuffey. He replaced George Tucker as professor of moral philosophy in 1845, a momentous shift for the fate of Jefferson's vision of religion on campus. When the religiously liberal Tucker retired, public opinion (especially in the western part of the state) demanded that he be replaced by a Christian.[203] Religious colleges in Virginia were combining to outrecruit UVA at about a 5:1 ratio by 1845 and rioting forced the school to close temporarily in 1844–1845.[204] McGuffey "put his hand firmly to the plow of religious reformation as soon as he entered upon his office, and he never relaxed his hold until his death" in 1873.[205]

McGuffey (d. 1873) was already famous throughout America. His *Eclectic Readers,* which stressed Calvinism, everyday moral maxims, and grammar, became the best-selling language textbooks in American history, surpassing fellow Patriot Noah Webster's 1783 "Blue-backed Speller."[206] When "Old Guff" was not lecturing on philosophy, sociology, ethics, logics, psychology, and political economy, he was busy ministering to Presbyterian, Methodist, and Baptist churches in Charlottesville.[207] McGuffey hired fellow Presbyterian William Henry Ruffner (1824–1908) as chaplain and Ruffner lectured on the evidences of Christianity from 1849 through 1851.[208] Ruffner's father, Henry, proposed a general system of education in 1842 that was the most elaborate plan since those submitted by Jefferson and Mercer in the 1810s. His son, William Henry, became the president of Washington College in Lexington, Virginia (now Washington and Lee).

McGuffey and Ruffner helped spark a religious revival on campus. Daily morning prayers and lectures were held. A parsonage, authorized by the Board of Visitors in 1851, was built in 1855. The Presbyterians built a seminary in 1859.[209] This was in keeping with Jefferson's 1822 plan for seminaries being built near the campus, as was the exemption of ministerial students from tuition.[210] A nondenominational chapel, built near the Rotunda in 1885, also reflected Jefferson's spirit of religious universalism. Other developments did not: even though religious services never became mandatory, professors could use their power over students' grades to encourage Christianity. Law professor John B. Minor, a devout Christian, gave Sunday morning Scriptural lectures that were wise to attend if a student wanted to stay in Minor's good graces.[211]

Another indicator of Christianity's strength was the establishment of a YMCA (Young Mens' Christian Association) in 1858.[212] UVA's Society of Missionary Inquiry, which preached to slaves around Charlottesville, converted itself into a YMCA chapter in 1858.[213] The zealotry of the society and the YMCA chapter indicate a strong interest in Christianity among some of the students. Around one-quarter were practicing Christians, most affiliated with the Baptist, Episcopalian, Presbyterian, and Methodist churches.[214]

Despite the lack of religious coercion, a sizable minority of UVA students

went into the ministry. In the nineteenth century, the University of Virginia produced over five hundred ministers of the aforementioned faiths, including eleven bishops in the Protestant Episcopal Church.[215] UVA's religious impact on Virginia rivaled that of Presbyterian Hampden-Sydney. When a typhoid epidemic worse than that of 1829 struck the campus in 1857–1858, critics of UVA found it difficult to scapegoat Jefferson's universalism as the cause.[216]

## Conclusion

In Jefferson's last letter, he wrote Washington, D.C. mayor Roger Weightman that the American Revolution aroused "men to burst their chains under which monkish ignorance and superstition had persuaded them to blind themselves, and to assume the blessings and security of self-government."[217] Politically, UVA's students were eager to burst chains and assume the right of self-government. Religiously, the YMCA, McGuffey, and Ruffner represent a departure at UVA from Jefferson's vision of pluralism and natural religion. Pluralism existed only within Protestantism. Since religion remained voluntary, however, it was not the cause of rioting. Disciplinary codes and political censorship were more likely to cause unrest among students.

Those who stuck it out were able to use the prestige of UVA to attain influential posts in life. Of course, most young men who attended the school already came from influential families. Over 90 percent of the students who attended the University of Virginia in the antebellum period came from the South, many of them from plantations. The University of Virginia was very successful at reinforcing pro-Southern politics in its students, most of whom were predisposed to such views when they arrived. Even the professors who arrived from Europe adapted quickly to slave society, though Bermudan-born professor George Tucker taught the students that slavery was inefficient economically. Tucker's moderation made UVA less doctrinaire in its pro-slavery, states' rights teachings than Thomas Cooper's College of South Carolina but, like that school, it contributed numerous alumni to the Southern cause.[218] In 1857 the university hired literary critic George Frederick Holmes (1820–1897) as professor of history and literature. Holmes, who was born in British Guiana and contributed essays to the *Southern Literary Messenger,* was an avid supporter of slavery and states' rights.[219]

When the South broke from the Union in 1860, UVA students solidly supported secession. In the fall of 1860 both the Washington and Jefferson societies voiced their support for disunion in the event of Lincoln's election. That same fall the faculty lifted its ban on student military exercises. Over two thousand UVA alumni served the South in the Civil War as soldiers, officers, surgeons, and chaplains. Five served in the Confederate States of America's cabinet and

thirty-one in the Confederate congress.[220] Their contribution to Confederate leadership and military service testifies to the regional pride reinforced by the school.

The school remained open during the war (Robert E. Lee Jr. was a student there) but was attended only by the young or maimed. After the Battle of Manassas (Bull Run) in 1861, the Rotunda was used as a makeshift hospital. George Armstrong Custer's men blew up bridges over the Rivanna River near Charlottesville in March 1865 and occupied the town and university for several days.[221] The Union armies left the campus unscathed, though, just as the British had at Monticello in 1781.

Karl Bitter's 1915 statue of Jefferson on UVA's lawn.
*Photo courtesy of Bill Sublette.*

The Infidel and the Christian have fought the battle, and the latter has won the victory. The Humes and Voltaires have been vanquished from the field . . . The argument is closed forever, and he who now obtrudes on the social circle his infidel notions, manifests the arrogance of a literary coxcomb, or that want of refinement which distinguishes the polished gentleman.

Thomas R. Dew,
President of William and Mary
1836

# The Impact of Jefferson's Vision

❋

Jefferson's plans foreshadowed future developments, despite his failure to establish a comprehensive education system in Virginia. His famous association with the cause gave momentum to public education. After the Civil War educational reformers were inspired by Jefferson's promotion of meritocracy, however qualified his own idea had been during the revolutionary and early national era. He also made more tangible contributions. Jefferson's plans for the Northwest Territories in the mid-1780s encouraged the construction of schoolhouses in the region beyond the Appalachians and north of the Ohio River. As president he signed the legislation establishing the United States Military Academy at West Point. The University of Virginia became one of the best colleges in the nation, but the partisan message of Jefferson's retirement years dominated its ideology. At UVA in the nineteenth century, that Southern sectionalism overrode the "amalgamated" nationalism Jefferson helped unleash in 1776 and nurture during his presidency.[1]

No one questions using education to foster political awareness among the electorate, however much we criticize ourselves for falling short in that objective. Jefferson's own plan was limited to white males, but the basic thrust of using public schools to offset aristocratic privilege remains the strength of the current system when it works. Today even the most strident conservatives would not openly disagree that education should provide opportunities for upward mobility. In Jefferson's time, his biggest impact was in higher education and religious freedom, not primary schools.

### Primary Education

Jefferson did not impact elementary education as much as he would have hoped, or is given credit for. Public education systems in the United States developed

because nineteenth-century Northerners realized they needed a workforce literate in words and numbers to operate a modern commercial and agricultural economy. Farmers and businessmen advocated education, and Protestants needed a mechanism to control the behavior of lower-class whites and immigrants.[2] The man most responsible for the implementation of public education—Horace Mann of Massachusetts—was a Protestant prejudiced against Catholicism. Because Mann's prejudice was typical, the public school systems were fractured between Protestant public and Catholic parochial schools. The nondenominational aspect of Jefferson's vision was thus betrayed during the century following his death, both in Virginia and nationally.

Jefferson's emphasis on practicality presaged later developments, namely the progressive movement of the early twentieth century, but his influence was indirect. At the grade-school levels, progressive education resulted from the demands of the Industrial Revolution, the increased enrollments of the early twentieth century, and the philosophical endorsement of John Dewey, a Jefferson admirer. The pragmatic emphasis of higher education evolved partly because the money used to fund both private and public schools was oftentimes generated by applications of useful knowledge.

By the second half of the nineteenth century, more people were being educated in the United States than anywhere in the world, but the vanguard of that movement was in the industrial Northeast and rural Midwest. Virginia's sectionally fractured democracy, compounded by its rural demography, prevented the full realization of Jefferson's dream. The planter economy, lacking a strong middle class, did not dovetail with compulsory education. Given these fiscal and political limitations, Jefferson and his friends pursued his university against the wishes of politicians from northern and western Virginia, who advocated building the system from the ground up. Jefferson still cared about primary education, and felt guilty about pilfering Virginia's Literary Fund for UVA, but the urgency of sectional politics and religious conflict motivated his desire to train the next generation of leaders.

It is tempting to use Jefferson as a gauge, and argue that his seeming transformation from an egalitarian to an elitist educator illustrates an opposite shift in Virginia politics; that by retirement the forces of democracy he helped unleash in the 1770s overtook him.[3] That is true to an extent, but Jefferson evolved personally over the same time period, becoming more conservative as he aged. Besides, Virginia was still aristocratic by national standards when Jefferson died, and he never turned his back theoretically on the importance of elementary schools. Nonetheless, those who wanted to spend on elementaries first, including western Virginians and politicians like Charles Fenton Mercer, were the men whom cosmopolitans like Jefferson and Joseph Cabell considered unenlightened.

Jefferson's ideas on decentralized primary and secondary education and local

initiative were not successful in Virginia in the nineteenth century. When a comprehensive education system was developed in Virginia after 1900, the impetus came from the top, not from below.[4] Nationally, the existence of local school boards and PTAs carry on a legacy of local and parental involvement of which Jefferson would have approved. Hostility toward the Federal Department of Education is also in the Jeffersonian tradition.

A version of Jefferson's ward scheme was tried in 1850 when Virginia's counties were divided up into districts, but they were less efficient at governing than counties.[5] Most nineteenth-century schools in Virginia and elsewhere were essentially private, but partially reimbursed by city or county governments.[6] Compulsory public education was a notable exception to Jefferson's philosophy of weak government, as was his proposed literacy requirement for citizenship. As the nineteenth century progressed, the Jeffersonian Democrats who earned the right to vote were mostly the "rubbish" he described raking out of the system with his educational pyramid in *Notes on the State of Virginia*.[7]

## Higher Education

The chartering of UVA and John Holt Rice's assistance illustrate the emergence of sectionalism as an overriding concern in Virginia politics after the War of 1812. Even Jefferson's enemies on other issues in Virginia conceded that something must be done to prevent Southern boys from going north to college. The Panic of 1819 and the Missouri Crisis of 1819–1820 helped facilitate his arguments.

The University of Virginia was chartered just prior to those events, but they helped fuel the campaign for its funding. Rice shared Jefferson's fear of Northern infiltration and agreed that establishing a state university mattered more than primary or secondary schools. Rice's alliance helped seal the chartering of the University of Virginia in 1819. Because of sectional politics, Jefferson stuck with his wish to hire Thomas Cooper, even though Cooper was a public relations liability. Cooper's political transition from progressive democrat to states' rights conservative coincided with Jefferson's.

Historian Merrill Peterson wrote that Jefferson's educational vision contained "the dominant forces of his life and mind, of democracy and enlightenment and nationality."[8] His vision was an embodiment of the Enlightenment, and his original plans were democratic, but the university was erected in direct opposition to nationalism and was aristocratic. The 1846 decision to draw UVA's students from different counties in Virginia was the biggest gesture toward egalitarianism in UVA's early history. Tucker's 1833 idea to offer state loans to the poor qualifies as the only real attempt to recapture the spirit of Jefferson's 1779 education bill—the one designed to overturn artificial aristocracies in favor of a meritocracy.[9]

Jefferson's college in Charlottesville was very successful, however. The University of Virginia became one of the best and most influential colleges in the country and served as a blueprint for later state universities. Its lecture method allowed for more students and, by 1860, it had the biggest enrollment in the South. In 1822 Jefferson asked *Richmond Enquirer* editor Thomas Ritchie to print six copies of the Rockfish Gap Report because of requests he received from other states.[10] UVA was not the first public university, but it was the prototype for state schools in the South and Midwest in the nineteenth century.[11] University of Virginia alumni founded the University of Texas, for instance, in the 1880s.[12] These public universities retained a strong denominational flavor for most of the nineteenth century, but their organizations and curriculums were oftentimes based on those of UVA.

Jefferson anticipated and influenced many facets of twentieth-century universities: their lack of denominational influence, the lecture method, the elective system, the predominance of the scientific outlook, and the emphasis on practical learning. The first American research universities of the sort Jefferson envisioned were at Cornell and Johns Hopkins in the 1870s. Their form of Enlightenment was rooted in the German notion of *Wissenschaft,* a full-fledged spiritual dedication to science of which Jefferson would have approved. Hopkins's administrators looked to UVA as the highest standard of domestic academic excellence, and were influenced by Jefferson's model.[13]

During the Civil War the Union passed the Morrill Act, which granted land to states for colleges of an agricultural and mechanical orientation. These schools captured the practical aspect of Jefferson's original vision, but arose from precisely the sort of federal intervention that UVA was set up to extinguish.[14] Schools founded under the act were based most directly on the Rensselaer Polytechnic Institute and Illinois Industrial (later the University of Illinois).[15] Iowa State, the first land grant college, opened in Ames in 1862. Jefferson had hoped UVA would become a center of agricultural research—at one point calling it his highest priority—but that never materialized.[16]

The campus did not foster healthy student/faculty relations and prevent disease in the short run, but it was an architectural masterpiece. The beauty of the lawn endeared the campus to most visitors, regardless of their politics, religion, or attitude toward Jefferson. One architectural historian wrote, "passionately conceived, and built under the persistent and demanding supervision of the master himself, both works [UVA and Monticello] reflect a degree and intensity of personal involvement which could not be surpassed by any other architect of the time, including [Benjamin] Latrobe."[17] Jefferson's tasteful application of Palladio and replication of the Roman Pantheon was rewarded during the United States' bicentennial. In 1976 the American Institute of Architects celebrated the anniversary by electing UVA the "proudest achievement" in American architecture.[18]

## Religious Freedom

Religiously, Jefferson contributed to a significant shift in the transition from religious tolerance to full freedom and rights of citizenship in the 1780s. He carried that fight through in Virginia until his death. If the various denominations had taken up Jefferson's offer of surrounding the campus with seminaries, UVA would have become a unique theological school. Instead the early history of the school shows the precariousness of religious freedom and how democracy was used to infiltrate Protestantism onto the campus. Jefferson's dream of an ecumenical atmosphere thrived at the University of Virginia, but only within mainstream Protestantism (Presbyterian, Baptist, Methodist, and Episcopalian). Atheism, deism, Judaism, and Catholicism were tolerated but disrespected. Alexander Campbell, with his strident brand of Biblical restorationism, was not allowed on campus. But voluntary Protestant Christianity thrived at UVA, just as Madison had predicted religion would generally under an noncoercive political system.

By midcentury, the public debate over secularism in higher education died down in Virginia, and the focus of church-state relations shifted to other areas. The Virginia legislature appointed a rotating chaplain in 1848 and introduced formal prayer into its sessions in 1849. That same year Jews and Catholics won the right to violate the Sunday Sabbath and worship on Saturdays. Ministers remained exempt from taxation, but churches failed to make headway in legally owning property.[19] The 1786 statute, rather than separating church and state in Virginia, merely made denominational property subject to legislative control.[20] Without the right to incorporate, it remained difficult for churches to acquire, own, or inherit land, and they could not sue or be sued in court as legal entities.[21]

Outside Virginia, Jefferson's advocacy of natural religion damaged his reputation after he died. The French traveler Alexis de Tocqueville noticed that, by 1835, there was a consensus in America that religion was essential to the success of republican institutions.[22] Jefferson was an easy target for the holders of that view, especially if that religion was defined as orthodox. John Quincy Adams made reference to Jefferson's heterodoxy when he criticized his towering ego. He hoped that "someone would take up the 'Cause of the Cross, the Cause of Justice, and the Cause of American Union' against Jefferson's effort to crowd American history with his own fame."[23]

Freethinking radicals like Fanny Wright and Robert Owen invoked Jefferson's name in toasts, dedicated books to him, and spread his ideas in newspapers. Conservatives, wary of links between religious heresy and socialism or full-fledged democracy, were anxious to smear Jefferson's reputation.[24] Consequently, most educators saw no benefit in invoking his name for their cause during the first half of the nineteenth century.[25] The Philadelphia Public Library pulled all books concerning Jefferson from its shelves in 1830.[26] During the nine-

teenth century, University of Virginia students even refused to erect a statue of Jefferson on the campus he created.

As his reputation among conservatives plummeted, influential Presbyterian and historian Samuel Miller came to regard his friendship with Jefferson as an embarrassment.[27] Other Presbyterians, like Robert Baird, argued that Jefferson degraded Christianity by putting the various denominations on an equal legal footing.[28] John Holt Rice expressed his feelings in a letter to James Madison in 1832. He continued to honor the tradition of religious liberty, tying it to original Christianity, Martin Luther's Reformation, and the American Revolution. But Rice undoubtedly referred to his old nemeses Jefferson and Madison when he lamented that religious freedom in America "was the result of prejudice, not conviction."[29]

Rice had nothing to complain about, at least concerning UVA or education in Virginia. George McGuffey was hired to replace George Tucker as professor of moral philosophy at UVA in 1845, and Presbyterians dominated the educational landscape in Virginia throughout the nineteenth century. The man most responsible for the limited public system that arose after the mid-nineteenth century was McGuffey's fellow Presbyterian William Henry Ruffner, the "Horace Mann of the South," who lectured on the evidences of Christianity at UVA. After Jefferson died, these two led the educational charge in Virginia. Ruffner was state superintendent after 1869, when the Virginia constitution first mandated a public school system. The public schools that came into existence in 1870 shared power among Protestant denominations in order to avoid giving public funds to Catholics, a travesty from the perspective of Jefferson's vision.[30]

Outside Virginia the debate over religion and education did not die down. The critical event that paved the way for the ascension of denominational colleges was the preservation of Dartmouth College's original charter in 1819. New Hampshire Governor William Plumer, a Yankee Jeffersonian, wanted the state to take over control of Dartmouth, declare it an arena of religious freedom and open its doors to the poor. Dartmouth's victory in maintaining its original colonial charter was consistent with a Virginia state ruling on William and Mary after the Revolution. These decisions forced states to start from scratch if they wanted to create public nondenominational universities, rather than converting existing colleges. Harvard, Yale, Princeton, Columbia, and Pennsylvania could remain independent.[31]

In the decades after the Dartmouth decision and the opening of the University of Virginia, graduates of Yale and Princeton streamed out into the South and West founding numerous denominational colleges.[32] Even public universities such as North Carolina were initially controlled by denominations (usually Presbyterians), though many new states included in their charters the future right to revise the make-up of boards of trustees.[33]

Only UVA, Harvard, and Pennsylvania resisted strong denominational influ-

ence. Elsewhere evangelicals dictated the choice of presidents and professors, sponsored and organized student groups, and subsidized ministerial candidates.[34] Classes were canceled for revivals and courses on the evidence for Christianity were required of all students. Students at the University of Arkansas could not attend without a Bible. Math classes at the University of Minnesota opened with prayer. Clergymen served as college presidents and hired their own to teach. This was partly because the ministry was the profession most similar to teaching in its reconciliation of missionary service and low pay. Compulsory chapel was not discontinued at most campuses until World War II.[35]

As denominational schools assumed their broader role of training the lay elite, their curriculums became increasingly centered on professional, secular training rather than on theology. Religion became the special prerogative of divinity schools. As the nineteenth century progressed, most denominational colleges were forbidden either by charter or public opinion to indulge in religious tests for faculty or students.[36] Secular viewpoints became dominant in both science and the humanities as mainstream Protestantism retreated on twentieth-century campuses. Today, most colleges treat religion as a topic of critical inquiry, generally housed in a department of religion.[37]

As the twentieth century came to a close, the University of Virginia was one of the top-ranked public universities in the United States, though its atmosphere and heavy reliance on private funding imbued it with the feel of a private school. Today there is no clear winner for the claim of academic superiority between public universities and private denominational schools. Many of the best colleges—like California-Berkeley, Michigan, Wisconsin, North Carolina, Indiana, and Virginia—are public universities. But three schools founded by Methodists—Northwestern, Boston University, and Emory—along with three others founded by Catholics—Georgetown, Notre Dame, and Boston College—are ranked in the top fifty of America's research universities.

Jefferson's academic village was more a throwback to Virginia's aristocratic roots than a vehicle of democracy. It sustained rather than curtailed aristocratic privilege, subverting the egalitarian spirit of Jefferson's 1779 education bill. This was because Jefferson's follow-through on the 1786 Statute for Religious Freedom and the Virginia and Kentucky Resolutions of 1799 ended up mattering more to him than his democratic bills of the late 1770s.

If it had been up to Jefferson or like-minded politicians, there would never have been a shortage of resources and such choices would have been unnecessary. Beginning in 1779, Virginia would have had the best education system in the Unites States from bottom to top. UVA's campus would have been surrounded by a ring of diverse theological seminaries and artisan workshops, and everyone

would have spoken French at meals. If Jefferson's ideas were indeed good ones, then blame for their failure to materialize goes to the reticent taxpayers and un-cooperative citizens of Virginia. Virginia taxpayers spent less than two cents per year on education between the poor schools and the university.[38] To his credit, Jefferson spent his seventies and early eighties devoted to a civic cause about which he felt passionate, rather than completely winding down. Unrelenting devotion to public service is one of the most inspirational aspects of his story.

Jefferson enjoyed success establishing the University of Virginia partly because of his brilliance in orchestrating other people's ideas, and partly because of good luck. Like the architecture of Monticello, which contains brilliant but un-original adaptations, Jefferson's educational vision was pulled from many sources—John Knox, Samuel Knox, Joseph Cabell, Thomas Cooper, Benjamin Latrobe, Andrea Palladio, and numerous European universities, buildings, and thinkers. Jefferson also shared ideas with contemporaries like William Davie, George Ticknor, and St. George Tucker, who were familiar with Jefferson and, in turn, influenced him.

The successes Jefferson enjoyed—the passage of the 1786 Statute for Religious Freedom and the founding of the university—were partly due to good fortune. Both Patrick Henry, who opposed Jefferson's and Madison's radical stance on religious freedom, and Charles Fenton Mercer, who wanted to put a premium on primary schools, were removed from the scene because their popularity got them elected to offices beyond the Virginia legislature, not because the public disliked their views. Henry left the legislature in 1784 to become governor and Mercer was elected to the U.S. Congress in 1817. They were the primary opponents of Jefferson's vision, along with Rice, who retired in 1822 after helping the university get chartered.

The fate of Jefferson's vision was filled with ironies. First, Presbyterians, who later fought against UVA's curriculum, influenced both Jefferson and Madison as young men on matters of education and religious freedom. Second, if Virginia had reformed its constitution by expanding power among poorer whites, the way Jefferson advocated, the University of Virginia would not have been chartered.[39] Third, Jefferson founded UVA to combat the influence of Northern politics and religion, but clerical critics feared the school as a bastion of Unitarianism, a religion that emanated from the Northeast. Finally, given Jefferson's insistence that UVA be antagonistic toward the growing power of the central government, it is ironic that Virginia's Literary Fund had stock invested in the Second National Bank of the United States. The Rotunda and pavilions were thus built partly with dividends earned from an institution Southerners and Jeffersonians loathed as a symbol of corruption: the very sort of corruption UVA was chartered to oppose.

If one envisions Jefferson's original plan in the shape of a pyramid, he sacrificed the base to insure the success of the tip. Nonetheless, the spirit of Jefferson's

message was that all children, not just a select few, could be educated. That was the idea that inspired John Dewey as he argued for more democratized education around the turn of the last century. Historian William Freehling wrote that, despite his later compromise on slavery, Jefferson's early opposition to that institution contributed to forces that restricted its spread and led to its eventual dissolution.[40] Jefferson's contribution to education followed a similar pattern. He started off idealistic, then worked against his own vision, but the mythological Jefferson helped inspire the establishment of public schools later on.

# *Rosenberger v. University of Virginia*

✸

In 1995 a University of Virginia student named Ronald W. Rosenberger won a Supreme Court case against the school for violating his First Amendment right to freedom of speech. Rosenberger applied for funding to publish the magazine *Wide Awake: A Christian Perspective at the University of Virginia.* UVA funded secular publications but turned down Rosenberger's request for $5,800 because *Wide Awake* "primarily promotes or manifests a particular belief in or about a deity or an ultimate reality," as prohibited by university guidelines. The Supreme Court ruled five to four that UVA discriminated against his right to free speech by imposing a financial burden on it. The majority opinion was that UVA should subsidize all groups' speech equally. The Court could have found UVA guilty of violating the (religious) establishment clause by promoting atheism at the expense of Christianity in its publication funding, but they found a pattern of neutrality, not discrimination, in the school's past policies toward publication funding.

# Bibliographic Essay

The scholarship on Thomas Jefferson and education is substantial. Each aspect of his interest in education—religious freedom, politics, wards, architecture, the founding of the university and its curriculum and student life—is covered in various articles and books. This book goes deeper into the archival sources, integrating old and recent scholarship to provide an updated synthesis and analysis of Jefferson's philosophy and his strategy of employing it. A summary of the secondary literature and printed primary documents will help the interested reader narrow his or her starting point down to the most essential sources.

Anyone interested in the role of Christianity in a liberal arts education should read John Henry Newman's *The Idea of a University* (1873). Newman (1801–1890) was a nineteenth-century British cleric and university administrator who articulated two educational ideas roughly opposed to Jefferson's. He advocated learning purely for its own sake, and also for the inclusion (but not dominance) of Christianity in college curriculums. Though deeply religious, Newman did not believe that education of any kind, Christian or secular, could lead to moral improvement or religious truth. He resisted indoctrinations of any kind, including Christianity or the scientific method of Francis Bacon. A 1996 abridgment of Newman's work includes commentaries by Sara Castro, George P. Landow, George M Marsden, Frank M. Turner and Martha McMackin Garland.[1] They discuss Newman's implications and the roles of Christian fundamentalism, postmodernism, and political correctness at today's universities—all potential forms of indoctrination.

The best overall study of religion and education in early national Virginia is Sadie Bell's 1930 Ph.D. dissertation "The Church, the State and Education in Virginia," reprinted in book form in 1969. A short, solid overview of Jefferson's specific role is Joseph Kett's "Education," in Merril Peterson's *Thomas Jefferson: A Reference Biography* (1986). A brief but insightful summary entitled "Liberty to

Learn" by Peter Onuf is in the Library of Congress's *Thomas Jefferson: Genius of Liberty* (2000). Two classics on Jefferson and education are Herbert Baxter Adams's *Thomas Jefferson and the University of Virginia* (1888), which includes an essay by William Trent on the impact of UVA on Southern culture, and Roy Honeywell's *The Educational Work of Thomas Jefferson* (1931), one of the first books to argue that Jefferson manipulated the Virginia legislature and built UVA at the expense of primary schools. Honeywell apologized for Jefferson's undercutting of primary schools in Virginia, rationalizing that others had taken up the fight by that time, and that academies were already serving the needs of the lower levels of education.[2] In *Thomas Jefferson and the Development of American Public Education* (1962), James Conant does not see the need for primary schools being met, but rationalizes that there was nowhere near enough money in the Literary Fund to establish a primary system, basically accepting Jefferson's and Joseph Cabell's argument.[3]

The most recent book on Jefferson and education is a collection of essays entitled *Thomas Jefferson and Education of a Citizen* (1999), gathered by James Gilreath. Many of the essays deal only tangentially with education, but for that reason they offer insight into how Jefferson's educational vision dovetailed with his views on Native Americans, slavery, family, law, wards, Europe, and so on. The compilation also includes more straightforward accounts of Jefferson's educational goals by Ralph Ketchum, Douglas Wilson, Benjamin Barber, and Jennings Wagoner. Another upcoming compilation, Robert McDonald's *Thomas Jefferson's Military Academy: Establishing West Point,* includes essays on the political context and curriculum of that institution.

The most recent synthesis of Jefferson's educational philosophy is Harold Hellenbrand's *The Unfinished Revolution: Education and Politics in the Thought of Thomas Jefferson* (1990). Hellenbrand provides an analysis of Jefferson's educational bills and their relation to his republican vision. He de-emphasizes the originality of Jefferson's ideas, pointing out that most of them were in the air by 1820. Hellenbrand's main contribution is to emphasize how Jefferson's educational ideals sprang from his notions of patriarchal relationships.

My study focuses instead on political partisanship and religious freedom. It concerns the triumph of Christian fidelity in America over the humanist philosophy of the Enlightenment. The best book on the American Enlightenment is Henry May's *Enlightenment in America* (1976), which underscores how moderates like Jefferson and Princeton President Samuel Stanhope Smith strove to balance faith and reason in the late eighteenth and early nineteenth centuries. May traces various threads of Enlightenment thought and their decline in early nineteenth century.

Scholars commonly presume that religious colleges, especially those of the Presbyterians and Congregationalists, had a hand in this intellectual decline, or

"retrogression." Clarence Hix suggested this argument in his 1937 dissertation "The Conflict between Presbyterianism and Free Thought in the South, 1776–1838." Clement Eaton's *The Freedom of Thought Struggle in the South* (1940) and W.J. Cash's *The Mind of the South* (1941) applied the same theory of intellectual decline to the South. In the area of education, Richard Hofstadter put forward the idea of a nationwide retrogression in *The Development of Academic Freedom in the United States* (1955).[4]

Hofstadter was harsh on theologians and argued that the religious and political democratization of colleges in the early nineteenth century inhibited free thought. In the last thirty years, historians have revised Hofstadter's retrogression theory. One problem with the theory of decline is that colleges flourished and grew in the nineteenth century. Consequently it makes little sense to regard the turn of the nineteenth century as the fulcrum of decline, since enrollments were much lower and course offerings were more limited than later in the century.[5] The most recent collection of essays dealing with the post-retrogression historiography is Roger L. Geiger's *The American College in the Nineteenth Century* (2000).

Mark Noll's *Princeton and the Republic, 1768–1822: The Search for a Christian Enlightenment in the Era of Samuel Stanhope Smith* (1989) complicates Hofstadter's view further. Noll's scholarship reveals the *embrace* of Enlightenment philosophies, especially that of Scottish Common Sense, in conjunction with Christianity, on the part of religious schools.[6] Noll's argument is that the synthesis of patriotism, faith, and science did not hold. He finds that Enlightenment philosophies of natural rights and free thinking formed a combustible mixture with Calvinist Christianity at Princeton, leading to student unrest, rioting, and a general breakdown in the functioning of the school. *Princeton and the Republic* is the best example of a work that examines the contradictions of republicanism and Christianity and places American higher education in the context of religious and intellectual change. The University of Virginia was not a denominational school like Princeton, but it, too, was rooted in the European Enlightenment.

Noll's book is a case study that builds on more general works by Howard Miller and Steven Novak, both of whom expand on Hofstadter's basic premise of a retrogression, rather than overturning it.[7] Miller examines the evolution of Presbyterian colleges, the most powerful and influential institutions of the era, in *The Revolutionary College: American Presbyterian Higher Education 1707–1837* (1976). Miller shows how Presbyterians were divided internally over questions of Revolutionary politics, theology, and how to proceed in the political arena. Since Miller's work, others have elaborated on the roll of intradenominational conflict as a motivating factor in school building. In *The Rights of Youth: American Colleges and Student Revolt, 1798–1815* (1977), Novak argues that the Christian educators who reacted by cracking down on student rebellions were not to blame. He

blames rowdy students, who "re-enact[ed] the bold strokes of defiance which gave birth to the American nation, symbolically proving their manhood."[8]

As Novak underscores, students in the early republic came by their interest in revolution and rioting naturally. In *Educating Republicans: The College in the Era of the American Revolution* (1985), David Robson shows how, during the War for Independence, American colleges served as agents of revolutionary change. Robson's book contradicts the thrust of Carl Kaestle's *Pillars of the Republic: Common Schools and American Society, 1780–1860* (1983) and Rush Welter's *Popular Education and Democratic Thought in America* (1962), which both argue that colleges had the conservative tendency to lessen revolutionary sentiment. For an excellent look at the interaction between colleges and politics in the antebellum era, see Michael Sugrue's "'We Desired Our Future Rulers to Be Educated Men': South Carolina College, the Defense of Slavery, and the Development of Secessionist Politics" in Geiger's *The American College in the Nineteenth Century*.

No one has situated the University of Virginia in the history of the early republic as Noll did with Princeton or Sugrue with South Carolina, but Jefferson's educational ideas and initiatives have received attention in their own right. Those interested primarily in the institutional history of UVA should start with selected chapters from Dumas Malone's *The Sage of Monticello* (1981) or Alf Mapp's *Thomas Jefferson, Passionate Pilgrim: The Presidency, the Founding of the University, and the Private Battle* (1981), then proceed to Philip Alexander Bruce's lively five-volume *History of the University of Virginia* (1922). More critical analyses of clerical opposition to UVA, its early student life and the politics of the meeting at Rockfish Gap are offered by three dissertations: Charles Woodburn's "An Historical Investigation of the Opposition to Jefferson's Educational Proposals in the Commonwealth of Virginia" (1974); Charles Wall's "Students and Student Life at the University of Virginia, 1825–1861" (1978); and Neil Shawen's "The Casting of a Lengthened Shadow: Thomas Jefferson's Role in Determining the Site for a State University in Virginia" (1980).

The best book on the political context of Jefferson's plans for education is Richard Brown's *Strength of a People: The Idea of an Informed Citizenry in America, 1865–1870* (1996). Brown shows how education was perceived by the elite in the early republic, and explains how the lack of an established religion in Virginia after the Revolution hurt their educational cause in comparison to Massachusetts. Brown also emphasizes how republican politics discouraged taxation for education.

The fundamentals of Virginia politics are covered in Anthony Upton's 1953 M.A. thesis "The Political Structure of Virginia, 1790–1830." Virginia politics are also covered in Daniel Jordan's *Political Leadership in Jefferson's Virginia* (1983), William Shade's *Democratizing the Old Dominion: Virginia and the Second Party System, 1824–1861* (1996), and Trenton Hizer's 1997 dissertation "'Virginia is Now Divided': Politics in the Old Dominion, 1820–1833." Conservatism

in Virginia and Jeffersonian Republicans are the subject of Norman Risjord's *The Old Republicans: Southern Conservatism in the Age of Jefferson* (1967) and Harry Ammon's 1948 dissertation "The Republican Party in Virginia, 1789–1824." Risjord also contributes "The Virginia Federalists" in the *Journal of Southern History* (1967). For a more detailed look at the idiosyncrasies of the Virginia legislature in the late 1810s see Douglas Egerton's "To the Tombs of the Capulets: Charles Fenton Mercer and Public Education in Virginia, 1816–1817" in *The Virginia Magazine of History and Biography* (April 1985).

For Jefferson's interest in wards and the relation of wards to education, see Hellenbrand's *Unfinished Revolution,* Richard Matthews's *The Radical Politics of Thomas Jefferson: A Revisionist View* (1984), Joseph Ellis's *American Sphinx: The Character of Thomas Jefferson* (1997), and Suzanne Morse's "Ward Republics: The Wisest Invention for Self-Government," in Gilreath's *Education of a Citizen.* Morse's work is strong on Jefferson's ward concept in the mid-1810s, but neglects his use of "hundreds" (a synonymous English term) in the late 1770s as the administrative basis of his educational plans. Matthews's book argues that wards were Jefferson's most democratic concept.

Jefferson's sectional outlook on politics is the subject of Robert Shalhope's "Thomas Jefferson's Republicanism and Antebellum Southern Thought," in the *Journal of Southern History* (1976). Shalhope connects Jefferson to the more militant, reactionary South of John C. Calhoun and the South Carolina Nullification crisis. The best works on Jefferson and the Missouri Crisis are John C. Miller's *The Wolf by the Ears: Thomas Jefferson and Slavery* (1991) and Peter Onuf's "Thomas Jefferson, Missouri, and the 'Empire of Liberty,'" in James Ronda's *Thomas Jefferson and the Changing West* (1997). Jefferson's views on John Marshall's Supreme Court and proper texts for a whig education are analyzed in David Mayer's *The Constitutional Thought of Thomas Jefferson* (1994). Leonard Levy's *Jefferson and Civil Liberties: The Darker Side* (1963) also has an illuminating discussion of Jefferson's pro-whig choices for UVA's textbooks.

The are several good books on Jefferson and religion. A solid factual account of Jefferson's views on religion in schools is Robert Healey's *Jefferson on Religion in Public Education* (1962). Healey was a theologian who supported core religious values being taught in the public schools of the early 1960s, but does a fair job assessing Jefferson. The book makes no attempt to explain the controversy of Jefferson's time from the perspective of his clerical opponents, or to explain nineteenth-century debates from a national perspective.

The best starting point for Jefferson's own religion is Edwin Gaustad's *Sworn on the Altar of God: A Religious Biography of Thomas Jefferson* (1996), which is concise and thorough. It introduces the reader to Jefferson's views on theology, religious freedom, and the proper formation of republican citizens. Noll and Nathan Hatch wrote that "modern conservative evangelicals have as much to learn from

[Gaustad's account of] Jefferson as to scorn . . . the book puts everyone in a better position to discriminate between essentials and nonessentials in contemporary culture wars."[9] Gaustad also wrote *Neither King Nor Prelate: Religion and the New Nation, 1776–1826* (1993). A slightly more detailed account of Jefferson's religion is Charles Sanford's *The Religious Life of Thomas Jefferson* (1984), which shows the relation between Jefferson's politics and religion, emphasizes his rebuttal of original sin, and argues that Jefferson's confrontation with religious conservatives foreshadowed modern debates.[10] Both Gaustad and Sanford do a good job of explaining Jefferson's unique combination of deism, Unitarianism, materialism, and enthusiasm for the Bible.

Shorter articles on Jefferson's religion can be found by Paul Conkin and Eugene Sheridan. Conkin's "The Religious Pilgrimage of Thomas Jefferson," in Onuf's *Jeffersonian Legacies* (1993) outlines the evolution of Jefferson's faith. Sheridan demonstrates how Jefferson connected religious and political virtue in Gilreath's *Education of a Citizen,* and in the introduction to Dickinson Adams's 1983 edition of Jefferson's Bible, *Jefferson's Extracts from the Gospels.* Sheridan's Jefferson hoped to use primitive Christianity to restore the republican virtues that were being eroded by liberal economic principles. He believes Jefferson's correspondence with Benjamin Rush in the late 1790s got Jefferson thinking about religion as a force in politics. Sheridan also discusses the campaign of 1800 and the attacks on Jefferson's infidelity.

Other articles concerning that campaign and clerical attacks on Jefferson are Fred Luebke's "The Origins of Thomas Jefferson's Anti-Clericalism," in *Church History* (September 1963), and Constance Schulz's "Of Bigotry in Politics and Religion," in the *Virginia Magazine of History and Biography* (January 1983). For the backlash against rational religion before and shortly after 1800, see James Smylie's "Clerical Perspectives on Deism: Paine's *The Age of Reason* in Virginia," in *Eighteenth-Century Studies* (1972–1973), and Gustav Koch's *Republican Religion, The American Revolution and the Cult of Reason* (1933).

The story of church-state relations in Virginia is explained by Thomas Buckley in various articles, speeches, and books, including *Church and State in Revolutionary Virginia, 1776–1787* (1977). His "After Disestablishment: Thomas Jefferson's Wall of Separation in Antebellum Virginia," in the *Journal of Southern History* (August 1995), calls for further scholarship on the fate of Virginia's 1786 statute in the nineteenth century.[11] Buckley also has an article on Jefferson's political theology in Merrill Peterson's and Robert Vaughan's *The Virginia Statute for Religious Freedom: Its Evolution and Consequences in American History* (1988). This outstanding collection includes essays by Gaustad, Buckley, Lance Banning, J.G.A. Pocock, Cushing Strout, David Little, A.E. Dick Howard, Rhys Isaac, Martin Marty, and philosopher Richard Rorty. Buckley is currently working on how the statute impacted Virginia politics in the early twentieth century.

Charles James's *Documentary History of the Struggle for Religious Liberty in Virginia* (1900) contains a valuable collection of source materials. For the impact of the 1786 Virginia Statute of Religious Freedom on the Federal Constitution, see Levy's *The Establishment Clause: Religion and the First Amendment* (1986) and Thomas Curry's *The First Freedoms: Church and State and America to the Passage of the First Amendment* (1986).

For an imaginative, anthropological treatment of church-state relations in Virginia, see Isaacs's *The Transformation of Virginia, 1740–1790* (1982), which discusses the relationship between religious denominationalism and political power, and suggests a strong link between evangelical religion and egalitarian sentiment. The best specific article on Jefferson's fight with the Presbyterian clergy in the early nineteenth century is David Swift's "Thomas Jefferson, John Holt Rice, and Education in Virginia," in the *Journal of Presbyterian History* (Spring 1971), which highlights the theological debate between Jefferson and Rice and its connection to legislative politics.

The national debate over church-state relations is discussed in Anson Phelps Stokes's *Church and State in the United States* (1950). More focused studies include Jon Butler's *Awash in a Sea of Faith: Christianizing the American People* (1990), Stephen Botein's "Religious Dimensions of the Early American State," in *Beyond Confederation: Origins of the Constitution and American National Identity* (1987) and William McLoughlin's "The Role of Religion in the Revolution: Liberty of Conscience and Cultural Cohesion in the New Nation," in Stephen Kurtz's and James Hutson's *Essays on the American Revolution* (1973). An efficient, well-illustrated account of church-state relations in the revolutionary and early national period is Hutson's *Religion and the Founding of the American Republic* (1998), the companion book to the Library of Congress's 1998 exhibition on the subject.[12] Hutson downplays the example of Virginia in the forming of the First Amendment. A recent contribution to our understanding of revolutionary religion is Derek H. Davis's *Religion and the Continental Congress, 1774–1789: Contributions to Original Intent* (2000).

Another scholar of church-state relations who sees the importance of Virginia to current debates is Daniel Dreisbach, who wrote "A New Perspective on Jefferson's Views on Church-State Relations: The Virginia Statute for Establishing Religious Freedom in its Legislative Context," in the *American Journal of Legal History* (April 1991), and "Thomas Jefferson and Bills Number 82–86 of the Revision of the Laws of Virginia, 1776–1786: New Light on the Jeffersonian Model of Church-State Relations," in *North Carolina Law Review* (November 1990). Other studies with an eye toward present debates are Mark Noll's *The Scandal of the Evangelical Mind* (1994), Alan Wolfe's "The Opening of the Evangelical Mind," in *Atlantic Monthly* (October 2000), and Marsden's *The Soul of the American University: From Protestant Establishment to Established Nonbelief* (1994).

A recent study criticizing the way religion is studied at modern universities is D.G. Hart's *The University gets Religion: Religious Studies in American Higher Education* (1999).

The impact of evangelical Christianity on Southern society, and vice versa, is covered by Christine Leigh Heyrman in *Southern Cross: Beginnings of the Bible Belt* (1997) and Beth Barton Schweiger in *The Gospel Working Up: Progress and the Pulpit in Nineteenth-Century Virginia* (2000). The role of the clergy in Southern society is covered by E. Brooks Holifield in *The Gentleman Theologians: American Theology in Southern Culture, 1795–1860* (1978). Holifield discusses how the clergy strove to attain legitimacy among the upper classes, especially in urban areas. Other books focusing on Southern religion include Donald Mathews's *Religion in the Old South* (1977), Anne Loveland's *Southern Evangelicals and the Social Order, 1800–1860* (1980), Robert Calhoon's *Evangelicals and Conservatives in the Early South, 1740–1861* (1988), Mitchell Snay's *Gospel of Disunion: Religion and Separatism in the Antebellum South* (1993), and Wesley Gewehr's *The Great Awakening in Virginia, 1740–1790* (1930).[13]

The best starting point on the architecture of UVA is Richard Guy Wilson's *Jefferson's Academical Village: The Creation of an Architectural Masterpiece* (1993), which includes essays by Wilson, James Murray Howard, Patricia Sherwood, and Joseph Lasala, and discusses the political and religious ramifications of Jefferson's plans. Wilson's work expands on older books by Fiske Kimball and William O'Neal. A smaller supplement to Wilson's book is Robert Vickery's *The Meaning of the Lawn: Thomas Jefferson's Design for the University of Virginia* (1998). Pendleton Hogan's *The Lawn: A Guide to Jefferson's University* (1987) is a well-illustrated guide for those touring UVA's grounds, and contains anecdotes about early student life. Any tourists who visit Monticello should take the time to visit UVA's campus as well. Jefferson's drawings for the university are available on-line at the Alderman Library's site under "digital resources and exhibitions." An accessible introduction to Jefferson's interest in architecture is Mike Edward's "Architect of Freedom: Thomas Jefferson," in *National Geographic* (February 1976).

Jack McLaughlin's outstanding book on Monticello, *Jefferson and Monticello: The Biography of a Builder* (1988), contains material relevant to UVA and Jefferson's use of Andrea Palladio. Mark Wenger's "Thomas Jefferson, the College of William & Mary, and the University of Virginia," in the *Virginia Magazine of History and Biography* (July 1995), explains how Jefferson's alma mater served as an architectural foil for his designs in Charlottesville. Frank Grizzard's on-line dissertation, "Documentary History of the Construction of the Buildings at the University of Virginia, 1817–1828" (1997), is a valuable source for the details of the university's construction, and contains a chronology of slaves' involvement in that process.

Numerous other articles tie Jefferson's "academical village" to specific antecedents in France or America, but the reader should be aware that Jefferson had seen many examples of neoclassical architecture in his time, and UVA's campus was adapted to the particular terrain and surroundings of the property on which it was built. Historians of architecture have also covered the University of Virginia in general texts. Among those who devote considerable space to Jefferson and the university are Spiro Kostoff, in *A History of Architecture: Settings and Rituals* (1995); William Pierson, in *American Buildings and their Architects: The Colonial and Neoclassical Styles* (1970); and Robert Tavernor, in *Palladio and Palladianism* (1991).

For general background on education in the early republic, the most recent synthesis is Thomas and Lorraine Smith Pangle's *The Learning of Liberty: The Educational Ideas of the American Founder* (1993). The book contains a wealth of information on the educational philosophies of the Founding Fathers, but mistakenly rejects Honeywell's and Kett's assertion that Jefferson emphasized his university over primary schools.[14] The middle installment of Lawrence Cremin's three-volume set on education, *American Education: The National Experience, 1783–1876*, is a dependable overview of educational developments between the Revolution and the Civil War.

For analyses of American scientific history in this period, see Brooke Hindle's *Pursuit of Science in Revolutionary America, 1735–1789* (1956), John Greene's *American Science in the Age of Jefferson* (1984), George Daniels's *American Science in the Age of Jackson* (1968), and the *Early Transactions of the American Philosophical Society*, reprinted in facsimile by the American Philosophical Society in 1969.

Primary sources on Jefferson are spread throughout the United States, but the most prominent collections are found in the well-indexed Jefferson Papers of the University of Virginia, the Library of Congress, and the Massachusetts Historical Society.[15] Smaller collections are at the Virginia Historical Society, the College of William and Mary, and the Huntington Library in San Marino, California. Since 1950, the primary Jefferson Papers project has been at Princeton University, mostly under the editorships of Julian Boyd, John Catanzariti, and Barbara Oberg. Princeton has published the most comprehensive collection of letters and documents up to the mid-1790s. Recently, the retirement portion of the project (1809 and after) was shifted to Charlottesville, where a new library is being built. The Jefferson Papers of the Library of Congress are available on the internet in a format that allows the user to search letters by subject, recipient, or date.

Beyond 1796, published Jefferson letters and documents are spread among various compilations, the best of which is Andrew Lipscomb and Albert Bergh's

*The Writings of Thomas Jefferson* (1903–1905). Volume 19 of the Lipscomb and Bergh editions contains the minutes of UVA's Board of Visitors from 1824–1825, when they finalized their plans for the university. Merrill Peterson has edited shorter collections, *The Portable Jefferson* (1975) and *Thomas Jefferson: Writings* (1984), which include many of Jefferson's most famous and representative letters and documents. The James Madison Papers are at the University of Virginia, under the editorship of J.C.A. Stagg and David Mattern. John Holt Rice's papers can be found at Union Theological Seminary's Morton Library in Richmond.

Nathaniel Francis Cabell (Joseph's nephew) compiled most of the Jefferson-Cabell correspondence in *Early History of the University of Virginia, as contained in the Letters of Thomas Jefferson and Joseph C. Cabell* (1856), a good starting point for those interested in the political history of UVA's founding. The text is out of print, and Nathaniel Cabell deleted some passages where the ink was blotted, but most of the original letters are available in the Jefferson Papers of the University of Virginia. The appendices of both the Jefferson-Cabell correspondence and Honeywell's *Educational Work of Thomas Jefferson* contain primary documents such as the Rockfish Gap Report, Sundry Documents Concerning Education, and Jefferson's 1814 letter to Peter Carr.

# Notes

## Introduction

1. Merrill D. Peterson, *The Jefferson Image in the American Mind* (New York: Oxford University Press, 1962), 238–239.
2. Leon Botstein entitled his 1997 book on public education *Jefferson's Children: Education and the Creation of a Hopeful Culture*. Charles W. Dabney, President of the University of Tennessee, brought attention to Jefferson's "holy cause" in *Jefferson the Seer* (1903).
3. The same controversy over evolutionary theory versus creationism made famous by the Scopes "monkey trial" in Tennessee (1925) has reemerged in various states, including Kansas. Prayer in school remains legal; but organized, state-sponsored prayers in public schools were overruled by the Supreme Court in 1962, 1992, and 2000. In *Sante Fe Independent School District v. Doe* (2000), the Court ruled that a chaplain (elected by the student council) could not conduct a prayer, or even a generic "invocation," before varsity football games. See *Engel v. Vitale* (1962) and *Weismans v. Providence, R.I.* (1992), where it was similarly ruled a rabbi could not lead a prayer before a graduation ceremony.
4. Humanism is a philosophy that asserts the dignity and worth of humankind and values critical reason over supernatural revelation.
5. Jon Butler, *Awash in a Sea of Faith: Christianizing the American People* (Cambridge, Mass.: Harvard University Press, 1990), 258.
6. James D. Richardson, *A Compilation of Messages and Papers of the President, 1789–1897* (Washington D.C.: Bureau of National Literature and Art, 1904), 1:409–410; James H. Hutson, *Religion and the Founding of the American Republic* (Washington, D.C.: Library of Congress, 1998), 93.
7. Butler, *Awash in a Sea of Faith,* 259–261. In the four states where no church was established during the colonial period—New Jersey, Delaware, Pennsylvania, and Rhode Island—no tax was established. In North Carolina freedom of belief was tolerated, but no one who denied the authority of either the Old or New Testament or otherwise "threatened the freedom or safety of the state" was allowed to hold office or "place of trust or profit in the civil department within this state." Those who did not believe in a future state of rewards and punishments could not work for the state in Tennessee or even vote in Pennsylvania and Vermont.

Similar laws prevailed in South Carolina, whose 1778 constitution established Protestantism as the state's official religion. The Supreme Court of Pennsylvania, a state traditionally associated with religious freedom because of William Penn and the Society of Friends (Quakers), declared in 1822 that "Christianity . . . is and always has been a part of the 'common law' of that state." See Hutson, *Religion and the Founding*, 60–62; Henry May, *The Enlightenment in America* (New York: Oxford University Press, 1976), 327; Edwin S. Gaustad, *Sworn on the Altar of God: A Religious Biography of Thomas Jefferson* (Grand Rapids, Mich.: William B. Eerdman's, 1996), 50, 56, 141.

8. State-supported religion was part of both the Presbyterians' Westminster Confession and the Congregationalists' Cambridge Platform of 1648. Hutson, *Religion and the Founding*, 61; Massachusetts was the last state to separate church and state, following Connecticut in 1818 and New Hampshire in 1819. Daniel L. Driesbach, *Religion and Politics in the Early Republic: Jaspar Adams and the Church-State Debate* (Lexington: University of Kentucky Press, 1996), 4; Gaustad, *Sworn on the Altar of God*, 192–194; Jefferson to John Adams, May 5, 1817, Lester J. Cappon, ed., *The Adams-Jefferson Letters: The Complete Correspondence Between Thomas Jefferson and Abigail and John Adams*, 2d ed. (Chapel Hill: University of North Carolina Press, 1987), 512, n.54.

9. John Adams to Jefferson, May 18, 1817, Cappon, ed., *Adams-Jefferson Letters*, 515.

10. Jefferson to John Adams, May 5, 1817; Cappon, ed., *Adams-Jefferson Letters*, 512; for clerical concerns, see Lyman Beecher to George Augustus Foote, September 28, 1819, Beecher Family Papers, Manuscript Archives, Yale University Library.

11. David McCullough, *John Adams* (New York: Simon & Schuster, 2001), 631.

12. Peterson and Robert Vaughan, eds., *The Virginia Statute for Religious Freedom: Its Evolution and Consequences in American History* (Cambridge, England: Cambridge University Press, 1988), xvii–xviii; for Jefferson's 1777 draft see Merrill D. Peterson, ed., *Thomas Jefferson: Writings* (New York: Library of America, 1984), 346–348.

13. The school was founded by Utilitarians and was also the first English college to admit women.

14. Butler, *Awash in Sea of Faith*, 279.

15. Lefferts A. Loetscher, *Facing the Enlightenment and Pietism: Archibald Alexander and the Founding of Princeton Theological Seminary* (Westport, Conn.: Greenwood, 1983), 148.

16. Louise L. Stevenson, "Colleges and Universities," in James T. Kloppenberg and Richard Wightman Fox, eds., *A Companion to American Thought* (New York: Blackwell, 1985), 134–137.

17. Neils Henry Sonne, *Liberal Kentucky, 1780–1828* (New York: Columbia University Press, 1939).

18. Mark A. Noll, *Princeton and the Republic, 1768–1822: The Search for a Christian Enlightenment in the Era of Samuel Stanhope Smith* (Princeton: Princeton University Press, 1989), 69.

19. The UNC plan was inspired by Davie's reading of Mary Wollstonecraft's *Rights of Women*. Steven J. Novak, *The Rights of Youth: American Colleges and Student Revolt, 1798–1815* (Cambridge, Mass.: Harvard University Press, 1977), 109.

20. Joseph Caldwell to William Davie, January 24, 1797 and Davie to Caldwell, February 26, 1797, University of North Carolina Papers and [Joseph] Caldwell Papers, University Archives, Wilson Library, University of North Carolina at Chapel Hill; Novak, *The Rights of Youth*, 150–161; Robert M. Calhoon, *Evangelicals and Conservatives in the Early South, 1740–1861* (Columbia: University of South Carolina Press, 1988), 122.

21. May, *The Enlightenment in America*, 312.

22. George Ticknor to George Bancroft, December 26, 1824, George Bancroft Papers, Massachusetts Historical Society.

23. Richard D. Brown, *The Strength of a People: The Idea of an Informed Citizenry in America, 1650–1870* (Chapel Hill: University of North Carolina Press, 1996), 98; Brown, "Bulwark of Revolutionary Liberty: Thomas Jefferson's and John Adams's Programs for an Informed Citizenry," in James Gilreath, ed. *Thomas Jefferson and the Education of a Citizen* (Washington, D.C.: Library of Congress, 1999), 98.

24. The award was shared by Samuel Knox (Presbyterian minister from Maryland) and Samuel Harrison Smith (later editor of the Jeffersonian *National Intelligencer*).

25. The term "public education" was used ambiguously, oftentimes referring to schools that charged tuition but were open to the public. Brown, *The Strength of a People*, 81, 100.

26. Brown, *The Strength of a People*, 85–118.

27. Peter S. Onuf, "State Politics and Republican Virtue: Religion, Education and Morality in Early American Federalism," in Paul Finkelman and Stephen E. Gottlieb, eds., *Toward a Usable Past: An Examination of the Origins and Duplications of State Protections of Liberty* (Athens: University of Georgia Press, 1991), 103–104; Webster's dictionary was published in 1828.

28. Jefferson to George Wythe, August 13, 1786; Julian T. Boyd, et al., eds., *The Papers of Thomas Jefferson*, 27 vols. (Princeton, N.J.: Princeton University Press, 1950-), 10:244.

29. Stiles wrote the charter for Rhode Island College in 1763, which later became Brown University.

30. George M. Marsden, *The Soul of the American University: From Protestant Establishment to Established Nonbelief* (Oxford, England: Oxford University Press, 1994), 72.

31. Jefferson to Colonel Yancey, January 6, 1816, H.A. Washington, ed., *The Writings of Thomas Jefferson* (Washington, D.C.: Taylor & Maury, 1854), 6:517.

32. The word "Tory" is a reference to the pro-British stance during the American Revolution or, more generally, a pro-monarchical stand in British history.

## Chapter 1

1. Jefferson to Joseph Cabell, December 18, 1817, Nathaniel Francis Cabell, ed., *Early History of the University of Virginia, as Contained in the Letters of Thomas Jefferson and Joseph C. Cabell* (Richmond, Va.: J.W. Randolph, 1856), 88.

2. A broad definition of the Enlightenment would include representative government, secularism, the articulation of economic theories like capitalism and communism, interest in foreign cultures, philosophical skepticism and, most of all, the dominance of science and technology. By that measure we are part of the same movement today. In this study I use a narrower definition of the term. I define it as an undying faith in the benevolence of scientific progress and intelligibility of social problems. This Enlightenment was a distinct movement that gradually gained popularity among the upper classes during the scientific revolution of the seventeenth and eighteenth centuries, and declined rapidly among intellectuals and Christians after the French Revolution. Romanticism, modernism, postmodernism, and evangelical Christianity are all reactions against the Enlightenment which deny the ability of humankind to improve its lot through studying the world around it.

3. Mark Wenger, "Thomas Jefferson, the College of William & Mary, and the University of Virginia," *Virginia Magazine of History and Biography* 103 (July 1995): 369.

4. David W. Robson, *Educating Republicans: The College in the Era of the American Revolution* (Westport, Conn.: Greenwood, 1985), 251.

5. The Anglican Church, or Church of England, was created by Henry VIII in the sixteenth century when he broke England away from the Roman Catholic Church.

6. Dumas Malone, *The Virginian* (Boston: Little, Brown & Co., 1948), 51–52.

7. I. Bernard Cohen, *Science and the Founding Fathers: Science in the Political Thought of Jefferson, Franklin, Adams, and Madison* (New York: W.W. Norton, 1995), 68–72; Malone, *The Virginian*, 52.

8. Cohen, *Science and the Founding Fathers*, 72.

9. Fred G. Luebke, "The Origins of Thomas Jefferson's Anti-Clericalism," *Church History* 32 (September 1963): 344.

10. Jefferson refers to Bolingbroke six times more than any other author in his *Commonplace Book*. Douglas L. Wilson, ed., *Jefferson's Literary Commonplace Book* (Princeton, N.J.: Princeton University Press, 1989), 24, 34–58, 213–15.

11. Luebke, "The Origins of Thomas Jefferson's Anti-Clericalism," 345.

12. Allen Jayne, *Jefferson's Declaration of Independence: Origins, Philosophy and Theology* (Lexington: University of Kentucky Press, 1998), 138.

13. Skepticism is commonly associated with nineteenth-century modernism and twentieth-century postmodernism (both reactions to Enlightenment philosophy), but it originated within the Enlightenment.

14. Knud Haakonssen, "From Natural Law to the Rights of Man: A European Perspective on American Debates," in Michael J. Lacey and Knud Haakonssen, eds., *A Culture of rights: The Bill of Rights in philosophy, politics, and law—1791 and 1991* (Cambridge, England: Cambridge University Press, 1991), 619.

15. Witherspoon taught revolutionaries James Madison and Benjamin Rush. Haakonssen, "From Natural law to the Rights of Man," 619; Howard Miller, *The Revolutionary College: American Presbyterian Higher Education, 1707–1837* (New York: New York University Press, 1976), 164–165.

16. Jayne, *Jefferson's Declaration of Independence*, 67.

17. Trevor H. Colbourn, *The Lamp of Experience: Whig History and Intellectual Origins of the American Revolution* (Chapel Hill: University of North Carolina Press, 1965), 158–184.

18. Peter S. Onuf, "The Founders' Vision: Education in the Development of the Old Northwest," in Paul H. Mattingly and Edward W. Stevens, Jr., eds., *Schools and the Means of Education Shall Forever Be Encouraged* (Athens, Ohio.: Ohio University Press, 1987), 5.

19. Rhys Isaac, *The Transformation of Virginia, 1740–1790* (Chapel Hill: University of North Carolina Press, 1982), 203.

20. Ralph Ketchum, "The Education of Those Who Govern," in James Gilreath, ed., *Thomas Jefferson and the Education of a Citizen* (Washington, D.C.: Library of Congress, 1999), 283–284.

21. D. Wilson, ed., *Literary Commonplace Book*, 259.

22. St. George Tucker, "Sketch of a plan for the Endowment & Establishment of a National University," April 16, 1797, Tucker-Coleman Papers, Swem Library, College of William and Mary.

23. By 1805, when Jefferson was thinking seriously about the subject himself, Tucker predicted the cost of such a university almost exactly ($300,000 plus $15,000 per year). St. George Tucker, "Sketch of a Plan for the endowment and establishment of a State-University in Virginia," January 4, 1805, Tucker-Coleman Papers, Swem Library, College of William and Mary.

24. Margaret C. Jacob, *The Enlightenment: A Brief History with Documents* (Boston: Bedford/St. Martin's, 2001), 3.

25. "A Bill for the More General Diffusion of Knowledge" was #79; "A Bill for Amending the Constitution of the College of William & Mary, and Substituting More Certain Revenues for Its Support" was #80; "A Bill for Establishing a Public Library" was #81, and "A Bill for

Establishing Religious Freedom" was #82. Julian T. Boyd, et al. eds., *The Papers of Thomas Jefferson,* 27 vols. (Princeton: Princeton University Press, 1950-), 2:526–547. Initially Jefferson, Wythe, and Pendleton were assisted by George Mason and Thomas Lee. Lee died and Mason resigned. James Madison to Nicholas Biddle, May 17, 1827, Galliard Hunt, ed., *The Writings of James Madison,* 9 vols. (New York: G.P. Putnam's Sons, 1900–1910), 9:288.

26. Boyd, et al., eds., *The Papers of Thomas Jefferson,* 2:526–535.

27. Adrienne Koch, *The Philosophy of Thomas Jefferson* (New York: Columbia University Press, 1943), 262.

28. Jefferson to John Adams, October 28, 1813, Lester J. Cappon, ed., *The Adams-Jefferson Letters; The Complete Correspondence Between Thomas Jefferson and Abigail and John Adams,* 2d ed. (Chapel Hill: University of North Carolina Press, 1987), 387–392. For Adams the problem of aristocratic privilege was more complex. For Adams, political problems would not be lessened by Jefferson's distinctions between the "aristoi and pseudo-aristoi." John Adams to Jefferson, November 15, 1813, Cappon, ed., *The Adams-Jefferson Letters,* 397–402.

29. Edmund Pendleton to Jefferson, May 11, 1779, Boyd, et al., eds., *The Papers of Thomas Jefferson,* 2:266. Pendleton refers to Jefferson's letter, December 18, 1778, ibid., 2:308.

30. For more on the tiered system, see Harold Hellenbrand, *The Unfinished Revolution: Education and Politics in the Thought of Thomas Jefferson* (London: Associated University, 1990), 60–184.

31. Garret Ward Sheldon, *The Political Philosophy of Thomas Jefferson* (Baltimore: Johns Hopkins University Press, 1991), 63; Daniel J. Boorstin, *The Lost World of Thomas Jefferson,* 3d ed. (Chicago: University of Chicago Press, 1993), 24.

32. Jefferson to Benjamin Banneker, August 30, 1791, Paul Leicester Ford, ed., *The Writings of Thomas Jefferson,* 10 vols. (New York: G.P. Putnam's Sons, 1892), 5:377.

33. Jefferson to Joel Barlow, October 8, 1809, Andrew A. Lipscomb and Albert E. Bergh, eds., *The Writings of Thomas Jefferson,* 19 vols. (Washington, D.C.: Thomas Jefferson Memorial Foundation, 1903–05), 12:321–322.

34. D. Wilson, "Rediscovered Letter Adds to Slavery Debate," *Monticello* 9 (Spring 1998): 8. Lucia Stanton, Shannon Senior Research Historian at the International Center for Jefferson Studies, points out that Jefferson's idea of mixing the races in the Pleasants letter is not consistent with the views on the subject he expresses elsewhere.

35. Ibid.

36. John Chester Miller, *The Wolf by the Ears: Thomas Jefferson and Slavery* (Charlottesville: University Press of Virginia, 1991), 257.

37. Jefferson, *Notes on the State of Virginia,* William Peden, ed., 2d. ed. (New York: W.W. Norton, 1982), 143; James Oakes, "Why Slaves Can't Read: The Political Significance of Jefferson's Racism," in Gilreath, ed., *Thomas Jefferson and the Education of a Citizen,* 186, 191.

38. For a discussion on Jefferson and female education, which incorporates the scholarship of Holly Brewer, Michael Grossberg, and Frank Shuffleton, see Jan Lewis, "Jefferson, the Family, and Civic Education," in Gilreath, ed., *Thomas Jefferson and the Education of a Citizen,* 63–75.

39. Jefferson to Martha Jefferson, November 28, 1783, Boyd, et al., eds., *The Papers of Thomas Jefferson,* 6:360.

40. Jefferson to John Hartwell Cocke, March 14, 1820, Barraud Papers, Swem Library, College of William and Mary. This letter is a copy of one that Jefferson wrote to Nathanial Burwell on March 14, 1818.

41. Louise L. Stevenson, "Colleges and Universities," in James T. Kloppenbuerg and Richard Wightman Fox, eds., *A Companion to American Thought* (New York: Blackwell, 1985), 134.

42. Jefferson, *Notes on the State of Virginia,* Peden, ed., 146.

43. Sheldon, *Political Philosophy of Thomas Jefferson,* 62.

44. For full discussions of Jefferson's later ward scheme and its relation to education (formal and political) and republicanism, see Suzanne W. Morse, "Ward Republics: The Wisest Invention for Self-Government," in Gilreath, ed., *Thomas Jefferson and the Education of a Citizen,* 264–277; David N. Mayer, *The Constitutional Thought of Thomas Jefferson* (Charlottesville: University Press of Virginia, 1994), 314–319.

45. Jefferson to John Tyler, May 26, 1810, Merrill D. Peterson, ed., *Thomas Jefferson: Writings* (New York: Library of America, 1984), 1225–1226; Onuf, "Thomas Jefferson, Missouri, and the 'Empire of Liberty,'" in James P. Ronda, ed., *Thomas Jefferson and the Changing West* (St. Louis: Missouri Historical Society, 1997), 120; Hellenbrand, *Unfinished Revolution,* 139.

46. Jefferson to Wilson Cary Nicholas, April 2, 1816, Lipscomb and Bergh, eds., *The Writings of Thomas Jefferson,* 14:451–454; John Adams to Jefferson, October 28, 1813, Cappon ed., *Adams-Jefferson Letters,* 387–392.

47. Sheldon, *Political Philosophy of Thomas Jefferson,* 67; Carl J. Richard, *The Founders and the Classics: Greece, Rome, and the American Enlightenment* (Cambridge, Mass.: Harvard University Press, 1994), 77.

48. Donald K. Matthews, *The Radical Politics of Thomas Jefferson: A Revisionist View* (Lawrence: University Press of Kansas, 1984), 77; wards are the subject of Hannah Arendt's appraisal of Jefferson as a democrat in *On Revolution* (New York: Viking, 1963), 217–285.

49. Jefferson to Samuel Kercheval, July 12, 1816, Peterson, ed., *The Portable Jefferson* (New York: Penguin Books, 1975), 557.

50. Jefferson, Autobiography, 1821, Lipscomb and Bergh, eds., *The Writings of Thomas Jefferson,* 1:70.

51. Jefferson to Joseph Cabell, January 31, 1814, Lipscomb and Bergh, eds., *The Writings of Thomas Jefferson,* 14:84.

52. Jefferson to Joseph Cabell, February 2, 1816, N.F. Cabell, ed., *Early History of the University of Virginia,* 52–56.

53. Jefferson to John Tyler, May 26, 1810, Lipscomb and Bergh, eds., *The Writings of Thomas Jefferson,* 12:391.

54. Joseph Kett, "Education," in Peterson, ed., *Thomas Jefferson: A Reference Biography* (New York: Charles Scribner's Sons, 1986), 235.

55. Despite Jefferson's political problems in New England, he always envied their demography. Both his ward scheme and his later layout for the University of Virginia were attempts to capture the effect of small New England towns. Jefferson's obsession with wards was also a way for him to avoid acknowledging that the strength of New England's school system during the colonial period was due to its clergy.

56. Samuel Stanhope Smith to Jefferson, March? 1779, Boyd, et al., eds., *The Papers of Thomas Jefferson,* 2:246–247.

57. Isaac, *Transformation of Virginia,* 294.

58. Samuel Stanhope Smith to Jefferson, April 19, 1779, Boyd, et al., eds., *The Papers of Thomas Jefferson,* 2:253; Jefferson's letter to Smith is lost; Mark A. Noll, *Princeton and the Republic, 1768–1822: The Search for a Christian Enlightenment in the Era of Samuel Stanhope Smith* (Princeton, N.J.: Princeton University Press, 1989), 69.

59. Jefferson to Anne Cary Bankhead, February 24, 1823, Lipscomb and Bergh, eds., *The Writings of Thomas Jefferson,* 18:255; Wilson, "Jefferson and Literacy," in Gilreath, ed., *Thomas Jefferson and the Education of a Citizen,* 81; Carl Becker, *The Heavenly City of Eighteenth-Century Philosophers* (New Haven, Conn.: Yale University Press, 1932), 102, 105–106.

60. Lorraine Smith and Thomas Pangle, *The Learning of Liberty: The Educational Ideas of the American Founders* (Lawrence: University Press of Kansas, 1993), 2.

61. Jefferson to Edward Carrington, January 16, 1787, Boyd, et al., eds., *The Papers of Thomas Jefferson,* 11:49. In the same letter, Jefferson comments that Indians are happier than whites because they have less government, and that white society is divided into two sections: the wolves and the sheep (Tories and Whigs).

62. Joel Spring, *The American School, 1642–1990: Varieties of Historical Interpretation of the Foundations and Development of American Education* (New York: Longman, 1990), 43.

63. Alfred J. Morrison, *The Beginnings of Public Education in Virginia, 1776–1860: Study of Secondary Schools in Relation to the State Literary Fund* (Richmond, Va.: Davis Bottom, 1917), 8–9.

64. Roy J. Honeywell, *The Educational Work of Thomas Jefferson* (Cambridge, Mass.: Harvard University Press, 1931), 14.

65. Hellenbrand, *Unfinished Revolution,* 119.

66. Jefferson, *Notes on the State of Virginia,* Peden, ed., 146–7; Elizabeth Wirth Marvick, "Thomas Jefferson and the Old World: Personal Experience in the Formation of Early Republican Ideals," in Gilreath, ed., *Thomas Jefferson and the Education of a Citizen,* 161.

67. Jefferson, *Notes on the State of Virginia,* Peden, ed., 159–160.

68. Ibid., 146–148.

69. In the late 1740s, Presbyterian preachers from New England, New York, and New Jersey preached in the Virginia Piedmont. By the 1760s Baptists had come to Virginia and North Carolina and English Methodist missionaries preached in the Chesapeake region. Christine Leigh Hyreman, *Southern Cross: The Beginnings of the Bible Belt* (New York: Alfred A. Knopf, 1997), 10–11; Baptists were the most numerous dissenters in the Tidewater and Piedmont areas of eastern and central Virginia. By the early nineteenth century, Baptists had the most members in Virginia, followed by the Methodists. Arminian Methodists and Calvinist Baptists competed for lower-class whites. Thomas E. Buckley, *Church and State in Revolutionary Virginia, 1776–1787* (Charlottesville: University Press of Virginia, 1977), 5, 11, 13, 19; Scotch-Irish Presbyterians and central European pietists like the Moravians, Dunkers, Mennonites, and Schenkfelders came south and west from Pennsylvania into Virginia, the Carolinas, and Georgia in the mid-eighteenth century and later migrated to Kentucky and Tennessee. They brought their faith with them in the form of Bibles, catechisms, missionaries, and the Westminster Presbyterian Confession of Faith. Billy Kennedy, *The Scots-Irish in the Shenandoah Valley* (Belfast, U.K.: Ambassador Productions, 1996), 39.

70. Colonial dissent was discussed by Edward Bond at an American Historical Association panel entitled "After Thomas Jefferson: Church and State in Virginia," San Francisco, January 4, 2002.

71. Isaac, "'The Rage of Malice of the Old Serpent Devil': The Dissenters and the Making and Remaking of the Virginia Statute for Religious Freedom," in Peterson and Robert C. Vaughan, eds., *The Virginia Statute for Religious Freedom: Its Evolution and Consequences in American History* (Cambridge, England: Cambridge University Press, 1988), 147; Isaac, *Transformation of Virginia,* 293.

72. Jefferson, *Notes on the State of Virginia,* Peden, ed., 158.

73. John B. Boles, *The Great Revival: Beginnings of the Bible Belt,* 2d ed. (Lexington: University of Kentucky Press, 1996), 155–156.

74. Richard Beale Davis, *Intellectual Life in Jefferson's Virginia, 1790–1830* (Chapel Hill: University of North Carolina Press, 1964), 131–132.

75. Charles A. Miller, *Jefferson and Nature: An Interpretation* (Baltimore: Johns Hopkins University Press, 1988), 38; also see William Christian, *Henry Home, Lord Kames, and the Scottish Enlightenment: A Study in National Character and in the History of Ideas* (The Hague, Netherlands: Martinus Nijhoff, 1971), xx–xxi.

76. James B. Conant, *Thomas Jefferson and the Development of American Public Education* (Berkeley: University of California Press, 1962), 18–19.

77. Quoted in David H. Fleming, *The Reformation in Scotland: Causes, Characteristics, Consequences* (London: Hodder and Stoughton, 1910), 518–519; cited in H. Miller, *Revolutionary College*, 60.

78. Jefferson to Thomas Cooper, March 13, 1820, Jefferson Papers, Special Collections, Alderman Library, University of Virginia.

79. Conant, *Thomas Jefferson and the Development of American Public Education*, 19.

80. Buckley, "After Disestablishment: Thomas Jefferson's Wall of Separation in Antebellum Virginia," *Journal of Southern History* 61 (August 1995): 451.

81. James H. Hutson, *Religion and the Founding of the American Republic* (Washington, D.C.: Library of Congress, 1998), 61.

82. Isaac, *Transformation of Virginia*, 162–163, 200–201.

83. Jefferson, *Notes on the State of Virginia*, Peden, ed., 157.

84. Miller, *Revolutionary College*, 139–140.

85. Mason's influence as a founding father was on par with his friends Jefferson and Madison. He is less famous because he never ran for public office and his opposition to slavery, among other things, prevented him from signing the Constitution.

86. Ronald L. Hatzenbuhler, "Growing Weary in Well-Doing: Thomas Jefferson's Life Among the Virginia Gentry," *Virginia Magazine of History and Biography* 101 (January 1993): 20–21.

87. Jefferson's three drafts for the Virginia Constitution are printed in Boyd, et al., eds., *The Papers of Thomas Jefferson*, 1:337–364.

88. Leonard Levy, *Jefferson and Civil Liberties: The Darker Side*, 2d ed. (Chicago: Ivan R. Dee, 1989), 43; two American editions of Furneaux were published in Philadelphia in 1773.

89  "Notes and Proceedings on Discontinuing the Establishment of the Church of England," Boyd, et al, eds., *The Papers of Thomas Jefferson*, 1:526–527.

90. Jefferson, "Notes and Proceedings," Boyd, et al., eds., *The Papers of Thomas Jefferson*, 1:525–558.

91. Ibid., 1:537.

92. Ibid., 1:526; *Journal of the Virginia House of Delegates, 1776,* October 24, 32–33.

93. Jefferson, *Autobiography,* in Adrienne Koch and William Peden, eds., *The Life and Selected Writings of Thomas Jefferson* (New York: Modern Library, 1944), 41.

94. Jefferson, "Notes and Proceedings," Boyd, et al., eds., *The Papers of Thomas Jefferson*, 1:552.

95. Edwin S. Gaustad, *Sworn on the Altar of God: A Religious Biography of Thomas Jefferson* (Grand Rapids, Mich.: William B. Eerdmans, 1996), 70–71.

96. Jefferson, "Notes on Locke and Shaftesbury" ("Notes and Proceedings"), Boyd, et al., eds., *The Papers of Thomas Jefferson*, 1:548.

97. Gaustad, *Sworn on the Altar,* 69–71.

98. Jefferson, *Notes on the State of Virginia,* Peden, ed., 158; Isaac, *Transformation of Virginia,* 278–293; Hatzenbuhler, "Growing Weary in Well-Doing," 22.

99. Jefferson, *Notes on the State of Virginia,* Peden, ed., 159.

100. "A Bill for Amending the Constitution of the College of William & Mary, and Substituting More Certain Revenues for Its Support," Boyd et al., eds., *The Papers of Thomas Jefferson*, 2:535–543; Jefferson, "Autobiography," Lipscomb and Bergh, eds., *Writings of Thomas Jefferson*, 1:71.

101. Isaac, *Transformation of Virginia,* 130.

102. Charles O. Woodburn, "An Historical Investigation of the Opposition to Jefferson's Educational Proposals in the Commonwealth of Virginia" (Ph.D. diss., American University Press, 1974), 147; Alma Pond Carey, "Thomas Jefferson's Ideal University: Dream and Actuality" (M.A. thesis, University of Texas, 1937), 9.

103. Jefferson to Joseph Cabell, February 22, 1821, N.F. Cabell, ed., *Early History of the University of Virginia,* 207; *Vital Facts: A Chronology of the College of William & Mary* (Williamsburg, Va.: College of William and Mary, 1992), 7.

104. James Morton Smith, ed., *The Republic of Letters: The Correspondence between Jefferson and Madison, 1776–1826,* 3 vols. (New York: W.W. Norton & Co., 1995), 1:52–53.

105. Jack N. Rakove, "Parchment Barriers and the Politics of Rights," in Lacey and Haakonssen, eds., *A Culture of Rights,* 127; Smith, ed., *Republic of Letters,* 1:50.

106. Edmund Randolph, *History of Virginia,* Arthur Schaffer, ed. (Charlottesville: University Press of Virginia, 1970), 234–235; quoted in Smith, *Republic of Letters,* 1:53–54.

107. Thomas J. Curry, *The First Freedoms: Church and State and America to the Passage of the First Amendment* (Oxford, England: Oxford University Press, 1986), 142; Rakove, "Parchment Barriers," 126–127.

108. James H. Smylie, "Madison and Witherspoon: Theological Roots of American Political Thought," *Princeton University Library Chronicle* 22 (1961), 118–132; cited in Noll, *Princeton and the Republic,* 71.

109. James Madison, *The Federalist* #10 (1788), Isaac Kramnick, ed. (New York: Penguin, 1987), 122–128; James Madison to Jefferson, October 17, 1788, Smith, ed., *Republic of Letters,* 1:562–564; Matthews, *Radical Politics of Thomas Jefferson,* 103; Lance Banning, "James Madison, the Statute for Religious Freedom, and the Crisis of Republican Convictions," in Peterson and Vaughan, eds., *Virginia Statute of Religious Freedom,* 129; Richard Hofstadter, *The Idea of a Party System: The Rise of Legitimate Opposition in the United States, 1780–1840,* 3d ed. (Berkeley: University of California Press, 1972), 56.

110. Levy, *Jefferson and Civil Liberties,* 10.

111. Isaac, *Transformation of Virginia,* 293; Hatzenbuhler, "Growing Weary in Well-Doing," 24.

112. Stephen Botein, "Religious Dimensions of the Early American State," in Richard Beeman, Stephen Botein, and Edward C. Carter II, eds., *Beyond Confederation: Origins of the Constitution and American National Identity* (Chapel Hill: University of North Carolina Press, 1987), 320.

113. Madison, "Detached Memoranda," *William & Mary Quarterly* 3 (October 1946), 557.

114. Hutson, *Religion and the Founding,* 66.

115. Curry, *The First Freedoms,* 141.

116. Miller, *Revolutionary College,* 144–145.

117. Jefferson to James Madison, December 8, 1784, Boyd, et al., eds., *The Papers of Thomas Jefferson,* 7:558.

118. Gaustad, *Sworn on the Altar,* 58.

119. Hutson, *Religion and the Founding,* 66.

120. James Madison to Jefferson, January 22, 1786, Smith, *Republic of Letters,* 1:402.

121. John T. Noonan Jr., *The Lustre of our Country: The American Experience of Religious Freedom* (Berkeley: University of California Press, 1998), 74.

122. Madison, *Memorial and Remonstrance against Religious Assessments,* Hutchinson and Rachel, eds., *Papers of James Madison,* 8:302.

123. Discussed in Daniel Dreisbach, *Religion and Politics in the Early Republic: Jasper Adams and the Church-State Debate* (Lexington: University of Kentucky Press, 1996), 16.

124. Discussed in Curry, *The First Freedoms*, 143.

125. For the most complete discussions of the controversy and its national legacy, see Peterson and Robert Vaughan, eds., *The Virginia Statute for Religious Freedom: Its Evolution and Consequences in American History* (Cambridge, England: Cambridge University Press, 1988). The statute is printed on xvii–xviii.; also see "Bill for Establishing Religious Freedom," Boyd, et al., eds., *The Papers of Thomas Jefferson*, 2:545–547.

126. Jefferson, *Autobiography*, Koch and Peden, eds., 47.

127. Jefferson to George Wythe, August 13, 1786, Peterson, ed., *Thomas Jefferson: Writings*, 858–859; Jefferson to James Madison, December 16, 1786, Smith, ed., *The Republic of Letters*, 458.

128. Hutson, *Religion and the Founding*, 73.

129. *Journal of the Virginia House of Delegates, 1786–1787*, 87; *Journal of the Virginia Senate, 1786–1787*, 91.

130. Cushing Strout, "Jeffersonian Liberty and American Pluralism," in Peterson and Vaughan, eds., *Virginia Statute of Religious Freedom*, 204.

131. Buckley, "After Disestablishment," 449.

132. Martin E. Marty, "The Virginia Statute Two-Hundred Years Later," in Peterson and Vaughan, eds., *The Virginia Statute of Religious Freedom*, 1.

133. In *Everson v. Board of Education* (1947), Justice Hugo L. Black wrote that the First Amendment was "meant to provide the same protection against governmental intrusion on religious liberty as the Virginia Statute;" quoted in Marty, "The Virginia Statute Two-Hundred Years Later," 4–5; modern judicial opinions "acknowledge the seminal role of the Virginia law in the development of religious liberty and its historic connection to the First Amendment." Buckley, "After Disestablishment," 446.

134. Peterson, *The Jefferson Image in the American Mind* (New York: Oxford University Press, 1962), 94.

135. Woodburn, "An Historical Investigation," 140.

136. John Mack Faragher, "Land Ordinance of 1785," in Faragher, ed., *The Encyclopedia of Colonial and Revolutionary America* (New York: De Capo, 1996), 228.

137. "Congressional Objections to the Proposal to Grant Public Lands for the Endowment of State Universities," in Edgar K. Knight, ed., *A Documentary History of Education in the South Before 1860*, 5 vols. (Chapel Hill: University of North Carolina Press, 1950), 3:180.

138. The planning of the Northwest Territories was one of the biggest such projects ever undertaken, comparable to the engineering projects of the Romans and Dutch. Spiro Kostoff, *A History of Architecture: Settings and Rituals* (New York: Oxford University Press, 1995), 626.

139. Hutson, *Religion and the Founding*, 57.

140. Neil McDowell Shawen, "Thomas Jefferson and a 'National University': The Hidden Agenda for Virginia," *Virginia Magazine of History and Biography* 92 (July 1984): 330.

141. See the upcoming collection of essays by Robert McDonald, tentatively entitled *Thomas Jefferson's Military Academy: Establishing West Point*.

142. Jennings L. Wagoner Jr. and Christine Coalwell, "In Search of Mr. Jefferson's Military Academy: An Educational Inquiry into the Founding of West Point," 2002 (typescript, 24), in Robert McDonald's upcoming *Thomas Jefferson's Military Academy: Establishing West Point*.

143. Jefferson to Joseph Priestley, January 18, 1800, Peterson, ed., *Thomas Jefferson: Writings*, 1070; Wagoner and Coalwell, "In Search of Jefferson's Military Academy," 17.

144. Peter S. Onuf, "Thomas Jefferson's Military Academy: A Summary View," 2002 (typescript, 6, 9, 12) in Robert McDonald's upcoming *Thomas Jefferson's Military Academy: Establishing West Point*.

145. Onuf, "Thomas Jefferson's Military Academy," 7, 16.

146. John M. Murrin, "The Jeffersonian Triumph and American Exceptionalism," *Journal of the Early Republic* 20 (Spring 2000): 14; for a detailed treatment, see Theodore J. Crackel, *Mr. Jefferson's Army: Political and Social Reform of the Military Establishment, 1801–1809* (New York: New York University Press, 1987); Wagoner and Coalwell, "In Search of Jefferson's Military Academy," 4.

147. Onuf, "Thomas Jefferson's Military Academy," 20, 32.

148. Wagoner and Coalwell, "In Search of Jefferson's Military Academy," 17–19, 24–25, 37.

149. William H. Goetzmann, *Army Exploration in the American West, 1803–1863* (New Haven: Yale University Press, 1959); Henry Adams, *History of the United States During the Administration of James Madison* (New York: Library of America, 1986), 1341–1342; cited in Wagoner and Coalwell, "In Search of Jefferson's Military Academy," 39–40.

150. Onuf, "Thomas Jefferson's Military Academy," 24–26.

151. Forrest McDonald, *The Presidency of Thomas Jefferson* (Lawrence: University Press of Kansas, 1976), 130.

152. Jefferson, "Sixth Annual Message," December 2, 1806, Lipscomb and Bergh, eds., *Writings of Jefferson,* 3:423.

153. See Shawen's "Thomas Jefferson and a 'National University.'"

154. Wagoner and Coalwell, "In Search of Jefferson's Military Academy," 6–8.

155. Jefferson, "Sixth Annual Message," 309–335.

156. During the ministry of Sir Robert Walpole in the 1720s and 1730s, "Real Whigs" (who carried on the reform spirit of the Glorious Revolution of 1688) opposed the arbitrary rule of the Crown and demanded representation in Parliament. They joined with the "country" party, which opposed the aristocratic power of the "court."

157. Wagoner and Coalwell, "In Search of Jefferson's Military Academy," 14.

158. Kett, "Education," 239.

159. Alf J. Mapp Jr., *Thomas Jefferson, Passionate Pilgrim: The Presidency, the Founding of the University, and the Private Battle* (Lanham, Maryland: Madison Books, 1991), 206.

160. Gustav Adolph Koch, *Republican Religion: The American Revolution and the Cult of Reason* (New York: Henry Holt, 1933), 269.

161. Jefferson, *Notes on the State of Virginia,* 159.

162. Gaustad, *Sworn on the Altar,* 74.

163. Joseph J. Ellis, "The First Democrats," *U.S. News & World Report,* August 21, 2000, 39.

164. Another ringleader of the attacks on Jefferson was Nathanael Emmons of Franklin, Massachusetts. Henry May, *The Enlightenment in America* (New York: Oxford University Press, 1976), 316.

165. Luebke, "Jefferson's Anti-Clericalism," 346–347.

166. *Massachusetts Mercury,* August 26, 1800. Deism thrived in late seventeenth and mid-eighteenth-century Britain. Deism, sometimes formerly called *physico-theology,* is the idea that God had constructed the universe but did not take an active, or intermediary, role in human affairs. The clockwork universe (the idea that God created the universe like a watchmaker, wound it, and let it run) is associated with Enlightenment deism. Jefferson was more of a pantheist, because he saw God as an active agent in nature. Edwin Gaustad called Jefferson a "warm deist," since his materialism included a live spirit. Gaustad, *Sworn on the Altar,* 36, 143–144.

167. Luebke, "Jefferson's Anti-Clericalism," 344–354; Constance Bartlett Schulz, "Of Bigotry in Politics and Religion," *Virginia Magazine of History and Biography* 91 (1983): 73–91.

168. Jefferson to Elbridge Gerry, March 29, 1801, Lipscomb and Bergh, eds., *Writings of Thomas Jefferson,* 10:252.

169. Luebke, "Jefferson's Anti-Clericalism," 352.

170. Gaustad, *Sworn on the Altar,* 114.
171. Thomas Jefferson to Benjamin Rush, September 23, 1800, Peterson, ed., *Thomas Jefferson: Writings,* 1082.
172. Jefferson to Benjamin Rush, April 21, 1803, Peterson, ed., *Thomas Jefferson: Writings,* 1122.
173. Eugene R. Sheridan, "Liberty and Virtue: Religion and Republicanism in Jeffersonian Thought," in Gilreath, ed., *Thomas Jefferson and the Education of a Citizen,* 256.
174. Eugene R. Sheridan, Introduction to Dickinson W. Adams, ed., *Jefferson's Extracts from the Gospels: "The Philosophy of Jesus" and "The Life and Morals of Jesus,"* (1804 & 1820?) (Princeton, N.J.: Princeton University Press, 1983), 19.
175. Gaustad, *Sworn on the Altar,* 112–114.
176. Jefferson to John Adams, July 5, 1814, Cappon, ed., *Adams-Jefferson Letters,* 433.
177. Sheridan, Introduction to *Jefferson's Extracts from the Gospels,* 28.
178. Jefferson to Colonel Yancey, January 6, 1816, H.A. Washington, ed., *The Writings of Thomas Jefferson* (Washington, D.C.: Taylor & Maury, 1854), 6:517.
179. Jefferson to Joseph Priestley, January 18, 1800, Peterson, ed., *Thomas Jefferson: Writings,* 1070.
180. Jefferson to M. Pictet, February 5, 1803, Lipscomb and Bergh, eds., *The Writings of Thomas Jefferson,* 10:355.
181. The bill was introduced by Delegate James Semple. "Extracts from the Journal of the House of Delegates," *Richmond Enquirer,* January 16, 1806. The bill was tabled and did not come up for a vote.
182. Jefferson to Littleton Waller Tazewell, January 5, 1805, Peterson, ed., *Thomas Jefferson: Writings,* 1149–1153. Tazewell was a Republican lawyer from Norfolk, Virginia.
183. Jefferson to David Williams, November 14, 1803, Lipscomb and Bergh, eds., *The Writings of Thomas Jefferson,* 10:429–430.
184. Carey, "Thomas Jefferson's Ideal University," 16.
185. Minutes from Albermarle Academy, March 13, April 5, and May 3, 1814, Jefferson Papers, Special Collections, Alderman Library, University of Virginia; Patricia C. Sherwood and Joseph Michael Lasala, "Education and Architecture: The Evolution of the University of Virginia's Academic Village," in Richard Guy Wilson, ed., *Thomas Jefferson's Academical Village: The Creation of an Architectural Masterpiece* (Charlottesville: University Press of Virginia, 1993), 13.
186. Mapp Jr., *Thomas Jefferson, Passionate Pilgrim,* 262.
187. Dumas Malone, *The Sage of Monticello* (Boston: Little, Brown & Co., 1981), 244.
188. Jefferson to Peter Carr, September 7, 1814, Lipscomb and Bergh, eds., *The Writings of Thomas Jefferson,* 19:211–221.
189. Kett, "Education," 235, 238.
190. The divisions of study were also close to those of the Marquis de Condorcet, a theorist of education killed during the French Revolution. This may have just been an ancillary effect of Jefferson's more important debt to Condorcet's theory of democratic growth being tied to the expansion of education. The fact that Jefferson advocated the elementary education of working men through evening classes also points to the influence of Condorcet. Jefferson was also influenced by Madame de Staël, whose *On Literature Considered in its Relation to Social Institutions* (1800) was a pioneering work in its analysis of thought and artistic creation in their social contexts. Jefferson shared Staël's view that this could be accomplished partly by an accumulation of knowledge, and partly by an extension to lower segments of society.
191. Carey, "Thomas Jefferson's Ideal University," 4, 125.

192. Robert M. Healey, *Jefferson on Religion in Public Education* (New Haven, Conn.: Yale University Press, 1962), 210, 213.

193. Jefferson to Thomas Cooper, January 16, 1814, Lipscomb and Bergh, eds., *The Writings of Thomas Jefferson,* 14: 54–62.

## Chapter 2

1. *Richmond Enquirer,* February 28, 1817; Joseph Cabell to Jefferson, January 12, 1817, Nathaniel Francis Cabell, ed., *Early History of the University of Virginia, as Contained in the Letters of Thomas Jefferson and Joseph C. Cabell* (Richmond, Va.: J.W. Randolph, 1856), 71–72; Joseph Kett, "Education," in Merrill D. Peterson, ed., *Thomas Jefferson: A Reference Biography* (New York: Charles Scribner's Sons, 1986), 243.

2. Herbert E. Sloan and Peter S. Onuf, "Politics, Culture and the Revolution in Virginia: A Review of Recent Work," *Virginia Magazine of History and Biography* 91 (July 1983): 269; Ronald L. Hatzenbuhler, "Growing Weary in Well-Doing: Thomas Jefferson's Life among the Virginia Gentry," *Virginia Magazine of History and Biography* 101 (January 1993): 7.

3. Norman K. Risjord, "The Virginia Federalists," *Journal of Southern History* 33 (1967): 514–515.

4. The Virginia Legislature discussed extending suffrage to free blacks and women at one point, but Democrats extinguished this idea and significant reapportionment until 1851. Also see the Diary of Hugh Blair Grigsby, October 16, 1829, Virginia Historical Society, Richmond, Virginia. African Americans secured the vote in 1965.

5. Anthony Frederick Upton, "The Political Structure of Virginia, 1790–1830" (M.A. thesis, Duke University, 1953), 17; Dumas Malone, *The Sage of Monticello* (Boston: Little, Brown & Co., 1981), 387.

6. Upton, "The Political Structure of Virginia," 87, 91, 101–104.

7. Elmer G. Dickinson, "The Influence of Sectionalism upon the History of the James River and Kanawha Company in Western Virginia" (M.A. thesis, Duke University, 1941), 31; Upton, "The Political Structure of Virginia," 20.

8. Ibid., 83, 86.

9. A similar ambition, to connect the Potomac River to the Ohio Country, was the subject of a conference in Alexandria, Virginia in 1785 which, in turn, led to a general meeting concerning commerce at Annapolis, Maryland in 1786. There it was decided to convene in Philadelphia to destroy the Articles of Confederation in 1787 and write the U.S. Constitution.

10. Cornelius J. Heatwole, *A History of Education in Virginia* (New York: Macmillan, 1916), 101, 124.

11. Edgar K. Knight, "The Evolution of Public Education in Virginia," *Sewanee Review Quarterly* 24 (1916): 29–34; James B. Conant, *Thomas Jefferson and the Development of American Public Education* (Berkeley: University of California Press, 1962), 10.

12. David E. Swift, "Thomas Jefferson, John Holt Rice, and Education in Virginia," *Journal of Presbyterian History* 49 (Spring 1971): 34.

13. Jefferson to John Adams, July 5, 1814, Lester J. Cappon, ed., *The Adams-Jefferson Letters; The Complete Correspondence Between Thomas Jefferson and Abigail and John Adams,* 2d ed. (Chapel Hill: University of North Carolina Press, 1987), 434.

14. "Supplement, Containing the Acts of the General Assembly" (Richmond, Va.: Samuel Pleasants, 1812); cited in Malone, *Sage of Monticello,* 236–237.

15. Biographical entry for James Barbour, *Encyclopedia of Virginia Biography,* Lyon Gardiner Tyler, ed. (New York: Lewis Historical Publishing, 1915), 48.

16. Richard D. Brown, *The Strength of a People: The Idea of an Informed Citizenry in America, 1650–1870* (Chapel Hill: University of North Carolina Press, 1996), 98; Carl F. Kaestle, *Pillars of the Republic: Common Schools and American Society, 1780–1860* (New York: Hill & Wang, 1983), chapters 1–3.

17. Swift, "Thomas Jefferson, John Holt Rice, and Education in Virginia," 36.

18. Risjord, "The Virginia Federalists," 505–506, 511.

19. Federalism was common in Virginia between 1800 and the War of 1812. Many of the elite merchants along the eastern seaboard were Federalists until the war because of their fear of France and Napoleon. The removal of France as a threat after 1815 coincided with the decline of the Southern Federalist Party. James H. Broussard, *The Southern Federalists, 1800–1816* (Baton Rouge: Louisiana State University Press, 1978), 402–403. Southern Federalists were embarrassed and alienated by the Hartford Convention because of its anti-Southern sentiment. The Republican Party held sway, but initially faced stiff competition from the Federalists and later frayed apart into the National and Democratic-Republicans. Most Federalists switched affiliation to the National Republicans and some later became Whigs in the second party system. By the 1820s, newspapers did not even carry party labels on votes because of the muddled nature of party politics. Newspapers even complained that they could no longer classify politicians in Richmond. *The* (Lynchburg) *Virginian* of January 5, 1824, asked, "Who are the Republicans? Is Mr. Morris of Hanover one? How long ago did he abandon his ultra-Federalist principles?" By the 1830s Democrats and Whigs came to represent complex coalitions that defy easy regional or ideological characterizations. The Whig Party continued to press for educational reform in opposition to Jefferson's old party, countering some Jacksonian Democrats who then wanted to abolish the entire Literary Fund. William G. Shade, *Democratizing the Old Dominion: Virginia and the Second Party System, 1824–1861* (Charlottesville: University Press of Virginia, 1996), 10, 188, 165; on slavery and the Federalists, see Rosemarie Zagarri, "Gender and the First Party System," 119, and Paul Finkelman, "The Problem of Slavery in the Age of Federalism," 152, in Doron Ben-Atar and Barbara B. Oberg, eds., *Federalists Reconsidered* (Charlottesville: University Press of Virginia, 1998).

20. Broussard, *The Southern Federalists*, 328.

21. Jefferson to Joseph Cabell, January 24, 1816, N.F. Cabell, ed., *Early History of the University of Virginia*, 50.

22. Mercer was later president of the American Colonization Society. "Autobiographical Sketch," Mercer-Hunter Family Letters, 1767–1842, The Library of Virginia, Richmond, Virginia.

23. Hugh Blair Grigsby, "Biographical Notes on Charles Fenton Mercer and Chapman Johnson" (Scrapiana of Virginia Convention of 1829–1830), Hugh Blair Grigsby Papers, Virginia Historical Society, Richmond, Virginia.

24. *Alexandria Gazette, Commercial & Political*, February 18, 1817.

25. Biographical entry for Charles Fenton Mercer, Lyon Gardiner Tyler, ed., *Encyclopedia of Virginia Biography*, 120; *Journal of the Virginia House of Delegates, 1816–17*, January 28, 1817 and February 20, 1817, 177, 223.

26. Charles Fenton Mercer, "Discourse on Popular Education, 1826," in Knight, ed., *A Documentary History of Education in the South Before 1860*, 5 vols. (Chapel Hill: University of North Carolina Press, 1950), 2:342.

27. Jefferson to Joseph Cabell, February 26, 1816, N.F. Cabell, ed., *Early History of the University of Virginia*, 60–61.

28. Jefferson to William Short, November 28, 1814, Andrew A. Lipscomb and Albert E. Bergh, eds., *The Writings of Thomas Jefferson*, 19 vols. (Washington D.C.: Thomas Jefferson Memorial

Foundation, 1903–1905), 14:217; quoted in Onuf, "Thomas Jefferson, Missouri, and the 'Empire of Liberty,'" in James P. Ronda, ed., *Thomas Jefferson and the Changing West* (St. Louis: Missouri Historical Society, 1997), 125.

29. Robert E. Shalhope, "Thomas Jefferson's Republicanism and Antebellum Southern Thought," *Journal of Southern History* 42 (1976): 543.

30. See Drew McCoy, *The Elusive Republic: Political Economy in Jeffersonian America* (Chapel Hill: University of North Carolina Press, 1980).

31. Jefferson to William H. Crawford, June 20, 1816, Lipscomb and Bergh, eds., *The Writings of Thomas Jefferson,* 15:28.

32. Shalhope, "Thomas Jefferson's Republicanism," 538–539.

33. Jefferson to Marquis de Lafayette, November 4, 1823, H.A. Washington, ed., *The Writings of Thomas Jefferson,* 6 vols. (Washington, D.C.: Taylor & Maury, 1854), 7:325–326.

34. Julian T. Boyd, "The Chasm that Separated Thomas Jefferson and John Marshall," in Gottfried Dietze, ed., *Essays on the American Constitution* (Englewood Cliffs, N.J.: Prentice-Hall, 1964), 18; quoted in David N. Mayer, *The Constitutional Thought of Thomas Jefferson* (Charlottesville: University Press of Virginia, 1994), 291–292.

35. "Letters on the Richmond Party, by a Virginian," *Washington Republican and Congressional Examiner* (1823?); quoted in Joseph H. Harrison Jr., "Oligarchs and Democrats: The Richmond Junto," *The Virginia Magazine of History and Biography* 78 (1970): 194–195.

36. Risjord, *The Old Republicans: Southern Conservatism in the Age of Jefferson* (New York: Columbia University Press, 1965), 176.

37. The Junto was a by-product of the legislative caucus that debuted in Virginia in 1800. Harry Ammon, "The Richmond Junto, 1800–1824," *Virginia Magazine of History and Biography* 61 (October 1953): 396.

38. Other organizations in Nashville, Tennessee and Concord, New Hampshire arose during the Jacksonian era.

39. Ammon, "The Richmond Junto," 397.

40. Wilson Cary Nicholas was elected as governor in 1814 and later served as president of the Richmond branch of the U.S. Bank. The Junto assumed control of the state's third biggest financial institution, the Farmer's Bank, in 1819, and also controlled four of eight Privy Council members. They got a bill passed prohibiting the circulation of notes drawn from any of the three banks they controlled. Robert Preston, who was from western Virginia, was elected governor in 1816 because of his connections with the coalition. Upton, "The Political Structure of Virginia," 107, 110–111; Ammon, "The Richmond Junto," 399–402.

41. Ibid., 418. The Junto limped on for thirty more years, until the alterations of the 1851 constitution, which broadened suffrage, deprived the legislature of its power to elect state officials, and made the county courts subject to election.

42. Upton, "The Political Structure of Virginia," 116.

43. Virginia editors like William Gray of Fredericksburg's *Virginia Herald* and James O'Conner of the *Norfolk & Portsmouth Herald* attacked the national bank, tariff, and any federal scheme of improvement. Risjord, *The Old Republicans,* 177.

44. Shade, *Democratizing the Old Dominion,* 2.

45. Biographical entry for Thomas Ritchie, *Encyclopedia of Virginia Biography,* Tyler, ed., 196.

46. Jefferson to Thomas Ritchie, and "A Correspondent" to Ritchie, August 28, 1817, Jefferson Papers, Library of Congress; cited in Stuart Leibiger, "Thomas Jefferson and the Missouri Crisis: An Alternative Interpretation" (Research Note), *Journal of the Early American Republic* 17 (Spring 1997): 128.

47. *Acts Passed at a General Assembly of the Commonwealth of Virginia, 1815–1816* (Richmond:

Thomas Ritchie, 1816), 191–193; Joseph Cabell to Jefferson, February 14, 1816, N.F. Cabell, ed., *Early History of the University of Virginia,* 56.

48. "The President and Directors of the Literary Fund of Virginia [1816] Report on 'The Establishment of an University,'" in Knight, ed., *A Documentary History of Education,* 3:131.

49. The new board included David Watson of Louisa County, John Hartwell Cocke of Fluvanna, and Joseph C. Cabell of Nelson County, along with Jefferson, Madison, and Monroe.

50. Alma Pond Carey, "Thomas Jefferson's Ideal University: Dream and Actuality" (M.A. thesis, University of Texas, 1937), 19.

51. Gene Crotty, *Jefferson's Legacy: His Own University,* 2d ed. (Virginia: Crotty, 1998), 19–20.

52. Jefferson to John Adams, May 26, 1817, Cappon, ed., *Adams-Jefferson Letters,* 518.

53. Kett, "Education," 235; Malone, *Sage of Monticello,* 255; Crotty, *Jefferson's Legacy,* 19.

54. "Extracts from the Minutes of the Board of Visitors of the University of Virginia during the Rectorship of Thomas Jefferson, 1817–1826," in Knight, ed., *A Documentary History of Education,* 3:136–139; Kett, "Education," 268.

55. Patricia C. Sherwood and Joseph Michael Lasala, "Education and Architecture: The Evolution of the University of Virginia's Academic Village," in Richard Guy Wilson, ed., *Thomas Jefferson's Academical Village: The Creation of an Architectural Masterpiece* (Charlottesville: University Press of Virginia, 1993), 18; Pendleton Hogan, *The Lawn: A Guide to Jefferson's University* (Charlottesville: University Press of Virginia, 1987), 2.

56. Jefferson to John Hartwell Cocke, July 19, 1817, Jefferson Papers, University of Virginia.

57. Jefferson to Martha Jefferson, August 31, 1817, Jefferson Papers, Massachusetts Historical Society.

58. "The First Stone of Central College, Virginia, is Laid, 1817," *Richmond Enquirer,* October 17, 1817.

59. Joseph J. Ellis, *American Sphinx: The Character of Thomas Jefferson* (New York: Alfred A. Knopf, 1997), 282.

60. Adrienne Koch, *Jefferson & Madison: The Great Collaboration* (New York: Oxford University Press, 1950), 263.

61. James Morton Smith, ed., *The Republic of Letters: The Correspondence between Jefferson and Madison, 1776–1826,* 3 vols. (New York: W.W. Norton & Co., 1995), 3:1796.

62. Clinton was a New York politician active in promoting the Erie Canal and other state programs during the early nineteenth century. Cabell's corresponding infrastructure project was the James River and Kanawha Canal.

63. Joseph Cabell to Jefferson, March 5, 1815, N.F. Cabell, ed., *Early History of the University of Virginia,* 39; Malone, *Sage of Monticello,* 247.

64. Jefferson, Monroe, W.C. Rives (U.S. Senator and Minister to France), Philip B. Barbour (justice of the Supreme Court), James Barbour (governor, senator, and minister to Great Britain), Andrew Stevenson (speaker of the U.S. House of Representatives), and William Clark, the explorer, all hailed from Albermarle County, along with six other governors, two secretaries of state and one secretary of the navy. Philip Alexander Bruce, *History of the University of Virginia, 1819–1919: The Lengthened Shadow of One Man,* 5 vols. (New York: Macmillan, 1920), 1:111–113.

65. Joseph Cabell to David Watson, March 4, 1798, David Watson Papers, Library of Congress.

66. Joseph Cabell to John Hartwell Cocke, July 7, 1825, Cabell Deposit, Special Collections, Alderman Library, University of Virginia; Joseph Cabell to Jefferson, March 5, 1815, N.F. Cabell, ed., *Early History of the University of Virginia,* 40.

67. Jefferson to Joseph Cabell, January 5, 1815, ibid., 37–38.

68. Col. Nicholas & Others, "Passages Erased from Jefferson's two bills, 1817–1818," Cabell Deposit, Special Collections, Alderman Library, University of Virginia.

69. Crotty, *Jefferson's Legacy,* 29.

70. Joseph Cabell to Jefferson, February 26, 1816, N.F. Cabell, ed., *Early History of the University of Virginia,* 61.

71. "Circular from Governor Wilson C. Nicholas of Virginia on a System of Education in that State" (1816), in Knight, ed., *A Documentary History of Education,* 2:535–543.

72. John B. Minor to Henry S. Randall, August 9, 1851; cited in Randall, *The Life of Thomas Jefferson* 2d ed. (Philadelphia: J.B. Lipponcott, 1888), 461.

73. *Norfolk Gazette & Public Ledger,* March 2, 1816; Neil McDowell Shawen, "The Casting of a Lengthened Shadow: Thomas Jefferson's Role in Determining the Site for a State University in Virginia" (Ph.D. diss., George Washington University, 1980), 155.

74. Charles O. Woodburn, "An Historical Investigation of the Opposition to Jefferson's Educational Proposals in the Commonwealth of Virginia" (Ph.D. diss., American University, 1974), 92.

75. Joseph Cabell to Jefferson, February 26, 1816, N.F. Cabell, ed., *Early History of the University of Virginia,* 61; also see Joseph Cabell to Jefferson, January 24, 1816, ibid., 50.

76. David Campbell to Clairborne Watts Gooch, December 22, 1816, Gooch Family Papers, Virginia Historical Society, Richmond, Virginia.

77. *Journal of the Virginia House of Delegates 1816–1817,* February 14, 1817, 211; Broussard, *The Southern Federalists,* 329.

78. Shade, *Democratizing the Old Dominion,* 165. "Consolidationists" was a term Jefferson came to use to describe nationalists, Federalists, or Tories.

79. Shawen, "Casting of a Lengthened Shadow," 164, 166–167.

80. David Campbell to Clairborne Watts Gooch, December 22, 1816, Gooch Family Papers, Virginia Historical Society, Richmond, Virginia.

81. *Norfolk Gazette & Public Ledger,* December 19, 1815.

82. Joseph Cabell to Jefferson, January 12, 1817, N.F. Cabell, ed., *Early History of the University of Virginia,* 72.

83. *Alexandria Gazette,* December 28, 1816.

84. *Richmond Enquirer,* January 4, 1817 and February 20, 1817.

85. Malone, *Sage of Monticello,* 272.

86. *Richmond Enquirer,* January 16, 1817.

87. *Richmond Enquirer,* February 18, 1817.

88. William A. Maddox, *The Free School Idea in Virginia before the Civil War* (New York: Columbia University Press, 1918), 65.

89. *Alexandria Gazette,* January 7 and 10, 1817.

90. Joseph Cabell to Jefferson, February 9, 1817, N.F. Cabell, ed., *Early History of the University of Virginia,* 73; *Richmond Enquirer,* January 4, 1817; *Alexandria Gazette,* January 27, 1817; *Journal of the Virginia Senate, 1816–17,* January 21, 1817.

91. *Sundry Documents on the Subject of a System of Public Education for the State of Virginia* (Richmond, Va.: Ritchie, Trueheart, and Du-val, 1817), 33; *Alexandria Gazette,* February 18, 1817.

92. Conant, *Thomas Jefferson and the Development of American Public Education,* 30–31.

93. Douglas R. Egerton, "To the Tombs of the Capulets: Charles Fenton Mercer and Public Education in Virginia, 1816–1817," *Virginia Magazine of History and Biography* 93 (April 1985), 172.

94. Kett, "Education," 242.

95. Joseph Cabell to Jefferson, February 19, 1817, N.F. Cabell, ed., *Early History of the University of Virginia,* 74.

96. Shawen, "Casting of a Lengthened Shadow," 215.

97. Joseph Cabell to Jefferson, January 12, 1817, N.F. Cabell, ed., *Early History of the University of Virginia*, 72.

98. Mercer, *An Exposition of the Weakness and Inefficiency of the Government of the United States* (n.p., 1845), 258; quoted in Shawen, "Casting of a Lengthened Shadow," 214; Woodburn, "An Historical Investigation," 81.

99. Joseph Cabell to Jefferson, February 9, 1817, N.F. Cabell, ed., *Early History of the University of Virginia*, 73.

100. Jefferson to Joseph Cabell, October 14, 1817, ibid., 82; Shawen, "Casting of a Lengthened Shadow," 211.

101. Jefferson to Joseph Cabell, September 9, and October 24, 1817, N.F. Cabell, ed., *Early History of the University of Virginia*, 79, 83; Lipscomb and Bergh, eds., *The Writings of Thomas Jefferson*, 17:418–434; Roy J. Honeywell, *The Educational Work of Thomas Jefferson* (Cambridge, Mass.: Harvard University Press, 1931), 233–243.

102. Jurist Archibald D. Murphey was introducing a similar plan into North Carolina's Legislature in 1817, which included wards and free education and scholarships for poor children. *North American Review* 30 (January 1821): 16–37.

103. Jefferson to Joseph Cabell, October 24, 1817, N.F. Cabell, ed., *Early History of the University of Virginia*, 84; Shawen, "Casting of a Lengthened Shadow," 219–220.

104. Lipscomb and Bergh, eds., *The Writings of Thomas Jefferson*, 17:425.

105. Jefferson to Chevalier de Ouis, April 28, 1814, Lipscomb and Bergh, eds., *The Writings of Thomas Jefferson*, 14:129–130.

106. Jefferson to P.S. Dupont de Nemours, April 24, 1816, Peterson, ed., *Thomas Jefferson: Writings* (New York: Library of America, 1984), 1387.

107. Col. Nicholas & Others, "Passages Erased from Jefferson's Two Bills, 1817–1818," Cabell Deposit, Special Collections, Alderman Library, University of Virginia.

108. Jefferson to Joseph Cabell, January 6, 1818, Jefferson Papers, Swem Library, College of William and Mary.

109. Joseph Cabell to Jefferson, December 29, 1817, N.F. Cabell, ed., *Early History of the University of Virginia*, 93.

110. Jefferson to Joseph Cabell, January 6, 1818, Jefferson Papers, Swem Library, College of William and Mary.

111. Elizabeth D. Samet, "Figures in Arms: John Adams, Thomas Jefferson, and the 'Military Spectre,'" 2002 (typescript, 12), in Robert McDonald's upcoming *Thomas Jefferson's Military Academy: Establishing West Point;* cited in Peter S. Onuf, "Thomas Jefferson's Military Academy: A Summary View," in *McDonald, Thomas Jefferson's Military Academy*.

112. Joseph Cabell to Jefferson, December 29, 1817, N.F. Cabell, ed., *Early History of the University of Virginia*, 90.

113. Jefferson to Francis T. Brooke, November 7, 1817, Edgar Erskine Hume, ed., *Papers of the Society of the Cincinnati in the State of Virginia, 1783–1824* (Richmond, Va.: Society of Cincinnati, 1938), 260.

114. William Hill to Reverend Dr. George Baxter, November 12, 1818, Scrapbook—Society of Cincinnati, Special Collections, Leyburn Library, Washington and Lee University.

115. "Extract from the Minutes of the Board of Trustees, 1819," ibid.

116. Jefferson refers to an April 24, 1796 letter to his former neighbor Mazzei, which started the rumor in Jefferson to Martin Van Buren, June 29, 1824, Lipscomb and Bergh, eds., *The Writings of Thomas Jefferson*, 16:62.

117. Joseph Cabell to James Madison, February 16, 1818, James Madison Papers, University of Virginia.

118. Mr. Jefferson's Letter relative to the School Bill, n.d., Cabell Deposit, Special Collections, Alderman Library, University of Virginia; Shawen, "Casting of a Lengthened Shadow," 245; *Richmond Enquirer,* February 11, 1818.

119. Jefferson "felt the foundations of government shaken under my feet by the New England township." Jefferson to Joseph Cabell, February 2, 1816, N.F. Cabell, ed., *Early History of the University of Virginia,* 55; Also see Jefferson to Cabell, January 14, 1818 and Cabell to Jefferson, January 22, 1818, ibid., 102–106, 108–110.

120. Joseph Cabell to John Hartwell Cocke, January 31, 1818, Cabell Deposit, Special Collections, Alderman Library, University of Virginia.

121. Joseph Cabell to James Madison, February 16, 1818, James Madison Papers, University of Virginia.

122. *Journal of the Virginia Senate, 1817–18,* February 19–20, 1818.

123. "Sketches of the Laws," *Norfolk & Portsmouth Herald,* March 4, 1818.

124. Swift, "Thomas Jefferson, John Holt Rice, and Education in Virginia," 48.

125. Woodburn, "An Historical Investigation," 103.

126. Shawen, "The Casting of a Lengthened Shadow," 251.

127. *Journal of the Virginia House of Delegates, 1817–1818,* February 18, 1818, 214–215; Risjord, "The Virginia Federalists," 516–517.

128. Joseph Cabell to Jefferson, December 29, 1817, N.F. Cabell, ed., *Early History of the University of Virginia,* 93.

129. John Brockenbrough to Joseph Cabell, January 31, 1818, Cabell Deposit, Special Collections, Alderman Library, University of Virginia.

130. Board of Trustees Minutes, July 18, 1818, Washington College, 68, Special Collections, Leyburn Library, Washington and Lee University.

131. Crotty, *Jefferson's Legacy,* 30.

132. Shawen, "Casting of a Lengthened Shadow," 274–275.

133. Ibid., 253.

134. Ibid., 256–257, 270.

135. Ibid., 267; Crotty, *Jefferson's Legacy,* 35–37.

136. Bruce, *History of the University of Virginia,* 1:210–211.

137. Joseph Cabell to Jefferson, February 6, 1818, N.F. Cabell, ed., *Early History of the University of Virginia,* 118.

138. Alf J. Mapp Jr., *Thomas Jefferson, Passionate Pilgrim: The Presidency, the Founding of the University, and the Private Battle* (Lanham, Maryland: Madison Books, 1991), 283.

139. Jefferson to James Madison, June 28, 1818, Smith, ed., *The Republic of Letters,* 3:1804–1805.

140. John Hartwell Cocke to Joseph Cabell, July 21, 1818, Cabell Deposit, Special Collections, Alderman Library, University of Virginia.

141. Jefferson to James Madison, June 28, 1818, Smith, ed., *The Republic of Letters,* 3:1805.

142. Jefferson to Spencer Roane, June 28, 1818, Jefferson Papers, Library of Congress.

143. Mapp Jr., *Thomas Jefferson, Passionate Pilgrim,* 276–277.

144. Ibid., 274.

145. Bruce, *History of the University of Virginia,* 1:211.

146. Mapp Jr., *Thomas Jefferson, Passionate Pilgrim,* 278; Malone, *Sage of Monticello,* 277.

147. John G. Jackson to Joseph Cabell, December 10, 1818, Cabell Deposit, Special Collections, Alderman Library, University of Virginia.

148. Mapp Jr., *Thomas Jefferson, Passionate Pilgrim*, 277.

149. Shawen, "Casting of a Lengthened Shadow," 280–285.

150. The Rockfish Gap Report was known officially as the "Report of the Commissioners appointed to fix the Site of the University of Virginia." For the full fifty-one page report, see Jefferson Papers (Series 3, Film 8, #1567), Special Collections, Alderman Library, University of Virginia. Also see Peterson, ed. *The Portable Thomas Jefferson* (New York: Penguin Books, 1975), 332–346.

151. Mapp Jr., *Thomas Jefferson, Passionate Pilgrim*, 278–279.

152. Malone, *Sage of Monticello*, 276.

153. Jefferson to John Adams, October 7, 1818, Cappon, ed., *Adams-Jefferson Letters*, 528.

154. Shawen, "Casting of a Lengthened Shadow," 291–292.

155. Joseph Cabell to Jefferson, December 24, 1818, N.F. Cabell, ed., *Early History of the University of Virginia*, 143–144.

156. Joseph Cabell to Jefferson, January 7, 1819, ibid., 146–149.

157. Joseph Cabell to Jefferson, November 18, 1818, ibid., 134.

158. Joseph Cabell to Jefferson, January 25, 1819, ibid., 153; Malone, *Sage of Monticello*, 282.

159. John Hartwell Cocke to Joseph Cabell, December 10, 1818, Cabell Deposit, Special Collections, Alderman Library, University of Virginia.

160. Joseph Cabell to John Hartwell Cocke, February 1, 1819, Nathaniel Francis Cabell Papers, Virginia Historical Society, Richmond, Virginia.

161. *Richmond Enquirer*, December 19, 1818.

162. Ibid., January 5, 1819.

163. Joseph Cabell to Jefferson, December 8, 1818, N.F. Cabell, ed., *Early History of the University of Virginia*, 137; Joseph Cabell to Jefferson, December 17, 1818, ibid., 139; Shawen, "Casting of a Lengthened Shadow," 296–297, 308.

164. Dabney Carr to Joseph Cabell, n.d., Nathaniel Francis Cabell Papers, Virginia Historical Society, Richmond, Virginia.

165. Joseph Cabell to Isaac Coles, December 23, 1818, Cabell Deposit, Special Collections, Alderman Library, University of Virginia.

166. Joseph Cabell to Jefferson, December 24, 1818, N.F. Cabell, ed., *Early History of the University of Virginia*, 142.

167. Jefferson to John Adams, October 28, 1813, Cappon, ed., *Adams-Jefferson Letters*, 389; Jefferson to Samuel Kercheval, July 12, 1816, Lipscomb and Bergh, eds., *The Writings of Thomas Jefferson*, 15:32–44.

168. William Cabell Rives to John Hartwell Cocke, January 20, 1819, Cocke Family Papers, Special Collections, Alderman Library, University of Virginia; William Cabell Rives to Jefferson, January 20, 1819, Jefferson Papers, Library of Congress; Joseph Cabell to Jefferson, January 18, 1819, N.F. Cabell, ed., *Early History of the University of Virginia*, 149–150. *Journal of the House of Delegates*, January 19, 1819, 112.

169. *Norfolk & Portsmouth Herald*, January 20, 1819.

170. Joseph Cabell to Jefferson, January 7, 1819, N.F. Cabell, ed., *Early History of the University of Virginia*, 147–148.

171. Ibid., 147; Joseph Cabell to John Hartwell Cocke, February 1, 1819, Nathaniel Francis Cabell Papers, Virginia Historical Society, Richmond, Virginia.

172. The earliest seal of the university was a representation of "Minerva enrobed in her peplum and characteristic habiliments of inventress and protectress of the arts, with the words 'University of Virginia' running around the verge, and the date, 1819, stamped at the bottom."

Bruce, *History of the University of Virginia*, 2:42. The Minerva was also the seal at William and Mary. *Journal of the House of Delegates*, January 25, 1819, 134.

173. Shawen, "Casting of a Lengthened Shadow," 309–310.

174. Jefferson to James Madison, March 2, 1819, Smith, ed., *The Republic of Letters*, 3:1807.

175. Jefferson to James Madison, March 6, 1819, ibid., 3:1808.

176. Jefferson to Joseph Cabell, January 28, 1819, N.F. Cabell, ed., *Early History of the University of Virginia*, 154.

177. Jefferson to Wilson Cary Nichols, January 28, 1819, Jefferson Papers, Library of Congress.

178. Joseph Cabell to Jefferson, March 8, 1819, N.F. Cabell, ed., *Early History of the University of Virginia*, 154; Joseph Cabell to John Hartwell Cocke, March 6, 1819, Cabell Deposit, Special Collections, Alderman Library, University of Virginia.

179. Jefferson to Thomas Ritchie, June 11, 1819, Jefferson Papers, Massachusetts Historical Society.

180. Jefferson to Joseph Cabell, January 5, 1815, N.F. Cabell, ed., *Early History of the University of Virginia*, 37.

181. Joseph Cabell to Jefferson, January 16, 1816, ibid., 44; Jefferson to Joseph Cabell, January 24, 1816, ibid., 49.

182. Jefferson to Joseph Cabell, January 13, 1823, ibid., 267.

183. Kett, "Education," 243, 263.

184. Egerton, "To the Tombs of the Capulets," 168.

185. Shawen, "Casting of a Lengthened Shadow," 214.

## Chapter 3

1. The Rockfish Gap Report was known officially as the "Report of the Commissioners appointed to fix the Site of the University of Virginia." For the full fifty-one page report, see the Jefferson Papers (Series 3, Film 8, #1567), Special Collections, Alderman Library, University of Virginia. For a condensed version, see Merril D. Peterson, ed., *The Portable Thomas Jefferson* (New York: Penguin Books, 1975), 332–346.

2. Jefferson to Joseph Cabell, November 28, 1820, Nathaniel Francis Cabell, ed., *Early History of the University of Virginia, as Contained in the Letters of Thomas Jefferson and Joseph C. Cabell* (Richmond, Va.: J.W. Randolph, 1856), 187.

3. James H. Smylie, "Clerical Perspectives on Deism: Paine's *The Age of Reason* in Virginia," *Eighteenth-Century Studies* 6 (1972–1973): 206.

4. Jefferson to Benjamin Waterhouse, July 19, 1822, and January 8, 1825, Paul Leicester Ford, ed., *The Writings of Thomas Jefferson*, 10 vols. (G.P. Putnam's Sons, 1892), 10:220–221, 336.

5. Jefferson to Ezra Stiles, June 25, 1819, Andrew A. Lipscomb and Albert E. Bergh, eds., *The Writings of Thomas Jefferson* 19 vols. (Washington, D.C.: Thomas Jefferson Memorial Foundation, 1903–1905), 15:203.

6. Thomas Edwin Buckley, "The Political Theology of Thomas Jefferson," in Peterson and Robert C. Vaughan, eds., *The Virginia Statute for Religious Freedom: Its Evolution and Consequences in American History* (Cambridge, England: Cambridge University Press, 1988), 96.

7. James H. Hutson, *Religion and the Founding of the American Republic* (Washington, D.C.: Library of Congress, 1998), 93.

8. Ibid., 84, 94–95.

9. On New Year's Day 1802 President Jefferson received a 1235-pound "mammoth cheese" (4' × 15") from the Baptist congregation of Chesire, Massachusetts, led by Elder John Leland.

10. Jefferson also anticipated the liberal Christianity of the nineteenth and twentieth centuries. Arthur Schlesinger Jr. wrote that Christian Social Action, Social Gospel, and the Catholic liberation theology are all essentially Jeffersonian. Quoted in Edwin S. Gaustad, *Sworn on the Altar of God: A Religious Biography of Thomas Jefferson* (Grand Rapids, Mich.: William B. Eerdmans, 1996), 139.

11. Jefferson to Isaac Story, December 5, 1801, Ford, ed., *The Writings of Thomas Jefferson*, 7: 107.

12. Buckley, "The Political Theology of Thomas Jefferson," 96.

13. Gaustad, *Sworn on the Altar of God*, xiii–xiv.

14. Ibid., 168.

15. Jefferson's account book shows he took possession of an apartment at the Hermitage of Mont Calvaire on Mont Valérien on September 5, 1787. Elizabeth Wirth Marvick, "Thomas Jefferson and the Old World: Personal Experience in the Formation of Early Republican Ideals," in James Gilreath, ed., *Thomas Jefferson and the Education of a Citizen* (Washington, D.C.: Library of Congress, 1999), 173–174.

16. Thomas Jefferson Coolidge, "Jefferson and His Family," Lipscomb and Bergh, eds., *The Writings of Jefferson*, 15:iv.

17. J.G.A. Pocock, "Religious Freedom and the Desacralization of Politics: From the English Civil Wars to the Virginia Statute," in Peterson and Vaughan, eds., *The Virginia Statute for Religious Freedom*, 66.

18. Jefferson, *Notes on the State of Virginia*, William Peden, ed., 2d ed. (New York: W.W. Norton, 1982), 159. Many historians agree with Jefferson's analysis.

19. Jefferson to Timothy Pickering, February 27, 1821, Timothy Pickering Papers, Massachusetts Historical Society.

20. Jefferson to Salma Hale, Hale Family Papers, July 26, 1818, Massachusetts Historical Society.

21. Calvinism is the brand of Protestantism founded by the French-Swiss theologian John Calvin, marked by its strong emphasis on God's sovereignty and the doctrine of predestination—that one's fate in the afterlife is predetermined before he or she is born.

22. Jefferson to Salma Hale, Hale Family Papers, July 26, 1818, Massachusetts Historical Society.

23. Gaustad, *Sworn on the Altar*, 117–118.

24. Ibid., 134.

25. Jefferson to James Smith, December 8, 1822, Jefferson Papers, Library of Congress.

26. Eugene R. Sheridan, Introduction to Dickinson W. Adams, ed., *Jefferson's Extracts from the Gospels: "The Philosophy of Jesus" and "The Life and Morals of Jesus"* (Princeton, N.J.: Princeton University Press, 1983). Adams reconstructed the work despite the loss of the original text. "Wee little book" comes from Jefferson to Charles Thomson, January 9, 1816, Lipscomb and Bergh, eds., *The Writings of Thomas Jefferson*, 14:385.

27. Jefferson was a heretic in the true sense of the Greek term: "one who picks and chooses those elements of a philosophical system which he likes, discarding the others." Carl J. Richard, *The Founders and the Classics: Greece, Rome, and the American Enlightenment* (Cambridge, Mass.: Harvard University Press, 1994), 193.

28. Sheridan, Introduction to *Jefferson's Extracts*, 32.

29. Jefferson to F.A. Vander Kemp, April 25, 1816, Lipscomb and Bergh, eds., *The Writings of Jefferson*, 15:1–3; Sheridan, "Liberty and Virtue: Religion and Republicanism in Jeffersonian Thought," in Gilreath, ed., *Thomas Jefferson and the Education of a Citizen*, 261.

30. Jefferson to William Short, October 31, 1819, Jefferson to William Short, October 31, 1819, Peterson, ed., *Portable Jefferson*, 565.

31. Jefferson to Charles Thomson, January 9, 1816, Lipscomb and Bergh, eds., *The Writings of*

*Jefferson,* 14:385–386. Jefferson also used Christ's radicalism to criticize Judaism and considered that religious code's claim to monopolize communication with the deity "fumes of the most disordered imaginations." Jefferson to William Short, August 4, 1820, Lipscomb and Bergh, eds., *The Writings of Jefferson,* 15:246.

32. Robert M. Healey, *Jefferson on Religion in Public Education* (New Haven, Conn.: Yale University Press, 1962), 249.

33. Allen Jayne, *Jefferson's Declaration of Independence: Origins, Philosophy and Theology* (Lexington, Ky.: University of Kentucky Press, 1998), 99–100.

34. Jefferson to John Adams, October 12, 1813, Lester J. Cappon, ed., *The Adams-Jefferson Letters; The Complete Correspondence Between Thomas Jefferson and Abigail and John Adams,* 2 d ed. (Chapel Hill: University of North Carolina Press, 1987), 384; Gaustad, *Sworn on the Altar,* 132, 135.

35. Jefferson to Peter Carr, August 10, 1787, Lipscomb and Bergh, eds., *The Writings of Thomas Jefferson,* 12:15–16. This echoed the view of John Locke in *Some Thoughts Concerning Education* (1690).

36. Jefferson to Thomas Law, June 13, 1814, Lipscomb and Bergh, eds., *The Writings of Thomas Jefferson,* 14:139, 143.

37. Jefferson to John Adams, May 5, 1817, Cappon, ed., *The Adams-Jefferson Letters,* 512.

38. Jefferson to James Fishback, September 27, 1809, Lipscomb and Bergh, eds., *The Writings of Thomas Jefferson,* 12:315.

39. Kant declared that two things filled him with awe: "the starry skies above and the moral law within." Robert C. Solomon and Kathleen M. Higgins, *A Short History of Philosophy* (New York: Oxford University Press, 1996), 16; Gaustad, *Sworn on the Altar,* 23–24.

40. Jefferson to Anne Cary Bankhead, February 24, 1823, Lipscomb and Bergh, eds., *The Writings of Thomas Jefferson,* 18:255; Joel H. Spring, *The American School, 1642–1990: Varieties of Historical Interpretation of the Foundations and Development of American Education* (New York: Longman, 1990), 41–43.

41. "Report of the Commissioners for the University of Virginia," Peterson, ed., *The Portable Thomas Jefferson,* 343. Ethics was not created as a full professorship when the university opened.

42. Sheridan, "'Liberty and Virtue,'" 246.

43. In the eighteenth century, for instance, political theorists often justified themselves by making analogies with the workings of the Solar System.

44. "Report of the Commissioners for the University of Virginia," Peterson, ed., *The Portable Thomas Jefferson,* 336.

45. Jefferson to James Madison, August 8, 1824, James Morton Smith, ed., *The Republic of Letters: The Correspondence between Jefferson and Madison, 1776–1826,* 3 vols. (New York: W.W. Norton & Co., 1995), 3:1896–1897.

46. James Madison to Jefferson, September 10, 1824, ibid., 3:1898–1901.

47. James Madison to Edward Everett, March 19, 1823, Gaillard Hunt, ed., *The Writings of James Madison,* 9 vols. (New York: G.P. Putnam's Sons, 1900–1910), 9:124–130.

48. E. Brooks Holifield, *The Gentleman Theologians: American Theology in Southern Culture, 1795–1860* (Durham, N.C.: Duke University Press, 1978), 58–59; Gilbert Chinard, *Jefferson et les Ideologues d'apres sa Correspondence Inedite avec Destutt de Tracy, Cabanis, J.-B. Say, et Auguste Comte* (Baltimore: Johns Hopkins University Press, 1925), 25, 231.

49. Positivism rejects metaphysics on the grounds that we can know nothing about ultimate principles, forces, or entities.

50. Cabanis's work was a precursor to the more systematic philosophy known as positivism. Positivism's most famous nineteenth-century proponents were August Comte and Herbert Spencer.

51. Daniel J. Boorstin, *The Lost World of Thomas Jefferson,* 3d ed. (Chicago: University of Chicago Press, 1993), 117.

52. Jefferson to John Adams, August 15, 1820, Cappon, ed., *The Adams-Jefferson Letters,* 567–568.

53. Adrienne Koch described Jefferson as fluctuating between materialism and "vitalistic pantheism." Adrienne Koch, *The Philosophy of Thomas Jefferson* (New York: Columbia University Press, 1943), 98.

54. Thomas Jefferson to Augustus Woodward, March 24, 1824, H.A. Washington, ed., *The Writings of Thomas Jefferson* 8 vols. (Washington D.C.: Taylor & Maury, 1854), 7:339–340. In the Enlightenment tradition, Jefferson loved to tinker with categories. He sometimes combined science and history or law and botany under history. Daniel P. Jordan, "President's Letter," *Monticello* 11 (Spring 2000): 2.

55. Emmet's son, also named Thomas Addis Emmet, protested against English rule until his death in 1918.

56. George Tucker, *Memoir of the Life and Character of John P. Emmet, M.D., Professor of Chemistry and Materia Medica in the University of Virginia* (Philadelphia: C. Sherman Printer, 1845); George H. Daniels, *American Science in the Age of Jackson* (New York: Columbia University Press, 1968), 148.

57. William H. Pierson, *American Buildings and their Architects: The Colonial and Neoclassical Styles,* 3 vols. (Garden City, N.Y.: Doubleday & Co., 1970), 1:326.

58. Peterson, ed., *The Portable Thomas Jefferson,* 337–338. *Belles lettres* was an eighteenth-century term for the study of literature.

59. Jefferson, *Notes on the State of Virginia,* Peden, ed., 146–148.

60. Gaustad, *Sworn on the Altar,* 35.

61. Ibid., 346.

62. Jefferson to James Madison, November 15, 1817, Smith, ed., *Republic of Letters,* 3:1788.

63. A. Koch, *The Philosophy of Thomas Jefferson,* 265, 274.

64. Articles 2 and 5, Abner Johnson Leavenworth Notebook, 1825, Presbyterian Church (U.S.A.), Presbyterian Historical Society, Montreat, N.C., 620.

65. Jefferson to James Smith, December 8, 1822, Jefferson Papers, Library of Congress.

66. Ibid.

67. Gaustad, *Sworn on the Altar,* 112–117.

68. Jefferson to Jared Sparks, November 4, 1820, Jefferson Papers, Library of Congress.

69. For Jefferson Trinitarianism was a form of polytheism and typified the foggy, superstitious, "Platonizing" of Christianity that Jefferson had learned to abhor from his readings of Henry St. John Bolingbroke (*Philosophical Works*), Constantine de Volney (*Ruins; or, Meditations on the Revolutions of Empires*), and Joseph Priestley (*History of the Corruptions of Christianity*). Jefferson to William Short, October 31, 1819, Peterson, ed., *Portable Jefferson,* 564; Jefferson to Jared Sparks, November 4, 1820, Jefferson Papers, Library of Congress; Gaustad, *Sworn on the Altar,* 135–140; Charles B. Sanford, *The Religious Life of Thomas Jefferson* (Charlottesville: University Press of Virginia, 1984), 11.

70. Jefferson to George Logan, November 12, 1816, Ford, ed., *The Writings of Thomas Jefferson,* 12:43; Jefferson to Matthew Carey, November 11, 1816, ibid., 12:42.

71. Jefferson to John Adams, April 11, 1823, Cappon, ed., *The Adams-Jefferson Letters,* 591.

72. Jefferson to Cooper, November 2, 1822, Lipscomb and Bergh, eds., *The Writings of Jefferson,* 15:403–404.

73. Jefferson to Reverend Mr. Whittemore, June 5, 1822, Ford, ed., *The Writings of Thomas Jefferson*, 7:245.

74. Jefferson to Joseph Marx and Dr. Jacob de La Motta, September 1, 1820, Jefferson Papers, Library of Congress.

75. Jefferson to Ezra Stiles, June 25, 1819, Lipscomb and Bergh, eds., *The Writings of Jefferson*, 15:202–204.

76. Thomas Jefferson to Thomas Cooper, November 2, 1822, Lipscomb and Bergh, eds., *The Writings of Jefferson*, 15:404.

77. Jefferson to Horatio Gates Spafford, March 17, 1814, Lipscomb and Bergh, eds., *The Writings of Jefferson*, 14:119.

78. Jefferson to Mrs. Samuel H. Smith, August 6, 1816, Lipscomb and Bergh, eds., *The Writings of Jefferson*, 15:60; Jefferson, *Notes on the State of Virginia*, Peden, ed., 157–161.

79. Jefferson to Charles Thomson, January 9, 1816, Ford, ed., *The Writings of Thomas Jefferson*, 6:518.

80. Timothy Pickering to Jefferson, February 12, 1821 and Jefferson to Pickering, February 27, 1821, Timothy Pickering Papers, Massachusetts Historical Society.

81. Jefferson to Elbridge Gerry, March 29, 1801, Peterson, ed., *Thomas Jefferson: Writings* (New York: Library of America, 1984), 1088–1089.

82. Jefferson to John Adams, July 5, 1814, Cappon, ed., *The Adams-Jefferson Letters*, 148.

83. Stephen J. Novack, *The Rights of Youth: American Colleges and Student Revolt, 1798–1815* (Cambridge, Mass.: Harvard University Press, 1977), 163.

84. Henry F. May, *The Enlightenment in America* (New York: Oxford University Press, 1976), 320–321.

85. Edward Everett, "University of Virginia," *North American Review* 36 (January 1820), 130. Everett had a wide-ranging career, which included ministering Boston's famous Brattle Street Congregation, editing the *North American Review,* serving in Congress and as secretary of state, running as a vice presidential candidate, and teaching and presiding over Harvard College. He also spoke before Lincoln's address at Gettysburg in 1863.

86. Margaret C. Jacob, *The Enlightenment: A Brief History with Documents* (Boston: Bedford/St. Martins, 2001), 30–31.

87. Jonathan Israel, *The Dutch Republic: Its Rise, Greatness, and Fall, 1477–1806,* 2d ed. (Oxford: Clarendon Press, 1998), 570; Leiden was the largest university in the Protestant world by the 1640s. Eleven thousand enrolled at Leiden between 1625 and 1650 compared to over eight thousand at Cambridge, England, and under seven thousand at Leipzig, in modern-day Germany.

88. David C. Humphrey, *From King's College to Columbia, 1746–1800* (New York: Columbia University Press, 1976), 313.

89. Howard Miller, *Revolutionary College: American Presbyterian Higher Education, 1707–1837* (New York: New York University Press, 1976), 156.

90. The College of Philadelphia was co-founded by William Smith and Francis Alison, an Old-Side Presbyterian who opposed revivals. George Marsden, *The Soul of the American University: From Protestant Establishment to Established Nonbelief* (Oxford: Oxford University Press, 1994), 57; Lawrence A. Cremin, *American Education: The Colonial Experience, 1607–1783* (New York: Harper & Row, 1970), 404–405.

91. Bernard Bailyn, *Education in the Forming of American Society: Needs and Opportunities for Study* (Chapel Hill: University of North Carolina Press, 1960), 46; Miller, *Revolutionary College,* 156.

92. Robert M. Calhoon, *Evangelicals and Conservatives in the Early South, 1740–1861* (Columbia:

University of South Carolina Press, 1988), 122–123; J.H. Hobart to Joseph Caldwell, November 30, 1796, Joseph Caldwell to Thomas Y. Howe, November 8, 1796, and Joseph Caldwell to Treasurer Haywood, March 23, 1822, University Archives, Wilson Library, University of North Carolina at Chapel Hill. The University of North Carolina was chartered in 1789, but opened in 1795, six years before the University of Georgia. Novack, *The Rights of Youth*, 106.

93. Novack, *Rights of Youth*, 109–111; Miller, *Revolutionary College*, 244–245.

94. David E. Swift, "Thomas Jefferson, John Holt Rice, and Education in Virginia," *Journal of Presbyterian History* 49 (1971): 40 n.20; Clarence E. Hix, Jr., "The Conflict between Presbyterianism & Free Thought in the South, 1776–1838" (Ph.D. diss., University of Chicago, 1937), 6.

95. Peterson, *The Jefferson Image in the American Mind* (New York: Oxford University Press, 1962), 243.

96. Neils Henry Sonne, *Liberal Kentucky, 1780–1828* (New York: Columbia University Press, 1939); Robert Peter, *Transylvania University: Its Rise, Decline and Fall* (Louisville, Ky.: J.P. Morton, 1896).

97. May, *Enlightenment in America*, 249.

98. Thomas Cooper to Dr. F. Ridgley, February 12, 1816, Thomas Cooper Papers, Special Collections, Douglas Gray Jr./Francis Carrick Thomas Library, Transylvania University; Public resentment to the Presbyterian trustees was expressed in the *Kentucky Gazette*, January 19, 1816, Sonne, *Liberal Kentucky*, 148.

99. Horace Holley Papers, Special Collections, Douglas Gray Jr./Francis Carrick Thomas Library, Transylvania University. After Holley's hiring, some disaffected Presbyterians left and started Centre College in Danville, Kentucky. See Miller, *Revolutionary College*, 239–241; May, *Enlightenment in America*, 332–333; Hix, "The Conflict between Presbyterians and Free Thought," 119.

100. On the University of Pennsylvania (Jefferson called it the University of Philadelphia), see Jefferson to Caspar Wistar, August 25, 1814, Jefferson Papers, Library of Congress.

101. Jefferson to Danbury [Ct.] Baptists, January 1, 1802, Lipscomb and Bergh, eds., *The Writings of Thomas Jefferson*, 16:281–282. In the same letter Jefferson echoes sentiments first expressed in *Notes on the State of Virginia*, writing that "religion is a matter that lies solely between man and God, that he owes account to none other for his faith or his worship."

102. May, *Enlightenment in America*, 332.

103. Jefferson to William Short, April 13, 1820, Jefferson Papers, Library of Congress.

## Chapter 4

1. Francis Lister Hawks, "The Character of Jefferson," *New York Review and Quarterly Church Journal* 1 (March 1837): 19.

2. Howard Miller, *The Revolutionary College: American Presbyterian Higher Education, 1707–1837* (New York: New York University Press, 1976), 124.

3. Donald Robert Come, "The Influence of Princeton on Higher Education in the South Before 1825," *William & Mary Quarterly* 2 (October 1945): 359–396.

4. John Holt Rice, *The Importance of the Gospel Ministry, a Sermon Preached at the Opening of the Synod of Virginia on the 16th of October, 1816* (Richmond, Va.: Shepard & Pollard, 1817), 8.

5. Ruth H. Bloch, *Visionary Republic: Millennial Themes in American Thought, 1756–1800* (Cambridge, England: Cambridge University Press, 1985), 200.

6. Ibid., 170.

7. Ibid., 160.

8. For a representative critique of deism, see Samuel Miller, *A Sermon Preached in New York, July 4th 1793* (New York: T. Greenleaf, 1793), 32.

9. Benjamin Rush, "The Establishment of Public Schools," in Frederick Rudolph, ed., *Essays on Education in the Early Republic* (Cambridge, England: Cambridge University Press, 1965), 17; quoted in Miller, *Revolutionary College*, 127–128.

10. Miller, *Revolutionary College*, 198.

11. William Meade, *Old Churches, Ministers and Families*, 2d. ed. (Philadelphia: J.B. Lippincott, 1889), 175.

12. Joseph Caldwell to Thomas Y. Howe, November 8, 1796, Southern Historical Collection, Wilson Library, University of North Carolina.

13. Timothy Dwight, *The Duty of Americans, At the Present Crisis, Illustrated in a Discourse, Preached on the 4th of July* (New Haven, Conn.: Thomas & Samuel Green, 1798), 8, 18.

14. John Holt Rice, "On the Unitarian Controversy," *Virginia Literary and Evangelical Magazine* 5 (January 1822): 31; Henry F. May, *The Enlightenment in America* (New York: Oxford University Press, 1976), 276–277; Lefferts A. Loetscher, *Facing the Enlightenment and Pietism: Archibald Alexander and the Founding of Princeton Theological Seminary* (Westport, Conn.: Greenwood, 1983), 65–66.

15. Charles O. Woodburn, "An Historical Investigation of the Opposition to Jefferson's Educational Proposals in the Commonwealth of Virginia" (Ph.D. diss., American University, 1974), 189.

16. Samuel Stanhope Smith to Jefferson, March? 1779, Julian T. Boyd, et al., eds., *The Papers of Thomas Jefferson* 27 vols. (Princeton, N.J.: Princeton University Press, 1950-), 2:247.

17. The Methodist Episcopal Church was founded in America in 1785 by Francis Asbury and Thomas Coke. Asbury founded Ebenezer Academy, the precursor to Randolph-Macon College in Richmond. Woodburn, "An Historical Investigation," 156–158.

18. Richard Beale Davis, *Intellectual Life in Jefferson's Virginia, 1790–1830* (Chapel Hill: University of North Carolina Press, 1964), 121. In 1832 the Virginia Baptist Seminary, later the University of Richmond, came into existence. Woodburn, "An Historical Investigation," 153–158.

19. Miller, *Revolutionary College*, 200.

20. The elect of God was based on the Calvinist idea that one's fate in the afterlife was predetermined before birth.

21. Miller, *Revolutionary College*, 202.

22. Schisms between Old and New Sides began in the eighteenth century. Similar debates over revivalism, gospel music, and other confessions and doctrines separated later Old and New School, or New Light, groups. Other groups splintered off from the Presbyterians and became Cumberland Presbyterians or Shakers, or joined the Disciples of Christ. Clarence E. Hix Jr., "The Conflict between Presbyterianism and Free Thought in the South, 1776–1838" (Ph.D. diss., University of Chicago, 1937), 9, 18–19, 24–27; Miller, *Revolutionary College*, 203.

23. Hix Jr., "The Conflict between Presbyterianism and Free Thought," 36–38; Davis, *Intellectual Life in Jefferson's Virginia*, 135.

24. John Holt Rice to Archibald Alexander, November 16, 1815; quoted in William Maxwell, *Memoir of the Life of John Holt Rice, D.D.* (Philadelphia: J. Wetham, 1835), 121.

25. Thomas Edwin Buckley, "After Disestablishment: Thomas Jefferson's Wall of Separation in Antebellum Virginia," *Journal of Southern History* 61 (August 1995): 449.

26. St. George Tucker to Philip Barraud, September 3, 1816, Tucker-Coleman Papers, College of William & Mary; May, *The Enlightenment in America*, 332.

27. Hix Jr., "The Conflict between Presbyterianism and Free Thought," 46.

28. Hawks, *Narrative of Events Connected with the Rise and Progress of the Protestant Episcopal*

*Church in Virginia,* in Hawks, ed., *Contributions to the Ecclesiastical History of the United States of America,* vol. 1 (New York: Harper & Bros., 1836), 191.

29. David Lynn Holmes Jr., "William Meade and the Church of Virginia, 1789–1829" (Ph.D. diss., Princeton University, 1971), viii, 213, 265.

30. The politician Charles F. Mercer was one more old-fashioned Episcopalian who resisted this trend. Ibid., 248.

31. Christine Leigh Heyrman, *Southern Cross: The Beginnings of the Bible Belt* (New York: Alfred A. Knopf, 1997), 82.

32. Samuel B. Wilson to William Henry Foote, December 29, 1818, Samuel B. Wilson Papers, Presbyterian Church (U.S.A.), Presbyterian Historical Society, Montreat, N.C.

33. Thomas E. Buckley, "Politics, Religion, and Property: A New Majority Emerges in the Old Dominion, 1786–1801," Speech delivered at the College of William and Mary, Williamsburg, Virginia, on April 20, 1977, under the auspices of the Institute for Early American History and Culture and Virginia Historical Society, 12.

34. John D. Blair, "Address of the Board of Education of the Synod of Virginia," *Virginia Evangelical and Literary Magazine* 2 (December 1819): 578.

35. Benjamin Brand to Francis Bowman, December 8, 1823, Virginia Historical Society, Richmond, Virginia.

36. Rice, *An Illustration of the Character & Conduct of the Presbyterian Church* (Richmond, Va.: Du-val and Burke, 1816), 9; Virginia Synod Records, Reel 53, Morton Library, Union Theological Seminary and Presbyterian School of Education, Richmond, Virginia.

37. Joseph Cabell to Jefferson, December 29, 1817, Jefferson Papers, Special Collections, Alderman Library, University of Virginia.

38. Heyrman, *Southern Cross,* 9.

39. Jon Butler, *Awash in a Sea of Faith: Christianizing the American People* (Cambridge, Mass.: Harvard University Press, 1990), 268.

40. *Extracts from the Minutes of the General Assembly, of the Presbyterian Church, in the United States of America, 1819* (Philadelphia: Thomas & William Bradford, 1819), 173; Moses Hoge, *Life of Moses Hoge, 1752–1820,* Moses Hoge Papers, Library of Congress, 198; Miller, *Revolutionary College,* 229.

41. *Extracts from the Minutes of the General Assembly, 1819,* 170–171.

42. Virginia Synod Minutes, October 25, 1819; Board of Education Reports, October 21, 1823, September 27, 1824, and May 5–6, 1825; Constitution of the Education Society of the Presbytery of Hanover Board of Education, October 4, 1825, Hanover Presbytery Minutes, Morton Library, Union Theological Seminary and Presbyterian School of Christian Education, Richmond, Virginia.

43. Joseph Cabell to Jefferson, January 24, 1816, and February 26, 1816, N.F. Cabell, ed., *Early History of the University of Virginia,* 50–51, 61.

44. Joseph Cabell to Jefferson, January 22, 1818 and February 22, 1818, Nathaniel Francis Cabell, ed., *Early History of the University of Virginia, as Contained in the Letters of Thomas Jefferson and Joseph C. Cabell* (Richmond, Va.: J.W. Randolph, 1856), 127.

45. David Rice organized the first religious congregation in Kentucky. Rice was the leading public figure among Presbyterians in Virginia after Archibald Alexander's departure from Hampden-Sydney in 1807. Union Theological Seminary General Catalogue of 1807–1824 (Richmond, Va.: Whittet & Shepperson, 1924), 7.

46. James H. Hutson, *Religion and the Founding of the American Republic* (Washington, D.C.: Library of Congress, 1998), 62.

47. Madge Goodrich to Reverend Bryden, June 21, 1936?, Protestant Episcopal Church Pa-

pers, Virginia Historical Society, Richmond, Virginia; Maxwell, *Memoirs of the Life of John Holt Rice*, 36.

48. The *Christian Monitor* was converted to *The Virginia Evangelical and Literary Magazine* in 1818. Julius Wemyss Melton Jr., *Pioneering Presbyter: A Collection and Analysis of the Letters of John Holt Rice* (Richmond, Va.: Union Theological Seminary, 1959), 120; David E. Swift, "Thomas Jefferson, John Holt Rice, and Education in Virginia," *Journal of Presbyterian History* 49 (Spring 1971), 32–33.

49. Rice also published John Smith's *True Travels* and *Generall Historie* [of Virginia] (1819) which almost bankrupted him; and started a periodical called *Family Visitor*. Davis, *Intellectual Life in Jefferson's Virginia*, 133–134.

50. Rice, "The Mutual Relations of Church and State," Parts 1 and 2, John Holt Rice Papers, Morton Library, Union Theological Seminary and Presbyterian School of Education, Richmond, Virginia.

51. P.B. Price, *The Life of the Reverend John Holt Rice, D.D.* (Richmond, Va.: Union Theological Seminary, 1963), 98.

52. May, *Enlightenment in America*, 321.

53. Library Holdings, Special Collections, Leyburn Library, Washington and Lee University.

54. Rice [signed "A Lay Protestant"], "The Christian Religion Vindicated from the Charge of Being Hostile to Knowledge," Part 1, *Virginia Literary and Evangelical Magazine* 1 (April 1818): 67–68; Samuel Stanhope Smith, *A Comprehensive View of the Leading and Most Important Principles of Natural and Revealed Religion: Digested in Such Order as to Present to the Pious and Reflecting Mind, a Basis for the Superstructure of the Entire System of the Doctrines of the Gospel* (New Brunswick, N.J.: Deare & Myer, 1815).

55. Rice, "Christian Religion Vindicated," Part 2 (May 1818): 230.

56. John Stark Ravenscroft, *The Doctrines of the Church Vindicated from the Misrepresentations of Dr. John Rice; and the Integrity of Revealed Religion Defended against the "No Comment Principle" of Promiscuous Bible Societies* (Raleigh, N.C.: J. Gales & Son, 1826), 90–91.

57. Swift, "Thomas Jefferson, John Holt Rice, and Education in Virginia," 33–34.

58. Rice, "Education #3," *Christian Monitor* 2 (June 7, 1817): 273–283, 289–297.

59. Rice [signed by "Provincial Protestant"], "Necessity of a better System of Instruction in Virginia," Part 3, *Virginia Evangelical and Literary Magazine* 1 (June 1818): 258.

60. Rice, "Literature and Science," *Virginia Evangelical and Literary Magazine* 2 (January 1819): 47.

61. Rice, *Six Addresses on the State of Letters and Science in Virginia Delivered Chiefly Before the Literary and Philosophical Society at Hampden-Sidney College and the Institute of Education of Hampden-Sidney College, 1824–1835*, A.J. Morrison, ed. (Roanoke, Va.: Stone Printing & Manufacturing Co., 1917), 10.

62. E. Brooks Holifield, *The Gentleman Theologians: American Theology in Southern Culture, 1795–1860* (Durham, N.C.: Duke University Press, 1978), 24.

63. Clement Read, "Charge Delivered to John Rice"; quoted in ibid., 81.

64. Holifield, *Gentleman Theologians*, 56; May, *Enlightenment in America*, 326.

65. *Extracts from the Minutes of the General Assembly, 1818*, 12; ibid., *1819*, 21.

66. Hoge, *Life of Moses Hoge*, 210.

67. Benjamin Brand to Francis Bowman, December 8, 1823, Virginia Historical Society, Richmond, Virginia.

68. Rice, "Letters to Rev. William Ellery Channing, containing remarks on his Sermon, recently preached and published at Baltimore," *Virginia Evangelical and Literary Magazine* 2 (November 1819): 506.

69. Rice, "On the Unitarian Controversy," *Virginia Evangelical and Literary Magazine* 5 (January 1822): 31.

70. John Holt Rice to "Sir," November 15, 1821, John Holt Rice Papers, Morton Library, Union Theological Seminary and Presbyterian School of Education, Richmond, Virginia.

71. Michael Durey, *Transatlantic Radicals and the Early American Republic* (Lawrence: University Press of Kansas, 1997), 19.

72. John Holt Rice to William Wirt, March 5, 1821, and January 30, 1822, John Holt Rice Papers, Morton Library, Union Theological Seminary and Presbyterian School of Education, Richmond, Virginia.

73. Rice and Conrad Speece, "The Mountaineer," featured in *Virginia Evangelical and Literary Magazine* 2 (August 1819), 365–376.

74. Jefferson to Benjamin Waterhouse, July 19, 1822, Andrew A. Lipscomb and Albert E. Bergh, eds., *The Writings of Thomas Jefferson*, 19 vols. (Washington, D.C.: Thomas Jefferson Memorial Foundation, 1903–1905), 15:391–392.

75. One definition of Unitarianism was a liberal strain that broke off from the Congregational churches of New England. Defined more broadly, as Jefferson did, Unitarianism referred to denial of the Trinity or the divinity of Christ, or even to liberal Christianity generally.

76. Jefferson to James Smith, December 8, 1822, Jefferson Papers, Library of Congress; also see Jefferson to Benjamin Waterhouse, June 26, 1822, Paul Leicester Ford, ed., *The Writings of Thomas Jefferson* 12 vols. (New York: G.P. Putnam's Sons, 1892), 12:220; Holifield, *Gentleman's Theologians*, 57.

77. William and Mary's situation was a precursor to another of John Marshall's rulings: the more famous case of *Dartmouth College v. New Hampshire* in 1819, which denied the state's control over the school in light of its older, colonial royal charter.

78. William G. McGloughlin, "The Role of Religion in the Revolution: Liberty of Conscience and Cultural Cohesion in the New Nation," in Stephen G. Kurtz and James H. Hutson, eds., *Essays on the American Revolution* (Chapel Hill: University of North Carolina Press, 1973), 248.

79. Ibid., 230, 232.

80. Minutes of the Virginia Synod, October 29, 1814 and October 14 and 16, 1815, Morton Library, Union Theological Seminary and Presbyterian School of Education, Richmond, Virginia; Buckley, "After Disestablishment," 452–453; Hoge, *Life of Moses Hoge*, 198–202.

81. Buckley, "After Disestablishment," 452.

82. St. George Tucker to John Page, July 18, 1806, Page Papers, Duke University; quoted in May, *Enlightenment in America*, 331.

83. Buckley, "After Disestablishment," 452.

84. John Holt Rice to William Wirt, January 3 and 31, 1816, John Holt Rice Papers, Morton Library, Union Theological Seminary and Presbyterian School of Education, Richmond, Virginia. Wirt was also a friend of Jefferson's.

85. John Holt Rice to Archibald Alexander, November 16, 1815; quoted in Maxwell, *Memoirs of the Life of John Holt Rice*, 122–123.

86. Jefferson to Thomas Ritchie, January 21, 1816, Lipscomb and Bergh, eds., *The Writings of Thomas Jefferson*, 14:406–407.

87. Thomas Jefferson, "To the Editor of the Enquirer," *Richmond Enquirer,* January 27, 1816; Jefferson to Thomas Ritchie, January 21, 1816, H.A. Washington, ed., *The Writings of Thomas Jefferson* (Washington, D.C.: Taylor & Maury, 1854), 6:533.

88. Rice, *An Illustration of the Character & Conduct of the Presbyterian Church* , 5, 6, 23, 43.

89. John Holt Rice to William Wirt, December 21, 1815 and January 3 and 31, 1816, John Holt

Rice Papers, Morton Library, Union Theological Seminary and Presbyterian School of Education, Richmond, Virginia; *Richmond Enquirer,* January 27, February 3, 5, and 13, 1816.

90. Boyd, et al., eds., *The Papers of Thomas Jefferson,* 2:546–547; Ronald L. Hatzenbuhler, "Growing Weary in Well-Doing: Thomas Jefferson's Life Among the Virginia Gentry," *Virginia Magazine of History and Biography* 101 (January 1993): 24.

91. The seminary project only had forty-six hundred dollars to its credit, most of it invested in the Virginia and Farmers Bank. Virginia Synod Minutes, October 20, 1817, Morton Library, Union Theological Seminary and Presbyterian School of Education, Richmond, Virginia.

92. Buckley, "After Disestablishment," 453.

93. Swift, "Thomas Jefferson, John Holt Rice, and Education in Virginia," 46.

94. Virginia Synod Minutes, October 25 and 28, 1816, Morton Library, Union Theological Seminary and Presbyterian School of Education, Richmond, Virginia.

95. Joseph Cabell to Jefferson, December 29, 1817, N.F. Cabell, ed., *Early History of the University of Virginia,* 89–93.

96. *Richmond Enquirer,* January 9, 1819.

97. For Rice's support of the university, see the editorial by "Crito," *Richmond Enquirer,* January 9, 1819.

98. Joseph Cabell to Jefferson, December 4, 1819, N.F. Cabell, ed., *Early History of the University of Virginia,* 157.

99. Jefferson to John Holt Rice, December 29, 1820, Jefferson Papers, Swem Library, College of William and Mary.

100. Conrad Speece and Rice, "The Mountaineer," in *Virginia Evangelical and Literary Magazine* 2 (August 1819): 365–376; John Holt Rice to Archibald Alexander, February 4, 1819, Maxwell, *Memoir of the Life of John Holt Rice,* 159.

101. John Holt Rice to William Maxwell, January 10, 1819; quoted in Maxwell, ibid., 154–155.

102. Rice, "Remarks on the Study of Natural Philosophy," *Virginia Evangelical and Literary Magazine* 1 (June 1818): 263.

103. Virginia Synod Minutes, October 28, 1816, Morton Library, Union Theological Seminary and Presbyterian School of Education, Richmond, Virginia.

104. Italian theologian Fausto Sozzini (d. 1604) launched a sixteenth-century religious movement which professed a belief in God and adherence to Scripture, but denied the divinity of God and the Trinity. Rice, "An Excursion into the Country," *Virginia Evangelical and Literary Magazine* 1 (November 1818): 547.

105. Rice, "Literature and Science," 46–47.

106. Speece and Rice, "The Mountaineer," 365–376.

107. Rice, "Excursion into the Country," 546.

108. Speece and Rice, "The Mountaineer," 375.

109. Minutes of Central College, July 28, 1817, N.F. Cabell, ed., *Early History of the University of Virginia,* 396; Robert M. Healey, *Jefferson on Religion in Public Education* (New Haven, Conn.: Yale University Press, 1962), 231.

110. Lorraine Smith and Thomas Pangle, *The Learning of Liberty: The Educational Ideas of the American Founders* (Lawrence: University Press of Kansas, 1993), 91–92.

111. Roy J. Honeywell, *The Educational Work of Thomas Jefferson* (Cambridge, England: Harvard University Press, 1931), 168–169.

112. Jefferson to Thomas Cooper, September 10 and October 7, 1814, Lipscomb and Bergh, eds., *The Writings of Jefferson,* 14:179–180, 200; Healey, *Jefferson on Religion in Public Education,* 215.

113. Robert P. Forbes, "Slavery and the Evangelical Enlightenment," in John R. McKivigan and Mitchell Snay, eds., *Religion and the Antebellum Debate Over Slavery* (Athens: University of

Georgia Press, 1998), 89; Dumas Malone, *The Public Life of Thomas Cooper, 1763–1839* (New Haven, Conn.: Yale University Press, 1926), 17–18.

114. Daniel L. Dreisbach, *Religion and Politics in the Early Republic: Jasper Adams and the Church-State Debate* (Lexington: University of Kentucky Press, 1996), 11.

115. Cooper later regretted the tactics used by the democratic societies in the 1790s. In a private pamphlet entitled *Extract of a Letter to a Student at Law* (1815) he wrote that, although they served a purpose fighting tyranny and oppression, the societies were "violent, turbulent, and perhaps mischievous." Malone, *Public Life of Thomas Cooper,* 8.

116. Joyce Appleby, *Capitalism and a New Social Order: The Republican Vision of the 1790s* (New York: New York University Press, 1984), 88.

117. Ibid., 89. Cooper's *Political Essays* were published in Philadelphia in 1800.

118. William Duane, James Thompson Callender, and Thomas Cooper all encouraged the Federalists to arrest them because they thought it would make good theater. Durey, *Transatlantic Radicals,* 255.

119. Ibid., 292–293.

120. Jefferson to Thomas Cooper, January 16, 1814, Lipscomb and Bergh, eds., *The Writings of Jefferson,* 14:54–62.

121. For Cooper's negotiations with Transylvania, see Thomas Cooper to Dr. F. Ridgley, February 2, 1816 and Thomas Cooper to the Trustees of Transylvania University, February 29, 1816, Thomas Cooper Papers, Special Collections, Douglas Gray Jr./Francis Carrick Thomas Library, Transylvania University, Lexington, Kentucky; for Cooper's troubles at Dickinson, see Dickinson Trustees to Cooper, September 29, 1815, Thomas Cooper Papers and Steven J. Novak, *The Rights of Youth: American Colleges and Student Revolt, 1798–1815* (Cambridge, Mass.: Harvard University Press, 1977), 151, 155; For the discussion of a theology professor, see Thomas Jefferson to Thomas Cooper, October 7, 1814; Malone, *Public Life of Thomas Cooper,* 227–230; William W. Freehling, *Prelude to Civil War: The Nullification Controversy in South Carolina, 1816–1836* (New York: Oxford University Press, 1992), 128–129; Neils Henry Sonne, *Liberal Kentucky, 1780–1828* (New York: Columbia University Press, 1939), 145.

122. Rector and Visitors Minutes, vols. 1–2, 1817–1836, University Archives, Special Collections, Alderman Library, University of Virginia, 6–24; Jefferson to James Madison, March 6, 1819, James Morton Smith, ed., *The Republic of Letters: The Correspondence between Jefferson and Madison, 1776–1826,* 3 vols. (New York: W.W. Norton & Co., 1995), 3:1808.

123. Philip Alexander Bruce, *History of the University of Virginia, 1819–1919: The Lengthened Shadow of One Man,* 5 vols. (New York: Macmillan, 1920), 3:197.

124. Rice, "Review: Memoirs of Dr. Joseph Priestley," *Virginia Evangelical and Literary Magazine* 3 (February 1820): 67–74.

125. Ibid., 74.

126. Rice, "University of Virginia," *Virginia Evangelical and Literary Magazine* 3 (January 1820): 49.

127. Rice [signed "A Lunatic"], "Something Curious," *Virginia Evangelical and Literary Magazine* 2 (December 1819): 567.

128. May, *Enlightenment in America,* 331.

129. John Holt Rice to John Hartwell Cocke, January 6, 1820, Cocke Family Papers, Special Collections, Alderman Library, University of Virginia.

130. Joseph Cabell to Jefferson, February 22, 1822, N.F. Cabell, ed., *Early History of the University of Virginia,* 165–167.

131. James Madison to Jefferson, March 6, 1819, and Jefferson to James Madison March 8, 1819, Smith, ed., *Republic of Letters,* 3:1808–1809.

132. Malone, *Sage of Monticello* (Boston: Little, Brown & Co., 1981), 6:369.

133. Rector and Visitors Minutes, vols. 1–2, 1817–1836, University Archives, Special Collections, Alderman Library, University of Virginia, 19; Bruce, *Early History of the University of Virginia*, 204.

134. Malone, *Sage of Monticello*, 378, 380.

135. Swift, "Thomas Jefferson, John Holt Rice, and Education in Virginia," 42.

136. John Hartwell Cocke to Joseph Cabell, March 1, 1819, and Joseph Cabell to John Hartwell Cocke, March 6, 1819, Cabell Deposit, Special Collections, Alderman Library, University of Virginia.

137. Jefferson to Joseph Cabell, January 22, 1820, Jefferson Papers, Library of Congress; Cabell to Jefferson, February 3, 1820, N.F. Cabell, ed., *Early History of the University of Virginia*, 180–182; Cited in Alf J. Mapp Jr., *Thomas Jefferson, Passionate Pilgrim: The Presidency, the Founding of the University, and the Private Battle* (Lanham, Maryland: Madison Books, 1991), 297.

138. Jefferson to Thomas Cooper, March 13, 1820, Jefferson Papers, Special Collections, Alderman Library, University of Virginia.

139. Jefferson to John Hartwell Cocke, April 9, 1820, Jefferson Papers, Library of Congress.

140. Jefferson to Jared Sparks, November 4, 1820, Jefferson Papers, Library of Congress.

141. Jefferson to Jose Francisco Correa de Serra, April 11, 1820, Jefferson Papers, Library of Congress.

142. Jefferson to William Short, August 4, 1820, Lipscomb and Bergh, eds., *The Writings of Jefferson*, 15:246.

143. Jefferson to James Madison, January 7, 1824, and Madison to Jefferson, January 14, 1824, Smith, ed., *Republic of Letters*, 3:1890–1891.

144. Freehling, *Prelude to the Civil War*, 128–129; Novak, *The Rights of Youth*, 154–156.

145. Carl J. Becker, *The Heavenly City of Eighteenth-Century Philosophers* (New Haven, Conn.: Yale University Press, 1932), 123.

## Chapter 5

1. Joseph Cabell, *Letter & Accompanying Documents Relative to the Literary Institutions of the State Addressed to Constituents* (Richmond, Va.: John Warrick, 1825), Rare Virginia Pamphlets #265, Cabell Deposit, Special Collections, Alderman Library, University of Virginia.

2. Jefferson to Hugh Nelson, March 12, 1820, Andrew A. Lipscomb and Albert E. Bergh, eds., *The Writings of Thomas Jefferson*, 19 vols. (Washington, D.C.: Thomas Jefferson Memorial Foundation, 1903–1905), 15:238; quoted in Peter S. Onuf, "Thomas Jefferson, Missouri, and the 'Empire of Liberty,'" in James P. Ronda, ed., *Thomas Jefferson and the Changing West* (St. Louis: Missouri Historical Society, 1997), 111–112.

3. Jefferson to Thomas Cooper, August 14, 1820, Lipscomb and Bergh, eds., *The Writings of Thomas Jefferson*, 15:264–268; Roy J. Honeywell, *The Educational Work of Thomas Jefferson* (Cambridge, Mass.: Harvard University Press, 1931), 153.

4. New York Senator James Tallmadge, who led the abolitionist crusade in the Missouri Crisis, also opposed slavery in Illinois in 1818. Alabama came in as a slave state in 1818.

5. The Northwest Ordinance passed the Confederation Congress in 1787, while Jefferson was minister to France, with slavery barred only above the Ohio River. The Roman Empire expanded by bringing in new territory on an equal basis, but England subordinated colonized territory.

6. Jefferson to Marquis de Lafayette, November 4, 1823, H.A. Washington, ed., *The Writings of Thomas Jefferson* (Washington, D.C.: Taylor & Maury, 1854), 7:326. In the same letter

96      Jefferson's Vision for Education, 1760–1845

Jefferson wrote, "for in truth, the parties of Whig and Tory, are those of nature" and existed in all countries despite names. The sickly, weak, and timid man, who feared the people, was always a Tory, while "the healthy, strong, bold individual who cherished the people was a Whig."

. Jefferson to David Baille Warden, December 26, 1820, Jefferson Papers, Library of Congress; Jefferson to Albert Gallatin, December 26, 1820, ibid.

8. Eugene R. Sheridan, "Liberty and Virtue: Religion and Republicanism in Jeffersonian Thought," in James Gilreath, ed., *Thomas Jefferson and the Education of a Citizen* (Washington, D.C.: Library of Congress, 1999), 262.

9. Jefferson to James Pleasants, April 27, 1822, Jefferson Papers, Swem Library, College of William and Mary.

10. *Richmond Enquirer,* March 23 and April 6, 1821; Jefferson to Charles Hammond, August 8, 1821, Lipscomb and Bergh, eds., *The Writings of Thomas Jefferson,* 15:331–332.

11. Modern dictionaries define the word federalism as implying subordinated power, but historically others have defined it as sharing power equally.

12. Jefferson to Major John Cartwright, June 5, 1824, Lipscomb and Bergh, eds., *The Writings of Thomas Jefferson,* 16:50–51; Jefferson to Spencer Roane, June 27, 1821, ibid., 15:328–329.

13. David N. Mayer, *The Constitutional Thought of Thomas Jefferson* (Charlottesville: University Press of Virginia, 1994), 281–282.

14. Jefferson to William Charles Jarvis, September 28, 1820, Lipscomb and Bergh, eds., *The Writings of Thomas Jefferson,* 15:277–278; quoted in Mayer, "Citizenship and Change in Jefferson's Constitutional Thought," in Gilreath, ed., *Thomas Jefferson and the Education of a Citizen,* 235.

15. Mayer, *The Constitutional Thought of Thomas Jefferson,* 258, 281.

16. Jefferson to Spencer Roane, September 6, 1819, Lipscomb and Bergh, eds., *The Writings of Thomas Jefferson,* 15:212–215; Norman K. Risjord, *The Old Republicans: Southern Conservatism in the Age of Jefferson* (New York: Columbia University, 1965), 179; Robert E. Shalhope, "Thomas Jefferson's Republicanism and Antebellum Southern Thought," *Journal of Southern History* 42 (1976): 545–546.

17. Trenton Eynon Hizer, "'Virginia is Now Divided': Politics in the Old Dominion, 1820–1833" (Ph.D. diss., University of South Carolina, 1997), 25.

18. Harry Ammon, "The Richmond Junto, 1800–1824," *Virginia Magazine of History and Biography* 61 (October 1953): 400.

19. Richard D. Brown, *The Strength of a People: The Idea of an Informed Citizenry in America, 1650–1870* (Chapel Hill: University of North Carolina Press, 1996), 96–97.

20. John Chester Miller, *The Wolf by the Ears: Thomas Jefferson and Slavery* (Charlottesville: University Press of Virginia, 1991), 259; Shalhope, "Thomas Jefferson's Republicanism," 541; Ellis, *American Sphinx,* 259.

21. Jefferson to Benjamin Waterhouse, October 13, 1815, Ford, ed., *The Writings of Thomas Jefferson,* 9:533; Shalhope, "Thomas Jefferson's Republicanism," 540.

22. Kentucky County, Virginia became its own state (Kentucky) in 1792.

23. Jefferson to Joseph Cabell, January 22, 1820, Nathaniel Francis Cabell, ed., *Early History of the University of Virginia, as Contained in the Letters of Thomas Jefferson and Joseph C. Cabell* (Richmond, Va.: J.W. Randolph, 1856), 178.

24. For more on this predicament, see J.C. Miller, *Wolf by the Ears,* 258.

25. Jefferson to Thomas Cooper, August 14, 1820, Lipscomb and Bergh, eds., *The Writings of Thomas Jefferson,* 15:264.

26. Jefferson to James Breckenridge, February 15, 1821, Jefferson Papers, Library of Congress;

Jefferson to John Taylor, February 14, 1821, Washburn Collection, Massachusetts Historical Society.

27. Jefferson to Joseph Cabell, February 25, 1820, N.F. Cabell, ed., *Early History of the University of Virginia,* 192–193.

28. Jefferson to Joseph Cabell, January 31, 1821, N.F. Cabell, ed., *Early History of the University of Virginia,* 201.

29. Jefferson to Joseph Cabell, February 15, and Cabell to Jefferson, February 20, 1821, ibid., 204–205; Stuart Leibiger, "Thomas Jefferson and the Missouri Crisis: An Alternative Interpretation" (Research Note), *Journal of the Early American Republic* 17 (Spring 1997): 127.

30. Jefferson to James Madison, July 7, 1819, Smith, ed., *Republic of Letters,* 3:1811.

31. The south end is the present-day sight of Cabell Hall and Amphitheater.

32. Palladio influenced English architects for two centuries, including Inigo Jones and Christopher Wren. Three buildings in Williamsburg—William and Mary's main building, the Governor's House, and the Capitol—were Wren-inspired examples of Palladianism. Jack McGlaughlin, *Jefferson and Monticello: The Biography of a Builder* (New York: Henry Holt, 1988), 24–25, 55.

33. Jefferson probably owned an English translation of the book, which was lost in the Shadwell plantation fire of 1770. McGlaughlin, *Jefferson and Monticello,* 38.

34. The orders on the columns of the five West Lawn pavilions—1, 3, 5, 7 and 9—are the Doric of the Baths of Diocletian (Fréart), Corinthian, Ionic, Doric, and the Ionic of the Temple of Fortuna Virilis (all Palladio). Those of the East Lawn—2, 4, 6, 8, and 10—are the Ionic Temple of Fortuna Virilis again, the Doric of Albano, Ionic of the Theater of Marcellus, Corinthian of the Baths of Diocletian, and Doric of the Theater of Mercellus (all from Fréart). Robert Tavernor, *Palladio and Palladianism* (London: Thames & Hudson, 1991), 205–206.

35. Latrobe provided designs for Pavilions 3, 4, 8, 9, and 10; Thornton for Pavilion 7. The numbers start at the closed north end. Tavernor, *Palladio and Palladianism,* 206.

36. The capitals for Pavilion 1 were taken wholesale from Fréart de Chambray's *Paralléle.* Tavernor, *Palladio and Palladianism,* 205.

37. Spiro Kostof, *A History of Architecture: Settings and Rituals* (New York: Oxford University Press, 1995), 624–625.

38. Richard Guy Wilson, "Jefferson's Law: Perceptions, Interpretations, Meanings," in R.G. Wilson, ed., *Thomas Jefferson's Academical Village: The Creation of an Architectural Masterpiece* (Charlottesville: University Press of Virginia, 1993), 68.

39. Harold Hellenbrand, *The Unfinished Revolution: Education and Politics in the Thought of Thomas Jefferson* (London: Associated University, 1990), 187.

40. Mark Wenger, "Thomas Jefferson, the College of William and Mary, and the University of Virginia," *Virginia Magazine of History and Biography* 103 (July 1995): 369. For the influence of Native Americans, see Ellis, *American Sphinx,* 286; Suzanne W. Morse, "Ward Republics: The Wisest Invention for Self-Government," in Gilreath, ed., *Thomas Jefferson and the Education of a Citizen,* 265–266.

41. Harriet Martineau, *Retrospect of Western Travel,* 2 vols. (London: Saunders & Otley, 1835), 2:32; quoted in R.G. Wilson, "Jefferson's Lawn," 47. Most colleges were single-building campuses. Princeton (the College of New Jersey), was informally known as Nassau Hall.

42. Jefferson to Trustees of East Tennessee College, May 6, 1810, Lipscomb and Bergh, eds., *The Writings of Thomas Jefferson,* 12:387. For Jefferson "village" was a metaphor for organization. R.G. Wilson, "Jefferson's Lawn," 68.

43. Bradford McKee, "Quite at Home Under the Spell of Jefferson," *New York Times,* September 6, 2001.

44. Pendleton Hogan, *The Lawn: A Guide to Jefferson's University* (Charlottesville: University Press of Virginia, 1987), 35, 84.

45. "Workman Wanted," *Richmond Enquirer,* March 23, 1819; Patricia C. Sherwood and Joseph Michael Lasala, "Education and Architecture: The Evolution of the University of Virginia's Academic Village," in R.G. Wilson, ed., *Thomas Jefferson's Academical Village,* 35.

46. Ibid., 55.

47. Ibid., 36; Alf J. Mapp Jr., *Thomas Jefferson, Passionate Pilgrim: The Presidency, the Founding of the University, and the Private Battle* (Lanham, Maryland: Madison Books, 1991), 269.

48. McGlaughlin, *Jefferson and Monticello,* 315, 333; Sherwood and Lasala, "Education and Architecture," 72; Mapp Jr., *Thomas Jefferson, Passionate Pilgrim,* 257, 288.

49. Frank L. Grizzard Jr., "Slave Involvement at the Central College and Early University of Virginia," May 1820 and February 1821. Available at: http://www.people.virginia.edu/~feg3 e/slave.html.

50. Jefferson to Joseph Cabell, December 19, 1817, N.F. Cabell, ed., *Early History of the University of Virginia,* 89.

51. M. Schele de Vere, "Mr. Jefferson's Pet," *Harper's Magazine* 44 (May 1872): 820–821.

52. Sherwood and Lasala, "Education and Architecture," 72; Minutes of the Board of Visitors of the University of Virginia (Extracts 1817–1826), October 4, 1819, in Edgar K. Knight, ed., *A Documentary History of Education in the South Before 1860,* 5 vols. (Chapel Hill: University of North Carolina Press, 1950), 3:144–145.

53. Randolph was married to Martha, who lived at Monticello with her children while Thomas resided in the governor's mansion in Richmond. He was governor from December 1, 1819 to December 1, 1822.

54. "Governor's Message," December 4, 1820, *Journal of the Virginia House of Delegates, 1820–1821* (Richmond, Va.: Thomas Ritchie, 1820), 7–8; "Governor's Communication," *Richmond Enquirer,* December 5, 1820.

55. William H. Gaines Jr., *Thomas Mann Randolph, Jefferson's Son-in-Law* (Baton Rouge: Louisiana State University Press, 1966), 126–127.

56. He was about $100,000 in debt; the modern equivalent of several million dollars. Ellis, *American Sphinx,* 287.

57. Jefferson to Jose Francisco Correa de Serra, October 24, 1820, Jefferson Papers, Library of Congress; Jefferson to William Short, November 10, 1818, Jefferson Papers, Massachusetts Historical Society; Jefferson to Spence Roane, March 9, 1821, Jefferson Papers, Library of Congress.

58. Jefferson to John Adams, October 12, 1823, Lester J. Cappon, ed., *The Adams-Jefferson Letters; The Complete Correspondence between Thomas Jefferson and Abigail and John Adams,* 2d ed. (Chapel Hill: University of North Carolina Press, 1987), 599; Jefferson to Destutt de Tracy, December 26, 1820, Paul Leicester Ford, ed., *The Writings of Thomas Jefferson,* 12 vols. (New York: G.P. Putnam's Sons, 1892), 10:174.

59. Herbert E. Sloan, *Principle and Interest: Thomas Jefferson and the Problem of Debt* (Oxford, England: Oxford University Press, 1995), 221.

60. Jefferson to Charles Thomson, January 9, 1816, Merrill D. Peterson, ed., *Thomas Jefferson: Writings* (New York: Library of America, 1984), 1373.

61. Horace Holley to Mary Holley, September 4 and 6, 1824, Horace Holley Papers, Special Collections, Douglas Gray Jr./Francis Carrick Thomas Library, Transylvania University, Lexington, Kentucky.

62. Mapp Jr., *Thomas Jefferson, Passionate Pilgrim,* 291.

63. Ellis, *American Sphinx,* 229–231.

64. Joseph Cabell to Jefferson, January 25, 1821, and Jefferson to Cabell January 31, 1821, N.F. Cabell, ed., *Early History of the University of Virginia*, 199, 202.

65. Jefferson to Joseph Cabell, January 24, 1816, and Jefferson to Cabell, January 14, 1818, ibid., 48, 102.

66. Thomas Mann Randolph, "Governor's Communication," *Richmond Enquirer*, December 5, 1820.

67. Jefferson to James Madison, October 31, 1821, James Morton Smith, ed., *The Republic of Letters: The Correspondence between Jefferson and Madison, 1776–1826*, 3 vols. (New York: W.W. Norton & Co., 1995), 3:1836; Joseph Cabell to Jefferson, November 21, 1821, N.F. Cabell, ed., *Early History of the University of Virginia*, 222.

68. Ellis, *American Sphinx*, 282.

69. Joseph Cabell to Jefferson, February 20, 1818, N.F. Cabell, ed., *Early History of the University of Virginia*, 126.

70. Joseph Cabell to Jefferson, December 22, 1820, ibid., 190; W.C. Rives to Jefferson, January 20, 1819, Jefferson Papers, Library of Congress. In 1821 an additional $20,000 was granted those schools, to be paid out only after the $60,000 was granted to UVA and the pauper schools. Sadie Bell, *The Church, the State, and Education in Virginia* (New York: Arno Press and the New York Times, 1969), 336.

71. Mapp Jr., *Thomas Jefferson, Passionate Pilgrim*, 297–298.

72. *Richmond Enquirer*, February 18 and 22, 1820; Jefferson to Thomas Mann Randolph, May 1, 1820, Jefferson Papers, Library of Congress; Philip Alexander Bruce, *History of the University of Virginia, 1819–1919: The Lengthened Shadow of One Man*, 5 vols. (New York: Macmillan, 1920), 1:292–293.

73. William Cabell to Joseph Cabell, March 30, 1820, Cabell Deposit, Special Collections, Alderman Library, University of Virginia.

74. *Journal of the Virginia House of Delegates, 1820–1821*, January 27, 1821, and March 3, 1821, 148, 230; Randolph, "Governors Message," ibid., 7.

75. Jefferson to Joseph Cabell, November 28, 1820, N.F. Cabell, ed., *Early History of the University of Virginia*, 184–189.

76. Jefferson to James Breckenridge, February 15, 1821, Jefferson Papers, Library of Congress.

77. Ibid.

78. Ibid.

79. *Richmond Enquirer*, February 8, 1821.

80. Joseph Cabell to Jefferson, December 20, 1820, N.F. Cabell, ed., *Early History of the University of Virginia*, 209.

81. *Richmond Enquirer*, February 24, 1821.

82. Ibid., 200; *Richmond Enquirer*, February 27, 1821.

83. Joseph Cabell to James Madison, March 10, 1821, James Madison Papers, University of Virginia.

84. I. Bernard Cohen, *Science and the Founding Fathers: Science in the Political Thought of Jefferson, Franklin, Adams, and Madison* (New York: W.W. Norton, 1995), 237–280 (chapter 5, "Science and the Constitution").

85. *Richmond Enquirer*, May 18, 1821.

86. Hampden-Sydney, started in 1776, had a charter but received no endowment. Washington College was endowed by a grant from George Washington of his shares in the James River Canal Project.

87. Jefferson to Joseph Cabell, October 24, 1817, and Cabell to Jefferson, October 14, 1817, N.F. Cabell, ed., *Early History of the University of Virginia*, 82, 84.

88. Brooks Holifield, *The Gentleman Theologians: American Theology in Southern Culture, 1795–1860* (Durham, N.C.: Duke University Press, 1978), 56.

89. Joseph Cabell to James Madison, March 10, 1821, James Madison Papers, University of Virginia.

90. David E. Swift, "Thomas Jefferson, John Holt Rice, and Education in Virginia." *Journal of Presbyterian History* 49 (1971): 50.

91. John Holt Rice, *Six Addresses on the State of Letters and Science in Virginia Delivered chiefly before The Literary and Philosophical Society at Hampden-Sidney College and The Institute of Education of Hampden-Sidney College, 1824–1835,* A.J. Morrison, ed. (Roanoke, Va.: Stone Printing and Manufacturing Co., 1917), 13.

92. "Hampden-Sydney," *Richmond Enquirer,* July 3, 1821; ibid., July 27, 1821.

93. Joseph Cabell to Jefferson, August 5, 1821, N.F. Cabell, ed., *Early History of the University of Virginia,* 215–216. John Holt Rice used the word "Socinian," another word for Unitarian derived from Fausto Sozzini (d. 1604), the founder of the movement that professed a belief in God and Scripture but denied the divinity of Christ (and Trinity).

94. Buckley, "Politics, Religion, and Property: A New Majority Emerges in the Old Dominion, 1786–1801," Speech delivered at the College of William and Mary, Williamsburg, Virginia, on April 20, 1977, under the auspices of the Institute for Early American History and Culture and Virginia Historical Society, 41; Joseph Cabell to David Watson March 4, 1798, David Watson Papers, Manuscripts Division, Library of Congress.

95. Steven J. Novak, *The Rights of Youth: American Colleges and Student Revolt, 1798–1815* (Cambridge, Mass.: Harvard University Press, 1977), 149.

96. Meade, Richard Channing Moore and John A. Smith, "Literary and Religious Intelligence," *Richmond Enquirer,* June 1, 1821.

97. *Richmond Enquirer,* July 31, 1821; ibid., July 17 and August 7, 1821.

98. Joseph Cabell to Jefferson, January 7, 1822, N.F. Cabell, ed., *Early History of the University of Virginia,* 230.

99. Joseph Cabell to Jefferson, January 14, 1822, ibid., 235–237.

100. Jefferson to Thomas Cooper, November 2, 1822, Lipscomb and Bergh, eds., *The Writings of Thomas Jefferson,* 15:405–406.

101. Jefferson to Thomas Mann Randolph, July 21, 1821, Jefferson Papers, Special Collections, Alderman Library, University of Virginia.

102. *Journal of the Virginia House of Delegates, 1821–22,* February 23, 28, and March 1, 1822, 200, 230, 233.

103. Ibid., 25.

104. "University of Virginia," *Richmond Enquirer,* January 3, 1822.

105. "UVA in Legislature," ibid., January 1, 1822.

106. Bruce, *History of the University of Virginia,* 1:299.

107. Joseph Cabell to Jefferson, February 11, 1822, N.F. Cabell, ed., *Early History of the University of Virginia,* 241.

108. Bruce, *History of the University of Virginia,* 1:301–302.

109. "An Act Concerning the Literary Fund," *Richmond Enquirer,* February 28, 1822.

110. Jefferson to Joseph Cabell, January 31, 1821, Lipscomb and Bergh, eds., *The Writings of Thomas Jefferson,* 15:312.

111. Jefferson to Joseph Cabell, January 13, 1823, N.F. Cabell, ed., *Early History of the University of Virginia,* 267.

112. Joseph Cabell to Jefferson, January 23, 1823, ibid., 268.

113. Jefferson to Joseph Cabell, January 28, 1823, ibid., 270.

114. "Report and Documents respecting the University of Virginia," *Norfolk Gazette & Public Ledger,* October 7, 1822.

115. Hogan, *The Lawn,* 13.

116. Cabell thought the opposition to UVA was not particular to the Rotunda. Joseph Cabell to John Hartwell Cocke, February 28, 1822, Cabell Deposit, Special Collections, Alderman Library, University of Virginia. An amendment to restrict the Board of Visitors from "erecting the Centre Building" failed in late February 1822. Grizzard Jr., "Documentary History of the Construction of the Buildings at the University of Virginia, 1817–1828" (Ph.D. diss., University of Virginia, 1997), 223.

117. Joseph Cabell to John Hartwell Cocke, December 25, 1823, Cabell Deposit, Special Collections, Alderman Library, University of Virginia.

118. Sherwood and Lasala, "Education and Architecture," 70; Hogan, *The Lawn,* 9–10.

119. Bruce, *Early History of the University of Virginia,* 1:261–262.

120. Union College (Schenectady, New York), designed by Jean Jacques Ramée, was also designed around an open mall, but had a chapel, not a library, at its head. William H. Pierson, *American Buildings and their Architects: The Colonial and Neoclassical Styles,* vol. 1 (Garden City, N.Y.: Doubleday & Co., 1970), 324. Yale's theological seminary is also evocative of Jefferson's lawn.

121. Tavernor, *Palladio and Palladianism,* 207.

122. Wenger, "Thomas Jefferson, the College of William & Mary, and the University of Virginia," 374.

123. Sherwood and Lasala, "Education and Architecture," 71.

124. Silvio Bedini, *Thomas Jefferson: Statesmen of Science* (New York: Macmillan, 1990), 453.

125. "Planetarium for the Dome of the Rotunda, University of Virginia, at and for the College" [n.d.], Jefferson Papers #1518, 3, 4, 39, Special Collections, Alderman Library, University of Virginia; Hogan, *The Lawn,* 23.

126. Hugh Blair Grigsby, "Biography of Chapman Johnson," Scrapiana of Virginia Convention of 1829–1830, Virginia Historical Society, Richmond, Virginia. Johnson, who was probably added to the board as a respectful dissident to diffuse western opposition to the university, served on the board from 1819 to 1845; Joseph Cabell to Jefferson, February 15, 1819, N.F. Cabell, ed., *Early History of the University of Virginia,* 161–162.

127. Jefferson to James Madison, April 7, 1822, Smith, ed., *Republic of Letters,* 3:1820; Joseph Cabell to Jefferson, March 10, 1822, N.F. Cabell, ed., *Early History of the University of Virginia,* 252.

128. Chapman Johnson to Jefferson, March 29, 1822, Jefferson Papers, Massachusetts Historical Society.

129. Jefferson to James Madison, April 7, 1822, Smith, ed., *The Republic of Letters,* 3:1840.

130. Grizzard Jr., "A Documentary History of Documents," 237.

131. John Hartwell Cocke to Joseph Cabell, November 18, 1828, Cabell Deposit, Special Collections, Alderman Library, University of Virginia. Jefferson gives thanks for a Polyglot Bible in a letter to John Hartwell Cocke, November 24, 1824, Jefferson Papers, Special Collections, Alderman Library, University of Virginia.

132. Henry F. May, *The Enlightenment in America* (New York: Oxford University Press, 1976), 331.

133. Grizzard Jr., "A Documentary History of Documents," 240, 245.

134. Joseph Cabell to Jefferson, March 6, 1822, N.F. Cabell, ed., *Early History of the University of Virginia,* 245–251.

135. Joseph Cabell to Jefferson, March 10, 1822, ibid., 252.

136. "Jefferson to President and Director of the Literary Fund," May 11, 1823, Jefferson Papers, Special Collections, Alderman Library, University of Virginia; Sherwood and Lasala, "Education and Architecture," 43; *Journal of the Virginia House of Delegates,* February 4, 6, and 15, 1823, 179, 202.

137. Mapp Jr., *Thomas Jefferson, Passionate Pilgrim,* 315.

138. Swift, "Thomas Jefferson, John Holt Rice, and Education in Virginia," 53.

139. Edwin S. Gaustad, *Sworn on the Altar of God: A Religious Biography of Thomas Jefferson* (Grand Rapids: William B. Eerdmans, 1996), 175.

140. *The Virginian,* February 11, 1823; Neil McDowell Shawen, "The Casting of a Lengthened Shadow: Thomas Jefferson's Role in Determining the Site for a State University in Virginia" (Ph.D. diss., George Washington University, 1980), 204; Bruce, *Early History of the University of Virginia,* 1:306.

141. *Journal of the Virginia House of Delegates, 1822–1823,* January 28 and February 1, 1823, 156, 173, 202; *The Virginian,* January 21 and 24, 1823.

142. Charles Fenton Mercer to Clairborne Watts Gooch, September 26, 1823, Gooch Family Papers, Virginia Historical Society, Richmond, Virginia.

143. *The Virginian,* January 27, 1824.

144. Bell, *The Church, the State, and Education,* 334–335.

145. "Communication from the President and Directors of the Literary Fund, Touching on the Primary Schools," *Journal of the Virginia House of Delegates, 1822–1823,* 6–10; "Extracts from the Reports of School Commissioners for the Year 1823, Containing Remarks of the Said Commissioners in Relation to the Progress and Situation of the Primary Schools," *Journal of the Virginia House of Delegates, 1823–24,* 17–31.

146. *The Virginian,* January 30, 1824. (Printed from *Lexington* [Virginia] *Intelligencer*).

147. Ibid., February 13, 1824.

148. Benjamin Brand to William Jessup Armstrong, June 30, 1823, Virginia Historical Society, Richmond, Virginia.

149. Francis Bowman to James Marsh, March 4, 1824, James Marsh Collection, Archives, University of Vermont; quoted in Swift, "Thomas Jefferson, John Holt Rice, and Education in Virginia," 45. Swift interprets this quote as meaning that Jefferson still favored putting seminaries near the campus, just as he had in 1822.

150. "Report and Documents Respecting the University of Virginia," *Journal of the Virginia House of Delegates, 1822–23,* 3–4; "Jefferson to President and Director of Literary Fund," October 7, 1822, Jefferson Papers, Special Collections, Alderman Library, University of Virginia; Minutes of the Board of Visitors for the University of Virginia, October 7, 1822, Lipscomb and Bergh, eds., *The Writings of Thomas Jefferson,* 19:414–416.

151. St. George Tucker, "Sketch of a Plan for the endowment and establishment of a State University in Virginia," January 4, 1805, Tucker-Coleman Papers, Swem Library, College of William and Mary; Richard Beale Davis, *Intellectual Life in Jefferson's Virginia, 1790–1830* (Chapel Hill: University of North Carolina Press, 1964), 61; Honeywell, *The Educational Work of Thomas Jefferson,* 168–169. Also the theological seminaries that William and Mary and Hampden-Sydney had proposed a few years earlier when they were seeking state funding were open to all denominations.

152. "Report and Documents respecting the University of Virginia," *Norfolk & Portsmouth Herald,* January 31, 1823.

153. Jefferson to Thomas Cooper, November 2, 1822, Lipscomb and Bergh, eds., *The Writings of Thomas Jefferson,* 15:405–406.

154. Ibid.

155. Joseph Cabell to Jefferson, February 3, 1823, N.F. Cabell, ed., *Early History of the University of Virginia,* 273.

156. Schele de Vere, "Mr. Jefferson's Pet," 820.

157. Joseph Cabell to James Monroe, April 2, 1824, Cabell Deposit, Special Collections, Alderman Library, University of Virginia.

158. Bruce, *Early History of the University of Virginia,* 1:307–308.

159. Leonard Levy, *Jefferson and Civil Liberties: The Darker Side* (Chicago: Ivan R. Dee, 1989), 157; J.C. Miller, *Wolf by the Ears,* 263.

160. James Madison to Jefferson, February 17, 1825, Smith, ed., *Republic of Letters,* 3:1927–1928; Jefferson to Charles Pinckney, September 30, 1820, Lipscomb and Bergh, eds., *The Writings of Thomas Jefferson,* 15:280.

161. Levy, *Jefferson and Civil Liberties,* 153; J.C. Miller, *Wolf by the Ears,* 262; Dumas Malone, *The Sage of Monticello* (Boston: Little, Brown & Co., 1981), 422–423. Henry St. George Tucker taught law at UVA in the mid-nineteenth century.

162. Smith, ed., *Republic of Letters,* 3:1843–1844.

163. Ellis, *American Sphinx,* 285.

164. Bruce, *Early History of the University of Virginia,* 2:26–31.

165. Grizzard Jr., "A Documentary History of Documents Relating to the Construction of the University of Virginia," 296.

166. Jefferson to Francis Walker Gilmer, October 12, 1824, Jefferson Papers, University of Virginia; James Madison to Richard Rush, April 17, 1824, Francis Walker Gilmer's "Book of Letters," Special Collections, Alderman Library, University of Virginia.

167. Ellis, *American Sphinx,* 282.

168. Rector and Visitors' Minutes, April 4, 1824, 1817–1836, 1:60, University Archives, Special Collections, Alderman Library, University of Virginia.

169. Dugald Stewart to Francis Walker Gilmer, September 27, 1824, Francis Walker Gilmer's "Book of Letters," Special Collections, Alderman Library, University of Virginia; Smith, ed., *Republic of Letters,* 3:1844.

170. George H. Daniels, *American Science in the Age of Jackson* (New York: Columbia University Press, 1968), 44; Clifton Waller Barret, "The Struggle to Create a University," *Virginia Quarterly Review* 49 (Autumn 1973), 504; Bruce, *Early History of the University of Virginia,* 2:1–2.

171. John Adams to Jefferson, January 22, 1825, Cappon, ed., *The Adams-Jefferson Letters,* 607.

172. Jefferson to Edward Everett, July 21, 1825, Edward Everett Papers, Massachusetts Historical Society.

173. Jefferson to James Madison, November 20, 1824, Smith, ed., *Republic of Letters,* 3:1908.

174. Smith, ed., *Republic of Letters,* 3:1884; Minutes of the Board of Visitors of the University of Virginia (Extracts 1817–1826), October 4, 1819, Knight, ed., *A Documentary History of Education,* 150.

175. James Madison to Jefferson, December 3, 1824, ibid., 3:1909–1910.

176. Jefferson to James Madison, December 10, 1824, Smith, ed., *Republic of Letters,* 3:1910.

177. Tucker wrote *Valley of the Shenandoah* and *Voyage to the Moon;* Rector and Visitors' Minutes, March 4, 1825, 84, University Archives, Special Collections, Alderman Library, University of Virginia.

178. Tucker was a cousin of St. George Tucker and his son Henry St. George Tucker. St. George Tucker taught law at William and Mary at the beginning of the century, and his son, Henry, taught law at UVA in the mid-nineteenth century. St. George Tucker, who edited Blackstone's *Commentaries* and advocated gradual abolition, died in the home of Joseph Cabell in 1827.

179. Jefferson to Joseph Cabell, February 3, 1825, N.F. Cabell, ed., *Early History of the University of Virginia,* 339.

180. Jefferson to James Madison, February 1, 1825, Smith, ed., *Republic of Letters,* 3:1923–1924.

181. James Madison to Samuel H. Smith, November 4, 1826, Gaillard Hunt, ed., *The Writings of James Madison,* 9 vols. (New York: G.P. Putnam's Sons, 1900–1910), 9:259; Adrienne Koch, *The Philosophy of Thomas Jefferson* (New York: Columbia University Press, 1943), 278.

182. The Resolutions opposed the Federalists' Alien and Sedition Acts of 1798. James Madison to Jefferson, February 8, 1825, Smith, ed., *Republic of Letters,* 3:1924–1925.

183. Minutes of the Board of Visitors of the University of Virginia, October 4–5, 1824, Lipscomb and Bergh, eds., *The Writings of Thomas Jefferson,* 19:460–461.

184. Jefferson to Major John Cartwright, June 5, 1824, ibid., 16:50; Jefferson to Thomas Cooper, February 10, 1814, Peterson, ed., *Thomas Jefferson: Writings,* 1325; Judge Joseph Story took up the challenge and issued a rebuttal in *American Jurist and Law Magazine* 9 (April 1833) entitled "Christianity a Part of the Common Law." Daniel L. Dreisbach, *Religion and Politics in the Early Republic: Jasper Adams and the Church-State Debate* (Lexington: University of Kentucky Press, 1996), 19.

185. Jefferson to Thomas W. White, February 5, 1820, Jefferson Papers, Library of Congress; Jefferson to Horatio Spafford, March 7, 1814, Lipscomb and Bergh, eds., *The Writings of Thomas Jefferson,* 14:120; Jefferson to John Norvell, June 11, 1807, ibid., 11:223–224; Jefferson to William Duane, August 10, 1810, ibid., 12:405–407; Craig Walton, "Hume and Jefferson on the Uses of History," in D. Livingstone and J. King, eds., *Hume: A Re-evaluation* (Dekalb: Northern Illinois University Press, 1976), 393–394; Douglas L. Wilson, "Jefferson and Hume," *William and Mary Quarterly* 46 (1989): 49–70.

186. Jefferson to John Minor, August 30, 1814, Ford, ed., *The Writings of Thomas Jefferson,* 9:483; Levy, *Jefferson and Civil Liberties,* 143; Julian S. Waterman, "Jefferson and Blackstone's Commentaries," *Illinois Law Review* 27 (1933): 629–659.

187. Jefferson to James Madison, Smith, ed., *Republic of Letters,* 3:1965.

188. For an excellent account of Jefferson and Blackstone's and Hume's American editions, see Levy, *Jefferson and Civil Liberties,* 144.

189. *Vital Facts: A Chronology of the College of William & Mary* (Williamsburg, Va.: College of William and Mary, 1992), 9.

190. *New York Observer,* November 13, 1824.

191. "Visitors and Professors of William and Mary College, Petition of the Visitors and Professors of William and Mary College," *Norfolk & Portsmouth Herald,* January 7, 1825; Report of the Committee of Schools and Colleges on the Subject of the Removal of the College of William and Mary (Richmond, Va.: Thomas Ritchie, 1824); *Richmond Family Visitor,* July 24, 1824; *Boston Weekly Newspaper,* July 15, 1824; Robert Scott to John Tyler, July 6, 1824, William and Mary College Papers, University Archives, Swem Library, College of William and Mary.

192. Holifield, *Gentleman Theologians,* 13–14.

193. Joseph Cabell to Jefferson, May 5, 1824, N.F. Cabell, ed., *Early History of the University of Virginia,* 306–306.

194. Jefferson to Joseph Cabell, December 22, 1824, ibid., 320; Shawen, "The Casting of a Lengthened Shadow," 317.

195. "Bill for discontinuance of the College of William and Mary and the establishment of the other Colleges in convenient distribution over the State," Rare Virginia Pamphlets #265, Cabell Deposit, Special Collections, Alderman Library, University of Virginia. Madison approved of the idea. James Madison to Jefferson, December 31, 1824, Smith, ed., *Republic of Letters,* 3:1913.

196. Joseph Cabell to Jefferson, January 23, 1816, N.F. Cabell, ed., *Early History of the University of Virginia*, 47; Jefferson to Cabell, February 2, 1816, ibid., 53; Cabell to Jefferson, August 4, 1816, ibid., 69.

197. University historian Philip Alexander Bruce wrote that "this was the only chapter in the university's history darkened by an illiberal and ungenerous spirit." Bruce, *Early History of the University of Virginia*, 1:319.

198. Joseph Cabell to Jefferson, March 5, 1815, ibid., 40.

199. Joseph Cabell, "Letter & Accompanying Documents relative to the Literary Institutions of the State addressed to Constituents, March 18, 1825," Rare Virginia Pamphlets #265, Cabell Deposit, Special Collections, Alderman Library, University of Virginia.

200. John August Smith to Joseph Cabell, March 7, 1825, Cabell Deposit, Special Collections, Alderman Library, University of Virginia.

201. Joseph Cabell to John August Smith, March 24, 1825, ibid.

202. John August Smith to Joseph Cabell, April 7, 1825, ibid.

203. William and Mary tried unsuccessfully to move to Richmond again after the Civil War.

204. Jefferson to Joseph Cabell, January 11, 1825, N.F. Cabell, ed., *Early History of the University of Virginia*, 330–332.

205. *Richmond Enquirer,* February 4, 1826.

206. Schele de Vere, "Mr. Jefferson's Pet," 821.

207. Jefferson to Joseph Cabell, February 17, 1826, N.F. Cabell, ed., *Early History of the University of Virginia*, 366.

208. Conor Cruise O'Brien, *The Long Affair: Thomas Jefferson and the French Revolution, 1785–1800.* (Chicago: University of Chicago Press, 1996), 196.

209. Jefferson to William Branch Giles, December 26, 1825, Lipscomb and Bergh, eds., *The Writings of Thomas Jefferson*, 16:151.

## Chapter 6

1. Charles Coleman Wall Jr., "Students and Student Life at the University of Virginia, 1825–1861" (Ph.D. diss., University of Virginia, 1978), 60.

2. Jefferson to James Madison, February 17, 1826, James Morton Smith, ed., *The Republic of Letters: The Correspondence between Jefferson and Madison, 1776–1826,* 3 vols. (New York: W.W. Norton & Co., 1995), 3:1965.

3. James Madison to Jefferson, February 24, 1826, ibid., 3:1967.

4. James Madison to Samuel H. Smith, November 4, 1826, Gaillard Hunt, ed., *The Writings of James Madison,* 9 vols. (New York: G.P. Putnam's Sons, 1900–1910), 9:259.

5. Frank L. Grizzard Jr., "Documentary History of the Construction of the Buildings at the University of Virginia, 1817–1828" (Ph.D. diss., University Press of Virginia, 1997), 317.

6. Pendleton Hogan, *The Lawn: A Guide to Jefferson's University* (Charlottesville: University Press of Virginia, 1987), 26.

7. Frances Wright to Edward Everett, December 15, 1824, Edward Everett Papers, Massachusetts Historical Society.

8. A landau is a four-wheeled carriage with a retractable top. Dumas Malone, *The Sage of Monticello* (Boston: Little, Brown & Co., 1981), 402–408.

9. [attributed to] Charles Downing, "Reception of General Lafayette in Albermarle," reprinted from *Richmond Enquirer,* November 16, 1824, in *Albermarle County Historical Society Magazine* 24 (1965–1966), 53–66.

10. *Charlottesville Central Gazette,* November 10, 1824, ibid., 61.

11. Marquis de Lafayette to Robert Barraud Taylor, August 21, 1826, Robert Barraud Taylor Papers, 1822–1831, Virginia Historical Society, Richmond, Virginia.

12. Harriet Martineau, *Retrospect of Western Travel,* 2 vols. (New York: Harper & Bros., 1838), 205–207.

13. B. Peyton to Jefferson, March 20, 1825, Jefferson Papers, Massachusetts Historical Society; Malone, *Sage of Monticello,* 423.

14. Philip Alexander Bruce, *History of the University of Virginia, 1819–1919: The Lengthened Shadow of One Man,* 5 vols. (New York: Macmillan, 1920), 2:69.

15. Ibid., 66–67.

16. Thomas W. Gilmer to Joseph Cabell, September 1, 1830, Cabell Deposit, Special Collections, Alderman Library, University of Virginia.

17. *The Chameleon* 1 (May 9, 1831), n.p.

18. *Address of the Society of Alumni of the UVA, Through their Committee, to the People of Virginia* (Charlottesville: Noel & Saunders, 1845), Rare Virginia Pamphlets #319, Alderman Library, University of Virginia.

19. Jefferson and Madison both wanted to distribute scholarships at the university, but in 1823 Jefferson wrote that they could only do one thing at a time, and the idea would have to wait. Jefferson to William Cabell Rives, January 28, 1823; quoted in Adrienne Koch, *Jefferson and Madison: The Great Collaboration,* 4th ed. (New York: Oxford University Press, 1967), 270. For the scholarship plan, see Wall Jr., "Students and Student Life at the University of Virginia," 64.

20. Ibid., 64.

21. Bruce, *History of the University of Virginia,* 2:128–129.

22. Rector and Visitors' Minutes, April 4, 1824, Rector and Visitors' Minutes, 1817–1836, 1:60, University Archives, Special Collections, Alderman Library, University of Virginia; Wall Jr., "Students and Student Life," 28.

23. Joseph Kett, "Education," in Merrill D. Peterson, ed., *Thomas Jefferson: A Reference Biography* (New York: Charles Scribner's Sons, 1986), 247.

24. Hogan, *The Lawn,* 65; Bruce, *Early History of the University of Virginia,* 2:109–111.

25. Minutes of the Board of Visitors of the University of Virginia, October 4–5, 1824, Andrew A. Lipscomb and Albert E. Bergh, eds., *The Writings of Thomas Jefferson,* 19 vols. (Washington, D.C.: Thomas Jefferson Memorial Foundation, 1903–1905), 19:439–461.

26. The elective system did not spread nationally until after the Civil War, with the exception of experiments at Harvard, Brown, and M.I.T. Jennings L. Wagoner Jr., *Thomas Jefferson and the Education of a New Nation* (Bloomington, Ind.: Phi Delta Kappa Educational Foundation, 1976), 35; Kett, "Education," 246.

27. Lorraine Smith and Thomas Pangle, *The Learning of Liberty: The Educational Ideas of the American Founders* (Lawrence: University Press of Kansas, 1993), 181–182.

28. Minutes of the University of Virginia Faculty, April 27, 1829, 1:458–459, University Archives, Special Collections, Alderman Library, University of Virginia; Bruce, *Early History of the University of Virginia,* 2:83, 138.

29. Minutes of the University of Virginia Faculty, June 7, 1829, 1:468–469, University Archives, Special Collections, Alderman Library, University of Virginia.

30. Bruce, *Early History of the University of Virginia,* 2:138–139.

31. Rector and Visitors' Minutes, July 20, 1831, 282, University Archives, Special Collections, Alderman Library, University of Virginia.

32. Tipton R. Snavely, *The Department of Economics at the University of Virginia, 1825–1956* (Charlottesville: University Press of Virginia, 1967), 16.

33. Jefferson ended up abandoning instruction in Anglo-Saxon, the ancient language of seventh

through thirteenth-century England, which had interested him since his days at William and Mary and which he included in the original 1818 plans for the university: "[Anglo-Saxon] leads to such an infinitude of minute rules and observances, as are beyond its worth, and render a knowledge of it no longer a compensation for the time, and labor its acquisitions will require; and, in that case, I would recommend its abandonment in our University, as an unattainable and unprofitable pursuit." Thomas Jefferson, "An Essay on the Anglo-Saxon Language" (Postscript, 1825), Adrienne Koch and William Peden, eds., *The Life and Selected Writings of Thomas Jefferson* (New York: Modern Library, 1944), 169. On use of foreign languages see Wagoner Jr., "'That Knowledge Most Useful to Us': Thomas Jefferson's Concept of Utility in the Education of Republican Citizens," in James Gilreath, ed., *Thomas Jefferson and the Education of a Citizen* (Washington, D.C.: Library of Congress, 1999), 129–132; Bruce, *Early History of the University of Virginia*, 2:94–96.

34. Thomas Jefferson Randolph, 182?, University of Virginia Chronological File, Special Collections, Alderman Library, University of Virginia; Bruce, *Early History of the University of Virginia*, 2:40.

35. David N. Mayer, *The Constitutional Thought of Thomas Jefferson* (Charlottesville: University Press of Virginia, 1994), 20, 24. For a complete list of the library books, see William H. Peden, ed., *1828 Catalogue of the Library of the University of Virginia* (Charlottesville: University Press of Virginia, 1945), or the appendix to Trevor H. Colbourn's *The Lamp of Experience: Whig History and Intellectual Origins of the American Revolution* (Chapel Hill: University of North Carolina Press, 1965), 217–221.

36. *A Theological Catalogue for the Library of the University of Virginia,* enclosed in James Madison to Jefferson, September 10, 1824, Smith, ed., *Republic of Letters,* 3:1899–1901.

37. Bruce, *Early History of the University of Virginia,* 2:191–200.

38. Jefferson to John Adams, July 5, 1814, Lester J. Cappon, ed., *The Adams-Jefferson Letters; The Complete Correspondence Between Thomas Jefferson and Abigail and John Adams,* 2d ed. (Chapel Hill: University of North Carolina, 1987), 434.

39. Joseph Cabell to Jefferson, January 30, 1825, Nathaniel Francis Cabell, ed., *Early History of the University of Virginia, as Contained in the Letters of Thomas Jefferson and Joseph C. Cabell* (Richmond: J.W. Randolph, 1856), 336–337; Malone, *Sage of Monticello,* 413.

40. Harold Hellenbrand, *The Unfinished Revolution: Education and Politics in the Thought of Thomas Jefferson* (London: Associated University, 1990), 146.

41. Dumas Malone, ed. *The Dictionary of American Biography,* Vol. 8 (New York: Charles Scribner's Sons, 1963), 115; William J. Cooper and Thomas E. Terrill, eds., *The American South: A History,* Vol. 1 (Boston: McGraw-Hill, 2002), 238.

42. Mark Wenger, "Thomas Jefferson, the College of William & Mary, and the University of Virginia," *Virginia Magazine of History and Biography* 103 (July 1995): 369.

43. Ibid., 369; Hellenbrand, *Unfinished Revolution,* 149.

44. Minutes of the Board of Visitors for the University of Virginia, April 5, 1824, Lipscomb and Bergh, eds., *The Writings of Thomas Jefferson,* 19:431.

45. Jefferson to Thomas Cooper, April 4, 1825, Jefferson Papers, Special Collections, Alderman Library, University of Virginia; Jefferson to James Madison, February 22, 1825, and March 22, 1825, Smith, ed., *Republic of Letters,* 3:1928, 1929–1930.

46. Hogan, *The Lawn,* 74.

47. Malone, *Sage of Monticello,* 422.

48. Bruce, *Early History of the University of Virginia,* 2:62, 76.

49. Minutes of the Board of Visitors for the University of Virginia, April 7, 1824, Lipscomb and Bergh, eds., *The Writings of Thomas Jefferson,* 19:436.

50. Hogan, *The Lawn,* 42–43.

51. William H. Pierson, *American Buildings and their Architects: The Colonial and Neoclassical Styles,* 3 vols. (Garden City, N.Y.: Doubleday & Co., 1970), 1:326.

52. George Ticknor to William H. Prescott, December 16, 1824, in Ticknor, *Life, Letters and Journals* (Boston: Houghton & Mifflin, 1909), 1:348; quoted in Malone, *Sage of Monticello,* 423.

53. Richard Guy Wilson, "Jefferson's Lawn: Perceptions, Interpretations, Meanings," in R.G. Wilson, ed., *Thomas Jefferson's Academical Village: The Creation of an Architectural Masterpiece* (Charlottesville: University Press of Virginia, 1993), 47.

54. "The University," *The Virginian,* January 30, 1824 (printed from the *Lexington Intelligencer*).

55. Ibid.

56. Joseph Cabell to Jefferson, January 16, 1816, N.F. Cabell, ed., *Early History of the University of Virginia,* 44; Jefferson to Trustees of East Tennessee College, May 6, 1810, Lipscomb and Bergh, eds., *The Writings of Thomas Jefferson,* 12:387; Steven J. Novak, *The Rights of Youth: American Colleges and Student Revolt, 1798–1815* (Cambridge, Mass.: Harvard University Press, 1977), 125–126.

57. Minutes of the Board of Visitors for the University of Virginia, October 4, 1824, Lipscomb and Bergh, eds., *The Writings of Thomas Jefferson,* 19:444–449.

58. *Massachusetts Federalist,* April 2, 1802, *Boston Gazette,* April 15, 1802; cited in Novak, *Rights of Youth,* 102–105; Kett, "Education," 247.

59. Jefferson to George Ticknor, July 16, 1823, Lipscomb and Bergh, eds., *The Writings of Thomas Jefferson,* 15:455.

60. Carl J. Richard, *The Founders and the Classics: Greece, Rome, and the American Enlightenment* (Cambridge, Mass.: Harvard University Press, 1994), 222.

61. Bruce, *Early History of the University of Virginia,* 2:73.

62. Bruce, *Early History of the University of Virginia,* 2:319.

63. John Hartwell Cocke to Joseph Cabell, September 20, 1825, Cabell Deposit, Special Collections, Alderman Library, University of Virginia.

64. John Hartwell Cocke to Joseph Cabell, February 15, 1826, Cabell Deposit, Special Collections, Alderman Library, University of Virginia.

65. Bruce, *Early History of the University of Virginia,* 2:299–300.

66. Cary was Jefferson's nephew on the paternal side, the son of Thomas Mann Randolph's sister. Malone, *Sage of Monticello,* 468.

67. Judge Henry St. George Tucker was the father of the honor system at the University of Virginia. Mary T. Armentrout and Glenn C. Smith, eds., "Madison-to-Cabell Letters, 1823–33," *Madison Quarterly* 1 (November 1941), 162, n.8.

68. Mark A. Noll, *Princeton and the Republic, 1768–1822: The Search for a Christian Enlightenment in the Era of Samuel Stanhope Smith* (Princeton, N.J.: Princeton University Press, 1989), 10, 237.

69. Lowell H. Harrison, "A Young Kentuckian at Princeton, 1806–1810: Joseph Cabell Breckinridge," *Filson Club History Quarterly* 38 (1964): 303–304; quoted in Noll, ibid., 230.

70. Ibid., 6–10, 233.

71. Ibid., 218; Novak, *Rights of Youth,* 81; Bertram Wyatt-Brown, *Southern Honor: Ethics and Behavior in the Old South* (New York: Oxford University Press, 1982); Anya Jabour, "Male Friendship and Masculinity in the Early National South: William Wirt and his Friends," *Journal of the Early Republic* 20 (Spring 2000): 86.

72. Hogan, *The Lawn,* 68; Bruce, *Early History of the University of Virginia,* 2:298–299; Snavely, *Department of Economics,* 16.

73. Malone, *Sage of Monticello,* 425.

74. "Student Petition Requesting Two Weeks," December 1831, University of Virginia Chronological File, Special Collections, Alderman Library, University of Virginia.

75. Bruce, *Early History of the University of Virginia,* 2:66–67.

76. Ibid., 2:262–273.

77. Ibid., 2:262–266.

78. Jefferson ordered a bell that could be heard two miles away cast in Medway, Massachusetts. Hogan, *The Lawn,* 9.

79. Rector and Visitors' Minutes, July 1, 1836, University Archives, Special Collections, Alderman Library, University of Virginia.

80. Ibid.

81. Ibid., October 7, 1826.

82. Hogan, *The Lawn,* 43. ·

83. Minutes of the University of Virginia Faculty, 1828, University Archives, Special Collections, Alderman Library, University of Virginia.

84. Bruce, *Early History of the University of Virginia,* 2:226–235. Rice, turnips and potatoes were daily staples.

85. Ibid., 2:222–223.

86. Ibid., 2:120–123, 337.

87. Ibid., 2:279–281.

88. Minutes of the University of Virginia Faculty, April 22, 1828, 2:297–303, University Archives, Special Collections, Alderman Library, University of Virginia; Bruce, *Early History of the University of Virginia,* 2:298–300.

89. October 4, 1825, Jefferson Papers, University of Virginia; Rector and Visitors' Minutes, October 7, 1825, University Archives, Special Collections, Alderman Library, University of Virginia.

90. Bruce, *Early History of the University of Virginia,* 2:299; Minutes of the University of Virginia Faculty, July 16, 1831, 3:721–733, University Archives, Special Collections, Alderman Library, University of Virginia.

91. Rector and Visitors' Minutes, [n.d.], 112, University Archives, Special Collections, Alderman Library, University of Virginia.

92. George Pierson to Albert Pierson, November 2, 1825, Chronological File, University Archives, Special Collections, Alderman Library, University of Virginia.

93. Hogan, *The Lawn,* 68.

94. Richard Beale Davis, *Intellectual Life in Jefferson's Virginia, 1790–1830* (Chapel Hill: University of North Carolina Press, 1964), 65.

95. Hogan, *The Lawn,* 134.

96. Edmund Clarence Stedman and George Edward Woodberry, eds., Introduction to *Selections from the Prose Tales of Edgar Allen Poe* (New York: Macmillan & Co., 1901), xix; Minutes of the University of Virginia Faculty, December 15, 20, and 25, 1826, 131–132, 146, 150, 160, University Archives, Special Collections, Alderman Library, University of Virginia.

97. Bruce, *Early History of the University of Virginia,* 2:295–298.

98. Named for the songs slaves sung when shucking corn. Minutes of the University of Virginia Faculty, December 3, 1833, 1041, University Archives, Special Collections, Alderman Library, University of Virginia.

99. A cow was mutilated on the grounds on June 18, 1825, but the perpetrators were never apprehended. Minutes of the University of Virginia Faculty, 5–6, University Archives, Special Collections, Alderman Library, University of Virginia.

100. Rector and Visitors' Minutes, October 25, 1825, 94–98, University Archives, Special Collections, Alderman Library, University of Virginia.

101. Letter Number One, May 1826, Letter Number Two, September 21, 1826, in Mary Newton Stannard, ed., *Edgar Allen Poe Letters 'Till Now Unpublished': In the Valentine Museum, Richmond, Virginia* (Philadelphia: J.B. Lippincott, 1925).

102. Minutes of the University of Virginia Faculty, April 18, and July 17, 1832, 822, 871, University Archives, Special Collections, Alderman Library, University of Virginia.

103. Bruce, *Early History of the University of Virginia*, 2:301–302.

104. The faculty was from Britain, except for math professor George Blaetterman, who was born in present-day Germany, but lived in London. Hogan, *The Lawn*, 65; Bruce, *Early History of the University of Virginia*, 2:16–17.

105. James Thomas?, "Slaves at the University" [typescript, n.d.], Special Collections, Alderman Library, University of Virginia.

106. Rector and Visitors' Minutes, July 18, 1832, 292, University Archives, Special Collections, Alderman Library, University of Virginia.

107. Minutes of the University of Virginia Faculty, February 3, 1826, 50, University Archives, Special Collections, Alderman Library, University of Virginia.

108. Hogan, *The Lawn*, 74.

109. Ibid., 130.

110. Bruce, *Early History of the University of Virginia*, 2:209.

111. Minutes of the University of Virginia Faculty, May 20, 1828, 313, University Archives, Special Collections, Alderman Library, University of Virginia. In 1920, Philip Alexander Bruce wrote that the free negro was "sinister" and the white woman "of a still more abandoned stripe." Bruce, *Early History of the University of Virginia*, 2:274.

112. The Carter G. Woodson Institute for Afro-American and African Studies at the University of Virginia has excavated Venable Lane since 1993. It was located across from present-day Cabell Hall, behind the music hall. For faculty concerns, see Minutes of the University of Virginia Faculty, April 22, 1828 and June 2, 1829, 309–310, 468, University Archives, Special Collections, Alderman Library, University of Virginia.

113. Ibid., March 2, 1839.

114. Ibid., June 26, 1828.

115. Henry F. May, *The Enlightenment in America* (New York: Oxford University Press, 1976), 347; Ellen Condliffe Lagemann, "Education," in Richard Wightman Fox and James T. Kloppenberg, eds., *A Companion to American Thought* (New York: Blackwell Publishers, 1995), 196.

116. For a fuller discussion, see Herbert A. Johnson, "Thomas Jefferson and Legal Education in Revolutionary America," in Gilreath, ed., *Thomas Jefferson and the Education of a Citizen*, 103–114.

117. Kett, "Education," 248.

118. Henry St. George Tucker, new incumbent of the chair of law, became a victim of ill health and retired. Snavely, *Department of Economics*, 25.

119. Bruce, *Early History of the University of Virginia*, 2:171.

120. Snavely, *Department of Economics*, 5–12.

121. Richard H. Popkin, "George Tucker, An Early American Critic of Hume," *Journal of the History of Ideas* 13 (June 1952): 370–375; Robert C. McClean, *George Tucker: Moral Philosopher and Man of Letters* (Chapel Hill: University of North Carolina, 1961); Snavely, *Department of Economics*, 17.

122. George Tucker, "A Discourse on the Progress of Philosophy and its Influence on the Intellectual and Moral Character of Man," *Southern Literary Messenger* 1 (April 1835): 405–421.

123. L.C. Helderman, "A Social Scientist of the Old South," *Journal of Southern History* 2 (1936): 157.

124. *The Collegian* 1 (June 1839), n.p.

125. "Notebooks on Political Economy, 1842–1843, 1843–1844," William C. Rives Papers, Manuscripts Division, Library of Congress, 33, 44; Merit M. Robinson Notebook from Tucker's class in the Cabell Family Deposit, Special Collections, Alderman Library, University of Virginia.

126. The Tucker clan was prominent on the island of Bermuda for over two hundred years. Helderman, "A Social Scientist in the Old South," 163; Trenton Eynon Hizer, "'Virginia is Now Divided': Politics in the Old Dominion, 1820–1833" (Ph.D. diss., University of South Carolina, 1997), 21–22.

127. George Long, George C. Porter, and George Tucker, *The Geography of America and the West Indies* (London: Society for the Diffusion of Useful Knowledge, 1841), 223–224; cited in Helderman, "Social Scientist in the Old South," 163.

128. "Notebooks on Political Economy," Rives Papers, Library of Congress, 4.

129. Tucker learned political economy under Bishop James Madison at William & Mary in the late 1790s. Madison was the first economics teacher in the United States and taught Adams Smith's *Wealth of Nations* (1776) after 1798. Tucker used Smith and Jean Baptiste-Say, but not Destutt de Tracy, Jefferson's favorite economist. Snavely, *Department of Economics*, 4–8.

130. Clement Eaton, *The Freedom of Thought Struggle in the Old South* (New York: Harper & Row, 1964), 221.

131. Snavely, *Department of Economics*, 10, 20–21, 28.

132. Helderman, "A Social Scientist in the Old South," 161.

133. Among the Rives Papers in the Library of Congress, there are lectures and examinations from Tucker's classes, discussed in Davis, *Intellectual Life in Jefferson's Virginia*, 66.

134. Bruce, *Early History of the University of Virginia*, 2:343.

135. Ibid., 2:351–352.

136. Ibid., 2:346–349.

137. "The Youth of Our Country," *New York American*, August 5, 1834, University of Virginia Chronological File, Special Collections, Alderman Library, University of Virginia; Martineau, *Retrospect of Western Travel*, 205.

138. Minutes of the University of Virginia Faculty, July 5, 1828, 264, University Archives, Special Collections, Alderman Library, University of Virginia.

139. Poor white men could not vote in Virginia until 1851. Dickson D. Bruce, *The Rhetoric of Conservatism: The Virginia Convention of 1829–1830 and the Conservative Tradition in the South* (San Marino, Calif.: Huntington Library, 1982), xii.

140. Bruce, *Early History of the University of Virginia*, 2:355–356.

141. Minutes of the University of Virginia Faculty, April 16, 1832, 3:816–820, University Archives, Special Collections, Alderman Library, University of Virginia.

142. Bruce, *Early History of the University of Virginia*, 2:359–360.

143. O.N. Ogden [of Louisiana], *An Anniversary Oration Delivered on the 13th of April 1836 at the request of the Jefferson Society of UVA* (Charlottesville: James Alexander, 1836), 17–20, 24, 28, Rare Virginia Pamphlets #319, Special Collections, Alderman Library, University of Virginia.

144. Robert Hamilton [of Spotsylvania], *An Oration Delivered Before the Washington Society of UVA February 22, 1838*, ibid., 12–15.

145. Richard Barnes Gooch, *The Anniversary Address of the Jefferson Society, of UVA, Delivered on the 13th of April 1840*, ibid., 5–9.

146. James C. Bruce, *An Address Delivered Before the Society of Alumni of the University of Virginia, July 4, 1840* (Richmond, Va.: Peter D. Bernard, 1840), ibid., 13–22.

147. Minutes of the University of Virginia Faculty, February 4, 1835, University Archives, Special Collections, Alderman Library, University of Virginia.

148. Ibid., April 28, 1836.

149. Bruce, *Early History of the University of Virginia*, 2: 302–311.

150. *Circular of the Students of the UVA in Answer to the Faculty in Regard to the Dismission of Seventy-Two Students* (Charlottesville: James Alexander, 1836), 8–11, Rare Virginia Pamphlets #319, Special Collections, Alderman Library, University of Virginia.

151. Minutes of the University of Virginia Faculty, November 9, 12, and 19, 1836, University Archives, Special Collections, Alderman Library, University of Virginia.

152. *Circular of the Students of the UVA in Answer to the Faculty in Regard to the Dismission of Seventy-Two Students.*

153. Wall Jr., "Students and Student Life," 196.

154. Bruce, *Early History of the University of Virginia*, 2:308.

155. Hunter H. Marshall, "The Shooting of Professor Davis," *Plume and Sword* 3 (May 31, 1963), 12–22.

156. Political Economy was transferred from law to moral philosophy in 1826 to accommodate Tucker. Snavely, *Department of Economics*, 4.

157. John S. Patton, *Jefferson, Cabell and the University of Virginia: Glimpses of its Past and Present* (New York: Neale, 1906), 106.

158. Jefferson to Arthur S. Brockenbrough, April 21, 1825, Jefferson Papers, Special Collections, Alderman Library, University of Virginia.

159. Emmet was Catholic and Blaetterman, Lutheran. Bruce, *Early History of the University of Virginia*, 2:364–365.

160. George Tucker to Henry S. Randall, May 28, 1856, Randall, *The Life of Thomas Jefferson*, 2d ed. (Philadelphia: J.B. Lippincott, 1888), 467–468.

161. Chapman Johnson to John Hartwell Cocke, October 5, 1827, Cocke Family Papers, Special Collections, Alderman Library, University of Virginia.

162. John Holt Rice to John Hartwell Cocke, September 19 and October 29, 1828, ibid.

163. George Pierson to Albert Pierson, November 2, 1825, University of Virginia Chronological File, University Archives, Special Collections, Alderman Library, University of Virginia; One student was shot while trying to steal a slave corpse in 1831. Bruce, *Early History of the University of Virginia*, 2:111.

164. R.L. Dabney to G. Woodson Payne Jr., March 18, 1840, Special Collections, Alderman Library, University of Virginia.

165. Sadie Bell, *The Church, the State, and Education in Virginia* (New York: Arno Press & the New York Times, 1969), 377.

166. Francis Lister Hawks, "Journals of the Conventions of the Protestant Episcopal Church in the Dioceses of Virginia, from 1785 to 1835 Inclusive," In Hawks, ed., *A Narrative of Events Connected with the Rise and Progress of the Protestant Episcopal Church in Virginia* (New York: Harper & Bros., 1836), 202.

167. Bruce, *History of the University of Virginia*, 2:370–373.

168. May, *Enlightenment in America*, 327–328.

169. David Lynn Holmes Jr., "William Meade and the Church of Virginia, 1789–1829" (Ph.D. diss., Princeton University, 1971), 232; E. Brooks Holifield, *The Gentleman Theologians:*

*American Theology in Southern Culture, 1795–1860* (Durham, N.C.: Duke University Press, 1978), 161–162.

170. Holmes Jr., "William Meade," 242, 258.

171. Meade later served as the bishop of the Protestant Episcopal Church of America and the Confederacy from 1861–1862. He freed his own slaves and was active in the American Colonization Society and the founding of Liberia, in Africa.

172. William Meade to John Hartwell Cocke, March 29, 1827, Cocke Family Papers, Special Collections, Alderman Library, University of Virginia.

173. Dr. Robley Dunglison to James Madison, March 19–25, 1829, University of Virginia Chronological File, University Archives, Special Collections, Alderman Library, University of Virginia; Minutes of the University of Virginia Faculty, January 22, February 6 and 25, 1829, 418–441, ibid. A year later, after a cholera outbreak, a cadaver wasted away to the skeleton was found in the pond, the ice and water from which were drawn to the dormitories. Bruce, *Early History of the University of Virginia*, 2:245.

174. Meade, *Sermon, Delivered in the Rotunda of the University of Virginia on Sunday May 24, 1829 On the Occasion of the Deaths of Nine Young Men, Who Fell Victims to the Diseases Which Visited That Place During the Summer of 1828, and the Following Winter* (Charlottesville, Va.: F. Carr & Co., 1829), Rare Pamphlets #315, Special Collections, Alderman Library, University of Virginia.

175. For an analysis of the 1811 fire, which killed seventy-five people, see Lefferts A. Loetscher, *Facing the Enlightenment and Pietism: Archibald Alexander and the Founding of Princeton Theological Seminary* (Westport, Conn.: Greenwood Publishing, 1983), 107.

176. Meade, *Sermon, Delivered in the Rotunda of the University of Virginia on Sunday May 24, 1829*.

177. Ibid.

178. Meade, *Old Churches, Ministers and Families,* 2d. ed. (Philadelphia: J.B. Lippincott, 1910), 53–54.

179. John B. Minor, "University of Virginia," Part 3, *The Old Dominion: A Monthly Magazine of Literature, Science and Art* 4–5 (May 15, 1870), 260; Meade, *Old Churches, Ministers and Families,* 56; Bruce, *Early History of the University of Virginia,* 2:370–373.

180. George Tucker to Joseph Cabell, March 18, 1835, Cabell Deposit, and William Cabell Rives to John Hartwell Cocke, August 2, 1839, Cocke Family Papers, Special Collections, Alderman Library, University of Virginia; David A. Dashiell, III, "Between Earthly Wisdom and Heavenly Truth: The Effort to Build a Chapel at the University of Virginia, 1835–1890" (M.A. thesis, University of Virginia, 1992), 4–16.

181. "Student Petition" in Proctor's Records, 1830 and Rector and Visitors' Minutes, July 17, 1833, 299, University Archives, Special Collections, Alderman Library, University of Virginia.

182. Beth Barton Schweiger, *The Gospel Working Up: Progress and the Pulpit in Nineteenth-Century Virginia* (Oxford, England: Oxford University Press, 2000), 24, 56–58.

183. Ibid., July 8, 1835, 347.

184. Joseph Martin, *A New and Comprehensive Gazetteer of Virginia and the District of Columbia* (Charlottesville, Va.: J. Martin, 1836), 123; quoted in Bell, *The Church, the State, and Education,* 380.

185. William Maxwell, *An Address Delivered before the Bible Society of the University of Virginia, May 13th, 1836* (Charlottesville, Va.: Moseley & Tompkins, 1836), 9.

186. Ibid., 11.

187. R.G. Wilson, "Jefferson's Lawn," 52.

188. Minutes of the University of Virginia Faculty, July 8, 1828, 335, University Archives, Special Collections, Alderman Library, University of Virginia.

189. Gessner Harrison to Dr. Peachy Harrison, April 1, 1833, Tucker-Harrison-Smith Family Papers, Special Collections, Alderman Library, University of Virginia.

190. Holifield, *Gentleman Theologians*, 6.

191. Gessner Harrison to Dr. Peachy Harrison, November 18, 1838, Tucker-Harrison-Smith Family Papers, Special Collections, Alderman Library, University of Virginia.

192. Patrick W. Carey and Joseph T. Lienhard, eds., *Biographical Dictionary of Christian Theologians* (Westport, Conn.: Greenwood Publishing, 2000), 113–114; Henry Ward Bowden, *Dictionary of American Religious Biography*, 2 d ed. (Westport, Conn.: Greenwood Publishing, 1993), 96–97; S. Morris Eames, *The Philosophy of Alexander Campbell* (Bethany, W.V.: Bethany College, 1966).

193. *Journal of the Virginia House of Delegates, 1841–42*, 36; quoted in Bell, *The Church, the State, and Education*, 347–348.

194. Bell, *The Church, the State, and Education*, 382.

195. Hawks, *Narrative of Events Connected with the Rise and Progress of the Protestant Episcopal Church in Virginia*, in Hawks, ed., *Contributions to the Ecclesiastical History*, 179.

196. Hawks, "The Character of Jefferson," *New York Review and Quarterly Church Journal* 1 (March 1837): 5, 7, 14–15.

197. Some students disagreed, arguing in the student newspaper that a statue should be built. *The Chameleon* 1 (May 9, 16, 1831), n.p.; Peterson, *The Jefferson Image in the American Mind* (New York: Oxford University Press, 1962), 127–128.

198. Septimus Tuston, "University of Virginia, *New York Observer*, 1837?, University of Virginia Chronological File, University Archives, Special Collections, Alderman Library, University of Virginia.

199. Tyng was influential in the Sunday school movement and St. Paul's Church in Philadelphia was known as "Tyng's Theater" from 1829–1834.

200. S.H. Tyng, "Correspondence from Charlottesville," *The Episcopal Recorder* (Philadelphia), May 27, 1840, 46, Archives of the Episcopal Church, Austin, Texas.

201. Tyng, "For the Episcopal Recorder," *The Episcopal Recorder* (Philadelphia), June 20, 1840, 50, ibid.

202. Martineau, *Retrospect of Western Travel*, 203–204.

203. Helderman, "A Social Scientist in the Old South," 153–154.

204. Bell, *The Church, the State, and Education*, 384.

205. Bruce, *Early History of the University of Virginia*, 3:135–137.

206. Ibid., 154; Hogan, *The Lawn*, 114–115. According to some estimates, the *Eclectic* (or McGuffey's) *Readers* sold over 120,000,000 copies.

207. Hogan, *The Lawn*, 115.

208. W.H. Ruffner, "Lectures on the Evidences of Christianity, delivered at the University of Virginia, during the session of 1850–51 (New York: Robert Carter & Brothers, 1852); quoted in William Maxwell, ed., *Virginia Historical Register & Literary Companion* (Richmond, Va.: MacFarlane & Ferguson, 1852), 5:231.

209. George Marsden, *The Soul of a University: From Protestant Establishment to Established Nonbelief* (Oxford, England: Oxford University Press, 1994), 76; Bell, *The Church, the State, and Education*, 386.

210. Bell, *The Church, the State, and Education*, 390.

211. University of Virginia *Alumni Bulletin* III 4 (February, 1897), 97; quoted in Bell, *The Church, the State and Education*, 385–386.

212. YMCAs were started in London in 1844 and transported to Boston and Montreal in 1851. The first chapters associated with colleges were at Michigan and UVA in 1858.

213. Bruce, *Early History of the University of Virginia*, 3:137–142.

214. Ibid., 3:147.

215. Edwin Anderson Alderman, *The University of Virginia in the Life of the Nation: Academic Address Delivered on the Occasion of the Installation of Edwin Anderson Alderman as President of the University of Virginia, April Thirteenth, Year of Our Lord, Nineteen-Hundred and Five* (Charlottesville: University Press of Virginia, 1905), 117.

216. Bell, *The Church, the State and Education*, 389.

217. Jefferson to Roger C. Weightman, June 24, 1826, Lipscomb and Bergh, eds., *Writings of Thomas Jefferson*, 16:181–182.

218. Under the presidency and teachings of the dogmatic Thomas Cooper, students at South Carolina were exposed to a virtual catechism of Southern political ideology. The school was intimately involved in the Nullification Crisis of the early 1830 s. One of Cooper's students, Nathaniel Gist, even named his son "States Rights." See Michael Sugrue, "'We Desired Our Future Rulers to Be Educated Men': South Carolina College, the Defense of Slavery, and the Development of Secessionist Politics" in Robert L. Geiger, ed., *The American College in the Nineteenth Century* (Nashville, Tenn.: Vanderbilt University Press, 2000), 105–112.

219. Dumas Malone, ed. *The Dictionary of American Biography*, Vol. 5 (New York: Charles Scribner's Sons, 1961), 164; Cooper and Terrill, eds., *The American South: A History*, Vol. 1, 234.

220. William P. Trent, "The Influence of the University of Virginia upon Southern Life and Thought," in Herbert Baxter Adams, ed., *Thomas Jefferson and the University of Virginia* (Washington, D.C.: United States Bureau of Education, 1888), 166, 169, 171.

221. John Hammond Moore, *Albermarle: Jefferson's County, 1727–1976* (Charlottesville: University of Virginia Press, 1976), 195, 202–208.

## Conclusion

1. For representative examples, see Jefferson's First Inaugural Speech and Jefferson to William Clairborne, July 23, 1801, in Paul Leicester Ford, ed., *The Writings of Thomas Jefferson*, 10 vols. (New York: G.P. Putnam's Sons, 1892), 8:72.

2. Patricia Cline Cohen, *A Calculating People: The Spread of Numeracy in America* (Chicago: University of Chicago Press, 1982); Linda Kerber, "The Revolutionary Generation: Ideology, Politics, and Culture in the Early Republic," in Eric Foner, ed., *The New American History* (Philadelphia: Temple University Press, 1997), 46; Charles Sellers, *The Market Revolution: Jacksonian America, 1815–1846* (New York: Oxford University Press, 1991), 366–369.

3. Gordon Wood, "The Significance of the Early Republic," in Ralph D. Gray and Michael Morrison, eds., *New Perspectives on the Early Republic: Essays from the Journal of the Early Republic* (Urbana: University of Illinois Press, 1994), 20.

4. Joseph Kett, "Education," in Peterson, ed., *Thomas Jefferson: A Reference Biography* (New York: Charles Scribner's Sons, 1986), 239.

5. Roy J. Honeywell, *The Educational Work of Thomas Jefferson* (Cambridge, Mass.: Harvard University Press, 1931), 149.

6. Lorraine Smith and Thomas Pangle, *The Learning of Liberty: The Educational Ideas of the American Founders* (Lawrence: University Press of Kansas, 1993), 98.

7. Ninety-nine out of one hundred would not have advanced beyond the primary level. Jefferson, *Notes on the State of Virginia*, William Peden, ed., 2 d. ed. (New York: W.W. Norton, 1982), 146; James B. Conant, *Thomas Jefferson and the Development of American Public Education* (Berkeley: University of California Press, 1962), 7.

8. Merrill D. Peterson, *Thomas Jefferson and the New Nation: A Biography* (New York: Oxford University Press, 1970), 963.

9. L.C. Helderman, "A Social Scientist of the Old South," *Journal of Southern History* 2 (1936): 152; *Journal and Documents of the Virginia House of Delegates, 1833–34* (Richmond, Va.: Thomas Ritchie, 1834), 167.

10. Jefferson to Thomas Ritchie, August 6, 1822, Jefferson Papers, Massachusetts Historical Society.

11. Conant, *Thomas Jefferson and the Development of American Public Education*, 29.

12. Pangles, *Learning of Liberty*, 180; Honeywell, *The Educational Work of Thomas Jefferson*, 153; Thomas Fitzugh, *The University of Virginia in Texas and the Southwest*.

13. D.C. Gilman to G.J. Brush, January 30, 1875; quoted in Lawrence R. Veysey, *The Emergence of the American University* (Chicago: University of Chicago Press, 1965), 160.

14. Lawrence A. Cremin, *American Education: The National Experience, 1783–1876* (New York: Harper & Row, 1980), 114.

15. Kett, "Education," 249–250.

16. Jefferson to David Williams, November 14, 1803, Andrew A. Lipscomb and Albert E. Bergh, eds., *The Writings of Thomas Jefferson*, 19 vols. (Washington, D.C.: Thomas Jefferson Memorial Foundation, 1903–1905), 10:429–430.

17. William H. Pierson, *American Buildings and their Architects: The Colonial and Neoclassical Styles*, 3 vols. (Garden City, N.Y.: Doubleday & Co., 1970), 1:334. Pierson wrote that UVA and Monticello are among the "most modern architectural conceptions of all time."

18. Pendleton Hogan, *The Lawn: A Guide to Jefferson's University* (Charlottesyille: University Press of Virginia, 1987), 12; American Institute of Architects, *Journal* 65 (1976): 91. The Rotunda was restored to its original design in 1973.

19. Thomas Edwin Buckley, "After Disestablishment: Thomas Jefferson's Wall of Separation in Antebellum Virginia," *Journal of Southern History* 61 (August 1995): 475–477.

20. Ibid., 477–479.

21. Ibid., 475–477. At the national level, Andrew Jackson eschewed religious oaths, Sabbath day observances, public prayer, and fast day proclamations such as Thanksgiving. Daniel Dreisbach points out that the development of a Christian "party" (led by Reverend Ezra Stiles Ely) in 1827 was an indicator of Christianity's declining influence. It was, by then, just one more partisan pressure group. Daniel L. Dreisbach, *Religion and Politics in the Early Republic: Jasper Adams and the Church-State Debate* (Lexington: University of Kentucky Press, 1996), 10–12.

22. James H. Hutson, *Religion and the Founding of the American Republic* (Washington, D.C.: Library of Congress, 1998), 114.

23. Peterson, *The Jefferson Image in the American Mind* (New York: Oxford University Press, 1962), 130.

24. Ibid., 93.

25. Conant, *Thomas Jefferson and the Development of American Public Education*, 37.

26. Charles B. Sanford, *The Religious Life of Thomas Jefferson* (Charlottesville: University Press of Virginia, 1984), 2.

27. Miller called Jefferson a "selfish, insidious, hollow hearted infidel." His "respect for him was exchanged for contempt and abhorrence. I now believe Mr. Jefferson to have been one of the meanest and basest of men." Samuel Miller, *The Life of Samuel Miller, D.D. I.* (Philadelphia: Claxton, Remsen, & Heffelfinger, 1869), 132.

28. Edwin S. Gaustad, *Sworn on the Altar of God: A Religious Biography of Thomas Jefferson* (Grand Rapids, Mich.: William B. Eerdmans, 1996), 216.

29. John Holt Rice, "Historical and philosophical considerations on religion: addressed to James Madison, late [former] President of the United States" (1832), 44–58, Rare Documents, Morton Library, Union Theological Seminary, Richmond, Virginia.

30. Cushing Strout, "Jeffersonian Liberty and American Pluralism," in Peterson and Robert C. Vaughan, eds., *The Virginia Statute for Religious Freedom: Its Evolution and Consequences in American History* (Cambridge, England: Cambridge University Press, 1988), 211.

31. In *Trustees of Dartmouth v. Woodward* (1819) the Supreme Court ruled that New Hampshire's attempt to take over the school's original charter was void because the college was a charitable institution, not a public corporation; hence the charter was a contract and could not be impaired under the Constitution. Eldon L. Johnson, "Public Versus Private: The Neglected Meaning of the Dartmouth College Case" (reprinted by permission of the *Journal of the Early Republic*), in Leonard Dinnerstein and Kenneth T. Jackson, eds., *American Vistas: 1607–1877*, 6 th ed. (Oxford, England: Oxford University Press, 1991), 195–215.

32. Earle D. Ross, "Religious Influences in the Development of State Colleges and Universities," *Indiana Magazine of History* 46 (December 1950): 343–362; Pangles, *Learning of Liberty*, 182.

33. Johnson, "Public Versus Private," 212.

34. Cremin, *American Education: The National Experience*, 67.

35. Ross, "Religious Influences in the Development of State Colleges and Universities," 350–354.

36. Pangles, *Learning of Liberty*, 181.

37. Robert Sullivan, "What Does Dartmouth Cry For?" *Dartmouth Alumni Magazine* 91 (March 1999): 34–42.

38. *Address of the Society of Alumni of the UVA, through Their Committee, to the People of Virginia* (Charlottesville, Va.: Noel & Saunders, 1845), Rare Virginia Pamphlets #319, Alderman Library, University of Virginia.

39. Jefferson to Samuel Kercheval, July 12, 1816, Ford, ed., *The Writings of Thomas Jefferson*, 10:35–37; Dumas Malone, *The Sage of Monticello* (Boston: Little, Brown & Co., 1981), 250.

40. William W. Freehling, "The Founding Fathers and Slavery," *American Historical Review* 77 (February 1972): 87–88; quoted in Charles B. Sanford, *The Religious Life of Thomas Jefferson* (Charlottesville: University Press of Virginia, 1984), 81.

## Bibliographic Essay

1. Frank M. Turner, ed., John Henry Newman, *The Idea of University* (New Haven, Conn.: Yale University Press, 1996).

2. Roy J. Honeywell, *The Educational Work of Thomas Jefferson* (Cambridge, Mass.: Harvard University Press, 1931), 12.

3. James B. Conant, *Thomas Jefferson and the Development of American Public Education* (Berkeley: University of California Press, 1962), 32.

4. Hix errantly argues that Presbyterians had no quarrel with Jefferson because of their alliance with him in the fight for religious liberty. Page 78.

5. Introduction to Roger L. Geiger, ed., *The American College in the Nineteenth Century* (Nashville, Tenn.: Vanderbilt University Press, 2000), 6.

6. Mark A. Noll, *Princeton and the Republic, 1768–1822: The Search for a Christian Enlightenment in the Era of Samuel Stanhope Smith* (Princeton, N.J.: Princeton University, 1989), 292–294.

7. M.L. Bradbury makes the same argument for Princeton in "Samuel Stanhope Smith: Princeton's Accommodation to Reason," *Journal of Presbyterian History* 48 (Fall 1970): 189–202.

8. Steven J. Novak, *The Rights of Youth: American Colleges and Student Revolt, 1798–1815* (Cambridge, Mass.: Harvard University Press, 1977), 166–168.

9. Edwin S. Gaustad, *Sworn on the Altar of God: A Religious Biography of Thomas Jefferson* (Grand Rapids, Mich.: William B. Eerdmans, 1996), xi.

10. Charles B. Sanford, *The Religious Life of Thomas Jefferson* (Charlottesville: University of Virginia Press, 1984), 79.

11. Thomas E. Buckley, "After Disestablishment: Thomas Jefferson's Wall of Separation in Antebellum Virginia," *Journal of Southern History* 61 (August 1995): 446–447.

12. Books focusing on church-state relations in the respective states include Jacob Meyer's *Church and State in Massachusetts from 1740 to 1833* (1930), Louise Greeen's *The Development of Religious Freedom in Connecticut* (1905), Richard Purcell's *Connecticut in Transition, 1775–1818* (1918), Reba Strickland's *Religion and the State of Georgia in the Eighteenth Century* (1939), and Albert Warrick Werline's *Problems of Church and State in Maryland during the Seventeenth and Eighteenth Centuries* (1948); Leonard Levy, *Jefferson and Civil Liberties: The Darker Side* (Chicago: Ivan R. Dee, 1989), 187–188.

13. Christine Leigh Hyreman, *Southern Cross: The Beginnings of the Bible Belt* (New York: Alfred A. Knopf, 1997), 269, 313.

14. Lorraine Smith and Thomas Pangle, *The Learning of Liberty: The Educational Ideas of the American Founders* (Lawrence: University Press of Kansas, 1993), 307.

15. For the Jefferson Papers at UVA, see C.E. Thurlow's *The Jefferson Papers of the University of Virginia* (Charlottesville: University Press of Virginia, 1973) and Douglas Tanner's *Guide to the Microfilm Edition of the Jefferson Papers of the University of Virginia, 1732–1828* (Charlottesville: University of Virginia Library, 1977).

# Bibliography

✳

## *Archival Sources*

Albert and Shirley Small Special Collections Library, Alderman Library, University of Virginia (Charlottesville, Virginia)

Cabell Family Papers (#38–111)
Chronological File (University Archives)
Cocke Family Papers (#640)
Dabney Family Papers (#38–219)
General Faculty Minutes (University Archives RG-19/1/1)
Thomas Jefferson Papers
James Madison Papers
Proctor's Records (University Archives)
Rare Pamphlets of Virginia
Rector and Visitors Minutes (University Archives RG-1/1/1)
Tucker-Harrison-Smith Family Papers (#3825)

Archives of the Episcopal Church-Episcopal Seminary of the Southwest (Austin, Texas)

John Henry Hobart Papers

## J. Douglas Gray Jr./Francis Carrick Thomas Library Transylvania University (Lexington, Kentucky)

Thomas Cooper Papers
Horace Holley Papers

## Leyburn Library, Washington and Lee University (Lexington, Virginia)

Board of Trustees Minutes (Washington College)
Scrapbook of the Society of Cincinnati
Special Collections

## Library of Congress, Manuscripts and Rare Books (Washington, D.C.)

Thomas Jefferson Papers (Presidential Series)
Moses Hoge Papers
Garret Minor and David Watson Papers
William C. Rives Papers
Joseph M. Toner Collection

## Library of Virginia (Richmond, Virginia)

Mercer-Hunter Family Letters, 1767–1842

## Massachusetts Historical Society (Boston, Massachusetts)

George Bancroft Papers
Coolidge Collection (Jefferson Papers)
Edward Everett Papers
Hale Family Papers
Horace Mann Papers
Timothy Pickering Papers
Washburn Autograph Collection

## Morton Library, Union Theological Seminary (Richmond, Virginia)

Jesse Scott Armistead Papers
William Henry Foote Papers
Hampden-Sydney Board of Trustees Minutes
Hanover Presbytery Minutes
John Holt Rice Papers
Henry Ruffner Papers
Synod of Virginia Minutes

New York Historical Society (New York, New York)

Charles Fenton Mercer Papers

Presbyterian Historical Society (Philadelphia, Pennsylvania)

Shane Collection

Presbyterian Church, U.S.A., History Department (Montreat, North Carolina)

Abner Johnson Leavenworth Notebook, 1825
Morton Family Correspondence
Judith Smith Letters
Samuel Wilson Papers

Sterling Library, Yale University (New Haven, Connecticut)

Beecher Family Papers
Dwight Family Papers

Early Gregg Swem Library, College of William and Mary

(Williamsburg, Virginia)
Barraud Family Papers
Tucker-Coleman Papers
Thomas Jefferson Papers
William and Mary College Papers, University Archives

Virginia Historical Society (Richmond, Virginia)

Nathaniel Francis Cabell Papers
Gooch Family Papers
Hugh Blair Grigsby Diary
Mercer Family Papers
Protestant Episcopal Church Papers
Martha Frances Blow (Hines) Rochelle Scrapbook, 1825
Robert Barraud Taylor Papers, 1822–1831

Wilson Library, University of North Carolina (Chapel Hill, North Carolina)

Southern Historical Collection
University of North Carolina Papers

## Newspapers

*Alexandria Gazette*
*Lexington Intelligencer*
*Norfolk and Portsmouth Herald*
*Norfolk Gazette & Public Ledger*
*Richmond Enquirer*
*The* (Lynchburg) *Virginian*

## Published Primary Sources

Adams, Dickinson W., ed. *Jefferson's Extracts from the Gospels: "The Philosophy of Jesus" and "The Life and Morals of Jesus."* Princeton, N.J.: Princeton University Press, 1983.

Alderman, Edwin Anderson. *The University of Virginia in the Life of the Nation: Academic Address Delivered on the Occasion of the Installation of Edwin Anderson Alderman as President of the University of Virginia, April thirteenth, Year of Our Lord, Nineteen-Hundred and Five.* Charlottesville: University Press of Virginia, 1905.

Armentrout, Mary T., and Glenn C. Smith, eds. "Madison-to-Cabell Letters, 1823–33." *Madison Quarterly* 1 (November 1943): 147–163.

Boyd, Julian T. et al., eds. *The Papers of Thomas Jefferson.* Princeton, N.J.: Princeton University Press, 1950-. 27 vols.

Cabell, Nathaniel Francis. *Early History of the University of Virginia, as Contained in the Letters of Thomas Jefferson and Joseph C. Cabell.* Richmond, Va.: J.W. Randolph, 1856.

Cappon, Lester J. *The Adams-Jefferson Letters: The Complete Correspondence Between Thomas Jefferson and Abigail and John Adams* (1959), 2d ed. Chapel Hill: University of North Carolina Press, 1987.

Congressional Objections to the Proposal to Grant Public Lands for the Endowment of State Universities, 1819. Edgar K. Knight, ed. *A Documentary History of Education in the South Before 1860.* vol. 3: The Rise of the State University. Chapel Hill: University of North Carolina Press, 1950. 136–162.

Culbreth, David M.R., M.D. *The University of Virginia: Memories of Her Student Life and Professors.* New York: Neale Publishing Co., 1908.

Dwight, Timothy. "The Duty of Americans, Illustrated in a Discourse, Preached on the 4th of July." New Haven, Conn.: Thomas & Samuel Green, 1798.

Everett, Edward. "University of Virginia." *North American Review* 36 (January 1820): 115–137.

*Extracts from the Minutes of the General Assembly, of the Presbyterian Church, in the United States of America.* Philadelphia: Thomas & William Bradford, 1817–1822.

Flourney H.W., ed. *Calendar of Virginia State Papers and Other Manuscripts from January 1, 1808 to December 31, 1835.* Richmond, Va.: H.W. Flourney, 1892.

Ford, Paul Leicester. *The Writings of Thomas Jefferson.* 12 vols. New York: G.P Putnam's Sons, 1892.

Gooch, Richard Barnes. *The Anniversary Address of the Jefferson Society, of the University of Virginia, Delivered on the 13th, April 1840.* Charlottesville: James Alexander, 1840.

Hawks, Francis Lister. "The Character of Jefferson." *New York Review and Quarterly Church Journal* 1 (March 1837): 5–58.

———. *A Narrative of Events Connected with the Rise and Progress of the Protestant Episcopal Church in Virginia.* New York: Harper & Bros., 1836.

Hume, Edgar Erskine, ed. *Papers of the Society of the Cincinnati in the State of Virginia, 1783–1824.* Richmond, Va.: Society of Cincinnati, 1938.

Hunt, Gaillard, ed. *The Writings of James Madison.* 9 vols. New York: G.P. Putnam's Sons, 1900–1910.

Hutchinson, William T., William R.E. Rachel, and Robert Rutland, eds. 17 vols. *Papers of James Madison.* Chicago: University of Chicago Press, 1962.

J.T.C. "Mr. Rives Address." *Southern Literary Messenger* 9 (September 1847): 575.

Jefferson, Thomas. "An Essay on the Anglo-Saxon Language" (1851) Adrienne Koch and William Peden, eds. *The Life and Selected Writings of Thomas Jefferson.* New York: Modern Library, 1944. 157–170.

———. *Autobiography.* Adrienne Koch and William Peden, eds. *The Life and Selected Writings of Thomas Jefferson.* New York: Modern Library, 1944. 3–114.

———. *Jefferson's Extracts from the Gospels: "The Philosophy of Jesus" and "The Life and Morals of Jesus."* (1820?) Dickinson W. Adams, ed. Introduction by Eugene R. Sheridan. Princeton N.J.: Princeton University Press, 1983.

———. *Notes on the State of Virginia.* (1794) William Peden, ed. 2d. ed. New York: W.W. Norton, 1982 (1954).

*Journal of the House of Delegates of the Commonwealth of Virginia.* Richmond, Va.: Thomas Ritchie (Printer for the Commonwealth) 1816–1825.

Knight, Edgar K. ed. *A Documentary History of Education in the South Before 1860.* 3 vols. Chapel Hill: University of North Carolina Press, 1950.

Lindsley, Philip. President Philip Lindsley of Cumberland College, Tennessee, on the Importance of Schools, 1825. Edgar K. Knight, ed. *A Documentary History of Education in the South Before 1860.* vol. 2: Toward Educational Independence. Chapel Hill: University of North Carolina Press, 1950. 585–591.

Lipscomb, Andrew A. and Albert E. Bergh. eds. 19 vols. *The Writings of Thomas Jefferson.* Washington, D.C.: Thomas Jefferson Memorial Foundation, 1903–1905.

Long, George, George R. Porter, and George Tucker. *America and the West Indies Geographically Described.* London: C. Knight, 1845.

Madison, James. "Detached Memoranda." *William & Mary Quarterly* 3 (October 1946): 535–568.

———. "Memorial and Remonstrance against Religious Assessments." William T. Hutchinson and William R.E. Rachel, eds. *Papers of James Madison.* Chicago: University of Chicago Press, 1962.

Martineau, Harriet. *Retrospect of Western Travel.* 2 vols. London: Saunders & Otley, 1835; New York: Harper & Bros., 1838.

Mattern, David B., ed. *James Madison's 'Advice to My Country.'* Charlottesville: University Press of Virginia, 1997.

Maxwell, William. *An Address Delivered before the Bible Society of the University of Virginia, May 13th, 1836.* Charlottesville: Moseley & Tompkins, 1836.

———. *Memoir of the Life of John Holt Rice, D.D.* Philadelphia: J. Wetham, 1835.

Meade, William. "The Autobiography of William Meade." *The Seminary Journal* 14 (December 1962): 30–43.

———. *Old Churches, Ministers and Families of Virginia.* 2 vols. 2d ed. Philadelphia: J.B. Lippincott, 1910 (1857).

———. *Sermon, Delivered in the Rotunda of the University of Virginia on Sunday May 24, 1829 On the Occasion of the Deaths of Nine Young Men, Who Fell Victims to the Diseases Which Visited That Place During the Summer of 1828, and the Following Winter.* Charlottesville, Va.: F. Carr, 1829.

Mercer, Charles Fenton. Bill for a System of Primary Schools, Academies, Colleges and a University for Virginia, 1817. Edgar K. Knight, ed. *A Documentary History of Education in the South Before 1860.* vol. 2: Toward Educational Independence. Chapel Hill: University of North Carolina Press, 1950. 550–563.

———. "Discourse on Popular Education, 1826." Edgar K. Knight, ed. *A Documentary History of Education in the South Before 1860*. vol. 2: Toward Educational Independence. Chapel Hill: University of North Carolina, 1950. 297–356.

Moore, Margaret, ed. "Letters of John Holt Rice to Thomas Chalmers, 1817–1819." *The Virginia Magazine of History and Biography* 77 (July 1959): 307–317.

Moore, Walter, William R. Miller, and John A. Lacey, eds. *General Catalogue of the Trustees, Officers, Professors and Alumni of Union Theological Seminary in Virginia, 1807–1924*. Richmond, Va.: Whitten & Shepperson, 1924.

Morse, Jedidiah. *Review of the Unitarian Controversy*. Boston: Armstrong, 1815.

Murphy, Archibald D. Report of Archibald D. Murphey to the Legislature of North Carolina, 1817. Edgar K. Knight, ed. *A Documentary History of Education in the South Before 1860*. vol. 2: Toward Educational Independence. Chapel Hill: University of North Carolina Press, 1950. 563–581.

Newman, John Henry. *The Idea of a University*. Frank M. Turner, ed. New Haven, Conn.: Yale University Press, 1996.

Peden, William H., ed. *1828 Catalogue of the Library of the University of Virginia*. Charlottesville: University Press of Virginia, 1945.

Perry, William Steven, D.D., ed. *Journals of General Conventions of the Protestant Episcopal Church, in the United States, 1785–1835*. 2 vols. Claremont: Claremont Manufacturing, 1874.

Peterson, Merrill D., ed. *The Portable Thomas Jefferson*. New York: Penguin Books, 1975.

———, ed. *Thomas Jefferson: Writings*. New York: Library of America, 1984.

Ravenscroft, John Stark. D.D. *The Doctrines of the Church Vindicated from the Misrepresentations of Dr. John Rice; and the Integrity of Revealed Religion Defended against the "No Comment Principle" of Promiscuous Bible Societies*. Raleigh, N.C.: J. Gales & Son, 1826.

Reports of the Rector and Visitors of the University of Virginia to the President and Directors of the Literary Fund. Richmond, Va.: Thomas Ritchie, 1819–1825.

Rice, John Holt. *Discourse Delivered Before the General Assembly of the Presbyterian Church in the United States of America, on the Opening of Their Session, in 1820*. Philadelphia: Thomas & William Bradford, 1820.

———. *A Discourse: Delivered Before the Literary and Philosophical Society of Hampden-Sydney College*. A.J. Morrison, ed. Roanoke, Va.: Stone Printing & Manufacturing, 1917.

———. *An Illustration of the Character and Conduct of the Presbyterian Church in Virginia*. Richmond, Va.: Du-val and Burke, 1816.

———. *The Importance of the Gospel Ministry, a Sermon Preached at the Opening of the Synod of Virginia on the 16th of October, 1816*. Richmond, Va.: Shepard & Pollard, 1817.

———. *Six Addresses on the State of Letters and Science in Virginia Delivered chiefly Before the Literary and Philosophical Society at Hampden-Sidney College and the Institute of Education of Hampden-Sidney College, 1824–1835*. A.J. Morrison, ed. Roanoke, Va.: Stone Printing & Manufacturing Co., 1917.

———, ed. *The Virginia Evangelical and Literary Magazine*. 11 vols. Richmond, Va.: William Gray, 1818–1828 (*Christian Monitor* 1816–1818).

Richardson, James D. *A Compilation of the Messages and Papers of the President, 1789–1897*. Washington, D.C.: Bureau of National Literature and Art, 1904.

Smith, James Morton, ed. *The Republic of Letters: The Correspondence between Jefferson and Madison, 1776–1826*. 3 vols. New York: W.W. Norton & Co., 1995.

Spence, Irving. *Letters on the Early History of the Presbyterian Church in America, Addressed to the Late Rev. Robert M. Laird with a Sketch of the Life of the Author, and a Selection from His Religious Writings*. Philadelphia: Henry Perkins, 1838.

Stannard, Mary Newton, ed. *Edgar Allen Poe Letters 'Till Now Unpublished': In the Valentine Museum, Richmond, Virginia*. Philadelphia: J.B. Lippincott, 1925.

*Sundry Documents on the Subject of a System of Public Education for the State of Virginia*. Richmond, Va.: Ritchie, Trueheart, and Du-val, 1817.

Thornwell, J. H., DD., "A Sermon Preached at the Dedication of a Church, Erected in Charleston, S.C., for the Benefit and Instruction of the Coloured Population." Charleston, S.C.: Walker & James, 1850.

Tucker, George. "The Character of Jefferson." *New York Review and Quarterly Church Journal* 1 (March 1837): 5–58.

———. "A Discourse on the Progress of Philosophy and Its Influence on the Intellectual and Moral Character of Man." *Southern Literary Messenger* 1 (April 1835): 405–421.

———. *Memoir of the Life and Character of John P. Emmet, M.D., Professor of Chemistry and Materia Medica in the University of Virginia*. Philadelphia: C. Sherman Printer, 1845.

"University of Virginia." *Southern Literary Messenger* 8 (January 1842): 50–54.

"University of Virginia." *Southern Literary Messenger* 13 (July 1847): 448.

Washington, H.A., ed. *The Writings of Thomas Jefferson*. 8 vols. Washington, D.C.: Taylor & Maury, 1854.

Wilson, Douglas L, ed. *Jefferson's Literary Commonplace Book*. Princeton, N.J.: Princeton University Press, 1989.

## Secondary Sources

Abernathy, Thomas Perkins. *Historical Sketch of the University of Virginia*. Richmond, Va.: Dietz, 1948.

Adams, Herbert Baxter. *Thomas Jefferson and the University of Virginia*. Washington, D.C.: United States Bureau of Education, 1888.

Allmendinger, David F. Jr. "The Dangers of Ante-Bellum Student Life." *Journal of Social History* 7 (Fall 1973): 75–85.

Ambler, Charles Henry. *Sectionalism in Virginia from 1776 to 1861*. Chicago: University of Chicago Press, 1910.

Ammon, Harry. "The Republican Party in Virginia, 1789–1824." Ph.D. diss., University of Virginia, 1948.

———. "The Richmond Junto, 1800–1824." *Virginia Magazine of History and Biography* 61 (October 1953): 395–418.

Appleby, Joyce. *Capitalism and a New Social Order: The Republican Vision of the 1790s*. New York: New York University Press, 1984.

Arrowood, Charles Minn, ed. *Thomas Jefferson and Education in a Republic*. New York: McGraw-Hill, 1931.

Axtell, James. *The School Upon a Hill: Education and Society in Colonial New England*. New Haven, Conn.: Yale University Press, 1974.

Bailyn, Bernard. *Education in the Forming of American Society: Needs and Opportunities for Study*. Chapel Hill: University of North Carolina Press, 1960.

Banning, Lance. "James Madison, the Statute for Religious Freedom, and the Crisis of Republican Convictions." Merrill D. Peterson and Robert C. Vaughan, eds. *The Virginia Statute for Religious Freedom: Its Evolution and Consequences in American History*. Cambridge, England: Cambridge University Press, 1988. 109–138.

———. *The Jeffersonian Persuasion: Evolution of a Party Ideology*. Ithaca, N.Y.: Cornell University Press, 1978.

Barber, Benjamin. "Education and Democracy: Summary and Comment." James Gilreath, ed.

*Thomas Jefferson and the Education of a Citizen.* Washington, D.C.: Library of Congress, 1999. 134–152.

Barret, Clifton Waller. "The Struggle to Create a University." *Virginia Quarterly Review* 49 (Autumn 1973): 494–506.

Barringer, Paul B., James Mercer Garnett, and Rosewell Page. *The University of Virginia: Its History, Influence, Equipment, and Characteristics.* New York: Lewis, 1904.

Bean, William B. "Mr. Jefferson's Influence on American Medical Education." *Virginia Medical Monthly* 87 (December 1960): 669–680.

Becker, Carl. *The Heavenly City of the Eighteenth-Century Philosophers.* New Haven, Conn.: Yale University Press, 1932.

Bedini, Silvio. *Thomas Jefferson: Statesmen of Science.* New York: Macmillan, 1990.

Bell, David. "Knowledge and the Middle Landscape: Thomas Jefferson's University of Virginia." *Journal of Architectural Education* 37 (Winter 1983): 18–26.

Bell, Sadie. *The Church, the State, and Education in Virginia.* New York: Arno Press & The New York Times, 1969.

Ben-Atar, Doron and Barbara B. Oberg, eds. *Federalists Reconsidered.* Charlottesville: University Press of Virginia, 1998.

Berns, Walter. *Making Patriots.* Chicago: University of Chicago Press, 2001.

Blanks, William Davidson. "Ideals and Practice: A Study of the Conception of the Christian Life Prevailing in the Presbyterian Churches of the South during the Nineteenth Century." Th.D. diss. Richmond, Va.: Union Theological Seminary, 1960.

Bloch, Ruth H. *Visionary Republic: Millennial Themes in American Thought, 1756–1800.* Cambridge, England: Cambridge University Press, 1985.

Boles, John B. *The Great Revival: Beginnings of the Bible Belt.* 2d ed. Lexington: University of Kentucky Press, 1996 (1972).

———. *The South through Time: A History of an American Region.* vol. 1. Englewood Cliffs, N.J.: Prentice Hall, 1995.

Boorstin, Daniel. *The Lost World of Thomas Jefferson.* 3d ed. Chicago: University of Chicago Press, 1993 (1948).

Botein, Stephen. "Religious Dimensions of the Early American State." Richard Beeman, Stephen Botein, and Edward C. Carter II, eds. *Beyond Confederation: Origins of the Constitution and American National Identity.* Chapel Hill: University of North Carolina Press, 1987. 315–330.

Botstein, Leon. *Jefferson's Children: Education and the Creation of a Hopeful Culture.* New York: Bantam Doubleday Dell, 1997.

Bradbury, M.L. "Samuel Stanhope Smith: Princeton's Accommodation to Reason." *Journal of Presbyterian History* 48 (Fall 1970): 189–202.

Broussard, James H. *The Southern Federalists, 1800–1816.* Baton Rouge: Louisiana State University Press, 1978.

Brown, Richard D. "Bulwark of Revolutionary Liberty: Thomas Jefferson's and John Adams's Programs for an Informed Citizenry." James Gilreath, ed. *Thomas Jefferson and the Education of a Citizen.* Washington, D.C.: Library of Congress, 1999. 91–102.

———. *Strength of a People: The Idea of an Informed Citizenry in America, 1650–1870.* Chapel Hill: University of North Carolina Press, 1996.

Bruce, Dickson D. *The Rhetoric of Conservatism: The Virginia Convention of 1829–1830 and the Conservative Tradition in the South.* San Marino, Calif.: Huntington Library, 1982.

Bruce, Philip Alexander. *History of the University of Virginia, 1819–1919: The Lengthened Shadow of One Man.* 5 vols. New York: Macmillan, 1920.

Buckley, Thomas E., S.J. "After Disestablishment: Thomas Jefferson's Wall of Separation in Antebellum Virginia." *Journal of Southern History* 61 (August 1995): 445–480.

———. *Church and State in Revolutionary Virginia, 1776–1787*. Charlottesville: University Press of Virginia, 1977.

———. "The Political Theology of Thomas Jefferson." Merrill D. Peterson and Robert C. Vaughan, eds. *The Virginia Statute for Religious Freedom: Its Evolution and Consequences in American History*. Cambridge, England: Cambridge University Press, 1988. 75–107.

Burns, Edward M. "The Philosophy of History of the Founding Fathers." *The Historian* 16 Spring (1954).

Butler, Jon. *Awash in a Sea of Faith: Christianizing the American People*. Cambridge, Mass.: Harvard University Press, 1990.

Calhoon, Robert M. *Evangelicals and Conservatives in the Early South, 1740–1861*. Columbia: University of South Carolina Press, 1988.

Carey, Alma Pond. "Thomas Jefferson's Ideal University: Dream and Actuality." M.A. thesis. University of Texas, 1937.

Clemens, Harry. *The University of Virginia Library, 1825–1950: A Story of a Jeffersonian Foundation*. Charlottesville: University Press of Virginia, 1954.

Cohen, I. Bernard. *Science and the Founding Fathers: Science in the Political Thought of Jefferson, Franklin, Adams, and Madison*. New York: W.W. Norton, 1995.

Colbourn, Trevor H. *The Lamp of Experience: Whig History and Intellectual Origins of the American Revolution*. Chapel Hill: University of North Carolina Press, 1965.

Come, Donald Robert. "The Influence of Princeton on Higher Education in the South Before 1825." *William and Mary Quarterly* 2 (October 1945): 359–396.

Conant, James B. *Thomas Jefferson and the Development of American Public Education*. Berkeley: University of California Press, 1962.

Conkin, Paul K. "The Religious Pilgrimage of Thomas Jefferson." Peter Onuf. ed. *Jeffersonian Legacies*. Charlottesville: University Press of Virginia, 1993. 19–49.

Cremin, Lawrence A. *American Education: The Colonial Experience, 1607–1783*. New York: Harper & Row, 1970.

———. *American Education: The National Experience, 1783–1876*. New York: Harper & Row, 1980.

Crotty, Gene. *Jefferson's Legacy: His Own University*. 2d ed. Virginia: Crotty, 1998 (1996).

Culbreth, David M.R. *The University of Virginia*. New York: Neale, 1908.

Curry, Thomas J. *The First Freedoms: Church and State and America to the Passage of the First Amendment*. Oxford, England: Oxford University Press, 1986.

Dabney, Charles W. "Jefferson the Seer: His Vision of a System of Public Education." *Virginia Pamphlets* 10 (1903): 1–16.

Daniels, George H. *American Science in the Age of Jackson*. New York: Columbia University Press, 1968.

Dashiell, David A. III. "Between Earthly Wisdom and Heavenly Truth: The Effort to Build a Chapel at the University of Virginia, 1835–1890." M.A. thesis. University of Virginia, 1992.

Davis, Richard Beale. *Francis Walker Gilmer: Life and Learning in Jefferson's Virginia*. Richmond, Va.: Dietz, 1939.

———. *Intellectual Life in Jefferson's Virginia, 1790–1830*. Chapel Hill: University of North Carolina Press, 1964.

Dewey, John. *The Living Thoughts of Thomas Jefferson*. Toronto: Cassel, 1946.

Dickinson, Elmer G. "The Influence of Sectionalism upon the History of the James River and Kanawha Company in Western Virginia." M.A. thesis. Duke University, 1941.

Dreisbach, Daniel L. "A New Perspective on Jefferson's Views on Church-State Relations: The

Virginia Statute for Establishing Religious Freedom in its Legislative Context." *American Journal of Legal History* 35 (April 1991): 172–204.

———. *Religion and Politics in the Early Republic: Jasper Adams and the Church-State Debate.* Lexington: University of Kentucky Press, 1996.

———. "Thomas Jefferson and Bills Number 82–86 of the Revision of the Laws of Virginia, 1776–1786: New Light on the Jeffersonian Model of Church-State Relations." *North Carolina Law Review* 69 (November 1990): 159–211.

Durey, Michael. *Transatlantic Radicals and the Early American Republic.* Lawrence: University Press of Kansas, 1997.

Eaton, Clement. *The Freedom of Thought Struggle in the Old South.* 2d ed. New York: Harper & Row, 1964 (1940).

Egerton, Douglas R. "To the Tombs of the Capulets: Charles Fenton Mercer and Public Education in Virginia, 1816–1817." *The Virginia Magazine of History and Biography* 93 (April 1985): 155–174.

Ellis, Joseph J. *American Sphinx: The Character of Thomas Jefferson.* New York: Alfred A. Knopf, 1997.

Emery, Robert Alan. "Hanover Presbytery, 1786–1824." M.A. thesis. University of Virginia, 1973.

Engeman, Thomas S., ed. *Thomas Jefferson and the Politics of Nature.* Notre Dame, Ind.: University of Notre Dame Press, 2000.

Ferguson, Robert A. *The American Enlightenment, 1750–1820.* Cambridge, Mass.: Harvard University Press, 1997.

Forbes, Robert P. "Slavery and the Evangelical Enlightenment." John R. McKivigan and Mitchell Snay, eds. *Religion and the Antebellum Debate Over Slavery.* Athens: University of Georgia Press, 1998. 68–106.

Freehling, William W. *Prelude to the Civil War: The Nullification Controversy in South Carolina, 1816–1836.* New York: Harper & Row, 1965; New York: Oxford University Press, 1992.

Gaines, William H. Jr. *Thomas Mann Randolph, Jefferson's Son-in-Law.* Baton Rouge: Louisiana State University Press, 1966.

Garrison, Albert L. "Legislative Basis for State Support of Public Elementary and Secondary Education in Virginia since 1810." Ed.M. thesis. Duke University, 1933.

Gaustad, Edwin S. *Sworn on the Altar of God: A Religious Biography of Thomas Jefferson.* Grand Rapids, Mich.: William B. Eerdmans, 1996.

Geiger, Roger, ed. *The American College in the Nineteenth Century.* Nashville, Tenn.: Vanderbilt University Press, 2000.

Gillespie, Neal. *The Collapse of Orthodoxy: The Intellectual Ordeal of George Frederick Holmes.* Charlottesville: University Press of Virginia, 1972.

Goode, James M. "A Rowdy Beginning, an Unusual History: The Jefferson Society from 1825 to 1865." *University of Virginia Magazine* (December 1965).

Greenbaum, Louis S. "Thomas Jefferson, the Paris Hospitals, and the University of Virginia." *Eighteenth Century Studies* 26 (Summer 1993): 607–620.

Greene, Jack P. "The Intellectual Reconstruction of Virginia in the Age of Jefferson." Peter Onuf, ed. *Jeffersonian Legacies.* Charlottesville: University Press of Virginia, 1993.

Greene, John C. *American Science in the Age of Jefferson.* Ames: Iowa State University Press, 1984.

Grizzard, Frank L. "Documentary History of the Construction of the Buildings at the University of Virginia, 1817–1828." Ph.D. thesis, University of Virginia, 1997. @ http://etext.virginia.edu/jefferson/grizzard.

———. "Slave's involvement at the Central College & Early History of UVA." @ http://www.people.virginia.edu/~feg3e/slave.html.

Haakonssen, Knud. "From Natural Law to the Rights of Man: A European Perspective on American Debates." Michael J. Lacey and Knud Haakonssen, eds. *A Culture of Rights: The Bill of*

*Rights in Philosophy, Politics, and Law—1791 and 1991*. New York: Cambridge University Press & Washington, D.C.: Woodrow Wilson International Center for Scholars, 1991. 19–61.

Harrison, James Albert. "Jefferson's University." *Dixieland* I (July 1904): 12–34.

Harrison, Joseph H. Jr. "Oligarchs and Democrats: The Richmond Junto." *The Virginia Magazine of History and Biography* 78 (1970): 194–95.

Harrison, Lowell H. "A Young Kentuckian at Princeton, 1806–1810: Joseph Cabell Breckinridge." *Filson Club History Quarterly* 38 (1964): 285–315.

Hatch, Nathan O. *The Democratization of American Christianity*. New Haven, Conn.: Yale University Press, 1989.

Hatzenbuehler, Ronald L. "Growing Weary in Well-Doing: Thomas Jefferson's Life Among the Virginia Gentry." *Virginia Magazine of History and Biography* 101 (January 1993): 5–36.

Healey, Robert M. *Jefferson on Religion in Public Education*. New Haven, Conn.: Yale University Press, 1962.

Heatwole, Cornelius J. *A History of Education in Virginia*. New York: Macmillan, 1916.

Helderman, L.C. "A Social Scientist of the Old South." *Journal of Southern History* 2 (1936): 148–174.

Hellenbrand, Harold. *The Unfinished Revolution: Education and Politics in the Thought of Thomas Jefferson*. London: Associated University, 1990.

Heller, Francis H. "Monticello and the University of Virginia, 1825: A German Prince's Travel Notes." *Papers of the Albermarle Historical Society* 7 (1946–48): 34–35.

Henderson, John Cleaves. *Thomas Jefferson's Views on Public Education*. New York: G.P. Putnam's Sons, 1890.

Herron, Dorothy Ann. "Educational Interests as Revealed in the Newspaper Advertisements of Virginia and North Carolina between 1800 and 1840." M.A. thesis. University of North Carolina at Chapel Hill, 1948.

Heslep, Robert D. *Thomas Jefferson and Education*. New York: Random House, 1969.

Heyrman, Christine Leigh. *Southern Cross: The Beginnings of the Bible Belt*. New York: Alfred A. Knopf, 1997.

Hix, Clarence E. Jr. "The Conflict between Presbyterianism and Free Thought in the South, 1776–1838." Ph.D. diss. University of Chicago, 1937.

Hizer, Trenton Eynon. "'Virginia is Now Divided': Politics in the Old Dominion, 1820–1833." Ph.D. diss. University of South Carolina, 1997.

Hofstadter, Richard and Richard and Wilson Smith. *American Higher Education: A Documentary History*. vol. 1. Chicago: University of Chicago Press, 1961.

——. *The Idea of a Party System: The Rise of Legitimate Opposition in the United States, 1780–1840*. 3d ed. Berkeley: University of California Press, 1972 (1969).

——. *The American Political Tradition and the Men Who Made It*. 2d ed. New York: Alfred A. Knopf, 1973 (1948).

Hogan, Pendleton. *The Lawn: A Guide to Jefferson's University*. Charlottesville: University Press of Virginia, 1987.

Hoge, John Blair. *Life of Moses Hoge*. Henry M. Brimm, ed. Richmond, Va.: Union Theological Seminary Library, 1964.

Holifield, E. Brooks. *The Gentleman Theologians: American Theology in Southern Culture, 1795–1860*. Durham, N.C.: Duke University Press, 1978.

Holmes, David Lynn, Jr. "William Meade and the Church of Virginia, 1789–1829." Ph.D. diss. Princeton University, 1971.

Honeywell, Roy. *The Educational Work of Thomas Jefferson*. Cambridge, Mass.: Harvard University Press, 1931.

Howard, A.E. Dick. "The Supreme Court and the Serpentine Wall." Merrill D. Peterson and

Robert C. Vaughan, eds. *The Virginia Statute for Religious Freedom: Its Evolution and Conse-quences in American History*. Cambridge, England: Cambridge University Press, 1988. 313–349.

Howe, Daniel Walker. *The Unitarian Conscience: Harvard Moral Philosophy, 1805–1861*. Cambridge, Mass.: Harvard University Press, 1970.

Hudnut, William H. III. "Samuel Stanhope Smith: Enlightened Conservative." *Journal of the History of Ideas* 17 (Autumn 1974): 540–552.

Humphrey, David C. *From King's College to Columbia, 1746–1800*. New York: Columbia University Press, 1976.

Hutson, James H. *Religion and the Founding of the American Republic*. Washington, D.C.: Library of Congress, 1998.

Isaac, Rhys. "Evangelical Revolt: The Nature of the Baptists' Challenge to the Traditional Order of Virginia, 1765 to 1775." Stanley N. Katz and John M. Murrin, eds. *Colonial America: Essays in Politics and Social Development*. New York: Alfred A. Knopf, 1983.

———. "'The Rage of Malice of the Old Serpent Devil': The Dissenters and the Making and Re-making of the Virginia Statute for Religious Freedom." Merrill D. Peterson and Robert C. Vaughan, eds. *The Virginia Statute for Religious Freedom: Its Evolution and Consequences in American History*. Cambridge, England: Cambridge University Press, 1988. 139–163.

———. *The Transformation of Virginia, 1740–1790*. Chapel Hill: University of North Carolina Press, 1982.

Jacob, Margaret C. *The Enlightenment: A Brief History with Documents*. Boston: Bedford/St. Martin's, 2001.

James, Thomas. "Rights of Conscience and State School Systems in Nineteenth-Century America." Paul Finkelman and Stephen E. Gottlieb, eds. *Toward a Usable Past: An Examination of the Origins and Duplications of State Protections of Liberty*. Athens: University of Georgia Press, 1991. 117–147.

Jarvis, Hilde Price. "A Sociological Study of the Privileged Groups of Albermarle County, the City of Charlottesville, and the University of Virginia, 1727–1935." M.S. thesis. University of Virginia, 1935.

Jayne, Allen. *Jefferson's Declaration of Independence: Origins, Philosophy and Theology*. Lexington: University of Kentucky Press, 1998.

Johnson, Eldon L. "Public Versus Private Education: The Neglected Meaning of the Dartmouth College Case." Leonard Dinnerstein and Kenneth T. Jackson, eds. *American Vistas, 1607–1877*. New York: Oxford University Press, 1991. 195–215.

Johnson, Herbert A. "Thomas Jefferson and Legal Education in Revolutionary America." James Gilreath, ed. *Thomas Jefferson and the Education of a Citizen*. Washington D.C.: Library of Congress, 1999. 103–114.

Jordan, Daniel P. *Political Leadership in Jefferson's Virginia*. Charlottesville: University Press of Virginia, 1983.

Jordan, Ervin. L. *Charlottesville and the University of Virginia in the Civil War*. Lynchburg, Va.: H.E. Howard, 1988.

Kaestle, Carl F. *Pillars of the Republic: Common Schools and American Society, 1780–1860*. New York: Hill & Wang, 1983.

Kay, Miryam Neulander. "Separation of Church and State in Jeffersonian Virginia." Ph.D. diss. University of Kentucky, 1967.

Kennedy, Billy. *The Scots-Irish in the Shenandoah Valley*. Belfast, U.K.: Ambassador Productions, 1996.

Kerber, Linda K. *Federalists in Dissent: Imagery and Ideology in Jeffersonian America*. Ithaca: Cornell University Press, 1970.

Ketchum, Ralph. "The Education of Those Who Govern." James Gilreath, ed. *Thomas Jefferson and the Education of a Citizen*. Washington, D.C.: Library of Congress, 1999. 281–294.

Kett, Joseph. "Education." Merrill D. Peterson and Robert C. Vaughan, eds. *Thomas Jefferson: A Reference Biography*. New York: Charles Scribner's Sons, 1986. 233–251.

Knight, Edgar K. "The Evolution of Public Education in Virginia." *Sewanee Review Quarterly* 24 (1916): 24–41.

Koch, Adrienne. *Jefferson and Madison: The Great Collaboration*. New York: Oxford University Press, 1950.

———. *The Philosophy of Thomas Jefferson*. New York: Columbia University Press, 1943.

Koch, Gustav Adolph. *Republican Religion: The American Revolution and the Cult of Reason*. New York: Henry Holt, 1933.

Krieger, Leonard. *Kings and Philosophers, 1689–1789*. New York: W.W. Norton, 1970.

Kostoff, Spiro. *A History of Architecture: Settings and Rituals*. New York: Oxford University Press, 1995.

Kruman, Marc W. "The Second Party System and the Transformation of Revolutionary Republicanism." *Journal of the Early Republic* 12 (Winter 1992): 509–537.

Leibiger, Stuart. "Thomas Jefferson and the Missouri Crisis: An Alternative Interpretation" (Research Note). *Journal of the Early American Republic* 17 (Spring 1997): 121–130.

Levy, Leonard. *The Establishment Clause: Religion and the First Amendment*. 2d ed. Chapel Hill: University of North Carolina Press, 1994 (1986).

———. *Jefferson and Civil Liberties: The Darker Side*. Cambridge, Mass.: Harvard University Press, 1963; Chicago: Ivan R. Dee, 1989.

Lewis, Jan. "Jefferson, the Family, and Civic Education." James Gilreath, ed. *Thomas Jefferson and the Education of a Citizen*. Washington, D.C.: Library of Congress, 1999. 63–75.

Little, Bryan. "Cambridge and the Campus: An English Antecedent for the Lawn of the University of Virginia." *The Virginia Magazine of History and Biography* 79 (April 1971): 190–201.

Little, David. "Religion and Civil Virtue in America: Jefferson's Statute Reconsidered." Merrill D. Peterson and Robert C. Vaughan, eds. *The Virginia Statute for Religious Freedom: Its Evolution and Consequences in American History*. Cambridge, England: Cambridge University Press, 1988. 237–255.

Litwicki, Ellen Marie. "The Development of the American University: The University of Virginia, 1825–1890." M.A. thesis. University of Virginia, 1985.

Loetscher, Lefferts A. *Facing the Enlightenment and Pietism: Archibald Alexander and the Founding of Princeton Theological Seminary*. Westport, Conn.: Greenwood Publishing, 1983.

Loveland, Anne C. *Southern Evangelicals and the Social Order, 1800–1860*. Baton Rouge: Louisiana State University Press, 1980.

Luebke, Fred G. "The Origins of Thomas Jefferson's Anti-Clericalism." *Church History* 32 (September 1963): 344–354.

Maddox, William A. *The Free School Idea in Virginia before the Civil War*. Teachers' College Contribution to Education #93. New York: Columbia University Press, 1918.

Maier, Pauline. *American Scripture: Making the Declaration of Independence*. New York: Vintage Books, 1998.

Malone, Dumas. *The Public Life of Thomas Cooper, 1763–1839*. New Haven, Conn.: Yale University Press, 1926.

———. *Jefferson and His Time*. 6 vols. Boston: Little, Brown & Co., 1948–1981.

Mapp, Alf J. Jr. *Thomas Jefferson, Passionate Pilgrim: The Presidency, the Founding of the University, and the Private Battle*. Lanham, Maryland: Madison Books, 1991.

Marsden, George M. *The Soul of the American University: From Protestant Establishment to Established Nonbelief*. Oxford, England: Oxford University Press, 1994.

Marshall, Hunter H. "The Shooting of Professor Davis." *Plume and Sword* 3 (May 31, 1963): 12–22.

Marty, Martin E. "The Virginia Statute Two Hundred Years Later." Merrill D. Peterson and Robert C. Vaughan, eds. *The Virginia Statute for Religious Freedom: Its Evolution and Consequences in American History*. Cambridge, England: Cambridge University Press, 1988. 1–21.

Marvick, Elizabeth Wirth. "Thomas Jefferson and the Old World: Personal Experience in the Formation of Early Republican Ideals." James Gilreath, ed. *Thomas Jefferson and the Education of a Citizen*. Washington, D.C.: Library of Congress, 1999. 155–176.

Matthews, Richard K. *The Radical Politics of Thomas Jefferson: A Revisionist View*. Lawrence: University Press of Kansas, 1984.

May, Henry. *The Enlightenment in America*. New York: Oxford University Press, 1976.

Mayer, David N. "Citizenship and Change in Jefferson's Constitutional Thought." James Gilreath, ed. *Thomas Jefferson and the Education of a Citizen*. Washington, D.C.: Library of Congress, 1999. 221–241.

———. *The Constitutional Thought of Thomas Jefferson*. Charlottesville: University of Virginia, 1994.

McCoy, Drew. *The Elusive Republic: Political Economy in Jeffersonian America*. Chapel Hill: University of North Carolina Press, 1980.

———. *The Last of the Fathers: James Madison and the republican Legacy*. Cambridge, England: Cambridge University Press, 1989.

McDonald, Forrest. *The Presidency of Thomas Jefferson*. Lawrence: University Press of Kansas, 1976.

McLachlan, James. "The American College in the Nineteenth Century: Toward a Reappraisal." *Teacher's College Record* 80 (1978): 287–306.

McLaughlin, Jack. *Jefferson and Monticello: The Biography of a Builder*. New York: Henry Holt, 1988.

McLean, Robert C. *George Tucker: Moral Philosopher and Man of Letters*. Chapel Hill: University of North Carolina, 1961.

McLoughlin, William G. "The Role of Religion in the Revolution: Liberty of Conscience and Cultural Cohesion in the New Nation." Stephen G. Kurtz and James H. Hutson, eds. *Essays on the American Revolution*. Chapel Hill: University of North Carolina Press, 1973. 197–255.

Melton, Julius Wemyss Jr. *Pioneering Presbyter: A Collection and Analysis of the Letters of John Holt Rice*. Richmond, Va.: Union Theological Seminary, 1959.

Metzger, Walter P. and Richard Hofstadter. *The Development of Academic Freedom in the United States*. New York: Columbia University Press, 1955.

Miller, Charles A. *Jefferson and Nature: An Interpretation*. Baltimore: Johns Hopkins University Press, 1988.

Miller, Howard. *The Revolutionary College: American Presbyterian Higher Education, 1707–1837*. New York: New York University Press, 1976.

Miller, John Chester. *The Wolf by the Ears: Thomas Jefferson and Slavery*. Charlottesville: University Press of Virginia, 1991.

Minor, John B. "University of Virginia." *The Old Dominion: A Monthly Magazine of Literature, Science and Art* 4 (May 15, 1870): 260–268.

Minor, Berkeley and James F., eds. *Legislative History of the University of Virginia as Set Forth in the Acts of the General Assembly of Virginia, 1802–1927*. Charlottesville: s.n., 1928.

Moore, John Hammond. *Albemarle: Jefferson's County, 1727–1976*. Charlottesville: University Press of Virginia, 1976.

Morrison, Alfred J. *The Beginnings of Public Education in Virginia, 1776–1860: Study of Secondary Schools in Relation to the State Literary Fund*. Richmond, Va.: Davis Bottom, 1917.

Morse, Suzanne W. "Ward Republics: The Wisest Invention for Self-Government." James Gilreath, ed. *Thomas Jefferson and the Education of a Citizen*. Washington, D.C.: Library of Congress, 1999. 264–277.

Mudge, Eugene Tenbroeck. *The Social Philosophy of John Taylor of Caroline: A Study in Jeffersonian Democracy*. New York: Columbia University Press, 1939.

Noll, Mark A. "Evangelicalism." James T. Kloppenberg and Richard Wightman Fox, eds. *A Companion to American Thought*. New York: Blackwell, 1985: 221–23.

———. *Princeton and the Republic, 1768–1822: The Search for a Christian Enlightenment in the Era of Samuel Stanhope Smith*. Princeton, N.J.: Princeton University Press, 1989.

Noonan, John T. Jr. *The Lustre of our Country: The American Experience of Religious Freedom*. Berkeley: University of California Press, 1998.

Novak, Steven J. *The Rights of Youth: American Colleges and Student Revolt, 1798–1815*. Cambridge, Mass.: Harvard University Press, 1977.

Oakes, James. "Why Slaves Can't Read: The Political Significance of Jefferson's Racism." James Gilreath, ed. *Thomas Jefferson and the Education of a Citizen*. Washington, D.C.: Library of Congress, 1999. 177–192.

O'Brien, Conor Cruise. *The Long Affair: Thomas Jefferson and the French Revolution, 1785–1800*. Chicago: University of Chicago Press, 1996.

O'Brien, Michael. *Rethinking the South: Essays in Intellectual History*. Baltimore: Johns Hopkins University Press, 1988.

Onuf, Peter S. "The Founders' Vision: Education in the Development of the Old Northwest." Paul H. Mattingly and Edward W. Stevens Jr., eds. *Schools and the Means of Education Shall Forever Be Encouraged*. Athens: Ohio University Library, 1987. 5–16.

———. "The Scholars' Jefferson." *The William & Mary Quarterly* 80 (October 1993): 671–699.

———. "State Politics and Republican Virtue: Religion, Education, and Morality in Early American Federalism." Paul Finkelman and Stephen E. Gottlieb, eds. *Toward a Usable Past: An Examination of the Origins and Duplications of State Protections of Liberty*. Athens: University of Georgia Press, 1991. 91–116.

———. "Liberty to Learn." Gerard W. Gawalt, ed. *Thomas Jefferson: Genius of Liberty*. New York and Washington, D.C.: Viking Studio in association with the Library of Congress, 2000. 138–143.

———. "Thomas Jefferson, Missouri, and the 'Empire of Liberty.'" James P. Ronda, ed. *Thomas Jefferson and the Changing West*. St. Louis: Missouri Historical Society, 1997. 111–153.

Pangle, Lorraine Smith and Thomas Pangle. *The Learning of Liberty: The Educational Ideas of the American Founders*. Lawrence: University Press of Kansas, 1993.

Patton, John S. *Jefferson, Cabell and the University of Virginia: Glimpses of its Past and Present*. New York: Neale, 1906.

Peterson, Merrill D. *The Jefferson Image in the American Mind*. New York: Oxford University Press, 1962.

Pierson, William H. *American Buildings and Their Architects: The Colonial and Neoclassical Styles*. vol. 1. Garden City, N.Y.: Doubleday, 1970.

Pocock, J.G.A. "Religious Freedom and the Desacralization of Politics: From the English Civil Wars to the Virginia Statute." Merrill D. Peterson and Robert C. Vaughan, eds. *The Virginia Statute for Religious Freedom: Its Evolution and Consequences in American History*. Cambridge, England: Cambridge University Press, 1988. 43–73.

Popkin, Richard H. "George Tucker, Early American Critic of Hume." *Journal of the History of Ideas* 13 (June 1952): 370–375.

Potts, David B. "American Colleges in the Nineteenth Century: From Localism to Denominationalism." *History of Education Quarterly* 11 (Winter 1971): 363–380.

Price, P.B. *The Life of the Reverend John Holt Rice, D.D.* Richmond, Va.: Union Theological Seminary, 1963 (Reprinted from the *Central Presbyterian*, 1886–1887).

Rahe, Paul. "Church and State: Jefferson, Madison and 200 Years of Religious Freedom." *American Spectator* 19 (January 1986): 18–23.

Rakove, Jack N. "Parchment Barriers and the Politics of Rights." Michael J. Lacey and Knud Haakonssen, eds. *A Culture of Rights: The Bill of Rights in Philosophy, Politics, and Law—1791 and 1991*. Cambridge, England: Cambridge University Press & Washington, D.C.: Woodrow Wilson International Center for Scholars, 1991. 98–143.

Randall, Henry S. *The Life of Thomas Jefferson*. 3 vols. 2d ed. Philadelphia: J.B. Lipponcott, 1888 (1871).

Richard, Carl J. *The Founders and the Classics: Greece, Rome, and the American Enlightenment*. Cambridge, Mass.: Harvard University Press, 1994.

Richardson, William D. *Democracy, Bureaucracy, and Character: Founding Thought*. Lawrence: University Press of Kansas, 1997.

Risjord, Norman K. *The Old Republicans: Southern Conservatism in the Age of Jefferson*. New York: Columbia University Press, 1965.

———. "The Virginia Federalists." *Journal of Southern History* 33 (1967): 486–517.

Ritchie, John. *The First Hundred Years: A Short History of the School of Law of the University of Virginia for the Period 1826–1926*. Charlottesville: University Press of Virginia, 1978.

Robson, David W. *Educating Republicans: The College in the Era of the American Revolution*. Westport, Conn.: Greenwood Publishing, 1985.

Rorty, Richard. "The Priority of Democracy to Philosophy." Merrill D. Peterson and Robert C. Vaughan, eds. *The Virginia Statute for Religious Freedom: Its Evolution and Consequences in American History*. Cambridge, England: Cambridge University Press, 1988. 257–282.

Ross, Earle D. "Religious Influences in the Development of State Colleges and Universities." *Indiana Magazine of History* 46 (December 1950): 343–362.

Rudolph, Frederick. *Curriculum: A History of the Undergraduate Course of Study Since 1636*. San Francisco: Jossey-Bass, 1978.

———, ed. *Essays on Education in the Early Republic*. Cambridge, Mass.: Harvard University Press, 1965.

Samuelson, Richard A. "What Adams Saw Over Jefferson's Wall." *Commentary Magazine* 104 (August 1997): 52–54.

Sanford, Charles B. *The Religious Life of Thomas Jefferson*. Charlottesville: University Press of Virginia, 1984.

Schele de Vere, Maximillion. "Mr. Jefferson's Pet." *Harper's Magazine* 44 (May 1872): 815–826.

Schulz, Constance B. "Of Bigotry in Politics and Religion." *Virginia Magazine of History and Biography* 91 (January 1983): 73–91.

Schweiger, Beth Barton. *The Gospel Working Up: Progress and the Pulpit in Nineteenth-Century Virginia*. Oxford, England: Oxford University Press, 2000.

Shade, William G. *Democratizing the Old Dominion: Virginia and the Second Party System, 1824–1861*. Charlottesville: University Press of Virginia, 1996.

Shalhope, Robert E. "Thomas Jefferson's Republicanism and Antebellum Southern Thought." *Journal of Southern History* 42 (1976): 529–556.

Shawen, Neil McDowell. "The Casting of a Lengthened Shadow: Thomas Jefferson's Role in Determining the Site for a State University in Virginia." Ed.D. diss. George Washington University, 1980.

———. "Thomas Jefferson and a 'National' University: The Hidden Agenda for Virginia." *Virginia Magazine of History and Biography* 92 (July 1984): 309–335.

Sheldon, Garret Ward. *The Political Philosophy of Thomas Jefferson*. Baltimore: Johns Hopkins University Press, 1991.

———. *Jefferson & Atatürk: Political Philosophies*. New York: Peter Lang, 2000.

Sheridan, Eugene R. "Liberty and Virtue: Religion and Republicanism in Jeffersonian Thought."

James Gilreath, ed. *Thomas Jefferson and the Education of a Citizen*. Washington, D.C.: Library of Congress, 1999. 242–263.

Sherwood, Patricia C. and Joseph Michael Lasala. "Education and Architecture: The Evolution of the University of Virginia's Academic Village." Richard Guy Wilson, ed. *Thomas Jefferson's Academic Village: The Creation of an Architectural Masterpiece*. Charlottesville: University Press of Virginia, 1993. 8–45.

Simms, Henry H. *The Rise of the Whigs in Virginia, 1824–1840*. Richmond, Va.: William Byrd, 1929.

Sloan, Herbert E. *Principle and Interest: Thomas Jefferson and the Problem of Debt*. Oxford, England: Oxford University Press, 1995.

———and Peter S. Onuf. "Politics, Culture and the Revolution in Virginia: A Review of Recent Work." *Virginia Magazine of History and Biography* 91 (July 1983): 259–284.

Smylie, James H. "Clerical Perspectives on Deism: Paine's *The Age of Reason* in Virginia." *Eighteenth-Century Studies* 6 (1972–1973): 203–220.

———. "Presbyterian Clergy and Problems of 'Dominion' in the Revolutionary Generation." *Journal of Presbyterian History* 48 (1970): 161–175.

Snavely, Tipton R. *The Department of Economics at the University of Virginia, 1825–1956*. Charlottesville: University Press of Virginia, 1967.

Sonne, Niels Henry. *Liberal Kentucky, 1780–1828*. Columbia Studies in American Culture #3. New York: Columbia University Press, 1939.

Spring, Joel H. *The American School, 1642–1990: Varieties of Historical Interpretation of the Foundations and Development of American Education*. New York: Longman, 1990.

Stevenson, Louise L. "Colleges and Universities." James T. Kloppenberg and Richard Wightman Fox, eds. *A Companion to American Thought*. New York: Blackwell, 1985: 134–137.

———. *Scholarly Means to Evangelical Ends: The New Haven Scholars and the Transformation of Higher Learning in America, 1830–1890*. Baltimore: Johns Hopkins University Press, 1986.

Stone, Lawrence, ed. *The University in Society*. 2 vols. Princeton, N.J.: Princeton University Press, 1974.

Strout, Cushing. "Jeffersonian Religious Liberty and American Pluralism." Merrill D. Peterson and Robert C. Vaughan, eds. *The Virginia Statute for Religious Freedom: Its Evolution and Consequences in American History*. Cambridge, England: Cambridge University Press, 1988. 201–235.

Swift, David E. "Thomas Jefferson, John Holt Rice, and Education in Virginia." *Journal of Presbyterian History* 49 (Spring 1971): 32–58.

Tanner, Carol Minor. "Joseph C. Cabell, 1778–1856." Ph.D. diss. University of Virginia, 1948.

Tavernor, Robert. *Palladio and Palladianism*. London: Thames & Hudson, 1991.

Tewskbury, Donald G. *The Founding of American Colleges and Universities before the Civil War*. New York: Teachers College Press, 1932.

Thompson, Ernest Trice. "Moses Hoge: First Professor of Theology in Union Theological Seminary. *Union Seminary Review* 49 (1937): 21–34.

Thompson, Robert Polk. "The Reform of the College of William and Mary, 1760–1860." *Proceedings of the American Philosophical Society* 115 (June 1971): 187–213.

Trent, William P. "The Influence of the University of Virginia upon Southern Life and Thought." In Herbert Baxter Adams, *Thomas Jefferson and the University of Virginia*. Washington, D.C.: United States Bureau of Education, 1888.

Upton, Anthony Frederick. "The Political Structure of Virginia, 1790–1830." M.A. thesis. Duke University Press, 1953.

Veysey, Lawrence R. *The Emergence of the American University*. Chicago: University of Chicago Press, 1965.

Wagoner, Jennings L. Jr. "Honor and Dishonor at Mr. Jefferson's University: The Antebellum Years." *History of Education Quarterly* 26 (Summer 1986): 155–180.

———. "'That Knowledge Most Useful to Us': Thomas Jefferson's Concept of Utility in the Education of Republican Citizens." James Gilreath, ed. *Thomas Jefferson and the Education of a Citizen*. Washington, D.C.: Library of Congress, 1999. 115–133.

———. *Thomas Jefferson and the Education of a New Nation*. Bloomington, Ind.: Phi Delta Kappa Educational Foundation, 1976.

Wall, Charles Coleman Jr. "Students and Student Life at the University of Virginia, 1825–1861." Ph.D. diss. University of Virginia, 1978.

Walton, Craig. "Hume and Jefferson on the Uses of History." D. Livingstone and J. King, eds. *Hume: A Re-evaluation*. Dekalb: Northern Illinois University Press, 1976.

Welter, Rush. *Popular Education and Democratic Thought*. New York: Columbia University Press, 1962.

Wenger, Mark. "Thomas Jefferson, the College of William and Mary, and the University of Virginia." *Virginia Magazine of History and Biography* 103 (July 1995): 339–374.

Wilentz, Sean. "Life, Liberty, and the Pursuit of Thomas Jefferson." *The New Republic* 215 (March 10, 1997): 32–42.

Wiley, Wayne. "Academic Freedom at the University of Virginia: The First Hundred Years: From Jefferson to Alderman." Ph.D. diss. University of Virginia, 1973.

Williams, John Sharp. *The University of Virginia and the Development of Thomas Jefferson's Educational Ideas*. Speech delivered before the St. Louis meeting of the Association of State Universities, June 28, 1904. Charlottesville: s.n., 1904.

Wilson, Douglas L. "Jefferson and Hume." *William & Mary Quarterly* 46 (1989): 49–70.

———. "Jefferson and Literacy." James Gilreath, ed. *Thomas Jefferson and the Education of a Citizen*. Washington, D.C.: Library of Congress, 1999. 79–90.

Wilson, Richard Guy. "Jefferson's Lawn: Perceptions, Interpretations, Meanings." Wilson, ed. *Thomas Jefferson's Academical Village: The Creation of an Architectural Masterpiece*. Charlottesville: University Press of Virginia, 1993. 46–73.

Wood, Gordon S. "The Significance of the Early Republic." Ralph D. Gray and Michael Morrison, eds. *New Perspectives on the Early Republic: Essays from the Journal of the Early Republic, 1981–1991*. Urbana and Chicago: University of Illinois Press, 1994. 1–22.

———. "The Trials and Tribulations of Thomas Jefferson." Peter Onuf, ed. *Jeffersonian Legacies*. Charlottesville: University Press of Virginia, 1993. 395–415.

Woodburn, Charles O. "An Historical Investigation of the Opposition to Jefferson's Educational Proposals in the Commonwealth of Virginia." Ph.D. diss. American University, 1974.

Woods, Mary N. "Thomas Jefferson and the University of Virginia: Planning of the Academic Village." *Journal of the Society of Architectural Historians* 44 (October 1985): 266–283.

Wright, John D. *Transylvania: Tutor to the West*. Lexington: University of Kentucky Press, 1976.

Wyatt-Brown, Bertram. *Southern Honor: Ethics and Behavior in the Old South*. New York: Oxford University Press, 1982.

Yarbrough, Jean M. *American Virtues: Thomas Jefferson and the Character of Free People*. Lawrence: University Press of Kansas, 1998.

Yazawa, Melvin C. "Creating a Republican Citizenry." Jack P. Greene, ed. *The American Revolution: Its Character and Limits*. New York: New York University Press, 1987. 282–303.

## *Reference Works*

Beach, Mark, ed. *A Subject Bibliography of the History of American Higher Education*. Westport, Conn.: Greenwood Publishing, 1984.

Benedetto, Robert. *Guide to the Manuscript Collections of the Presbyterian Church, U.S.A.* New York: Greenwood Press, 1990.

Cappon, Lester J., ed. *Virginia Newspapers, 1821–1935: A Bibliography with Historical Introduction and Notes.* New York: D. Appleton-Century, 1936.

Dictionary of Virginia Biography project. @ http://leo.vsla.edu/public/vabio.html

Duncan, Richard R. *Theses and Dissertations on Virginia History: A Bibliography.* Richmond, Va.: Virginia State Library, 1986.

Martis, Kenneth C. *Historical Atlas of Political Parties in the United States Congress, 1789–1989.* New York: Macmillan, 1989.

McNeil, William H. *Population and Politics since 1750.* Charlottesville: University Press of Virginia, 1990.

Meisel, Sandy, ed. *Political Parties and Elections in the United States: An Encyclopedia.* 2 vols. New York: Garland Publishing, 1991.

Peterson, Merrill D. *Thomas Jefferson: A Reference Biography.* New York: Scribner, 1986.

Stroupe, Henry Smith. *The Religious Press in the South Atlantic States, 1802–1865: An Annotated Bibliography with Historical Introduction and Notes.* Durham, N.C.: Duke University Press, 1956.

Tanner, Douglas W., ed. *Guide to the Microfilm Edition of the Jefferson Papers of the University of Virginia, 1732–1828.* Charlottesville: University of Virginia Library, 1977.

Thurlow, C.E. et al., ed. *The Jefferson Papers of the University of Virginia Library.* Charlottesville: University Press of Virginia, 1973.

Virginia Newspaper Guide project. @ http://leo.vsla.edu/vnp/artne3.html

Wilson, Howard McKnight, ed. *Records of the Synod of Virginia: Presbyterian Church in the United States.* Richmond, Va.: Synod of Virginia, 1970.

# Index

❀

THIS SERIES EXPLORES THE HISTORY OF SCHOOLS AND SCHOOLING in the United States and other countries. Books in this series examine the historical development of schools and educational processes, with special emphasis on issues of educational policy, curriculum and pedagogy, as well as issues relating to race, class, gender, and ethnicity. Special emphasis will be placed on the lessons to be learned from the past for contemporary educational reform and policy. Although the series will publish books related to education in the broadest societal and cultural context, it especially seeks books on the history of specific schools and on the lives of educational leaders and school founders.

For additional information about this series or for the submission of manuscripts, please contact the general editors:

Alan R. Sadovnik                    Susan F. Semel
Rutgers University-Newark           The City College of New York, CUNY
Education Dept.                     138th Street and Convent Avenue
155 Conklin Hall                    NAC 5/208
175 University Avenue               New York, NY 10031
Newark, NJ 07102

To order other books in this series, please contact our Customer Service Department:

800-770-LANG (within the U.S.)
212-647-7706 (outside the U.S.)
212-647-7707 FAX

Or browse online by series at:

www.peterlangusa.com